An Enduring Vision

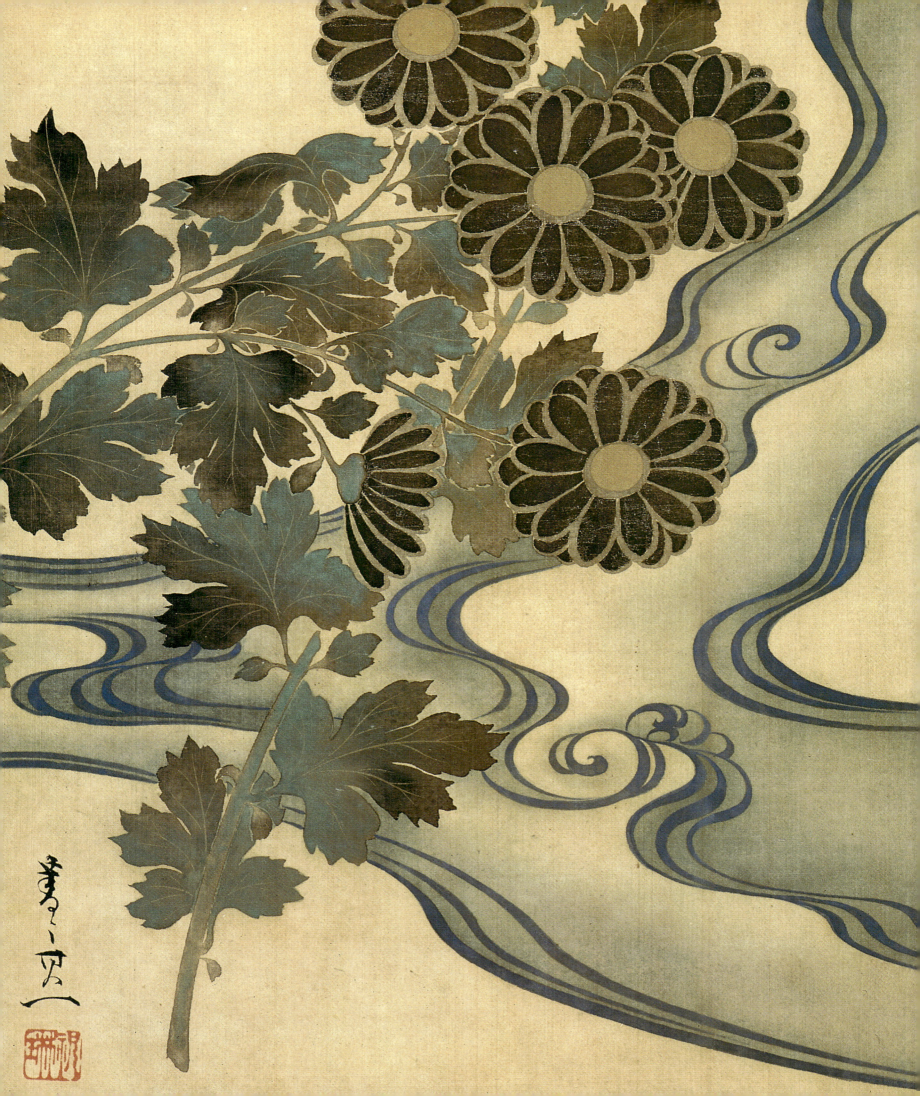

An Enduring Vision

17th- to 20th-Century Japanese Painting from the Gitter-Yelen Collection

Guest Curator

Tadashi Kobayashi

Editor

Lisa Rotondo-McCord

New Orleans Museum of Art

in association with

University of Washington Press

Seattle • London

This publication was made possible in part by funding from the E. Rhodes and Leona B. Carpenter Foundation, The Blakemore Foundation, and The Cain Foundation.

Three thousand copies of this book were published in conjunction with the exhibition *An Enduring Vision: 17th- to 20th-Century Japanese Painting from the Gitter-Yelen Collection*, organized by the New Orleans Museum of Art and presented from August 31 through October 26, 2002. The exhibition will be presented subsequently by the Seattle Asian Art Museum, April 10 through June 15, 2003, and The Japan Society, New York, March 15 through July 10, 2004.

Library of Congress Control Number: 2002 107151
ISBN: 0-89494-087-2

Distributed by University of Washington Press
P.O. Box 50096
Seattle, Washington 98145-5096

Frontispiece: Suzuki Kiitsu, *Chrysanthemums and Flowing Stream* (detail; cat. no. 95).
Page 223: Kitagawa Sōsetsu, *Flowering Sweet Pea* (detail; cat. no. 81, pl. 85).
Page 298: Obaku Taihō, *Bamboo* (detail; cat. no. 126, pl. 11).

Edited by Suzanne Kotz with assistance by Lorna Price
Proofread by Laura Iwasaki
Designed by Jeff Wincapaw
Photography by John Tsantes and Judy Cooper
Color separations by iocolor, Seattle
Produced by Marquand Books, Inc., Seattle
 www.marquand.com
Printed and bound by C&C Offset Printing Co., Ltd., Hong Kong

Contents

Foreword

Soon after I arrived in New Orleans in 1973 to assume my duties as museum director, one of our longtime trustees, Muriel Bultman Francis, took me to see a collection of Japanese art at the home of a young doctor, Kurt Gitter. His enthusiasm and knowledge immediately impressed me, as did the quality and beauty of the artworks from a culture unfamiliar to me. The instant rapport Kurt and I established, founded on a shared love of Japanese art, has become an enduring friendship of nearly thirty years. Kurt has been one of the most active collectors of Japanese art in America, pioneering the appreciation of both *nanga* and *zenga* in this country. He became a trustee of the New Orleans Museum of Art in 1975, and after many years of service he was elected an honorary life trustee in 1999. Over the past three decades, Kurt's generous donation of numerous Japanese artworks has encouraged our museum to develop one of the largest public collections of Edo-period painting in the United States.

Alice Rae Yelen joined the education department staff of the New Orleans Museum of Art in 1975, eventually becoming Chief Curator of Education. Since 1985 she has served as Assistant to the Director for Special Projects, organizing numerous exhibitions at NOMA. She is a member of many national boards, including the Institute of Museum and Library Services, the primary source of federal funding for nonprofit museums and libraries in the United States. Alice was introduced to Japanese art through her early work at the museum and became more actively involved with this material after her marriage to Kurt Gitter in 1986. Together they formed another, nationally important collection of contemporary American self-taught art.

Kurt and Alice have always been willing to share their collections with the public, and *An Enduring Vision* is the seventh exhibition organized by the New Orleans Museum of Art drawn in whole or in part from the Gitter collection. The first, which also began our museum's long collaboration with the distinguished American scholar Stephen Addiss, was *Zenga and Nanga: Paintings by Japanese Monks and Scholars* (1976). Like each succeeding exhibition, it traveled to other museums across the country, this first one to Cincinnati; Honolulu; San Diego; Portland, Oregon; and Ann Arbor. This survey exhibition was followed by *A Japanese Eccentric: The Three Arts of Murase Taiitsu* (1979); *A Myriad of Autumn Leaves: Japanese Art from the Kurt and Millie Gitter Collection* (1983), another survey of the Gitter collection; *The World of Kameda Bōsai* (1984); *Japanese Fan Paintings in Western Collections* (1985), cocurated by Kurt Gitter and Patricia Fister; and *Zenga: Brushworks of Enlightenment* (1990), cocurated by John Stevens and Alice Rae Yelen. I am proud that these beautiful exhibitions, each accompanied by a scholarly catalogue, have made a significant contribution to American understanding and appreciation of Japanese art of the Edo period.

Now comes the present exhibition, *An Enduring Vision: 17th- to 20th-Century Japanese Painting from the Gitter-Yelen Collection*. Even though this is the seventh exhibition drawn from the collection, of the 138 paintings shown here only 45 appeared in one or more of the earlier shows. This is a testament to Kurt's continuing search for new and important works, especially from traditions other than *zenga* and *nanga*. Of the twenty-five Rinpa works in this exhibition, twenty are newly

acquired; none of the fifteen *ukiyo-e* paintings has been included in previous NOMA exhibitions. The show's title not only reflects Kurt Gitter's and Alice Yelen's longtime love of and commitment to Japanese art, it also recognizes the enduring relationship between these great collectors and the New Orleans Museum of Art.

Once again the New Orleans Museum of Art is pleased to share this exhibition with other institutions: the Seattle Asian Art Museum and The Japan Society Gallery in New York. I would especially like to thank Mimi Gardner Gates and Yukiko Shirahara, respectively Director and Curator of Japanese art at SAAM, and Alexandra Munroe, Director of the Japan Society Gallery, for their encouragement and support of this project. All three institutions deeply appreciate the generous support of the E. Rhodes and Leona B. Carpenter Foundation of Philadelphia, Pennsylvania, the Blakemore Foundation of Seattle, Washington, and the Cain Foundation of Austin, Texas, for funding, in part, both the exhibition and the catalogue. We also thank the Gitter-Yelen Foundation for research preparation, photography, and curatorial assistance for the duration of this project.

Finally, I am pleased to recognize the extraordinary contribution to this project made by Lisa Rotondo-McCord, Curator of Asian Art at the New Orleans Museum of Art. Not only did she write most of the catalogue entries, she coordinated the visits and work of the curatorial team, read and edited the essays, and supervised much of the photography. Without her highly capable, professional direction, this exhibition would not have been possible.

E. John Bullard
The Montine McDaniel Freeman Director

Acknowledgments

Projects the size and scale of An Enduring Vision are products of a large and talented team. Professor Tadashi Kobayashi provided the inspiration for the exhibition during one of his visits to New Orleans. His subsequent visits proved enlightening and enriching as he shared not only his conception of the exhibition but also his vast knowledge of Edo-period art. I deeply appreciate his curatorial vision in both the selection of the works of art and the assembling of the curatorial team that contributed the essays in this book.

I am most grateful to the members of the curatorial team—Stephen Addiss, Paul Berry, John Carpenter, Patricia Fister, Patricia Graham, Christine Guth, Masatomo Kawai, Motoaki Kōno, Jōhei Sasaki, and James Ulak—who not only wrote stimulating essays but also generously shared their expertise and scholarship during the course of the project. I am likewise indebted to the scholars who worked on earlier exhibitions of the Gitter-Yelen collection, in particular to Stephen Addiss, whose association with it dates to 1976, when he curated the exhibition *Zenga and Nanga: Paintings by Japanese Monks and Scholars*. I am particularly grateful to the scholarly team Addiss assembled for *Myriad of Autumn Leaves*, the second exhibition of the collection in 1983. Their scholarship forms the foundation of many of the entries in the catalogue section of this volume; their contributions far exceed the limitations of bibliographic citation. I especially thank Jonathan Chaves, who translated many of the inscriptions for the earlier exhibitions and who graciously and expertly translated inscriptions on paintings recently added to the collection; his contributions afford both continuity and clarity. John Stevens, who also has a long relationship with the Gitter-Yelen collection, kindly provided insightful translations for many of the Zen paintings' enigmatic inscriptions. I also thank David Lanoue, who contributed several translations and welcome advice, as well as Martha McClintock, who translated the texts submitted in Japanese with efficiency, accuracy, and great skill.

My thanks also to the former curators of the Gitter-Yelen collection, Tanya Ferretto and Maiko Behr. Maiko's continued participation in the project proved an invaluable asset. I also appreciate the tremendous effort of Junko Kamata, a Ph.D. candidate at Gakshuin University, Tokyo, who read and transcribed the vast majority of the seals on the paintings in the Gitter-Yelen collection during the summer of 1999.

At the New Orleans Museum of Art, I am grateful to Director John Bullard for his unfailing support of *An Enduring Vision*. His own love of Japanese art has fueled not only this project but also the museum's own collection efforts. Thanks are also owed Judy Cooper, NOMA's photographer, for her contributions, as well as Wanda O'Shello and Aisha Champagne of the Publications Department. Wanda oversaw this project with diligence and good humor. Asian Art Department interns Jessica Abadie and Leah Levkowicz made significant contributions to this project in its inital phases. The contributions of Jennifer Smith, an Asian Art Department intern in 2001, greatly facilitated the creation of the catalogue section, a not inconsiderable feat. My thanks also to the registrar's office and exhibition staff at NOMA, who expertly handled all preparations and activities that fell under their purview.

The staff at Marquand Books created an elegant catalogue; my thanks to Ed Marquand, Jeff Wincapaw, and Marie Weiler. Our editors, Suzanne Kotz and Lorna Price, and proofreader, Laura Iwasaki, worked with skill and grace, maintaining twelve individual voices and yet creating a consistent whole.

Final and greatest thanks are owed, of course, to the collectors themselves, Kurt Gitter and Alice Yelen. Without their unfailing enthusiasm and love for the art, the collection simply would not exist. They have opened their collection, their home, and their hearts to hundreds, if not thousands, of scholars, students, and enthusiasts of Japanese art over the past decades. On their behalf, and particularly my own—thank you.

Lisa Rotondo-McCord
Curator of Asian Art and Exhibition Coordinator

Notes on Collecting

MY RELATIONSHIP WITH JAPAN, WHICH QUICKLY BECAME A SIGNIFICANT BOND, began in 1963 when I was drafted into the United States Air Force as a medical doctor. For two years, I lived with my young family in the small rice-farming village of Saitozaki, twenty miles from Fukuoka City on the island of Kyushu, facing the Japan Sea. Coming from the intensity of New York City, my hometown, I was struck by the serenity of the countryside, the peacefulness of the village, and the quiet demeanor of the people. The experience of living in an authentic Japanese home—with tatami mats, *ofuro* (sunken tub), and gardens with a fish pond—was my first step in a long process of coming to understand the aesthetics and culture of Japan. I studied the Japanese language and visited historical and cultural sites all over the country. My collecting began with ceramic pieces, acquired after I visited nearby kiln sites on Kyushu. The first important piece I purchased was a fifth-century terra-cotta *haniwa* warrior, which we still own.

My interest in collecting intensified in 1969, when I returned to Japan after a four-year absence to attend a conference on retinal diseases (my area of specialization). Since then, I have traveled annually to Japan, meeting with curators, dealers, scholars, and friends whose companionship has become a valuable component in the act of collecting. Among our long-term friendships in Japan, those with Yoshihide Idemitsu, Meiko Mukasa, and Hajime Uno remain meaningful.

Zen paintings, or *zenga*, were readily available in Japan in the 1970s. I responded in particular to their immediacy; their bold, gestural strokes seemed related to the work of abstract expressionists that I admired in New York. The *nanga* exhibition at New York's Asia Society in 1972, organized by James Cahill, was my earliest introduction to literati paintings. Initially it was difficult to learn about these areas of art, as so little was published in English. I bought Japanese books, studying their illustrations after having at least their captions translated. Eventually books in English became more available, and my tutoring continued, mostly through adept and conscientious art dealers such as Kenzaburo Marui, Daizaboro Tanaka, and the Mizutani, Yabumoto, and Yanagi families. We formed substantial relationships with dealers Fred Baekeland, Joe Brotherton, Nat Hammer, Harry Nail, Klaus Naumann, and Harry Packard. Over time, I developed associations with collectors, including Sylvan Barnett, Mary Burke, Bill Burto, Bill Clark, Willem Dreesman, Peter Drucker, Bob Feinberg, John Powers, and Joseph Price, each of whom opened their collections to us and became our friends.

My wife, Alice Yelen, studied Japanese art with Miyeko Murase at Columbia University, after having completed a master's program in museum education. In her professional career, she has organized symposia, authored catalogues, and curated exhibitions of Japanese art, including *Brushstrokes of Enlightenment*, devoted to Zen paintings. Alice brings the incisive questions of a scholar-educator to the collection and a welcome direction to our plans for it.

Since the last major exhibition of the collection (*A Myriad of Autumn Leaves*) in 1983, we have continued to expand our holdings in all schools of Edo art. We pursued the best *zenga*, *nanga*, and Rinpa paintings and acquired masterworks by Tani Bunchō, Takahashi Sōhei, Nakamura Hōchū, Hakuin Ekaku, Itō Jakuchū, Soga Shōhaku, Yosa Buson, Ike Taiga, Nagasawa Rosetsu,

and Watanabe Shikō. We have also begun to add important *ukiyo-e* works and are committed to extending our holdings into the modern periods, acquiring works by Kamisaka Sekka, Fukuda Kodōjin, Nakahara Nantenbō, Takeuchi Seihō, and others.

Simultaneously Alice and I turned toward collecting the art of self-taught American artists of the twentieth century (exhibited and published in *Pictured in My Mind*, 1995). In temperament far different from the serenity and tranquility of most Japanese paintings, this art shares their honesty, dynamism, and strong individuality. Like Japanese monks and scholars, who frequently gave their *zenga* and *nanga* works to fellow artists, admirers, students, or training monks, these American artists also created for the pure joy of individual expression.

As the collections developed, we realized the importance of sharing our resource. In 1997 we established the Gitter-Yelen Study Center, a private, nonprofit foundation dedicated to the research and study of Japanese art and American self-taught art. The foundation supports Alice's integrated view of scholarship and education. At the study center, visitors, students, and scholars may view the collection in an atmosphere that we hope approaches the refinement and openness we have experienced in Japan. The study center has become our principal focus over the last six years. More than 100 scholars and students have visited, staying from days to months. The collection is also accessible to the public, students, and scholars worldwide through our website (www.gitter-yelen.org).

In recent years, our associations with Japanese scholars, dealers, and friends have been increasingly active in our lives. Many of these relationships go back twenty or thirty years and extend beyond the borders of art scholarship into deeply personal friendships with me, Alice, and our daughter, Manya Jean. We welcomed with great pleasure the participation of Tadashi Kobayashi, Jōhei Sasaki, Masatomo Kawai, and Motoaki Kōno in this project. These four important scholars, as well as John Stevens, Atsushi Wakisaka, a Zen monk and art historian, and Yuji Yamashita, the scholar who curated our exhibition *Zenga: Return from America* (2002), have all visited our study center on numerous occasions. All have influenced and deepened our understanding. We also value our ongoing interactions with other scholars from the United States and around the world, including the distinguished contributors to this catalogue, all of whom came to New Orleans to view the art in preparation for this project. In particular, Stephen Addiss has been a close associate since 1970. His enthusiasm and knowledge are a continuing inspiration in the maturation of our connoisseurship. E. John Bullard, Director of the New Orleans Museum of Art, has been a dear friend for thirty years. He both nurtured our collecting and became enamored of the art of Japan. We have also been rewarded by our relationship with Lisa Rotondo-McCord, Curator of Asian Art at the museum, who adroitly edited *An Enduring Vision* with commitment and excellence.

We hope this catalogue and exhibition will both introduce the general public to Edo-period painting and provide deeper insights to students, scholars, and aficionados of Japanese art. Our ultimate dream is to reawaken interest in and excitement for the study and appreciation of the visual arts of the Edo through modern periods among a broader audience, who might then share with us in the pure joy of this richly creative art.

Kurt Gitter, M.D.

Chronology of Historical Periods

Japan

Protoliterate	c. 10,500 B.C.–A.D. 538
Asuka	552–710
Nara	710–794
Heian	794–1185
Kamakura	1185–1333
Muromachi	1333–1573
Momoyama	1573–1615
Edo	1615–1868
Meiji	1868–1912
Taishō	1912–1926
Shōwa	1926–1989

China

Tang	618–907
Five Dynasties	907–960
Northern Song	960–1127
Southern Song	1127–1279
Yuan	1279–1368
Ming	1368–1644
Qing	1644–1911

EDO REGNAL ERAS 1615–1868

Genna	1615–1624
Kan'ei	1624–1644
Shōhō	1644–1648
Keian	1648–1652
Shōō	1652–1655
Meireki	1655–1658
Manji	1658–1661
Kanbun	1661–1673
Enpō	1673–1681
Tenna	1681–1684
Genroku	1688–1704
Hōei	1704–1711
Shōtoku	1711–1716
Kyōhō	1716–1736
Genbun	1736–1741
Kanpō	1741–1744
Enkyō	1744–1748
Kan'en	1748–1751
Hōreki	1751–1764
Meiwa	1764–1772
An'ei	1772–1781
Tenmei	1781–1789
Kansei	1789–1800
Kyōwa	1801–1804
Bunka	1804–1818
Bunsei	1818–1830
Tenpō	1830–1844
Kōka	1844–1848
Kaei	1848–1854
Ansei	1854–1860
Man'en	1860–1861
Bunkyū	1861–1864
Genji	1864–1865
Keiō	1865–1868

Tadashi Kobayashi

For the People's Pleasure

Paintings in the Gitter-Yelen Collection

THE GITTER-YELEN COLLECTION FOCUSES ON PAINTINGS OF THE EDO PERIOD (1615–1868), a time of unusually long peace in Japan's turbulent history. For the nearly thirty years that I have specialized in the art history of this period, I have enjoyed a special relationship with Kurt Gitter, a world-renowned ophthalmologist and the force behind this collection. He is an irreplaceable friend with whom I can share discussions about Japanese art. Dr. Gitter's fervent love of Edo-period paintings is a taste rare in Japan today, and in choosing and organizing the works for this exhibition, I found myself gaining an even deeper understanding of this superb collection. The following introduction to the history of Edo-period society and its painting world also gives an overview of the special features of the Edo-period paintings in the Gitter-Yelen collection.

JAPAN DURING THE EDO PERIOD

Since the beginning of its history, Japan has responded to significant cultural influences from both China and the Korean peninsula. At times, however, the island-nation turned away from the Asian continent and, over the centuries, developed a unique culture that differs from those not only of the distant lands of America and Europe but also of its closer neighbors. During the Edo period, the Japanese emperor in Kyoto delegated administration of the country's government to the Tokugawa shogunate in Edo, and in turn the Tokugawa shogunate entrusted the country's regional government to more than two hundred clan lords, or daimyo. During the Tokugawa shogunate, Japan had no formal diplomatic relations with other countries and exercised a strict closed-country policy that prohibited its citizens from traveling overseas. Trade was also severely limited; only a few boats called each year from Chinese and Dutch trading firms, and they were restricted to the port at Nagasaki. Japanese ships could not traffic to other countries.

Japan's internal society was also closed. It was strictly arranged in a formal hierarchy of classes, with the warrior class ranking as rulers above the townspeople and peasants. Only members of the military class and higher aristocracy were allowed to carry swords and to pass on a family surname. Because class, occupation, and residence were all tightly controlled, there was little social mobility, creating an essentially stagnant society.

And yet, over the course of some 250 years, there were no wars and no major domestic conflicts. It was a period of peace and good fortune for Japan. The waterways and roads of the country were laid out and improved, and thanks to the effective shipment of goods, commercial activity burgeoned. Without the burden of wartime expense, the warrior class and commoners, especially urban merchants and tradesmen, had a particularly full lifestyle that allowed them to enjoy cultural activities in their daily lives. This era of peace provided superb conditions for the formation of Japan's distinctive culture and arts.

A similar condition had existed in the distant Heian period (794–1185), during which Japan's national culture also experienced a rich flowering. The Heian period coincided with

Pl. 1. Tani Bunchō. *Landscape Screens* (detail, cat. no. 33).

a tumultuous era in China, from the end of the Tang dynasty through the Song, and during this time diplomatic and trade activities between China and Japan diminished. For once, Chinese culture was not crossing the sea and exerting its full force on Japan, allowing the usually more assimilative Japanese to expand and develop their unique culture. The Edo period, like the Heian, was one of the few times in which Japan independently nurtured its cultural growth.

CHARACTERISTICS OF EDO-PERIOD PAINTING

Edo-period painting can be divided into two main groups: official paintings created by artists serving the military classes and unofficial works made for the pleasure of the common classes. The family of artists forming the Kanō school, established as the official painters for the military classes in the mid-fifteenth century, set the prevailing trends. It was the Kanō school that transformed Japanese painting from its Chinese origins into a wholly Japanese style. The most influential Kanō painter of the early Edo period was Kanō Tan'yū (1602–1674); his ink paintings with simplified expression and compositions with ample white space spoke of his search for a gentle, directly voiced beauty. The members of the Kanō school closely protected their painting traditions; leadership of the school passed from father to son or to a close relative. Talented outsiders might be "adopted" as apprentices. The Kanō style served as the standard for all other painters throughout the Edo period and, indeed, influenced them all to some degree.

But the Kanō school stagnated as it worked to preserve its academic style. Meanwhile, the town painters (machi eshi) who worked in the cities, supported by the commoner classes, developed into diverse, independent artists, ranging from the Rinpa school, with its affinity for a purely decorative aesthetic, to the ukiyo-e school, with its emphasis on contemporary trends and fashions,

and the Maruyama-Shijō school, with its interest in realist painting. These schools of painting boldly and directly reflected the thoughts, preferences, and aesthetic tastes of their day. Because the artists did not work for specifically determined patrons, they were free to challenge themselves, as schools of painters and as individuals, with various new experiments, bringing a lively vitality to their paintings.

In addition to these purely professional painters, intelligentsia or scholars from both the military and commoner classes created paintings for their own enjoyment. They sought to break free from the restrictions of society and turned toward the arts of other countries. These scholars felt a particular resonance with the literati painting (C. wenrenhua; J. nanga or bunjinga) popular in China from the eleventh through nineteenth centuries. They drew fresh impressions from nature and enjoyed a heightened poetic sensibility as they expressed their thoughts and moods without restraint. Painters also showed an interest in European art as introduced via Japan's trade with Holland during the Edo period. European-style painting provided Japanese artists with an opportunity to study formal scientific painting principles that incorporated visual perspective and shading. Painters working in this style sought to visually re-create the scenery of Japan and the world around them. Although instituted by individual scholars exploring personal interests, the literati and Western-painting styles eventually were adopted by professional painters, and both styles became more widely popular in Japan.

Religious activities in general were at a low ebb in the Edo period, but some members of the Zen clergy used their talents in painting and calligraphy to help educate the masses. Hakuin (1685–1768) and his disciples, and Sengai Gibon (1750–1837) are representative of these so-called amateur painters. None of them had any specialized training or painting experience. Their "artless"

approach is readily apparent in their free, bold expression, unhindered by conventional teachings or methods. Their works, appealing viscerally to their viewers, had a distinctively different look among the varied Edo painting styles.

Thus Japanese painting during the Edo period can be divided into higher and lower (official and unofficial) and elegant and worldly (classical paintings and paintings that expressed the trends and fashions of the day). As the years progressed, the unofficial, worldly paintings came to be loved by ever larger audiences.

PURE, SIMPLE, AND HONEST BEAUTY

In response to a Japanese interviewer, Kurt Gitter commented that his fascination with Edo-period painting stemmed from its "pure, simple, and honest beauty." Dr. Gitter noted that this aesthetic is shared by the contemporary American self-taught art he and his wife, Alice Yelen, also collect.[1]

Unlike Western oil paintings, the paintings of Japan and Asia rely on line and black ink, with a minimal use of colored pigments. In general, Japanese paintings are light in tone, a form of expression not suited to presenting nuances of space or a sense of weighty mass. And more so than Chinese painters, Japanese artists, particularly those of the Edo period, sought to convey a sense of reality, turning to a lighter, fresher feeling of beauty that appeals to the heart. Edo-period painting is rich with a playfulness that is easily understood by all.

Kurt Gitter began collecting Japanese art when he was stationed in Kyushu as a doctor for the U.S. Air Force in 1963–64. His collecting activities now span a full forty years. He began with examples of haniwa sculpture from the Tumulus period (fifth to sixth century) and sculptures and ceramics from the fourteenth to sixteenth centuries. Gradually, however, he came to focus on Edo-period genres such as zenga and nanga.

The Zen priests who created zenga and the scholars who made nanga were not impelled by monetary gain. Zenga were meant to teach Buddhism to the masses, while nanga were brushed for the private amusement of the scholar or poet. In large measure, these painters were self-taught, having neither teachers nor schools to refine their painting technique. Although somewhat lacking in technical skill, their paintings are individualized expressions of the artists' original views.

At the time Kurt Gitter began to collect this type of Edo-period painting, these genres were largely ignored in Japan, apart from the admiration given to a few major literati painters. Almost no other collectors competed for the zenga works that Gitter was acquiring, and in a relatively short time he was able to assemble a collection spanning the entire genre, from Hakuin to the modern Zen masters.

The fruits of this early collecting were presented to the public in the exhibition Zenga and Nanga: Paintings by Japanese Monks and Scholars, which originated at the New Orleans Museum of Art in 1976 and traveled to five other major American museums. A second exhibition, A Myriad of Autumn Leaves (1983–84), showcased the fuller formulation of the collection. More recently, in 2000, Yūji Yamashita organized Zenga—The Return from America, which opened at the Shoto'in Museum in Tokyo and traveled to two other venues in Japan. This show provided an impressive introduction to zenga paintings for many Japanese viewers, including a younger audience not usually found at exhibitions of traditional Japanese painting.

The Gitters continue to refine and expand the Gitter-Yelen collection; they have acquired a number of important works in the past decade. It was with the intention of presenting the mature configuration of the collection to the general public that I suggested undertaking the present exhibition.

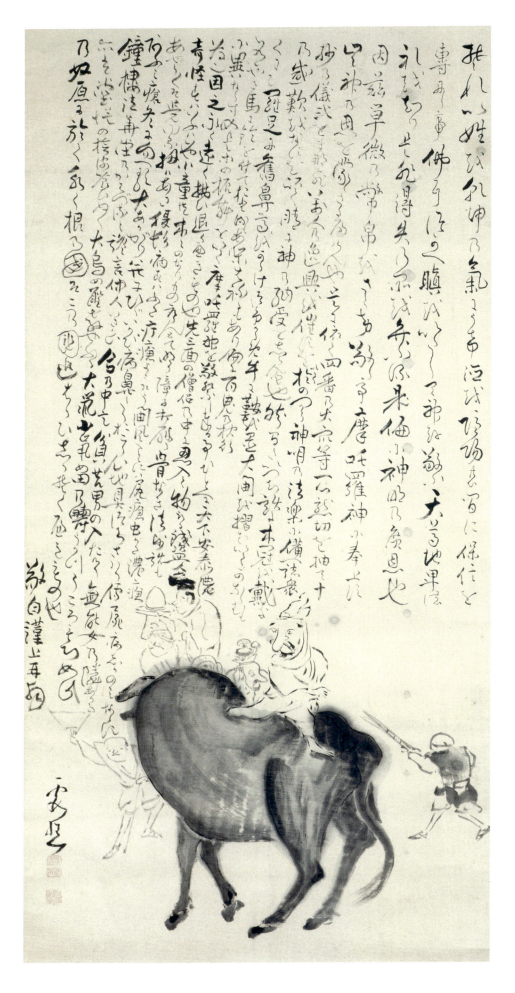

Pl. 2. Ike Taiga. *Uzumasa Festival* (cat. no. 9).

ZENGA AND NANGA

The Gitters love that which is direct and frankly honest; both lead active work lives; and they give the highest acclaim to arts that express the true character of a person, forthrightly and without artifice. Surely the best example of this aesthetic can be found in *zenga* and *nanga*.

Even if one does not know a great deal about *zenga* paintings, one senses a surpassing human spirit and character in the calligraphies of the greatly revered Hakuin, whether his massively brushed *Virtue* calligraphy (cat. no. 119) or his humorous *Seven Gods of Good Fortune* (cat. no. 124). Similarly Sengai's *Hotei Yawning* (cat. no. 134) and *Procession of Monks* (cat. no. 138), by the modern Zen monk Nantenbō (1839–1925), reveal bold, freely playful forms that are truly fun to behold. Such *zenga* images lighten and ease our hearts, often too tightly bound by the strictures of our daily lives.

In like manner we can trace the annals of *nanga* through the Gitter-Yelen collection, which provides masterworks at each stage of the genre's history. The names of Ike Taiga (1723–1776) and Yosa Buson (1716–1783) come immediately to mind when we consider the great masters of early literati painting in Japan.

While Taiga's large-scale landscape works, such as his *Lake Landscape* screen (cat. no. 7), are wonderful, I find his *Uzumasa Festival* (pl. 2) particularly fascinating. For the festival, held since antiquity at Kōryūji in Kyoto's Uzumasa district, monks don masks and ride on the backs of bulls as townspeople pull the beasts through the night streets. Taiga inscribed at the top of his hanging scroll a section of the texts offered to the gods at the festival, and the unusual manner of the calligraphy and painting is truly captivating.

Buson was an accomplished poet in haiku, the traditional seventeen-syllable Japanese form, and a famous painter. He created his own distinctive blend of haiku and painting, the *haiga*

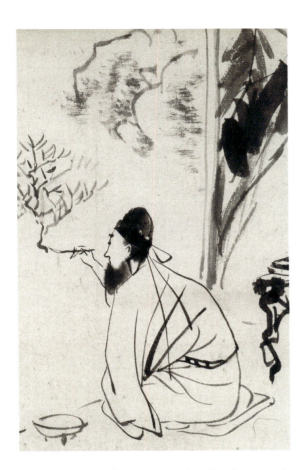

Pl. 3. Tachihara Kyōshō. *Painting a Landscape* (detail, cat. no. 42).

Pl. 4. Kameda Bōsai. *Gourd* (cat. no. 29).

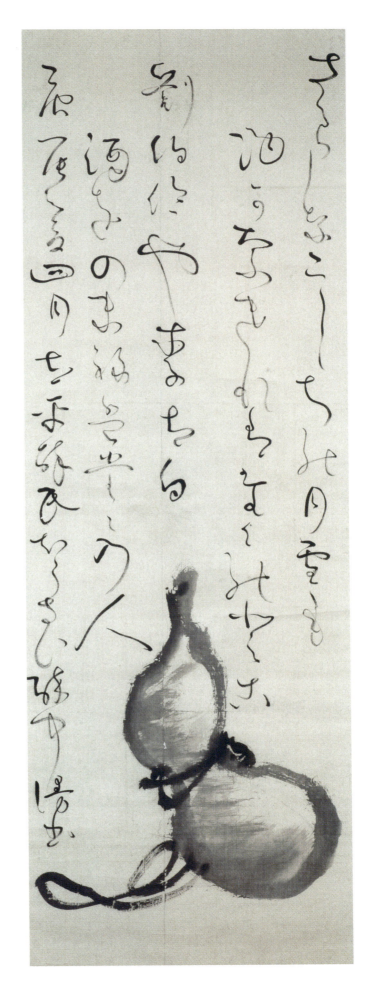

poem-painting, as seen in his *Oku no hosomichi*
(*Narrow Road to the Far North*; cat. no. 20). The
Gitter-Yelen collection also contains two major
works by Buson in the more traditional literati
style (see cat. nos. 19, 21).

There are many other noteworthy literati
paintings in the Gitter-Yelen collection. Of special
note are Uragami Gyokudō's (1745–1820) *Colors
Change from Red to Gold* (cat. no. 16), Tani Bunchō's
(1763–1840) landscape screen painting (pl. 1),
and Tachihara Kyōshō's (1785–1840) *Painting
a Landscape* (pl. 3). And for sake lovers, mention
must be made of the poet-painter Kameda Bōsai's
(1752–1826) calligraphy and painting scroll
(pl. 4) depicting a large gourd, which would have
been used to hold sake. Above it, Bōsai brushed
a brief comic poem:

> Without sake, Sarashina with its moon-
> light, snow, and flowers is just another
> place;
> Without sake to drink, Li Bo and Liu
> Ling were just ordinary men.

Bōsai, who loved sake and was a bit drunk when he painted this work (as evidenced by his signature, "painted while inebriated"), surely made a marvelous excuse for his behavior with this charming scroll.

THE REFINED PAINTINGS OF THE TOWN PAINTERS

In recent years, Kurt Gitter's and Alice Yelen's interest in Japanese painting has extended beyond *zenga* and *nanga* to include an even wider array of works by the professional town painters of the Edo period.

The Rinpa school patronized by the wealthy townspeople of Kyoto was begun by Tawaraya Sōtatsu (act. c. 1600–1640); the attributed *Four Sleepers* (cat. no. 78), with its Zen-like feel, was an early Gitter acquisition. A recent addition to the collection, Watanabe Shikō's (1683–1755) *Spring and Summer Flowers* (cat. no. 85), is a richly

decorative work in the full Rinpa tradition with its vivid depiction of colorful flowers.

The Rinpa style moved away from Kyoto when it was developed in Osaka by Nakamura Hōchū (d. 1819) and in Edo by Sakai Hōitsu (1761–1828). Not until the beginning of the Meiji era was the Rinpa style revived in Kyoto, through the activities of Kamisaka Sekka (1866–1942). Hōchū's *Flowers of the Twelve Months* screens (pl. 5), decorated with twelve fan-shaped paintings, and Hōitsu's *Triptych of Flowers and the Rising Sun* (pl. 6) are superb works that fully radiate the strengths of each artist. Hōchū's work displays a splendid use of the signature Rinpa technique of *tarashikomi* (the addition of ink or pigment to an already wet paper ground), and Hōitsu's refined sense of form and palette unifies his three hanging scrolls into an elegant composition. Sekka's *Momoyogusa* (pl. 7), three albums of woodblock prints, are a particularly noteworthy example

Pl. 6. Sakai Hōitsu. *Triptych of Flowers and the Rising Sun*
(detail, cat. no. 91).

Pl. 7. Kamisaka Sekka. *Momoyogusa* (World of Things; detail, cat. no. 97).

of the modern sensibility that is typical of the Rinpa tradition.

Another school arose in Kyoto, that known as Maruyama-Shijō, centered on Maruyama Ōkyo (1733–1795) and Goshun (Matsumura Gekkei, 1752–1811). This school emphasized the importance of sketching from life, and its adherents brought a full sense of the real into their paintings. This realism can be seen in Ōkyo's *Half-body Daruma* (pl. 8), which was painted as a *sekiga*, or a type of performance piece in which the artist created a work while others watched. The painting depicts Bodhidharma, who founded Zen and brought it from India to China; his appearance is truly foreign, as seen in the large eyes, high-bridged nose, and dense beard.

Kyoto fostered three distinctive artists—Itō Jakuchū (1716–1800), Nagasawa Rosetsu (1754–1799), and Soga Shōhaku (1730–1781)—who cannot be readily assigned to any of the prominent painting schools. Superb works by all three grace the Gitter-Yelen collection. In particular, Jakuchū's *Kanzan and Jittoku* (cat. no. 65), with its triangular rendering of two figures, reveals his truly eccentric vision. A more recent acquisition, *Boy and Ox* by Rosetsu (cat. no. 71), is fascinating for its technical display, with each of the three elements—tree, boy, and bull—depicted in a different brush style.

The *ukiyo-e* painting *Court Lady through a Round Window* (cat. no. 109), depicting a court lady in classical style, was created by Chōbunsai Eishi (1756–1829), an artist born a high-ranking

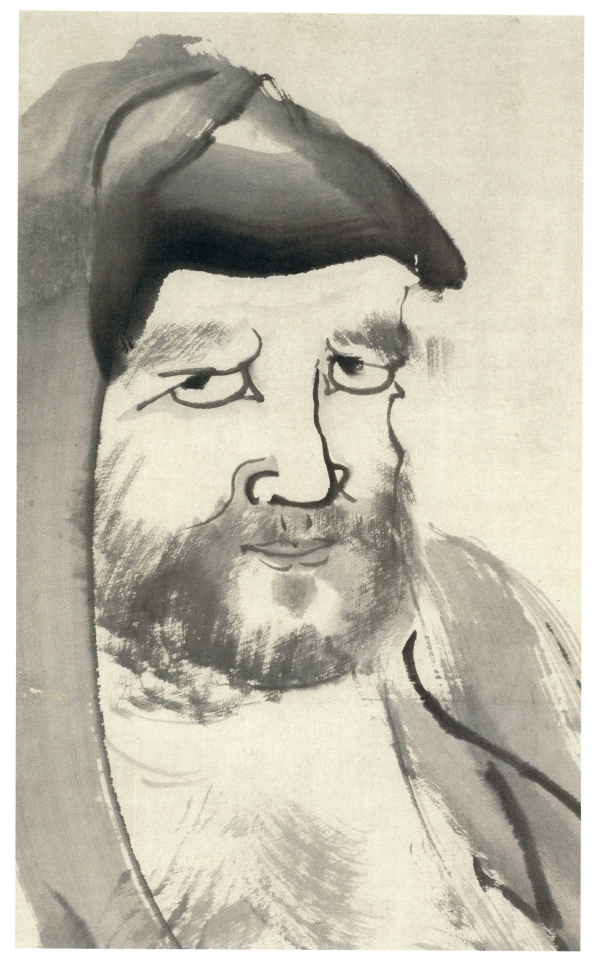

Pl. 8. Maruyama Ōkyo. *Half-body Daruma* (detail, cat. no. 55).

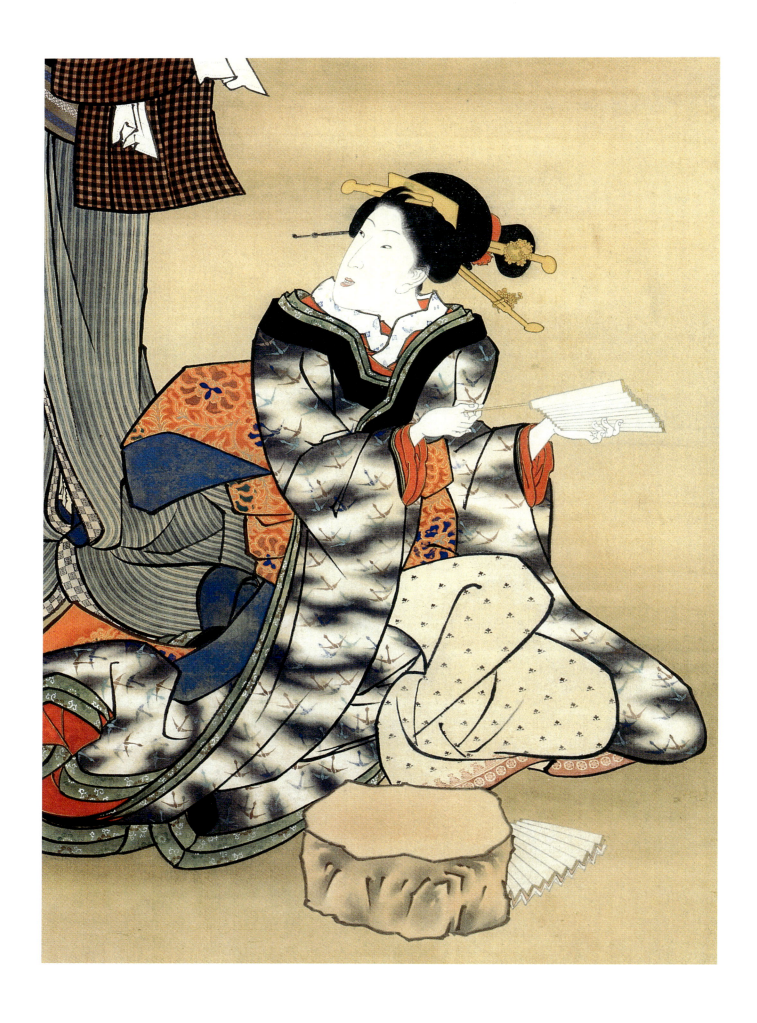

hatamoto samurai, a close attendant to the shogun. At the other end of the *ukiyo-e* spectrum is the wittily contemporary genre scene *Women Representing the Four Social Classes* (pl. 9), by the town painter Utagawa Kunisada (1786–1864), in which four women represent the Edo-period classes of samurai, farmer, craftsman, and merchant.

This exhibition does not include paintings by the Kanō artists who served as official painters to the Tokugawa shogunate or daimyo lords, or the traditional Tosa school painters who were patronized by the emperor's court. Within the realm of Edo-period art, the Gitters have instead preferred the paintings of artists who freely wielded their brushes to create images for themselves, their friends, and the general public, rather than the formal, stylized works of the official painters of the day.

Living with Paintings

In a traditional Japanese home, a *byōbu* folding screen was set up on a tatami-covered floor, and a hanging scroll of calligraphy or painting was hung in the tokonoma, the small display space designed for the appreciation of art objects. These paintings were created on silk or paper, fragile media that require special care in handling and preservation. The painting displayed in a tokonoma was thus hung for only a short period and was changed with the seasons or for a special family occasion or ceremony. When not used, screens were folded and placed in cloth bags, while hanging scrolls were rolled up and wrapped in cloth. Both formats were stored in wooden boxes made specifically to the works' measurements. They were safely kept in the family storehouse until they were needed again.

Thus paintings and calligraphy were an everyday, enriching part of the lives of ordinary Japanese citizens. In the past it was common for Japanese paintings to be created on either felicitous themes or didactic subjects. Many works, however, were created for pure enjoyment, for the pleasure of viewing them.

I believe that many of the people who deeply admire Japanese painting are those who are adept at living richly fulfilled lifestyles. These paintings were loved by the Japanese who, even if poor, would surround themselves with beauty. Such works are replete with a sense of the playful heart, for which the Japanese of the past had great sympathy. Today many individuals in Japan are over-busy, living their lives with little leisure. Given these lifestyles, it is regrettable, and yet probably inevitable, that fewer collectors in Japan today concentrate on the art of Edo and earlier periods. For me, then, the Gitter-Yelen collection, while geographically distant, exists like a splendid oasis of art where I can quench my spiritual thirst and revive my tired, parched soul.

Note

1. Tadashi Kobayashi, "Amerikan korekuta: Nihon bijutsu ni akogareta hitobito" (American collectors: People beguiled by Japanese art), *Asahi Graph* 4050 (October 1999).

Pl. 9. Utagawa Kunisada. *Women Representing the Four Social Classes* (detail, cat. no. 114).

Stephen Addiss

The Flourishing of Nanga

EACH OF THE MANY APPROACHES TO THE STUDY OF JAPANESE ART FOSTERS ITS OWN rewards. One method compares the forms of art that display a strong foreign influence with those considered more indigenous to Japan. Of course this is dangerous, since the latter forms may also once have been affected by currents from abroad.[1] Nevertheless, the manner in which Japanese artists have been able to borrow from other countries and then transform these formats and styles into something all their own is fascinating and suggests a great deal about the fundamentals of Japanese aesthetics.

In modern times, the study of foreign influences is primarily the investigation of how Japan has reacted to Western artistic values, although until the later nineteenth century, China and Korea had had the greatest impact upon Japanese culture. Korean influence is only now being thoroughly researched and acknowledged, but the impact of China has long been known and appreciated. In this exhibition, the paintings of the Rinpa, Maruyama-Shijō, and *ukiyo-e* schools are considered more Japanese in spirit; *nanga* and *zenga* are thought to be closer to Chinese literati and Chan (Zen) traditions.

What is *nanga*? The word itself is sometimes criticized as not appropriate for Japanese art. Literally meaning "southern painting," it stems from the theoretical division in China between professional artists, presumably concentrated in the north, and amateur scholar-artists of the south. Another term for this art is *bunjinga*, "literary person's painting," a designation also sometimes criticized because not all Japanese artists of this school were actually poets or scholars of high renown.

Whichever term is used, it was the renewed interest in Chinese culture during the Edo period (1615–1868) that led to the *nanga* or *bunjinga* school. The Tokugawa government's sponsorship of neo-Confucianism resulted in the training of Chinese-style scholars, many of whom developed an interest in the arts as part of their cultural world. Poetry and calligraphy came first, with painting following soon after. The importance of self-cultivation for a scholar-poet was a tenet of literati art in China; immersion in both nature and the works of the past was thought to lead to a deepening of spirit in one's own creative efforts. Professional artists might gain great skill, but it was more important to "read ten thousand books and walk ten thousand miles," according to the Chinese theoretician-artist Dong Qichang (1555–1636). Ultimately creativity stemmed from one's inner self as deepened through study of nature, the past, and other forms of art and was to be expressed naturally, without thought of success or failure. At most, it was to be shared with friends and enjoyed by other like-minded literati.

In *nanga*, the ideals of amateurism and literary connotations are therefore important, along with the belief that personal expression can be found in every stroke of the brush. In this way, the three arts of painting, poetry, and calligraphy were united in spirit, as well as in actuality, when a painting had a poem inscribed upon it. Since all three arts began and ended with brush, ink, and paper or silk, it was not a difficult stretch for a scholar or poet to move to painting as an expression

Pl. 10. Ike Taiga. *Landscape* (detail, cat. no. 4).

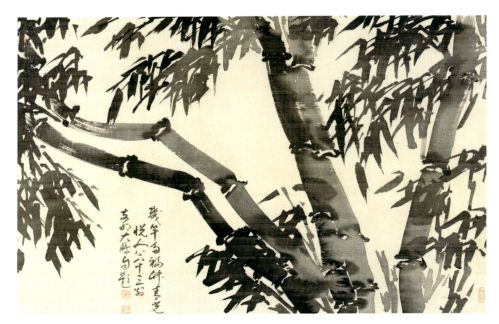

Pl. 11. Ōbaku Taihō. *Bamboo* (cat. no. 126).

their focus was not as secular as that of Confucian scholars. Nevertheless the literati subjects of bamboo and orchids[3] were painted, often with poetic inscriptions, by Japanese artists such as the monk Gyokuen Bonpō (c. 1348–c. 1420) in a manner very close to that of their Chinese literati counterparts, even though Bonpō himself never went to China. But this literati movement did not take firm hold in Japan. Instead, a form of art emerged that featured landscapes painted by monks in a semiprofessional style; these sometimes had not one but many Zen poems inscribed upon them.[4] The most famous of all Japanese painters, Sesshū Tōyō (1420–1506), was a monk who visited China, but he never seems to have met with literati artists. Sesshū later claimed to have been more influenced by the Chinese landscape itself than by Chinese painters.

The audience for painting in Japan's Muromachi period (1333–1573) was composed primarily of government officials, courtiers, and high-ranking monks rather than literati, and therefore this first opportunity for a Japanese literati painting tradition in Chinese style did not fully develop. It was not until the Edo period, when the fascination for Chinese art again became a feature of Japanese culture, that scholar painting became popular. With government support of Confucian studies, literati accomplishments such as Chinese-style poetry and calligraphy gained favor, followed shortly by painting. It is no coincidence that the *nanga* pioneer Gion Nankai (1677–1751) was the finest Chinese-language poet of his time in Japan as well as a brilliant calligrapher; his efforts at painting arose from his mastery of these two arts.

Ike Taiga (1723–1776) represents the central figure among the next generation of *nanga* artists, and he too was a brilliant calligrapher in Chinese. As a child, Taiga was a celebrated prodigy in both writing and painting, and as a result, he was taken to visit and perform for the Chinese monks at the

of his or her individual spirit. The arts were best accomplished, then, as personal and poetic responses to nature rather than at the behest of a patron. In China, however, scholars were usually supported with government positions earned through competitive examinations; in Japan, one's position was still based strongly upon heredity. Therefore literati artists, usually amateurs in China, in Japan often had to face the question of how to earn a living. Some became Confucian teachers for the shogunate or local rulers, others of samurai background held bureaucratic positions, but as time went on, many sold their paintings.[2] For this they needed patronage, which developed as more and more people became literate. Because Chinese philosophy, along with Chinese poetry and calligraphy, was a mainstay of much of Japan's quickly developing educational system, many members of the public were primed to take an interest in the literati painting tradition, long established in China, that was now making strong inroads in Japan.

Considering that in China this tradition had been flourishing for hundreds of years, we might ask not why it succeeded in Japan but rather why it took so long to become established. The question is one of fertile ground: A protoliterati movement actually occurred in Japan during the fourteenth century, when travelers to China brought back with them an interest in literati brushwork. These travelers, however, were usually Zen monks, and

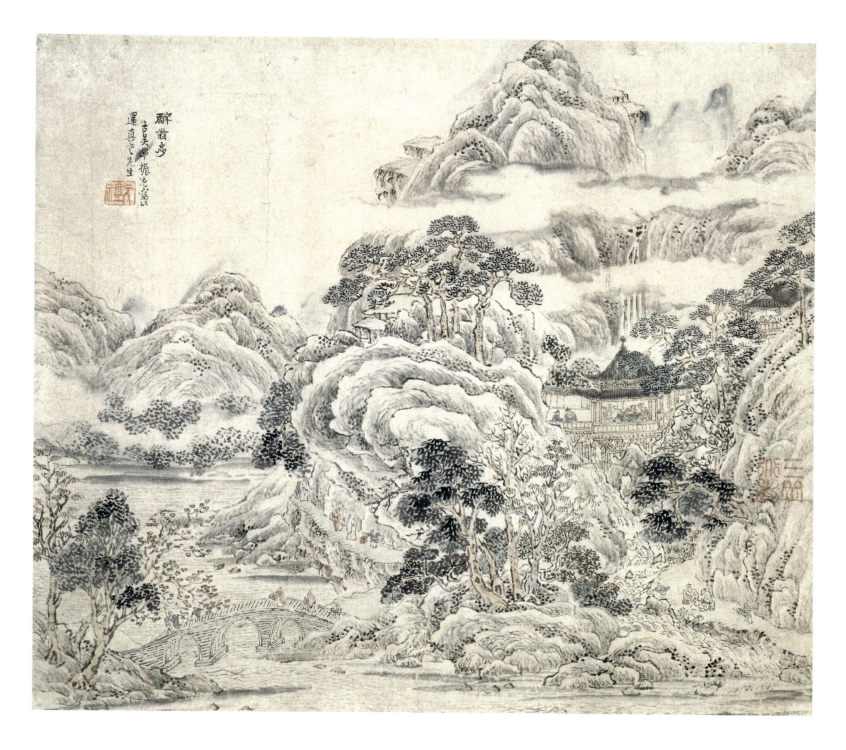

temple Manpukuji. Although Chinese traders were allowed to enter the southern port city of Nagasaki, these Ōbaku Zen monks were the only Chinese permitted within territorial Japan, and several of them were fine calligraphers and painters. The Gitter-Yelen collection includes works by Ōbaku monks such as *Bamboo* by Taihō (pl. 11); his style may have influenced some of Taiga's bamboo paintings.

The Gitter-Yelen collection is particularly strong in works by Taiga (see cat. nos. 2–10). They show not only his prowess with the brush but also the broad scope and great freedom of his style, which ranged from delicately painted landscapes in color to fluent and bold scrolls in ink. How did he learn this rich and intricate literati tradition? One way was through seeing and copying a few original Chinese paintings, as he did for his *Zuiweng Pavilion* (pl. 12). Here we can see a complex buildup of small strokes of the brush to create a rather delicate and somewhat bland composition, but Taiga was to utilize many of its motifs, such as the small figures, the patterns of tree foliage, and the small pavilion, in his own landscapes.

Pl. 12. Ike Taiga. *Zuiweng Pavilion* (cat. no. 2).

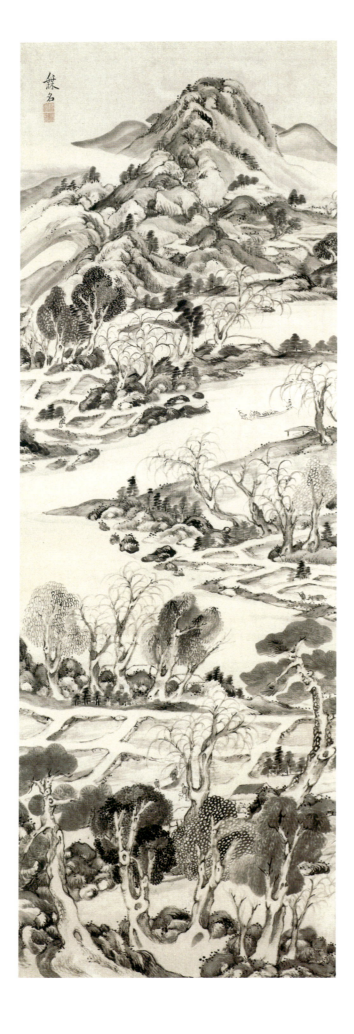

The more dramatic features that appear in Taiga's most visually compelling works are fully evident in his *Ink Landscape with Rice Fields* (pl. 13), a true tour de force of *sumi* (Japanese monochrome ink) painting. At the bottom of the scroll, Taiga has painted a row of trees, each with its own pattern of foliage set behind its trunk to expose their powerful forms clearly. Next come rice fields, now viewed from above in a new perspective. Higher in the painting, the viewpoint again changes, so in effect, we are not stationary, as in Western one-point perspective, but move up and down as well as across the painting. Every form seems to have a sense of movement, and the different tonalities of gray-to-black ink tones also help give this landscape its amazing variety, which clearly demonstrates Taiga's creative mastery of composition as well as brushwork.

Taiga's works became so popular that they were copied and forged in large numbers even during his lifetime, making connoisseurship difficult.[5] In the late 1950s, a group of Taiga scholars gathered together to publish as many genuine works of Taiga as they could locate, under the stipulation that only paintings and calligraphy authenticated by at least three of them could be included. Many works were not available for their research at the time, but the resulting portfolio edition, *Ike Taiga gafu* (Ike Taiga painting album; 1957–59), republished in smaller form in 1960 as *Ike Taiga sakuhin shū* (Collection of works by Ike Taiga), contains 811 works, several of which are in the Gitter-Yelen collection. Number 631 in this compendium is a landscape (pl. 14) that shows many of the artist's characteristic forms, including the broad outlines of rocks and mountains; the cluster of trees, each with its own distinct foliage pattern; the empty space indicating a waterfall; and the dashes and dots creating texture strokes to help define the landmasses. A sage-poet crosses a bridge toward a Chinese-style pavilion, and Taiga's inscription consists of the third and fourth

Pl. 14. Ike Taiga. *Landscape* (cat. no. 4).

lines from a classic poem of farewell by the Tang-dynasty master Wang Wei.

> *Seeing Off Inspector Li of Zizhou*
> In ten thousand gullies, trees pierce sky;
> A thousand mountains echo with
> cuckoos' songs.
> Half the mountains are covered with
> rain;
> At the tips of those trees, thousand-foot
> waterfalls.
> Women of the Han Valley pay tribute
> in Tong-tree cloth;
> Men of the Ba region sue each other
> over the taro fields.
> Wen Weng transformed the folk
> through educating them;
> Dare you fail to follow this former sage?[6]

The somewhat similar *Spring Landscape* by Taiga (pl. 15; *Sakuhin shū*, no. 76) is dated the second month (corresponding to our March–April) of 1760. Again, trees in a cluster are distinguished by varying foliage, and once again a pine tree is the tallest among them. This pine, however, is set off from the other trees by a horizontal branch that creates a strong compositional force. Now the pavilion is tiny and placed near the top of the painting, and a boat on the left is rather playfully located in space, moving at a strong diagonal to the picture plane. This landscape therefore conveys more of a sense of movement than does the previous, more serene scroll, and it has stronger contrasts of black and gray ink tones.

We may well compare several works of Taiga's pupils to this landscape. Taiga's poet-painter wife Gyokuran (1727/28–1784) followed her grandmother Kaji and her mother Yuri by specializing in five-line classical *waka* verse; she helped teach Taiga this tradition, while he instructed her in painting. Gyokuran's *Mountain Landscape* (pl. 16) has many of the features just mentioned, including a cluster of trees with a tall pine, a pavilion set high

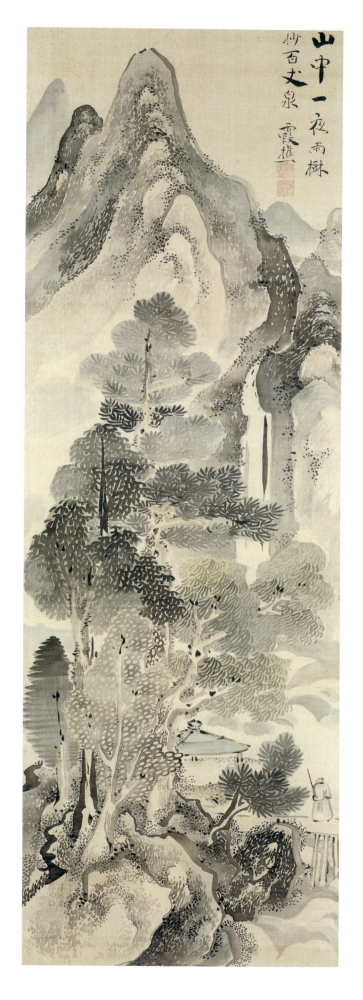

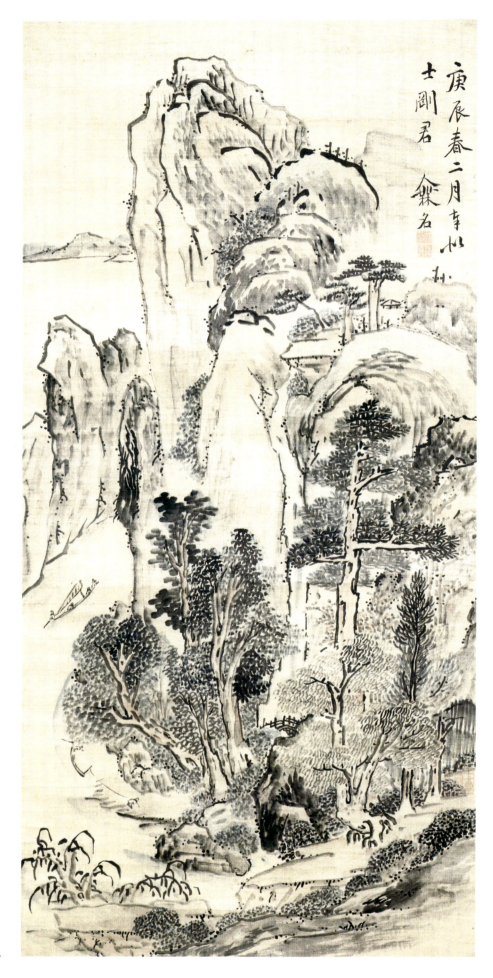

Pl. 15. Ike Taiga. *Spring Landscape* (cat. no. 5).

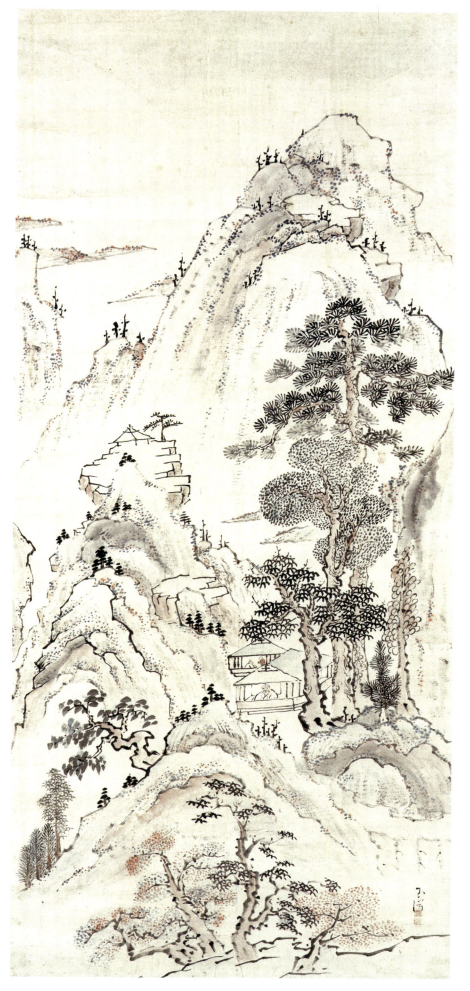

Pl. 16. Ike Gyokuran. *Mountain Landscape*
(cat. no. 11).

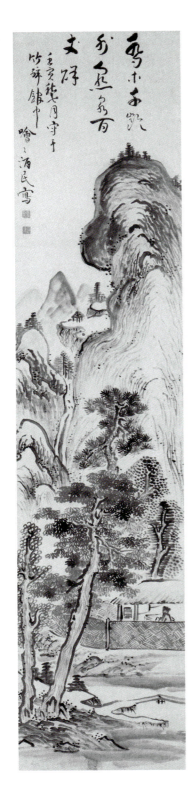

Fig. 1. Satake Kaikai. *Landscape with Man in Hut*. Hanging scroll: ink and light color on paper, 135.3 × 29.5 cm. Gitter-Yelen collection.

in the cliffs, and mountain masses structured in a similar fashion. Her texture strokes, however, are made up almost entirely of color dots, and her trees and rocks seem less integrated and more mannered, as though she painted them as distinct elements to be enjoyed on their own. In this way, her landscape moves away from the organic toward fantasy while still maintaining an appealing immediacy.

Another pupil of Taiga was Satake Kaikai (1738–1790), who sold sake in the same Gion park in Kyoto where Gyokuran (and her mother and grandmother before her) ran a teashop not far from the cottage home of Taiga and Gyokuran. Kaikai's *Landscape with Man in Hut*, painted in the seventh month of 1782 (fig. 1), repeats the basic composition of the previous two works, including the tall pine, lofty mountains, and a tiny pavilion high on a plateau. The brushwork here, however, is broader and wetter than that of Taiga or Gyokuran, and the texture strokes are in the so-called tangled hemp-fiber tradition, creating a more dramatic but less firmly structured scene than ones by Taiga or Gyokuran. Kaikai, like Taiga and Gyokuran, was an expert in fan paintings, and his *Peach Blossom Landscape* (pl. 17) shows his brushwork at its most delightful. The riverbank is enhanced by three blossoming peach trees, recalling the famous poem by Tao Yuanming about a fisherman discovering a forgotten, idyllic village surrounded by peach blossoms. Kaikai's brushwork is crisp and slightly angular; the single poetic line of calligraphy reads:

> The banks are lined with flowering
> peach—
> embroidered ripples rise.

Aoki Shukuya (1737?–1802), another of Taiga's pupils, was skillful at the challenging curving format of the fan. His *Lanting Pavilion* of 1795 (pl. 18) is really a large work in a small size, showing the masterful calligrapher Wang Xizhi

writing his *Orchid Pavilion Preface*, while below the pavilion, wine cups are floated on lotus leaves to poets sitting beside a stream. They are required to drink the wine if they cannot come up with a verse before the cup passes them. Yet this famous scene (often painted by Taiga) is given only the center of the format; groups of trees and rocks painted with "pepper-dot" strokes flank the poets, and double dots of green within black add visual accents. The use of color on the jackets of the tiny figures helps to punctuate the composition; otherwise they might be totally lost within nature.

The monk Kanryō (1753–1830), one of Taiga's last pupils, also helped officiate at his funeral. Kanryō's works now remain mostly in the Notō Peninsula, where he served at a small temple after leaving Kyoto, but the Gitter-Yelen collection features one of his strongest landscapes in a horizontal format (pl. 19). We see a composition that owes much to Taiga, with clumps of trees in different foliage patterns, rising above them a pine, small figures, and the tangled hemp-fiber strokes texturing the rocks and mountains. As in the landscapes by Gyokuran, Kaikai, and Shukuya, light colors add charm to the scene, and in comparison with Taiga's landscapes, the motifs are more distinct, with less effort to integrate them as fully into the total composition.

These works, like all landscape paintings, ultimately refer to the interconnection between humans and nature; even if there were no figures, first the artist and then the viewers interact imaginatively within the space. We can also see that each artist, and each work, displays a personality that is unique in interpreting this interconnection. The more we look, the more individual characteristics we will find; this very important feature of *nanga* stems from the belief that each stroke of the brush reveals the inner qualities of the artist.

Returning to Taiga: he was expert not only at the favored theme of landscape but also at the Confucian theme Four Gentlemen: bamboo,

Pl. 17. Satake Kaikai. *Peach Blossom Landscape* (cat. no. 13).

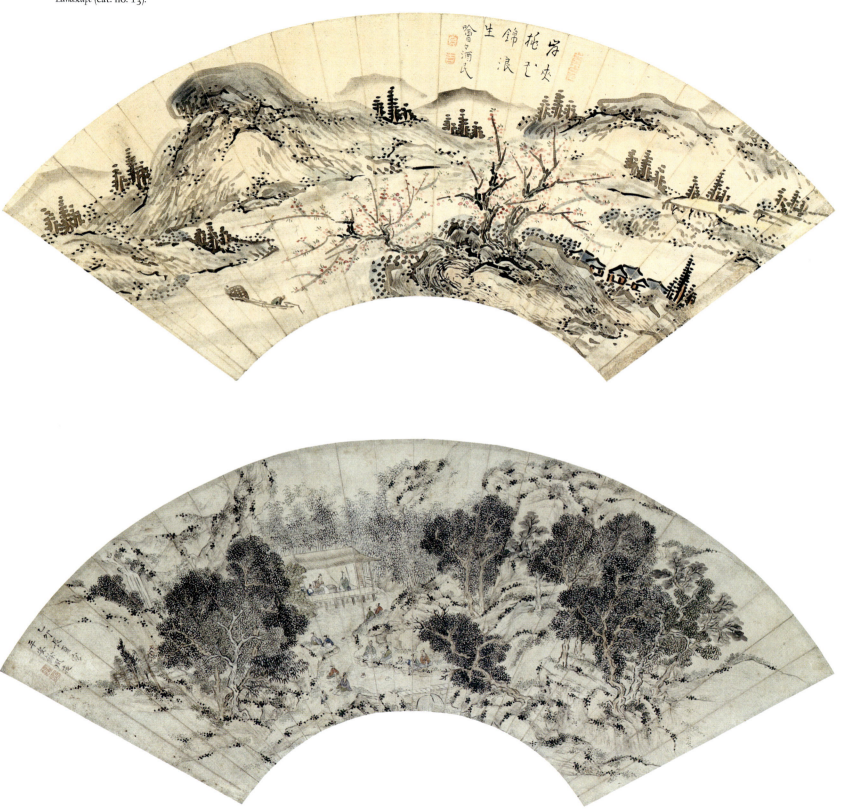

Pl. 18. Aoki Shukuya. *Lanting Pavilion* (cat. no. 12).

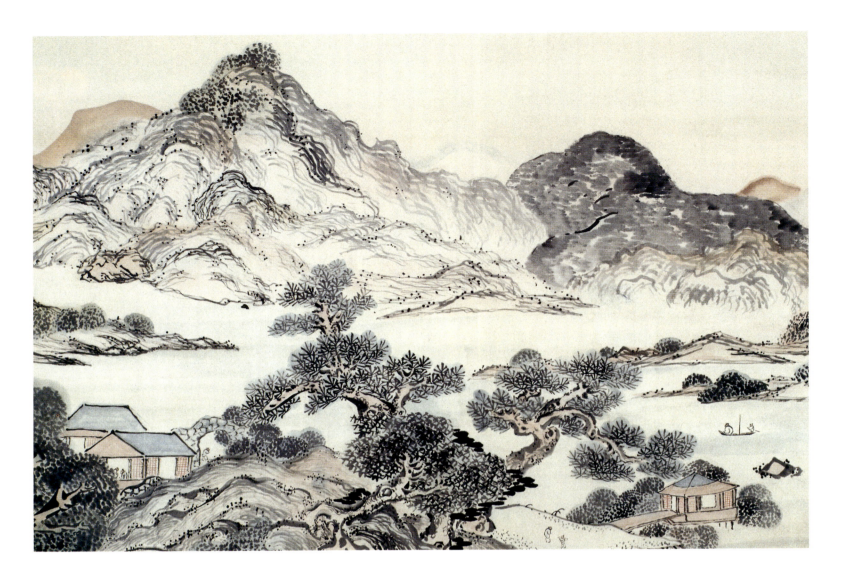

Pl. 19. Ike Kanryō. *Landscape*
(detail, cat. no. 14).

orchids, plum blossoms, and chrysanthemums. It
is significant that bamboo and orchids were now
being depicted frequently by *nanga* masters such as
Nankai and Taiga, since they had mostly died out
as painting subjects after the time of Bonpō. Taiga's
Orchids in a Vase (pl. 20; *Sakuhin shū*, no. 288) shows
his literati spirit, with the flowers growing out
of a Kangxi-style crackleware vase in a display
of brushwork both lively in lineament and subtle
in ink tones. The painting was done quickly, so
where strokes overlap we can sometimes see the
ink merging, while the orchid flowers create a
kind of expressive punctuation amid their long,
curving leaves. Taiga's signature also uses "orchid-
leaf" lines, integrating it with the painting style.

 Above the painting is a Chinese-style quatrain
by Taiga's good friend Kan Tenju (1727–1795),
a noted calligrapher who was also a painter and
seal carver:

The dancing goddess once came to him
 in a dream
And the man from Chu was overcome
 with love.

Try tying this waist ornament from the
 banks of the Xiang:
Mysterious fragrance blooming in purple
 flowers.

Nanga is not usually thought of as sexy, but this
poem compares orchids with the alluring goddess
of the Xiang River in the region of Chu. The poet
drops a waist ornament into the river as an offer-
ing to her, and the sinuous orchid becomes both offer-
ing and the goddess, the "divine woman" herself.

 Another Four Gentlemen subject that Taiga
often painted was the chrysanthemum, which
blooms even in the cold of late autumn to early
winter. A master of fan painting, Taiga painted

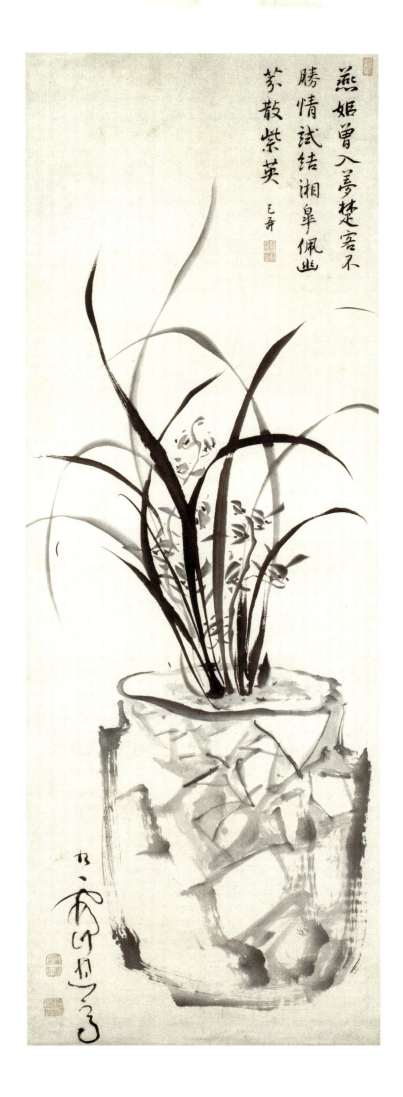

燕姫曾入夢楚客不
勝情試結湘皋佩幽
芳散紫英　己奇

Pl. 20. Ike Taiga. *Orchids in a Vase*
(cat. no. 6).

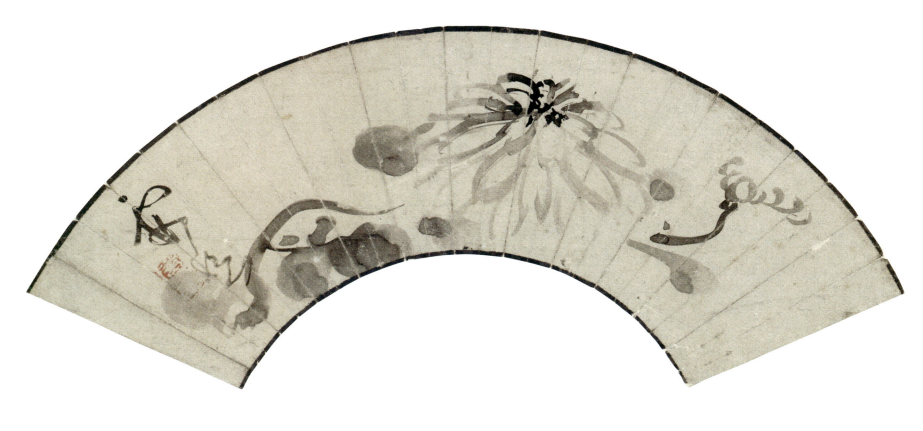

Pl. 21. Ike Taiga. *Chrysanthemum*
(cat. no. 8).

Chrysanthemum (pl. 21) on the special mica surface that allows the ink to dry more slowly than does the usual paper or silk. This can create the effect called *tarashikomi*, in which one layer of ink or color puddles over another, giving a rich and soft effect that Taiga gently exploits in this fan. He needs only two flowers, one of them fully open, a twisting stem (which echoes his signature), and a few leaves to attain a result akin to a musical composition in which one element flows into another with the grace of a fine melody.

Taiga did not only paint Chinese-derived themes; his work includes a number of "true view" paintings of Japanese scenery[7] as well as other Japanese subjects such as Kyoto's delightful Uzumasu (Bull) Festival (pl. 2). Here we can see seven humorously depicted figures in the festival, some wearing masks or helmets and one riding

backward on a bull. The long text in Taiga's idio-syncratic calligraphy is part of the *saimon* (incantation) with which the Shinto priest attempts to drive away many kinds of illnesses, devils, and other misfortunes. The rough style of brushwork shows Taiga deliberately countering any attempt to make his painting "pretty"; instead he captures the rustic vitality of the scene on its own terms.

In another boldly brushed ink painting (pl. 22), Taiga depicts Mibu Kyōgen, a form of folk theater that is still performed for one week every spring on the balcony of one of the halls at Mibu Temple in Kyoto. Taiga depicts three of the musical and dramatic performers and their audience, which seems to be made up of children, or of adults who are childlike in their happy responses and eager-ness to come as close as possible to the entertain-ment. The inscription in Japanese plays on the

Pl. 22. Ike Taiga. *Mibu Kyōgen* (cat. no. 10).

idea of response and reflection: "Where water does not gather, the moon does not dwell."

The style of both these ink paintings is somewhat akin to *zenga*, which is noted for its relaxed and spontaneous freedom instead of a concern for elegant strokes of the brush. Taiga was highly impressed by meeting the Zen master Hakuin in 1751 (see cat. nos. 118–125). Perhaps from his exposure to Zen and Zen art, Taiga's brushwork style in later years was often bolder and rougher than before, especially in his ink paintings of figures.

The largest of Taiga's paintings in this exhibition is a six-panel screen (possibly cut down from *fusuma* sliding panels) that returns us to the theme of landscape (pl. 23). The broad, curving strokes depicting the trees may remind us of orchid leaves, and they seem to lean and gesture over the waterside building and the boat, leading the eye to the scenery on the horizon. Taiga may well have painted the rather large number of charming figures in the screen with his fingernails; as a young artist, he was celebrated for finger painting, a technique that came from China but which Taiga utilized in his own way. Perhaps most notable in this screen, however, is the use of space, in which the motifs created freely with ink and light colors seem to float playfully in an ideal world of art and nature. This was but one of the artist's many creative gifts; when examining his work as a whole, it seems fair to nominate Taiga as the *nanga* master with the greatest scope and range of talents.

The artist from the next generation of *nanga* who is now most admired was not a direct follower of Taiga but the self-taught painter Uragami Gyokudō (1745–1820).[8] He was born into a samurai position for the Ikeda clan in Bizen, and as a young man, he accompanied his daimyo on the required half-year stays in Edo, where the shogunate could watch over all feudal lords to forestall any possibilities of rebellion. In the new capital, Gyokudō studied the seven-string *qin* (J. *shichigenkin*), a form of zither that produced quiet, low, meditative

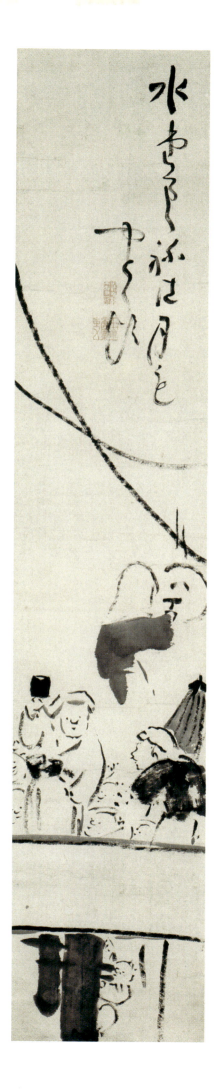

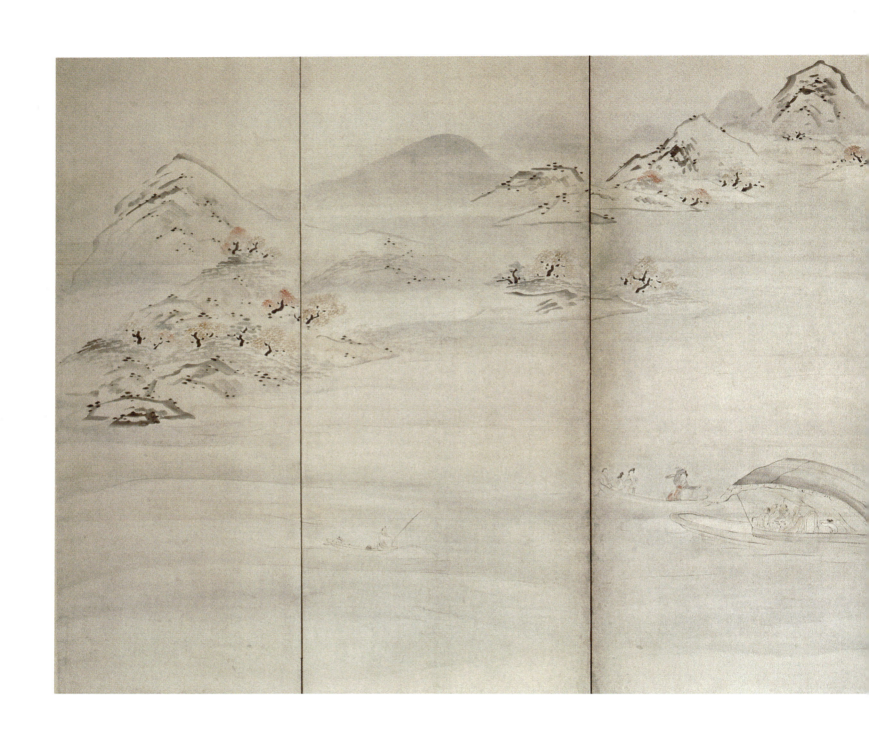

Pl. 23. Ike Taiga. *Lake Landscape* (cat. no. 7).

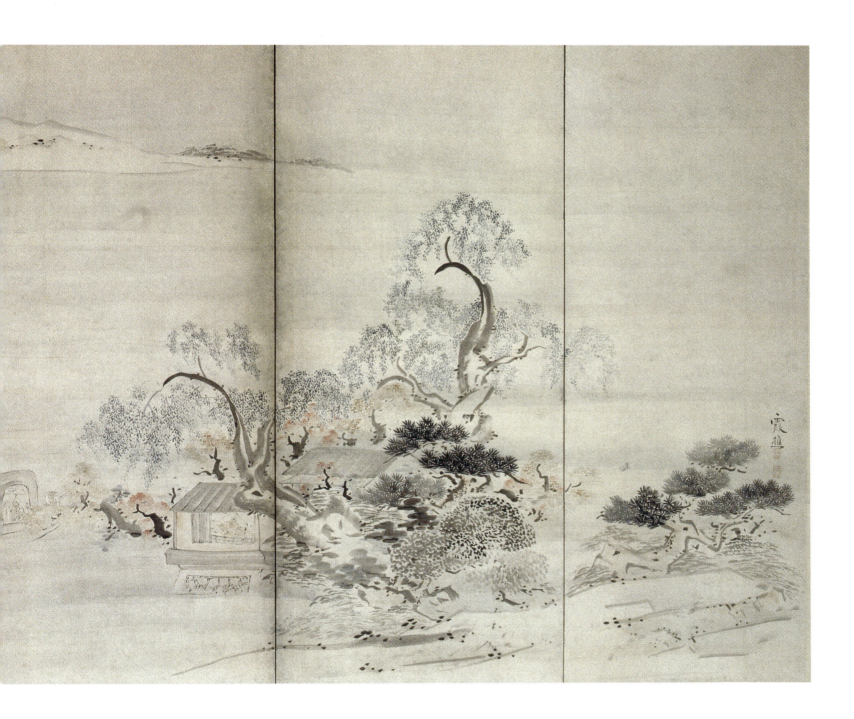

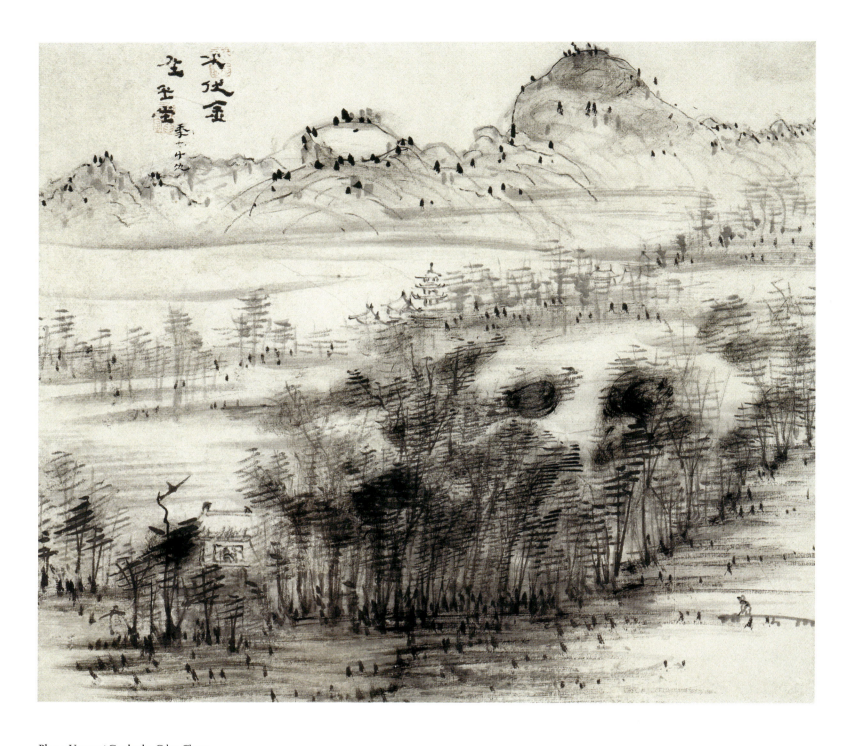

Pl. 24. Uragami Gyokudō. *Colors Change
from Red to Gold* (cat. no. 16).

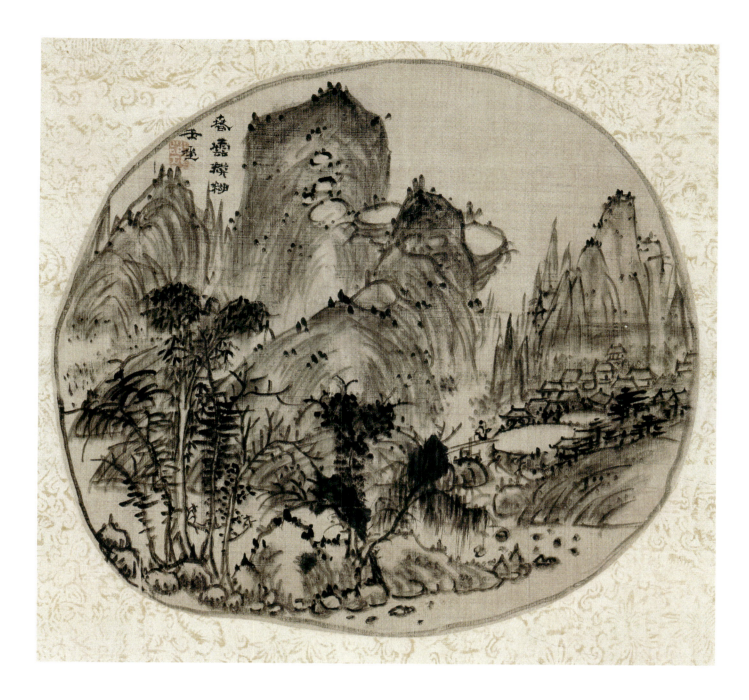

Pl. 25. Uragami Gyokudō. *Spring Landscape* (cat. no. 17).

music and was played for oneself or a close friend. He gradually added poetry, calligraphy, and finally painting to his creative life, and he took the rare step of giving up his samurai status at age fifty[9] in order to wander through Japan for seventeen years with his *qin* and brushes. He spent his final years in Kyoto with his painter-son Shunkin (Spring Qin), by which time Gyokudō had mastered a personal style of landscape painting that featured overlapping brushstrokes of great rhythmic intensity.[10]

Both Gyokudō works in this exhibition are from his final decade. In *Colors Change from Red to Gold* (pl. 24), painted at age seventy, he sets up a powerfully shimmering wall of foliage across the foreground, a lighter screen of trees in the middle ground, and a rhythmic row of mountains and plateaus in the distance. A tiny sage on the bridge in the lower right, a favorite motif of the artist, pauses in front of the scenery, which is grand in scope within the small format of the work.

Spring Landscape (pl. 25) was painted perhaps two or three years later and displays equally dynamic brushwork on the medium of silk, a choice rather rare for the artist. Gyokudō painted this work within a drawn circle, perhaps a reference to the Chinese fan shape, or possibly just a

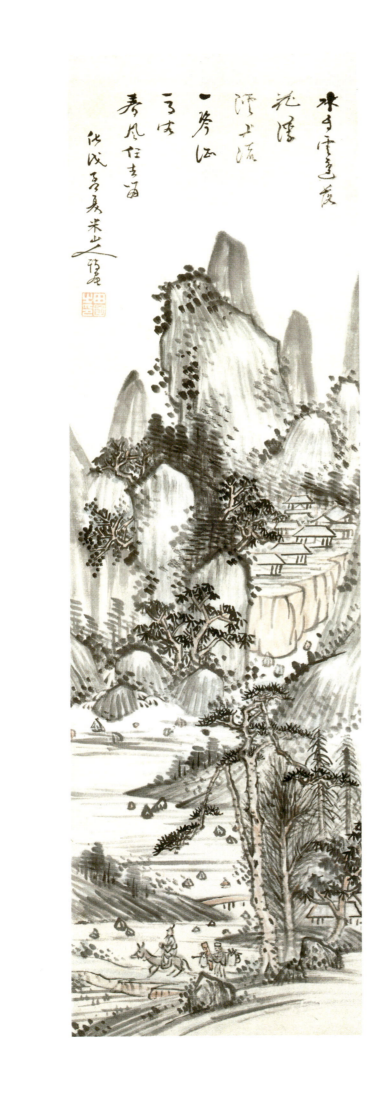

Pl. 26. Okada Beisanjin. *Landscape* (cat. no. 18).

boundary that he could use to enclose (and by contrast increase) the great sense of latent energy in his brushwork. Nature almost overwhelms the human element in Gyokudō's world; houses and people are sometimes almost obliterated by trees and rocks. His landscapes were too intense and individualistic to be much appreciated in his own time except by fellow artists, but today Gyokudō is considered one of the great masters in Japanese history.

How was *nanga* learned and disseminated? Although considered a school of Japanese painting, it was quite different from the family-oriented schools such as Kanō and Tosa, with their strict methods of teaching through copybooks and apprenticeship. Literati painters were mostly self-taught or learned informally from one another, and even father-and-son painters such as Okada Beisanjin (1744–1820) and Okada Hankō (1782–1846) developed their own distinctive styles.

Beisanjin was a rice merchant in Osaka who seems to have preferred painting, poetry, and calligraphy to his business. *Landscape* of 1814 (pl. 26) demonstrates his personal form of rather blunt calligraphic brushwork, with broad parallel lines helping to define rock and mountain masses, and overlapping strokes and dots creating a sense of texture. At the top of the scroll is Beisanjin's Chinese poem, structured in four lines of five words each, but here written from top right in columns of 5-2-3 and 3-2-5 characters, creating an archlike form that hovers over the mountains:

> Water falls beside the clouds;
> flowers fill the stream, and flow.
> A wanderer at sky's edge, with only his
> single lute:
> like the spring wind, he just comes and
> goes.[11]

In contrast to his father, Okada Hankō was more conservative in his painting, and he became a leader in the more sinophile trend in *nanga* that

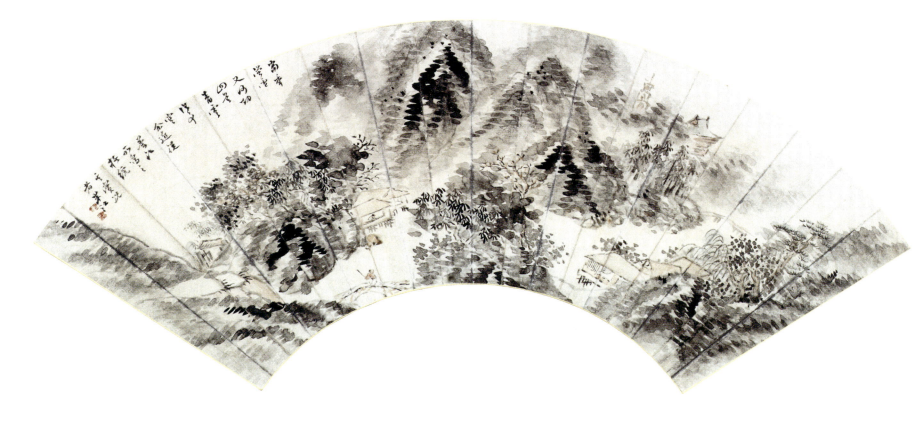

Pl. 27. Okada Hankō. *Landscape* (cat. no. 39).

took place in the third generation of literati artists. He mastered the wet horizontal ink-dot (Mi dot) method associated with the early Chinese masters Mi Fu and his son, Mi Youren, and for it created a number of variations and transformations. One of his most ambitious scrolls is *Village among Plum Trees* of 1838 (pl. 44), in which a river valley divides imposing cliff and mountain forms. The contrast of landmasses painted in ink and the bridges, huts, and blossoming plum trees in light colors gives this work its sense of visual drama. Hankō's poem refers to Wang Mian, a Yuan dynasty Chinese painter who specialized in plum blossoms; he came to represent the pure scholar-artist:

> Wang Mian was unwilling to pass down
> his wonderful technique

And so today there is no one who
 can paint the Immortal of Luofu
 Mountain;
But I have managed to achieve a few
 good brushstrokes
And now three hundred years have been
 added to the plum blossom's life.

Hankō's painting of a landscape in the format of a fan (pl. 27) shows even more clearly the artist's use of Mi dots. Here they not only represent both mountains and the foliage of trees, but they also help to create the structure of the total composition through the different tones of black and gray ink. By utilizing his own variations of the Mi dot technique, Hankō paid his respects to the past while creating a visual world of his own.

As noted at the beginning of this essay, many of the arts of Japan took their initial inspiration

from China, or China and Korea, but a process of transformation always took place to satisfy the indigenous Japanese aesthetic. When comparing *nanga* with continental literati works, however, sometimes the differences are more easily felt than described, and so these concluding remarks must be considered provisional.

Perhaps the most salient feature that distinguishes much *nanga* from Chinese literati painting is the contrast between the continental emphasis on brushwork and the greater Japanese concern for total emotive effect. Chinese scholar-artists, trained in calligraphy since childhood as part of their Confucian education, seem to value the brushstroke above all, and their paintings are usually constructed of a large number of well-considered strokes that systematically create the total composition. In contrast, Japanese *nanga* masters seem more concerned with the total effect that the painting offers the viewer, even if some strokes of the brush might seem unusual or imperfect at times. In addition, there are likely to be fewer brushstrokes and more empty space. As the scholar John Rosenfield has written so tellingly about Japanese art, "The greater the power of poetic inspiration, the less the need for pictorial detail."[12]

Chinese paintings therefore often invite the viewer to examine them carefully at close range; Japanese scrolls make more of their impact at first sight. Of course a good *nanga* painting will always repay further viewings; this is one of the special features of the tradition. Yet it still can have an immediate impact that may be, in a sense, more than the sum of its parts. The Chinese works can be said to appeal more strongly to the mind and *nanga* to the emotions, but of course there are bound to be exceptions to any such generalizations. Many nineteenth-century *nanga* painters, for example, were more conservative than artists such as Taiga and adhered more closely to Chinese precedents. The beautifully constructed works of Yamamoto

Baiitsu (1783–1856; see cat. nos. 40, 41), for example, can be subjected to intense scrutiny and never falter, while paintings by some Chinese individualists such as Shitao (1642–1718) may offer as dramatic an impression as any *nanga* work. Nevertheless, a different aesthetic usually prevails in the two countries, and it often becomes apparent in literati painting; while Chinese works are most often constructed of controlled and refined brushwork, *nanga* paintings tend to be less architectonic and to inhabit the pictorial space more loosely and freely. The works of Taiga and his pupils, and those of several fine artists of the next generation, vary in style, but they all exemplify the special values that Japanese painters brought to the literati world of art.

NOTES

1. For example, *yamato-e*, literally meaning "Japanese paint-ing," was also influenced by certain Chinese styles, but these became so integrated into Japanese aesthetics at an early period that *yamato-e* was regarded as fully native in contrast to *kara-e* (Chinese painting) styles.

2. *Nanga* artists have sometimes been criticized for not follow-ing the Chinese amateur tradition, but recent studies have shown there was more professionalism among Chinese literati artists than theory would suggest, and in any event, it was the amateur ideal of painting for the expression of one's own spirit, rather than on direct commission, that seems to have been of most importance.

3. These themes had symbolic values in Chinese culture. For example, the bamboo stayed green all year, symbolizing the scholar who did not waver in his beliefs and service, while the orchid (rather different from ours) grew quietly and sent out its delicate aroma without fanfare.

4. For further discussion, see Joseph Parker, *Zen Buddhist Landscape Arts of Early Muromachi Japan (1336–1573)* (Albany: State University of New York Press, 1999).

5. In contrast, the forgeries of Gyokudō's works did not occur until the late nineteenth century, when his landscapes began to become popular; in general, later forgeries are usually easier to detect than those done during the life of the original artist.

6. This and the other poems in this essay are translated by Jonathan Chaves.

7. See Melinda Takeuchi, *Taiga's True Views* (Stanford, Calif.: Stanford University Press, 1992), for more discussion.

8. Not to be confused with the later *nihonga* painter Kawai Gyokudō (1873–1957).

9. By Japanese count; in Western age, he was forty-nine.

10. For more information on Gyokudō's music, poetry, calligraphy, and art, see Stephen Addiss, *Tall Mountains and Flowing Waters: The Arts of Uragami Gyokudō* (Honolulu: University of Hawaii Press, 1987).

11. Since Beisanjin and Gyokudō were friends, it is tempting to think that the wandering musician might be Gyokudō himself.

12. John M. Rosenfield and Fumiko E. Cranston, *Extraordinary Persons*, Naomi Noble Richard, ed. (Cambridge: Harvard University Art Museums, 1999), 2:85.

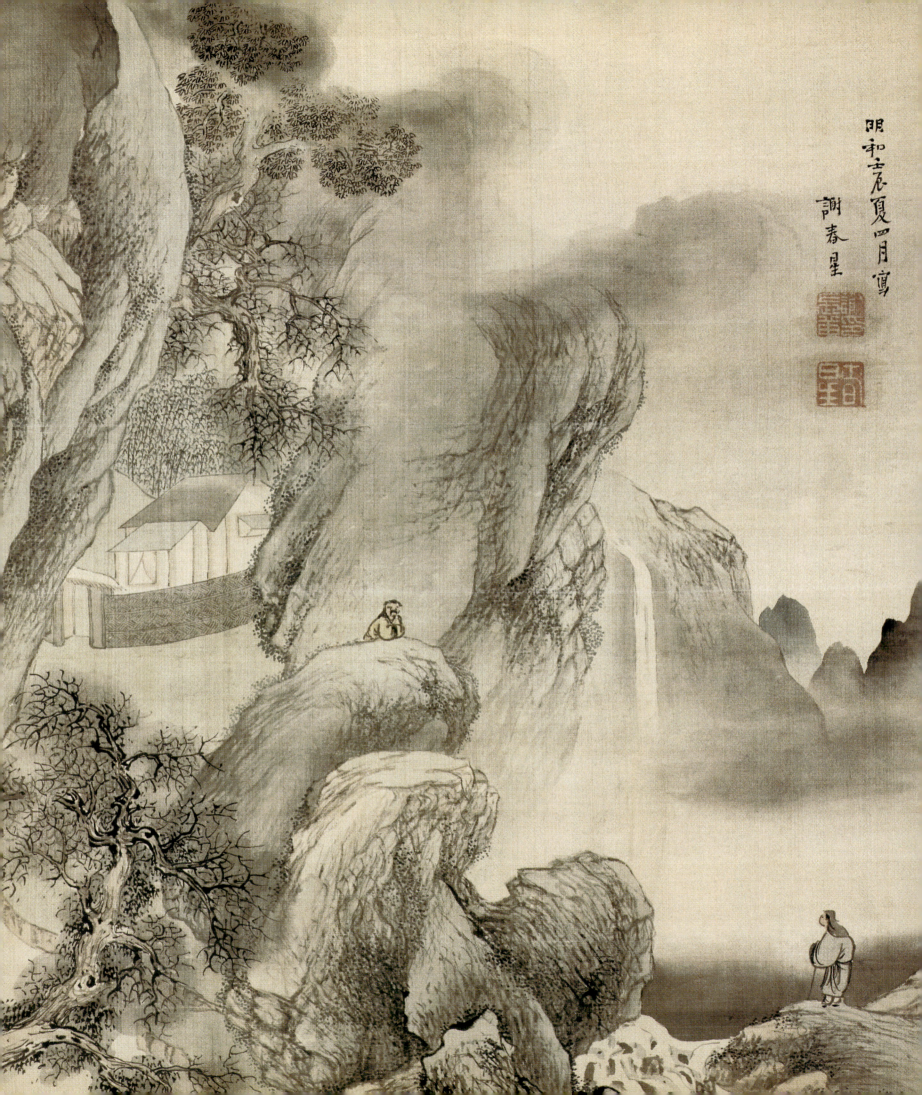

明和壬辰夏四月寫

謝春星

Patricia Fister

The Legacy of Yosa Buson

Exploring the Impact of His Painting Tradition in Ōmi, Owari, and Osaka

YOSA BUSON (1716–1783) WAS AN EXTRAORDINARY POET WHO BECAME ACCLAIMED as a painter only toward the end of his life. Although he was listed in the *Heian jinbutsu shi* (Record of Heian [Kyoto] notables) as a painter from 1768, he had only two major painting disciples from Kyoto: Matsumura Gekkei (Goshun) and Ki Baitei. Buson's mature styles of painting, however, became springboards for a number of later artists. Interestingly, it was in the neighboring provinces, especially Ōmi and Owari (present-day Shiga and Aichi prefectures), that the Buson painting tradition was continued and appreciated. This was due largely to the presence in these areas of flourishing *haikai*[1] societies devoted to the comic linked verse for which Buson became celebrated; he is considered the second-greatest *haikai* poet after Matsuo Bashō (1644–1694). In this essay I will try to bring the poet-artist Buson into focus and consider the circumstances through which his painting tradition was transmitted and subsequently transformed by pupils and followers into original forms of visual expression.

YOSA BUSON

"Buson loved change." This statement by Sasaki Masako in her essay on Buson's "inner journey"[2] succinctly sums up Buson's life and art. Although it is not unusual for artists to undergo stylistic changes in the course of their careers, Buson's range of experimentation is staggering. Moreover, he did not abandon one style upon going on to the next but painted in multiple styles simultaneously throughout his life. To some extent this was the result of painting to please a variety of patrons, but Buson himself never seems to have been tied to any one particular style. He had a range of complex interests and enjoyed the variation implicit in being conversant in a number of painting styles and subjects, Chinese as well as Japanese. In this respect he was a product of his time, for in eighteenth-century Japan both Chinese and Japanese painting traditions—new and old—proliferated. Buson also liked changes of scenery. Until his mid-forties he led a more or less itinerant life, during which he associated with many poets and encountered many kinds of art. A crucial source of stimulation for Buson, these travels fueled his imagination as a poet and painter. The Gitter-Yelen collection includes several paintings done at different stages of Buson's career. While by no means comprehensive, they give some hint of the breadth of Buson's oeuvre.[3]

Buson's early life may have been intentionally obscured. Born in Kema village of Settsu province (part of present-day Osaka), he left his hometown around the age of twenty and went to Edo, presumably to further his study of *haikai*. Because Buson seems never to have returned, and his extant writings contain no mention of his parents, we may infer that he did not wish to make public his early background. In Edo he became a pupil of the *haikai* master Hayano Hajin (also known as Sōa and Yahantei, 1677?–1742). Buson's poems began to appear in *haikai* publications by 1733, and influenced by fellow poets who occasionally painted for amusement, he also began to create simplified illustrations to accompany his *haikai*.

Pl. 28. Yosa Buson. *Autumn Landscape* (detail, cat. no. 19).

49

When Hayano Hajin died in 1742, Buson took to the road with a poet friend, Isaoka Gantō, and went to Yūki in Shimōsa province (present-day Ibaraki prefecture), where several of Hajin's pupils lived. It was a common practice for aspiring *haikai* poets to associate with other poets while traveling. With Yūki as a base, Buson spent much of the next ten years making journeys in eastern and north-eastern Japan, cultivating his skills in poetry and painting while retracing the footsteps of the great *haikai* poet Bashō, as recounted in his *Oku no hoso-michi* (Narrow road to the far north; 1694).

Though mainly immersed in the study of *haikai*, Buson probably took up painting to support himself during this period of roaming. He apparently studied independently, and judging from extant works, his early models were paintings of diverse styles including those of the Tosa, Kanō, and Rinpa schools. His early landscapes and figure paintings were rather simply conceived and often rendered with a combination of outlines and broad strokes done with a flat *hake* brush. Stimulated by the burgeoning interest in Chinese culture in Edo-period Japan, and with Chinese books and artworks flowing into the country, Buson also began to study and make copies of Chinese paintings as well as illustrations from woodblock-printed painting manuals.

In 1751, at the age of thirty-six, Buson went to Kyoto, where he visited temples and associated with other *haikai* poets. For someone with Buson's multifaceted interests, Kyoto was unquestionably the place to be. In the eighteenth century, artists and poets of all kinds gathered in the city, and a plethora of painting models, old and new, could be seen. In 1755 Buson went to Miyazu in Tango province near the Japan Sea, in northern Kyoto prefecture, where he took up residence at the Jōdo temple Kenshōji, whose chief priest was a *haikai* acquaintance. While he was never formally tonsured, Buson seems to have shaved his head and worn priestlike robes. He associated with many

Buddhist priests (several of whom were *haikai* poets), and during his journeys he often stayed at temples. Hayakawa Monta has suggested that shaving his head may have been a convenient way for Buson to facilitate travel rather than an expression of his devotion to Buddhism.[4] The nature and extent of Buson's spiritual practice still need to be clarified; it is probably safest to think of him as a Buddhist layperson.[5]

Surviving works from Buson's sojourn in Tango reveal that he was pouring tremendous energy into painting and experimenting with a variety of styles. He seems to have been impressed by the range of expressive brushstrokes (detailed in painting treatises) found in Chinese painting and the different kinds of rhythms in comparison with Japanese painting. Through copying Chinese paintings, he learned how to structure compositions and articulate layers of space, and he experimented with different types of brushstrokes. He found he could animate figures with tremulous outlines and capture the gentle rhythms of nature with combinations of texture strokes, sinuous lines, and washes. The compositions and brush techniques he learned from Chinese painting became the foundation for his art, which was gradually overlaid with his own poetic and aesthetic sensibilities. The unique style he developed from this complex *wakan* (Japanese/Chinese) blending sparked admiration as well as criticism.[6]

Buson returned to Kyoto in 1757 and at the age of forty-five (1760) married a woman named Tomo. Until then, Buson had lived a rather care-free life. Now, with the birth of a daughter, he had a family to support. He adopted a more settled lifestyle and continued to work diligently at establishing himself as a painter and poet. Painting was a more expeditious way to make a living than composing *haikai* poems, and consequently he turned to producing folding screens and colorful paintings of horses and of birds and flowers in the newly introduced and popular Shen Nanpin style.[7]

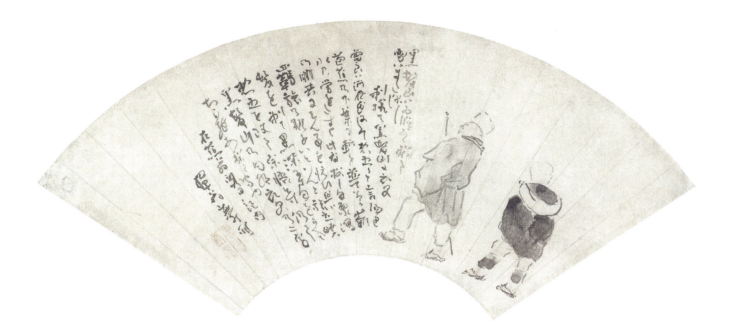

To fulfill painting commissions and cultivate patrons, during the late 1760s Buson made several trips to Sanuki province (present-day Kagawa prefecture) on Shikoku Island, where he had *haikai* friends. James Cahill has pointed out that in Sanuki, Buson also likely had access to imported Chinese paintings and books coming from Nagasaki.[8] In Kyoto he continued to be active in diverse circles: he was the central figure of the Sankasha *haikai* society and a frequent visitor to Sumiya, the elegant Shimabara restaurant-teahouse and home of a thriving cultural salon. Buson fully immersed himself in the pleasures offered by the city's entertainment districts; he especially loved going to Kabuki and *jōruri* plays.

By 1768 Buson had become fully recognized as a painter in Kyoto. His patrons included well-to-do townspeople, samurai scholars and officials, farmers, and temples in Kyoto and other parts of Japan.[9] His mastery of *haikai* was also formally acknowledged about this time, for in 1770 Buson inherited the *gō* (sobriquet) Yahantei of his teacher Hayano Hajin, officially becoming his successor. The 1770s was a time when poets throughout Japan were paying special tribute to Bashō. As Yahantei II, Buson played a leading role in this revival, refurbishing the Bashōan in Kyoto and hosting many visiting poets. The honor of becoming Yahantei II, coupled with the whirlwind of activity in *haikai* circles, must have provided a

strong incentive to compose poetry, for Buson wrote more *haikai* in 1777 than in any other year.[10]

As noted previously, Buson had begun to do paintings to accompany his *haikai* from his early years in Edo. He gradually brought the art of *haikai* painting (later called *haiga*)[11] to its fruition, and by the late 1770s it had become a major genre within his painting oeuvre. Buson's *haiga* embrace an enormous range of subjects. His scroll and screen versions of the *Oku no hosomichi*, combining Bashō's text with his own illustrations, stand out as among the finest in this genre. A number of fans decorated with individual scenes from the *Oku no hosomichi* are also extant (pl. 29).

Scholars have generally upheld the conviction that Buson's prime motivation for such works was homage to Bashō. The fact that he painted multiple versions of the *Oku no hosomichi* indeed suggests that the act of creation may have been for him a kind of ritual. Okada Rihei has firmly stated that such scrolls were not done for money but out of respect for Bashō,[12] but financial incentives should not be discounted. It is a well-known fact that Buson depended upon his painting, rather than his poetry, for his livelihood. After he became Yahantei II, the demand for his *haiga* no doubt increased. Moreover, he himself seems to have become concerned with the issue of lineage and his place within the Bashō school, which may have prompted him to illustrate the *Oku no hosomichi*.

Pl. 29. Yosa Buson. *Oku no hosomichi* (*Narrow Road to the Far North*; cat. no. 20).

Evidence of this concern can be found in a letter Buson wrote to the Nagoya poets Hisamura Gyōdai (1732–1792) and Inoue Shirō (1742–1812), in which he expressed his interest in placing sets of the *Oku* scrolls in different parts of the country where they would be appreciated.[13] This sounds as though Buson were making a noble gesture to perpetuate one of Bashō's literary masterpieces; however, his intentions probably went beyond simple veneration. A further motive for the multiple versions may have been Buson's desire to promote himself as an important figure within the Bashō lineage. If he was concerned only with seeing that Bashō's writings were passed on, he could have arranged to republish the *Oku no hosomichi*. Buson was obviously familiar with Bashō's text, and in his early career had relived some of Bashō's experiences by walking the same paths, but he did not illustrate the *Oku no hosomichi* until late in his life. This suggests that Buson wanted to preserve and disseminate his own illustrated versions, not just Bashō's text.

Clearly this linkage with Bashō and the display of his own artistic ability were in Buson's mind when he painted the *Oku no hosomichi* handscrolls, screens, and fans. As a master artist and a master poet, Buson was in a unique position to contribute something special to the *Oku no hosomichi* by adding illustrations that effectively communicated a sense of Bashō as a person as well as highlights of his journey. But it is Bashō seen through Buson's eyes. It is his own role as medium and inheritor of the Bashō lineage that Buson cherished and wished to promulgate. To a large extent he succeeded: when people today think of the *Oku no hosomichi*, they think not only of Bashō but also of Buson.

Buson began his studies of poetry and painting as separate pursuits, but as he matured, they became fused, visually and spiritually. This is true not only of his *haiga* but also of his landscape painting. In *Autumn Landscape* (pl. 28), dated 1772, not only did Buson capture the outward beauty of the mist-shrouded mountains, which are carefully structured and meticulously described with his characteristic hemp-fiber strokes, but he also expressed a mood, achieved here largely through the presence of humans. Chinese literati paintings often include tiny generic sagelike figures, but Buson's tend to be more human and approachable. In *Autumn Landscape* one cannot help but notice the man leaning over a cliff ledge in the center of the painting. Below, another figure resting on a staff gazes upward toward him. By the poses, placement, and connecting line of vision of the two figures, Buson causes us to wonder about their relationship—who are they and what are they thinking, feeling?

After close examination of this painting, Hayakawa Monta concluded that the figure leaning on a staff is dressed as a traveling nun, which is very unusual for *nanga* (literati painting), suggesting that this painting represents or alludes to an actual separation.[14] Takahashi Shōji further speculates that this is a scene of a man and woman parting, perhaps sparked (consciously or unconsciously) by Buson's memories of his own parents' separation.[15] Although their identities remain uncertain, this depiction of two figures sharing a final wistful moment amid the misty peaks is surely one of the most evocative parting scenes in the history of Japanese art.

A slightly later work in the Gitter-Yelen collection, painted in Buson's so-called golden age, is *Spring Landscape* (pl. 30). The brushwork forming the rocks, mountains, and trees is looser and more relaxed, and the feathery foliage characteristic of Buson's late work is clearly visible. It is often said that Buson sought inspiration for his *haikai* in the profane (*zoku*) world, which he then turned into something "refined." The same can be said of his painting. Here the subject is a humble rural village, but through the vibrant rhythms in the brushstrokes of the trees and bamboo, and the fresh

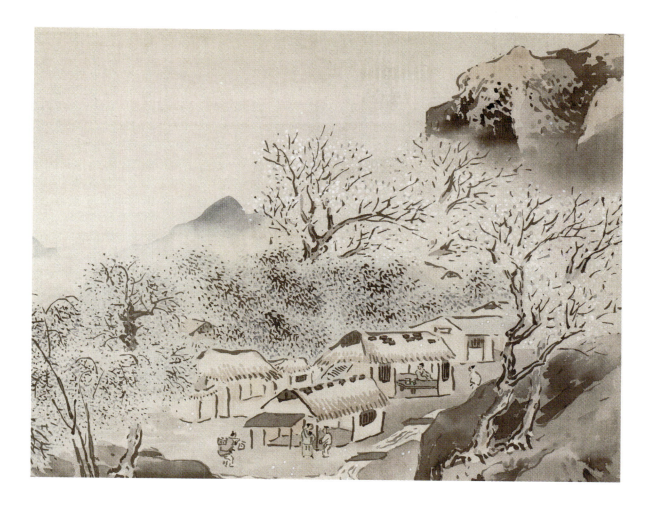

application of ink and color washes, Buson imbued the plebeian scene with a lyricism that warms the heart and makes one long for the simple pleasures of the countryside.

In sum, Buson mastered and digested an amazing array of models over the course of his career. These models were transformed over time to accord with his own spirit and brush rhythms, and by the end of his life he was capable of a tremendous range of expression in his art. As a result of his travels throughout Japan and his intellectual exploits in the realms of poetry and painting, Chinese as well as Japanese, Buson's paintings slowly acquired depth as well as breadth. It is when his dual backgrounds as poet and painter come together that Buson achieves his greatest brilliance.

Buson had many *haikai* pupils, but he had only two long-term pupils who fully mastered his mature styles of painting *haiga*, landscapes, and figures: Matsumura Gekkei (Goshun, 1752–1811) and Ki Baitei (1734–1810). Both men studied poetry as well as painting with Buson. Goshun was unquestionably Buson's stellar pupil, but after

Buson's death in 1783 he switched over to the style of Maruyama Ōkyo (1733–1795), who by the late eighteenth century had risen to fame in Kyoto. Because Goshun is discussed in Jōhei Sasaki's essay (see pp. 93–97), I will focus on Baitei and other pupils, as well as some painters who did not study directly with Buson but independently adopted his style. These artists transmitted the Buson tradition to provinces outside Kyoto.

THE BUSON TRADITION IN ŌMI: BAITEI, RYŌGA, AND RITSUZAN

Although often thought of as an Ōmi (Shiga prefecture) artist, Ki Baitei was actually born in Toba in the southern part of Kyoto.[16] He learned both painting and *haikai* from Buson, and by 1782 he had achieved enough renown to be listed as a painter in the *Heian jinbutsu shi*. Paintings datable to 1782 confirm that he had mastered and was faithfully maintaining his teacher's tradition.[17] The following year Buson became ill; Baitei along with Goshun diligently tended the master during his final days.

Pl. 30. Yosa Buson. *Spring Landscape* (detail, cat. no. 21).

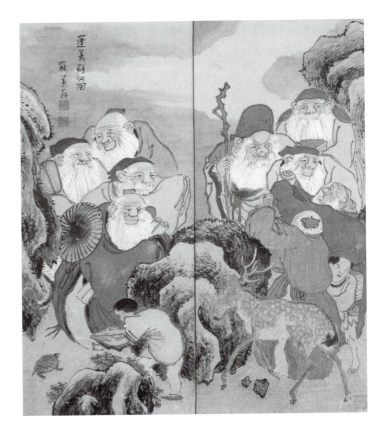

Fig. 1. Ki Baitei. *Group of Immortals from Mount Hōrai*. Two-panel folding screen: ink on paper, 130.8 × 110 cm. Gitter-Yelen collection.

After Buson's death, Baitei continued to paint, but the course of his life changed dramatically after Kyoto's great fire of 1788. Having lost his home, he was invited by Ryōga (1745–1812), the chief priest at the Jōdo Shinshū temple Chōjuji in Ōtsu and a close friend and fellow pupil of Buson, to make his home in Ōtsu. Baitei accepted his offer, and around the age of fifty-five moved there with his wife and child. With the move Baitei by no means severed his ties with the Kyoto art world. He participated in an exhibition of calligraphy and painting held at the temple Kiyomizudera in the Higashiyama district in 1797.[18] The organizer, the Kyoto *bunjin* Minagawa Kien (1734–1807), also inscribed a landscape painting by Baitei signed "Konan Kyūrō" (Old Man from South of the Lake [Biwa]), a signature Baitei used after moving to Ōtsu.[19]

Baitei was able to establish a reputation in Ōtsu through the support of Ryōga and his ties with Buson and the *haikai* world. Located on the south shore of Lake Biwa and the last stop on the Tōkaidō Road before Kyoto, Ōtsu was a bustling port and center of commerce. Its merchants were affluent and interested in learned pursuits. *Haikai* was especially popular due to

the region's long-standing connections with Bashō.[20] Bashō had first visited Ōtsu in 1685, at which time he accepted some pupils, establishing in effect what came to be called the Ōmi Bashō school. Although born in Iga, Bashō seems to have had a warm feeling toward Ōtsu, residing there for nearly one and a half years, from 1689 to 1691, after returning from his *Oku no hosomichi* journey. He decreed that he was to be buried at the Ōtsu temple Gichūji, which later became a site for memorial services and *haikai* gatherings. Buson visited Gichūji in 1774 when he presided over a memorial service for Bashō, and again in 1782.

With his knowledge of *haikai* and status as Buson's pupil, Baitei would have had no trouble securing patrons in this "*haikai* friendly" region. Even Baitei's rice merchant landlord, Nakamura Gohei Yūgaku, was an amateur *haikai* poet. A particularly important patron was the well-to-do Ōtsu shipping merchant Yoshizumi Yojihei Yoshikatsu. The large number of extant works in the Shiga area and the fact that Baitei remained there until the end of his life imply that his work was appreciated enough for him to enjoy a comfortable life in Ōtsu.

The majority of Baitei's paintings are copies of or freely modeled after compositions by Buson. Although not represented in the current exhibition, the Gitter-Yelen collection includes several fine examples. In his two-panel screen *Group of Immortals from Mount Hōrai* (fig. 1), Baitei followed his teacher in the basic compositional design and the brushwork defining the figures and rocks. But the good-natured expressions of the old men, especially the open-mouthed laugh, are features that became hallmarks of Baitei's style.

Judging from the large number of depictions of old wizened men or immortals, paintings embracing the theme of longevity were popular with Baitei's Ōtsu clientele. Beyond his numerous landscape paintings, Baitei's common themes include the gods of good fortune such as Daikoku and Jurōjin, fishermen, laborers, festival revelers, Ōtsu-e folk painting subjects, beautiful women, and poet portraits. Though at times Baitei suppressed his own personality in order to remain faithful to Buson, perhaps in response to clients who specifically requested Busonesque paintings, as he matured as an artist, his own rough, angular brushwork and bold design sensibility came to the fore. Both styles seem to have been popular in the Kyoto-Ōtsu area.

Baitei's transformation of the Buson tradition can be seen in *Two Crows on a Branch* (fig. 2), a painting in the Gitter-Yelen collection that follows a well-known Buson composition.[21] Baitei remained faithful to the original in the placement and postures of the birds, but the brushwork of the branches is rougher and more freely rendered. In another example, *Fisherman with Catch* (fig. 3),[22] undoubtedly a popular subject in the harbor city of Ōtsu, Baitei took one of the humble rural figures that commonly people Buson's paintings and transformed it into a dramatic subject on its own, which is intensified by the large size of the scroll. Characteristic of Baitei's mature style are the vigorous outlines defining the forms and the cartoonlike face of the fisherman, with his large, squared-off mouth and protruding ear.

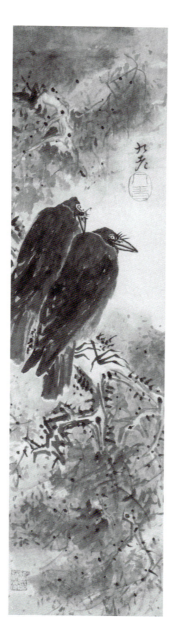
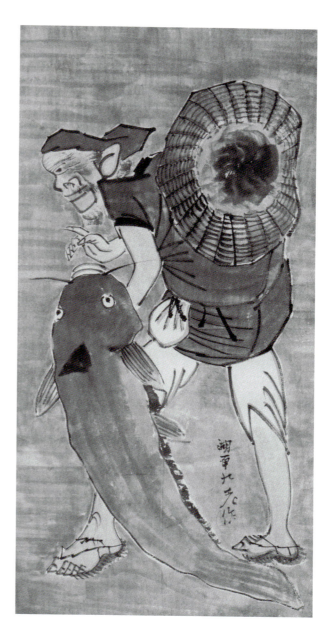

Baitei continued to paint in the Buson tradition until his death, which led people to refer to him as "Ōmi Buson." One could say that he successfully both maintained and transformed the Buson tradition, which included *haiga*. His participation in Ōtsu *haikai* circles is not well documented, but Baitei must have been an active member since numerous *haiga* are extant and a collection of his poems was published posthumously by his friend Ryōga.[23] Additionally, Baitei's reputation is attested by the popularity of the *Kyūrō gafu* (Book of pictures by Kyūrō [Baitei]), a volume containing dynamic woodcut illustrations of Baitei's paintings with a preface by Ryōga. First published in Kyoto

Fig. 2. Ki Baitei. *Two Crows on a Branch.* Hanging scroll: ink on paper, 110.5 × 28.5 cm. Gitter-Yelen collection.

Fig. 3. Ki Baitei. *Fisherman with Catch.* Hanging scroll: ink and color on paper, 125.4 × 59 cm. Gitter-Yelen collection.

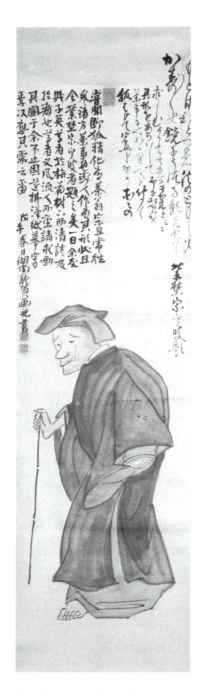

Fig. 4. Ryōga. *Fox Disguised as Sen Sōtan*, dated 1786. Inscriptions by Sōin (right) and Ryōga (left). Hanging scroll: ink and color on paper. Ōtsu City Museum of History.

about 1795, it was republished in 1797, 1799, and 1824.[24]

Ryōga himself had been a painting and *haikai* pupil of Buson's. His paintings, however, are rather rare: I have seen only two examples, both paintings in the Buson tradition. This scroll is accompanied by a poem by the Daitokuji priest Sōin and a long text by Ryōga himself, dated 1786 (fig. 4). He used the signature "Konan Ryōga" (Ryōga of South of the Lake), which may have inspired Baitei to adopt Konan Kyūrō as his signature after moving to Ōtsu. The subject is the tea master Sen Sōtan (1578–1658), one of Sen no Rikyū's grandsons. Sōtan once lived near the Kyoto temple Shōkokuji, and according to folklore, a white fox from that area would playfully take the form of the famous tea master and appear at temple tea ceremonies. To appease this prankster, Emperor Higashiyama ordered a shrine dedicated to "Sōtan Kitsune (Fox)" constructed on the grounds of Shōkokuji in 1705.[25] Ryōga refers to this legend in his inscription, reporting that paintings of the subject were popular and that Priest Sōin of Daitokuji was frequently asked to add verses alluding to the trickster fox's transformations. (Before succeeding in the family line, Sōtan himself had been a novice at Daitokuji.) Ryōga writes that when his friend, the priest Kōshie, implored him to do a painting, he was unable to refuse, resulting in this humorous portrait of the trickster fox posing as Sōtan. While Ryōga's training in the Buson *haiga* tradition is clearly evident in this humorous portrait of Sōtan, the brusque and angular brushwork is also reminiscent of Baitei. This is not surprising given their close relationship. The dearth of extant works by Ryōga, however, suggests that the Buddhist priest never relied on painting for his livelihood as did his friend Baitei.

A third Ōmi artist who is often noted as following the Buson tradition is Oka Ritsuzan (c. 1760–c. 1844),[26] whose family operated one of the teahouses along the Tōkaidō in the area of present-day Kusatsu city. The *Ōmi Kurita-gun shi* (History of the Kurita district in Ōmi) records that Ritsuzan went to Kyoto and studied with Yosa Buson,[27] but there is no documentation to confirm this. A thorough study of Ritsuzan's work is still pending, but a cursory examination of currently known paintings reveals that he was very eclectic, drawing upon *nanga*, Nagasaki, and Maruyama-Shijō school traditions.[28] Some examples, such as *Summer Landscape* (fig. 5), clearly display Buson-style compositions and brushwork. In particular, the light, feathery strokes used to describe some of the foliage here, and the figures conversing in the lower left, are reminiscent of Buson. In other works, however, diverse painting styles are blended together, and the Buson connection is not obvious. I have not seen any examples that Ritsuzan inscribed as following Buson. Moreover, he did not paint *haiga*. Thus Ritsuzan's place in the Buson lineage is rather tenuous, despite the fact that he has been referred to as one of the *shitennō*, or four guardians, of the Buson tradition in Ōmi.[29]

THE BUSON TRADITION IN OWARI: KINKOKU, SANKYŪ

Yokoi Kinkoku (1761–1832), who was born in Kasanui village (present-day Kusatsu city) in Shiga prefecture, is also fondly referred to as "Ōmi Buson" by local residents. In all fairness, however, Kinkoku should first be considered as an "Owari Buson," because it was only after moving to the province of Owari (present-day Aichi prefecture) in his thirties that he began to seriously study Buson's *haiga* and landscapes and gradually carved out his own niche as an artist in the Buson tradition.

The first half of Kinkoku's life as a wayward monk, documented in his autobiographical *Kinkoku Shōnin goichidaiki* (Record of the eminent priest Kinkoku), is recounted in numerous publications and therefore will not be repeated here.[30] Portions

of the *Goichidaiki* seem to be modeled upon or borrowed from other travel accounts, the dates are sometimes mistaken, and some events Kinkoku describes seem too comical or outrageous to be true, casting doubt on the reliability of his account. But a surprising amount of what Kinkoku wrote can now be confirmed. For example, Kinkoku reported that during his travels he had painted sets of scrolls for various temples depicting the life of the Buddhist priest Hōnen (1133–1212, post-humously known as Enkō Daishi). Titled *Enkō Daishi ekotoba* (Story of Enkō Daishi), they are grad-ually coming to light,[31] and a survey of cultural artifacts in the Kurashiki area in 1988 uncovered thirteen paintings by Kinkoku, including some done for temples.[32] Kurashiki is located near Akō (present-day Hyōgō prefecture), where Kinkoku resided awhile during his travels through western Japan after his Kyoto temple burned down in the same devastating 1788 fire that prompted Baitei's move to Ōtsu. It was in Akō that Kinkoku met Hisa, a granddaughter of Hara Sōemon (1648–1703, one of the famous Forty-seven Rōnin); she later became his wife.

After leaving Akō, Kinkoku and Hisa trav-eled to the old province of Owari and settled in the city of Nagoya sometime in the late 1790s. Kinkoku's associations with Nagoya *haikai* poets, and how those contacts were influential in his turning to the Buson tradition, are detailed in earlier publications.[33] Nagoya *haikai* and *bunjin* circles offered Kinkoku a stimulating artistic environment, and he experimented with painting subjects ranging from figures, birds, and animals to landscape. While the *bunjin* artists mentioned above were cultivating sinophile tastes and im-mersing themselves in the study of Chinese mod-els, Kinkoku opted to follow the Buson tradition.

In addition to personally admiring Buson's style, he probably realized that Busonesque paint-ings were popular with practitioners and admirers of *haikai*. By modeling his style upon Buson and

occasionally inscribing works as "after Buson-sensei's idea or brushwork," Kinkoku made a place for himself in the Buson lineage. The concept of lineage is very fluid in Japan. Not all artists studied directly with the master with whom they aligned themselves. Soga Shōhaku (1730–1781) is one of the better-known examples (see cat. nos. 69, 70). In Kinkoku's case, his declarations were so con-vincing that some later biographies record that he was Buson's pupil. But because Kinkoku's auto-biographical writings do not mention Buson, and since a thorough examination of dated paintings reveals that Kinkoku did not earnestly begin painting in Buson's style until about ten years after Buson's death, we can assume that this error occurred because someone recognized his paintings as being in the Buson vein and jumped to conclu-sions. The fact that Kinkoku remained silent about his painting studies suggests that he was self-taught, like Buson, and learned through copying models. Moreover, like Buson, he probably took up painting to make a living during his years as a wayfaring monk and decided to make it his vocation.

Kinkoku's earliest known dated paintings, done in 1790, are a set of six works, originally mounted on a folding screen, including a *nanga*-style landscape, a monkey trainer in the Shijō tradition, and a woodcutter riding on a horse in the Buson tradition.[34] Tentatively painted with unskillful, abbreviated brushwork, they reveal that he was just starting his studies of painting and experimenting with multiple models. Beginning in the early 1790s, Kinkoku also painted works for Buddhist temples he visited or with which he was connected, such as the above-mentioned *Enkō Daishi ekotoba* (portraits of priests), and *nehan-zu* (paintings of the Buddha's nirvana).

While living in Nagoya, Kinkoku seems to have taken some painting lessons from Chō Gesshō (1772–1832), a slightly younger artist who was a member of local *haikai* and *bunjin* circles.[35] A

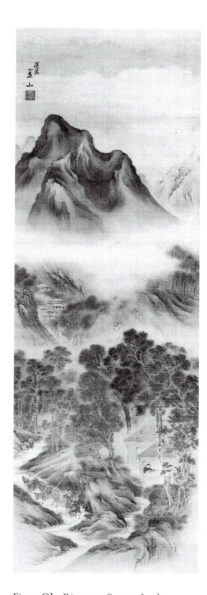

Fig. 5. Oka Ritsuzan. *Summer Landscape.* Hanging scroll: ink and colors on silk. Rittō History Museum.

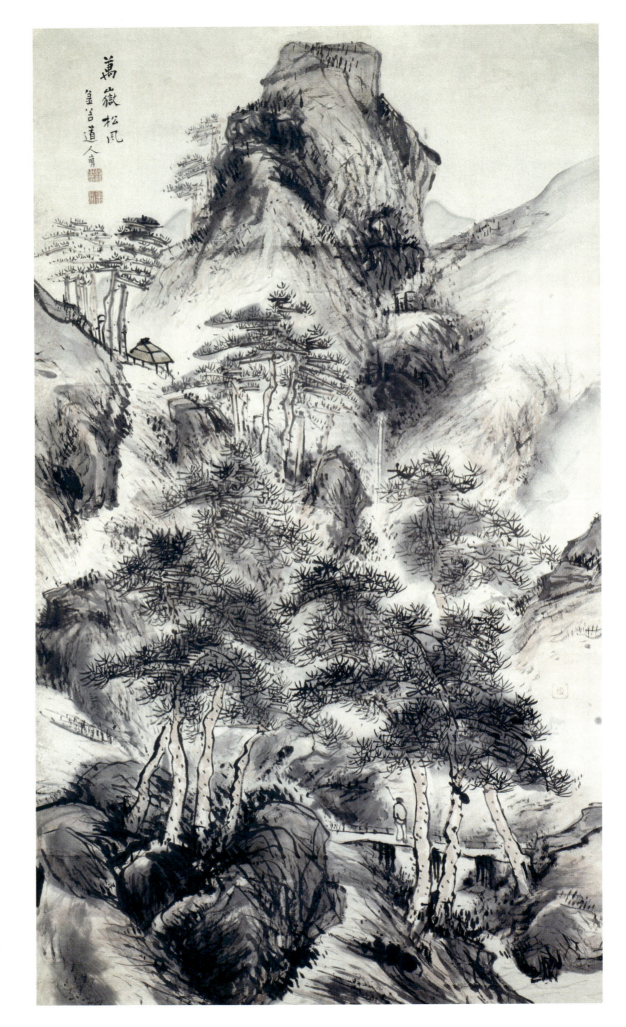

Pl. 31. Yokoi Kinkoku. *Breeze through the Pines in the Myriad Peaks* (cat. no. 34).

comparison of their paintings reveals that Kinkoku was not greatly influenced by Gesshō's personal style.[36] What he probably received was instruction in basic brush methods. Gesshō had studied with Buson's pupil Goshun and thus would have been familiar with the Buson tradition, although he himself did not practice it. A study of Kinkoku's extant paintings suggests that he learned to paint in the Buson style primarily through making copies. A thorough review of the *Buson zenshū*[37] (Complete collection of Buson), the most comprehensive compendium of Buson paintings to date, reveals that many more Kinkoku paintings are in fact modeled directly on Buson's works. This implies that Buson's paintings must have been plentiful in Owari, which is not surprising given the sizable *haikai* community there. One of the most prominent Owari *haikai* poets, Inoue Shirō, had developed close ties with Buson in his late years. Shirō, along with his teacher Hisamura Gyōdai, would go out drinking with Buson during visits to Kyoto.[38] Buson's letters reveal that Gyōdai, Shirō, and others connected with the Nagoya *haikai* world were customers.[39] Shirō seems to have been well acquainted with Kinkoku, for there are numerous extant paintings by Kinkoku to which Shirō added poems. One can surmise that Shirō may have been instrumental in showing Kinkoku works by Buson in local collections.

The earliest confirmable actual copy of a Buson landscape by Kinkoku is a painting dated 1798,[40] in which the brushwork is stilted and awkward. Other works from about this time display features of Goshun's Shijō style, presumably learned from Gesshō. While Shijō brush mannerisms continued to flavor Kinkoku's painting until about 1804, he began to experiment with more freely applied linear strokes and dotting in the Buson *nanga* tradition. Kinkoku's complete shift from the Shijō tradition to *nanga* seems to have occurred in 1804–5 and is directly connected with his participation in a special pilgrimage to

Mount Ōmine in the summer of 1804 led by Kōen Hōshinnō (d. 1848), the abbot of Sanbōin in Kyoto.

Sanbōin is the headquarters of the Tōzan sect of Shugendō, a religion blending esoteric Buddhist practices with ancient mountain worship. As part of their practice, adherents ascend designated sacred mountains, performing rituals along the way. The details of this particular pilgrimage, which started out with about five thousand *yamabushi*[41] (practitioners of Shugendō) from temples throughout Japan, are recounted in Kinkoku's *Goichidaiki*. There is no question after reading Kinkoku's account that this journey through the sacred mountains of Japan's Kinki district was a life-changing experience. Taking nearly two months to complete, it was more challenging and arduous than anything he had ever attempted. He was moved by the fierce storms the pilgrims endured as well as the mystic rituals they performed. All this profoundly affected him spiritually and would have a tremendous effect on his art.

Upon the group's return, Kinkoku was given a ceremonial purple robe and the prestigious rank *hōin* (Great Master of the [Buddhist] Law) and the title *daisendatsu* (Great Leader of Mountain Ascetics). He continued to live at the Shugendō temple Daihōin in Nagoya, to which he had moved prior to the Ōmine pilgrimage, and enthusiastically began to make pilgrimages to other sacred mountains in Japan. These journeys served as catalysts in his development as a painter, for he began to focus more and more on landscapes in which he could express directly his experiences and new vision of nature.

Kinkoku noted in his *Goichidaiki* that after the Ōmine pilgrimage he received many requests for landscapes depicting the sacred mountains he had ascended. His new appreciation of nature, filled with turbulent energy, is expressed in both landscapes in the Gitter-Yelen collection. *Breeze through the Pines in the Myriad Peaks* (pl. 31) is undated, but

similarities in brushwork and signature style with paintings dated 1806 suggest it was done about that time. In comparison with Kinkoku's earlier, often derivative works, here he drew more upon his own creativity. A mountain peak rising in the center serves to stabilize the composition. Below, pines bend to form an arch framing the small figure on a bridge, who is treated to a view of a slender waterfall. While the overall mood is calm, the splattered ink and vigorous brushwork describing the rocks in the lower and middle left hint at the energy that was to become the hallmark of Kinkoku's style.

The pulsating rocks and vigorous brushwork for which Kinkoku became renowned can be seen in *Solitary Path through the Cold Mountains and Myriad Trees* (pl. 32), inscribed as painted in the winter of 1810. Here everything is moving: mountain peaks, rocks, trees—even the body of the figure flows in tune to the animistic forces around him. Wet, suffused strokes were applied with tremendous energy as Kinkoku's memories of the powerful wind and storms he experienced amid Japan's sacred mountains flowed through the medium of his brush. The dynamic process of painting was now an important element in Kinkoku's artistic expression.

Kinkoku was clearly drawn to the *nanga* tradition because of the expressive potential of line and texture strokes. Fueled by his admiration for Buson as a *haikai* poet, Kinkoku must have found aspects of Buson's landscape style attractive, especially the rhythms inherent in Buson's freely rendered brushwork. Buson was a master at capturing the vibrancy and flux of nature, which Kinkoku, too, now felt compelled to express. He began to adapt Buson's compositional designs and basic patterns of brushwork. But he was no longer a mere imitator. Kinkoku transformed the Buson landscape tradition to suit his own ideals, applying brushstrokes in a distinctly looser and unstructured manner.

The very different experiences and personalities of the two artists are reflected in their landscapes. Buson nurtured his relationship with nature through traveling, composing poems, and studying Chinese paintings. As a result, his paintings are generally pastoral in nature and imbued with a sense of tranquillity. Kinkoku's experience with nature was primarily physical. He was less inspired by Chinese paintings of mountains than by his own actual experiences of climbing them. When Shugendō could not provide Kinkoku with a style to express these experiences, he chose to adapt Buson's, which was familiar to him, because it allowed him to communicate his unique vision of nature. One could say that the idiosyncrasies of Kinkoku's style are concentrated in his energetic brushwork.

By 1819 Kinkoku had moved from Daihōin in Nagoya to Taizanji in the Hazu district of Mikawa province (present-day Aichi prefecture). He also resided for awhile at Taichōin in Seto, where for a time he painted landscape and *haiga* designs on Seto ware plates and bowls.[42] Earning his livelihood largely through painting, Kinkoku continued to do traditional Buddhist subjects for temples (Jōdo and Shingon)[43] and, occasionally, *haiga* based on Buson models. Without question, however, his forte was now landscape painting. It was commonly believed that *yamabushi* gained special powers through their ascents, and they were called upon to perform healing ceremonies and exorcisms as well as to administer general blessings. Kinkoku established himself as a Shugendō painter, claiming in a letter that his works not only embodied some of the mystical powers he himself possessed but could function as talismans.[44]

Inscriptions on paintings as well as dated works in temples document that Kinkoku was traveling around Aichi, Shizuoka, Hyōgo, and Okayama prefectures. His wanderlust came to an end about 1823, when he was in his early sixties. Kinkoku retired to his homeland in Shiga prefecture, living in a temple or hut near Sakamoto at the base of Mount Hiei. Judging from the large number of late-period works in Shiga private collections, as

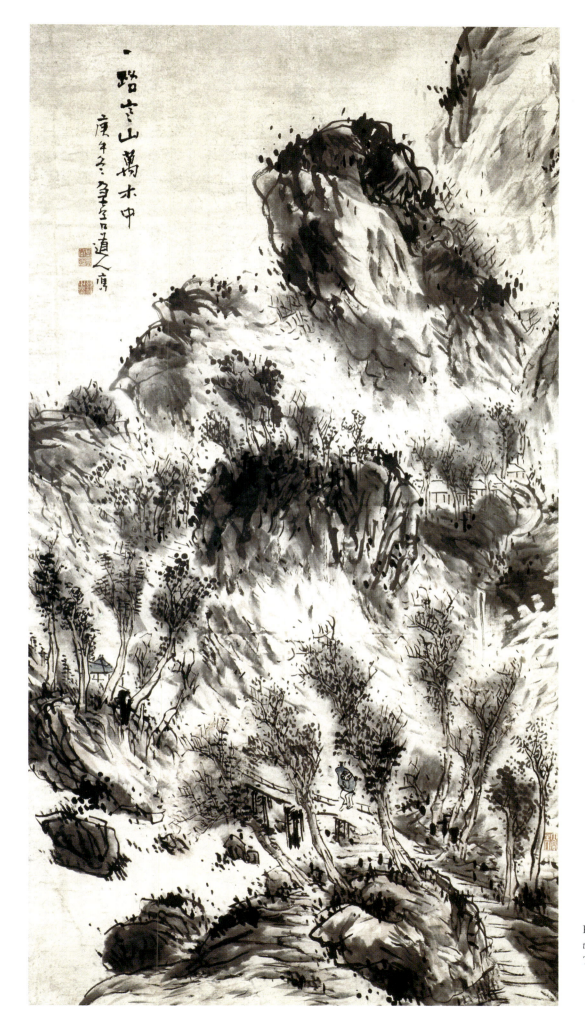

一路寒山萬木中
庚午冬 辛□□道人廣

Pl. 32. Yokoi Kinkoku. *Solitary Path through the Cold Mountains and Myriad Trees* (cat. no. 35).

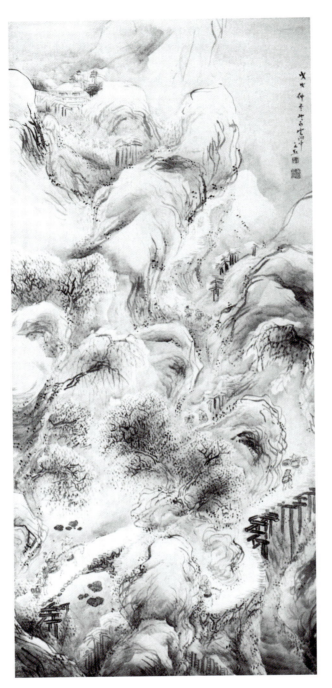

Fig. 6. Yokochi Sankyū. *Landscape: The Road to Shu*, dated 1838. Hanging scroll: ink and color on paper. Collection of Robert and Betsy Feinberg.

his later years in Shiga prefecture was probably related not so much to Buson as to his status as a *yamabushi*.

Kinkoku is recorded as having had one major pupil in Nagoya, Yokochi Sankyū (d. 1838), who carried on what could perhaps be termed the Kinkoku-Buson lineage. An example by Sankyū, dated 1838, depicts small groups of travelers ascending steep paths through snow-covered mountains (fig. 6). The scroll is reminiscent of Kinkoku's numerous versions of the Chinese mountains of Shu, a subject also painted by Buson.[45] Sankyū's pupil Toki Sankō is recorded as continuing the Kinkoku tradition,[46] but examples of his work are yet to emerge.

An artist who is never mentioned as part of the Kinkoku lineage, but who certainly should be included, is his wife, Hisa (also known as Fusenjo). Kinkoku recorded in his *Goichidaiki* that he taught her reading and writing when they were living in Akō.[47] Later he seems to have taught her painting as well, judging from the small landscape (fig. 7) included in a handscroll of works by women artists collected by the female *bunjin* Ema Saikō (1781–1867). The note attached to the upper left of this painting records that it was done by Kinkoku's wife, a descendant of Hara Sōemon, one of the loyal retainers of Akō; the address given is Sakamoto in Kōshū (Lake [Biwa] province). While the touch is slightly different, the style is strikingly similar to the cursory one often employed by Kinkoku in his late years. One wonders to what extent Hisa helped him with commissions. Kinkoku's son, Fukutarō, is also reported as being skilled at painting, but no works signed by him have been discovered.

THE BUSON TRADITION IN OSAKA: HŌJI

Buson had many *haikai* pupils in Osaka; among them, Matsumoto Hōji (act. eighteenth–nineteenth century) is recorded as also having studied painting with the master. Biographies of Hōji note his skillfulness at landscapes and his fondness for painting

well as the large numbers of forgeries extant in this region, the *yamabushi* painter was quite popular. Like his predecessor Baitei, Kinkoku is popularly referred to as "Ōmi Buson." There is no documentation that the two artists ever met; in fact, at the time of Baitei's death, Kinkoku was still living in Nagoya. Yet a few works by Kinkoku seem to have been influenced by Baitei's mature style. Given Kinkoku's interest in Buson, it is not surprising that he would find Baitei's work worthy of study. Nevertheless, Kinkoku's fame during

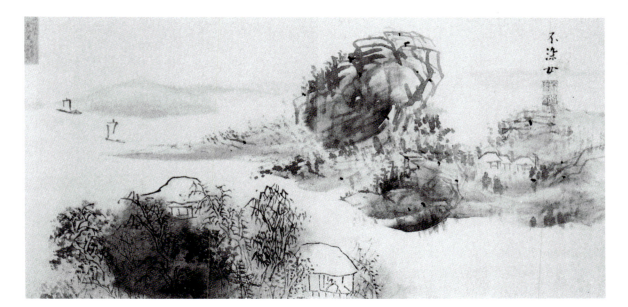

Fig. 7. Fusenjo (Hisa). *Landscape.* Ink and light color on paper. Ema Collection, Ōgaki.

toads and frogs.[48] This latter claim is substantiated by extant paintings, the majority of which depict frogs brushed playfully in ink (fig. 8). Buson occasionally painted frogs, but rather than imitating his teacher, Hōji seems to have taken up this subject from personal interest. He purportedly collected different species; evidence of this hobby is an album made up completely of paintings of frogs and toads.[49]

Hōji also painted landscapes, but the single example I have seen (fig. 9), with a poetic inscription by the Confucian scholar Shinozaki Santō (1737–1813), does not overtly show Buson's influence. The feathery application of strokes forming the bamboo, overlaid with verdant color washes, could be considered faintly reminiscent of Buson, but as a whole this painting follows the growing trend in *nanga* to adhere more closely to Chinese models. Of particular interest are the fifty-five seal impressions on the paper surrounding the landscape.[50] Presumably from Hōji's own collection, they reveal his sinophile interests and passion for collecting.

A survey of known works by Hōji indicates that he experimented with diverse styles. For example, he copied an elephant painting by Itō Jakuchū (1716–1800).[51] In sum, the Buson tradition was only one of many avenues he explored, and Hōji does not seem to have promoted himself as being part of the Buson lineage. In some respects, he was similar to his Osaka *bunjin* colleague Kimura

Kenkadō (1736–1802), who, though he had studied painting with Ike Taiga (1723–1776), was a dilettante with many interests. Moreover, like Kenkadō, Hōji cultivated contacts with hundreds of painters and poets and assembled a collection comprising hundreds of album leaves by major painters and calligraphers active in the Kansei era (1789–1800). One album has been published in full,[52] but this is only part of Hōji's original collection, which included albums filled with jointly painted works. A thorough investigation of his collection and the scope of Hōji's activities in Osaka remains to be done.

Though not maintained by Hōji, the Buson tradition, especially *haiga*, continued to inspire other artists in Osaka, such as the *haikai* poet Miura Unkyo (1772–1842).[53] As was the case in Ōmi and Owari, the popularity of Buson's painting style was linked to his reputation as a *haikai* poet. Buson's poems and paintings had an enduring appeal, so that even after his death he exerted a powerful presence in the *haikai* world.

CONCLUSION

Using examples from the Gitter-Yelen collection and a few selected other examples as markers, I have tried to briefly outline the development of Buson's complex and multifarious painting tradition and to trace his "lineage" as it traveled beyond Kyoto in the late eighteenth and early nineteenth centuries, focusing particularly on artists active in

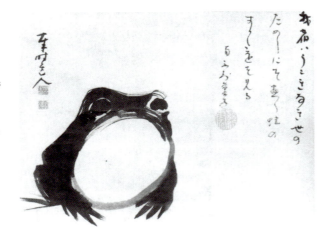

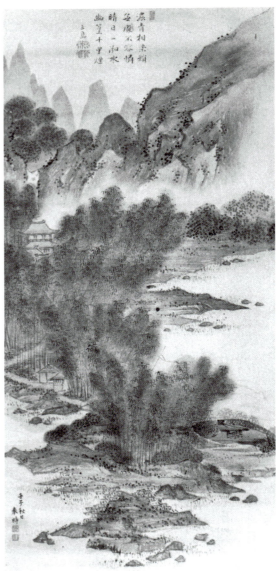

Fig. 8. Matsumoto Hōji. *Frog*. Inscription by Jiun Sonja. Hanging scroll: ink on paper. Private collection.

Fig. 9. Matsumoto Hōji. *Seal Impressions with Landscape*, 1792. Inscription by Shinozaki Santō. Hanging scroll: ink and color on paper. Private collection.

the regions comprising old Ōmi and Owari, as well as Osaka. Of course due to Goshun's overriding influence in the Kyoto painting world, elements of the Buson tradition, especially his *haiga*, were carried on by members of the Shijō school[54] and frequently appear in *nihonga*.[55] Among Buson's direct pupils discussed here, however, Baitei was the only one who continued to paint in his teacher's tradition until his death. In his hands, Buson-style figures and landscapes were infused with a new, rugged spirit that appealed to patrons in his home in Ōtsu. His success as a painter in Ōmi is closely linked with the popularity of *haikai* in that region and his connections via fellow Buson pupil Ryōga. In Ōmi, Owari, and Osaka, the prior establishment of flourishing *haikai* traditions, in which Buson was recognized as a key member of the Bashō lineage, played a seminal role in encouraging and supporting artists painting in the Buson style. Kinkoku "appropriated" the Buson lineage during his Nagoya years but ultimately transformed the Buson landscape painting tradition into a more dynamic style that vividly conveyed the mystical energy of the mountains he had seen and felt during his Shugendō experiences. All the artists discussed here shared Buson as the source for their art, but they discovered and singled out different aspects of his painting to emulate and then to transform in accordance with their individual backgrounds and aspirations. In this respect, they inherited and passed on the process of change begun by Buson himself, as he copied and assimilated the compositions and brush styles of a rich

diversity of Chinese and Japanese painting to forge one of the most lyrical traditions in the history of Japanese art.

ACKNOWLEDGMENTS

I would like to extend my gratitude to Paul Berry, for sharing with me his vast knowledge and for his critical reading of this manuscript, and to Patricia Graham, for her editorial comments at an early stage. I would also like to thank Yabumoto Kōzō as well as Matsuura Kiyoshi, curator of the Osaka Museum of History, for graciously making available to me materials related to Matsumoto Hōji, and Yokoya Ken'ichirō of the Ōtsu City Museum of History, for providing me with data on Ryōga and a transcription of one of the inscriptions on fig. 4. Sasaki Susumu, director of the Rittō History Museum, and Robert and Betsy Feinberg kindly provided photographs.

NOTES

1. The terms *haikai* and "haiku" are sometimes mistakenly used interchangeably. The latter are independent poems, which evolved from the opening verse (*hokku*) of a *haikai* sequence.

2. "Buson: Sono naiteki sekai no tabi" (Buson's inner journey), in Sasaki Jōhei and Sasaki Masako, eds., *Buson: Sono futatsu no tabi* (Buson: His two journeys), exh. cat. (Tokyo: Asahi Shinbunsha, 2001), 18.

3. For the information regarding Buson's life and the chronology of his works, I am indebted to the scholarship of several individuals, especially Sasaki Jōhei, Sasaki Masako, and Hayakawa Monta: Sasaki and Sasaki, *Buson: Sono futatsu no tabi*; Sasaki Jōhei and Sasaki Masako, "Yosa Buson: Edo jidai runesansu saidai no maruchi aatisuto" (Yosa Buson: The most versatile artist of the Edo renaissance), *Geijutsu shinchō* (February 2001): 5–60; Ogata Tsutomu, Sasaki Jōhei, and Okada Akiko, eds., *Buson zenshū* (Complete works of Buson) (Tokyo: Kōdansha, 1998); Hayakawa Monta, "Eighteenth-century Kyoto and Yosa Buson," unpublished manuscript; Hayakawa Monta, *Yosa Buson hitsu "Yashoku rōdai zu"* ("Night Snow over the City" by Yosa Buson), E wa kataru (Cultural memory in art), no. 12. (Tokyo: Heibonsha, 1994).

4. Hayakawa, *Yosa Buson hitsu "Yashoku rōdai zu,"* 61.

5. Hayakawa draws attention to Buson's interest in the Jōdo priests Hōnen and Shinran, who espoused the idea that one could practice Buddhism while living a worldly life, and points out affinities with Buson's lifestyle; ibid., 61–74.

6. The *bunjin* painter-theorist Tanomura Chikuden (1777–1835) considered Buson an "unorthodox" painter whose works strayed from the "correct" path of *bunjinga* exemplified by Ike Taiga. See Sasaki Jōhei's analysis of Chikuden's commentary in *Yosa Buson*, Nihon no bijutsu (Arts of Japan), no. 109 (Tokyo: Shibundō, 1975), 19–24.

7. The Chinese painter Shen Quan (Nanpin, 1682–c. 1760) stayed for almost two years in Nagasaki, from 1731 to 1733. He painted descriptive, colorful images of flowers, birds, and animals, which attracted much attention in Japan. Captivated by the "naturalism," many artists enthusiastically studied Nanpin's style, which came to be called *Nagasaki-e* as it rapidly spread throughout the country.

8. James Cahill, "Yosa Buson and Chinese Painting," *Proceedings of the Fifth International Symposium on the Conservation and Restoration of Cultural Property* (Tokyo: National Research Institute of Cultural Properties, 1982), 252.

9. For further information concerning Buson's relationships with patrons, see Mark Morris, "Group Portrait with Artist: Yosa Buson and His Patrons," in C. Andrew Gerstle, ed., *Eighteenth Century Japan: Culture and Society* (Sydney: Allen and Unwin, 1989), 87–105.

10. See Leon Zolbrod, "The Busy Year: Buson's Life and Work, 1777," *Transactions of the Asiatic Society of Japan*, 4th series, 3 (1988).

11. Buson never employed the term *haiga*; he referred to such paintings as *haikai mono no sōga* (cursive paintings of *haikai* subjects).

12. Okada Rihei, *Oku no hosomichi emaki* (The *Oku no hosomichi* illustrated handscrolls) (Tokyo: Tōyō Shobō, 1973), 65.

13. Ibid., 64.

14. Personal conversation with Hayakawa Monta, September 2001. See Haga Toru and Hayakawa Monta, *Buson*, vol. 12 of *Suibokuga no kyoshō* (Great masters of ink painting) (Tokyo: Kōdansha, 1994), 101.

15. Takahashi Shōji, *Buson denki kōsetsu* (A consideration of Buson's biography) (Tokyo: Shunshūsha, 2000), 13, 217.

16. The information on Baitei's life in this essay was drawn primarily from Ishimaru Shōun, "Ōmi ni okeru Buson-ha no keifu" (The Buson lineage in Ōmi), in Uno Shigeki, ed., *Ōmi no bijutsu to minzoku* (Kyoto: Shibunkaku, 1994), 299–302, and Shiga-ken Kyōiku Iinkai, ed., *Ōmi jinbutsu shi* (Record of Ōmi notables) (1917; Tokyo: Rinsen Shoten, 1986), 537–39.

17. See, for example, the pair of landscapes reproduced in Shiga Kenritsu Biwako Bunkakan, *Kyūrō* (Old man [Baitei]) (Ōtsu: Shiga Kenritsu Biwako Bunkakan, 1964), 5.

18. Ōtsu-shi Rekishi Hakubutsukan handout; Aimi Shigekazu, "Higashiyama no shogakkai" (The Higashiyama exhibitions of calligraphy and painting), *Shoga kotto zasshi* 88 (1915): 6.

19. See Kyōto Hakubutsukan, ed., *Ōmi Buson Kyūrō tenkan mokuroku* (Catalogue of an exhibition of Ōmi Buson Kyūrō) (Kyoto: Kyōto Hakubutsukan, 1934), 12.

20. For information concerning Bashō's connections with Ōtsu and his pupils in that region, see Ōtsu-shi Yakusho, *Konan no haidan* (The haikai world of Konan), in *Shinshū Ōtsu-shi shi*, vol. 3 (Ōtsu: Ōtsu-shi Yakusho, 1980), and Ōtsu-shi Rekishi Hakubutsukan, ed., *Bashō to Ōmi no monjintachi* (Bashō and his pupils in Ōmi) (Ōtsu: Ōtsu-shi Rekichi Hakubutsukan, 1994).

21. For a thorough discussion of this work, see cat. no. 48 in the catalogue of an exhibition of the Gitter collection held at the New Orleans Museum of Art in 1983, Stephen Addiss et al., *A Myriad of Autumn Leaves* (New Orleans: New Orleans Museum of Art, 1983).

22. See ibid., cat. no. 47.

23. Ōtsu-shi Rekishi Hakubutsukan, ed. *Baitei hokku shū* (Collection of Baitei's hokku). Privately published?, 1810.

24. For information on the *Kyūrō gafu*, see Jack Hillier, *The Art of the Japanese Book* (London: Philip Wilson Publishers, 1987), 2:619; Charles Mitchell, *Biobibliography of Nanga, Maruyama and Shijō Illustrated Books* (Los Angeles: Dawson's Bookshop, 1972), 402–4; and Toda Kenji, *Descriptive Catalogue of Japanese and Chinese Illustrated Books in the Ryerson Library of the Art Institute of Chicago* (Chicago: Art Institute of Chicago, 1931), 419.

25. See Komatsu Kazuhiko, *Kyōto makai annai* (Guide to the world of spirits in Kyoto) (Tokyo: Kobunsha, 2002), 64–66.

26. Ritsuzan's birth and death dates are problematic. The dates given here are based on the research presented in Rittō Rekishi Minzoku Hakubutsukan, ed., *Ōmi Kotō/Konan no gajin tachi* (Painters of the Koto and Konan areas of Ōmi) (Rittō: Rittō Rekishi Minzoku Hakubutsukan, 1999), 77.

27. Shiga-ken Kurita-gun Yakusho, ed., *Ōmi Kurita-gun shi Yakusho* (Gifu: Shiga-ken Kurita-gun Yakusho, 1926), 3: 603.

28. For reproductions of Ritsuzan's paintings, see Rittō Rekishi Minzoku Hakubutsukan, ed., *Oka Ritsuzan to Yokoi Kinkoku: Kurita no bunjin gaka* (Oka Ritsuzan and Yokoi Kinkoku: Bunjin painters of Kurita) (Rittō: Rittō Rekishi Minzoku Hakubutsukan, 1991) and *Ōmi Kotō/Konan no gajin tachi.*

29. Nishimura Tajirō, "Yokoi Kinkoku to Ki Baitei" (Yokoi Kinkoku and Ki Baitei), *Shoga kottō zasshi* 286 (1932): 10.

30. See my dissertation *Yokoi Kinkoku: The Life and Painting of a Mountain Ascetic* (Ann Arbor, Mich.: University Microfilms, 1983); "The Impact of Shugendō on the Painting of Yokoi Kinkoku," *Ars Orientalis* 18 (1990): 163–95; and John M. Rosenfield and Fumiko E. Cranston, *Extraordinary Persons*, Naomi Noble Richards, ed. (Cambridge: Harvard University Art Museums, 1999), 3:113–16.

31. A set of six scrolls dated 1792 has been discovered at Shinkōji in Himeji, and a set of four scrolls dated 1795 was found at the temple Dairenji in Kurashiki. Previously a set of four scrolls done in 1799 for the temple Sōeiji located near Kinkoku's home village was known, but that set was not one of those mentioned in the *Goichidaiki.*

32. These works formed the core of an exhibition held at the Kurashiki City Museum of Art; see Kurashiki Shiritsu Biju-tsukan, ed., *Yokoi Kinkoku to Kurashiki* (Yokoi Kinkoku and Kurashiki) (Kurashiki: Kurashiki Shiritsu Bijutsukan, 1990).

33. Fister, "Kinkoku and the Nagoya Haiku World," *Oriental Art* 31, no. 4 (1985/86): 392–407. For further background on the history of *haikai* in Nagoya, see "Kinsei zenki ni okeru Owari no haikai" (Haikai in Owari in the early Edo period), in Shinshū Nagoya-shi Shi Henshū Iinkai, ed., *Nagoya-shi shi* (History of Nagoya city), vol. 3 of *Kinsei zenki ni okeru Owari no haikai* (Haikai in Owari in the early Edo period) (Nagoya: Shinshū Nagoya-shi Shi Henshū Iinkai, 1999), 800–823.

34. I was shown these works by Kobayashi Katsuhirō in Tokyo in 1984.

35. In a letter to Gesshō, Kinkoku thanks him for a model book and asks for more examples. The text of the letter is recorded in Tabei Ryūtarō, *Chūkyō gadan* (Discussions of Nagoya painting) (Tokyo: Tōyō Insatsu Kabushiki Kaisha, 1911), 32.

36. For reproductions of Gesshō's paintings, see Sasaki Jōhei and Sasaki Masako, *Koga sōran: Maruyama Shijō ha* (Survey of old paintings: Maruyama-Shijō school), vol. 3 of *Koga sōran* (Tokyo: Kokusho Kankōkai, 2001).

37. See note 2, Sasaki and Sasaki, eds., 2001, for complete reference.

38. See Maruyama Kazuhiko, "Buson to Gyōdai to no kōshō" (The relationship of Buson and Gyōdai), in *Buson/Issa* (Tokyo: Yuseidō, 1975), and Ōtani Tokuzō, "Tegami ni miru Buson: Gyōdai e no kizukai" (Buson seen through letters: His concern toward Gyōdai), *Biburiya*, no. 76 (April 1981).

39. See Ōtani Tokuzō, ed., *Buson shū* (Collected works of Buson), vol. 12 of *Koten haibungaku taikei* (Collection of classical haikai) (Tokyo: Shūeisha, 1972), letters 140, 148, 193, 285, and 286.

40. Collection of the Shiga Kenritsu Biwako Bunkakan. The Buson original is published in Ogata et al., eds., *Buson zenshū* (Complete works of Buson) (Tokyo: Kōdansha), 6:no. 260.

41. Kinkoku relates that the initial procession started with five thousand, but the number of participants gradually decreased. According to another document, the *Tōzan gonyūbu gyōretsu ki* (Record of mountain pilgrimage processions of the Tōzan sect), the number of participants was 796. See Miyake Hitoshi, "Monzeki no mineiri ni mirareru kyōdan soshiki" (The organization of the religious fraternity seen in the mountain pilgrimages of imperial abbots), *Shinto shūkyō* 69 (1973): no. 19.

42. Tabei, *Chūkyō gadan*, 3, 244; Seto-shi Shi Hensan Iinkai, *Tōji shi hen* (Section on history of ceramics), vol. 3 of *Seto-shi shi* (History of Seto) (Tokyo: Daiichi Hōki Shuppan, n.d.), 316–18.

43. Temples with Kinkoku's works from this period include Tōkaiji, Nagoya city; Gyokurinji and Saimyōji, Toyokawa city (Aichi prefecture); Sankōji, Toyota city (Aichi prefecture); Chōkyūji, Seto city (Aichi prefecture); Fukumanji, Gamagori city (Aichi prefecture); Seiganji and Kanryūji, Kurashiki city (Hyōgo prefecture); Myōkakuji, Mitsu-gun (Okayama prefecture); and Kongōin, Shūchi-gun (Shizuoka prefecture).

44. Letter from Kinkoku to his relative Yokoi Yasozaemon, presently in the collection of Yokoi Keinosuke.

45. For a discussion of this theme, see Fister, *Yokoi Kinkoku*, 201–7.

46. Tabei, *Chūkyō gadan*, 133.

47. Fujimori Seikichi, *Kinkoku shōnin gyōjō ki* (Record of the eminent monk Kinkoku's activities), Tōyō Bunko series, no. 37 (Tokyo: Heibonsha, 1965), 84.

48. Nakao Chōken, *Kinsei itsujin gashi* (Painting history of the early modern eccentrics), in Tadashi Kobayashi and Motoaki Kōno, eds., *Nihon kaigaron taisei*, vol. 10 (Tokyo: Perikansha, 1998), 288.

49. For some reproductions, see Suntory Museum of Art, *Kohitsu tekagami to gajō no meihin* (Masterpiece albums of calligraphic exemplars and paintings). *Kinsei Nihon no aato arubamu* (Art albums of Edo-period Japan), no. 69, pp. 57, 108 (Tokyo: Suntory Museum of Art, 2001).

50. The box for this scroll is inscribed with the title *Inpu sen* (Book of selected seals). The seals are impressed on the same piece of paper on which the landscape was painted.

51. Published in Amagasaki Sōgō Bunka Sentaa, ed., *Itō Jakuchū ten* (Exhibition of Itō Jakuchū) (Amagasaki: Amagasaki Sōgō Bunka Sentaa, 1981), cat. no. 81.

52. For reproductions of one album, see Takeda Kōichi, ed., *Yoriai shogajō: Bunjin shoka* (Assembled albums of calligraphy and painting: Bunjin and other artists), vol. 10 of *Edo meisaku gajō zenshū* (Tokyo: Shinshindō, 1997).

53. For an illustration of Unkyo's *haiga* and further information about the artist, see the catalogue of an exhibition at the Ōtsu City Museum of History, *Avenues of Japanese Painting: The Hakutakuan Collection* (Seattle: University of Washington Press, 2001), cat. no. 97, pp. 104 and 179. I am indebted to one of the authors, Paul Berry, for calling my attention to this work.

54. Notable examples are Yokoyama Seiki (1793–1865) and Shiokawa Bunrin (1801–1877). A document published by Paul Berry, evidencing the continued appreciation of Buson's work, is a letter written by Seiki to authenticate a Buson painting; see ibid., cat. no. 95, pp. 102 and 155.

55. See Inui Norio, *Kindai no haiga to haiku* (Haiga and haiku of the modern era) (Kyoto: Kyōto Shoin, 1997). As noted by Paul Berry, the prevalence of the *haiga* tradition in *nihonga* is a worthy topic that has not yet been explored.

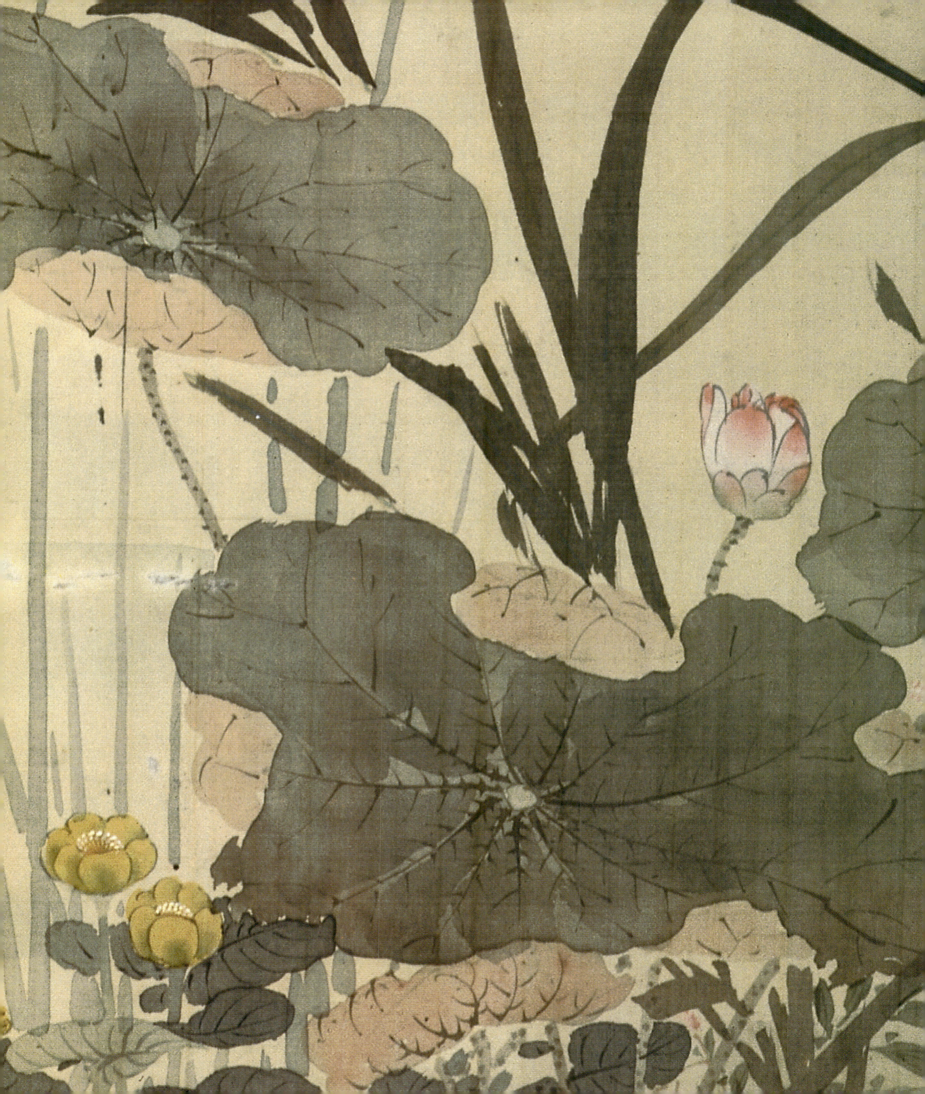

Patricia J. Graham

The Later Flourishing of Literati Painting in Edo-period Japan

THE NUMEROUS ARTISTS INCLUDED IN THE EXHIBITION THAT ACCOMPANIES THIS catalogue represent the full spectrum of interests and backgrounds of the dominant group of literati painters active in the first half of the nineteenth century. These artists lived and studied in, or paid extensive visits to, the nation's largest urban areas where intellectuals congregated— the Kyoto and Osaka region (Kansai district) and Edo (now Tokyo). They embraced, with varying degrees of commitment, later Chinese artistic and literati values, shared through an informal and complex network of personal associations.

Although diverse in social status, wealth, artistic inclination, and political involvement, these artists shared a study of the aesthetic and theoretical principles of Chinese literati painting, which forged a common bond among them. The commonality of their interests reveals two striking features of Japanese society during the late Edo period. First, despite efforts to the contrary by the ruling warrior-elite, a significant breakdown in barriers between social classes was occurring, especially among those individuals with intellectual interests. Second, following trends begun in the eighteenth century, distinctions between amateur and professional practitioners of the arts were becoming increasingly blurred.

Hundreds of literati painters practiced during the late Edo period, but the focus here is upon some of the most important and influential of them, whose formative years and main period of activity occurred between 1804 and 1868.[1] Although the exact date for the beginning of this later period for literati painting is unclear, this essay assumes it commenced around the beginning of the Bunka (1804–18) and Bunsei (1818–30) eras. These eras, jointly called the Kasei period, were a time of prosperity that coincided with the high point of urban popular culture of the late Edo period. Literati painting continued to flourish during the Tenpō era (1830–44)—when horrific famines caused economic and environmental crises—and beyond, throughout the final decades of the Tokugawa shoguns' regime. At that time, the country was plagued intermittently by famines and earthquakes, and the shoguns faced increasing political dissent.

The most influential elder artists in the late Edo era were Kameda Bōsai (1752–1826) and Tani Bunchō (1763–1840), in Edo, and Aoki Mokubei (1767–1833), in Kyoto. Through their devotion to Chinese scholarship and their interest in connoisseurship of Chinese literati painting and antiquities, they inspired the burgeoning ranks of aspiring, younger literati artists—born between 1777 and 1817—to pursue similar courses of study.

These artists were a varied lot, even those born into the same status group, such as samurai. Some samurai-painters, particularly those active in Edo, such as Bunchō and Tachihara Kyōshō (1785–1840), had direct contact with the shoguns or their high-ranking warrior-retainers (daimyo). Bunchō, who served the shogun's chief councilor and consequently received many prestigious commissions, attracted hoards of students and grew exceedingly wealthy. Many other samurai-painters, however, especially those from impoverished, outlying domains, were

Pl. 33. Yamamoto Baiitsu. *Flowers and Birds by a Pond* (detail, cat. no. 41).

Pl. 34. Tani Bunchō. *Spring Flowers and Butterfly* (cat. no. 32). Inscription by Kameda Bōsai.

unhappy with shogunal policies and became imperial loyalists who favored overthrowing the shoguns (as did a number of the literati painters not of the samurai class). Among these men were swordsmen like Fujimoto Tesseki (1817–1863) of Kyoto, who fought against the shogun's supporters and was killed in battle. Some other defiant samurai-painters simply renounced their hereditary positions to study Confucianism and become masters in the arts of Chinese painting and calligraphy. They eventually earned their living teaching these subjects. Tanomura Chikuden (1777–1835), Rai San'yō (1780–1832), and Nukina Kaioku (1778–1863)—all active in Kyoto loyalist circles—followed this course. Still others, such as Watanabe Kazan (1793–1841) of Edo, spoke out and were imprisoned. Kazan, incidentally, was a painting student of Bunchō's, whose political loyalties were the opposite of his own. Although no paintings by these men are included in this exhibition, their moral perseverance and mastery of literati painting styles inspired many of the artists whose works are represented.[2] Finally, others, such as Tsubaki Chinzan (1801–1854) of Edo, gave up their official positions because of a physical inability to serve.

Other literati painters of the late Edo period were born into the urban middle classes, a nebulous category that included artisans, merchants, and learned professionals, such as physicians. Artists of this background included Kameda Bōsai, who was active in Edo; Okada Hankō (1782–1846), of Osaka; Yamamoto Baiitsu (1783–1856), who was born in Nagoya but lived and worked for most of his career in Kyoto; Takahashi Sōhei (1802–1858), from Kyushu, although he had visited and studied in Kyoto; Nakabayashi Chikutō (1776–1853), from Nagoya but also a longtime resident of Kyoto; and his son, Nakabayashi Chikkei (1816–1867), who lived his whole life in Kyoto. Still others were born in rural villages but moved to larger cities where they could more

easily practice their art and engage in political activism. Artists of this group included Hine Taizan (1813–1869), from a small town near Osaka; Yanagawa Seigan (1789–1858), who was born in Minō (near Nagoya) and lived at various times in Edo and Kyoto; Hosokawa Rinkoku (1782–1842), who was born on Shikoku Island but lived and worked in Edo for most of his career; and Murase Taiitsu (1804–1881), who lived briefly in Kyoto before settling in Nagoya to teach.

In spite of their different political viewpoints, statuses at birth, and the geographical distances that separated them, most of these painters knew one another, either directly or by reputation. What brought them together was a devotion to learning about Chinese literati painting and related arts, as well as a demonstrated talent in these endeavors. Literati painters met frequently with like-minded individuals as they traveled about and often held informal gatherings at which the sharing of knowledge and exchange of ideas created an inspiring learning experience. The homes of certain individuals, because of their gregarious or magnanimous natures, became gathering points for visitors from near and far who had an interest in literati painting and Chinese studies, regardless of their social status. In Osaka, Kimura Kenkadō (1736–1802), a painting pupil of Ike Taiga (1723–1776), was one such individual whose parties, sponsorship of painting exhibitions, and personal collection of antiquities and books were deservedly famous.[3] After Kenkadō died, the Kyoto home of the scholar-painter Rai San'yō became another important locus for literati gatherings. We know of the encounters among these artists at these places and elsewhere through letters and diaries (some of which were published at the time) and through poetic inscriptions brushed on paintings by these various people. Several paintings presently and formerly in the Gitter-Yelen collection include such inscriptions. For example, Kameda Bōsai and Tani Bunchō were frequent

collaborators. In *Spring Flowers and Butterfly* (pl. 34), both the placement and the large, loose brushwork of Bōsai's poem complement the broad brushstrokes of Bunchō's image. The painting and poem were probably conceived together, as the pictorial composition would have appeared incomplete and unbalanced without the poem. Yet this was not always the case. Oftentimes, after a painter finished a picture, the artist begged illustrious calligrapher-friends to honor the work with an inscription. We know this happened with the screen *Waiting for the Ferry* (fig. 1) by Uragami Shunkin (1779–1846)[4] because the inscriber, Rai San'yō, said so in an afterword to his poem. San'yō's poem describing travelers waiting for a ferry is so descriptive of the picture's subject that it may have been written especially for the painting. Somewhat different circumstances probably accounted for the appearance of short four-line poems by Yanagawa Seigan and Nukina Kaioku on Hine Taizan's *Dawn Bell at Nanpin* (pl. 35). Although elegantly brushed and well conceived as poetry, their subjects seem chosen at random, as they do not directly relate to the theme of the painting upon which they have been inscribed.[5]

EDUCATIONAL OPPORTUNITIES FOR ASPIRING LITERATI PAINTERS IN LATE EDO JAPAN

Nanga artists were generally drawn to the style of the Chinese literati because of childhood experiences and influences. Many of them exhibited artistic creativity as youngsters, which their families encouraged. Some had fathers who were Confucian scholars, poets, calligraphers, or literati painters themselves, and these men served as their first teachers. Tani Bunchō's father was a well-respected poet. Rai San'yō's father was a famous Confucian scholar. Okada Hankō's father was the literati painter Okada Beisanjin. Uragami Gyokudō was the father of Uragami Shunkin. Nakabayashi Chikkei studied literati painting first with his

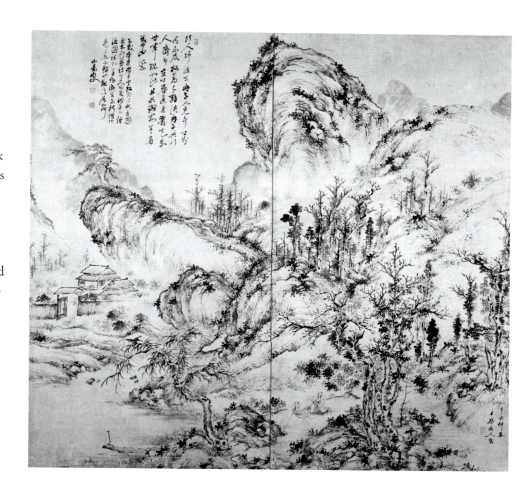

Fig. 1. Uragami Shunkin. *Waiting for the Ferry*. Ink on paper, 158.8 × 167 cm. New Orleans Museum of Art, gift of Dr. Kurt A. Gitter and Millie Hyman Gitter, in honor of Malcolm and Dorothy Woldenberg (81.215).

father, Chikutō, and then with Yamamoto Baiitsu, Chikutō's best friend.

Other literati painters of the late Edo period were introduced to the art during classes in Chinese studies or in the ateliers of professional painters of other schools, although a few were initially or entirely self-taught. Often, enthusiasm for their calling drove them to travel far from their homes in the provinces to intellectual enclaves in Edo or Kyoto, or far south to Japan's sole international port, Nagasaki, where they studied with emigrant Chinese artists in residence there.

In all cases, Confucian studies fueled these artists' interest in literati painting. The desire to appreciate and master cultivated arts such as Chinese literati painting was a natural extension of Confucian learning and ethics, which dictated the edifying effect of practicing certain arts. At first this learning was confined to the samurai class, but the teachings quickly spread throughout the country, even to well-to-do farmers. Not everyone, however, attended the same types of schools or learned

Pl. 35. Hine Taizan. *Dawn Bell at Nanpin* (cat. no. 48).

from a standardized curriculum. National and regional (warrior clan—sponsored) academies, established in the seventeenth century, were the first schools at which Confucianism was taught. Because these institutions were designed to impart moral virtues and military training to the samurai class, their curriculum followed a course set by the shogunate.

Although some samurai-status literati painters began their study at these institutions, most received their main education from private tutors or at privately run, independent academies. These schools were open to students from all classes of society and taught more diverse curricula than did official samurai clan schools They first appeared in the late seventeenth century but increased dramatically in number beginning in the following century. Most were located in Kyoto, the unrivaled center for Chinese scholarly studies throughout the Edo period. Not coincidentally, although *nanga* painters hailed from all parts of Japan and could be found practicing in most cities, most literati artists came to Kyoto at some point in their lives for study and camaraderie with like-minded individuals.

The most popular curriculum at the private academies focused on Chinese studies, encompassing readings of Chinese prose, poetry, and Confucian classics. Some private schools included the teaching of Chinese calligraphy, painting in the Chinese manner, and poetry composition in Chinese, but these subjects also were taught separately at more specialized, privately run schools, most of which were devoted to calligraphy. Other academies focused on the teaching of diverse subjects such as calculation, Western learning, writing in Japanese, military science, and Japanese studies.[6] As the Edo period progressed, the number of such schools increased significantly, especially from the 1830s onward, as a broader segment of the population grew interested in Chinese culture. This proliferation of private academies resulted in a swelling of the numbers of Japanese literati artists and their patrons.

Apprenticeship with practitioners of traditional arts, including painting, was another important educational avenue in Edo-period Japan.[7] This system stressed teachings, often "secret," transmitted directly from master to pupil. Practical instruction was offered by a master, who not only guided students in their studies but also expected disciples to become proficient enough to assist in projects for clients. To perpetuate their hallmark styles, painting schools that followed this system advocated the copying of models, both actual paintings and woodblock-printed or manuscript copybooks, and students were not encouraged to develop personal artistic identities. Among the literati painters under discussion here, significantly, only Tani Bunchō, the most eclectic and best connected to the shogunal regime, received his initial art training through formal apprenticeship, in the well-established Kanō school.

To a large extent, the regimented course of study advocated by these schools was directly at odds with literati painting's avowed intention— to serve as an outlet for artistic creativity and self-expression. Many prominent literati painters of the late Edo period became teachers in ateliers they personally established, and these were run more along the lines of the private academies. Still, Bunchō and other *nanga* painting teachers produced painting manuals as well as theoretical treatises, similar in conception to those of the Kanō school. In keeping with the mission of their tradition—to transmit the philosophy and form of Chinese literati painting to Japan—their publications incorporated ideas and images from Chinese materials of the Ming (1368–1644) and Qing (1644–1911) dynasties, both theoretical treatises and woodblock-printed books, such as the late seventeenth-century *Mustard Seed Garden Manual* (C. *Jieziyuan huajuan*; J. *Kashien gaden*).

These books on literati painting techniques and theory were instrumental in disseminating knowledge about the tradition in the first half of the nineteenth century. They explained the theoretical basis of Japanese literati painting, traced its history from China to Japan, and proclaimed its superiority over other Japanese painting schools. Most important for transmitting aesthetic principles, many provided explicit rules for painting and some included illustrations. Although the first literati painting treatises had been authored by practitioners whose main periods of activity were during the eighteenth century, the early nineteenth century can really be considered the high point for the publication of painting treatises by Japanese literati artists. For many of the latter-day literati painters in Japan, this freshly published material significantly influenced their professional development. In addition to Bunchō, prominent theorists from this period include Tanomura Chikuden, Nakabayashi Chikutō, Uragami Shunkin, and Kanai Ujū (1796–1857). These writers also advocated copying imported Chinese paintings, which, as the Edo period progressed, became increasingly available.

From the late eighteenth century and continuing into the first half of the nineteenth century, most Japanese literati artists emphasized careful studying and copying of later Chinese paintings and calligraphies of the Ming and Qing periods. They considered the study of these artworks to be an essential part of their training and produced both direct copies and freer interpretations of them. Exposure to actual examples of these Chinese paintings had been less common among eighteenth-century literati painters in Japan simply because few such paintings had entered the country. Chinese works, especially those dating to the sixteenth through early nineteenth centuries, became increasingly available as more and more were imported in response to the interests of Japanese consumers. From the late eighteenth century onward, sinophile scholars and artists themselves began amassing personal collections of newly imported Chinese paintings and calligraphies.

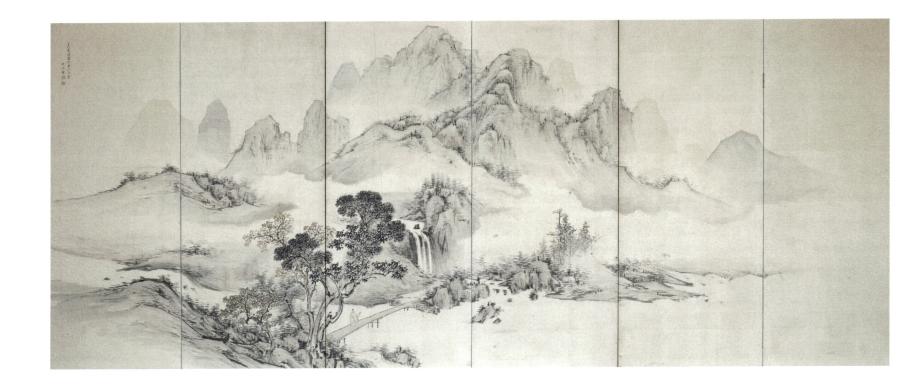

Only a few Chinese literati paintings of earlier periods could be found in Japan, and most of these were then in the possession of Buddhist temples or in old daimyo or shogunal collections. When they could, Japanese literati artists studied these as well. Baiitsu and Chikutō, for example, took their art names, Plum Recluse and Bamboo Grotto respectively, from Chinese paintings they had seen and studied in a Buddhist temple in Nagoya during their formative years. Yet the vast majority of what the Japanese literati painters studied was newly imported material.

Semiprivate exhibitions of Chinese paintings became important learning opportunities for literati artists. In some cases, these gatherings took place in conjunction with celebrations of the birthdays of illustrious persons or as part of memorial services after they died. The painters Yamamoto Baiitsu and Tanomura Chikuden both were honored in this way, and catalogues of these exhibitions survive. Sometimes Chinese paintings and calligraphies were displayed at lively gatherings that featured the ritual drinking of *sencha*, a

steeped, green leaf-tea, which was served with Chinese accoutrements in rooms filled with Chinese furniture. On such occasions, rooms separate from where the tea was served were turned into galleries for the display of art.[8]

Under the influence of the newly published theoretical and practical guides for literati painting, and as a result of greater access to Chinese paintings, diverse artists came to incorporate into their respective paintings a common vocabulary of visual forms and stylistic traits, although their individual creations continued to be distinguished by peculiarities of their personal brushwork. These influences can be seen in adaptations of Chinese brushwork and the rational and formally organized compositions, visible especially in some of the landscapes in the Gitter-Yelen collection, including Chikkei's *Summer and Autumn Landscapes* screens (pl. 36 a, b) and Chikutō's *Summer Landscape* (fig. 2). These paintings contain similarly applied, layered brushstrokes and compositional devices that emphasize foreground spaces divided from distant mountain peaks by large bodies of water.

PAINTING IN THE PERSONAL AND PROFESSIONAL LIVES OF LATE-EDO LITERATI ARTISTS

Many literati painters worked as freelance professionals, selling their paintings on the open market in competition with individuals working in other styles. Although the numbers of literati artists grew significantly during the first three decades of the nineteenth century, they never constituted a majority among the painters then active, even in Kyoto, where literati painting was, by the early nineteenth century, a well-established tradition.[9] Competition for patrons was fierce, and most painters could derive only part of their income from sales. Many earned additional income by teaching.

Some literati painters, in both the Kyoto-Osaka area and Edo, practiced primarily as amateurs, deriving their livelihoods from other fields of Chinese studies. Kameda Bōsai taught Confucianism early in life and Chinese calligraphy later. Rai San'yō and Murase Taiitsu taught Confucianism. The poet Yanagawa Seigan also instructed

pupils in the art of Chinese poetry. Nukina Kaioku taught Chinese calligraphy.[10] Hosokawa Rinkoku gave instruction in seal carving, an art form related to Chinese calligraphy, but earned his main income from selling his beautifully carved seals. Seal impressions were required on all official documents and generally, following established custom, were also stamped onto finished paintings and calligraphies, either below an artist's signature or elsewhere, as certification of authorship. Although artists sometimes carved their own seals, many employed the services of a talented professional such as Rinkoku.

Patrons of those literati painters working as professional artists came from all walks of life and diverse regions of the country. The boom in Chinese studies during the late Edo period aided these artists' attempts to make painting a career. Although some patrons undoubtedly displayed paintings in their homes as status symbols indicative of their sophistication and good taste, most must have been genuinely interested in the style, for it was not an easy one to understand. Many

literati paintings were augmented with prose or poetry in Chinese, references to Chinese painters, or depictions of imaginary scenes of Chinese locales famous in literati lore. Hine Taizan's scroll *Dawn Bell at Nanpin* (pl. 35), for example, is an evocative representation of a faraway and never-seen Chinese place, and Okada Hankō inscribed his *Village among Plum Trees* (pl. 44) with a poem that mentions the great Yuan-dynasty literati painter Wang Mian (1287–1359).

The brushwork, compositional features, and other pictorial elements in these paintings make frequent visual references to Chinese painting styles and particular artists, as is the case with Chikutō's *Summer Landscape* (fig. 2). It is brushed in a style later Chinese and Japanese artists came to associate with the Song literati painter Mi Fu (1051–1107), with a rounded mountain defined by overlapping layers of oval brushstrokes. Patrons needed considerable knowledge of Chinese painting and literati culture to decipher images such as this. Competing schools of artists, particularly those derived from the naturalist traditions promoted by Maruyama Ōkyo and Matsumura Gekkei (Goshun) in Kyoto, also painted many pictures with Chinese themes but limited the literati references to the most well known subjects, and they painted in a more visually accessible style than did the literati.

Urban patrons for professional literati artists were largely Confucian scholars, physicians, samurai-bureaucrats, or well-educated merchants whose education and personal taste had instilled in them an appreciation for such pictures. Yet, even with a supplemental income derived from teaching, many artists could not rely on nearby patrons for their livelihoods. Artists sometimes sent paintings brushed on commission to patrons in their home districts, or they made the rounds of outlying regions themselves, selling paintings as they traveled and obtaining food and lodging in exchange for a bit of teaching and bravura demonstrations of their talents with brush and ink.

Some artists, such as San'yō, also served as brokers for clients, assembling albums of paintings, with each page brushed by a different artist at the request of a patron.

Semipublic painting and calligraphy exhibitions (*shogakai*), with admittance by invitation or a nominal fee, became an important means of attracting patrons and selling art. Kimura Kenkadō is credited with organizing the first exhibition of this sort in Japan, in Osaka in 1770. In 1792 the Kyoto Confucian scholar Minagawa Kien (1734–1807), who was also an amateur literati-style painter, organized a larger exhibition of this sort in Kyoto. It continued, semiannually, until 1864. Reflecting the relative popularity of various artistic

Fig. 2. Nakabayashi Chikutō. *Summer Landscape.* Hanging scroll: ink on silk, 127 × 78.5 cm. Gitter-Yelen collection.

Pl. 37. Yanagawa Seigan. *Mount Kōya in Autumn* (cat. no. 43).

traditions, participating artists came from various painting lineages, with literati painters consistently constituting a minority. The city of Edo had painting and calligraphy gatherings as well. These were especially popular from the 1820s through the mid-1840s, but records indicate their existence into the 1870s. Exhibitions in Edo differed significantly in nature from Kyoto-Osaka gatherings, being larger, more extravagant (some would say vulgar) banquet-style affairs. Literati and other artists attended as celebrities, allowing the common folk a rare opportunity to fraternize with intellectuals and artists. These parties offered artists a means of attracting pupils as well as patrons.[11]

In addition to producing paintings and calligraphies for paying customers, professional literati artists painted for their own enjoyment, to express spiritual devotion, or to make an informal gift for a friend. In these various personal paintings, the Japanese literati most closely resembled the spirit of their Chinese forebears, who saw painting as an expression of the individual spirit of its cultured practitioners.

Like the Chinese literati artists they admired, the Japanese literati enjoyed rambling about in nature and visiting various scenic spots throughout Japan. They frequently recorded impressions of these excursions in painting and poetry. For example, the inscription on Yanagawa Seigan's *Mount Kōya in Autumn* (pl. 37) indicates it was painted after a trip to the Buddhist holy site of Mount Kōya. Sometimes, artists produced more informal paintings at private gatherings of scholars, artists, and poets. Rice wine (sake) or Chinese-style *sencha*, or both, would usually be served. Many paintings brushed at these events—quickly dashed-off hanging scrolls, handscrolls, or smaller-format album leaves—were more intimate than the larger hanging scrolls and screens, usually commissioned, for more formal, grander spaces. Kameda Bōsai's painting of a gourd, a receptacle

for serving sake, is an example of this type of painting (cat. no. 29), and indeed, the inscription indicates he painted it while inebriated. A final type of personal painting was that created as an expression of individual religious devotion. One painting of this type is Fujimoto Tesseki's small-scale, simply brushed album of Buddhist saints, *Sixteen Rakan* (pl. 38).

THE SUBJECTS AND PAINTING STYLES OF LATER LITERATI PAINTERS

Although regional differences can be seen in the styles and subjects of these later *nanga* painters, they are less pronounced than the characteristics the artists share. Differences seem more dependent upon the personal inclinations and talents of the artists, the models from which they learned, and

the technical advice of their individual teachers. For many literati artists active in the late Edo period, any reference to the tenor of the times remained conspicuously absent from their paintings, even among those who were strongly opposed to the political status quo. As some politically active literati painters discovered, the government dealt harshly with outspoken critics of its regime, whether such criticism came in the form of art or in words. Artists responded in nonconfrontational ways to the cruelties and hardships that confronted them daily by using imagery that was either idyllic or symbolic. Imaginary landscapes of pastoral Japanese locales or of rural China, peopled by eremitic scholars, represented an ideal world removed from their grim surroundings, as in Tani Bunchō's landscape screens (pl. 42 a, b).

Pl. 39 a, b. Takahashi Sōhei. *Bamboo* and *Plum Blossoms* (cat. no. 46).

Takahashi Sōhei's pair of hanging scrolls, *Bamboo* and *Plum Blossoms* (pl. 39 a, b), typifies the monochromatic or lightly colored paintings of plants, such as bamboo, orchid, plum, and pine, that literati artists brushed to symbolically convey an appreciation for Chinese literati values. These subjects were generally defined with brushwork closely akin to calligraphy, an art all Chinese literati had mastered. Thus, they were well suited to portrayal by literati artists, who professed to partake of the art as amateurs and used their skill at calligraphy to define pictorial forms. Baiitsu often depicted these plants as well, with truly virtuoso handling of the brush. Often, he incorporated these subjects into lush scenes of blossoming flowers and trees, as in his *Flowers of the Four Seasons* screens (pl. 40 a, b). This monumental composition exemplifies his ability to render with great sensitivity the beauty of the natural world.

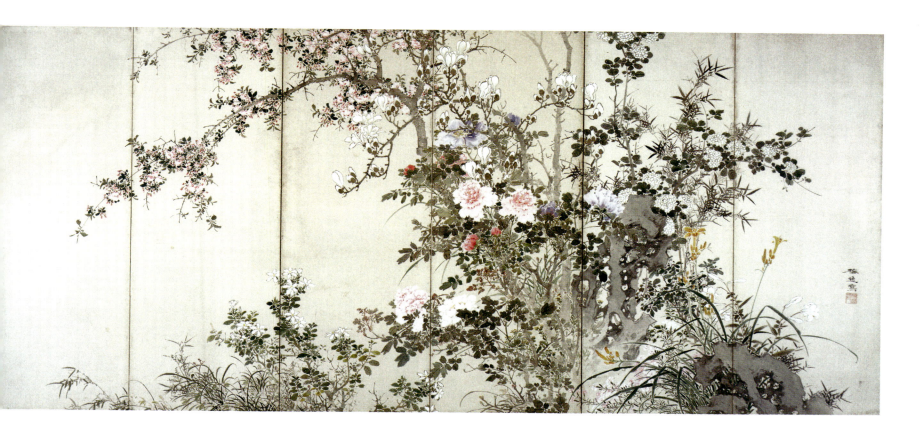

Many literati artists, such as Murase Taiitsu (cat. no. 47), Fujimoto Tesseki, Yanagawa Seigan, Hosokawa Rinkoku (cat. no. 37), and Kameda Bōsai, were true amateurs in that they pursued painting exclusively as a hobby. They eschewed polished, complicated painting styles in favor of more overtly amateurish brush mannerisms, with sparse brushwork that closely resembled calligraphy, in which they all were well trained. Because of its association with Chinese literati values, this amateur style also came to be popular with professional literati artists and their patrons. Chikutō (cat. no. 36) and Tachihara Kyōsho (cat. no. 42) were two of many professional literati painters who perfected styles that only appeared amateurish because of an emphasis on relaxed, calligraphic brushstrokes and little or no application of color.

Many literati artists, particularly those who worked as professionals, mastered a more eclectic approach to painting than did those for whom

Pl. 40 a, b. Yamamoto Baiitsu. *Flowers of the Four Seasons* (cat. no. 40).

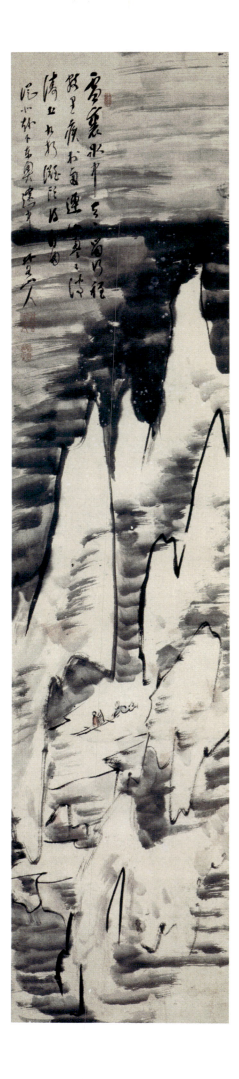

Pl. 41. Hosokawa Rinkoku. *Sledding in the Icy Mountains* (cat. no. 37).

painting was an avocation. Among all the literati artists of this group, Tani Bunchō was the most famous for his experimentation with various painting traditions. In addition to forays into Western-style realistic painting, he frequently based his brush styles on the manner of the professional Chinese Zhe school artists of the Ming dynasty rather than the amateur literati painting tradition. The Zhe school style is evident in his two landscape paintings in this exhibition (pl. 42 a, b; cat. no. 31). Unlike traditional Chinese literati painting, in which multiple layers of calligraphic brushstrokes define the forms, Bunchō's paintings rely on ink applied in broad, angular washes and rough, bold strokes, hallmarks of the Zhe school style.

More often though, eclecticism was subtler and took the form of incorporating Western-influenced naturalistic modes with those based on Chinese literati painting traditions, especially in paintings of birds and flowers. Such is the case with Chinzan's *Triptych of Flowers* (pl. 43 a–c). In its careful description of lily, medlar, and pomegranate blossoms, the rendition of flowers in the center painting looks like a quickly brushed sketch based on actual observation, yet overall, in its use of a "boneless" brushwork in which forms are defined without outlines, it more closely resembles Chinese prototypes, particularly the style of the literati painter Yun Shouping (1623–1690). Baiitsu, in a handscroll of pond-side birds, plants, and insects (pl. 33), employed a similar melding of styles in his adoption of a Western-influenced microscopic view of pond life in a painting created wholly with Chinese brush conventions.

Access to authentic examples of Chinese paintings greatly influenced the later literati artists, who moved away from the eccentric and unconventional painting compositions and brush styles of eighteenth-century masters such as Ike Taiga (see cat. nos. 2–10), who were inspired more from the study of woodblock-printed manuals and their own imaginations. The later artists

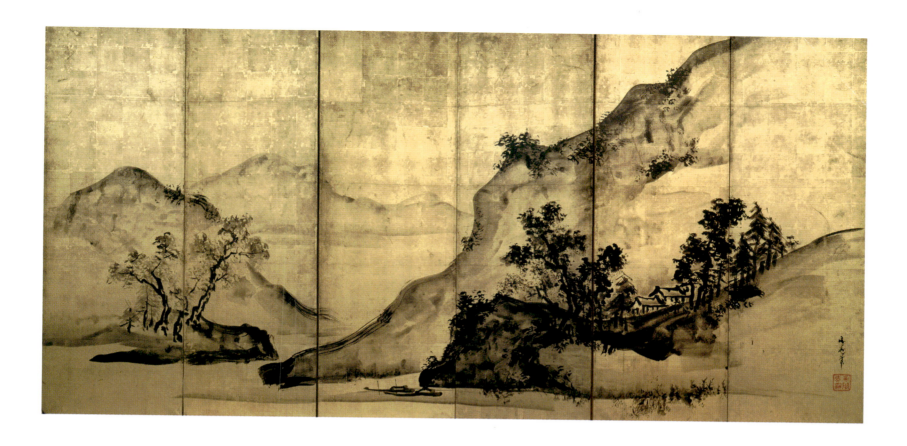

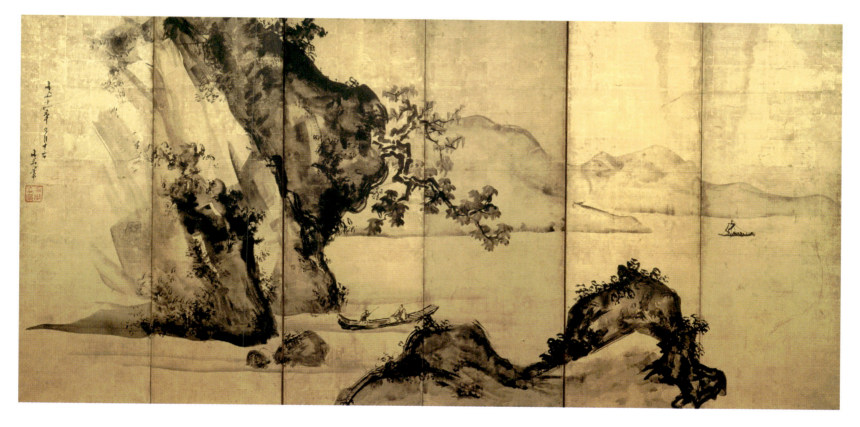

Pl. 42 a, b. Tani Bunchō. *Landscape Screens* (cat. no. 33).

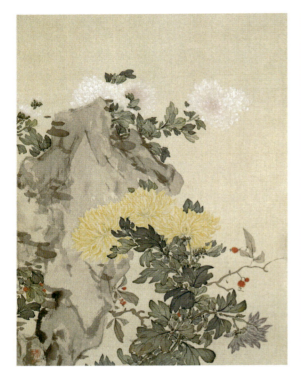

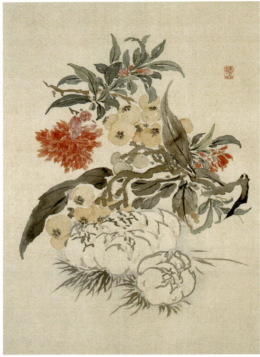

Pl. 43 a–c. Tsubaki Chinzan. *Triptych of Flowers* (cat. no. 44).

strove to re-create the subtle brushwork and compositional structure of the Chinese paintings they saw. Hankō's *Village among Plum Trees* (pl. 44) and Taizan's *Dawn Bell at Nanpin* (pl. 35) exemplify landscapes that were undoubtedly based on Chinese Ming-dynasty literati painting models. Both paintings employ delicate, careful brushwork and feature a favorite Ming literati pictorial device, a river meandering from foreground to background via a circuitous route around mountains that progressively increase in size. Despite their attempts to master Chinese painting styles, the literati artists were far from slavish imitators. Each used Chinese paintings as sources of inspiration in an effort to create a distinct, personal style, which was, after all, an important attribute of the literati painting tradition. Although most artists, especially those working as professionals, proved to be highly talented and capable of painting diverse subjects in a range of styles, artists usually developed specialties for which they became famous and which they repeated often with slight variation.

Chikutō, for example, is perhaps best known for his delicate landscapes, such as his *Plum Blossom Studio* (pl. 45), while Baiitsu and Chinzan, although quite capable of painting landscapes, are more renowned for their flower paintings (see pls. 40 a, b, 43 a–c).

THE PLACE OF LATER LITERATI PAINTERS WITHIN THE JAPANESE LITERATI PAINTING MOVEMENT AND JAPAN'S CULTURAL HERITAGE

Nearly one hundred years ago, the Japanese publisher Shinbi Shoin produced a two-volume book featuring paintings by artists who were then considered the ten great literati painters of Japan.[12] Apart from two widely celebrated eighteenth-century figures, Yosa Buson and Ike Taiga, the eight remaining artists included in Shoin's selection belonged to the nineteenth-century Kyoto-Osaka and Edo literati painting circles discussed in this essay: Tani Bunchō, Watanabe Kazan, Tsubaki Chinzan, Tanomura

Chikuden, Nakabayashi Chikutō, Yamamoto Baiitsu, Okada Hankō, and Nukina Kaioku.

Much more recently, during the 1970s, a larger compilation of Chinese and Japanese literati painting was published in twenty volumes, each devoted to a single artist.[13] This set includes only three of the artists featured in this essay: Rai San'yō, Tanomura Chikuden, and Watanabe Kazan. The other Japanese literati in the set are Gion Nankai, Ike Taiga, Yosa Buson, Okada Beisanjin, Uragami Gyokudō, and Aoki Mokubei. The selection clearly represents a shift in the canon toward those artists influential in founding and naturalizing the literati tradition as well as those whose idiosyncratic personal styles, while clearly based on Chinese literati prototypes, adhered less closely to Chinese models than did the early nineteenth-century artists under consideration here. San'yō, Kazan, and Chikuden probably owe their continued high status to admiration for their moral integrity and scholarship as much as for their paintings. The most curious, prominent omission from the 1970s compilation is Kazan's highly influential and versatile teacher Tani Bunchō, perhaps because his oeuvre was considered eclectic and his output somewhat uneven in quality.

Many of the literati painters active during the first half of the nineteenth century were among the leading artists and intellectuals of their day. Through their inspirational expressions in writing, art, and poetry, as well as their involvement in the conflicts that ended the Tokugawa shogunate, they figured prominently in the creation of the modern Japanese nation-state. Those literati artists who lived through these turbulent times into the early years of the Meiji period also played an important role in instilling an appreciation for Chinese literati values in the minds of the new political leaders and younger intellectuals. These leaders avidly collected Chinese paintings and antiquities in order to position Japan as the

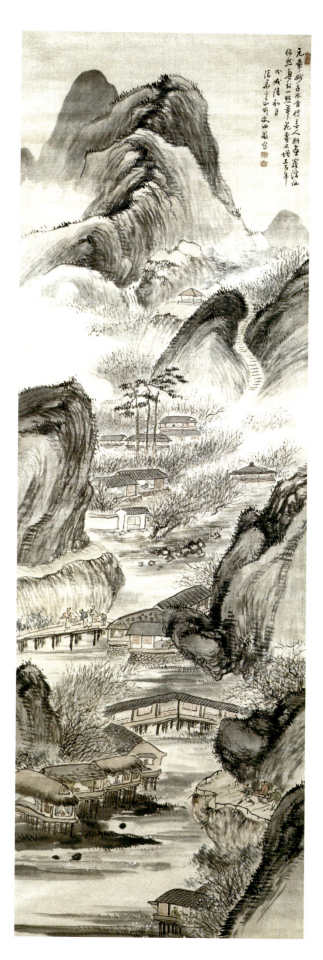

Pl. 44. Okada Hankō. *Village among Plum Trees* (cat. no. 38).

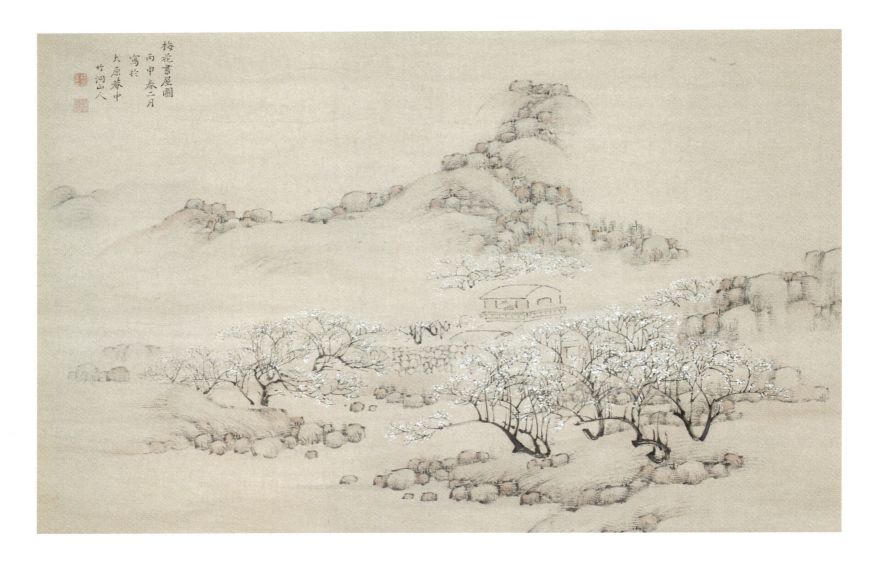

梅花書屋圖
丙申春二月
寫於
大原庵中
竹洞山人

Pl. 45. Nakabayashi Chikutō.
Plum Blossom Studio (cat. no. 36).

intellectual heir to China, preserver of the great cultural heritage of the East. Their goal was to create a uniquely Asian identity for the new modern nation of Japan in the face of encroaching Western influences. In the early twentieth century, scholarly interest shifted to promotion of more nationalistic traditions, and much of the Chinese-oriented cultural heritage of Japan was neglected. Recently, as scholars reassess the formation of Japan's modern identity in the early years of the Meiji period, the contribution of these artists to the richness of Japanese painting history is becoming increasingly apparent.[14]

NOTES

1. I have excluded both those elders of the tradition who lived into the early years of the nineteenth century—Uragami Gyokudō (1745–1820; see cat. nos. 16, 17) and Okada Beisanjin (1744–1820; see cat. no. 18), whose artistic proclivities were more akin to those of their predecessors—and the later generation born in the first half of the nineteenth century, who worked primarily after the Edo period ended, such as Tomioka Tessai (1836–1924) and Taki Katei (1830–1901).

2. For paintings by Rai San'yō and Nukina Kaioku in the Gitter-Yelen collection, see Stephen Addiss et al., *A Myriad of Autumn Leaves: Japanese Art from the Kurt and Millie Gitter Collection* (New Orleans: New Orleans Museum of Art, 1983), pl. 58 (San'yō) and pl. 61 (Kaioku).

3. Kenkadō and his friends are the subject of a recent publication in Japanese: Nakamura Shin'ichirō, *Kimura Kenkadō no saron* (Kenkadō's salon) (Tokyo: Shinchōsha, 2000).

4. Shunkin's painting is published in Stephen Addiss, *Zenga and Nanga: Paintings by Japanese Monks and Scholars* (New Orleans: New Orleans Museum of Art, 1976), pl. 61.

5. For translations of these poems, see the entry for this painting (cat. no. 48).

6. Exact figures can be found in Richard Rubinger, *Private Academies of Tokugawa Japan* (Princeton, N.J.: Princeton University Press, 1982), 13.

7. Recent studies in English on this method of learning include John Singleton, ed., *Learning in Likely Places: Varieties of Apprenticeship in Japan* (Cambridge: Cambridge University Press, 1999), and John Singleton, ed., *Competition and Collaboration: Hereditary Schools in Japanese Culture* (Boston: Isabella Stewart Gardner Museum, 1993).

8. On exhibitions of Chinese paintings in Japanese literati painting circles, and in connection with *sencha* gatherings, see Patricia Graham, *Tea of the Sages* (Honolulu: University of Hawaii Press, 1998), 115–21, 171–72, 175–76.

9. The number of literati painters in Kyoto relative to other artists active there, gleaned from lists in various early nineteenth-century editions of the *Heian jinbutsu shi* (Record of Heian [Kyoto] notables), appear in Sasaki Jōhei, *Bunjinga no kanshō kiso chishiki* (Appreciation and basic knowledge of literati painting) (Tokyo: Shibundō, 1998), 154.

10. For writings by San'yō, Seigan, and Kaioku, see Donald Keene, *World within Walls: Japanese Literature of the Pre-Modern Era, 1600–1867* (Tokyo: Tuttle, 1976), chap. 22 (535–62).

11. For more on these Edo *shogakai*, see Andrew Markus, "Shogakai: Celebrity Banquets of the Late Edo Period," *Harvard Journal of Asiatic Studies* 53, no. 1 (1993): 135–67.

12. Tajima Shiichi, ed., *Nanga jū taika shū* (A collection of the ten great literati painters), 2 vols. (Tokyo: Shinbi Shoin, 1909–10).

13. Ishikawa Jun et al., *Bunjinga suihen* (The essence of literati painting), 20 vols. (Tokyo: Chūō Kōronsha, 1974–79). Half the volumes focus on Chinese literati painters; the rest concentrate on Japanese inheritors of the tradition.

14. Recent explorations by younger scholars in Japan into regional artistic traditions and artists active during the transitional era from Edo to Meiji reveal a revival of interest in the artistic currents of this time. Many of these artists, including Bunchō (about whom there have been many catalogues and books), Kaioku, Baiitsu, Chikkei, Sōhei, Taiitsu, Chinzan, and Bōsai, have been the subjects of recent exhibition catalogues.

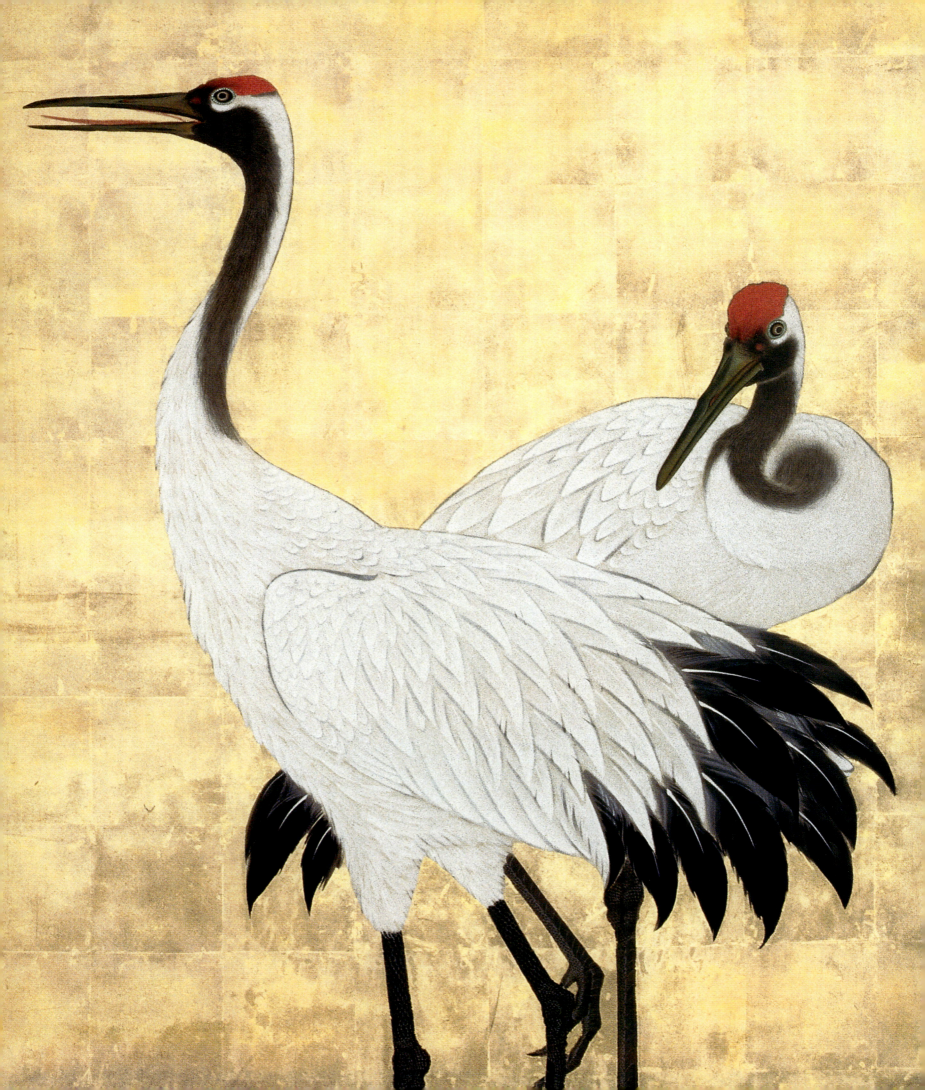

Jōhei Sasaki

The Maruyama-Shijō School

THE EDO PERIOD WAS ONE OF THE LIVELIEST AGES IN JAPANESE HISTORY. In particular, the art world of the mid and later decades of the period experienced a rich cornucopia of styles, and among these, the Maruyama-Shijō school played an important role as a bridge from the classical to the modern in Japanese painting. This essay, after noting the historical background behind the evolution of the style, will focus on the role of the Maruyama-Shijō school within Japanese painting and key developments within the painting style itself.

The establishment in 1603 of the Edo *bakufu*, or military government, created a new political center in Japan. Edo, founded in a previously undeveloped geographical region, gained importance as a capital city. Although the military government was the true power—the country's "ruler"—the emperor continued in residence in Kyoto, the historical center of his sphere of influence. Thus, when the *bakufu* established Edo as its capital, two power spheres were in force.

The effect of this duality was not restricted to politics; it also brought about massive economic changes. Edo, formerly a small village, had to be outfitted as a large capital city, and the major merchant houses of Kyoto worked feverishly to supply their wares. Using the advanced skills of Kyoto craftsmen, these specially privileged merchants and wealthy townsmen produced high-quality products to sell in the Edo shops, thereby ushering in a massive consumer class in the new metropolis. The merchants and the townspeople of Edo thus came to form the third power sphere of the Edo period. The urban residents of the day wielded immense economic clout.

These power spheres, the imperial court in Kyoto and the shogunal government in Edo, joined by the economic might of a newly developed wealthy merchant class and an urban consumer society, defined and maintained an unwavering social structure that persisted throughout the next 250 years, an era of domestic stability and peace.

This remarkable social phenomenon also affected the painting world of the day. In fact, it is not an exaggeration to attribute the unprecedented flourishing of the painting world in the Edo period to these new circumstances. Kyoto was home to the Kanō and the Tosa, the two schools of official painters in service to the aristocrats and military elite of the city. The wealthy merchant class was an important factor in the rise of the painters known as *machi eshi*, literally, "town painters." Unlike Edo, which was bound by considerable rules and strictures in its role as the political capital, Kyoto enjoyed a relatively free atmosphere in which the line between officially commissioned painter and town painter is thought to have been less rigidly maintained. As the merchant class emerged, its members became clients for these painters and commissioned projects that kept the artists of the various *machi eshi* lineages quite busy. The painting shops, screen shops, and novelty dealers of the day were all part of this new trade.

The painting world of the mid Edo period witnessed the development, intermingling, and cross-fertilization of myriad painting styles created by all manner of painting schools, ranging from the Kanō and Tosa through the literati style, the Nagasaki school, the Maruyama-Shijō style, and the eccentrics. The *bakufu* system of shogunal and clan power developed over the course

Pl. 46. Watanabe Nangaku. *Cranes* (detail, cat. no. 60).

89

of the Meiwa (1764–72), An'ei (1772–81), and Tenmei (1781–89) eras before its full flowering in the Kansei era (1789–1800). Although vexed by many internal conflicts and problems, this new political structure brought a lively energy to all of Japan, as seen in increased travel to both Kyoto and Edo, more marine trade, developments in industry and commerce, and the arrival of foreign goods through the official external port of Nagasaki.

The military and aristocratic classes were not the only ones to benefit from the period's advances; the urban masses also sought a better lifestyle and developed a spirited curiosity about the world around them. Genre paintings of the day depict streets lined with vegetable stalls and the wares of other merchants, along with shops selling sweets and prepared foods, and even establishments, the forerunners to today's restaurants, where guests are seated inside and eating. Shops selling cosmetics, hairpins, kimono and related garments, and the myriad accessories worn with kimono as well as toy and novelty stores lined other streets. The city, with its masses of people coming and going along its streets, is depicted in lively renderings in these paintings. Because farm villages at the time suffered from locust plagues, famine, and disease, waves of villagers came to the cities to find work. As the cities grew, so did the number of trades and ways to earn a living; younger sons were sent to the cities to apprentice in the new trades.

On the one hand, then, farm villages suffered greatly, but on the other, the appearance of a social economy based on trade and commerce in the cities enlivened Edo society. Thoughts of the capital city—of its splendid buildings lined up beside huge temples and shrines, of the delicious sweets to eat and cosmetics to buy—lived in the hearts of people even as they endured the shogunate's strict feudal system. The feelings of the common people, their thoughts and their changing lives, contributed to the zeitgeist of the era. And by necessity, new products emerged, one after another, in response to their expectations, built upon a growing curiosity, love of learning, and taste for pleasure.

Thus emerged a circle of activity that formed this lively new society. Products of every kind took on significance as status symbols or luxury items. For example, certain sweets made in Kyoto were considered luxury items, and fans or hairpins became pieces of decorative art whose designs were seen as the pinnacle of chic. The wives of wealthy merchants competed to see who could wear the most gorgeous kimono and whose daughters were outfitted with the most sumptuous bridal goods. To design these decorative arts, wealthy patrons hired painters whose works were not confined to a single style or school of painting, and indeed the artists made them all the more splendid. Even commoners participated in the better life, giving their children rice crackers as treats or taking them to see the wondrous beasts such as peacocks found at amusement halls. They could even afford to buy imported novelties, to go to the courtesans' pleasure quarters, or to amuse themselves at archery stands, similar to today's game arcades.

Amid this acquisitive era, the educated members of society sought books from far-off China as their hunger grew for knowledge of the world outside Japan. Women were eager to adorn themselves with ever more exquisite garments and accessories, while the newly wealthy strove to furnish their homes with beautiful arts and decorative objects. The painting circles of the day were not unaffected by these trends. Painters sharpened their skills to meet these increasing needs, competing with rival painting schools and striving to create even more stunning works. If one school made works in a desired style, then others also used the technique. Many schools pushed themselves to invent styles that could not be copied, and in the process they developed new skills that improved their technical ability while they hammered out their individuality. This process resulted in even more superior products.

Biographical gazettes such as the *Kyōhabutae* and *Heian jinbutsushi*, essentially "who's whos" of Kyoto notables, introduced painters and ranked them against their contemporaries. Extant copies of these gazettes speak tellingly of the passionate interest generated by the creative activities of the day.

Besides heightening their skills and refining the individuality of their works in response to the demand for beautiful products, artists now addressed the curiosity of their patrons and, particularly, the intellectuals' interest in *shinsha*, literally, "true depictions." For people of the mid Edo period, this did not necessarily mean a painting that made its subject seem to appear before their very eyes (works that would be considered realistic today). *Shinsha* were a response to the era's interest in natural history and the general trend toward scientific studies, which reflected an intense curiosity and desire to discover nature's truths. In an age that did not yet have photography, accurate information—knowing the true facts of an object or matter—was difficult to obtain. For this reason, there emerged a heightened desire for *shinsha* images (or *shinkeizu* and *shinjinzu*, literally, "true view" and "true portrait") by which all visual phenomena, whether object, scene, or person, could be depicted—copied from the real.

In the case of ink landscapes, a genre of Japanese painting that grew from Chinese models, Edo-period artists created images based on Chinese landforms and scenes they had never personally witnessed. And, indeed, there were no such places as those depicted in their paintings. It was at the same time that painters were creating this kind of imaginative imagery that the *shinsha* painting genre developed to depict the real forms of actual objects. This movement was propelled not only by painters but also by the commoners of the day, who wanted to focus on the objects and things that had brought about such great change in their society. It was in this context that Maruyama

Ōkyo (1733–1795), the man seen as the founder of the realist school of Japanese painting, became overnight the darling of society with his simple but realistic works. Indeed, his influence was so great that contemporary painting circles all took on some degree of the realist style after Ōkyo appeared on the scene.

ŌKYO'S EMERGENCE

Ōkyo was born in 1733, the second son of a farming family in Anō village, Kuwata-gun (present-day Anō village in Kameoka city), in Tamba province. At that time the farming villages of western Japan were suffering plagues of locusts, and their inhabitants led extremely impoverished, meager lives. For economic reasons the majority of these farmers sent their younger sons to the cities at an early age to be apprenticed to trades. It is thought that Ōkyo similarly left his hometown for Kyoto in his early teens.

Ōkyo was apprenticed to the toy and novelty merchant Owariya. Known for carrying the most intriguing, sophisticated novelties of the day, the shop sold *gosho ningyō* (a type of doll), *bidōro* (a glass noisemaker), and such amusing devices as *nozoki karakuri*, which is a box for viewing landscape or city scenes. Its customers included the upper classes and temples affiliated with the imperial household.

Ōkyo's natural genius was allied with a straightforward, deeply affectionate nature. In a text left by one Seida Tansō, Ōkyo is described as "affable" and "lovable to all." Ōkyo's benevolent character significantly contributed to his great success.

Ōkyo's talents were first recognized by Kanbei, the head of his apprenticeship at Owariya; Kanbei hired the Kanō school artist Ishida Yūtei (1721–1786) to teach Ōkyo the fundamentals of painting. At the time, Ōkyo was assigned to make *gosho ningyō*, and one of the customers for these dolls, Renchi'in, a nun of aristocratic lineage at Hōkyōji, took an interest in him. Thanks to an

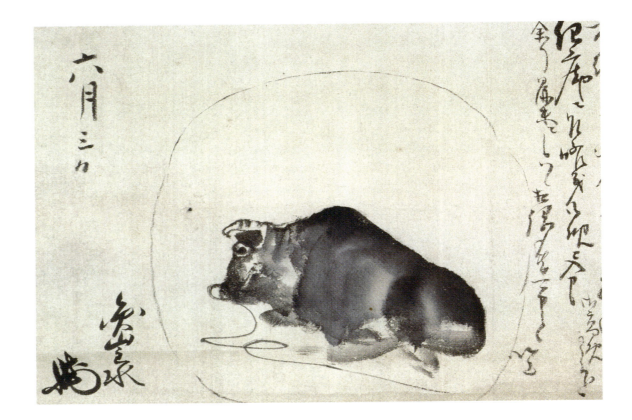

introduction from her, paintings by Ōkyo on playing cards and other formats were donated to Enman'in, a temple in Ōtsu. The temple's head priest, Yūjō, then commissioned numerous paintings from Ōkyo.

During these years, known as his Enman'in period (1765–74), Ōkyo gained in painterly strength with remarkable speed. He established a personal style based on sketching from life while he became famous as one of Kyoto's most talented painters. This period saw the creation of numerous major works such as his peacock and peonies paintings and his dragon and cloud compositions.

Thanks to Renchi'in and Yūjō's close connections with the imperial family, Ōkyo was later commissioned to create wall paintings for several palaces. When the main imperial palace itself was rebuilt, Ōkyo worked on *fusuma* panels for some of the rooms. He also interacted with the imperial prince Shinnin of Myōhōin, the elder brother of Emperor Kōkaku, and made wall paintings for the prince's study.

Ōkyo was popular as well with all levels of local commoners, as seen in his commissions from the Mitsui, a wealthy merchant family, for whom he created his *Pine Trees in Snow* screens (Mitsui collection, Tokyo), as well as his designs for kimono decoration and his underdrawings for tapestries used on floats in Kyoto's Gion Festival. Ōkyo's fame also spread beyond Kyoto with his creation of wall paintings for distant temples and shrines such as Kotohiragū and Daijōji.

Ōkyo's works are characterized by a brushwork that reveals the artist's close observation of his subjects (see pl. 47). His detailed depictions of these observed forms bring a remarkable three-dimensionality to the two-dimensional painterly format. This was even more the case in his large wall paintings, in which, with his superb expressiveness, he effortlessly introduced the three-dimensional expanse of the outside world into his painted realm; he created a sense of unity among the disparate realities, drawing connections between that outer realm, the painted spaces found in the paintings-within-paintings of his *fusuma* panels, and the actual spaces of the viewers in their interior settings. In his later years, Ōkyo suffered from eye problems, but he continued to paint until the month before his death, when he completed his last work, the *Hozu River* screens

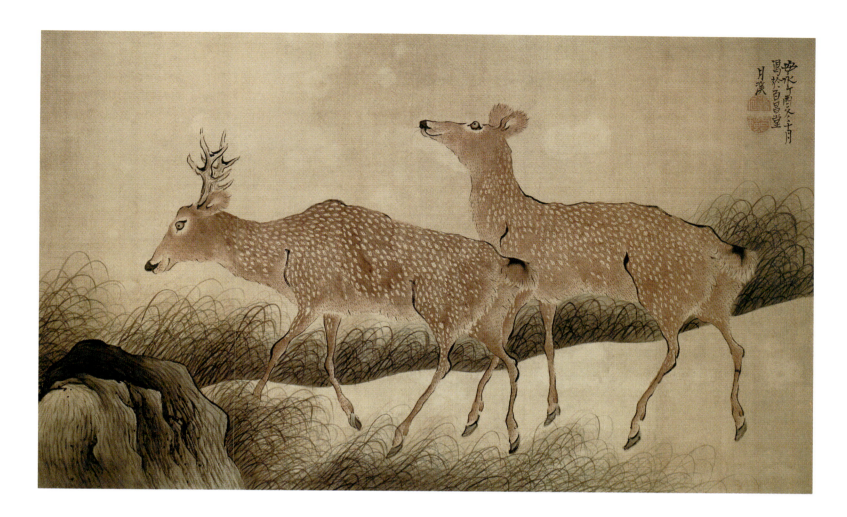

Pl. 48. Matsumura Goshun. *Deer* (cat. no. 23).

(Nishimura collection, Kyoto). Ōkyo is buried at Goshinji, a temple in the Shijō-Ōmiya district of Kyoto (present-day Uzumasa), and his gravestone is carved with an inscription brushed by Prince Shinnin.

THE MARUYAMA SCHOOL AFTER ŌKYO'S DEATH

Ōkyo's appearance was like that of a firework, shooting in a single arching flame across the night sky. As it ascends, the firework explodes, showering a new power through the heavens and scattering into a massive blossoming flower. The Maruyama-Shijō school's efforts after Ōkyo's death can be likened to this spreading flower of light.

Ōkyo's students included the painters Komai Genki (1747–1797), Nagasawa Rosetsu (1754–1799), Goshun (1752–1811), and Yamaguchi Soken (1759–1818). These painters had master-disciple relationships with Ōkyo, but unlike the rigid vertical hierarchy that existed in the Kanō

school, Ōkyo gathered students around him in a natural assemblage, forming a painters' group rather than a pure school. No other comparable gathering of artists can be found in the history of Japanese art. Instead of the usual model, in which numerous students studied under a single master and then copied that master's style fully and continued it unmodified, the members of this group developed their own personal styles. Upon Ōkyo's death, his disciples formed their own schools based on their individual painting styles, returning, in essence, to the lineage practice of most traditional painting schools and setting out to continue their own unified painting styles. In other words, Ōkyo's direct disciples, each of whom had demonstrated a range of development under their teacher, did not then endorse or establish similar freedoms in the next generation.

The special structure of this group of painters derived from Ōkyo's painting philosophies and pedagogical ideals, namely, that although sketching

Pl. 49. Komai Genki. *Woman Washing Clothes in a Stream* (cat. no. 56).

from life was the basis of one's work, in terms of style, each artist must develop individually. Ōkyo's teaching philosophy, that art could be responsive to changes in society and to each artist's personality, was unusual in the layered traditions of Japanese painting. In the Ōkyo group there was no inheritance of such traditions, which were based on prescribed model books. Rather, Ōkyo directed his followers to thoroughly master the fundamentals, which they could freely apply in expressing themselves in any manner as long as they did not abandon the essential foundation of sketching from nature. Sketching from nature was the basis of painting, and it was necessary to observe the features of the external world, but when it came to expressing those features, it was perfectly acceptable for the artists to produce images that might not resemble nature studies.

Ōkyo's students demonstrate a range of styles from Nagasawa Rosetsu's boldness, to Goshun's expressions of sentiment (see pl. 48), to Yamaguchi Soken's elegant images of beautiful women and Mori Tetsuzan's powerful realism. Overall, works by these artists were more lyrical than the realist paintings of their teacher. As a preference for realist paintings (*shinzu*) spread widely throughout Japan, more so than for didactic, pictorial images, people came to enjoy works that successfully wed a bit of lyricism to realism, a clear example of how changes in taste drove trends in art.

With Ōkyo's death and the loss of its powerful teacher, this special group dissolved, splintering into several smaller factions, each focused on one of Ōkyo's direct disciples. First there was the Maruyama family, represented by Komai Genki, the only one of Ōkyo's direct disciples to carry on Ōkyo's style intact (see pl. 49). Genki became the guardian of Ōkyo's son Ōzui and generally supported the Maruyama family after Ōkyo's death. Although not a blood relative, Genki had studied under Ōkyo at an early age and essentially became a member of his family. While Ōkyo's

other disciples developed their own richly indi-
vidualistic styles, Genki remained Ōkyo's assis-
tant to the end. He was always at his master's side,
serving in whatever way was needed and prepar-
ing Ōkyo's painting materials or pigments. The
strength of their bond of trust can be seen in con-
firmed extant works that reveal brushwork by
both men and the signature of Ōkyo. The Maru-
yama family lived on in Ōkyo's sons, Ōzui (1766–
1829) and Ōju (1777–1815), in his grandson
Ōshin (1790–1838), and in Ōritsu (1817–1875),
Ōshin's pupil and adopted son, whose career
extended into the Meiji period. Ōzui trained a
painter named Nakajima Raishō (1796–1871)
and Raishō's son Yūshō (b. 1837). Raishō's dis-
ciples Kawabata Gyokushō (1842–1913) and
Kōno Bairei (1844–1895) worked through the

end of the Edo period and throughout the Meiji
period. All these artists painted with a realism that
carried on a deep sense of Ōkyo's style, but they
tended to create smaller-format works with a mix-
ture of motifs and an overall loss of the breadth of
scale found in Ōkyo's paintings.

Outside the Maruyama family, Ōkyo's follow-
ers included Nagasawa Rosetsu and his disciples
Roshū and Rohō; Yamaguchi Soken (see pl. 50) and
his student Sogaku; Mori Tetsuzan (1775–1841)
and his disciples Ippō, Kansai, and Nihō; and others
such as Nomura Bunkyo and Yamamoto Shunkyo.
The lineage of Watanabe Nangaku (1767–1813)
included Ōnishi Chinnen and Suzuki Hyakunen,
continued into the Meiji period with Kubota Bei-
sen, Imao Keinen, and Suzuki Shōnen, and finally
connected to Uemura Shōen in the Taishō period.

Pl. 50. Yamaguchi Soken. *Kamo River Party*
(cat. no. 59).

Pl. 51. Matsumura Goshun. *Haiga Album*
(cat. no. 58)

THE FORMATION OF THE SHIJŌ SCHOOL

After Ōkyo's death, then, who became the central
painter of the day? It would be natural to assume
that either Ōkyo's older son, Ōzui, or his close
disciple, Genki, or indeed Nagasawa Rosetsu,
who began his career as Ōkyo's disciple, might
have assumed the mantle of lead painter. But it
was Goshun who took control.

Goshun was born the oldest son of the
Matsumura family of Kyoto and painted using
the art name Matsumura Gekkei under the literati
Yosa Buson. Goshun often produced wonderful
haiga paintings in the Buson style (see pl. 51). After
Buson's death, Goshun entered the studio of Ōkyo,
who had been one of Buson's close affiliates. Thus
Goshun switched from the literati approach to
its stylistic opposite, realism. It was, in a sense, like
a general changing camps mid-battle. Unlike the
Kanō school, in which teachers were different with
each generation but the structure stayed the same,
the Maruyama school changed after Ōkyo's death

because Goshun, a painter from another lineage,
inherited it and transformed it into what came to
be called the Shijō school. Goshun's *Flowers and
Birds in the Rain* (pl. 52) represents the height of his
Buson style and the beginning of the Shijō school.
Ōkyo himself had happily allowed Goshun to
enter his group of artists, but he had not treated
Goshun as a disciple, insisting instead on seeing
Goshun as a disciple of Buson's. Goshun's paint-
erly talents can be said to have leaned more to-
ward expressive brushwork than the purely realist
style of the Maruyama school. From the beginning
Goshun expressed his own free individuality (as
did the painters Itō Jakuchū and Soga Shōhaku),
and his talents did not seem in keeping with a
form of expression based on sketching from nature,
which suppressed the painter's ability to personally
interpret. Goshun's original artistry, characterized
by a flowing line, did not lend itself to realist forms.
Thus the Shijō school that centered around Goshun
was not purely realistic but more inclined toward

Pl. 52. Matsumura Goshun. *Flowers and Birds in the Rain*
(cat. no. 26)

lyricism. In that sense we can say that the Shijō
painting style evoked realist elements while pro-
viding an emotive, lyrical expression. In other
words, while Shijō artists had a firm grasp of realist
forms, they also gave credence to the creation of
atmosphere; through their brushwork, combined
with that atmosphere, they gave voice to an inter-
nal realm that could not be expressed in purely
realistic forms.

Matsumura Keibun (1779–1843) inherited
the Shijō school from Goshun and expanded it.
He did not believe that the contourless painting
method, purported to be a realist technique, was
necessarily linked to realism alone, and he trans-
formed it through a formalizing and patterning
of expression. Indeed, there was a return to a
pre-Ōkyo form of painting after Ōkyo's death.

In addition to Keibun, Goshun's lineage
includes Okamoto Toyohiko, Shibata Gidō,
and many others in the late Edo period such as
Shiokawa Bunrin, Shibata Zeshin, Yokoyama
Seiki, and, into the Meiji period, Takeuchi Seihō
(1864–1942) and Kikuchi Keigetsu.

Once Ōkyo began his practice of *shasei*, sketch-
ing from life, all the paintings in Kyoto seemed
to come from the same hand. For better or worse,
the concept of sketching from life had deeply pene-
trated the art world, and in the late Edo period
one could see its effects. Many Shijō school paint-
ers, and painters of the school begun by Mochizuki
Gyokusen (1794–1852), were working with both
Ōkyo's realism and Goshun's lyricism. The Kishi
school begun by Ganku (1790–1838), the Hara
school begun by Hara Zaichū (1750–1837), and
the Mori school begun by Mori Sosen (1747–
1821) all took some form of realism as the basis
of their painting styles. These various realist paint-
ing schools brought a unifying trend to the Kyoto
painting world.

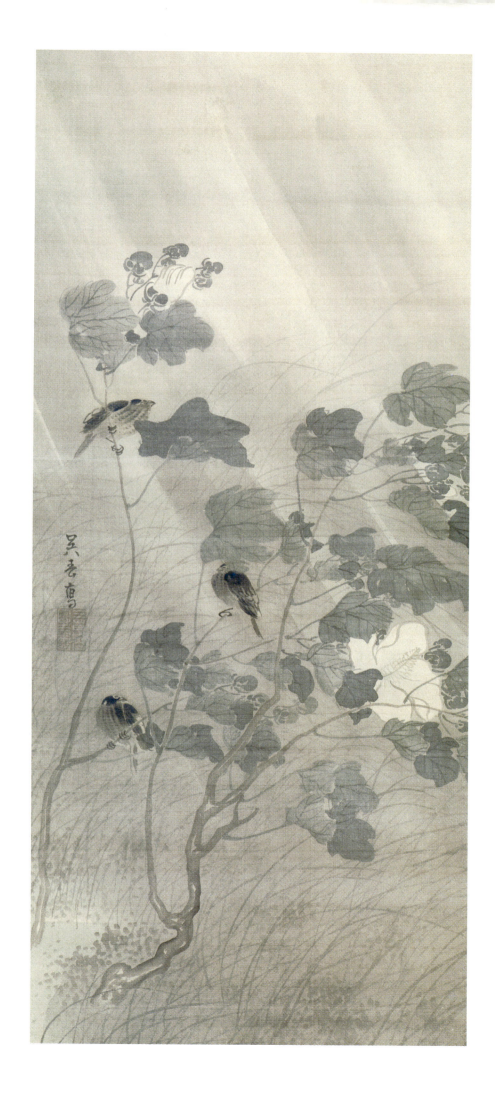

THE BRIDGE TO MODERN JAPANESE PAINTING

If we examine more closely the painting styles of the Maruyama-Shijō school artists in the late Edo to Meiji periods, we find that although Maruyama Ōritsu continued the Ōkyo style unchanged, his compositions became small and cozy, exhibiting an almost Tosa-like, finely wrought decorativeness. Nakajima Raishō had an approximate grasp of forms, and he developed a style that revealed his somewhat slack brushstrokes. Kawabata Gyokushō moved toward modern painting styles as he developed realistically expressed compositions with an emphasis on outlines and depth rendered through the use of shading and shadows. Mori Kansai (1814–1894) maintained the traditional brush styles of the Maruyama school but broke new ground with his compositions. Yamamoto Shunkyo (1871–1933) revealed a rare sensibility in his depictions of water scenes, and with a new flair he created a realism that conveyed the transparency and depth of water and the weighty mass of surrounding cliffs.

The breadth and variety of this period's realist painters can be seen in Yokoyama Seiki's and Yokoyama Kakei's creation of somewhat idealized compositions, Shibata Zeshin's sharply individualistic style (see pl. 53 a, b), and Shiokawa Bunrin's decidedly rough brushstroke (see pl. 54). By the time of Takeuchi Seihō, some degree of classical brushwork remained, but Seihō broke new ground with his more Western-style compositions.

The Maruyama-Shijō school did not restrict its disciples as the Kanō school did, and in a sense, a painter who created paintings on the basis of *shasei* realism could be called a follower of the style. Both the Maruyama and Shijō schools shared this painterly ideal, and thus in many instances their names are grouped together. If one were forced to differentiate the two, one could say that, rather than simply a lineage of direct-descent disciples, the Maruyama school was based on an architectural style of painting that emphasized realism, while the Shijō school constituted those artists who based their work on realism and the incorporation of an enhanced lyricism and brushwork. The Maruyama-Shijō school allowed artists the liberty to develop their own styles as long as they maintained the painterly philosophy and ideal that emphasized realism as the basis of artistic creation. And thanks to this overarching philosophy, it was a style with the potential to be appropriate for each succeeding age. The major difference between the Kanō and Maruyama-Shijō schools was the fact that while the Kanō school transmitted an end result, a completed form, the Maruyama-Shijō school taught fundamentals that were to be applied at the artist's will. This principal element allowed each individual painter's style to develop and greatly determined whether the style was appropriate for its period.

Unlike the Kanō school, the Maruyama-Shijō school did not have a licensing system or directly inherited painting lineages, which meant that a large number of surrounding painters could "inherit" the painting philosophy of the school and freely incorporate the influences of its style, compositions, and techniques. Thus the school had an enormous potential for expansion. The ideal of a painting style based on sketching from life, at the heart of Ōkyo's philosophy, had not existed in Japan's painting circles prior to Ōkyo, and after he brought it to the fore, it permeated the entire artistic world. Even after the painters' group that Ōkyo assembled from his direct disciples dissolved, his conception of paintings based on realism remained and, indeed, remains potent yet today.

The fundamental philosophy—the skeleton—of the style was shared alike by these artists, each of whom fleshed it out according to his individuality and the needs of his time. This is the characteristic essence of the realist or *shasei* school of

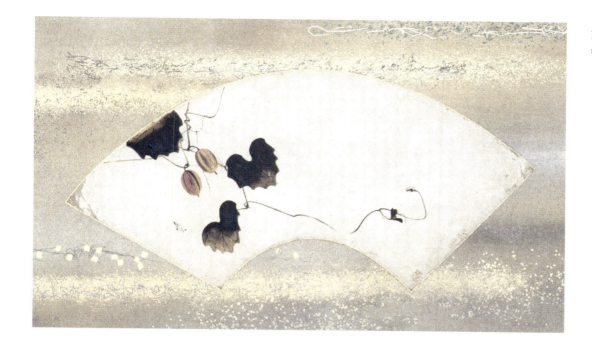

Pl. 53 a, b. Shibata Zeshin. *Tea Screen with Two Fans* (cat. no. 61).

painting in Japan. The Kanō school revered the master-disciple relationship, and while its strict adherence to school form created a tight construct of affiliated artists, it did not allow for stylistic development and thus in the end drove the school into obscurity. Conversely, the Maruyama-Shijō school spread widely because an artist need only share the ideals of the school and not participate in a strict master-disciple relationship with one of its practitioners. Against the backdrop of the radical societal and political changes of the late Edo and Meiji periods, the Kanō school collapsed because of its reliance on a visible, codified form. But the Maruyama-Shijō school spread, thanks to its philosophy. The two schools personified the differences between the official painting teacher, in service to the court and military, and the town painter, who experienced the freedom to interpret.

Pl. 54. Shiokawa Bunrin. *Waiting for the Ferry Boat* (detail, cat. no. 62).

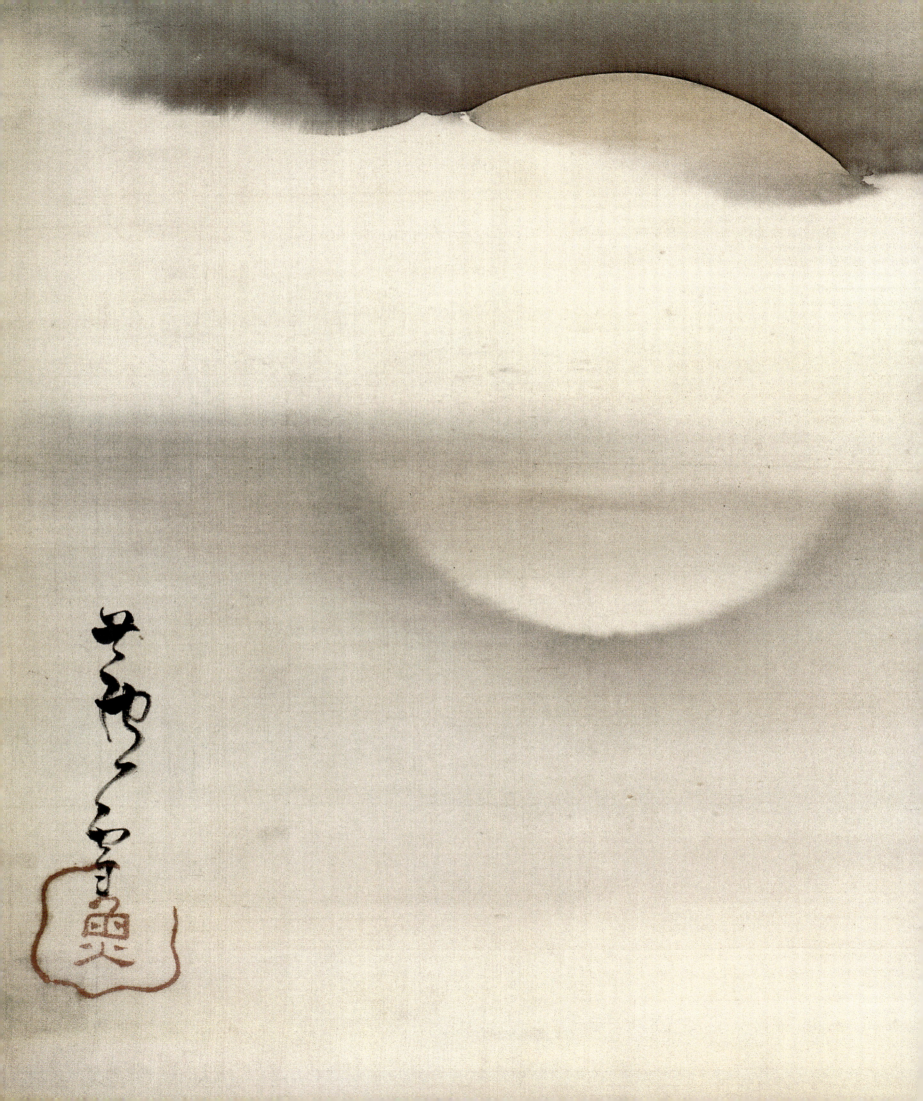

James T. Ulak

Three Eccentrics

Itō Jakuchū, Soga Shōhaku, and Nagasawa Rosetsu

ITŌ JAKUCHŪ

THE KYOTO ARTIST ITŌ JAKUCHŪ (1716–1800) STANDS CHRONOLOGICALLY AS the first in a triumvirate of eighteenth-century Japanese painters—the others are Soga Shōhaku (1730–1781) and Nagasawa Rosetsu (1754–1799)—who, by the startlingly fresh quality of their vision, distinctive manifestations of independence, and mannered defiance, are traditionally grouped as the great "individualists" or "eccentrics" of their time.[1] By 1760 Jakuchū had completed fifteen paintings in a projected thirty-painting ensemble that would come to be regarded as his life's masterwork. Even in an incomplete state, individual units of the huge project revealed the artist's consummate control of all aspects of polychromy and large-scale composition. Conceived as a celebratory description of the immense variety and beauty of sentient life, *Dōshoku sai-e* (Colorful realm of living beings) is densely configured on silk supports with multiple images of birds, fish, plants, insects, reptiles, and amphibians. It was intended to flank a similarly lush triptych of paintings by Jakuchū featuring Buddhist deities. The whole grouping was meant to be understood as a representation of the interrelatedness of the created and transcendent worlds. In 1765 the nearly complete ensemble would be presented to Shōkokuji, a major Rinzai Zen Buddhist temple in Kyoto, as a memorial for Jakuchū's recently deceased younger brother.[2]

In the midst of the *Dōshoku sai-e* project, Jakuchū undertook and completed a commission in 1759 for another Kyoto temple, Rokuonji. Virtually antithetical to his Shōkokuji offerings, these ink-monochrome paintings on paper, spread over a series of sliding door panels, depicted botanical life and fowl in a long, tautly controlled horizontal format, with considerable and confident employment of negative space.[3]

This astounding simultaneous display of range and vision revealed the forty-five-year-old painter to be at the height of his powers. All the more remarkable was the fact that only five years earlier Jakuchū had formally extricated himself from the day-to-day responsibilities of managing his family's greengrocery, Masugen, in Kyoto's central market district. He emerged from no established atelier; records of Jakuchū's training as a painter are minimal and speculative, although the ubiquitous Kanō school probably played a part. Central to his rise were the good offices of his friend and confidant Daiten Kenjō (1719–1801), a monk of Shōkokuji. Daiten was the impresario of an evolving circle of poets, artists, and intellectuals. His patronage and friendship with Jakuchū would extend over nearly half a century, providing the painter with extraordinary access to patrons and to their collections.

The sense of Jakuchū's sudden appearance as a major talent, fully formed at midlife, is perhaps exaggerated by the paucity of documentation on his development as an artist. There is, however, no mistaking that his somewhat unorthodox arrival underscores an important phenomenon of the eighteenth-century Japanese art world: unaffiliated talent gaining the attention and major patronage that previously was the purview of established ateliers. Further, that talent was especially

Pl. 55. Nagasawa Rosetsu. *Moon* (detail, cat. no. 74).

103

beholden to the beneficence of Buddhist sources, ordained and lay, willing to reinvigorate traditional iconography with bristling and edgy new visions.

It is especially noteworthy that in 1760, an observed moment in Jakuchū's development when his technical maturation is undisputed, there was an occasion of important recognition of his status from the religious dimension of his life. In that year Jakuchū's still-incomplete *Dōshoku sai-e* project was viewed by one of midcentury Kyoto's most curiously influential figures, Baisaō. Baisaō Kō Yūgai (1675–1763) was an aged itinerant who supported himself by brewing steeped tea leaves at a portable stand in and around Kyoto and by proselytizing in direct and easily understandable ways a syncretic Buddhism highly influenced by Daoist notions. A native of western Kyushu and formerly a monk of the Ōbaku sect, Baisaō returned to lay status in his later years. He practiced *sencha*, or steeped tea, as a vehicle of enlightenment. Indeed, the practice of this rather informal tea style favored by literati differed from the use of powdered tea (*macha*) in the formal *chanoyu* ceremony that developed most fully in the late Momoyama (1573–1615) and early Edo periods (1615–1868).

The two tea styles expressed differing philosophical and political alignments. *Sencha*, at least in the view of its practitioners, represented a pure, renewing simplicity in contrast to the severe formalism of *chanoyu* and its perceived associations with a moribund Buddhist establishment. The sage and humble Baisaō attracted a diverse range of devotees from many levels of society. His appeal can be understood as a manifestation of the reformist instincts that were active in Buddhism of the period.[4] At any rate, his highly positive assessment of Jakuchū's still-unfinished painting ensemble— in a viewing probably arranged by Daiten—was expressed with a commemorative line of calligraphy that the artist deeply cherished. The Baisaō imprimatur seems to have not only conferred a

level of recognition on Jakuchū's painting efforts, but also clearly paid homage to the substantive quality of his spiritual pursuits.

It is from this pivotal year of 1760 that records of Jakuchū's interactions with other important figures within the Daiten circle begin to be seen. And it is surely within this context of assured stature and acceptance that there begins to appear a handful of Jakuchū's ink paintings bearing poetic inscriptions by the prominent Kyoto Ōbaku monk-poet Musen Jōzen (1693–1764), most often known by the sobriquet Tangai and a member of Daiten's inner circle.[5] The Gitter-Yelen collection holds two of these important collaborative works. An image of the Zen adepts Kanzan and Jittoku (C. Hanshan and Shide), dates to 1761 (pl. 56); another undated work features a carp traversing powerful waves, the traditional Chinese symbol of the efforts of young scholars to pass rigorous tests in order to assume a career in the bureaucracy (pl. 57).

The legendary Kanzan and Jittoku resided in a temple on Cold Mountain (Guoqinqsi, near Tiantaishan in Zhejiang province). Depicted as disheveled and scruffy, Kanzan the monk-poet and Jittoku the scullion were traditionally described by their respective attributes of sutra scroll and broom. Images of this pair composed a cherished Zen Buddhist reference to the consuming search for enlightenment and the ephemeral nature of life's possessions. Their union also implied a shattering of social distinctions that was consistent with the ultimate logic of Buddhism. Jakuchū's rendering is an unexpected interpretation of the traditional subject, at once implying the painter's familiarity with Chinese prototypes while suggesting a disregard for conventional approaches. The ragged harshness of figural representation of the pair, which was first seen in Japan in the early fourteenth century, in time gave way to humorous representations.

In the last years of the Momoyama and first of the Edo period, comically oval-faced types begin

臨睡三昧苦幕

佛足邻中年

末村諭龍屯流

弘古庄

平崖影蓝

辛己仲夏

以遠叙主写

to appear, notably in the renderings of sages and immortals by Sesson Shūkei (1504–1589). Jakuchū's version indicates both an awareness of the Sesson style and an understanding of the early fourteenth-century renderings that featured strong tonal contrasts and relative disregard for spatial context.[6] Jakuchū assumes the viewer's familiarity with the iconography by using only the broom as an identifying attribute. Thus he ensures unmistakable recognition while injecting a note of ambiguity as to the differentiation of the two adepts. Elongated oval faces and simply defined, doll-like body forms convey a comforting softness oddly disjunctive from the expected goals of such paintings. Tangai's inscription, virtually descriptive of the cozy pair, seems to celebrate a rich friendship achieved. Whether this might refer to the long, gradual route from acquaintance to companion in

the relationship between Tangai and Jakuchū, or whether the verse and image were composed for entirely other purposes, remains unknown.

> Drowsily dozing they enter *samadhi*,
> Broom of twigs entirely forgotten;
> Forgotten is the journey of ten years
> leading here.
> Flowers fall, water flows, the world is
> vast and vague.[7]

Dating presumably from the same period is the image of a carp (pl. 57), again bearing a Tangai inscription. Jakuchū's earliest known painting of a carp, dated to approximately 1755, was a full polychrome rendering in the Chinese stylistic tradition of depicting fish and water plants.[8] The Gitter-Yelen painting stands apart from Jakuchū's earlier mode of lyric realism and offers a rendering solidly

Pl. 56. Itō Jakuchū. *Kanzan and Jittoku* (cat. no. 65).

Pl. 57. Itō Jakuchū. *Carp* (cat. no. 66).

in the tradition of the scholarly talisman. Longmen (Dragon Gate) Mountain is located on the Yellow River at the borders of China's Shenxi and Shanxi provinces. Climbing the daunting rapids in this section of the river had long been compared with the difficulty of passing state examinations to attain positions in the bureaucracy. Success meant becoming a "dragon." The resolute carp also became the symbol of a more generalized form of encouragement for anyone engaged in a trying endeavor.

This painting, one of Jakuchū's earliest ink-monochrome renderings on the subject, is all the more important for its collaborative nature. He was producing similar images well into his final years.[9] To vary the clichéd image of the assertively upright fish, Jakuchū depicts the carp twisting in the waves at a downward angle. Tangai's inscription assists in elevating the message of encouragement as he reminds the viewer that the dragon's higher purpose is not achievement of status but service. Again, the structure of the carp, while fully recognizable, is assembled from ever more apparent geometric forms, defining dark brush accents and units of varying wash tone.

> Wandering far, he does not swallow the
> fisherman's bait.
> Plunging deep, why should he leap into
> the sage's boat?
> In hiding he grows horns, becomes a
> dragon, and departs,
> Sending down timely rain to succor man
> from drought.

The modest body of Tangai-inscribed works, all seeming to be creations of the first few years of the 1760s, are excellent examples of an expansion and shift in Jakuchū's use of the ink-monochrome style. In these collaborative efforts, Jakuchū departs from the techniques he used in the massive Rokuonji sliding panel paintings of 1759. In those works, Jakuchū enriched a Ming dynasty

Pl. 58. Itō Jakuchū. *Crane* (cat. no. 67).

ink-painting style in which forms were rendered without outline in a sharply defined manner that allowed great tonal contrasts with the light color of alum-treated paper. Edges of forms stood out in particularly sharp contrast to the ground, achieving a sense of crystalline, precise detail that did not rely on a defining brush line. Jakuchū, in these occasional pieces, brings forward the lesson of stark tonal contrast, but he modulates the sharp silhouette forms of the Rokuonji paintings with a fuller, lusher application of ink and the undisguised use of wash for visual effect rather than verisimilitude. Jakuchū's paintings continually assert the geometric basis of natural forms. The Rokuonji paintings represent a turning point; thereafter, and until his final decade, basic and geometric forms would assume increasing prominence in his work over any approximation of realism. The Tangai-inscribed paintings are harbingers of that shift.

Throughout the 1760s and into the 1770s, recognition of Jakuchū's talents grew almost in proportion to the degree that he began to distance himself from life in the center of the capital and to seek extended periods of seclusion at the Ōbaku Zen temple of Sekihōji, in Fukakusa just south of Kyoto. In 1777, at age sixty-one, Jakuchū devised the design for a diorama of stone sculptures of the Five Hundred Arhats that would cover a hillside in the temple compound at Sekihōji.[10] To finance this project, he produced paintings, mostly ink monochrome, in some profusion.

Two paintings in the Gitter-Yelen collection are excellent examples of the ink-monochrome production from the final three decades of Jakuchū's life. A single standing crane profiled with beak pointing left is planted in an angled swath of grass-tufted ground (pl. 58). The bird's clawed feet are obscured by the ground line. This undated work can perhaps be located in the mid to late 1770s, judging from a continuum of Jakuchū crane paintings that begins in the late 1750s and moves to elegant and complex abstractions of form and

Pl. 59. Itō Jakuchū. *Moon and Plum Blossom* (cat. no. 68).

wash in the early 1780s.[11] A painting inscribed by the artist in his "eighty-fifth year" (1800) presents a sharply angled prunus branch with blossoms before a perfectly round moon (pl. 59). The moon is formed as a reserve on an otherwise lightly washed paper. Branches are given rugged form through a swift transition from wet to dry brush. That allusion to the verisimilitude of tree bark is in contrast to the painter's irrepressible gesture to patterned design and geometry in the presentation of branches in near perfect angles.[12]

Only on rare occasions can the remarkable scope of Jakuchū's achievement be fully appreciated. Nevertheless, consideration of these representative works in the Gitter-Yelen collection points up the artist's elegantly mannered eremitism, wry humor, and a constant paring down to essential visual elements, a search well served by the ink-monochrome brush. Jakuchū seemed to bring the spiritual concerns of the Kamakura and Muromachi monk-painters into the refined urban salons of eighteenth-century Kyoto. In that effort, polish and barely detectable but exquisite technique always lay just below the surface of what in an earlier time might have been spontaneous.

SOGA SHŌHAKU

In marked contrast to the well-documented and city-centered life of Jakuchū, a biography of Soga Shōhaku remains a developing exercise in discerning between a carefully postured persona of instability and a truly aberrant and volatile character surviving at the edges of society. Lore describes Shōhaku as a wild eccentric whose painting style, for a period in his life, was so excessive and willful that it seemed to reflect psychological chaos and inevitably gave excessive weight to biography in any assessment of his work. The scarcity of biographical detail only complicates matters. While there can be no question that the powerful and often bizarre creations emerging from Shōhaku's

brush were fueled by a personal vision that vigorously articulated extreme expressions of traditional themes, he was nevertheless grounded, even in his flamboyance, in tradition and technique.

Shōhaku's birth date has been calculated from a no longer extant painting created for Sairaiji, a temple in the city of Tsu in Ise province. An inscription on the painting noted the artist's age as twenty-nine and the date of its execution in 1758. Although Kyoto is presumed to be the place of his birth, for much of his career his relationship with the city was one of distance. Records indicate that he was born into a Kyoto merchant family and that he was orphaned by the time he was seventeen. The only figure known to be a professional mentor for Shōhaku was Takada Keiho (1674–1755), a painter in Ōmi province (present-day Shiga prefecture). Keiho's most important work is still extant at Shingyō in a temple in his hometown of Hino. Executed in 1743, this ceiling painting of a dragon and Buddhist deities demonstrates a penchant for powerfully expressed and exaggerated figural types. The length of Shōhaku's apprenticeship is not known, but it would have been during Keiho's late age. Even then, Keiho's distinctive methods for creating figures, his techniques of tonal contrast that suggest an underglow of light emitting from his landscape renderings, and his willingness to attempt and his success with bravura brushwork seem to have been particularly instructive to the young Shōhaku.[13]

A few years after Keiho's death, Shōhaku found work in Ise province to the east of Kyoto. Based primarily in the provincial cities of Tsu and Matsuzaka, Shōhaku's activities in that region can be recorded from 1758 until 1771. Whether his work in Ise was accomplished in a series of forays from Kyoto or whether he survived as an itinerant painter in the province for that long period of time remains unclear. It seems reasonable to accept the suggestion that at least his extended activity in the Ise region had to do with family connections and the hope of settling in that area as a teacher. A series of commissions in Harima (present-day Hyogo prefecture) to the southwest of Kyoto seem to date from after his Ise tenure. Documentation locates Shōhaku in Kyoto from at least 1775 until his death.

Over the course of his career, Shōhaku assumed a series of identities that would underscore his eccentricity and highlight his chosen outsider status. Most significant among those choices was the assumption of the Soga sobriquet. Soga Dasoku (d. 1483) stood at the head of a lineage of painters who served the Asakura clan in Echizen province on the Japan Sea to the north of Kyoto and who also had strong connections to the Kyoto temple of Daitokuji. The association of Soga painters with the eccentric prelate of Daitokuji, Ikkyū Sōjun (1394–1481), an acerbic critic of the pretensions of Kyoto's elite, could not have escaped Shōhaku's notice. The Soga repertoire especially favored renderings of fierce birds of prey, but in all its aspects, the artists were proficient in intensely rendered and emotive ink-monochrome paintings. It is noteworthy that the Soga claimed the Korean Yi Chumen (J. Ri Shūbun, fl. mid-fifteenth century) as an antecedent to their line. The Soga name, with no successors in the mid Edo period, bore what was surely, for Shōhaku, the strong intimations of a powerful and challenging line that was independent of the cultural whims of the capital.

Shōhaku's fierce independence did not preclude associations with contemporary artists, and he was a careful observer of rivals. He was known to have had friendly contact with Ike Taiga and was reported to have made sardonic references to the popularity of his younger contemporary Maruyama Okyo (1733–1795). Thus the emerging image is of a character who quite consciously resisted incorporation in the professional world around him but who also astutely marketed that defiance.

Pl. 60 a, b. Soga Shōhaku. *Ink Landscapes* (cat. no. 69).

The paired hanging scrolls by Shōhaku in the Gitter-Yelen collection (pl. 60 a, b) are generalized renderings that quote from any number of possible Southern Song Chinese views later assumed by Japanese interpreters from the fourteenth century. Certainly, the Eight Views of Xiao and Xiang is a likely source. A broad, wavy, dry brush defines large vertical landmasses and lush, wet ink accents of plant life and architecture. Yet the highly stylized, rounded forms in the boats at the foreground and the middle distance in the respective images, and the furrowed brush lines on the mountain forms, proclaim the painter's insistence that the viewer attend more to the quirky presence of the various manifestations of his hand than to the sense of atmosphere attained in the work. This exercise in brush display can be found in several larger compositions of the Eight Views of Xiao and Xiang attributed to Shōhaku, with suggested datings in the late 1760s or early 1770s. Seals and signature styles seem reasonably consistent with works of that period.[14] In these sorts of exercises, Shōhaku at his best manages to inject a sense of the unstable, shifting, irruptive qualities of nature, while never allowing the viewer to forget that he observes a world of the artist's whim and creation. That edgy, intelligent presence and the refusal to be subordinated to programmatic visions are Shōhaku's contribution to Japanese artistic individuality.

Shōhaku's figural representations—most often of Chinese sages or Buddhist adepts, but with scattered references to legendary Japanese personae—rely on extreme caricature of form and expression. Whether in ink monochrome or polychrome, his constructions of various fabulous forms for these types continually remind the viewer of the building blocks of brushstroke, tonality, color, and shading that constitute the whole. A two-panel screen recently acquired by the Gitter-Yelen collection (pl. 61), by Shōhaku, shows two figures excitedly examining a painting or manuscript while positioned on a rocky outcropping above a churning pool at the base of a waterfall. The figure on the right has the easily recognizable attributes of Shōki the Demon Queller, but the seated sage or monk is yet to be identified. This scene may well prove to be a case of the artist's original union of previously unassociated legendary figures for some humorous or satirical purpose. It bears the compositional traits found in many of Shōhaku's other works: a figure or figures are dramatically posed and interacting while the larger world of nature swirls about them in a tumultuous framing that highlights the occasion.[15] A discernible pattern in the development of Shōhaku's style is a general movement to a mannered, tight, and polished composition in his later years. Further study may show that this painting, like the pair of hanging scrolls previously discussed, was produced in the 1760s.

The past several decades have seen an ongoing and rigorous assessment of Shōhaku's oeuvre. While acknowledging the probability of an eccentric and congenitally independent persona, resultant studies have rightly concentrated on stylistic approaches to establish a developmental chronology for Shōhaku, as the majority of his paintings notoriously lack inscribed dates. It has been observed that the number, variety, and often large scale of Shōhaku's extant paintings indicate both great productivity over several concentrated decades and benefactors sufficiently pleased with the outré quality of his images to support their output. The sense of the lone, slightly mad, itinerant painter inherited from late eighteenth- and nineteenth-century assessments should now give way to the growing perception of an exceptionally gifted artist of difficult temperament who was recognized by the art establishment in the last quarter of the eighteenth century in Kyoto.

Indeed, examination of Shōhaku's bizarre, grotesque, comic, and haunting paintings has focused on the painter's personal eccentricities

rather than on the obvious existence of an appreciative audience: his was not an unshared vision. In the eighteenth century, Japan's renewed interest in Ming Chinese culture, so importantly stimulated by the influential presence of Ōbaku Zen, was reflected broadly in popular culture. A parallel intellectual resistance to the sinophilic craze was also taking shape, most prominently in the writings of Motoori Norinaga (1730–1801). Norinaga's nativism—his search for an indigenous philosophy distinct and separate from reigning neo-Confucianism—relied heavily on his interpretations of Japanese classical literature.

Whatever their contentions with neo-Confucianism, at a popular level, the strengthening nativist currents revisited the eerie, allusive, gothic qualities in earlier Japanese literature and reasserted the Japanese sense of the numinous properties of nature. Translated into eighteenth-century terms, this nativism fueled interest in imagery of the weird, haunted, and peculiar—the world inhabited often by ominous spirits. This convergence of Chinese and Japanese sources could be seen, for example, in the revitalized imagery of sages, immortals, and arhats—all traditionally rendered with craggy and eccentric physiognomies representing a studied disinterest in attractive appearance—but ready for permutation into more indigenous and threatening Japanese ghost forms. The writer Ueda Akinari (1734–1809), a contemporary and frequent companion of Kyoto painters, most notably of Matsumura Goshun (1752–1811), provided gripping adaptations of Chinese tales as well as original formulations of the macabre and grotesque. His role as a catalyst within the painters' community cannot be discounted.

Pl. 61. Soga Shōhaku. *Two Figures*
(cat. no. 70).

NAGASAWA ROSETSU

In this environment of high cultural synergy of artists and writers juggling imagery, text, and ideas, the third of the eccentrics, Nagasawa Rosetsu, was nurtured.[16] Rosetsu was regarded as one of the most talented of the pupils to emerge from the atelier of Maruyama Ōkyo. As the founder of an independently flourishing school, certainly the dominant Kyoto studio in the late eighteenth century, Ōkyo himself might be considered a major independent force. But the fact that Ōkyo's original vision and style resulted in the creation of a prosperous commercial studio, with no apparent instinct on his part to cast a querulous eye toward establishment support, has traditionally excluded him from the category. Ōkyo's most recognizable style, a carefully observed but softened and lyrical realism, was absorbed by Rosetsu, whose first known study in the master's style is dated to 1778. By 1781 Rosetsu, while continuing to work under Ōkyo's auspices, seems to have established his own studio, and until his death he independently cultivated important benefactors. References to Rosetsu's youthful drinking and brawling have contributed to a personality mosaic of contentious independence and to the persistent rumor that he was expelled from Ōkyo's studio. Rosetsu's early death in Osaka under suspicious circumstances further added to his image as an immensely talented but somewhat incorrigible figure. Yet, in the final two decades of the eighteenth century, commissions rained on Rosetsu through Ōkyo's recommendation, and the two collaborated on important projects virtually to the end of Ōkyo's life.

While Rosetsu's oeuvre contains what might be considered the standard Ōkyo-school subjects—bird-and-flower, children, landscapes, and animals—he increasingly brought to these a hauntingly preternatural, wry humor and frequent reference

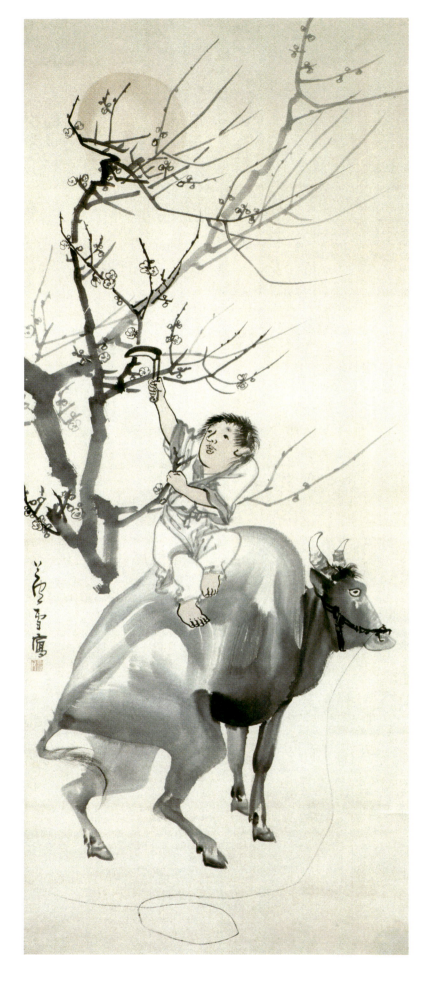

Pl. 62. Nagasawa Rosetsu. *Boy and Ox* (cat. no. 71).

to the sometimes amorphous precepts of Zen Buddhism. Clearly, most of his important commissions were given by Zen temples, but his associations were more than commercial. His friend Minagawa Kien (1734–1807) remarked that all of Rosetsu's works were infused with a Zen perspective.

Several of the Rosetsu paintings in the Gitter-Yelen collection are explicit in their reference to Zen. In one painting, a lone boy, sickle in hand, balances atop a docile and compliantly squatting ox and prepares to cut a branch from a flowering tree (pl. 62). This tableau is played out under a full sun. In a tellingly subtle essay on the ways to describe forms with ink, the ox and the branches of the tree are defined by interconnected washes of varying ink tones devoid of outline, while the figure of the young boy, poised between tree and beast, is rendered in a soft, light ink outline. The ox's rein, a single twisting line of ink, falls below the animal in the only delicate reference to a ground line. The theme of young boys on oxen, whether bearing flowering branches or playing flutes, is recurrent in Rosetsu's paintings. A painting in the Toyama Sato Museum (Japan), dated generally to the final two decades of the eighteenth century, is very similar to the Gitter-Yelen work. The Toyama Sato painting shows two boys using the ox as a ladder from which to clip branches, the ox solidly planted on an earth embankment next to a stream.[17] The general thematic reference may be to the Zen description of the journey toward enlightenment as being like the gradual taming of an ox. This metaphor was the subject of a series of ten sequential pictures known as the "ox-herding pictures," which were available in Japan from the thirteenth century on.[18] Rosetsu's penchant for highly sympathetic studies of children may also be an allusion to the Zen suggestion that the child's open mind is a model for the prerequisite to enlightenment.

In contrast, Rosetsu's simply rendered image of a monk warming his backside at a fire fueled by

Pl. 63. Nagasawa Rosetsu. *Tanka shō butsu* (cat. no. 72).

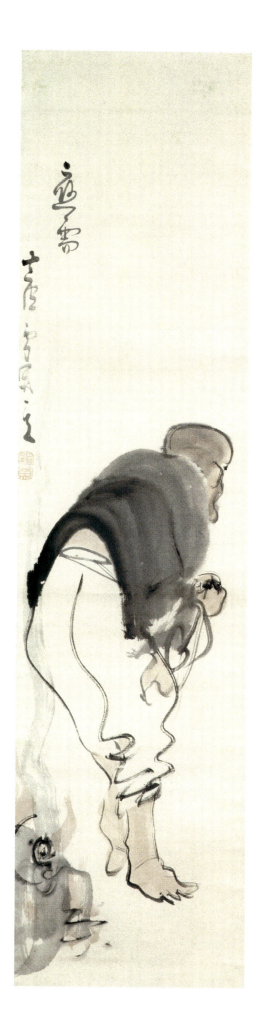

a burning Buddhist sculpture (pl. 63) refers, as is noted in the title *Tanka shō butsu*, which refers to an episode in the life of the Chinese Zen master Tianran Chanshi (738–824). Variant versions of the tale concur that the master, while visiting a temple in winter, burned a wooden statue of the Buddha to keep warm. Challenged by his angry and perplexed host, the master explained that he was burning the statue to retrieve the ashes of the Buddha. When the host pointed out that this was a wooden statue and could not contain the ashes of the Buddha, the master then laughed at the excessive concern over a mere chunk of wood.[19] Again, as with the ox-and-boy paintings, this more explicit and iconoclastic theme appears several times in Rosetsu's work. A panel in a six-fold screen dated circa 1786–87 is in full ink monochrome, in variation with the Gitter-Yelen painting's light color. The posture of the monk is more extreme, with fully presented rump obscuring his head.[20] One of a pair of two-fold screens in Sōdōji, the Wakayama temple that houses some of Rosetsu's greatest works, shows a related scene of sutra burning dated to 1787.[21]

Two other paintings in the Gitter-Yelen collection reveal Rosetsu's ability to produce highly evocative and atmospheric renderings of night scenes. The small horizontal compositions that describe cormorant fishing (pl. 64) are framed, with finger pulls in place, for use as sliding panels or doors in a shelf system called *chigaidana*. This fragment of an interior decorative commission is an unusual representation of Rosetsu's work at a diminutive scale. The light of brazier-held fires extended from boats lures fish, in this case *ayu*, a delicate sweet fish. Cormorants, managed from the boats by rope lines, dive for the fish, but the iron collars on their necks prevent their swallowing the prey. This activity was often seen on many Japanese rivers; Arashiyama, at the western border of Kyoto, may be the site Rosetsu observed.[22]

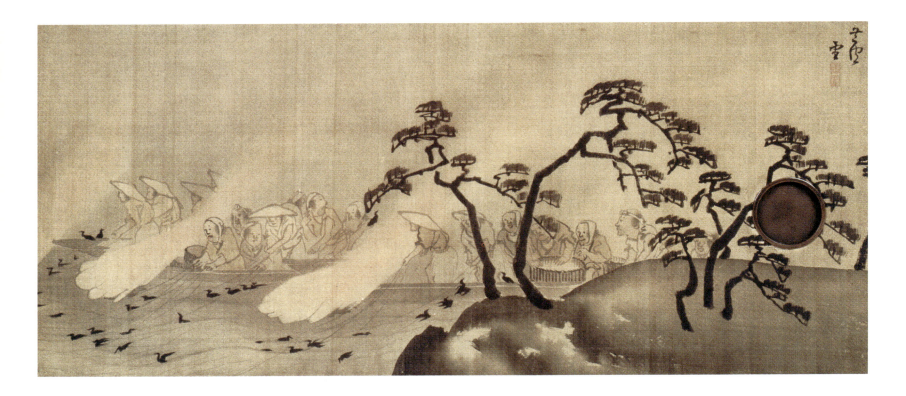

Pl. 64. Nagasawa Rosetsu. *Cormorant
Fishing* (detail, cat. no. 73).

Rosetsu's well-known, large-scale representations of wide expanses of water bordered by tree-covered landmasses gave the artist considerably more latitude to display dramatically washed forms and multiple variations of his usually silhouetted trees. The opposite of those windswept expanses, this fishing scene is a study of a calm, still evening. The pressing, tugging birds and the forward-leaning postures of the fishermen provide the compositional tension. Here, Rosetsu's normal actors—water and trees—are unmoving in what is suggested as a close, damp atmosphere.

The moon, most frequently seen in Rosetsu's paintings as an element in a more complex tableau, is rendered in a Gitter-Yelen work as the sole subject (pl. 55). Gold and ink on a horizontal swath of silk combine to render a light gold moon partially obscured by a band of cloud. Somewhat comparable to the techniques used in the cormorant painting, in which touches of red play against the overall ink-monochrome study, here the painting is softened at all borders where varying washes meet, except for the crisply defined upper curve of the moon. While hints of gold shimmer warmly throughout the ink wash, this sharp and bright lunar sliver becomes the focal point of the painting. This partial revelation and sudden contrast have a distinctly erotic quality, with the hazy

ink atmosphere serving as a diaphanous garment with a glimpse of flesh momentarily exposed.

Uncertain social or professional status, erratic personal behavior, and painting styles incompatible with traditional categories have been the standard criteria for defining the eccentric or individualist painter. The three painters considered here were, at once, uneasy fits in the society of their time, yet unavoidable in the scale of their talents. This brief review of an idiosyncratic selection of a limited number of their works can be no more than a reminder of their positions in the traditional firmament and, perhaps, can offer some clues for further research. For example, art historical discussion of the seventeenth- and eighteenth-century movements to renew popular Buddhism have, to date, focused largely on the proselytizing images of figures such as Hakuin, Enkū, or Sengai. Studies of the structural impact of the art of Ōbaku Zen have generally treated the Ōbaku movement as a crucible for renewing the world of Japanese painting and as a vehicle for fresh insights from the continent. Consideration of the paintings of Jakuchū, Shōhaku, and Rosetsu clearly suggests that many kinds of religious visions were under renewal, and that the traditional art historical focus on populist endeavors deserves to be

broadened in order to more fully appreciate the social role of eccentric and individualist painters. The collision of neo-Confucianism and nativism in eighteenth-century Japan provided an incredibly rich assortment of new imaginings for the Japanese painter to articulate for an eager and appreciative clientele.[23] The various roles played by the eccentrics and individualists in that homogenizing process is yet a further area for discussion.

NOTES

1. The single best treatment of individualists and eccentrics of the Edo period is John M. Rosenfield and Fumiko E. Cranston, *Extraordinary Persons: Works by Eccentric, Non-Conformist Japanese Artists of the Early Modern Era (1580–1868) in the Collection of Kimiko and John Powers*, Naomi Noble Richard, ed., vols. 1–3 (Cambridge: Harvard University Art Museums, 1999).

2. For the most comprehensive English-language work on Jakuchū, see Money L. Hickman and Yasuhiro Satō, *The Paintings of Jakuchū* (New York: The Asia Society Galleries, 1989). The recent Jakuchū retrospective is an invaluable Japanese-language source (Kano Hiroyuki, ed., *Jakuchū!* [Kyoto: Kyoto National Museum, 2000]), as is the important study by Tsuji Nobuo, *Jakuchū* (Tokyo: Bijutsu Shuppansha, 1974). Biographical references in this essay are taken from these well-known sources.

3. For information on the images and their architectural placement, see Kobayashi Tadashi, Tsuji Nobuo, and Yamakawa Takeshi, *Jakuchū, Shōhaku, Rosetsu*, in Suiboku bijutsu taikei (A survey of the art of ink painting), no. 14 (Tokyo: Kōdansha, 1977), 49.

4. See Patricia Graham, *Tea of the Sages: The Art of Sencha* (Honolulu: University of Hawaii Press, 1998), 66–95.

5. Kano, *Jakuchū!*, 24, 28, 347–49, and pls. 77, 78, and 83.

6. See Michael R. Cunningham in Stephen Addiss et al., *A Myriad of Autumn Leaves: Japanese Art from the Kurt and Millie Gitter Collection* (New Orleans: New Orleans Museum of Art, 1983), 204–5. See also Kano, *Jakuchū!*, 347–48.

7. I am grateful to my colleague Stephen D. Allee, research specialist, Freer Gallery of Art and Arthur M. Sackler Gallery, Smithsonian Institution, Washington, D.C., for his translations seen in this essay.

8. Hickman and Sato, *The Paintings of Jakuchū*, 102–3.

9. Ibid., 186–87.

10. In Buddhist iconography, canonical groupings of the disciples (J. *rakan*) of Buddha appear in units of sixteen, eighteen, and five hundred. Japanese interest in the five hundred arhats (or *rakan*) ensemble was stimulated by Ōbaku monks.

For helpful discussions of this general phenomenon, see Timon Screech, "The Strangest Place in Edo: The Temple of the Five Hundred Arhats," *Monumenta Nipponica* 48, no. 4 (winter 1993): 407–28, and Robert T. Singer, "Old Worlds, New Visions: Religion and Art in Edo Japan," in Robert T. Singer et al., *Edo: Art in Japan, 1615–1868* (Washington, D.C.: National Gallery of Art, 1998), 209–10.

11. For a useful discussion of Jakuchū's crane types in relation to a specific work, see Kōno Motoaki, "Itō Jakuchū hitsu tsuru zu sofuku" (A pair of crane paintings by Itō Jakuchū), *Kokka* 1225 (November 1997): 23–25. See also James T. Ulak in Thomas Lawton and Thomas W. Lentz, *Beyond the Legacy: Acquisitions for the Freer Gallery of Art and the Arthur M. Sackler Gallery* (Washington, D.C.: Freer Gallery of Art and Arthur M. Sackler Gallery, 1998), 318–19.

12. Kano, *Jakuchū!*, 353 and pl. 101. Kano disputes the 1800 dating of this painting and suggests a 1798 date, presumably on stylistic grounds. The painting is signed by Jakuchū in his "eighty-fifth year."

13. For excellent discussions on Shōhaku, see Money Hickman, *The Paintings of Soga Shōhaku (1730–1781)*, (Ann Arbor, Mich.: University Microfilms). See also Tsuji Nobuo and Itō Shiori, eds., *Edo no kisai: Soga Shōhaku* (Edo genius: Soga Shōhaku) (Tokyo: Asahi Shimbun, 1998).

14. For a comparative example of the Xiao-Xiang theme, see Amy Poster et al., *Crosscurrents: Masterpieces of East Asian Art from New York Private Collections* (New York: Japan Society, 1999), 148–49.

15. See Tsuji, *Edo no kisai*, for multiple examples.

16. See Kōno Motoaki, "Kyōto gadan to Edo gadan—Kansei kara Bakumatsu e" (The painting worlds of Kyoto and Edo—from the Kansei era to the close of the Edo period) and "Ōkyo to Goshun" (Ōkyo and Goshun), in Matsuda Osamu et al., *Ueda Akinari*, in Nihon no koten (Classical literature of Japan), vol. 17 (Tokyo: Shueisha, 1981), 141–64, 165–75.

17. Tsuji Nobuo, *Nagasawa Rosetsu: Botsugo 200 kinen* (Nagasawa Rosetsu: 200th anniversary exhibition) (Tokyo: Nihon Keizai Shinbunsha, 2000), pl. 58.

18. Jan Fontein and Money Hickman, *Zen Painting and Calligraphy* (Boston: Museum of Fine Arts, 1970), 113. See also Miyeko Murase, *Bridge of Dreams: The Mary Griggs Burke Collection of Japanese Art* (New York: The Metropolitan Museum of Art, 2000), 114–15.

19. Fontein and Hickman, *Zen Painting and Calligraphy*, 36–38.

20. Tsuji, *Nagasawa Rosetsu*, pl. 36.

21. Ibid., pl. 18.

22. Cunningham, in Addiss et al., *Myriad of Autumn Leaves*, 213–15.

23. A welcome effort to present a unified understanding of the role of religion in the Edo period is found in Singer, "Old Worlds, New Visions," in Singer et al., *Edo: Art in Japan*, 205–57.

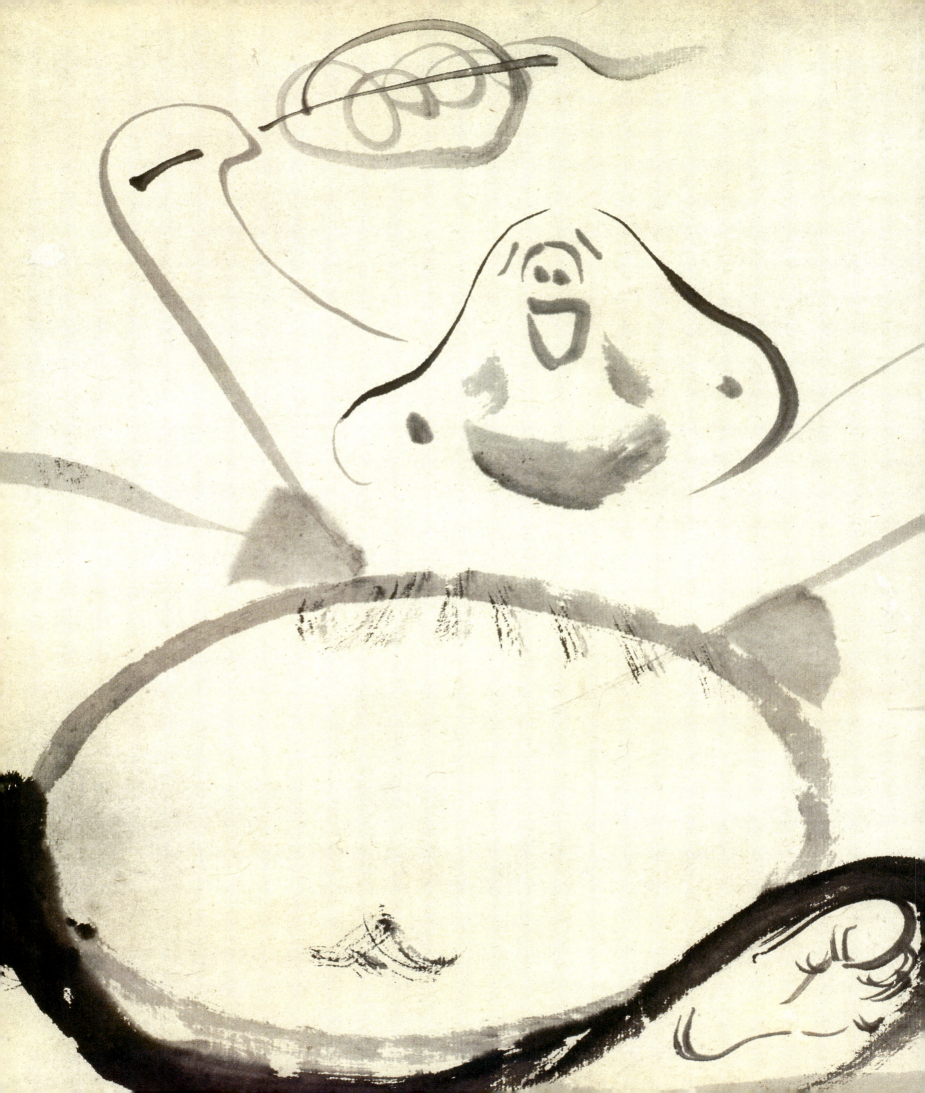

Masatomo Kawai

Hakuin and Zenga Painting

> A monk asked Jōshū, the Chinese Zen master:
> "Has a dog Buddha nature?"
> Jōshū answered: "*Mu.*"
>
> —Ekai, *The Gateless Gate*[1]

ZEN IS A MEDITATIVE BUDDHIST PRACTICE WHOSE ADHERENTS SEEK AN INTUITIVE path to the truths of life and the universe. One aid to Zen enlightenment is the koan, a riddling proposition in the form of an anecdote, question, or assertion that is devoid of logic. Its purpose is to deflect and so utterly halt the restless mind's unremitting quest for an answer, opening it instead to the revelation of truth—of enlightenment. In Joshu's famous Zen koan, the term *mu*, nothingness, refers to an attitude that affords direct contact with truth, removing from our daily life its temporal distractions. Sakyamuni (c. 563–c. 483 B.C.), the historic Buddha, is said to have attained a "state of nothingness" in which material things had become irrelevant. Through meditation, he attained *mu* and hence enlightenment.

Zen's "state of nothingness" is self without form, thought, or feeling—a concept of "no self" that leaves behind temporal concepts of aspiration or expectation and transcends the differentiation of "self" and "other." Thus, when Zen addresses formlessness, it alludes to formlessness of body, mind, awareness of self. It is *mu*—the state of "no thing"—that purest emptiness into which, once attained, enlightenment may then flow.

Zen teachings were conveyed from Sakyamuni through twenty-eight generations of disciples. In the sixth century, Bodhidharma (d. 528) came to oppose Indian Buddhist practice, which had developed along more doctrinaire and ritualistic lines, turning away from meditation and the concept of each person's ability to possess and to know his or her own Buddha nature. Bodhidharma set out to discover how he might restore this essential component and traveled widely. This quest eventually took him to China. He sat in meditation for nine years at the Shaolin temple in Henan, conveyed his teachings to the monk Huike (487–593), and so became the founding patriarch of Zen in China, where it took root in the seventh century, maintaining its more active, vital spirit even as other Buddhist sects were becoming more rigidly formalized.

Not until the thirteenth century did Zen come to be widely practiced in Japan. Kohan Shiren (1278–1346), in *Genkōshakusho*, Japan's first true history of Zen (compiled 1322), states that Eisai (1141–1215) first transmitted Rinzai Zen Buddhism to Japan in 1191. After him, in 1228, Dōgen (1200–1253) transmitted Sōtō Zen to Japan. The Ming-dynasty priest Yinyuan Longqi (1592–1673) brought Ōbaku Zen to Japan during the Edo period (1615–1868). These three sects constitute Zen in Japan today.

During the Kamakura period (1185–1333), Rinzai Zen spread through the upper ranks of the military classes of Kamakura and Kyoto, whose members largely dominated Japanese politics and culture of the day. Zen beliefs then spread to the imperial household and court aristocrats.

Pl. 65. Sengai Gibon. *Hotei Yawning* (detail, cat. no. 134).

119

Dōgen established Eiheiji in Fukui prefecture as his headquarters, and thus the Sōtō sect developed its power base among the landed gentry and upper classes of regional Japan. By the Edo period, Sōtō had become a major sect. The beliefs of all these sects then spread into the upper ranks of the merchant and townspeople classes, which prevailed during Japan's premodern period; its full extension into the commoner classes occurred around the middle of the Edo period, about the time that Hakuin was active. Haga Kōshirō emphasized:

> The flourishing and spread of the Zen faith in Japan over the approximately 800 years from the Kamakura period through the present one was one of the noteworthy events in Japanese religious history, and Zen itself became one of the more important elements of Japanese cultural history.[2]

Though Zen exerted a major influence on the development and history of Japanese culture, the renowned Tamamura Takeji, a scholar of Zen's history, comments that it is questionable how deeply Zen was understood as pure religion.[3] Zen observance has no written texts but gives precedence to direct intuitive experience—it is a religion whose principle aim is attainment of satori, or enlightenment. The Kamakura samurai, Zen's most fervent observers, found in it a directness that appealed in its simplicity to the warriors' tastes. It is clear, however, that only a few of the higher-ranking samurai, such as Hōjō Tokiyori (1227–1263) and Hōjō Tokimune (1251–1284), the most powerful men in the Kamakura shogunate, may have approached a full understanding of it. At the same time, some of the Chinese priests who came to Japan lamented the lack of fervor on the part of Japanese Zen priests who founded the Zen community there.[4] Thus the understanding of Zen by the Japanese was apparently limited in scope.

At some point, the spread of Zen in Japan reached a limit. The Kamakura military classes possessed a unique religion and philosophy that differed from those of the original aristocratic classes, and the Zen sect provided this difference. Yet this new military aristocracy did not seek out Zen as a religion so much as they sought the arts, knowledge, and techniques of China that came from Chinese Zen priests who had traveled to Japan as well as through Japanese priests who had studied in China. These seekers took in the cultural variety that came with Zen and immediately put it to use in their own diverse fields. This fact established the direction for the later development of Japanese Zen and made Zen priests proponents of Chinese culture. Their imitation of the social forms of China's landed literati classes focused on scholarly attainment, Confucianism, and literature.[5] In Zen society the enjoyment of the arts, such as Gozan literature, arises from this circumstance, as did the flourishing production and enjoyment of Chinese-style poetry and paintings by Zen priests.

Zen's nonverbal methods—"transmission outside the scriptures" (kyōge betsuden) or "doctrine without words" (furyūmonji)—turned to direct experience, thus excluding dogmatic thought arising from the study of texts. Sayings such as "pointing directly at the human heart" (jikishi ninshin), and "see one's own nature and become a Buddha" (kenshō jōbutsu), indicate that direct interaction between humans could result in direct transmission of intuitively experienced enlightenment.

Zen's "from heart to heart" approach does not mean that it altogether abandoned writing and words. Words themselves were used symbolically, and as a result, Zen priests frequently employed metaphor as an intuitive expression. They borrowed the ge and ju poetic forms of Tang dynasty China; in them lie the roots of Zen literature. In other words, these forms mediated the

exchange between Zen priest and educated court aristocrat. The Kamakura samurai greatly embraced this interest, and it became the background for the Muromachi-period Ashikaga shogunate's patronage, which saw the creation of the Gozan Zen literature that derived from the Zen priest's love of Chinese poetry and literature. Long-standing tradition in China also equated painting with poetry; Zen priests expressed their religious sentiment through both. Thus began the tradition of the Zen monk-painter.

Because Zen is experienced rather than learned from texts, everyday practice is important; one must cultivate the awareness that enlightenment lies outside scholarly discourse. This aspect of practice meant that Zen teachers employed question-and-answer sessions. It also gave rise to the frequent exchange of poems or paintings that originally served a proselytizing function, as one metaphor for an expression of the religious sentiment between master and disciple, or fellow clerics.

The earliest examples of this exchange in Japanese Zen temples are two inscriptions. The first is on the painting *Bodhidharma* (Kogakuje, Yamanashi prefecture) by the Chinese priest Lanqi Dalong (1213–1278), who arrived in Japan in 1246. The second is on *The Six Patriarchs* (Masaki Museum, Osaka) by Wuxue Zuyuan (1226–1286), who was invited to Japan by Hōjō Tokimune in 1279. Both were probably created by professional painters of Buddhist imagery (*ebushi*) working under the direction of Lanqi or Wuxue. A *White-robed Avalokitesvara* (Nara National Museum) inscribed by Lanqi's disciple Yakuo Tokuken (1245–1320) is an early example of an inscription by a Japanese Zen priest. Some Zen literati priests, such as Kao (d. 1345), Mokuan Reian (d. c. 1345), and Tesshū Tokusai (d. c. 1397), created their own paintings. They had studied in China, where they were in direct contact with the Chinese Zen community's literature and arts.

They also painted images of the Zen patriarchs, of Guanyin (J. Kannon), or of simple forms of plum, orchid, and bamboo.

Some Japanese monk-painters also attained professional skills with the new techniques from China. Two of them, Ryōzen (act. c. 1328–60) and Minchō (1351–1431), painted numerous Buddhist themes—images of arhats, or Sakyamuni's Nirvana, or portraits of Zen priests. Jōsetsu of Shōkokuji (act. 1415), who served as a painter to the Ashikaga shogunate, and Shūbun (d. c. 1464) appeared in the Muromachi period (1333–1573), which also saw the creation of the *shigajiku*, or poem-painting scroll, on which appeared a poem inscribed by one priest and a scene based on the poem's sentiments painted by another. Images important to the Zen community appear in the works of the famous Sesshū Tōyō (1420–1506), who made landscapes of the ideal settings in nature sought by Zen priests. Yet during the early Edo period, several Zen priests criticized such works as falling short of Zen practice, or inviting corruption.

This situation spurred Hakuin Ekaku (1685–1768), an artist who eventually became a zealous religious reformer, to return to the concept of the Buddha nature innate in each person. He lectured on self-realization, reiterating its importance, and followed a thoroughly Zen path, seeking to correct this period's mistaken discounting of enlightenment by transforming the declining Rinzai Zen of the mid-Edo period into the religion of the Japanese people. He transformed impenetrable Zen texts into terms anyone could grasp and used his own paintings to illustrate his sermons, along with karma tales and other subjects close to people's hearts.

Hakuin painted many images of Bodhidharma (J. Daruma). His belief in Bodhidharma's lineage is said to have revived the Japanese understanding of the Zen patriarch's teachings. His *Daruma* (cat. no. 120) is inscribed *Jikishi ninshin Kenshō jōbutsu* (Pointing directly at the human heart: / See one's own nature and become Buddha).

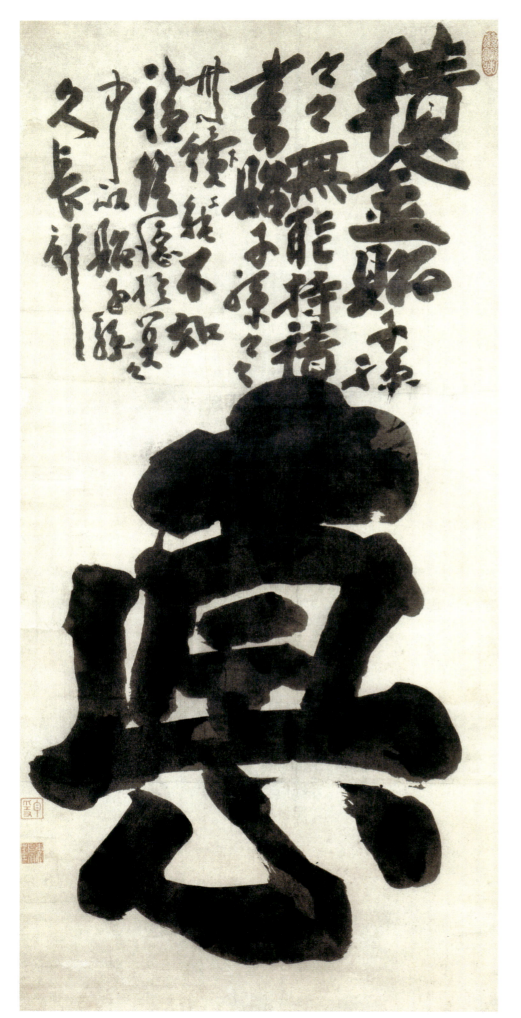

Pl. 66. Hakuin Ekaku. *Virtue* (cat. no. 119).

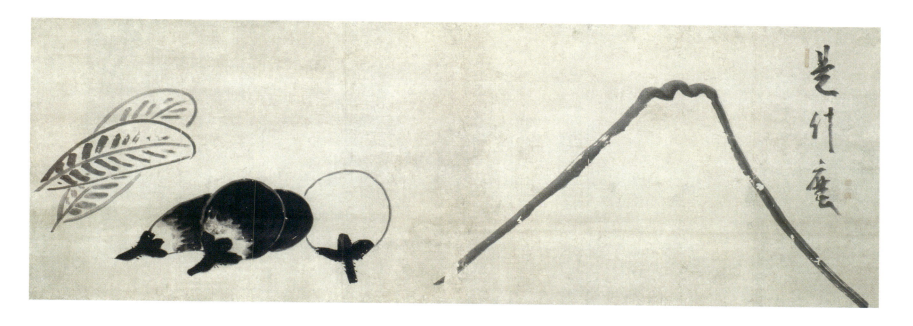

Hakuin's calligraphy has a richly nuanced personal style. *Virtue* (pl. 66), the large rendering of the single character *toku*, fills the sheet with brawny black strokes imbued with martial power. The brush moved slowly, as if to reveal the energy that swelled from Hakuin's very center as he brushed its impact upon the viewers. A strange balance can be felt in the placement of this text above the single character. The inscription translates:

> Pile up money for your sons and
> grandsons—
> They won't be able to hold onto it.
> Pile up books for your sons and
> grandsons—
> They won't be able to read anything.
>
> No, the best thing to do
> is to pile up merit
> quietly, in secret,
> And pass on this method to your
> descendants:
> it will last a long, long time.[6]

Mount Fuji and Eggplant (pl. 67) is a superb rendering of this felicitous New Year's dream theme. But it is inscribed *Kore somo*, literally, "What's this!"—a typically puzzling Zen exclamation. The text fills the space casually, yet with a limitless sense of mass. The painting is the embodiment of Hakuin's wit.

Hakuin was born in Hara, Suruga province (present-day Numazu city, Shizuoka prefecture). At fifteen he became the disciple of Tanrei Soden of Shōinji, in Hara. From childhood, tales of hell and heaven impressed him, and it is said that even after he entered the Zen temple, he was unable to escape his occasional fear of hell. At age twenty-four, he heard a sermon by Shōtetsu, priest at Eiganji in Echigo Takada (present-day Takada city, Niigata prefecture), which told of the fates that await all men in hell. Hakuin struggled with his faith, experiencing doubt. He achieved his spiritual breakthrough after falling into the state of *mu* for several days. One morning the faint tones of a temple bell penetrated his trancelike state, and in that moment he attained great enlightenment. The exhilarated Hakuin, confident in his exalted spiritual state, then embarked on a search for a

Pl. 67. Hakuin Ekaku. *Mount Fuji and Eggplant* (cat. no. 121).

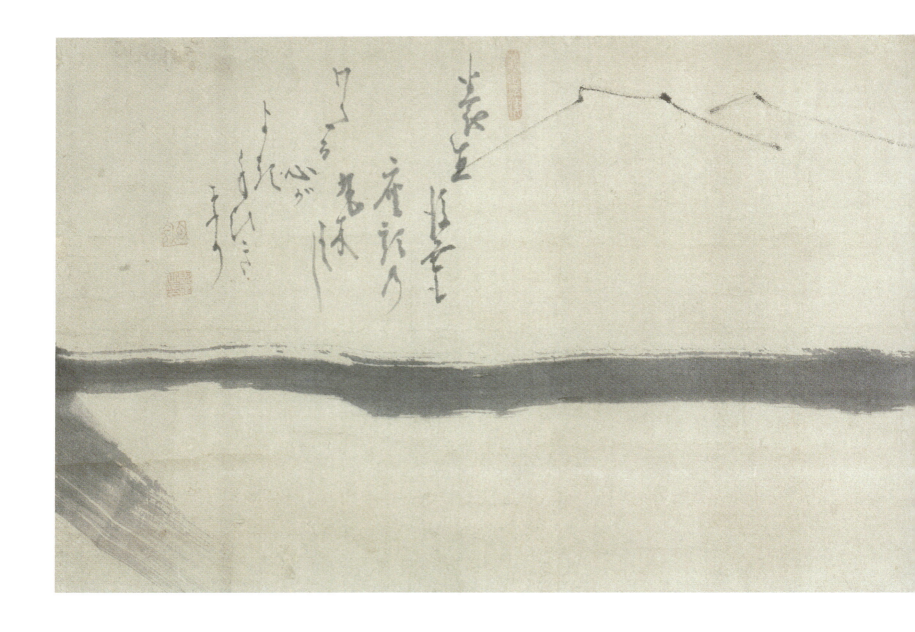

teacher who would grant him instant certification as a Zen master. But teacher after teacher refused to do so, unanimous in the opinion that he was still far from attaining the full enlightenment he sought.

At last, somewhat humbled, he came to Rinzai master Shōju Rojin (Dōkyō Etan, 1642–1721), who rejected Hakuin's glib responses and challenged him with strict practice and harsh discipline. Shōju finally shouted at him that he would never attain the peerless practice of Zen available only to serious aspirants.

Hakuin, disheartened by Shōju's confrontation and abuse, began to doubt his teacher and determined to leave. Early the following morning,

he took up his begging bowl and went to the village in front of Iiyama castle. Preoccupied with the koans he had been pondering, he ignored a voice shouting, "Go on! Go somewhere else!" He remained standing near a house until its occupant suddenly dashed out and began to flail at his head with a broom, knocking him to the ground. When he regained consciousness, he realized that all his impenetrable koans were now lucid and accessible. Full of joy, he returned at once to Shōju, who immediately understood the transformation and welcomed Hakuin kindly with sage advice to not fall again into complacency.

Hakuin chose a difficult path, but in the end, he was finally freed from his fear of hell and had

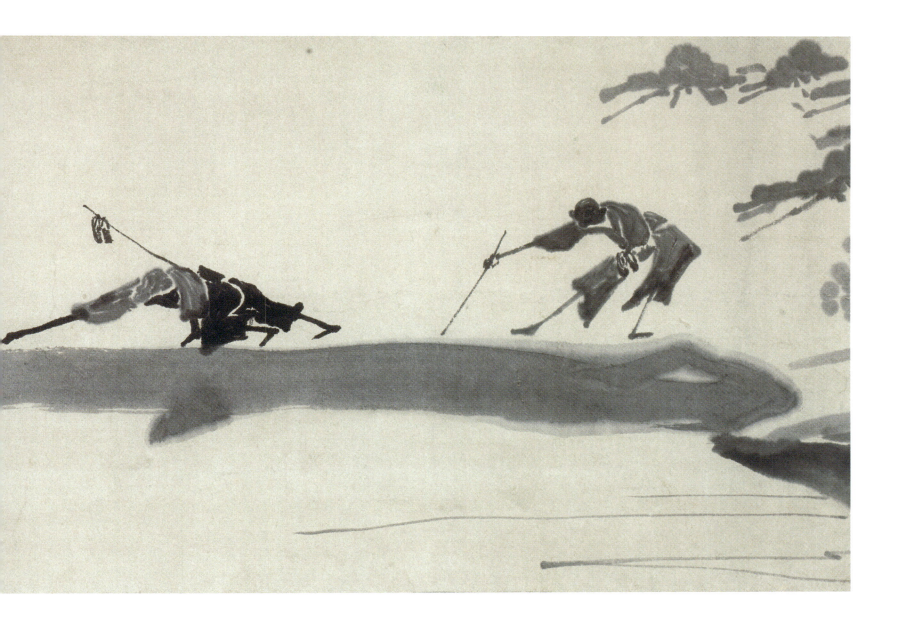

at last gained a true understanding of Zen's meaning. At age thirty-two, he bowed to his father's wishes and returned to Shōinji, where he set about revitalizing the temple. He used it as his base as he turned to energetically proselytizing Zen among Japan's commoners. At this time, he began to use his own paintings in this endeavor. Hakuin's paintings are not limited to religious themes; in fact they tend toward the secular, with subjects arising from human experience and conveying human meanings. Kurt Brasch used the term "*zenga*," a word he coined in the 1950s, to describe the work of Hakuin and others.[7] Such paintings expressed Hakuin's religious heart; they can be called Zen itself.

Two Blind Men Crossing a Bridge (pl. 68) is at once both timely and deeply affecting. The pair fumble their way across a bridge depicted in light ink that makes thorough use of a spreading stain. Dotted with just a bit of darker ink, this work is at first glance humorous. But its carefully applied, detailed brush lines speak of the artist's heart. The figure of a blind man can be seen as an allegory of our own stumbling through life; its inscription reminds us that the care with which a blind man crosses a bridge is a good example of how we should live our lives.

The painting of Shinnō, *God of Medicine* (pl. 69), and *Kannon Emerging from a Clamshell* (cat. no. 123) are relatively early in Hakuin's oeuvre. Shinnō is

Pl. 68. Hakuin Ekaku. *Two Blind Men Crossing a Bridge* (cat. no. 118).

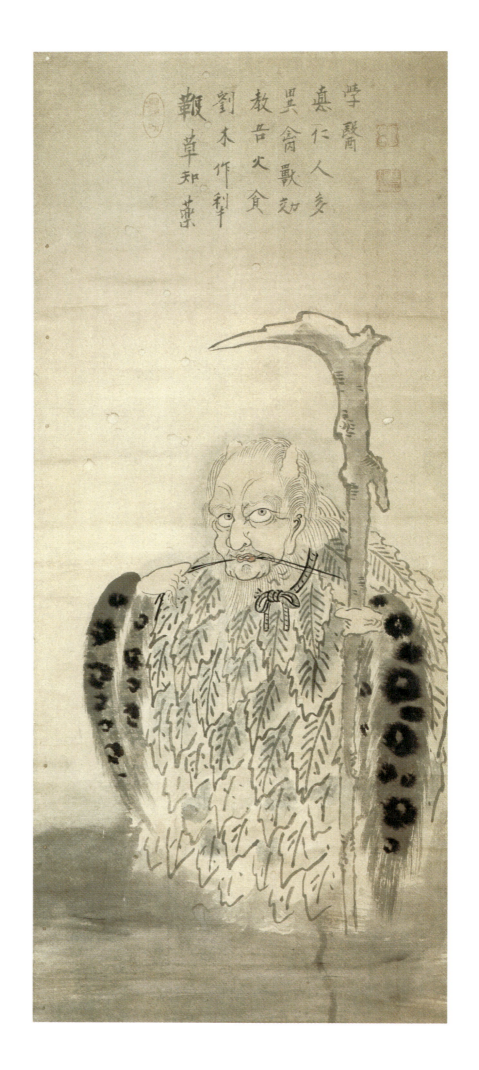

學醫商
慕仁人多
吳禽獸知
教吞火食
劉木作犁
鞭草知藥

Pl. 69. Hakuin Ekaku. *God of Medicine*
(cat. no. 122).

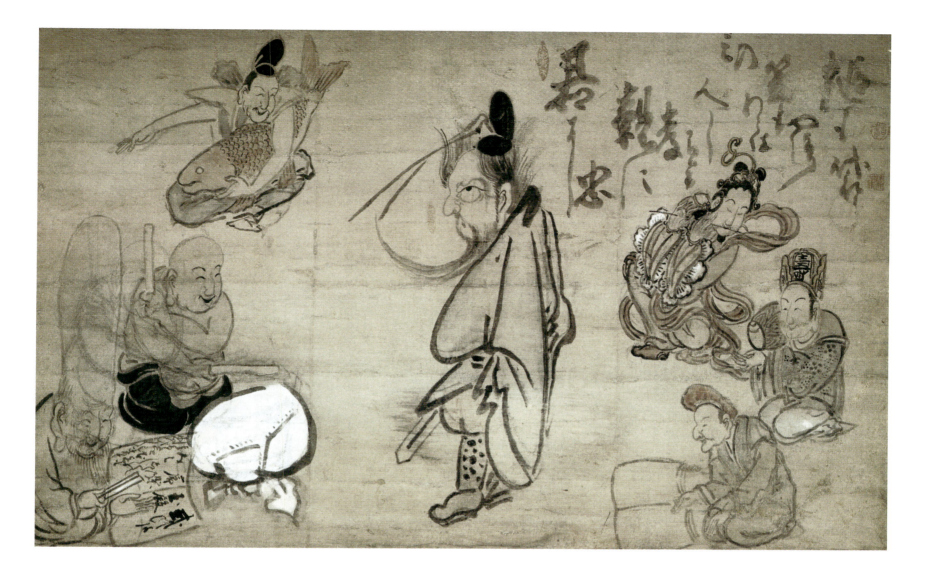

an ancient legendary Chinese emperor who attained symbolic existence as the Chinese folk deity of agriculture and medicine. Hakuin's chronic poor health led him to a deep interest in medicine; he even developed his own health regimes. Kannon, the bodhisattva who seeks to end all suffering and save all souls, is known to have thirty-three manifestations. Hakuin explained that his own salvation had come from the section of the Lotus Sutra (J. Hokkyō bosatsu fumonbon). It is said that he envisioned the Kannon as a gentle mother. Both works were made to appeal to the masses. The inscriptions are written in everyday Japanese, and the images are depicted in simple brushstrokes.

Seven Gods of Good Fortune (pl. 70) is based on a Shinto-Buddhist concept and depicts Buddhist and Shinto deities popularly worshiped in the Edo period as harbingers of good fortune. Hakuin repeated this theme often, possibly because of demand for them. His grasp of the subject in this truly superb work is just right; there is a stunning harmony between ink tones and composition. Though metaphorical, Hakuin's works are by no means inaccessible. In his paintings, he used metaphor to convey simply the depths of Zen thought.

Several of Hakuin's disciples also became painters; Tōrei Enji (1720–1792) and Suiō Genrō (1716–1789) were his most talented students. Tōrei became Hakuin's disciple in 1743. Hakuin regarded him highly and entrusted him with the operation of Ryūtakuji in Mishima, Shizuoka prefecture. It is said he was quite learned in Zen matters, and seems to have particularly absorbed Hakuin's teaching regarding the shared nature of Zen and Buddhism. In *Ensō* (pl. 71), he drew

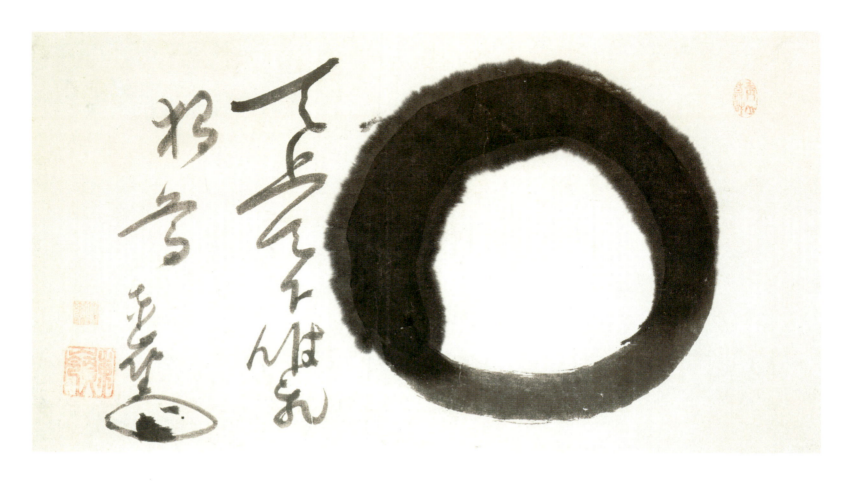

Pl. 71. Tōrei Enji. *Ensō* (cat. no. 130).

the circle that symbolizes absolute truth in Zen. Suiō, however, preferred painting, calligraphy, and drinking to the discipline of Zen practice, and so was given his name, whose characters mean "drunk old man"; they were later changed to a more seemly set of homonymous characters. He became Hakuin's student in 1746 and was strictly trained. His casual personality and outlook toward Zen led him to maintain a certain distance from his teacher; he lived nearby, on his own. After Hakuin's death, Suiō succeeded him at Shōinji.

An image of the Zen priest Bukan sleeping with a tiger is often used as an allegory for the absolute realm that exists in Zen; in his painting, Suiō simply suggests the tiger by its footprints (pl. 72). Gessen Zenne (1701–1781), the priest who inscribed Suiō's *Zen Monk Bukan*, became the eighteenth head priest of Hōrinji, in the Nagata district of Yokohama. He moved to this temple around 1747 and later built and retired to the Tōkian subtemple within Hōrinji. He trained both

Sengai Gibon (1750–1837), of Hakata's Shōfukuji, and Seisetsu Shūchō (d. 1820), of Kamakura's Enkakuji. Sengai is considered the greatest *zenga* painter after Hakuin. His *Hotei Yawning* (pl. 65) and *Dazaifu Shrine* (pl. 73) reveal an open-hearted character and a humor not found in Hakuin's works. The Hotei inscription may be translated: "What a great feeling! I dreamed I became a Zhou prince." This son of the Zhou dynasty king, a ruler in eleventh-century B.C. China, was a Confucian saint, the ideal ruler envisioned by Laozi.

Dazaifu was the site of the Tenmangū shrine of the spirit of the tragic Heian-period politician, Sugawara no Michizane (845–903). The small wooden sculpture of a bird seen in the lower right of *Dazaifu Shrine* depicts the *uso*, which is a kind of bullfinch whose name is a homonym for a character meaning "lies." These sculptures are used in the *uso gae* ritual that changes last year's *uso*, or lies, into this year's felicities. It is held on New Year's day before the torii gates of this shrine.

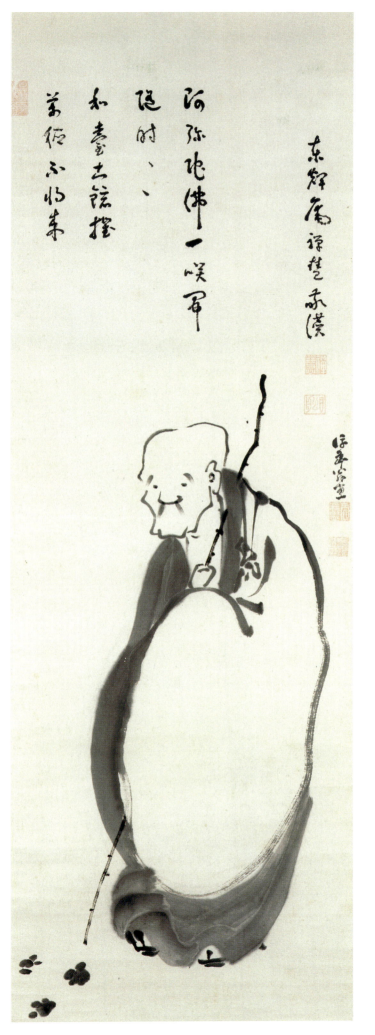

阿弥陀佛一噄軍
饶时、
和毒去院控
苦佑不听来

東輝廣禄拴承漢

Pl. 72. Suiō Genro. *Zen Monk Bukan* (cat. no. 127).

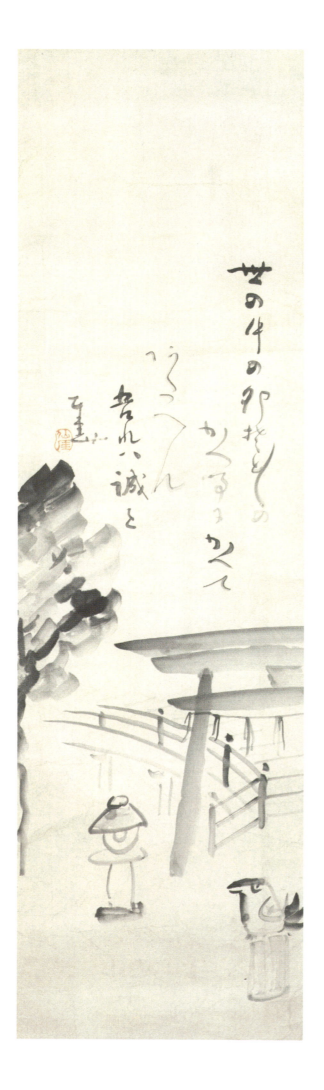

Pl. 73. Sengai Gibon. *Dazaifu Shrine* (cat. no. 135).

Fūgai Ekun (1568–1654) was a Sōtō Zen priest and early pioneer of *zenga* before Hakuin and Sengai. We know nothing of his teacher or his disciples. The somewhat reclusive Fūgai lived alone in a cave. He ended his life in the Kanesashi-Ishioka region of Shizuoka prefecture, where he is said to have ordered the villagers to dig a hole in which he then stood and simply died. From this final act came his regional name, Ana Fūgai, or "Cave Fūgai." The Gitter-Yelen collection has six works by Fūgai, of which *Hotei Pointing at the Moon* is the masterpiece (pl. 74). The figure of Hotei is done in fast, fluent brushstrokes. Fūgai's paintings are said to be talismans against calamity and thus were greatly treasured by the common people of his day. Traces of Muromachi Zen painting style still appear in his works as well as a sense of the painting styles of the early Edo-period painters Takuan Sōhō (1573–1645) and Shōkadō Shōjō (1584–1639).

The *zenga* section of this exhibition includes distinctive paintings by Konoe Nobutada (*Half-body Daruma*, cat. no. 116), Jiun Sonja (*A Single Path*, pl. 75), Reigen Etō (*Hotei in a Boat*, pl. 76), Kōgan Gengei (*Daruma*, cat. no. 132), Shunsō Shōju (*Daitō Kokushi as a Begging Monk*, pl. 77), Yamaoka Tesshū (*Dragon*, pl. 78), and Nakahara Nantenbō (*Procession of Monks*, pl. 79 a, b). Each one offers a powerful sense of the artist's individuality and spiritual depths. Of these artists, Reigen was Hakuin's disciple; after receiving his *inka* certificate of enlightenment from his master, he went to Tenryūji in Kyoto, where he spread Hakuin's style of Zen to the Kyoto Gozan community. Kōgan sought to study under Hakuin and the Shōinji in Suruga, but owing to Hakuin's advanced age, he actually studied under Suiō, from whom he received his certification. Kyokai Jikō (1800–1874) is said to have studied under Seisetsu Shūchō and was thus of the Sengai lineage.

Not all these artists were necessarily members of the Rinzai sect or followers of Hakuin. Jiun was

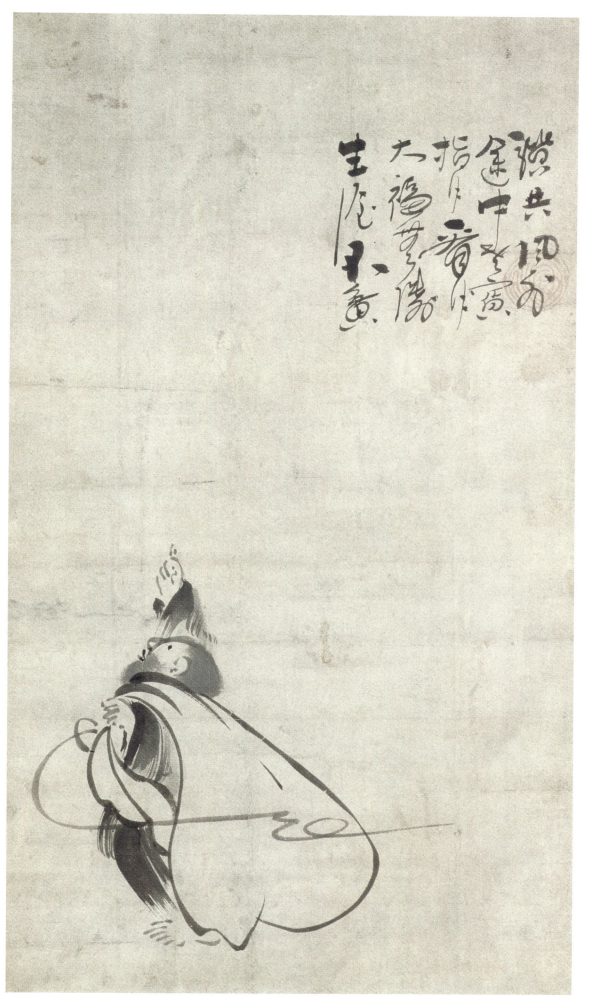

Pl. 74. Fūgai Ekun. *Hotei Pointing at the Moon* (cat. no. 117).

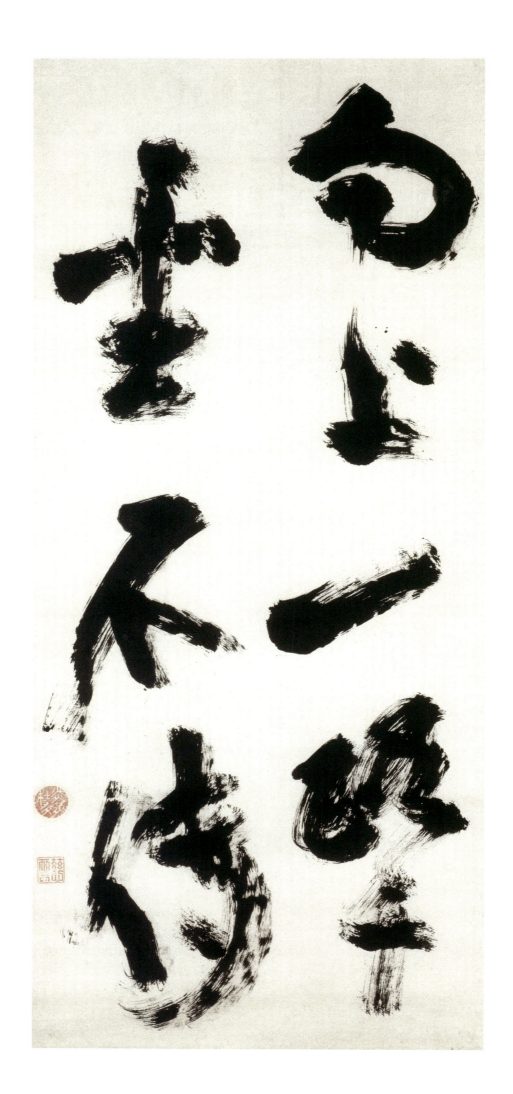

Pl. 75. Jiun Sonja. *A Single Path*
(cat. no. 128).

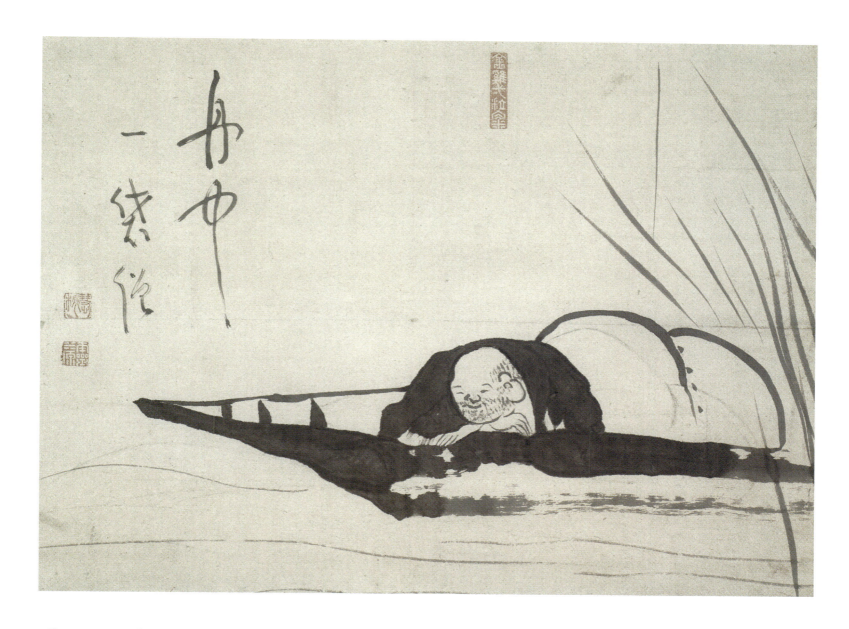

a Shingon priest, Chingyū was Sōtō, and Taihō (Dapeng Zhengkun; 1691–1774) was an Ōbaku Zen priest who came to Japan from China, to become the fifteenth head priest of Manpukuji. Nobutada was a famous early Edo calligrapher, while Yamaoka, a samurai at the end of the Edo period, became a Meiji-period politician. These two laymen were deeply affected by Zen, and that spirit in their paintings places them in the *zenga* genre.

Tesshū was also close to and a follower of Nantenbō, one of the foremost priests of the

modern age. Nantenbō's name derives from the fact that while on a pilgrimage around Kyushu, he became fascinated by a *nanten* shrub (*Nandina domestica*, or heavenly bamboo—actually a barberry) growing in a farmer's garden. He cut a 3½-foot-long staff from it, and then, in imitation of Deshan Xuanjian (J. Tokusan Senkan, c. 781–867), a high cleric of China's Tang dynasty, he used it to command his listeners' attention as he preached. Many others also studied Zen under Nantenbō, including military officers, literary figures, and actors. In *Procession of Monks* (pl. 79 a, b), the line of priests

Pl. 76. Reigen Etō. *Hotei in a Boat* (cat. no. 129).

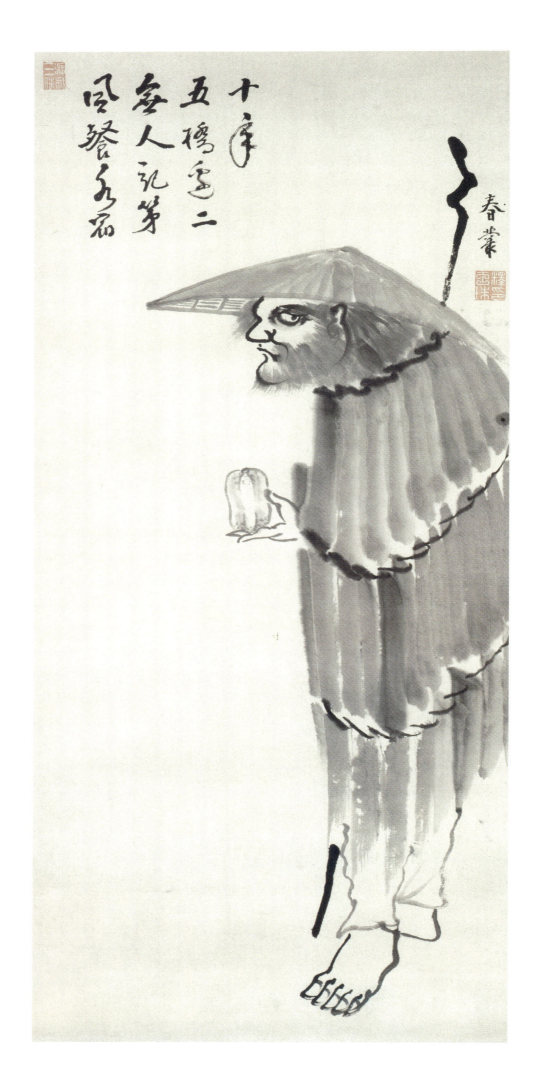

Pl. 77. Shunsō Shōju. *Daitō Kokushi as a Begging Monk* (cat. no. 133).

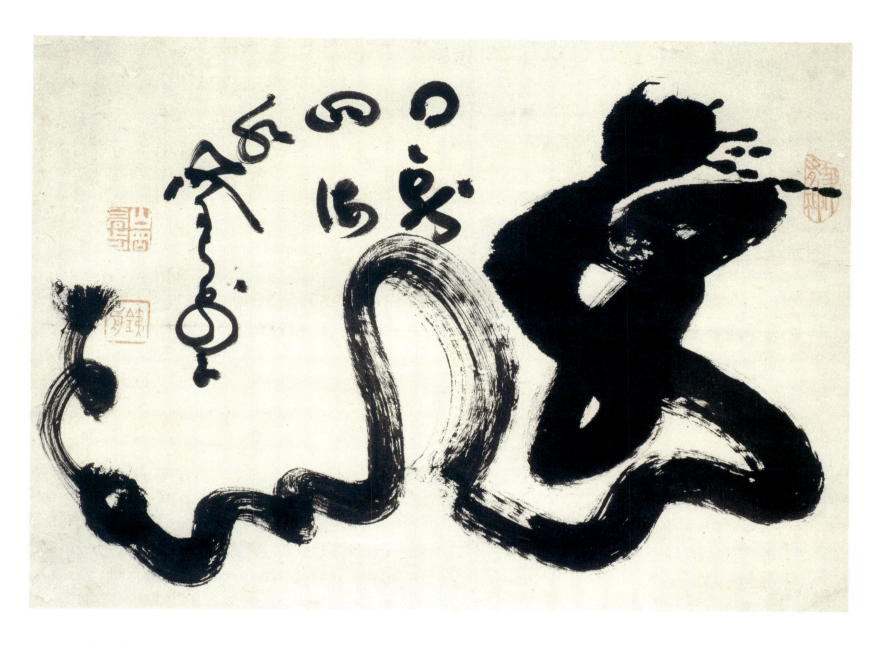

Pl. 78. Yamaoka Tesshū. *Dragon* (cat. no. 136).

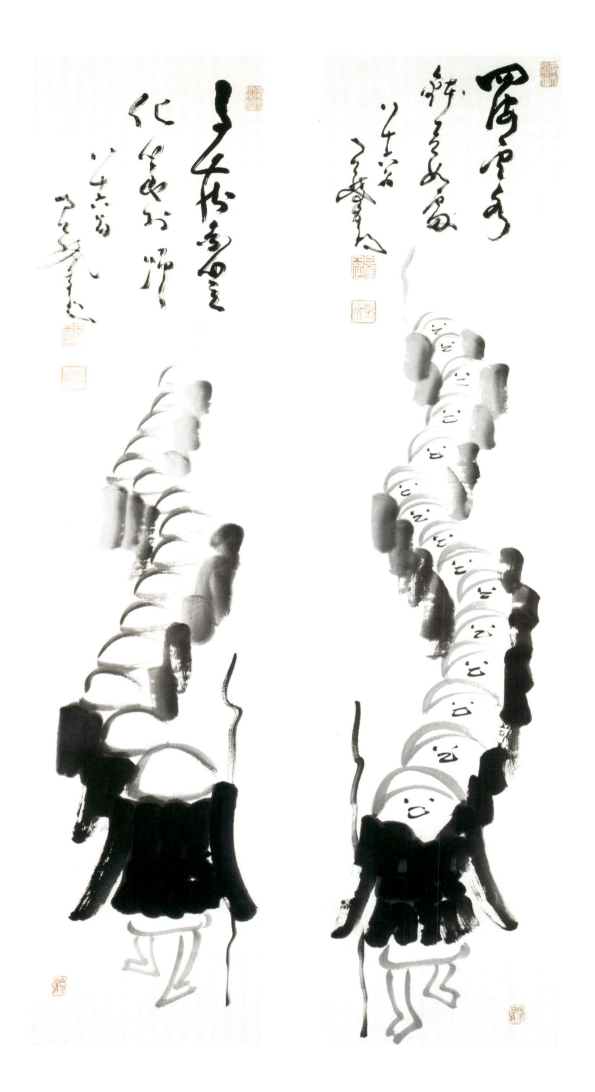

Pl. 79 a, b. Nakahara Nantenbō. *Procession of Monks* (cat. no. 138).

going out to beg and the line returning are drawn effortlessly with a brush seeming to move of its own volition. Nantenbō favored this subject; this example is one of the masterpieces of the Gitter-Yelen collection. The style of *Half-body Daruma* (cat. no. 137) resembles that of Tesshū's *Dragon* (pl. 78) and here we can see how Tesshū learned from Nantenbō's painting style.

Modern Zen has spread throughout the world, thanks to Suzuki Daisetsu (1870–1966), whose writings on Zen's history and direction appeared in English between 1949 and 1956, and Hisamatsu Shinichi (1889–1980), whose work furthered the religious understanding of Zen in greater depth.[8] Here, in the work of the *zenga* painters, who depict Zen patriarchs and anecdotes, and illustrate key elements of Zen teachings, we can observe the abstract becoming representation and, simultaneously, representation becoming the abstract—creating a paradoxical unity as engaging as the Zen koan, and which goes beyond an elegant minimalism of technique to embody and make visual the very spirit of Zen.

NOTES

1. Ekai, "The Gateless Gate," in *Zen Flesh, Zen Bones: A Collection of Zen and Pre-Zen Writings*, ed. and comp. Paul Reps (Rutland, Vt., and Tokyo: Charles E. Tuttle, 1957).

2. Haga Kōshirō, "Zen geijutsu to wa nani ka" (What is Zen art?), special edition of *Taiyō* (Tokyo: Heibonsha, 1980).

3. Tamamura Takeji, *Gozan bungaku* (Gozan literature) (Tokyo: Shibundō, 1955).

4. Ibid.

5. Ibid.

6. Translated by Jonathan Chaves in Stephen Addiss, *Zenga and Nanga: Paintings by Japanese Monks and Scholars* (New Orleans: New Orleans Museum of Art, 1976), no. 14.

7. Kurt Brasch, *Hakuin to Zenga* (Hakuin and Zen painting) (Tokyo: Japanisch-deutsche Gesellschaft, 1957) and *Zenga* (Tokyo: Nigensha, 1962).

8. Suzuki's selected work appears in several volumes in English, including his *Zen and Japanese Culture* (New York: Pantheon Books, 1959) and the widely read *Zen Buddhism: Selected Writings of D. T. Suzuki*, ed. William Barrett (New York: Doubleday, 1956). In 1999 Suzuki's complete works, forty volumes, were published in Japan: *Suzuki Daisetsu zenshū* (Tokyo: Iwanami Shoten). Hisamatsu Shin'ichi's *Hisamatsu Shin'ichi chosakushū* (Collected writings of Hisamatsu Shin'ichi) appeared in 1970 (Tokyo: Risōsha).

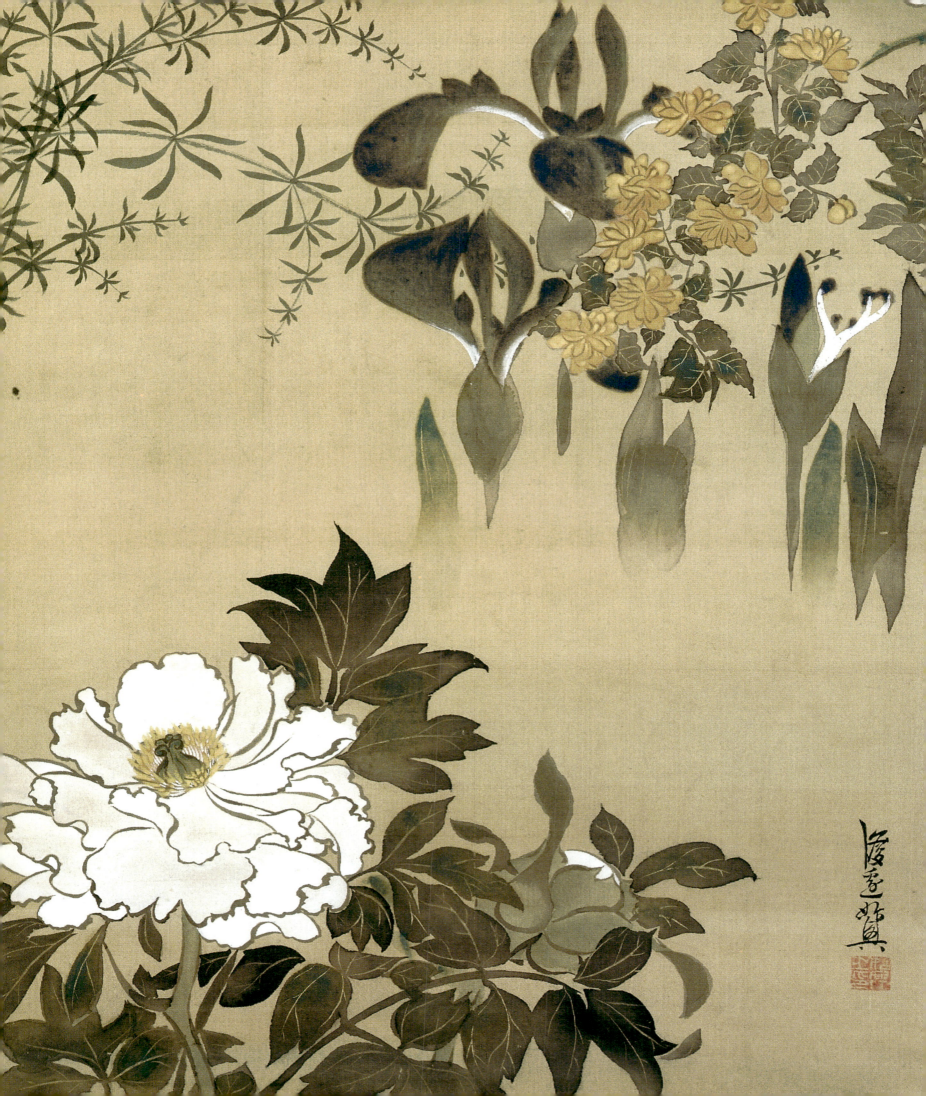

Motoaki Kōno

Rinpa School Works in the Gitter-Yelen Collection

IN 1815 (BUNKA 12) SAKAI HŌITSU HELD AN EXHIBITION OF THE WORK OF OGATA Kōrin (1658–1716), whom he greatly revered, to commemorate the hundredth anniversary of his death. Hōitsu also published a seal compendium for which he brushed the outer volume title *Ogata ryū ryaku inpu* (Abbreviated seal compendium of the Ogata school); the inner volume title is the same. Hōitsu composed a postscript to the compendium, which reads in part:

> I have sought out impressions of the seals used by the Ogatas and have collected all
> of them. I like their painting styles and so whenever I had a chance to see their works,
> I made copies of their seals and saved them. Recently a certain antique dealer decided
> that he wanted to create and publish a compendium of these seal impressions. So, for
> my honored lord, I looked among my various writing boxes, gathered up the seal
> impressions, and gave them to the antique dealer. And my request to viewers of this
> compendium is this: if you find other seals not published here, please add them to
> the compendium.

The Ogata school to which Hōitsu refers is obviously the one we identify today as the Rinpa school. Elsewhere Hōitsu clearly and correctly states that the artistic lineage whose brilliance radiated throughout the history of Japanese premodern painting began with Tawaraya Sōtatsu (act. c. 1600–1640). Naturally, Hōitsu's own seals are not included in the *Ogata ryū ryaku inpu*; modern scholars named this group the Rinpa school and included Hōitsu within it. His own conceit led Hōitsu to consider himself a descendant in this artistic lineage, and thus he felt qualified to publish the seal compendium for his followers and for those modern painters who loved and continued the style.

When Hōitsu discusses the painting style of the Ogata artists in his postscript, he means, strictly speaking, the style of Kōrin, or Kōrin and Ogata Kenzan (1663–1743). But if we look at the contents of Hōitsu's book, which starts with Sōtatsu, Kōrin, and Kenzan and continues up to Tawaraya Sōri (fl. c. 1764–80), we can see that Hōitsu clearly intends the entire Rinpa lineage. In the following paragraphs I will review the history of the Rinpa school through a discussion of its representative works in the Gitter-Yelen collection, which contains numerous and outstanding examples.

Tawaraya Sōtatsu is considered the founder of the Rinpa style of painting. It seems he came from a family who operated an *e-ya*, or painting shop, named Tawaraya. Painting became an industry in the late Muromachi period, when artisans working in shops filled the orders of ordinary citizens. They created the preparatory drawings for woven textile designs and the underpaintings that adorned decorated papers used for calligraphy. They even painted fans and created the paintings that were mounted on folding screens for room decoration.

By the Keichō era (1595–1615), Sōtatsu himself had become accepted among the wealthy merchant class of Kyoto and was closely acquainted with such major Kyoto personalities as the

Pl. 80. Watanabe Shikō. *Spring and Summer Flowers* (detail, cat. no. 85).

Pl. 81. Tawaraya Sōtatsu. *The Four Sleepers* (detail, cat. no. 78).

tea master Sen Shōan and the famous Nishijin textile-district figure Iseki Myōji. It is possible that Sōtatsu was related to Hon'ami Kōetsu (1558–1637) by marriage. During the Genna era (1615–24), the Tawaraya painting shop became extremely popular in Kyoto, and the Tawaraya name was known even at the imperial palace. By the Kan'ei era (1624–44), Emperor Gomizunoo had sent an imperial commission for three pairs of folding screens to the Tawaraya shop. Sōtatsu's colophon for the copy of the *Saigyō monogatari emaki* (Life of the priest Saigyō scrolls; formerly in the Mōri family collection), made from the version in the Imperial Household collection, indicates that by 1630 (Kan'ei 7) he had already been elevated to the rank of *hokkyō*. Thus, we can see how he became the honorable Hokkyō Sōtatsu, a progression from painting shop artisan to recognized artist.

The earliest confirmed extant work by Sōtatsu is the 1602 (Keichō 7) repair he completed on the *Heike nōkyō* sutras, which had been presented by the Taira family to the Itsukushima shrine during the Heian period. In this repair, Sōtatsu added new paintings of deer, evergreens, plum trees, and other motifs in gold and silver paint to the severely damaged outer covers and frontispiece paintings of three of the offertory scrolls. Many of Sōtatsu's early works are painted in silver and gold pigments. These metallic pigments visually enlarge the motifs they form and impart a rich aura to the work, elevating the images from minor "underpainting" to the heights of painterly accomplishment. As Sōtatsu sought a more painterly, rather than simply decorative expression, he gradually shifted his creative endeavors from gold and silver pigments to ink painting. Indeed, one of Sōtatsu's noteworthy accomplishments was his transformation of the brushwork-centered, ink-painting style brought to Japan from China to a more Japanese style of ink painting that gave particular weight to the subtle harmonies and tones of ink washes.

The Four Sleepers (pl. 81) and *Duck Flying over Iris* (pl. 82) are well-known examples of Sōtatsu's ink painting. The Four Sleepers theme refers to the Chinese Zen priest Fenggan (J. Bukan), of Guoqingsi temple on Mount Tiantai, who sleeps with the tiger on which he rides, and his two disciples, Hanshan and Shide (J. Kanzan and Jittoku). This painting theme has long been a favorite for its depiction of symbols of Zen enlightenment and truth. Here Sōtatsu has enveloped the soft forms in elegantly shaded ink tones to create a truly dreamlike scroll. The presence of this type of Zen painting theme in Sōtatsu's oeuvre must not be overlooked. This *Four Sleepers* is impressed with only the round Inen relief seal and no signature, a configuration that corresponds to his earliest period, as found on the famous *Waterfowl in Lotus Pond* scroll (Kyoto National Museum). Sōtatsu's later works, such as *Duck Flying over Iris*, date to after his elevation to

Pl. 82. Tawaraya Sōtatsu. *Duck Flying over Iris*
(detail; cat. no. 79).

Pl. 83. Hon'ami Kōetsu and Tawaraya
Sōtatsu. *Waka Poem with Design of
Shinobugusa Ferns* (cat. no. 77).

hokkyō rank, and those dating from the Kan'ei era
bear signatures in addition to seals.

Hon'ami Kōetsu created works jointly with
Tawaraya Sōtatsu, and he may have directed
Sōtatsu's artistic development and success. His role
in Sōtatsu's early career was particularly decisive.
Kōetsu was born into a high-ranking townsman's
family, with the hereditary occupations of sword
polisher, purification expert, and connoisseur.
Kōetsu had a brilliantly creative career as an artist
and was also a superb art director, as seen in his roles
as publisher of the *Sagabon* series of Japanese literary
classics and founder of an artistic and religious com-
munity known as Kōetsu-mura (literally, "Kōetsu
village"). Although the relationship between

Sōtatsu and Kōetsu is not completely understood,
the confirmed handscrolls that combine Sōtatsu's
underpaintings in gold and silver pigment with
Kōetsu's *waka* poetry written in his own hand stand
as monuments to the dazzling creativity of both
men. A fragment of a collaborative Sōtatsu and
Kōetsu *waka* handscroll (pl. 83) in the Gitter-Yelen
collection is one such example. Sōtatsu painted
fern fronds in silver and gold, creating a beautiful
rhythm across the page. (Even if this part of the
work were carried out by Sōtatsu's pupils, un-
doubtedly Sōtatsu supervised the process.) Kōetsu
then brushed a verse by Emperor Kazan from the
Kōkinwakashū imperial anthology over the deco-
rated paper. The poem can be loosely translated:

Pl. 84. Hon'ami Kōetsu. *Letter to Suga-oribe no kami* (cat. no. 76).

Autumn seems early,
already the ninth month.
The nights grow longer
as we approach midwinter.
Naturally I awaken
in the midst of my sleep.

Kōetsu excelled at calligraphy and was known as one of the three famous calligraphers of the Kan'ei era (along with Konoe Nobutada, 1565–1614, and Shōkado Shōjō, c. 1584–1639). An example of Kōetsu's calligraphy in a looser style can be found in a letter in the Gitter-Yelen collection (pl. 84). Suga-oribe no kami, its recipient, was lord of Zeze castle in Ōmi province and later moved to Kameyama in Tamba province. Other extant letters from Kōetsu to Suga-oribe seem to indicate that the two were close friends. Even this brief note, stating that Kōetsu's messenger, Roku, will relay the message verbally due to its urgency, gives a direct sense of Kōetsu's warm personality.

The artist traditionally called Nonomura Sōsetsu (fl. 1639–50), whose name is written with

the "snow" character, inherited the Tawaraya shop from Sōtatsu. One generation later, Kitagawa Sōsetsu (the name "Sōsetsu" written with different but like-sounding characters) emerged as a member of Nonomura Sōsetsu's painting studio and was active in the latter half of the seventeenth century. Like Sōtatsu and Nonomura Sōsetsu before him, Kitagawa Sōsetsu used a round Inen seal. The bare facts known about Kitagawa Sōsetsu indicate that he learned the styles of both Sōtatsu and Nonomura Sōsetsu, attained the rank of *hokkyō*, and worked as a painter until age seventy-two. Kitagawa Sōsetsu may have continued one of the painting studios established by Nonomura Sōsetsu, but no details exist to confirm such possibilities. Earlier art historians have suggested that the two artists named Sōsetsu were the same man, but clearly they were not. Kitagawa Sōsetsu continued the preference for grasses-and-flowers themes painted by the earlier Sōsetsu; in fact, almost all the extant works by Kitagawa Sōsetsu are images of grasses and flowers. While Nonomura Sōsetsu's style included a tendency to paint elegantly flowing images of

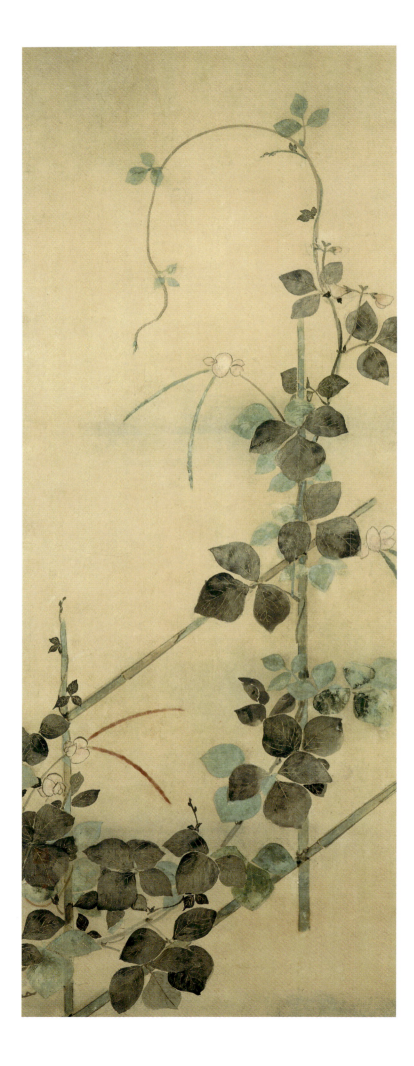

Pl. 85. Kitagawa Sōsetsu. *Flowering Sweet Pea* (cat. no. 81).

this theme in richly applied pigments on gold, Kitagawa Sōsetsu's grasses-and-flowers works express a refined mood, either in color on paper or through the effective use of light ink washes on paper.

Kitagawa Sōsetsu's *Flowering Sweet Pea* (pl. 85) focuses on a pea plant twining on a bamboo trellis. The elegant scheme played out in the colors of the pea pods, an umber red and blue, can surely be considered a precursor to the tastes of the later Edo Rinpa school. Many of the extant works by Kitagawa Sōsetsu were made to be pasted onto folding screens, and it is likely that this work was removed from such a format and then mounted as a hanging scroll. It seems that, until his middle years, Sōsetsu used the homonymous alternate *sō* character for his name, which is the same as the *sō* in Sōtatsu's name. *Flowering Sweet Pea* is impressed with a round relief seal with these characters: *Sōsetsu.*

Autumn Flowers and Grasses (pl. 86) is an important example of a screen format with attached paintings. The painting style is quite close to that of Sōtatsu; colorful arabesques of grasses and flowers fill the composition. The painting is impressed with a square intaglio Inen seal.

Ogata Kōrin and Ogata Kenzan were brothers who sought out and studied the works of both Sōtatsu and Kōetsu. They synthesized the essence of Sōtatsu's and Kōetsu's styles with their own distinctive individuality and brought a new freshness to the Rinpa style. Ogata Kenzan's *Square Ceramic Dish* (pl. 87) is representative of their work. The ceramic plate is brushed with a softly rendered image of a small boat floating in the shady depths of a tree on a rainy evening; it is accompanied by a *waka* poetic inscription in Kenzan's distinctive hand:

> The quiet fall of evening rain
> erased by the splash of waves,
> I sat unaware of the damp evening
> until drops silently dripped their way
> through my boat's thatched roof.

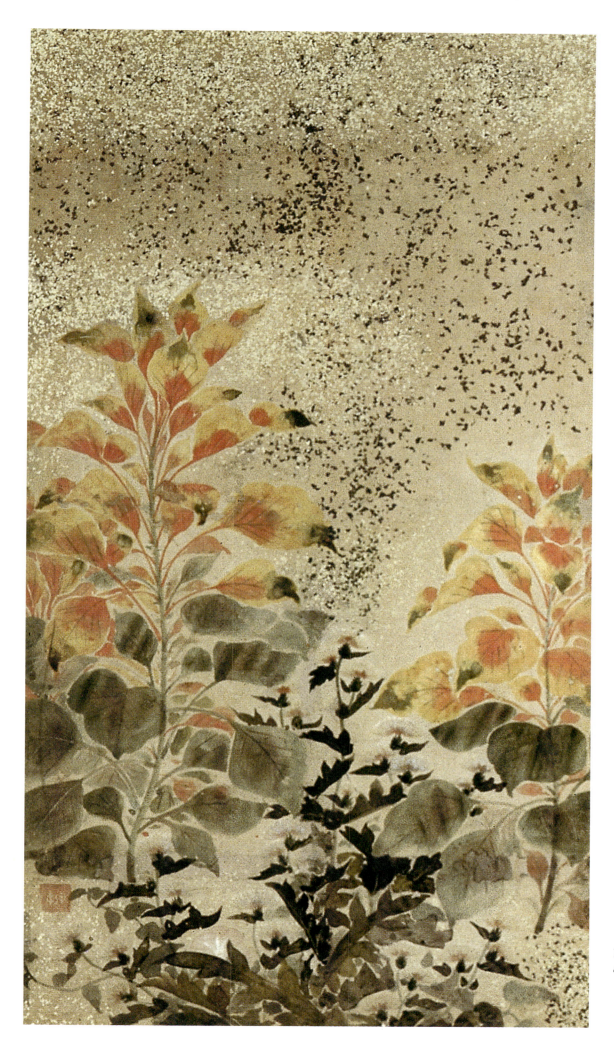

Pl. 86. Kitagawa Sōsetsu. *Autumn Flowers and Grasses* (detail, cat. no. 80).

The back of the work is signed *Kenzan sei* (literally, "Kenzan produced"). This inscription is probably more a kiln name mark than a specific individual's signature.

This plate, with its lyrical rendering of a rainy night, done in deftly economical brushstrokes, is a frank portrayal of Kenzan's painting style, the work of a man who consciously distinguished himself from the ranks of specialist painters. As others have indicated in the past, it is possible that Kenzan himself did not brush this image and that the plate is an example of Kenzan ware fired under his direction. The poem inscribed on it was not Kenzan's own composition but is thought to have possibly come from the poetry anthology *Setsugyokushū*, by Sanjōnishi Sanetaka (1455–1537). Nevertheless, Kenzan must have chosen this verse for use, and the selection clearly reveals his aesthetics.

Kenzan was Kōrin's younger brother. They were born into the wealthy kimono-merchant household of the Kariganeya. Kenzan first studied pottery, simply as a hobby, with Ninsei, the originator of the Kyoto school of art potters. But after he had depleted his inheritance from his father, Kenzan built a kiln in the Narutaki area of northwest Kyoto in 1699 (Genroku 12). He took the name Kenzan, incorporating the traditional designation for "northwest" as the first character of the name; in general, works from this period are known as Narutaki Kenzan ware. In 1712 (Shōtoku 2) Kenzan moved his kiln to the Chōjiyamachi district of Nijō street in central Kyoto and developed a new type of ware that encouraged a sudden rise in the popularity of Kenzan ware. Kenzan moved to Edo in 1731 (Kyōhō 16) and continued his production of ceramic wares at the kiln he built in the community of Iriya on land owned by the temple complex of the Kan'eiji. The works from this late period are known as Iriya Kenzan ware.

Thus Kenzan's oeuvre can be divided into three periods, and *Square Ceramic Dish* can be attributed to the middle period, when Kenzan ware was being produced in the Nijō Chōshamachi district. It happens that in 1715 (Shōtoku 5) Kenzan ware was mentioned in Chikamatsu Monzaemon's play *Ikudama shinjū*, then being performed at Osaka's Takemotoza theater. A journalistic skit about contemporary life, *Ikudama shinjū* drew its subject matter from the actual events of modern life. A reference to Kenzan ware in such a skit clearly demonstrates how fashionable these ceramics had become. Chikamatsu probably had works such as the square dish in mind when writing his script.

Kōrin had a number of talented disciples, but besides Kenzan—who can be considered a collaborator rather than a disciple—it was Watanabe Shikō (1683–1755) whose superb skills raised him above the rest. Shikō studied painting under a Kanō school teacher before becoming part of Kōrin's circle, where he studied the decorative effects achieved by the master. There is no proof that Kōrin directly taught Shikō, but there are examples of paintings on Kenzan ware by an artist named Watanabe Soshin, who very possibly could be Shikō (for example, a square dish with wild orchids in the Nezu Art Museum). From an early age, Shikō was employed as a retainer in the aristocratic Konoe family, and he was influenced especially by Konoe Iehiro, known for his interest in *honzogaku* naturalist studies and the creation of sketchbooks such as the *Kaboku shinsha* (Yōmei Bunko collection). The handscroll *Sketches of Bird Species* (private collection) and other works in this genre reveal Shikō's own active experiments with realist techniques, which prepared the way in Japan for the later naturalism of Maruyama Ōkyo.

Flowers and Birds at the Shore, an eight-panel screen by Shikō (pl. 88), is a fascinating and superb work. The seasons are autumn and winter, and narcissus, small chrysanthemums, and tea blossoms bloom as a shorebird plays along the calm water's edge. While ordinary painters preferred still forms

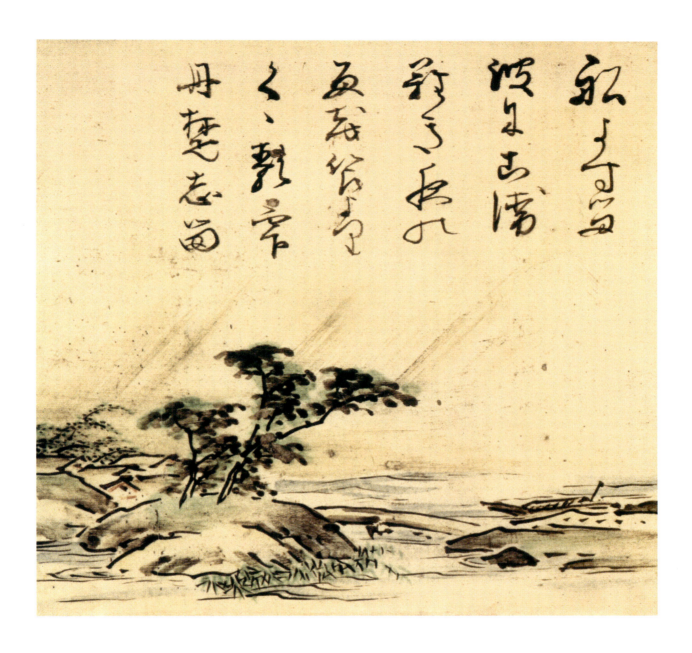

Pl. 87. Ogata Kenzan. *Square Ceramic Dish*
(detail, cat. no. 82).

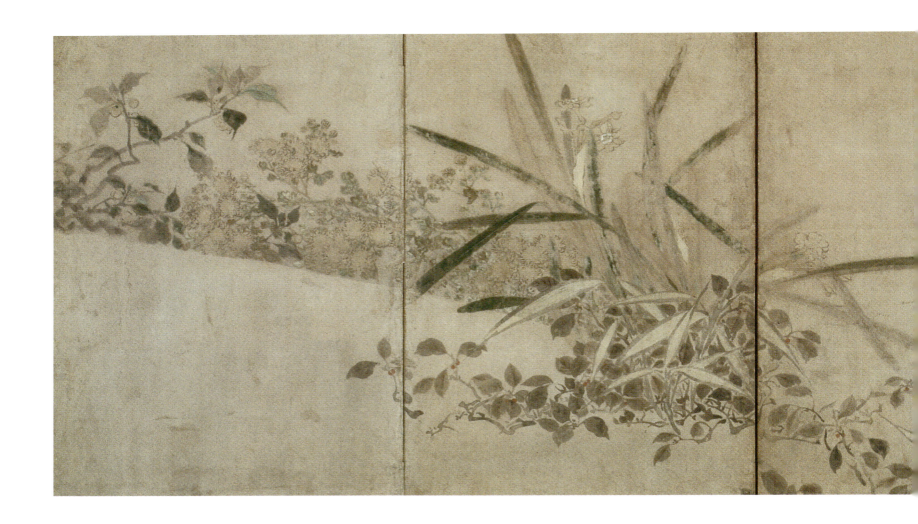

Pl. 88. Watanabe Shikō. *Flowers and Birds at the Shore* (detail, cat. no. 83).

to show off the dazzling wings of the male mandarin duck, here Shikō boldly captures the bird in flight. Shikō surely discovered this beautiful moment through his careful observation of nature. Although the screen is essentially in the Kanō school style, the broad handling of the landmasses clearly is drawn from the Rinpa tradition. It has been said that Shikō was unable to fuse the Kanō and Rinpa traditions, and it is generally considered that he used them in tandem, but separately. This screen, however, prompts a serious reconsideration of this conventional view of his abilities.

Spring and Summer Flowers (pl. 89) is a hanging scroll by Shikō. Peonies and iris rise straight from the ground, and wisteria and *yamabuki* dance across the sky. A corner of an early summer garden resounds with two vectors of colorful array. Shikō,

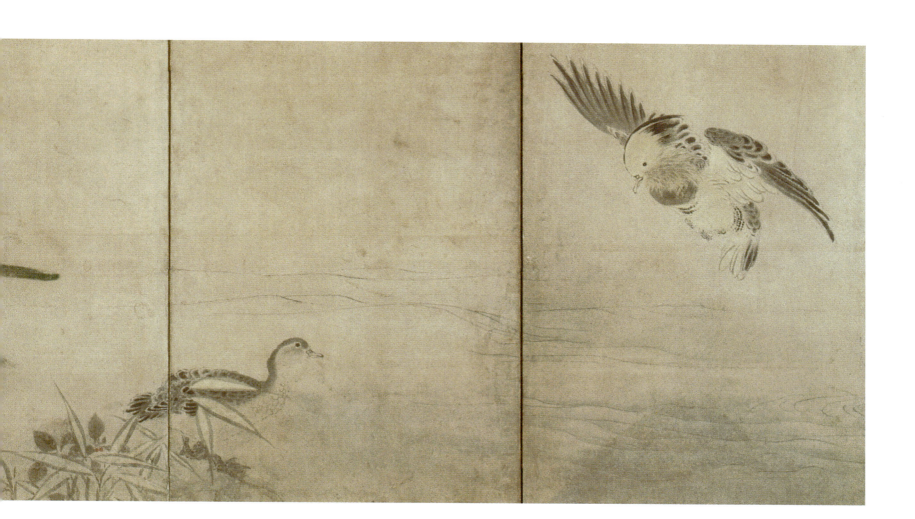

with superb color sense, chose white for the lovely peonies and wisteria.

Another image painted by Shikō, *Fukurokuju*, the god of good fortune (pl. 90), is completely Rinpa in tone and style. Dairyū Sojō, the 342nd abbot of Daitokuji, inscribed it with the title *Tenka taihei kokudo annon* (Peace in the universe, stability in the nation). Surely Tairyū sought to express the idea that the three forms of individual good fortune—*fuku* (children), *roku* (wealth), and *ju* (longevity)—were the same elements that contributed to the peace of the nation.

After his move to Edo, Kenzan turned his hand to painting, creating works in the style of Kōrin. It has been posited that Kenzan thus transplanted the Rinpa style from Kyoto to Edo. The artist known as Tatebayashi Kagei (dates

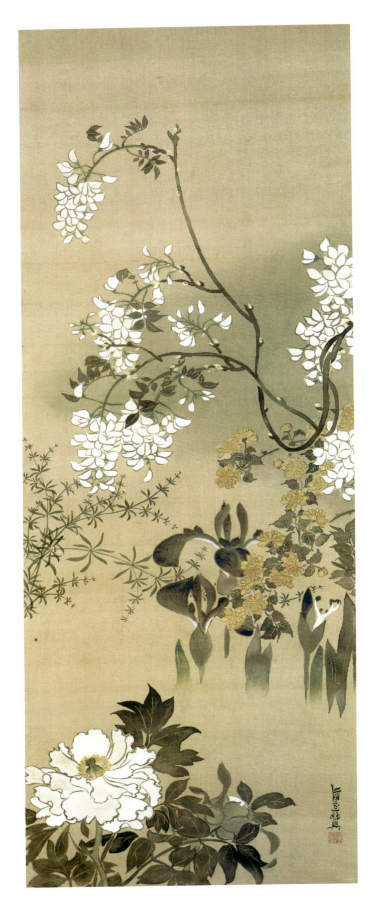

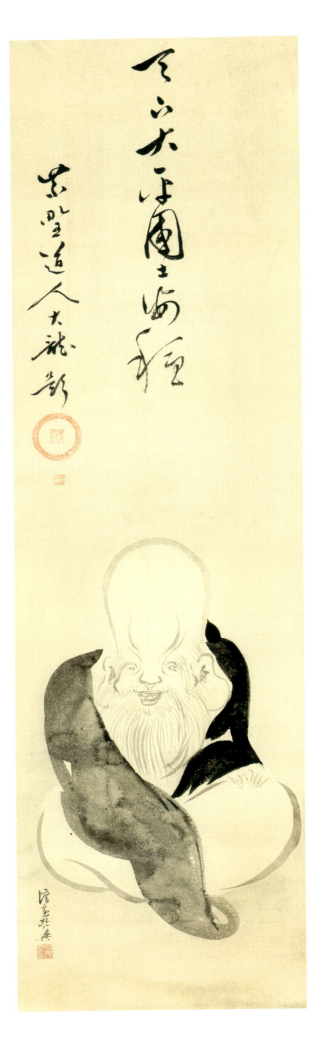

Pl. 89. Watanabe Shikō. *Spring and Summer Flowers* (cat. no. 85).

Pl. 90. Watanabe Shikō. *Fukurokuju* (cat. no. 84).

unknown) was in fact a doctor named Tatebayashi
Rittoku. He had been in the service of the Maeda
family of Kaga and changed his name to Shirai
Sōken when he moved to Edo. In the capital,
Kagei studied the Kōrin style of painting with
Kenzan. It seems that Kagei was a longtime resi-
dent of Kamakura, signing some of his works
Tsurugaoka itsumin referring to the Tsurugaoka
Hachiman shrine in his adopted hometown.
Morning Glories and Grasses (pl. 91), with its lovely
stylized forms created within a curving fan for-
mat, reflects the origins of the Japanese name for
the morning glory, *asa no kaobana* (beautiful flower
of the morning). By signing this painting *Hokkyō
monryū* (literally, "in the school of the Hokkyō
painter"), Kagei chose to designate himself a dis-
ciple of Hokkyō Kōrin.

This self-alignment with the Rinpa school
was probably the reason for Kagei's conscious use
of *tarashikomi*, the trademark ink-puddling tech-
nique of the Rinpa style. The second volume of
Kōrin hyaku-zu (One hundred works by Kōrin),
published by Sakai Hōitsu, introduced a document
that was handed down from Kenzan to Kagei with
Kōrin's copy of a Sōtatsu fan. The transmission of
such a letter from an earlier master, from teacher
to pupil, was a kind of imprimatur in the manner
of a Zen master's certificates of enlightenment,
and it indicates that Kenzan recognized Kagei
as a member of the Kōrin stylistic lineage. The
phrase "Hokkyō monryū" was somehow deeply
meaningful. The round relief seal with indeci-
pherable text, almost like an *ito-in* seal, can also
be found impressed on fan-shaped paintings

Pl. 91. Tatebayashi Kagei. *Morning Glories
and Grasses* (cat. no. 86).

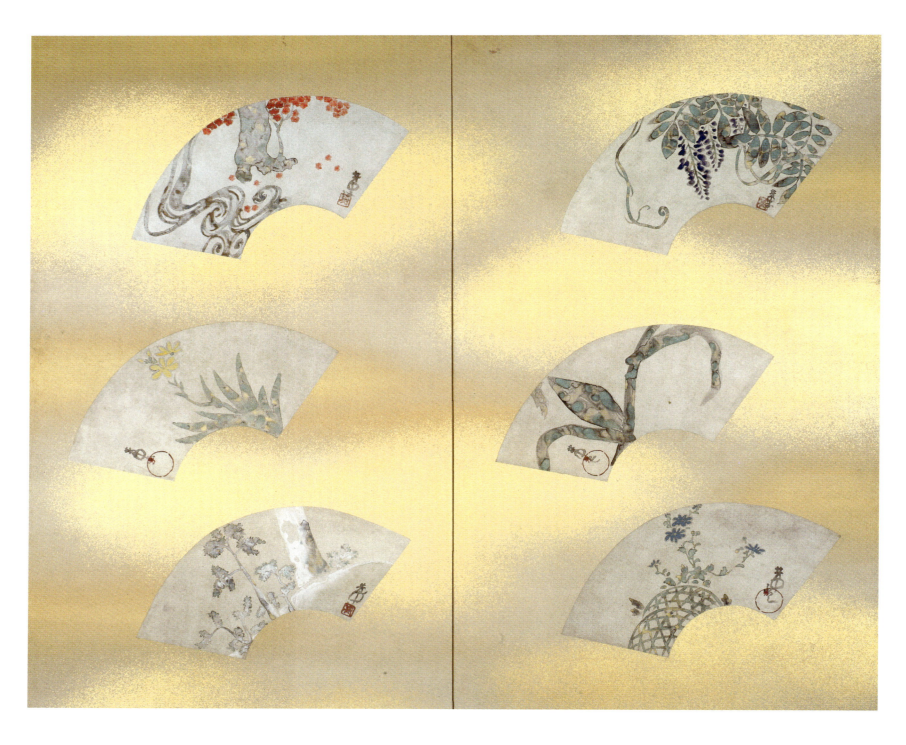

Pl. 92 a, b. Nakamura Hōchū. *Flowers of the Twelve Months* (cat. no. 88).

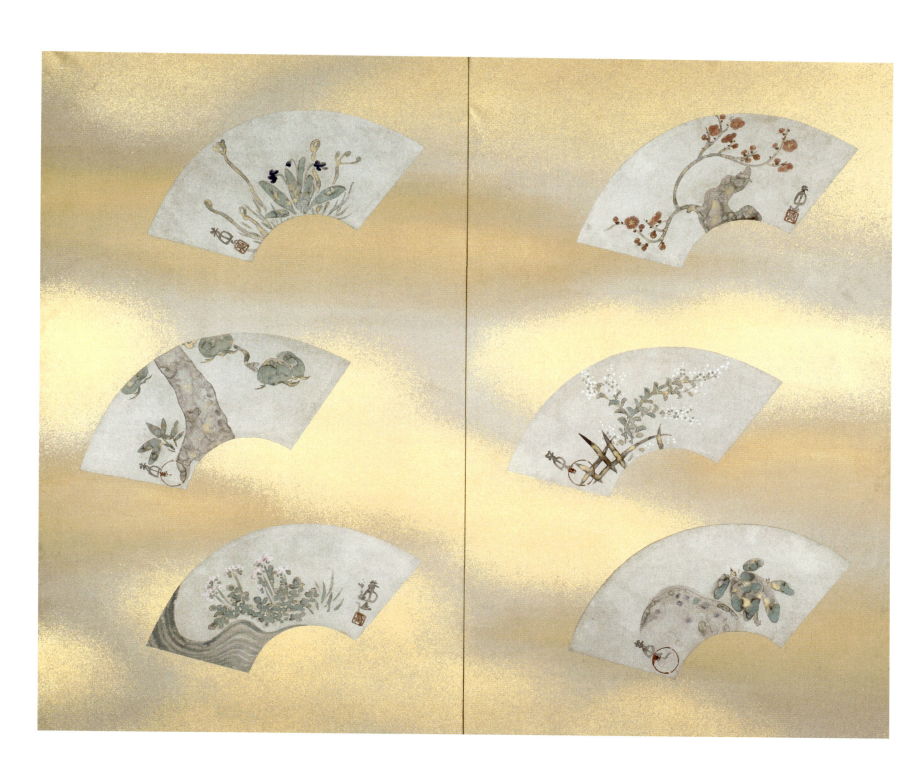

mounted on screens; it seems to have been Kagei's favorite seal for use on fan formats. (*Ito-in* seals were attached to silks imported from China during the Muromachi through Edo periods.)

We must also note a superb artist working in the Kansai area in the style of Kōrin. Nakamura Hōchū (d. 1819), born in Kyoto and active mainly in Osaka, should thus be considered a member of the Osaka painting circles. But Hōchū took Kōrin as his personal artistic model, and he seems to have been particularly enamored of the *tarashikomi* technique as he developed his warm-hearted and decorative painting style. Hōchū spent a brief time in Edo and is known to have published a *Kōrin gafu* (Kōrin painting compendium; 1802).

Flowers of the Twelve Months (pl. 92 a, b), a pair of two-panel screens decorated with twelve fan paintings, is a particularly stunning example of Hōchū's painterly achievements. Depictions of red plum blossoms, violets and fern shoots, *sakura-so* primroses, wisteria, iris, *hiōga* iris (*Belamcanda chinensis*), corn stalks, white bush clover, chrysanthemums, autumn foliage, pines, and a snow-covered *maki* evergreen tree each appear in individual fan formats arranged in almost seasonal order. Hōchū also created the appealing framed fan paintings *Doves* (cat. no. 89) and *Hollyhocks* (cat. no. 87).

In *Kaiji higen* (Humble opinions on pictorial art; 1799), Kuwayama Gyokushū counts both Sōtatsu and Kōrin among the representatives of the Japanese *nanshūga* school of painting—known today as *nanga*, or literati painting. There is a literati sensibility at work in Rinpa paintings, and of all the Rinpa artists, this mood is expressed most strongly by Hōchū. A *Landscape* in the Gitter-Yelen collection, done very much in the manner of Chinese literati works, clearly partakes of *nanga*. Hōchū sometimes impressed secondary seals of literary intent on his works, a practice followed by the literati painters. His literati inclinations did not stop there. On his Rinpa-style painting *Deer*

(inscribed by Inoue Shirō, Gitter-Yelen collection), Hōchū went so far as to use a reversed seal, a practice normally reserved for literati painters. Hōchū is mentioned as an artist famous for his finger painting—a technique beloved by *nanga* artists— in the 1794 publication *Kyojitsu satonamari*, and the famous *nanga* artist Kimura Kenkadō (1736–1802) frequently mentioned Hōchū in his *Kenkadō nikki* (Kenkadō diary). Thus it is highly likely that Hōchū first debuted as a literati-style painter.

The history of Edo-period culture unfolds in a move eastward from the ancient cultural center of Kyoto to the new shogunal capital of Edo. The history of painting is no exception. As noted above, Kenzan began the transfer of Rinpa painting, created and developed in Kyoto, to Edo, but Sakai Hōitsu (1761–1828) was the real founder of the Edo Rinpa school with its own distinctive style. Hōitsu was born in Edo, the younger brother of Sakai Tadazane, lord of Himeji castle, and he fully inherited the family's predilections for scholarly and artistic attainment. Hōitsu grew up a fashionable member of the military aristocracy and was graced with many talents and abilities. From this bon-vivant life, he turned to the Buddhist priesthood in 1797, when he became a disciple of the Nishihonganji priest Bunnyō and took the Buddhist name of Tōkakuin Bunsen Kishin.

It was about this time that Hōitsu became interested in the painting styles of Ogata Kōrin. Kōrin had received support from the Sakai family while he lived in Edo, and undoubtedly Hōitsu's love of Kōrin's style came when he viewed—and was deeply impressed by—the works by Kōrin that had entered the Sakai family collection. Before coming in contact with Kōrin's works, Hōitsu had studied various painting methods, including those of *ukiyo-e* and the Kanō, Shen Nanpin, Maruyama, and Tosa schools. These styles all worked their way into Hōitsu's rendition of the Rinpa style as he developed yet a new phase in its history. Hōitsu gathered his meticulously and elegantly depicted

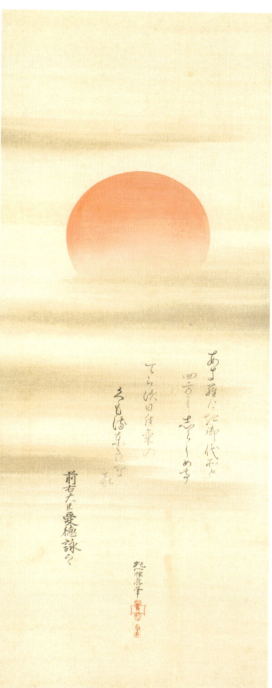

Pl. 93 a–c. Sakai Hōitsu. *Triptych of Flowers and the Rising Sun* (cat. no. 91).

motifs into wittily resourceful compositions to create a painting style that summed up the Edo chic of the Bunka and Bunsei eras.

The Gitter-Yelen collection includes two masterpieces by Hōitsu. One is a set of hanging scrolls, *Triptych of Flowers and the Rising Sun* (pl. 93 a–c). A large image of the dawn sun is featured on the central scroll, with cherry blossoms and irises shown on the right scroll and red maple leaves and narcissus on the left, in a lively and bright composition. The central scroll is further distinguished by a poetic inscription brushed beneath the sun:

Brightly shining
Is our emperor's reign
Throughout the world;
Its radiant beams
Will never be overshadowed.

Kazan'in Yoshinori (1754–1829), a famous calligrapher and court noble, inscribed the poem. He was elevated to the rank of *udaijin*, or Minister of the Right, on the first day of the sixth month of Bunsei 3 (1820) but then resigned the post on the fifteenth day of the tenth month of the same year. Because Yoshinori signed the inscription with the term "former Minister of the Right," the date of the work can be placed sometime after the tenth month of 1820. The calligraphy of Hōitsu's signature allows us to suggest a date before 1824 (Bunsei 7). In this period Japan faced wave after wave of both domestic and international problems. Yoshinori's poem acknowledges these difficulties as well as his hopes for a peaceful realm.

Hōitsu's *Mount Fuji and Cherry Blossoms*, a pair of hanging scrolls (pl. 94 a, b), is an extreme example of the purely Japanese landscape type that emerged over the centuries as Japanese painters sought simple, unfettered compositions different from those created in China. It is important to note Hotta Masaatsu's (1758–1832) addition of poetic inscriptions on these scrolls. Hotta was the clan

lord of the Shimotsuke Sano clan (of Tochigi prefecture), and he was known for his summarization of the shogunate's genealogical materials, an indication of tastes much older than his chronological age. Besides his artistic accomplishments, as seen in these poetic inscriptions, Hotta was a general and natural sciences scholar who edited and published *Kanbun kinpu* (Record of birds with observed patterns). Hotta's poems on this pair of paintings can be interpreted:

Spring
My heart is afloat
With the beauty of the cherry blossoms
On the hill path soon to be climbed,
The white clouds of the peaks

Summer
Drifting mists and clouds
Float across the heavens,
Yet they never reach beyond
The lower slopes of lofty Mount Fuji

The manner in which the inscriptions were written suggests that these two works were originally part of a set of four on the theme of the four seasons. It is said that Yoshinori was in close contact with Tani Bunchō, who was part of Hoitsū's cultural circle, leading us to surmise that Yoshinori was also acquainted with Hōitsu. Judging from the calligraphy style seen in the signatures, this pair of scrolls was probably created during the same period as the triptych discussed above.

Sakai Ōho (1808–1841) was Hōitsu's adopted heir. The second son of the head priest of Jōeiji in the Ichigaya district of Edo, a branch temple of Tsukiji Honganji, Ōho studied under Hōitsu and showed talent as a painter. After his mentor's death, Ōho assumed one of Hōitsu's artist names, Ukaan, and thus became Ukaan II. While he was no more than Hōitsu's adopted heir, it seems they enjoyed a relationship as close as that of birth father and son. Among the superb paintings by

Pl. 95. Sakai Ōho. *Autumn Maple* (cat. no. 96).

Ōho in the Gitter-Yelen collection, his *Autumn Maple* (pl. 95) presents a truly unforgettable image. Ōho's dramatic composition and use of contrasting painterly techniques create balance and tension in the painting. Isolated against a blank ground, the tree trunk's gently swelling columnar form is defined by muted ink tones enlivened by *tarashikomi* in green and gold. These elegant patches of "moss" contrast with the sharply delineated and heavily colored maple leaves clustered at the upper edge and lower regions of the scroll. Although the work is a reinterpretation of an established Rinpa composition, we can see in it Ōho's stylish sensibilities.

Suzuki Kiitsu (1796–1858) was the truly unique genius of the Edo Rinpa school. He studied under Hōitsu and continued his master's style before he took the Edo Rinpa style to ever greater heights. Kiitsu was first a resident disciple of Hōitsu's, but he went on to marry the older sister of Suzuki Reitan (1782–1817), a fellow student of Hōitsu's who died young, and thereby attained the rank of Sakai family retainer. Kiitsu worked as an assistant to his master, but after Hōitsu's death his own style suddenly assumed an enormous energy. Kiitsu was long underrated, but since the 1970s high praise has been accorded his Bakumatsu-era works for their fully developed aesthetics, visibly awakened lyricism, and precise compositional forms, which stood as precursors to the modern age.

Judging from the calligraphy style of its signature, *Morning Glories* (pl. 96) can be suggested as a rare example from Kiitsu's earliest period. Another important factor in the dating of the work is the inscription by Kameda Bōsai, the artist's close friend, which would give a terminus date of 1826 (Bunsei 9), Bōsai's death date. Bōsai's late "earthworm"-style calligraphy is typically hard to decipher, but the inscription seems to compare morning glories with Buddhist precepts. *Mount Hōrai* (cat. no. 93) and the other Kiitsu works in

the Gitter-Yelen collection all carry the artist's
late-period *Seisei* signature. *Mount Hōrai*, a par-
ticularly striking example of Kiitsu's unique sense
of active forms, provides an endlessly stimulating
visual experience.

Kiitsu's *Misogi Scene from the Tales of Ise* (pl. 97)
is also unforgettable. Although a well-known
work of Kōrin's has the same title (Hatakeyama
Memorial Museum of Fine Art, Tokyo), and
there is also a Hōitsu copy after the Kōrin work,
it is thought that Kiitsu based his version on his
teacher Hōitsu's painting. It is highly likely that
Kōrin depended on Sōtatsu's *Tales of Ise* screens
(private collection) for this version, and so Kiitsu's
scroll stands in the line of inheritance from Sōtatsu
to Kōrin, and Kōrin to Hōitsu. Each artist em-
ployed essentially the same composition and motifs,
but with fascinating additions that impart a dis-
tinctive individual touch to each rendering.

In 1868 the Tokugawa shogunate, which had
endured for more than 250 years, came to an end.
With the beginning of the Meiji era, Japan ushered
in a modern age that modeled itself on Western
European social systems. The arts of Japan were
swept up in this violent influx of modernization,
and Japanese painting was no exception. This did
not mean, however, that the excellent traditions
of the Rinpa school were lost or forgotten; they in
fact exerted a powerful influence that can be seen
in a variety of art forms in the Meiji period.

Kamisaka Sekka (1866–1942) wholeheart-
edly absorbed the Rinpa tradition and then added
a modern individuality to it. He was born into a
family of samurai charged with protecting the
Imperial Palace in Kyoto, and he first studied
painting under the Shijō school artist Suzuki
Mizuhiko. He went on to learn the fundamentals
of Rinpa painting and design from the designer
and Kōrin painting collector Kishi Kōkei. Sekka
spent about six months traveling in Europe in
1901 (Meiji 34). Upon his return to Japan, he cre-
ated and exhibited splendid designs for decorative

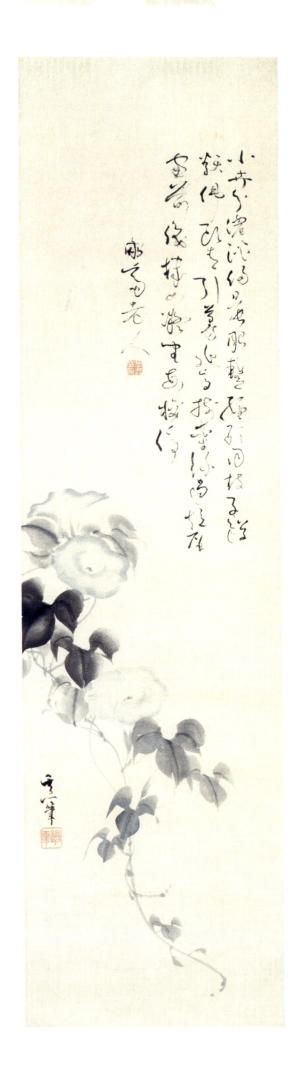

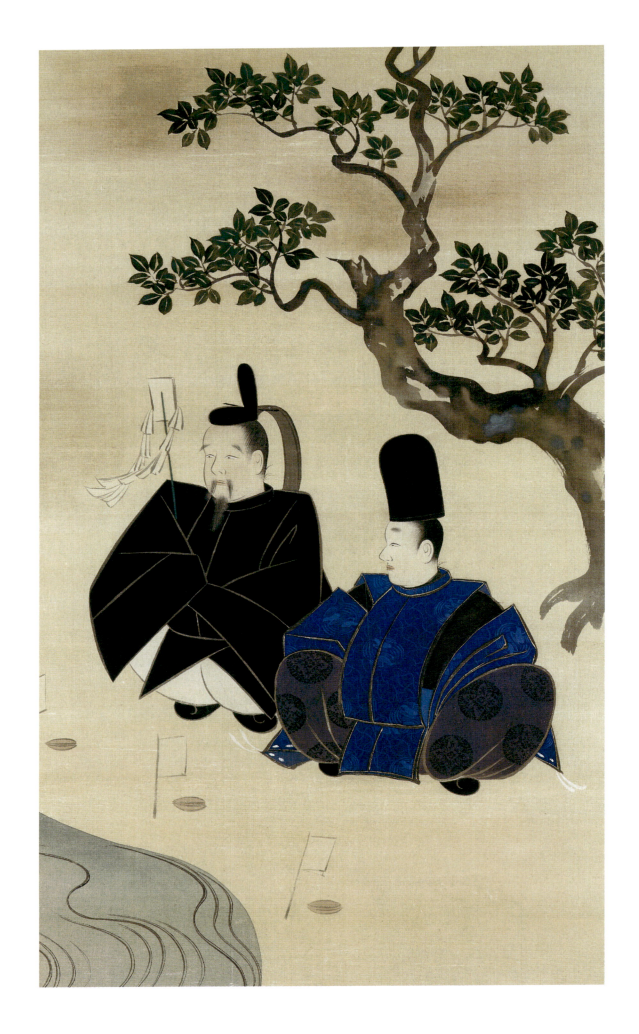

Pl. 97. Suzuki Kiitsu. *Misogi Scene from the Tales of Ise* (detail, cat. no. 94).

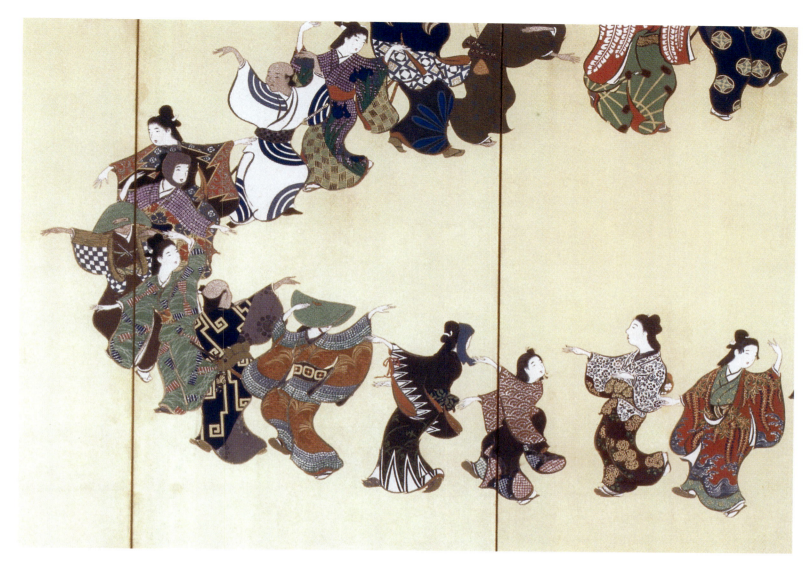

artworks in lacquer, ceramics, and textiles, and his works were awarded numerous prizes in the various expositions held in Japan during this period. Sekka also applied his considerable design vision to the realm of paintings, becoming the hero of modern Rinpa for his ground-breaking innovations to the style.

In Sekka's *Dancing Figures*, a single six-panel screen (pl. 98), a snaking line of dancers—old and young, men and women—in Genroku-period costumes is arranged in a clearly depicted, geometrical composition. A *Dancing Figures* screen (Yamato Bunkakan, Nara) by an unknown Kan'ei-era artist is well known, and it or a similar work likely inspired Sekka's screen. *Autumn Flowers and Grasses* (cat. no. 100), an image of dark blue aster, red chrysanthemums, cockscomb, bellflowers, and Japanese pampas grass, is a strong expression of the

modern transformation of the Rinpa style. According to documents preserved with the painting, it was made for a member of the Kuninomiya family, the household of a former imperial prince. The wording in Sekka's signature, *Sekka kinsha* (literally, "respectfully painted by Sekka"), leaves no doubt as to the status of his aristocratic patron.

Sekka's *Gathering of Waka Poets* is truly fascinating (pl. 99). On the near side of the river that runs through the middle of the scroll, thirty-five figures in imperial court costume enjoy autumn flowers. On the far side of the river, fifteen figures amuse themselves in spring fields. Adding the artist to each group, increases the numbers to thirty-six and sixteen, clearly a play on the traditional groupings of thirty-six famous *waka* poets and sixteen Buddhist arhats. Thus, the painting becomes an image that advances from the present-day world

Pl. 98. Kamisaka Sekka. *Dancing Figures* (detail, cat. no. 98).

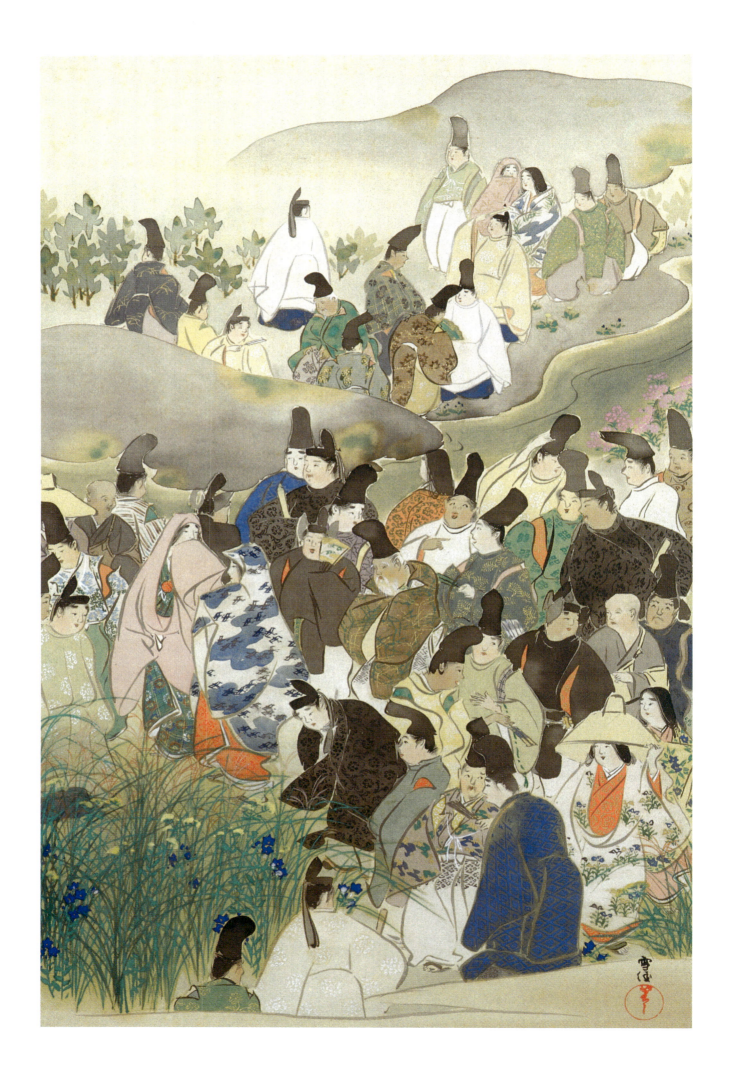

on the near riverbank to the enlightened realm on the far side. The pink *nadeshiko*, or dianthus, seen on the riverbanks, whose alternate name in Japanese, *tokonatsu*, makes them a seasonal symbol for summer, are contrasted with the distant view of snowy mountains, a clear indicator of winter. Thus the full array of four seasons—spring, summer, autumn, and winter—can be interpreted as rendering this painterly space into a symbol of an ideal world. Such a reading of the painting stands as testament to Sekka's intellectualism and modernity.

Appreciation for Sekka's accomplishments has grown in recent years; in 1982 the Shoto Museum of Art in Tokyo held a retrospective exhibition of his works. His paintings show how the Rinpa tradition, starting with the religious iconography of Sōtatsu's *Four Sleepers*, has attained its culmination and come full circle, returning to its original home in imperial Kyoto as well as to Rinpa's religious content, as seen in Sekka's *Gathering of Waka Poets*.

Pl. 99. Kamisaka Sekka. *Gathering of Waka Poets* (detail, cat. no. 99).

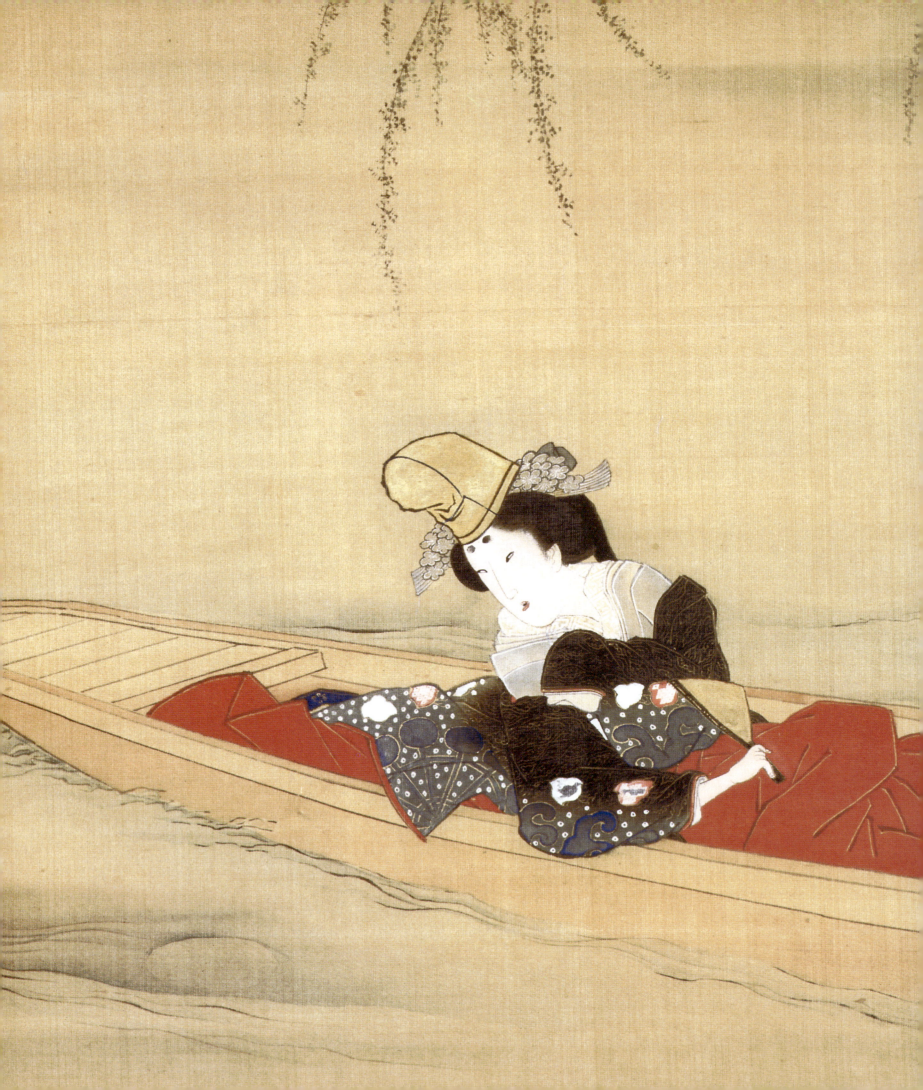

John T. Carpenter

The Fictive Realms of Ukiyo-e Painting

But what enhanced for Kublai every event or piece of news reported by his inarticulate informer was the space that remained around it, a void not filled with words. The descriptions of cities Marco Polo visited had this virtue: you could wander through them in thought, become lost, stop and enjoy the cool air, or run off.

—Italo Calvino, *Invisible Cities*

UKIYO-E, "PICTURES OF THE FLOATING WORLD," PRESENT PARTLY REAL, PARTLY imaginary visions of the flashy, exuberant, and hedonistic world of brothels and theaters in Japanese cities of the seventeenth to nineteenth centuries. Marked by a bold and brightly colored style, *ukiyo-e* has an immediate aesthetic appeal that, more easily than most varieties of world art, transcends historical and cultural boundaries. However, since it so elegantly weaves its own pictorial realities and glosses over the more sordid aspects of systems of female and male prostitution, *ukiyo-e* does not offer credible social documentation. It consistently skirts the painful realities that prostitutes faced: sexual abuse, venereal disease, abortion, and early death.[1] We sense nevertheless that the artists saw themselves as sympathetic participants in the world of their subjects rather than as detached chroniclers of the demimonde. Elevating the gorgeous, playful, and cultured side of bordello life over ugly, painful, and vulgar aspects undoubtedly allowed emotional solace and aesthetic transcendence for both artists and their subjects. The prurient or pornographic appeal of some *ukiyo-e*, especially the genre of erotica known as *shunga*, should not be downplayed.[2] But even in scenes of elaborate copulation, it is the fictitiousness of the images, not what they reveal about inequitable sexual or social relationships between men and women, that makes them appealing and entertaining. Ultimately, *ukiyo-e* is a fictional art offering sensual, emotional, and intellectual escape. It invites the viewer to exchange the worries of the workaday world for a realm of pleasure: *ukiyo-e* offers what it depicts.

Despite its ostensible antimoralistic and subversive ideological stance, which went outside the confines of prevailing artistic orthodoxy, one should not hastily dismiss *ukiyo-e* as simplistic or anti-intellectual in its motives or choice of subjects. *Ukiyo-e* compositions often invite intense intellectual engagement with their sophisticated presentation of fictive and poetic narratives centering on the denizens of the pleasure quarters. This literary sophistication partly reflects the undeniable cultural accomplishments of many courtesans—especially in the arts of calligraphy, poetry, and music—and the inherent theatrical plot-weaving of Kabuki. Without some familiarity with the literature and theater of the day, some of these allusions in images and texts may go unrecognized. Conversely, *ukiyo-e* provides us with rich material for the study of popular culture of the Edo period (1615–1868).

Ukiyo-e records the activities and appearances of courtesans and actors in the media of painting, for a wealthier clientele, and the better-known woodblock prints (omitted from discussion here), for popular consumption. Its emphasis on the human figure and daily activities

Pl. 100. Teisai Hokuba. *Boat Prostitute at Asazuma* (*Asazuma-bune*; detail, cat. no. 113).

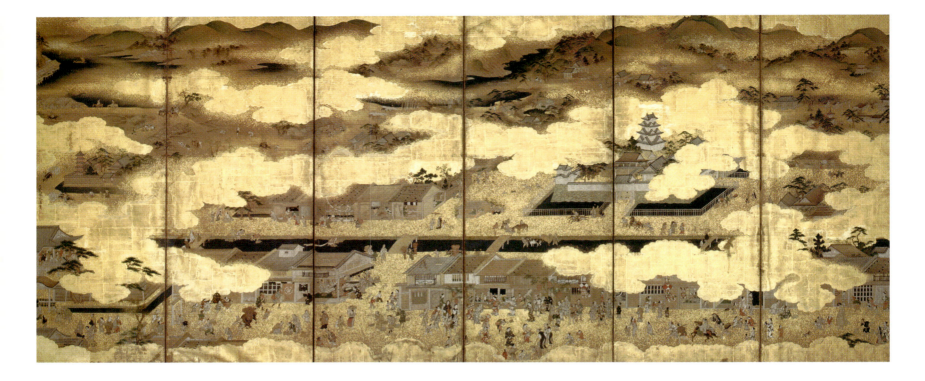

distinguishes *ukiyo-e* from other genres.[3] Our focus here, however, is on the fictive space that surrounds figures in *ukiyo-e* paintings: both physical settings and abstract symbolic or literary contexts. Of particular concern are the pictorial metaphors that accompany imaginary portraits of courtesans, such as landscapes and cityscapes or trees and flowers, and closer to the body, clogs and umbrellas, hair ornaments and hats—in short, anything that frames or covers the human figure. In the extra-pictorial realm, calligraphy, poems, and other forms of text that frame images are deciphered and discussed. We discover that the pictorial spaces surrounding figures in *ukiyo-e* paintings are charged with fictive and poetic signification.

Cities of the Imagination

To better situate ourselves geographically and art historically, let us visualize the cityscape of Kyoto in the seventeenth century, where the story of *ukiyo-e* begins. Although an imperial palace was located in one site or another in the city for more than a thousand years, beginning in 794, rarely did the emperor hold real political power: his role was mostly ceremonial, cultural, and symbolic. The shogunal castle in Edo was the seat of the

military government from 1603 until 1868, when the palace was moved there and the city renamed Tokyo (Eastern Capital). "Kyoto" had not been widely used as the name of the ancient capital until the late eighteenth century. The city was first officially referred to as Heian-kyō (Capital of Peace and Tranquillity), and then from around the eleventh century, it was more commonly called Kyō or Miyako (written either with the single graph *to* or *kyō*). Keishi, a sinitic compound meaning "great metropolis," was an elegant designation for the capital frequently found in Chinese writings, though not used by people on the street.[4] Another literary name used from ancient times was Rakuyō—abbreviated as Raku—derived from the Japanese pronunciation for Luoyang, one of the ancient capitals of China.

The inspiration to transpose the image of Luoyang on the Japanese capital can be traced to various early Chinese literary sources, going back as far as *fu* rhapsodies of the Eastern Han dynasty (25–220) that describe a majestically arrayed city of grand tile-roofed pavilions, wide boulevards, and luxuriant parks and gardens.[5] The most detailed and impressive description of the ancient Chinese capital, however, is *Luoyang*

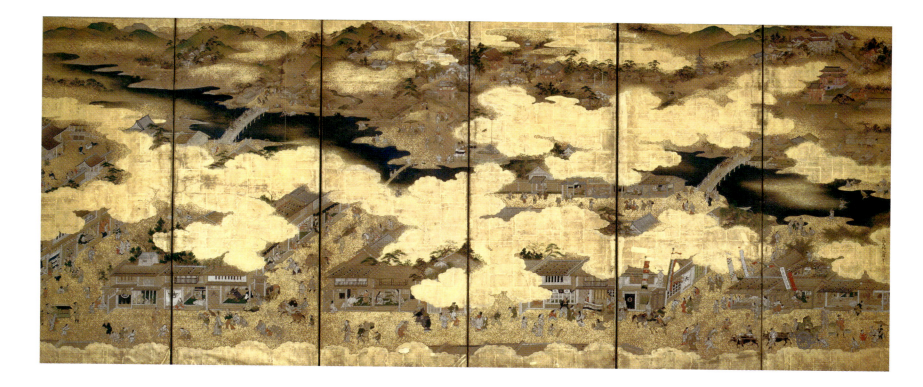

qielan ji (J. *Rakuyō garan ki*; Record of the monasteries of Luoyang).[6] Originally penned in 547 by Yang Xuanzhi, a court official of the Northern Wei dynasty (386–535), it describes the period when Luoyang served as the capital, beginning in 493 until the city and surrounding areas were suddenly evacuated by imperial decree in 534. Luoyang was already dilapidated by the time Yang Xuanzhi passed through it thirteen years later, so rather than describe the unpleasant reality, he superimposed on urban ruins a vision of a great city at the height of its prosperity. Along with documenting its famous sites, not only Buddhist monasteries and convents as the title implies, he gave detailed accounts of court ceremonies, annual events, and daily activities of the populace. Beginning in the Heian period (794–1185), Rakuyō was used as an alternative name for the area east of the palace and, eventually, the entire capital, since its western sections were never developed. Therefore Raku, in both its ancient Chinese and Japanese usage, conjures up the image of an elegant city in a faraway place or a remote courtly past.

Such connotations of nostalgia and imagined grandeur are borne out by the idealized images of Kyoto in screens, scrolls, and albums that are collectively referred to as *Rakuchū rakugai zu*, or "Scenes in and around the Capital." Produced in great number throughout the early Tokugawa period, the genre originated in the early sixteenth century, when the country was still torn by war, and then flourished when peace and relative prosperity had been restored.[7] The example of a *Rakuchū rakugai zu* in the Gitter-Yelen collection, attributed to Tosa Daijō Genyō, an otherwise unknown artist, probably dates to the end of the seventeenth century (pl. 101 a, b).[8] It conforms for the most part to the earlier formulas: the right screen depicts the southern and eastern areas of the city; the left the northern and western areas. Overall, the scenes convey a sense of social order, geniality, and prosperity. No signs of decay are permitted in this idealized view of the capital. Golden clouds and sprinkles of gold dust— decorative accents often appearing in medieval narrative scroll paintings—signal to viewers that they have entered a realm of fiction.

In the two rightmost panels of the right screen, we can observe the Higashiyama, or Eastern Hills, district of southeastern Kyoto. Though the imposing Great Buddha Hall of Hōkōji was one

Pl. 101 a, b. Attributed to Tosa Daijō Genyō. *Scenes in and around the Capital* (cat. no. 101).

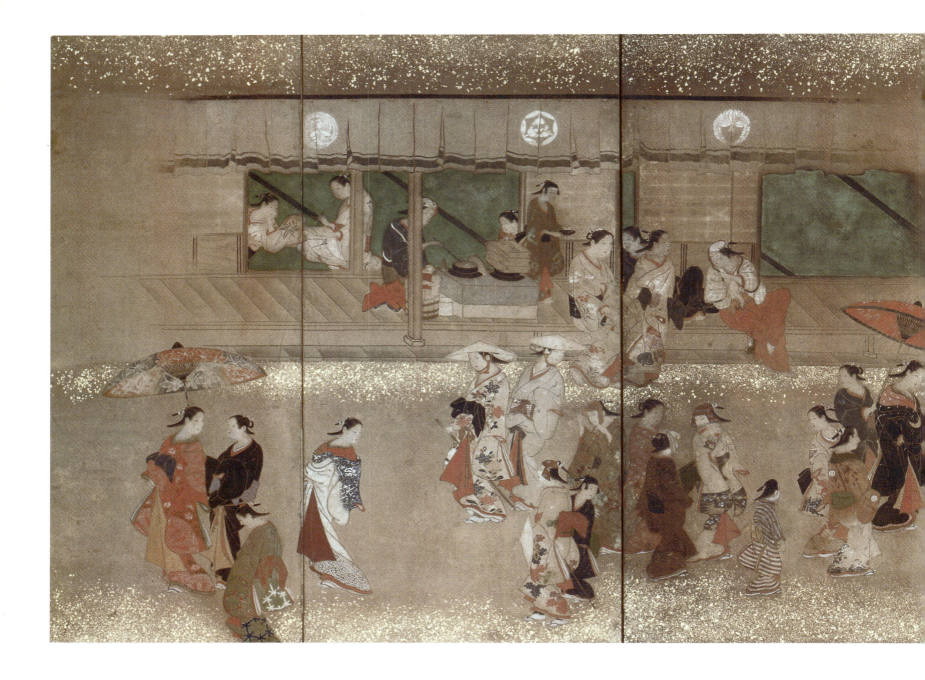

of the largest wooden buildings in the world at the time, here it is painted into the landscape like a little red dollhouse. It hardly conveys the religious or political grandiosity that its patron, the warlord Toyotomi Hideyoshi (1537–1598), envisaged. In front of it, the grassy mound known as the Mimizuka (Ear Mound), topped with a Buddhist stupa, is not a holy place but a war monument that contains the severed and pickled ears and noses of Korean and Japanese soldiers slain by Hideyoshi's troops. The serenity of the scene erases the memory of war. Behind the Great Buddha Hall is the Buddhist temple Kiyomizudera, famous for the gantried verandah of its main worship hall and for the spectacular views it affords of cherry blossoms in spring and foliage in autumn. Many poems and popular legends attach to the temple's history. To the right, part of the same temple complex, is a red shrine building beneath which emerge the triple waterspouts known collectively as Otowa Falls. According to folklore, drinking water from these falls cured maladies and ensured long life; also, as seen here, pilgrims chanted prayers or did penance standing beneath its chilly waters. Behind the depiction of each sacred site are countless stories that would have held resonance for the original patrons or viewers of the screens.

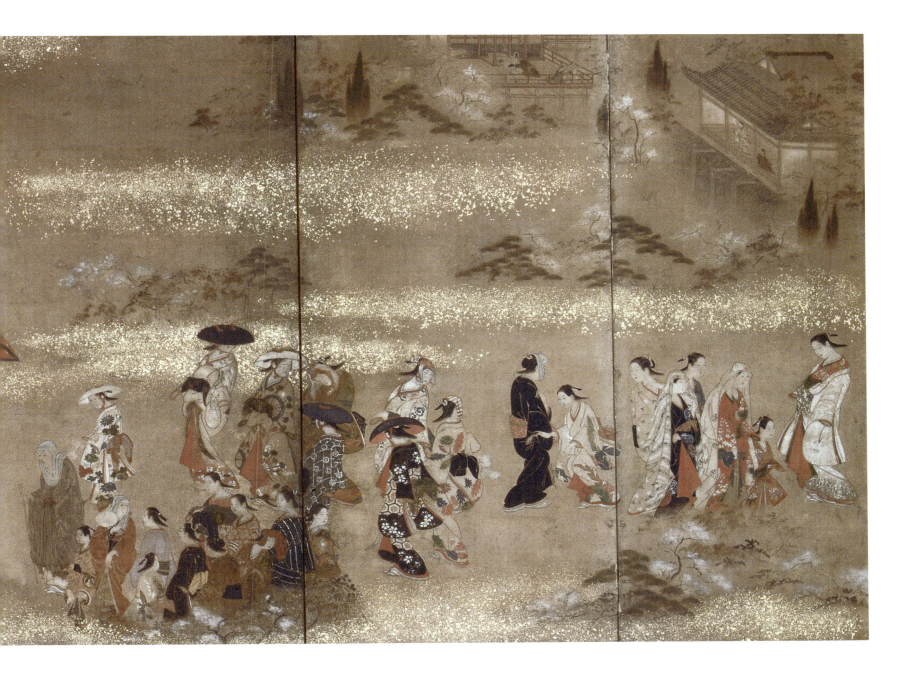

Whether in the blurring of physical reality, the rendering of landscapes with poetic or legendary associations, or the recording of activities of a spiritual purpose, a fantasy-making machine is at work. Selected monuments are arranged in a contrived topography that the artist could never have seen for himself: it was drawn from a template based on earlier illustrations to create an ideal city of the imagination. Of course, a large and quite impressive city actually existed. But for every grand residence there were thousands of hovels, for every well-maintained thoroughfare hundreds of muddy alleys, and for every gorgeously garbed townsperson scores of plainly dressed peasants—

though we would never know that from these screens. The artist presents the capital in an idealized mode not unlike Yang Xuanzhi's recollection of the lost city of Luoyang.

This cult of invented landscapes also underlies a screen painting of a few decades later, circa 1720s, showing groups of women coming and going from viewing cherry blossoms in the Eastern Hills district of Kyoto (pl. 102). It is representative of a type of genre painting that had its origins in *Rakuchū rakugai zu*, but which abandons a comprehensive view of the city for one that focuses on just a few famous places. It encapsulates earlier trends toward the creation of imaginary portrayals of

women situated within fantastic settings, a theme by this time already established as one of those central to a distinct *ukiyo-e* school of painting, print design, and book illustration.

The fictiveness of the setting is immediately evident from the impossible, and rather disconcerting, discontinuities of spatial recession. For instance, clusters of pines and cherry trees, rendered in traditional *yamato-e* (Japanese-style painting), are scattered throughout the right half of the composition. Yet those depicted in the foreground are the same size as those in the middle distance or background, creating a visual paradox in which the human figures are larger than full-grown trees. The eye often prioritizes human activities over natural settings, and the proportions of the figures in the landscape here reflect that visual hierarchy. Also, we often perceive distant vistas before we see objects closer to us, so there is no rule in painting that requires an artist to depict things as they are arranged in the physical world. Thus we have background confused with foreground, figures and structures all out of proportion. The defamiliarization of reality, the artist's stock in trade, helps convey the surreal effect.

The right panels blur into a distant view of Kiyomizudera and Otowa Falls, while the left panels bring us up close to the tea stalls of Yasaka shrine, which are represented as structures with no clearly demarcated framework—they simply fade away into space. As in a dream vision, juxtapositions of scenes completely disregard realistic topographic relations. To further the effect of fantasy, all elements not essential to cherry-blossom viewing are omitted. None of the sites with political associations in the southeast of the capital, such as the Great Buddha Hall or Hōkoku shrine, which was dedicated to Hideyoshi's memory, intrude into the field of vision.

Though a flower-viewing excursion can hardly be considered a sacred activity, this painting, through its depiction of religious sites and places of pilgrimage, evokes the otherworldly effect of medieval topographic mandalas showing sacred sites in seasonal settings. Respecting conventions derived from Chinese cosmology, in which each of the four cardinal directions correlates to a season, paintings of the capital often link sectors of the city with the appropriate time of year: northern with winter; eastern with spring; southern with summer; western with autumn. Thus, although the Eastern Hills district is as well known for its stunning autumn foliage, convention dictates that it be shown with vernal cherry blossoms.[9] The religious element—only an undercurrent here, not a primary motif—is a means of suggesting otherworldliness, a fundamental characteristic of *ukiyo-e* painting. Dreams of ultimate salvation and ultimate pleasure, both equally unobtainable, merge easily in the transcendent domain of art.

In this imaginary realm, women come and go in a male-free world. This exclusive focus on the depiction of women with stylized facial features and wearing gorgeous robes is another characteristic of *ukiyo-e*. The painting style of the individual figures—featuring gentle, rounded faces with comparatively compact bodies—betrays the influence of Nishikawa Sukenobu (1671–1751; see pl. 104). The arrangement and interaction of figures, however, harks back to compositions of *ukiyo-e* pioneer Hishikawa Moronobu (d. 1694). The discrete clusters of figures are self-sufficient compositions within the larger one, but within each grouping at least one person is looking back over her shoulder or gazing out of the circle. This *migaeri* (glancing back) pose is one that Moronobu and his followers made popular in paintings of solitary courtesans, as in the Shigenobu portrait discussed next. This technique of linking groups of figures gives a sense of visual continuity and a relational spark that imbue dynamism in a composition that otherwise might have succumbed to inertia or pure stasis.

Finally, a more specific connection between the *Women on a Flower-viewing Excursion* screen and Moronobu's fictive imagination can be established by referring to a popular book he illustrated entitled *Wakoku hyakujo* (One hundred women of Japan; 1695), which shows women of every age and walk of life in various settings and poses.[10] The link becomes even more plausible if we assume that this screen was once accompanied by another depicting a similar array of fifty women. *Wakoku hyakujo*, an account of cherry-blossom viewing at Kiyomizudera, germane to the scene here, records the conversations of women as they return from a flower-viewing excursion:

> Someone told me he encountered a great number of women from some lord's household who were on a flower-viewing excursion to see the cherry blossoms at Jishu Gongen, at Kiyomizu Temple in the Eastern Hills district. On their way home after viewing blossoms from various vantage points, one of the maid-servants in the entourage remarked, "Well then, I think among all cherry blossoms we saw today, the double-petaled Shiogama cherry was really the most spectacular."
>
> "No, no," said another, "the Ise cherry was superb!"
>
> "The most beautiful was the Yōkihi (Yang Guifei) cherry!" added yet another.
>
> Then a man with gray hair, leading the retinue, chirped, "No, not at all, the way I see things, among all the cherry blossoms, the finest were the Uba 'Older Lady' cherry blossoms."[11]

Whether or not Moronobu's illustrated book was a direct inspiration for this work (the painting seems to have more courtesans than members of a lord's household), its commentary can be used to create an imaginary libretto of women talking about their impressions of a day of flower viewing. It also allows us to imagine an exterior narrator with a male point of view, which is inherent in *ukiyo-e*. We are encouraged to reread the depictions of the women as representing cherry blossoms that the artist could never paint convincingly. In the mind's eye, each of the women represents a variety of blossom or one at a different stage of maturity—each having a beauty all its own. The very name of Yōkihi, the Japanese pronunciation of Yang Guifei (719–756)—the Tang imperial consort immortalized in "The Song of Everlasting Sorrow," by Tang poet Bo Juyi (772–846)—conjures up the ideal of feminine beauty. Yet the old man puns on the two meanings of *uba-zakura*, a type of cherry that blooms even before its leaves appear, and an elderly woman who still has great beauty.[12]

Viewing the painting again with this in mind, we look at its central visual confrontation (between the third and fourth panels): a high-ranking courtesan and a Buddhist nun. The figure of the courtesan, at the very peak of beauty and fame, is juxtaposed with the elderly woman who, in leaving the "floating world" behind for the spiritual realm, has acquired an elegance all her own. Hints from Moronobu's narrator encourage such an interpretation. This reading may simply be overlaying one fiction upon another—a dialogue in an illustrated novella superimposed on a fictional painting. Yet in this way, previously hidden meanings can be discovered in the interstices of parallel fictive worlds.

WOMEN WRAPPED UP IN WORDS

If we look closely at the details of the *Women on a Flower-viewing Excursion* screen, we may note eruptions of poetic dissonance in certain examples of textile decoration it records. Two of the courtesans flaunt robes featuring calligraphic motifs (one prominently situated on the far right panel, the other on the second panel from the left). For closer study of this phenomenon of inscribed dress,

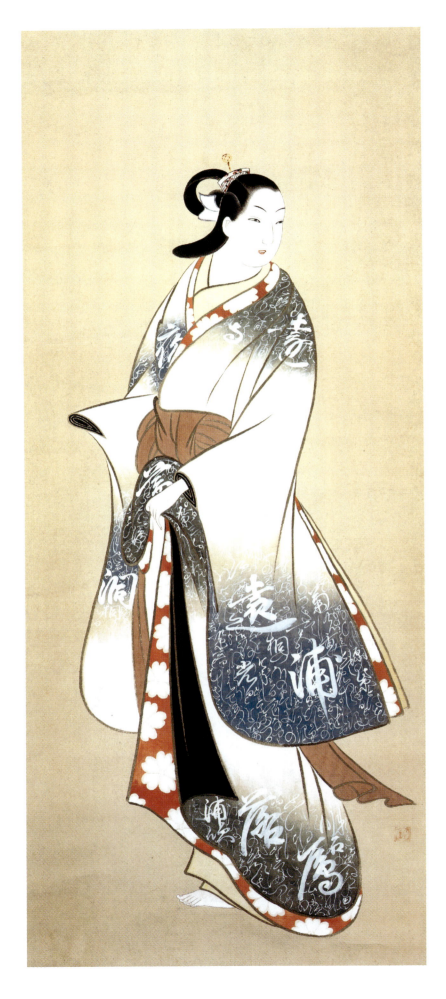

we can turn to a painting by Takizawa Shigenobu (fl. c. 1716–36) showing the solitary figure of a statuesque courtesan who is wrapped in similar robes (pl. 103). It probably dates to the 1720s or early 1730s, about the same period as *Women on a Flower-viewing Excursion*. The pose of a courtesan looking back over her shoulder (perhaps responding to an admirer's flirtatious glance) recalls certain figures in group scenes in Moronobu-inspired scrolls or screens as discussed above. More germane here, a fair number of *ukiyo-e* paintings are known that resemble Shigenobu's work in their depiction of women in magnificent robes with patterns of calligraphy. During the 1710s to 1730s, artists of the Kaigetsudō school and their stylistic heirs such as Baiyūken Katsunobu (fl. 1710s–20s) as well as a number of *ukiyo-e* print designers of this era incorporated similar visual effects into their designs.[13]

Textile designs such as this usually juxtapose a scattered constellation of boldly inscribed cursive forms of kanji (Chinese characters) and kana (phonetic syllables) against a graded background. Although in the paintings the characters are inscribed in white pigment over colored surfaces, we can assume such patterns represent an actual *yūzen* paste-resist dyeing technique that would have rendered characters in reserve against dyed fabric. Unfortunately, no actual textile examples are known to survive from the early eighteenth century to corroborate this.[14] Various references in contemporaneous poems and *jōruri* (puppet play) librettos, however, mention garments decorated in a technique referred to as *hoguzome*, or calligraphy-scraps dyeing. The name suggests that the designs resemble discarded calligraphy practice sheets on which fragments of letters or poems are crushed together into accidental and random configurations. The kana are disposed according to *chirashi gaki* (scattered writing) conventions dating back to Heian times, when letters and poems—especially on amorous themes—were composed in such formats, marked by columns of arbitrary length

and words confusingly split up or arranged out of logical sequence. Through the centuries, this inscription convention was associated particularly with aristocratic women but was used by male courtiers as well. Women in such robes are literally wearing the history of Japanese calligraphic inscription on their sleeves.

The use of *hoguzome* on the robes depicted in paintings, as on the original robes that inspired these paintings, must have been a bit of an intellectual tease for early eighteenth-century customers who bought such works. The reading experience—a pleasurable frustration—is replicated for modern viewers tutored in premodern script types. The superscribed kanji unravel relatively easily, but one soon gives up trying to disentangle the web of kana beneath. The individual characters are legible, and certain phonic clusters constitute words, but it is hard to fit together all the pieces of the verbal jigsaw puzzle, and one gets the sense that some pieces have been intentionally hidden. It is a little game of tantalization, wordplay in which we are drawn toward the shape of words, but in the end they resist comprehension. Not unlike a courtesan singing a passage from an old love ballad or whispering sweet nothings into a client's ear, the meaning cannot be ascertained, but a mood-setting *jouissance* is nonetheless evoked.

Similarly, in Shigenobu's composition, we can immediately detect the underlying poetic intention, but not the semantic details. Gliding atop the confection of kana graphs in tangled strands, the boldly inscribed cursive kanji graphs are readily decipherable. They are all associated with phrases linked with the famous Eight Views of Xiao and Xiang (Shōshō hakkei), a favorite painting theme of Zen and Kanō painters. For instance, the characters on the left sleeve read "distant shores," part of the expression "Returning sails off distant shores" (*enpo kihan*). On the lower hem of the garment, the graphs "geese descending" allude to "geese descending to a sandbar" (*heisa rakugan*).

On the lapels of the robe we can make out "evening" and "rain," referring to "Evening rain at Xiao and Xiang." On the left sleeve, the character *dō*, "cave," is one of the characters making up "Lake Dongting," another of the octet of idyllic scenes. The Eight Views of Xiao and Xiang, however, were never intended as realistic topographic depictions of specific locales, but as scenic impressions of poetic moods. Likewise, in Shigenobu's painting, even though the background of the painting is completely blank, lacking even an inscription, the calligraphy on the robes lures the imagination into poetic reverie. In the mind's eye, the image of the courtesan is placed in an atmospheric landscape, calling to mind those invented by Kanō artists.

In contrast to the figures in the previous paintings, which are completely wrapped in inscribed textiles, an image by the highly influential Kyoto artist Nishikawa Sukenobu shows other ways in which texts can frame and give poetic voice to the subject of a painting. The hanging scroll *Courtesan Reading a Poem Card* (pl. 104) features potential writing surfaces of all types, with texts of various kinds—some readable, others intractable, some clever in meaning, others textual babble— operating at different planes of suggestiveness. Even the mounting that frames the painting, fashioned in modern times, picks up on the levels of verbal play and contributes to the wittiness of the texts. It is made up of scraps of an Ise calendar (*Ise goyomi*), its lists of seasonal events and auspicious days completely irrelevant, it seems, to the themes of the painting, except that they are mutually concerned with texts. One section of the calendar is dated Genroku 17 (1704), two or three decades too early to actually be connected to the original painting.

Within the painting proper, a courtesan reads a poem card (*tanzaku*), purposely illegible, though the first character can be construed as *sakura* (cherry), hinting that the card may be intended to be hung

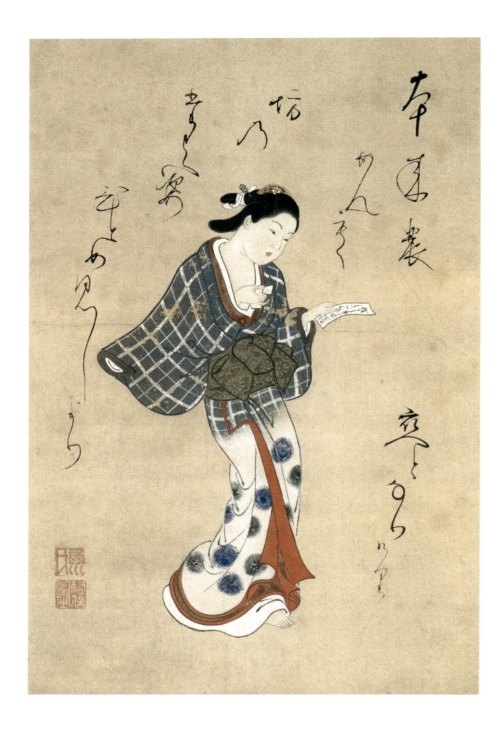

on a blossoming tree, as happens in other Sukenobu paintings and book illustrations. In her right hand, she holds a still-folded letter, which because of her profession we can imagine to be a missive from an admiring client. It can never be unfolded, so we can only imagine what it says, or interpolate into it sentiments of our own fabrication.

A former owner of this painting also tried to imagine the contents of the letter and inscribed, or had someone inscribe, a poem on the painting—like a cartoon's thought bubble revealing the inner thoughts of the character. Here we have a common convention of *ukiyo-e* painting, in which the portrait of a courtesan is surrounded by a calligraphed text, either added by the artist, a poetic acquaintance, an owner of the painting, or even sometimes a courtesan. Often, as here, the inscription is unsigned, so we can only speculate about its authorship. In this case, the handwriting is extremely practiced, highly fluent, but a bit pretentious: some of the kana are rendered in an overly showy manner with curlicue flourishes that in a couple of places cover up poorly proportioned characters. The poem, as we shall see, was written in the narrational voice of a male patron, though it is not implausible to conceive of a patron requesting a courtesan to inscribe it in her own hand. We can never know, but the mystery is part of the seductive pleasure of the work. The inscription reads:

> *honrai no*
> *menmoku bō no*
> *tachi sugata*
> *hitome mishi yori*
> *koi to narikeri*

Since I first glimpsed
this standing figure
of a Buddhist monk
who knows the "original face,"
I've fallen into love.

At first reading the poem is a bit confusing: Who is speaking? Where is the Buddhist monk of the inscription? If it refers to a monk, does that mean the courtesan has fallen in love with him? The key to the meaning is the phrase *honrai no menmoku* (original face), a concept derived from Zen Buddhism, referring to the original, undifferentiated state of awareness, or Buddhahood. One monk who discovered his "original face" is Bodhidharma (J. Daruma), the first patriarch of Zen Buddhism who, legend recounts, sat in solitary meditation for nine years in a cave. Bodhidharma is the subject of countless paintings, depicted either seated in meditation or standing, by Zen artists of all ages (see, e.g., cat. nos. 116, 120, 131, 132, 137). But to understand the poem here, we must also know that in Edo-period slang, prostitutes were nicknamed *daruma*, since according to a cruel but humorous observation they were like roly-poly *daruma* dolls that if knocked down, immediately bounce back into an upright position.

Reread in light of this knowledge, the poem becomes a patron's ironic declaration of love for the standing figure of the prostitute depicted in the image. This tradition of juxtaposing portraits of courtesans with texts or images alluding to Bodhidharma or other Zen Buddhist themes becomes quite common in *ukiyo-e*, and nearly every artist took up the theme in one permutation or another. Sukenobu himself created a fascinating painting (in the Bigelow Collection of the Museum of Fine Arts, Boston), with a signed inscription by a Yanagimachi courtesan, which depicts the juxtaposed standing figures of a courtesan in *ukiyo-e* style and Bodhidharma in a Zen style.[15] In the final analysis, Sukenobu's composition here, with all its different accretions of texts—on the poem card, in the inscription, and even in the mounting—invites a dynamic reading process, of going back and forth to the work to explore its visual and verbal messages. Like a Zen practitioner, we may never satisfactorily know the "original face" of

things (or of the courtesan), but the contemplative process itself, in this case aesthetic rather than spiritual, is rewarding in and of itself.

In contrast to portrayals by Shigenobu or Sukenobu of women enveloped in texts of ambiguity, which invite unfolding or decipherment, a late eighteenth-century work by Chōbunsai Eishi (1756–1829) presents an image that awaits inscription (pl. 105). Beneath an ample expanse of blank pictorial space that could have accommodated a calligraphed literary text, we see an elegantly attired court lady, posed holding a calligraphy brush and contemplating the emptiness of a blank piece of paper on her writing table. We peer in from outside through an *ensō* (circular window) partly framed by plum blossoms.[16] We are voyeurs of the process of writing, a most private inner act. The artist invites us to ponder with the subject of the painting: What will she write next? Is there an infinite array of possibilities, or is she predestined, as if in a Borges short story, to write a story already inscribed?

An added dimension of fictive purposefulness is suggested by the pose, which calls to mind imaginary depictions of the Heian writer Murasaki Shikibu (d. c. 1014), author of the *Tale of Genji*. As in other such images representing Lady Murasaki, the desk is arranged with writing accoutrements—paper, ink stick, inkstone, and water dropper. Alongside are tied-up scrolls that are perhaps finished or potential chapters of the novel. The long, flowing hair and elegant red formal skirt, which indicate she is of aristocratic standing, accord with such an interpretation. The blue over-cloak decorated with a motif of *fuji* (wisteria) is probably an allusion to the Fujiwara clan, to which a branch of Shikibu belonged. She is a fiction writer weaving a tale, and we share in her literary wistfulness.

The imaginary settings, moods of reverie, and suggestive poetic inscription so effectively used in earlier paintings are assimilated in a set of deluxe screen paintings by Hōtei Gosei (fl. 1804–44),

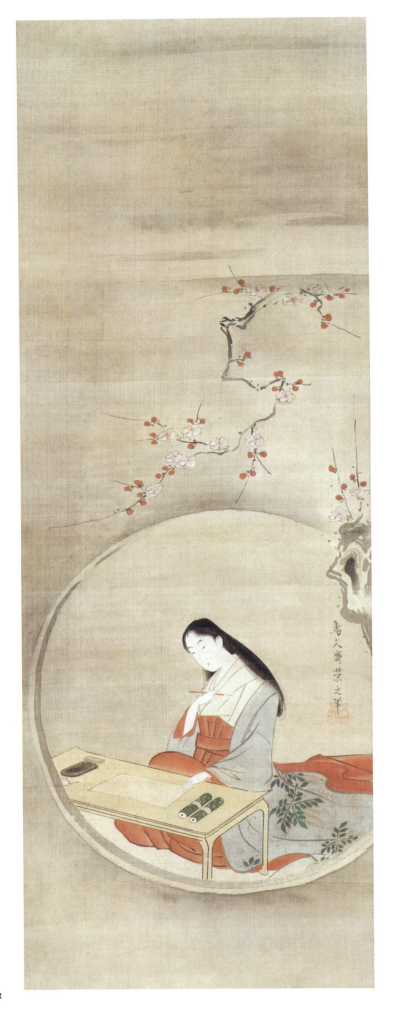

probably dating to the 1820s (pl. 106). The screens comprise a panoramic scene of women harvesting tea leaves in a landscape that vaguely calls to mind the area of Uji, a major center of tea production near Kyoto.[17] Recalling *Women on a Flower-viewing Excursion*, here we have, a century later, a *ukiyo-e* artist reconstructing the same kind of composition with impressionistic, receding landscapes on the side panels and the main action in the foreground. The townswomen—probably geisha—bedecked in gorgeous raiment appear completely out of place in the agrarian setting. Beyond the fictionality of setting and the incongruity of the figures in the landscape, there is a complex literary subtext. In a manner reminiscent of the work of Shigenobu, Gosei has reintroduced the archaic technique of *hoguzome* motifs, fashionable a century before, into an early nineteenth-century literary context. One of the geisha has spectacular robes featuring a pattern of poems in the entangled kana script format of *chirashi gaki*. Two complete *kyōka* (thirty-one-syllable playful verse) can be teased from the maze of texts on her robes; traces of yet a third can be detected.[18]

The *kyōka* on the left sleeve, the most prominently inscribed, invites unraveling. Still, the sequence of reading is a bit convoluted since the phrases of the lower two registers have to be read left to right, the reverse of normal (the slash marks in the transcription indicate actual divisions of columns). The text can be reconstructed as follows:

[top] *yo no naka wa /
sate mo /* [middle] *sewashiki
sake no kan /*
[bottom] *chirori no hakama /
kitari / nuidari*

And isn't life just like that!
Everything so hurry-scurry—
like sake-warming pitchers
heated up and placed on stands—
as we don and doff our *hakama*.

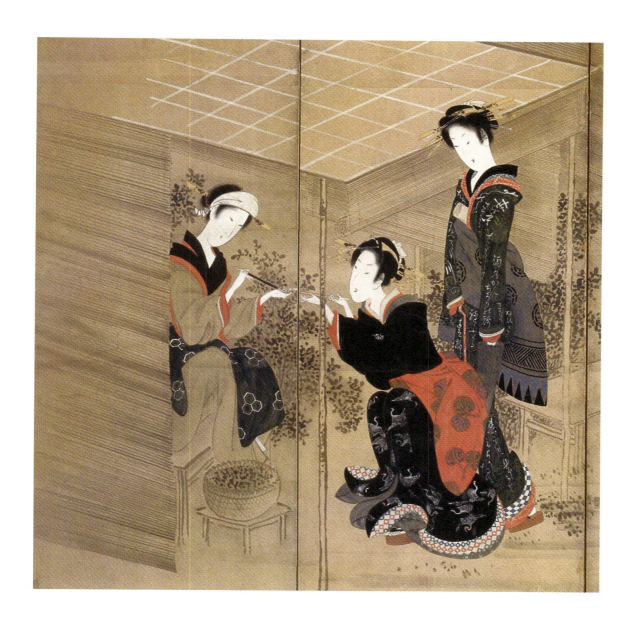

Pl. 106. Hōtei Gosei. *Picking Tea* (detail, cat. no. 111).

The poem puns on the two meanings of *hakama*: a stand for a sake-warming pitcher, or the formal skirt worn by samurai for official functions. Read in the first sense, it suggests a picture of geisha or perhaps a male host of a party involved in the bustle of serving guests who come and go. On another level, it suggests a samurai who is constantly putting on or taking off his *hakama*, suggesting that he is stepping in and out of his official responsibilities as a samurai official.

The latter reading makes more sense when we learn that the author of the unsigned poem is Ōta Nanpo (1749–1823), a minor samurai official who was one of the most influential *kyōka* poets and cultural arbiters in Edo during the late eighteenth and early nineteenth centuries.[19] In her study of the literary salon culture centering on him, Haruko Iwasaki cites this poem as evidence of Nanpo's

desire to keep his official and private literary lives separate.[20] Though dated to the 1820s on the basis of painting and signature style, the presence of the poem makes one wonder if this painting were created as a tribute of sorts to Nanpo. Other motifs on the women's robes (which to modern viewers appear to be merely decorative) would have been spotted by persons in the artist's literary circle as personal emblems of poets affiliated with the *kyōka* circles that Nanpo had helped nurture a few decades earlier.[21]

Although it is impossible to reconstruct the details behind the commissioning of this set of screens, it seems clear that Gosei must have had connections through poetry circles to the patron, whose name is given as Senshuken beside the artist's signature. His identity cannot be positively ascertained, but Tanaka Tatsuya has identified a

resident of Matsumoto (where Gosei was living) who used the shop name Senshuken. He was an owner of a sake brewery known as Izumiya, which would help explain the use of Nanpo's famous poem on warming sake. Underlying the incongruous scene of elegantly dressed geisha on an excursion to a tea-harvesting plantation, we sense the existence of a sophisticated literary salon culture that was noted for breaking down barriers between cultured men and women of various social classes.

MULTILAYERED GUISES OF SOCIAL CLASS

Teisai Hokuba (1771–1844), another disciple of Hokusai's, was also intimately involved in *kyōka* circles of his day, and like Gosei specialized in the design of *surimono* and *ukiyo-e* painting rather than commercial prints. As a painter he earned esteem for his renditions of meticulously detailed figures in landscapes, as seen in a tableau of three geisha on a flower-viewing excursion (pl. 107), or in this evocative portrayal of a gorgeously attired woman in a small boat beneath dangling branches of willow (pl. 100). Garbed in the costume of a *shirabyōshi* (a female dancer who wore male court costume), she represents one of the boat prostitutes who plied the Asazuma inlet, along the eastern shore of Lake Biwa, near Osaka. Keeping in mind that Hokuba was known for his frequent allusion to classical literary or legendary subjects in his paintings and prints, our reading shifts according to the level of historical fictionality we impose on the image.[22] The painting is effective on an immediate aesthetic level (it is meticulously painted using expensive pigments on finely woven silk), but the incongruity of visual signals, such as the male courtier's cap accented in brilliant gold, or conspicuously lavish robes, triggers our historical curiosity.

Shirabyōshi in both medieval and early modern contexts were seen as women of cultural attainment who also made themselves available as amorous companions; they serve as archetypes of the high-ranking courtesan of the licensed quarters. In early medieval times, they often were women originally of high social status who had fallen on bad times, and who then had to resort to offering their services as performers or prostitutes. Their cross-dressing, often wearing a long ceremonial sword at hip, was part of the provocative appeal of their dances and songs. Some became mistresses of high-ranking courtiers; one *shirabyōshi* even rose in status to become the chief consort of the retired emperor Gotoba (1189–1239). Their proximity to bastions of power, however, was part of both their allure and their tragedy—many of the most famous *shirabyōshi* met early deaths. On one level, therefore, *ukiyo-e* images of such performer-prostitutes conjure up allusions to medieval historical romances such as *The Tale of the Heike* (comp. thirteenth century), in which three of the central heroines of the novel were *shirabyōshi*. On another level, their seductive presence fits well with the emphasis of *ukiyo-e* on pictures of beautiful women and men or, as is the case here, androgynous beauty. Images of solitary *shirabyōshi* became a common theme in paintings of the late seventeenth century, which served as precursors of their regular appearance in paintings and prints of *ukiyo-e* artists.

A more direct inspiration for this painting theme were images created in the early eighteenth century by Hanabusa Itchō (1652–1724). One version, entitled *Asazuma-bune* (Asazuma boat), was reproduced in the influential woodblock-printed *Itchō gafu* (Itchō drawing manual) compiled by Suzuki Rinshō in 1770, several decades after the artist's death.[23] According to standard accounts, an earlier version by Itchō of a prostitute in a boat had caught the eye of government censors, since it was construed as a parody of the shogun Tsunayoshi's custom of joining his concubine for boat rides on a small lake in the precincts of Edo castle. Although this does not appear to have been the specific reason behind Itchō's decade-long exile

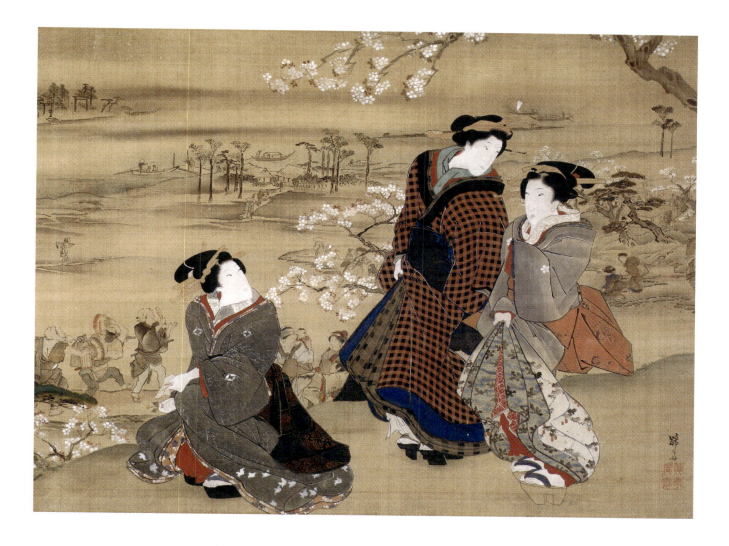

Pl. 107. Teisai Hokuba. *Women Enjoying Cherry Blossoms* (detail, cat. no. 112).

from Edo, he must have understood the controversial nature of this subject. In any case, in later versions the artist was careful to conceal the subject by presenting the woman in the guise of an Asazuma boat prostitute. The Hokuba version here has all the elements of the Itchō illustration. By the early nineteenth century, the theme of the Asazuma boat prostitute had become part of the standard repertory of *ukiyo-e* artists, no doubt because it incorporated so many of their favorite visual tropes: water and boats as metaphors for the buoyant world of bordello life; willow branches that symbolized the pliant wills of courtesans; women cross-dressed in elegant male costume (the reverse of Kabuki); and *mitate* (parodic) juxtapositions of courtesans posing as women of courtly standing.

In both of the previous paintings by Gosei and Hokuba, the women seem to be overdressed for their respective settings, inviting the viewer to investigate the real motives behind the work. Likewise, something seems incongruous about a

diptych of hanging scrolls by Utagawa Kunisada (1786–1864), each featuring a pair of young women rendered in the artist's distinctive, hard-edged style of feminine beauty (pl. 108 a, b). There is a discrepancy between the lavish multilayered costumes, elegant hairstyles, and visual props such as the peasant's basket (similar to the tea-harvesting basket in Gosei's painting). The light mist of gold wash on an otherwise blank background, while adding a feeling of opulence, serves as visual signal of our entry into a transformative narrative space, not unlike the gold clouds in medieval scroll and screen paintings. On the right-hand scroll, the standing woman, dressed in dramatic, red, long-sleeved robes decorated with dangling boughs of cherry blossoms, appears to be the daughter of a member of the samurai elite. Her dress is so flashy that only a woman of wealth or a high-ranking courtesan would or could wear it, but the coiffure and obi style point to a woman of high social status. She looks down at a barefoot

peasant woman kneeling beside a farmer's basket, who is dressed more sedately in deep-blue robes, their lower hem decorated (ironically perhaps) with symbols of good fortune. On the left panel kneels an elegantly coiffed woman in tastefully chic, dappled robes with crane motifs tied with a brilliant orange obi. She is fashioning a folding fan, indicating that she is of the artisan class (a certain subliminal eroticism is conveyed, since women who worked in fan shops often sidelined as unlicensed prostitutes).[24] On the far left, the standing woman can be identified as the daughter of a merchant family, as suggested by the box for food or wares she carries as well as by the understated colors of her checkered robes.

In a discussion of this work, Tadashi Kobayashi points out that the women of Kunisada's composition can be interpreted as parodic representations of the four social classes of premodern Japanese society: warriors, farmers, artisans, and merchants (listed in order of their officially perceived status and privilege).[25] In reality, samurai were often impoverished and merchants much wealthier than members of the other three classes. Kunisada does not betray any overt social satire in his composition, though the economic relationships of warrior to peasant and merchant to artisan are surely not accidental. Further hints on how to interpret this set of paintings can be suggested by print versions of the same theme by Kunisada and other *ukiyo-e* artists. For instance, Torii Kiyonaga (1752–1815) set the *ukiyo-e* precedent several decades earlier in a set of four *koban* (small format) prints of circa 1779 entitled *Yasa sugata shi-nō-kō-shō*, or "The Four Classes in Seductive Poses." Kunisada and fellow Utagawa-school artist Kuniyoshi (1797–1861) both created print triptychs on the theme that included *mitate* in the title and similarly featured women in up-to-date fashion.[26] Kuniyoshi gave a clever twist to his series by

having a high-ranking courtesan represent the merchant class, subversively suggesting that women who sell sexual services deserve recognition in a socially stratified economy.[27] All the print versions as well as Kunisada's painting poke fun at a male-configured Confucian hierarchy and represent it in a female guise.

Compositions such as these by Hokuba and Kunisada, at first glance innocuous, demonstrate how *ukiyo-e* artists sought to upset routine habits of perception, to create a defamiliarization of visual and social hierarchies of their day. Rather than espousing a carefully calculated social or political agenda, we sense that they wanted to superimpose an idealized vision of feminine beauty on an artificial, male-dominated social structure—a process at work even in earlier examples in the *ukiyo-e* tradition, such the early eighteenth-century painting *Women on a Flower-viewing Excursion* (pl. 102) discussed at the beginning of this essay. Although the artists' motives seem to have been more in jest than in satire, the authorities—betraying fluctuating impulses toward censorship—were certainly concerned that *ukiyo-e* artists not overstep acceptable bounds of social dissent. Ultimately, *ukiyo-e* creates a supreme fiction in which the gender distinctions and tiers of social strata are turned topsy-turvy. Figures of men and women depicted in *ukiyo-e* become emblems of corporeal desire. Their multilayered costumes and elaborate hairstyles are superficial symbols of social status. The fictive and poetic spaces they inhabit expand into imaginary landscapes of lost or nostalgically recollected cities. The uninscribed space that surrounds them, "a void not filled with words" that Kublai Khan respected in Marco Polo's descriptions of invisible cities, represents the potential of new readings or rewritings of the histories of painted dreamworlds.

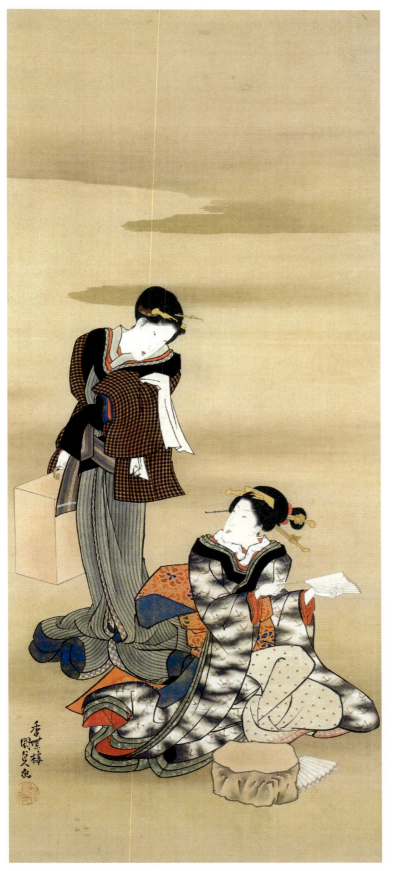
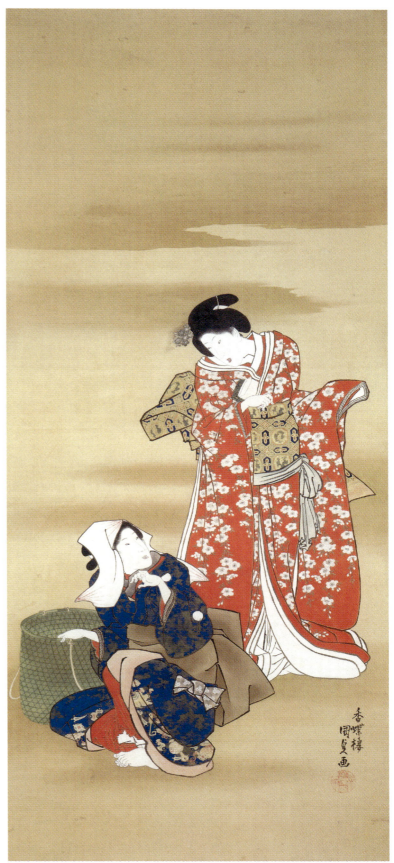

NOTES

1. Some suggestion of the physical suffering of prostitutes is given in Cecilia Segawa Seigle, *Yoshiwara: The Glittering World of the Japanese Courtesan* (Honolulu: University of Hawaii Press, 1993), 211–17. This study also is the best introduction in English to the economic, social, and cultural contexts of Edo bordello culture.

2. The use and abuse of *shunga* is discussed in Timon Screech, *Sex and the Floating World: Erotic Images in Japan, 1700–1820* (London: Reaktion Books, 1999).

3. A short history of *ukiyo-e* focusing on figural styles is given in John T. Carpenter, "The Human Figure in the Playground of Edo Artistic Imagination," in Robert T. Singer, ed., *Edo: Art in Japan 1615–1868* (Washington, D.C.: National Gallery of Art; New Haven, Conn.: Yale University Press, 1998). For an analysis of the tension between realism and idealization in *ukiyo-e* depictions of courtesans, see Timothy Clark, "Utamaro's Portraiture," *Proceedings of the Japan Society*, no. 130 (winter 1997).

4. Timon Screech, *The Shogun's Painted Culture: Fear and Creativity in the Japanese States, 1760–1829* (London: Reaktion Books, 2000), 9, 102.

5. For example, *fu* by Zhang Heng (78–139) contain descriptions of the ancient capital of Luoyang; see various translations in E. R. Hughes, *Two Chinese Poets: Vignettes of Han Life and Thought* (Princeton, N.J.: Princeton University Press, 1960). Luoyang, capital of China at various times in ancient history, was frequently the subject of poems treating *huai gu* (meditation on the past) themes; see also Wu Hung, *Monumentality in Early Chinese Art and Architecture* (Stanford, Calif.: Stanford University Press, 1995), 251–52.

6. For an English translation, see W. J. F. Jenner, *Memories of Loyang: Yang Hsüan-chih and the Lost Capital, 493–534* (Oxford: Clarendon Press, 1981). For a history of the transmission of this work in Japan, see Hatanaka Jōen, "Rakuyō garanki no sho hanpon to sono keito" (The lineage of printed versions of *The Record of Monasteries of Luoyang*), *Ōtani gakuhō* 30, no. 4 (1951): 39–55.

7. See Elizabeth Berry, *The Culture of Civil War in Kyoto* (Berkeley: University of California Press, 1994), 285–302. Also for an introduction to early examples of *Rakuchū rakugai zu*, see Matthew P. McKelway, "The Partisan View: Rakuchū Rakugai Screens in the Mary and Jackson Burke Collection," *Orientations* 28, no. 2 (February 1997): 48–57.

8. No information can be ascertained concerning the artist who signed himself Tosa Daijō Genyō (Motoyasu). *Daijō* was an honorary title given to townspeople or artisans, usually puppet makers, puppeteers, or *jōruri* masters, but not painters. Sometimes *machi eshi* (town painters) added the prestigious Tosa family name to their signatures to give an added cachet to a deluxe commission, such as we have here. One of the artist's seals can be deciphered as *fuji* or *tō*, a common abbreviation for the Fujiwara family—another name that was frequently borrowed by craftsmen to put a stamp of prestige on their works.

9. A point noted in comments on this work by Melinda Takeuchi in Christie's, *An Important Collection of Japanese Ukiyo-e Paintings* (New York: Christie's, October 27, 1998), no. 16.

10. A facsimile reproduction of *Wakoku hyakujo*, originally published in 1695, is included in Kurokawa Mamichi, ed., *Nihon fūzoku zue* (Japanese social customs in illustrated books), vol. 1 (Tokyo: Nihon Fūzoku Zue Kankōkai, 1914–15). I am indebted to Iwata Hideyuki for his assistance in reading sections of this volume.

11. Cited in Kobayashi Tadashi, ed., *Azabu Bijutsu Kogeikan* (Azabu Museum of Arts and Crafts), vol. 6 of *Nikuhitsu ukiyo-e taikan* (Compendium of ukiyo-e paintings) (Tokyo: Kōdansha, 1995), no. 87, commentary by Tajima Tatsuya.

12. The word *uba-zakura* (Old Lady cherry) is said to derive from the observation that it blooms even before it has leaves (*ha*). Since *ha* is a homonym for "teeth," the suggestion is that the *uba-zakura* is toothless, just like an old woman.

13. Timothy Clark, *Ukiyo-e Paintings in the British Museum* (Washington, D.C.: Smithsonian Institution Press, 1992), no. 26. Another similar example by Katsunobu is introduced in Sharon Sadako Takeda, "Clothed in Words: Calligraphic Designs on Kosode," in Dale Carolyn Gluckman and Sharon Sadako Takeda, *When Art Became Fashion: Kosode in Edo-period Japan* (New York: Weatherhill; Los Angeles; Los Angeles County Museum of Art, 1992), 168–69, fig. 48. Examples of other prints and paintings by artists such as Torii Kiyomasu I, Okumura Masanobu, and Kaigetsudō Anchi are included in Timothy Clark et al., *The Dawn of the Floating World, 1650–1765: Early Ukiyo-e Treasures from the Museum of Fine Arts, Boston* (London: Royal Academy of Arts, 2001), nos. 32, 63, 83, respectively.

14. Takeda, "Clothed in Words," 168.

15. The painting has an inscription signed "Miyako no Nishi Yanagimachi yūjo Ōhashi" (The courtesan Ōhashi of West Yanagimachi in the capital); see Tsuji Nobuo et al., *Bosuton Bijutsukan nikuhitsu ukiyo-e* (Ukiyo-e paintings in the Museum of Fine Arts, Boston), 3 vols. (Tokyo: Kōdansha; Boston: Museum of Fine Arts, 2000), 2:no. 25.

16. Eishi and his pupils did a number of paintings using this device of viewing an elegantly attired woman through a round window framed by a bough of plum; cf. Klaus J. Brandt, *Hosoda Eishi, 1756–1829: Der Japanische Maler und Holzschnittmeister und Seine Schüler* (Hosoda Eishi, 1756–1829: The Japanese artist and woodcut master and his followers) (Stuttgart: Eike Moog, 1977), 25. In 1796 Eishi created a design for the illustrated poetry anthology *Yomo no haru* (Spring in all directions) in which he shows a similar image, but with a high-ranking courtesan at the writing desk flanked by two attendants; see Matthi Forrer, ed., *Essays on Japanese Art Presented to Jack Hillier* (London: Robert G. Sawers, 1982), 45, fig. 7.

A magnificently detailed painting on a similar theme in the Tokyo National Museum by his pupil Eiri shows Eishi's influence and does the master proud; see Tokyo National Museum, *Nikuhitsu ukiyo-e* (Ukiyo-e painting) (Tokyo: Tokyo National Museum, 1993), no. 64.

17. See the discussion of this painting in Tanaka Tatsuya, "Hōtei Gosei no kenkyū" (Research on Hōtei Gosei), *Azabu Bijutsukan kenkyū kiyō* (Bulletin of the Azabu Museum of Art), no. 1 (spring 1986): 38–39.

18. The transcriptions of the poems are given in Tanaka, "Hōtei Gosei no kenkyū," 38.

19. The poem is included in *Saizō shū* (Treasury of talented kyōka poets; 1786), section 12 (miscellaneous topics), and again in 1818 in the *Shokusanjin jihitsu hyakushu kyōka* (One hundred kyōka verses brushed by Shokusanjin).

20. Haruko Iwasaki, *The World of Gesaku: Playful Writers of Late Eighteenth-century Japan* (Ann Arbor, Mich.: University Microfilms, 1984), 336. It is a delightful scholarly coincidence that this particular *kyōka* by Nanpo, out of several hundred republished in modern editions, is among those that Iwasaki chose to discuss in her doctoral dissertation.

21. For instance, a poem by Kyōkadō Magao is featured on the black obi of the woman holding the parasol in the fourth panel from the right of the right screen (virtually impossible to see in reproduction). The poem is written in archaic *manyōgana* script (in which semicursive forms of kanji are used as phonetic characters). It is signed "Kyōkadō" with a *kaō* (handwritten seal), but we may safely assume this is just Gosei, a talented calligrapher, imitating Kyōkadō's handwriting. Kyōkadō took over the leadership of the Yomo poetry group after Nanpo retired from his public role in the *kyōka* scene in the late 1780s. Kyōkadō's fan-shaped personal emblem is also included in the design. Some of the other women's robes have motifs linked to poetry groups with links to Nanpo. For instance, the arc-in-a-circle emblem is associated with Tsubo-gawa (Jug group), based in Asakusa in Edo, which was founded by Asakusa-an Ichibito (this emblem appears on the robe of a woman in the right screen, and on the obi of another in the middle ground of the left screen). The crane emblem would normally be connected with Tsuruya no Osamaru, the head of a Kansai-based *kyōka* circle, which makes one wonder if that may be related to the setting in Uji.

22. For an example of how visual *mitate* was employed in other Hokuba paintings, see the discussion "Beauty Catching Fireflies in the Sumida River," in John M. Rosenfield and Fumiko E. Cranston, *Extraordinary Persons: Works by Eccentric, Non-Conformist Japanese Artists of the Early Modern Era (1580–1868) in the Collection of Kimiko and John Powers*, Naomi Noble Richard, ed. (Cambridge: Harvard University Art Museums, 1999), 2:no. 225.

23. Miriam Wattles, "Ukiyo-e's Debt to the Hanabusa *Gafu*," *Ukiyo-e Society Bulletin* [Ukiyo-e Society of America], (spring 2001): 4–5.

24. A point raised by Kano Hiroyuki in his discussion of Fujimoto Kizan's *Shikidō ōkagami* (The great mirror of the art of love), in a paper delivered at the symposium "Early Ukiyo-e: New Perspectives," SOAS, University of London, February 2–3, 2002.

25. Kobayashi Tadashi, "Utagawa Kunisada hitsu onna mitate shi-nō-kōshō" (*Women representing the four social classes*, by Utagawa Kunisada), *Kokka*, no. 1165 (1992); see also Sebastian Izzard, *Kunisada's World* (New York: Japan Society, 1993), no. 72.

26. Examples of the *shi-nō-kō-shō* theme by *ukiyo-e* artists are mentioned in the entry on this subject in Asana Shūgō et al., eds., *Genshoku ukiyo-e dai hyakka jiten* (Encyclopedia of ukiyo-e in full color), vol. 4 (Tokyo: Taishūkan, 1982) (commentary by Suzuki Jūzō). The full title of the print series by Kuniyoshi is *Mitate tōsei shi-nō-kō-shō* (Parody of the four classes of our times); Kunisada's is entitled *Imayō mitate shi-nō-kō-shō* (An up-to-date parody of the four classes).

27. Hokusai in his *Santei gafu* (Painting in three aspects; 1816) also uses the device of representing the merchant class with a high-ranking courtesan. I thank Iwata Hideyuki and Ellis Tinios for bringing to my attention this and other references to the use of the Four Classes theme in *ukiyo-e*.

Paul Berry

The Transformation of Traditional Painting Practices in Nineteenth- and Twentieth-century Japan

THE MODERNIZING OF TRADITIONAL PAINTING PRACTICES IN JAPAN IS OFTEN attributed to multiple factors: sweeping changes in the training of Japanese artists, the new manner in which exhibitions were mounted at the turn of the twentieth century, the impact of Western painting techniques and conceptions of artistic identity, and the metamorphosis of scroll paintings from artworks intended for intimate tokonoma display to large-scale framed paintings suitable for the walls and spaces of Western-style architecture. Yet it is possible to understand these transformations as part of an ongoing pattern of historical assimilation of foreign influences in Japanese painting. Beginning with depictions of the animals of the Four Directions on the walls of early tombs, Japanese painters have continually adopted aspects of foreign painting traditions, molding and altering them to suit characteristics of the Japanese cultural environment.[1]

Japanese culture can be conceived as enveloped by a membrane that allows certain facets of foreign cultures to enter while excluding others. Once an element passes through, it is adjusted to fit the interior environment and customarily cut off from its original context. Thus, although the desired type and its successors are allowed continual or repeated entrance, the changes they undergo in the new environment prevent a return to the source. In other words, the Japanese cultural environment is essentially inward looking, and aspects of foreign culture are assimilated into its internal aesthetic discourse. Japanese adaptation of foreign painting models and practices was not ordinarily an attempt to replicate or even engage in dialogue with other cultures but was used as a means of fertilizing and reinvigorating practices internal to Japan.

Many of the economic and social forces active within the Japanese cultural environment parallel those found in other cultures, and in this sense it is far from unique. Nonetheless, the effect of its membranelike boundary renders many aspects of Japanese practice specific to the features of this enclosed environment. To say "enclosed," however, is quite different from saying "closed" along the lines of the frequently cited "island nation" concept. In the ancient world, water was as much a means of transport as a barrier. Even internal travel in Japan was most expeditious by river and coastal boat traffic. Japan, far from being isolated, was in contact through water-based trade routes with many cultures, as attested by the diverse origins of the objects in the eighth-century Shōsōin collection; the multitude of phonetic Chinese readings (on-yomi) for characters, revealing contact with distant areas of China; and so forth. Rather than geography, it is the closely integrated nature of Japanese society, with its own value system distinct from foreign ones, that gives Japanese culture its selective boundary. This inward focus is found in other cultures as well, from the Han Chinese emphasis on the Middle Kingdom to the periodically resurgent "go it alone" attitudes in the United States.

Japan is not unaided in fostering this type of semipermeable membrane, which receives but does not exchange. It is maintained and ensured by the unwillingness of foreign societies

Pl. 109. Kamisaka Sekka. *Momoyogusa* (World of Things; detail, cat. no. 97).

to understand or value aspects of their cultures once these have been transformed within Japan (e.g., the lack of recognition in China for Japanese painting based on Chinese models, which is mirrored by the lack of recognition in the West for Japanese oil painting based on Western models).[2] Even in the contemporary world, characterized by easy and frequent international travel and Internet communication, the membrane has been only slightly compromised.[3] The few aspects of Japanese aesthetics that have taken root overseas have likewise been transformed to fit the attitudes and practices of the receiving cultures, as can be seen in the impact of imported *ukiyo-e* prints on nineteenth-century European artworks or the "Zen-influenced" brushwork in some examples of abstract expressionist works in the postwar period.

In the history of Japanese painting, the interpretation of features adopted from foreign cultures gradually shifted over the centuries until older imports became perceived as "native." Eventually, schools of *kanga* (Chinese painting) could be contrasted with the "Japanese" qualities of *yamato-e*, a style that was rooted largely in Chinese Tang-period (618–907) landscape painting. By the late Edo period much of the iconic world of Japanese painting was based on either Confucian themes or Indian Buddhist motifs as transformed by Chinese and Korean Buddhist practices. Indigenous trends continued in areas such as *kasen-e* portraits of noted poets and the genre paintings and festival screens (see cat. no. 101) that preceded the rise of *ukiyo-e* painting (see cat. nos. 104–114). Even though the foreign origins of Confucian and Buddhist painting themes were not forgotten, the treatments of these motifs were increasingly naturalized because Confucian and Buddhist practices and positions in Japanese society were often quite different than in their countries of origin, especially given that the class divisions and the shogunal and imperial systems of Japan were not parallel to those found on the continent.

THE STRUCTURE OF JAPANESE PAINTING TRADITIONS

The Edo-period *bakuhan* system[4] supported the official branches of the Kanō school as the hereditary, designated painters for the ruling hierarchy. Likewise, other schools of painting, such as the Unkoku and Kaihō, passed their authority from

generation to generation, supplemented by strate-
gic adoptions when either biology or talent failed
to produce suitable heirs. Some lineages, for ex-
ample, the Maruyama school, broke from the Kanō
line and maintained themselves through fidelity to
the style of a founding person, such as Maruyama
Ōkyo (1733–1795; see cat. nos. 54, 55). The Shijō
lineage was more complex because the generations
that came after Matsumura Goshun (1752–1811;
see cat. nos. 23–28, 58) could choose to follow
either of Goshun's teachers, Ōkyo or Yosa Buson
(1716–1783; see cat. nos. 19–22), or an amalgam
of the two. Shiokawa Bunrin (1808–1877), trained
by Goshun's talented follower Okamoto Toyohiko
(1773–1845), displayed his sensitive fidelity to a
Shijō school interpretation of Buson's loose, ropy
brushwork and engagingly depicted facial expres-
sions in the everyday genre setting of *Waiting for
the Ferry Boat* (pl. 110 a, b). These late Edo-period
screens, from 1865, do not yet reveal the interest
in more literal renderings of objects and atmosphere
that would emerge in some of Bunrin's Meiji-
period works.

Other traditions were distinguished by
stylistic references, as seen in Rinpa paintings in
which fidelity to the earlier works of Tawaraya
Sōtatsu (act. c. 1600–1640; see cat. nos. 78, 79)
or Ogata Kōrin (1658–1716) would have been
easily recognized even before the ex post facto
rise of the term "Rinpa" as a stylistic label.
Ukiyo-e contained numerous schools within its
broad outlines, and its painters were identified
as much by their choice of theme and their posi-
tion as cognoscenti of the demimonde as by
their style of painting.

Among these multiple hereditary lineages
and style-based traditions, the rise of *bunjinga*,
or literati painting, represented a new form of
painting practice in Japan. Although nominally
following the model of Chinese literati painting
(*wenrenhua*), Japanese literati adopted and mixed
painting styles far more eclectically, and they
came from diverse origins in a social structure
that bore little resemblance to that found in China.
An examination of the *bunjingadan* (literati paint-
ing groups) in various regions of Japan reveals that,
whether linked by heredity or friendship, these
groupings were not based on a common style.
The tremendous stylistic differences between
Okada Beisanjin (1744–1820; see cat. no. 18)

Pl. 110 a, b. Shiokawa Bunrin. *Waiting for
the Ferry Boat* (cat. no. 62).

and Uragami Gyokudō (1745–1820; see cat. nos. 16, 17), and their sons Okada Hankō (1782–1846; see cat. nos. 38, 39) and Uragami Shunkin (1779–1846), are matched by the radical dissimilarity in the painting styles of the close friends Gyokudō and Tanomura Chikuden (1777–1835). It was a shared vision of the literati lifestyle that prompted these painters to welcome a diversity of stylistic approaches within their friendship and patronage groups. As their name implies, literati painters admired poetry and calligraphy, and they typically included Chinese inscriptions on their works. Their social contacts tended to revolve around *sencha* (steeped tea) gatherings, which often incorporated displays of calligraphy and painting (one of the precursors of public painting exhibitions in Japan).[5] These literati were the first Japanese artists to gather together on the basis of a shared vision of the artist's role and lifestyle rather than the usual hereditary and stylistic lineages. This manner of artistic association was to be duplicated in the twentieth century by many groups of *nihonga* and *yōga* painters.

From their eighteenth-century origins onward, literati artists tended to be patronized by well-educated members of the merchant class. Originally seen as comparatively apolitical, in the nineteenth century many literati painters critiqued the *bakuhan* system and became increasingly vocal supporters of the swelling movement for imperial restoration. These political sympathies triggered the persecution of some literati figures, as in the 1858 crackdown (*Ansei taigoku*) on antishogunate dissidents. Yanagawa Seigan (1789–1858; see cat. no. 43), for example, was to have been seized but died before he could be arrested. Fujimoto Tesseki (1817–1863; see cat. no. 50) was killed while fighting shogunal forces in Nara, and paranoid suspicions about Watanabe Kazan's (1793–1841) supposed disloyalty to the shogunate led to his house arrest, the proscription of his painting activities, and his eventual suicide.

This outsider or resister position of literati artists abruptly reversed after 1868, in the first years of the Meiji period, when the new ruling class came to highly prize literati painting and calligraphy as an art form expressive of the ideals of those who had overthrown the shogunate. Some artists, like Yamanaka Shinten'ō (1822–1885), even received governmental appointments in appreciation for supporting imperial loyalists. During these same years, the Kanō artists lost their official sinecures with the abolishment of the *bakuhan* system that had patronized them. It was during this time of tumultuous change that the process of training artists and exhibiting works underwent a great transformation in Japan.

EXHIBITION PRACTICES

One of the oldest forms of painting exhibition in Japan is the yearly *mushiboshi*, or airing of paintings, practiced to avoid problems with insects. Carried on by many Buddhist temples and some private collections, the *mushiboshi* ordinarily lasted a full day, during which many people might have a chance to see works normally kept in storage. Spring-Autumn Exhibitions at Higashiyama (*Higashiyama shunjū tenkan*), held in Kyoto from 1792 to 1798, were among the first public showings to include a diverse range of painters and printed catalogues giving painting titles and artists' names.[6] Additionally, painting exhibitions were frequently held at memorials for deceased artists in the late Edo period.[7] As noted above, *sencha* gatherings often became occasions to view paintings and calligraphies.

At the beginning of the Meiji period, new exhibition venues emerged under the stimulation of recently formed painting organizations such as the Jounsha (1868) in Kyoto and the Ryūchikai (1879) in Tokyo.[8] Japanese artists also participated in international exhibitions such as the 1873 Vienna Exposition. Competitive shows were held in ongoing series, including the Kyoto Exposition (*Kyōto*

Fig. 1. A Western-style exhibition hall, the *nihonga* division at the seventh Bunten exhibition, 1913. Reproduced in *Nittenshi* 3 (Tokyo: Nitten, 1980).

hakurankai) from 1871, the Domestic Industrial Exposition (*Naikoku kangyō hakurankai*) from 1877, and the Domestic Competitive Painting Exhibition (*Naikoku kaiga kyōshinkai*) from 1882. Government-sponsored shows (*kanten*) began in 1907 with the first Bunten, organized by the ministry of education. The exhibitions quickly shifted from displays in traditional *shoin*-style rooms to cavernous Western-style exhibition halls without interior ceilings and lined with temporary display walls (fig. 1).

Eventually these temporary exhibition structures gave way to permanent Western-style museum buildings. These new architectural settings dwarfed the usual proportions of hanging scroll paintings, and artists began making oversize scrolls and folding screens before gradually shifting to the large-format framed works still common at major *nihonga* exhibitions. Public and critical attention became focused on the works selected for exhibition and, among them, the artists who received awards. The ever controversial judging process prompted many artists to submit works calculated to win the approval of selection panels, which often became more conservative as the judges aged. From the late Meiji through early Shōwa periods, internal tensions within exhibiting groups led to periodic attempts at reformation and the emergence of new artist associations. Although indicative of the turbulent politics of the art world, these changes also reveal the vitality of the *nihonga* painting circles,

especially when compared to the relative stability of the major exhibition groups since the 1950s.

The first modern schools for teaching painting developed simultaneously with the changes in exhibition practice during the Meiji period. The Kyoto Prefecture Painting School (Kyōto-fu Gagakkō), founded in 1880, was followed by the Tokyo School of Fine Arts (Tōkyō Bijutsu Gakkō) in 1887 and the Japan Art Institute (Nihon Bijutsuin) in 1898.[9] Although each school had its own curriculum, they shared a desire to systematize the training process, including the introduction of some aspects of Western technique, in the hope of modernizing *nihonga* painting. Major artists also maintained their own schools (*juku*) into the Shōwa period, and students often continued their studies under senior painters well after their graduation from art school.

An awareness of certain Western attitudes toward training, technique, and exhibition catalyzed changes in Japanese painting practices within the context of *wakon yōsai* (Japanese spirit, Western learning). This attitude, pervasive among the forces promoting change in Meiji society, is most often related to social policy, yet the dilemma of how to preserve Japanese cultural identity in the face of large-scale adoptions from foreign cultures was widespread and still haunts artistic production in Japan. This problematic formulation was an updating of the *wakon kansai* (Japanese spirit, Chinese

learning) pattern that had preceded it during the Edo period.

THE EMERGENCE OF *NIHONGA*

As the practice of Western-style oil painting developed in mid-Meiji Japan, the term *nihonga* began to appear in art magazines to differentiate paintings in traditional media from those in oil. With the growing popularity of oil painting, the features held in common among the traditional groups of painters came to appear more significant than the issues that divided them, and the value of a collective term that would emphasize their role in a distinctly Japanese tradition was increasingly appreciated. By the early Taishō period (1912–26), dictionaries described modern paintings in traditional materials as *nihonga* and employed *seiyōga* (later abbreviated to *yōga*) for Japanese oil painting.[10] Artists occasionally critiqued this division, oil painters being especially keen to assert their status as Japanese artists. The question of national identity as represented by traditional versus Western media became so charged symbolically that the noted oil painter Umehara Ryūsaburō (1888–1986) went so far as to mix his oils from the ground minerals used in traditional painting. Although the division between *nihonga* and *yōga* became entrenched in art school training programs, and led to separate sections in national shows or even different exhibiting organizations as well as separate specialities for art historians, artists themselves were often more fluid, moving from one mode to another at different times in their careers or sometimes working in both materials simultaneously.[11] This flexibility appears to have been facilitated by an awareness that one's fundamental identity as an artist was not determined by medium. Curators and scholars, however, often focus on the predominant medium used by a painter while excluding discussion of works created with other materials.[12]

To understand the significance of the word *nihonga* as a means for asserting the Japanese character or spirit (*wakon*), it is important to consider the context of its usage. *Nihonga* developed as a term in Japan for a Japanese audience; it operates within the special cultural environment outlined above. From a foreign viewpoint, all painting done in Japan (including *yōga*) is, fundamentally, "Japanese painting" (the literal meaning of the *nihonga* term). It was from an internal need to preserve and express visual elements that were held to be quintessential to Japan as a culture and a nation that the *nihonga* term was developed and maintained. Just as the concept of "Japan" can develop in an international context only through cultural comparisons and contrasts that permit a definition of national "boundaries," the idea of a national painting that applies to only one part of Japan's artistic production can only be defined by considering *yōga* within the spectrum of Japanese painting practice. Thus, although the term arose in response to Westernization in the arts, it is critical to understand that it was coined for the internal vocabulary of the Japanese art world.

As an umbrella-like concept that focuses on issues of national character, *nihonga* is not a "style" among styles but a romantic movement of diverse art associations and individual artists intent upon the expression of aesthetics believed to be Japanese through the use of traditional materials. Although the primary stylistic references include *yamato-e*, Rinpa, *ukiyo-e*, the Maruyama and Shijō schools, and iconic Buddhist painting, *nihonga*'s sources are much broader than this list would suggest. *Nihonga* was often thought to exclude *bunjinga* (literati painting), which was deemed a Chinese convention, but this apparent rejection parallels the blind spot for the ancient Chinese blue-and-green landscape tradition that exists in the definition of *yamato-e* as *the* ancient Japanese landscape painting style. In fact, aspects of *bunjinga* and other Chinese-based tendencies, such as the sense of mist

and space found in Southern Song landscape painting, emerge in many *nihonga* works. Interestingly, as long as traditional pigments and brushes were employed, the influence of Western styles of brushwork, color, and treatments of form and space were more openly acknowledged because, often held to be more "neutral" features of the modern world, they were not so expressive of national characteristics. Furthermore, as elements of the modern world, they were necessary for the expression of modern sentiments, even those of a nationalistic nature. Indeed, the current Japanese practice of using aspects of a Western paradigm for communicating sentiments about Japan to a Japanese audience seems to be an updating of elements of the Chinese paradigm with which *bunjinga* artists had earlier conveyed Japanese sensibilities to the Japanese community. In this sense, *bunjinga* can be considered an application of *wakon kansai* (Japanese spirit, Chinese learning) to painting, and the addition of features of Western painting in *nihonga* as a kind of *wakon yōsai*.

Painters further emphasized the national character of *nihonga* by employing traditional pigments to produce classic themes, such as *hinode* (rising sun), Takasago (elderly couple beside a pine tree), *tachibina* (a couple portrayed as paper dolls), and other decorative motifs linked to specific times during the year. Because most of these themes employ rigid iconographies, art historians rarely discuss such paintings, yet their sale was a reliable means of income for painters, and they were the kind of painting most likely to be owned by the average household. Moreover, because *yōga* artists usually did not treat these archetypically Japanese themes, *nihonga* painters acquired status as literal preservers of Japanese motifs.

THE ROLE OF WESTERN INFLUENCE

The assimilation of aspects of Western painting into *nihonga* practices was consciously pursued from the Meiji period onward. In Japan's adaptation of

Western culture, even older features of the West (such as oil painting itself) were perceived in the context of modernization. Although introduced piecemeal during the Edo period, Western-style painting effects—the modeling of figures, apparent light sources, reduction or abandonment of outline, dramatizations of historical episodes, and genre scenes of everyday life—were prominent elements in the Meiji-period "modernization" of *nihonga*. Enthusiasm for these changes prompted Takeuchi Seihō (1864–1942; see cat. no. 64) to change the character *sei* used in writing his name to one that included the graph for "west" after his return from Europe in 1901.[13] Yet this passion for change was not intended to overthrow traditional culture but to revivify it as a viable part of contemporary Japanese life. Because Western learning was perceived within Japan as fundamental to modernism, the slogan "Japanese spirit, Western learning" (*wakon yōsai*) can be considered a form of conservative modernism. In this sense, the adaptation of some modern elements of Western painting practice was intended to preserve the significance of traditional painting.

This transition to conservative modernism appeared in various forms. For *White Heron on Willow* and *Crows and Persimmon* (pl. 111 a, b), Seihō employed a dramatic brushwork faithful to the Shijō-school interpretation of Buson's brushwork as transmitted by Shiokawa Bunrin, the teacher of Seihō's principal instructor, Kōno Bairei (1844–1895). The practice of placing birds against a chiefly blank gold background had been current for some centuries (as seen in the noted *Crows on Snowy Branches* by Unkoku Tōgan, 1545–1618), and Seihō's treatment is generally traditional. The flamboyant calligraphy of his large signature, however, reveals the bravura attitude common in artwork of the late Meiji period. The use of a blank background to silhouette the birds, although presented in this customary manner, was a key feature of many of Seihō's most popular works in the

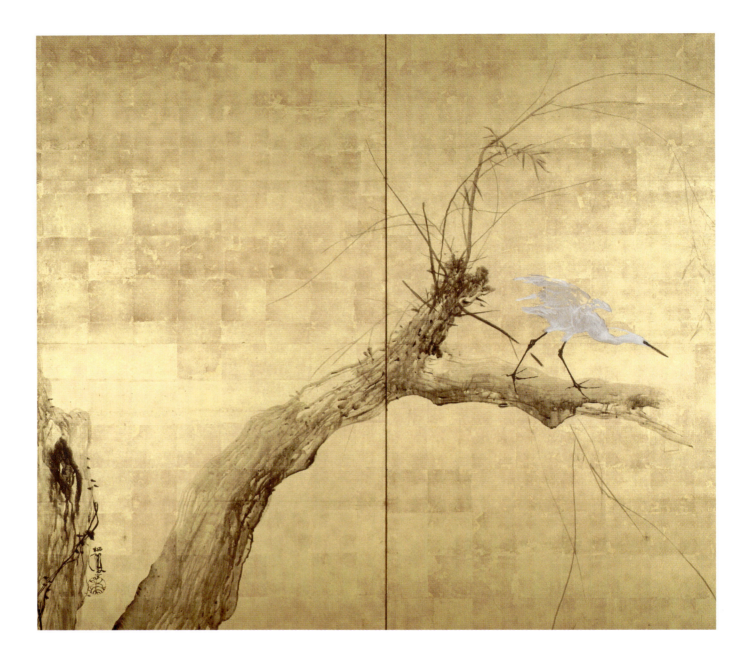

Pl. 111 a, b. Takeuchi Seihō. *White Heron on Willow* and *Crows and Persimmon* (cat. no. 64).

1920s and 1930s. This isolation of the key pictorial elements coupled with skillful, abbreviated brushwork and a small signature composed of elegant, angular strokes were to become hallmarks of Seihō's modern approach in the last decades of his life.

During the Taishō period the popularity of postimpressionism among both *yōga* and *nihonga* painters caused a shift in the nature of Western influence. In new *nihonga* groups like the Association for the Creation of National Painting (Kokuga Sōsaku Kyōkai), Meiji-period adaptations from the West directed toward literal depictions of objects and space were forsaken for expressive color, brush-

work, and form. This new attitude was encouraged by the likes of the sculptor, painter, and poet Takamura Kōtarō, whose essay "The Green Sun"[14] defended the right of painters to express a personal vision of the world even if it meant using the color green to depict the sun. *Nihonga* painters employed this expressive freedom: Nonagase Banka (1889–1964) boldly brushed a procession of naked fishermen in shades of red and orange in his *Fishermen Returning at Sunset*, shown at the third exhibition of the Association for the Creation of National Painting in 1920. Others moved toward surreal imagery. Kayukawa Shinji (1896–1949), for example, exhibited *Bewitching Shadow*, an image

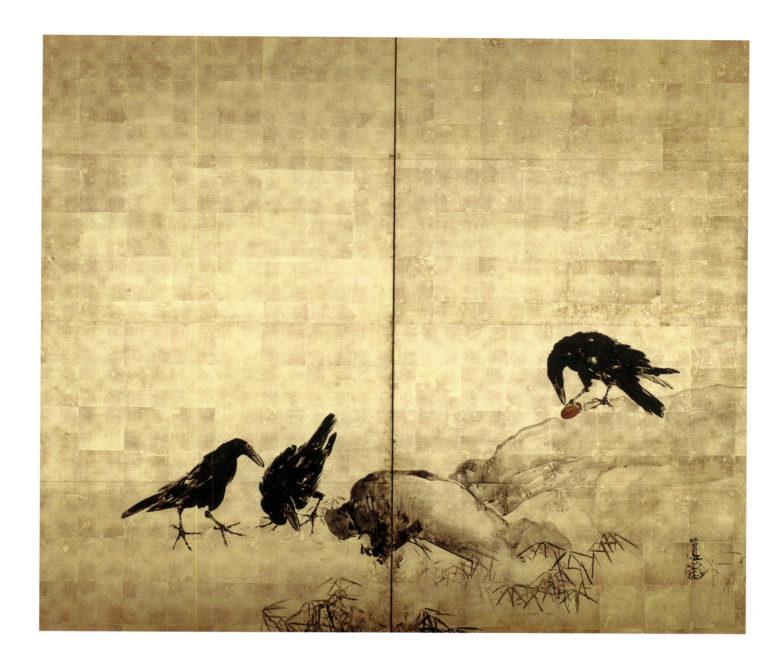

of a giant nude woman lying below the waters of
a mountain lake, at the fourth show of the same
group in 1924.[15]

THE ADVENT OF NEW CLASSICISM

By the early 1930s an increasingly conservative
social environment reacted against the individ-
ualist expressions of some *nihonga* painters of the
Taishō period, whose works were now considered
decadent. Clear pure colors, precise outlines, and
static compositions that rendered old themes in an
emotionally restrained iconic fashion, often called
"new classicism" (*shinkoten yōshiki*), became popular.
Artists such as Kobayashi Kokei (1883–1957)

and Tsuchida Bakusen (1887–1936) were promi-
nent in this move toward modernized classicism in
the early Shōwa period. Although sharing a desire
to glorify tradition, Kawabata Ryūshi (1885–
1966) led his Seiryūsha group toward emotionally
charged, boldly brushed paintings whose grand
scale would project a sense of monumentality in
large exhibition halls; his new interpretations of
ancient themes endorsed the rapidly developing
reactionary trends in 1930s Japan. A few unusual
painters, such as Kamisaka Sekka (1866–1942;
see cat. nos. 97–100), whose skillful Rinpa works
resemble those of Sakai Hōitsu (1761–1828; see
cat. nos. 90, 91),[16] pursued revivals of older styles.

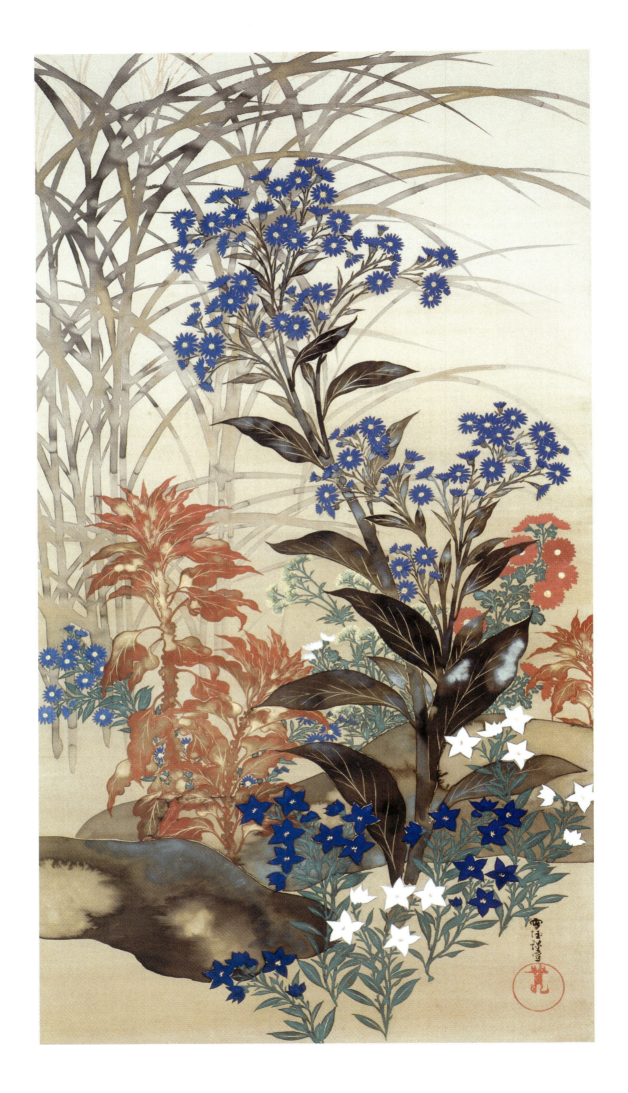

Pl. 112. Kamisaka Sekka. *Autumn Flowers and Grasses*
(cat. no. 100).

Sekka was trained in the Shijō school by Shiokawa Bunrin's disciple Suzuki Zuihiko (1848–1901), but he pursued an interest in decoration and applied arts as promoted by the Yamaguchi politician and patron Shinagawa Yajirō (1843–1900). Sekka embarked on the study of the Rinpa style in 1890 under the designer Kishi Kōkei (1840–1922). Eventually he became convinced that most forms of Japanese painting were overly indebted to China, and in 1919 he stated that to achieve a "pure *nihonga*" (*junsui na nihonga*), it was necessary to follow the methods of Ogata Kōrin.[17] Sekka's *Autumn Flowers and Grasses* (pl. 112) displays his skillful approach to Rinpa, which is technically very close to Hōitsu but with a richer, more complex layering than is typical in his precursor's work. Sekka's interpretation of the modernist search for a truly Japanese *nihonga* resulted in his advocating a rebirth of the traditional emphasis on brightly colored elegance as found in the Rinpa style.

As Japan entered ever more deeply into military actions on the continent during the period known as the Fifteen-Years War (1931–45), many *nihonga* painters turned to an extreme valorization of traditional themes of Japanese culture, including idealized treatments of historical military campaigns and forceful rulers of the past. The induction of *nihonga* painters alongside *yōga* artists as *jūgun gaka*, painters who accompanied the military, resulted in so-called *kirokuga*, or reportage painting. This instant historical painting (*rekishiga*) was intended to give current events on the battlefield the kind of iconic presence usually associated with re-creations of the ancient past. Dōmoto Inshō (1891–1975) directed the members of his painting school, the Tōkyūsha, to create a large series of folding screens whose themes were reflected in titles such as *Smoldering City Streets* (fig. 2) and *Victory Dance of the Ocean Eagles* (showing dive-bombers sinking an aircraft carrier).[18] Hashimoto Kansetsu (1883–1945) painted a colossal image of

the Buddhist icon Ryōmen Aizen Myōō hovering over soldiers firing weapons on the front line in China (fig. 3). This kind of painting, like the politics and social mood that inspired it, took the conservative modernism of the Meiji period to such extremes that it could well be labeled reactionary modernism,[19] in which modern technology is engineered to reconfigure Japanese society according to a hypothesized construction of the Japanese spirit (*nippon seishin*).

POSTWAR CONTINUITIES

The collapse of normal life after the Allied fire bombing and nuclear attacks on Japan, and the severe social problems that succeeded the surrender, led to a reconsideration of wartime activities. The more extreme features of the reactionary modernist embrace of the imagined purity of Japanese culture were suppressed during the postwar occupation. The valorizations of martial spirit and authoritarian rulers like Minamoto Yoritomo (1147–1199) and Toyotomi Hideyoshi (1537–1598) were gone. Yet the national Nitten exhibitions saw the return of the prewar themes of the *shinkoten* painters, who resumed the more moderate aims of conservative modernism that had been maintained from the Meiji period until the early 1930s. *Nihonga* works gained an ever greater resemblance to oil painting with the development of a rich impasto effect that was achievable with traditional pigments only on framed paintings that would never be folded or rolled. The 1950s saw the emergence of experimentation and powerful new forms of expression in the works of artists such as Yokoyama Misao (1920–1973), who initially created startling images like the 1956 *Smelting Furnace*, which employed rough sumi ink made from carbon scraped from a bathhouse chimney. Yet even Yokoyama, unable to escape artistic and social pressures, directed his work into more conventional channels at the height of his popularity near the end of his life.[20] Senior artists such as

Fig. 2. Domoto Inshō's Tōkyūsha painting school. *Smoldering City Streets* (Iburu shigai). Reproduced in Tōkyūsha, *Daitōa sensōga* (Greater East Asia war painting) (Tokyo: Fuzanbō, 1942).

Fig. 3. Hashimoto Kansetsu. *Ryōmen Aizen Myōō*. 1941. 308.0 × 173.6 cm. Reproduced in *Seisen youn* (Inexhaustible sacred war) (Kyoto: Hashimoto Kan'ichi, 1939).

Higashiyama Kaii (1908–1999), whose slightly abstracted views of mountains, forests, and seashores represented the essence of *nihonga* painting to the general public, continued to dominate the major exhibitions.

ZENGA IN THE MODERN ERA

Because Zen priests operated outside the milieu of painting solicitations and competitive exhibitions, they continued the traditional practices of painting and calligraphy, seemingly unaffected by trends in the broader art world. Regarded as an untutored folk art or religious practice more than art, Zen painting and calligraphy from the mid Edo period to the present has been largely ignored by art historians in Japan. The studies that do appear are usually written by scholars of religion or calligraphy. The enthusiasm of some American and European collectors and museums for the works of selected monks has begun to prompt an art historical reevaluation of these works in Japan.[21]

It is useful to consider that the term "Zen" can have three separate, yet often overlapping meanings in reference to painting. The first category would define Zen painting as any work made by a Zen priest. A second would define Zen painting as any made with a recognized Zen theme (e.g., Daruma, koan themes, *ensō* circles). A third conception would define Zen painting as any work that manifested a Zen aesthetic. This last is the most slippery, yet the formulation of a Zen aesthetic, especially as regards untutored directness in brushwork, has been enough to encompass works by the Shingon monk Jiun Sonja (1718–1804; see cat. no. 128) and the statesman Yamaoka Tesshū (1836–1888), among others, in the category

of Zen-related artwork.[22] These conceptions of Zen painting can be imagined as three overlapping circles arranged in a triangle. A specific work could fall within any one of the three definitions, or any combination of two definitions, or all three simultaneously. A painting of Daruma by Hakuin Ekaku (1685–1768; cat. no. 120) fulfills all three categories by being a work created by a Zen priest on a Zen theme and employing a Zen aesthetic. Yet a Taiga-style colored landscape by the Ōbaku Zen priest Aiseki (act. early nineteenth century) would be included only in the first category, a work created by a Zen monk. A Western-style painting of Daruma by a secular artist (sometimes created in Nagasaki) would fit only the second definition. An abbreviated ink landscape by a Kanō school painter would fit the Zen aesthetic category, yet a depiction of Daruma by the same artist would fit both the second and third definitions. Awareness of these distinct approaches to the definition of Zen painting and calligraphy can help clarify discussions of Zen-related artwork.

So-called *zenga*[23] most often includes all three meanings as the term is usually applied to the untutored, didactic works of Zen priests from the Edo period onward. The career of the Zen priest Nakahara Nantenbō (Tōjū Zenchū, 1839–1925, fig. 4) exemplifies the situation of *zenga* in the early twentieth century. Like many of the noted Zen monks who preceded him, Nantenbō was a prolific producer of *zenga*; he once claimed to have created more than 100,000 calligraphies and paintings.[24] Recently discovered notebooks in which Nantenbō recorded requests for calligraphies and paintings, including the titles desired and names of the patrons, allow a detailed look into his artistic output (fig. 5).[25] Although prices are not listed, a note at the end of the first book ("*kane ichi en*") suggests that the anecdote in which Nantenbō states he received one yen for each work is true.[26] In some cases the theme of the work was left open, yet the request frequently specified the text, topic,

Fig. 4. Nantenbō writing calligraphy at Kaiseiji for the General Nogi stela planned for Kobe. Reproduced in *Chinki shashinshū* (Album of novel photographs) 2, no. 3 (March 1915).

Fig. 5 a, b. Cover and first page of Nantenbō's notebook, *Nantenbō rōrō kigō i seimei haku chō* (Small album of those requesting Nantenbō's playful works). Hakutakuan collection, Seattle.

size, and format. Lay individuals made the majority of the orders, although the names of requesting monks and temples are scattered throughout the notebooks. Due to its didactic nature, the initial importance of *zenga* depended on the meaning of the text and image, coupled with the esteem accorded the priest who created it. The quality of the calligraphy and compositions found among the large output of priests like Nantenbō varied greatly, with those having the most arresting brushwork being much appreciated and sought after, while weaker works were largely ignored. As Nantenbō's fame increased, requests for his work skyrocketed; the notebook for six months of 1912 is equal in size to an earlier one that covered six years.

Paintings of Daruma are frequently inscribed with various sayings attributed to the Indian monk Bodhidharma (d. 528, J. Daruma). Many were selected from the account of Daruma meeting the Liang emperor Wudi which forms the first of the hundred anecdotes presented in the Chinese collection *Biyanlu* (J. *Hekiganroku*).[27] On his many paintings of the monk (cat. no. 120), Hakuin most commonly inscribed the phrase "pointing directly at the human heart/see one's own nature and become a Buddha," which appeared in Yuanwu Kedong's (1065–1135) commentary to the primary account by Xuedou Zhongxian (980–1052), compiler of the *Biyanlu*. It became the most common inscription on *zenga* Darumas (see Suiō's version of it, cat. no. 127). Nantenbō frequently employed "Vast emptiness, nothing sacred," the reply

Daruma gave when the emperor asked, "What is the first principle of the sacred Truth?" Nantenbō's *Half-body Daruma* in the Gitter-Yelen collection (pl. 113), however, is inscribed with Daruma's two-character response "Don't know!" to the emperor's next question, "Who is facing me?"

Daruma *zenga* images from the mid-eighteenth century to the present move from the massive brushwork and gravity of Hakuin's images to increasingly comic treatments such as the quizzical expression of Nantenbō's depictions. Although the *manga*-like imagery of later *zenga* is sometimes taken as evidence of a slackening of the Zen spirit, it may instead be an attempt to freshly confront and deflate the viewer's expectation of an impressive, iconic image. The contrast between the sidelong glance of the seemingly puzzled Daruma and the powerful brushwork of "Don't know!" (*fushiki*), coupled with the explosive stroke used for Daruma's robe, challenges the viewer who may not "know" this Daruma.

Although differing over time in brush style and aesthetic impact, the practice of *zenga* in its religious context has changed little since the time of Hakuin, who first established a wide following for the form. With few exceptions, the creation of *zenga* remained unaffected by the larger art world and vice versa. Only in the context of the expressionist calligraphy and painting of the 1950s and 1960s did Zen works have a significant impact

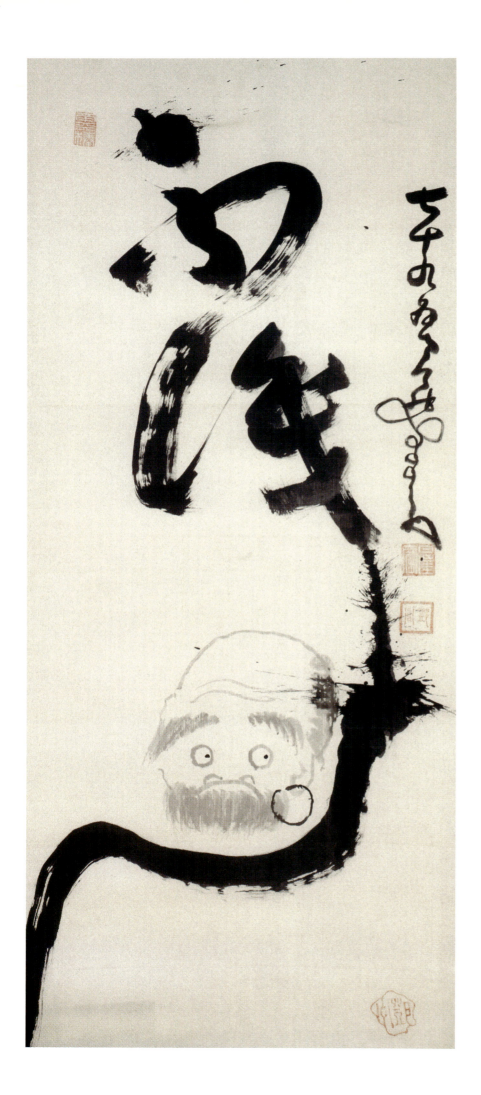

on artists such as Morita Shiryū (b. 1912), who helped popularize the works of Nantenbō and other Zen priests through articles in his journal of calligraphy, *Bokubi*.[28] Even though the postwar art world increasingly ignores Japanese calligraphy, the production of *zenga* continues because its origin as a religious practice binds priests and parishioners, and it is not dependent on exhibitions or critical success.

INDEPENDENT ARTISTS

The supportive, yet restrictive world of the major painting associations and competitive exhibitions largely determined the direction of most Japanese painters in the twentieth century. Yet even in the prewar period, a variety of painters stayed clear of these organizational networks, depending on patrons and the occasional independent exhibition for their livelihood. Fukuda Kodōjin (1865–1944) provides an interesting example of this atypical approach to painting. First appearing under the pen name Haritsu as a *haijin* poet in the circle around Matsuoka Shiki (1867–1902), Fukuda later developed a career as a literati painter using the name Kodōjin.[29] Although he lived on a modest income for most of his life, Kodōjin had acquired a powerful patronage group by the early 1930s. Among his supporters were Kuhara Fusanosuke (1869–1965), a wealthy industrialist who backed right-wing causes in the 1930s; Nakagawa Kojūrō (1866–1944), who helped found Ritsumeikan University; and the noted scholar of Chinese culture Naitō Kōnan (1866–1934).[30] In the early 1930s this group supported an exhibition at Mitsukoshi department store where Kodōjin's works were priced from 100 yen, for small scrolls, to 5,000 yen, for a pair of folding screens. Although he took a difficult and uncertain path for a painter, Kodōjin's career not only proves the high esteem given literati painting in prewar Japan but demonstrates that a measure of success was possible for a persistent artist who

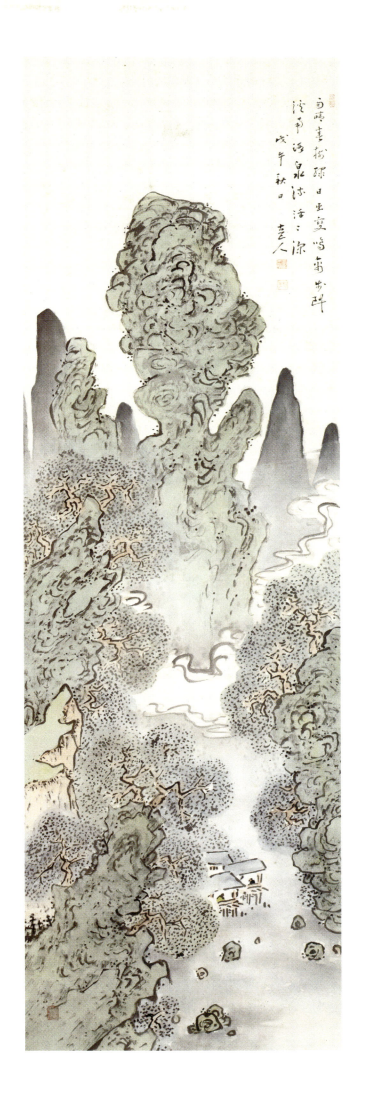

Pl. 114. Fukuda Kodōjin. *Landscapes of the Four Seasons* (cat. no. 53).

refused the usual pattern of membership in groups and participation in competitive shows.

Kodōjin's 1918 *Landscapes of the Four Seasons* (pl. 114) is unusually impressive among his works, which include few such sets of scrolls. The splendid quality of the mountings demonstrates that Kodōjin had already achieved a high level of patronage at this comparatively early stage of his career. Rough, vigorous brushwork and freely applied color are found in his work of this period; later paintings often have softer, more fluid brushstrokes in increasingly complex compositions. The tradition of eccentricity in Japanese literati painting nurtured an appreciation for the fantastic mountain shapes and unusual rocky cliffs seen in these landscapes. That Kodōjin's wealthy and prominent supporters so appreciated the free spirit of the poetry and painting of this comparatively unheralded artist seems ironic, yet the social necessities of aristocratic life may have generated a longing for such idealized, otherworldly vistas.

NIHONGA TODAY

In the contemporary art world in Japan, public museums are filled every spring and autumn with the large-scale exhibitions put on by the major art associations, and the works of leading members still attract the attention of the press and command impressive prices. But many art schools today regard the Nitten, Inten, and other major exhibiting organizations as institutional relics that are obstacles to new developments in artistic expression. Younger generations of *nihonga* painters are experimenting with original uses of traditional materials and are attempting to find other avenues for developing their careers and funding their work. Occasionally, as in some of the works of Aida Makoto (b. 1965),[31] twentieth-century *nihonga* is satirized. More and more artists are working with multimedia in a manner that renders meaningless the traditional divisions between *nihonga*, *yōga*, and sculpture.

The fundamental question raised by the term *nihonga*—how to make a viable contemporary painting that is identifiably Japanese—remains even today. Some artists have resorted to garnering reputations in Western countries as a way of gaining attention within Japan. Although circumventing the internal barriers of the Japanese art world, this practice runs the risk that the artist will conform to either of the two main overseas attitudes toward Japanese art: a nostalgia for the themes and skills of tradition or, conversely, a desire for startling, new avant-garde forms. The market power and critical authority of Western countries make the production of art for a global audience a far from equitable endeavor, and artists who reject specific cultural identification run the risk of assimilation into the nearly worldwide institutionalization of Western standards. Diverse forms of cultural expression might simply disappear, like so many endangered species, under the exportation and adoption of Western-based sensibilities around the globe. The interaction of national sensibilities and foreign attitudes that plays on Japanese culture, plus the great attention given the arts, make Japan an interesting test of the possibilities for a contemporary art that expresses distinctive aspects of the culture that supports it.

NOTES

1. I intend the term "cultural environment" to emphasize the idea of culture as a relational process wherein the addition of a new element affects the whole. Culture in this sense is seen as an organic process that is in continual flux, with cultural traits resembling rivers whose contents are in motion and whose channels change over time, like the shifting twists of riverbeds. In this way, cultures cannot be understood through lists of characteristics that are simply added to or subtracted from, for each change has an impact upon the whole.

2. A membrane generated by the contact of two substances can be seen in the physical world when a dicarboxylic acid is poured into a beaker of diamine; a membrane of nylon forms at the point of contact between the liquids. In this metaphor of a membrane between contacting cultures, the membrane is likewise generated by the properties of both cultures.

3. Japanese cinema, *anime*, and architecture stand out as areas that are close to achieving a real dialogue of back-and-forth interchange with foreign cultures, although in-depth knowledge of Japanese cinema is rare even among foreigners who specialize in the topic.

4. *Bakuhan*, a contraction of *bakufu* and *han*, represents the combination of national and local rule during the Tokugawa period.

5. The meaning and development of literati painting are considered in greater detail in my essay "The Relation of Japanese Literati Painting to *Nihonga*," in Michiyo Morioka and Paul Berry, *Modern Masters of Kyoto: The Transformation of Japanese Painting Traditions* (Seattle: Seattle Art Museum, 1999), 32–39.

6. Two of these exhibitions are described based on the contents of extant catalogues in Aimi Shigekazu, "Higashiyama shogakai" (The Higashiyama exhibitions of calligraphy and painting), *Shoga kottō zasshi* 88 (September 1915): 2–9. The organizer, Minagawa Kien (1734–1807), although nominally a student of Ōkyo's, derived his wide following in literati circles from his position as a noted Confucian scholar.

7. These memorial exhibitions often included works by the friends and disciples of the deceased painters.

8. See the essays on these groups by Harada Heisaku and Satō Dōshin in Ellen Conant et al., *Nihonga: Transcending the Past* (Saint Louis: Saint Louis Art Museum, 1995), 76–79.

9. See Michiyo Morioka's "The Kyoto Prefecture Painting School," in Morioka and Berry, *Modern Masters of Kyoto*, 24–26, and several relevant essays on the Tokyo schools in Conant, *Nihonga*.

10. See my essay, "The Origins of the Term *Nihonga*," in Morioka and Berry, *Modern Masters of Kyoto*, 19–20, and the extensive studies of Kitazawa Noriaki, "'Nihonga' gainen no keisei ni kansuru shiron" (A personal view of the formulation of the concept of "nihonga"), in Aoki Shigeru, ed., *Meiji nihonga shiryō* (Tokyo: Chūō Kōron Bijutsu Shuppan, 1991), and Satō Dōshin, "*Nihon bijutsu*" *tanjō: Kindai Nihon no "kotoba" to senryaku* (The birth of "Japanese art": Strategies of "terminology" in modern Japan) (Tokyo: Kōdansha, 1996).

11. Among the painters who worked with both media are Tamura Gesshō (Sōritsu, 1846–1918), Kosugi Hōan (Misei,

1881–1964), Yorozu Tetsugorō (1885–1927), Kishida Ryūsei (1891–1929), Ishii Hakutei (1882–1958), Fujita Tsuguji (1886–1968), and Suda Kunitarō (1891–1961).

12. This tendency is gradually disappearing as recent retrospective exhibitions have attempted more inclusive surveys of artists' careers. The continuing distinction between the study of yōga and nihonga in academia, however, has resulted in many scholars being deeply knowledgeable in one area while remaining comparatively untutored in the contemporary careers of artists working in the other. This pattern of mutual exclusiveness has hampered the development of a comprehensive history of twentieth-century Japanese painting.

13. The general meaning of both sei characters is the same; Seihō's name can be interpreted as "nesting phoenix."

14. Published the year after Takamura returned from an extended sojourn in Europe, the essay was originally titled "Ryokushoku no taiyō" in the journal Subaru (April 1910), reprinted in Gendai shi yomihon Takamura Kōtarō (Tokyo: Shichōsha, 1985), 204–7, and translated as "A Green Sun" in Takamura's A Brief History of My Imbecility (Honolulu: University of Hawaii Press, 1992), 180–86. Although Takamura's essay is about recent trends in yōga painting, his defense of freedom of individual expression in painting applies equally well to the new trends in nihonga.

15. Kyōto Shinbunsha, Kindai nihonga no kakushin to sōzō— Kokuga Sōsaku Kyōkai no gakatachi ten (Innovation and creation in modern nihonga—Exhibition of artists of the Association for the Creation of National Painting) (Kyoto: Kyōto Shinbunsha, 1997), pls. 4-3 and 11.

16. Sakakibara Yoshirō's Kindai no Rinpa Kamisaka Sekka (Modern Rinpa Kamisaka Sekka) (Kyoto: Kyōto Shoin, 1981) shows several aspects of Sekka's work in different media. Technically excellent yet conservative in his larger paintings, Sekka was innovative in smaller works and designs, which were the principal focus of his career, that attempted to elevate the status of illustration and design (zuan).

17. Kamisaka Sekka, "Shumi no kakumeika toshite no Kōrin" (Kōrin as the revolutionary of taste), Geien 2, no. 2 (February 1919), quoted in Sakakibara, Kindai no Rinpa, 295.

18. These works are pls. 7 and 12 among the twelve screens published in color in the folio, Tōkyūsha, Daitōa sensōga (Greater East Asia war painting) (Tokyo: Fuzanbō, 1942).

19. This term is adapted for use in a Japanese context. Jeffrey Herf employed the concept in his analysis of Germany in his Reactionary Modernism: Technology, Culture, and Politics in Weimar and the Third Reich (Cambridge: Cambridge University Press, 1984).

20. The evolution of Yokoyama's work is clearly seen in the retrospective exhibition catalogue, Tōkyō Kokuritsu Kindai Bijutsukan, Yokoyama Misao ten (Tokyo: Tōkyō Kokuritsu Kindai Bijutsukan, 1999). The collecting activities of large corporations and wealthy individuals who preferred conservative works drove the market for high-priced works by noted painters, even those known for their individuality.

21. See the reevaluation advocated in Yamashita Yūji, ed., Zenga—Kaettekita zenga (Zenga—The return of zenga) (Tokyo: Asano Kenkyūjo, 2000).

22. This "untutored character" ranges from the powerful, often massive and monumental qualities of Hakuin's major works to the loosely brushed whimsy typical of Sengai's (1750–1837; see cat. nos. 134, 135) paintings. Even though the aesthetic categories proposed by Hisamatsu Shin'ichi in his Zen and the Fine Arts (Tokyo: Kōdansha International, 1971) can be critiqued, they represent qualities commonly associated with the idea of Zen aesthetics.

23. This term was popularized in the postwar period.

24. Matthew Welch, The Painting and Calligraphy of the Japanese Zen Priest Tōjū Zenchū, Alias Nantenbō (Ann Arbor, Mich.: University Microfilms, 1995), 112. This work remains the most detailed study of the priest in English, although Welch's chapter on Nantenbō in Audrey Seo and Stephen Addiss, The Art of Twentieth-century Zen (Boston: Shambala, 2000), is more readily accessible.

25. Coming to light in early 2002, the first notebook, titled Nantenbō rōrō kigō i seimei haku chō (Small album of those requesting Nantenbō's playful works), includes the period from the end of the seventh month of 1900 through the beginning of the ninth month of 1906. Another notebook, titled Dai san gō Nantenbō kigō seimei ki (The third record of names of those requesting Nantenbō's works), covers 1912 from January until the middle of the seventh month.

26. Welch, Painting and Calligraphy, 144. At the time, the yen was a silver coin the size of the U.S. silver dollar.

27. Consult the translations and commentaries given in Thomas Cleary and J. C. Cleary, trans., The Blue Cliff Record (Boston: Shambala, 1992), 1:1–9, and Iriya Yoshitaka et al., eds., Hekiganroku (Tokyo: Iwanami Shoten), 1:35–53.

28. For an examination of Morita's influence, see Hyōgo Kenritsu Kindai Bijutsukan, Morita Shiryū to "Bokubi" (Morita Shiryū and "Bokubi"), exh. cat. (Kobe: Hyōgo Kenritsu Kindai Bijutsukan, 1992).

29. See the detailed treatment of Kodōjin's life and poetry in Stephen Addiss and Jonathan Chaves, Old Taoist: The Life, Art, and Poetry of Kodōjin (New York: Columbia University Press, 2000).

30. Kokufu Shutoku, Kodōjin shushi (A viewpoint on Kodōjin) (privately published broadside, 1928). This aspect is discussed in greater detail in my commentary on Kodōjin's work; see Paul Berry and Yokoya Ken'ichirō, Unexplored Avenues of Japanese Painting (Ōtsu: Ōtsu City Museum of History; Seattle: University of Washington Press, 2001), 191–92.

31. See Aida's Azemichi (A path between rice fields), from 1991, which parodies Higashiyama Kaii's 1950 Michi (The way), and Inu: Setsu, getsu, ka (Dog: Snow, moon, flowers), from 1996–98, which satirizes nature triptychs, in Aida Makoto, Aida Makoto sakuhinshū (Collected works of Aida Makoto) (Tokyo: Mizuma Art Gallery, 1999).

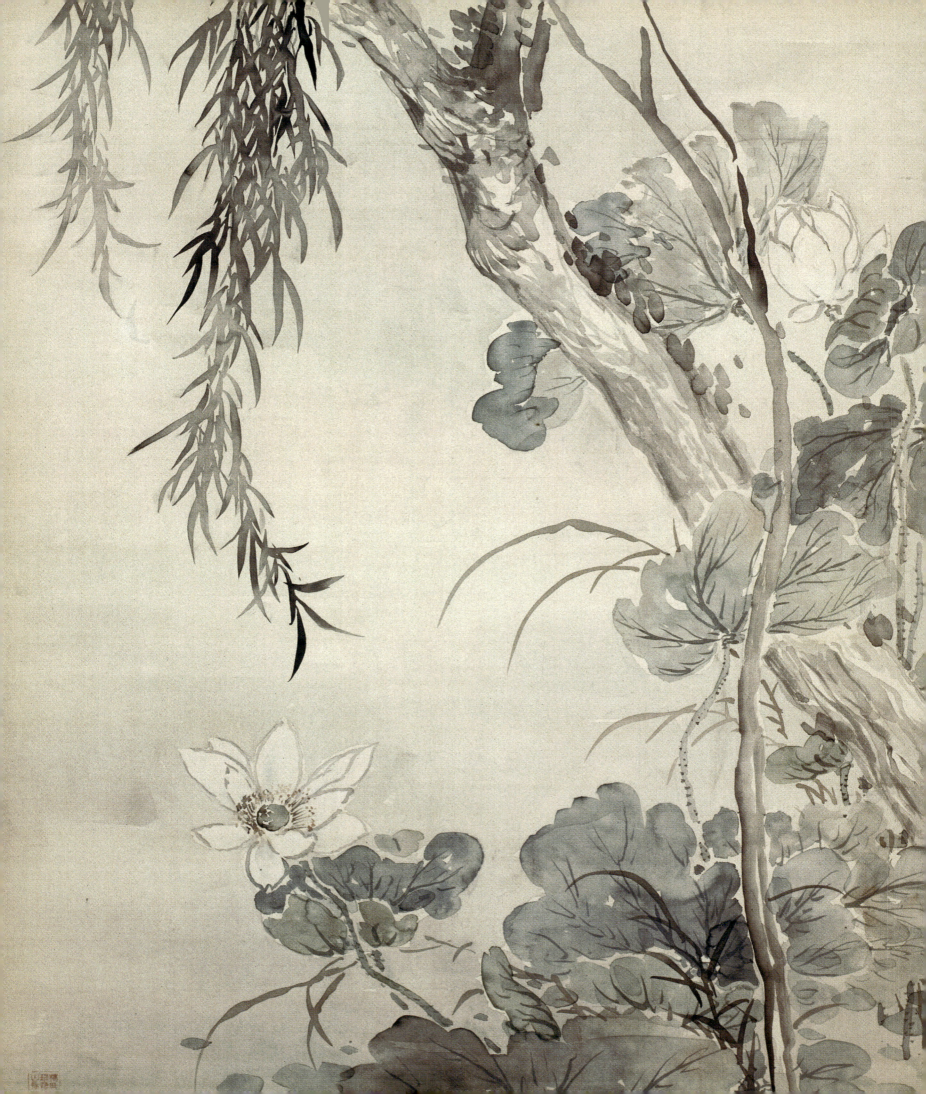

Christine M. E. Guth

Nanga and Zenga in America

1956 to 1976

> The history of art is not the same thing as the history of taste, but the two may be conceived as existing in an elegant helical arrangement, intertwined with a third history—the history of perception itself.
>
> —James Fenton

NANGA AND ZENGA, TWO GENRES OF JAPANESE PAINTING THAT ARE PARTICULARLY well represented in the Gitter-Yelen collection, and other American collections formed in the 1960s and early 1970s, are in many ways emblematic of the postwar embrace of Japanese culture. Between 1963, when Dr. Gitter bought his first painting by Sengai Gibon (1750–1837), and 1976, when the first exhibition of his collection was held, he amassed more than seventy *nanga* and *zenga* paintings (fig. 1).[1] During the same period, many American museums and private collectors, including Stephen Addiss, Joe Brotherton, Avery Brundage, Mary Burke, Peter Drucker, and John Powers, also were acquiring paintings by literati and Zen monk-painters.[2] Not all American collectors of Japanese art at that time were uniformly receptive, and none bought exclusively in these areas. *Nanga* and *zenga* were but two genres within the broad spectrum of schools and styles they admired, but these stand out because neither had found much favor among prewar Euro-American collectors. How and why did *nanga* and *zenga*, products of very specific and limited contexts of Edo-period Japan, become accessible to twentieth-century American viewers? To answer these questions, we must look broadly at the sociocultural and political mechanisms of the international art world at the time. Although the epigraph by James Fenton addresses changing tastes in European painting, it also aptly characterizes the postwar American trajectory of *nanga* and *zenga*.[3]

Francis Haskell, whose posthumously published *The Ephemeral Museum* was the subject of Fenton's review, has shown that every aesthetic system is bound up with events and conditions that appear to have little relation to art but which may have to be disrupted before any change in perception becomes possible. World War II was such a disruption, unleashing many forces that had an impact on receptivity to Japanese art. The existential crisis precipitated by the horrors of the war led many in the West to question the values of their own culture and to find new insights in those of Asia. After the war, Europeans and Americans, who had been bombarded by wartime propaganda depicting the Japanese as barbarous, bellicose fanatics, learned of other aspects of the nation's character and discovered the richness of its traditional culture. At the same time, the postwar economic boom gave Americans new self-confidence as both consumers and producers of culture. Modernism, and especially the advent of abstract expressionism, the first internationally acclaimed form of avant-garde art to arise in the United States, altered visual expectations for all forms of artistic expression. Developments in poetry, music, and film also brought new perspectives on Japanese culture. Even the political realignments of the Cold War, in which Japan was transformed from enemy to ally in the battle against communism, played a role in promoting

Pl. 115. Tsubaki Chinzan. *Lotus Leaves and Willow Tree in Moonlight* (detail, cat. no. 45).

203

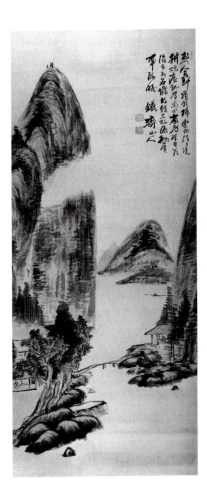

Fig. 2. Tomioka Tessai. *Landscape.* Hanging scroll: ink and color on silk, 49⅜ × 19⅞ in. Seattle Art Museum, Eugene Fuller Memorial Collection (60.68). The museum acquired this painting in 1960.

States.[13] For Abbot Sakamoto, the show provided international validation for his having amassed the largest collection of Tessai's work in Japan on behalf of his charismatic religious movement. His aim in forming this collection, he declared, had been to make the mountain on which the temple Kiyoshi Kōjin Seichō was located "into a shrine of art as well as a sanctuary of the faith."[14] Diplomatic and political motives underlay the participation of various governmental organizations. Japan had a long tradition of using art for self-presentation abroad, and American museums, eager to promote better relations between the two countries, were willing partners in such ventures.[15] Toward that end, Sakamoto was even invited to do a broadcast to Japan via the Voice of America.[16]

But what did the public make of it? Despite the enormous publicity it generated, it is hard today to assess the show's impact. The invitation to the opening at the Seattle Art Museum, declaring it "an exhibition of Classical Japanese Literati painting," shows that even scholarly understanding of the artistic context from which Tessai emerged was still limited.[17] There were feature articles in magazines ranging from *Time* to *Apollo*, and local newspapers throughout the tour published reviews with varying degrees of understanding.[18] Art critics on the East and West Coasts interpreted the show in terms of what they already knew and liked. Alfred Frankenstein of the *San Francisco Chronicle* showed off his knowledge of Japanese art by drawing an analogy between Tessai and Hokusai: both were "old men mad about painting." He also praised the freedom and vigor of Tessai's brushwork. "Sometimes," he wrote, "he approached sheer abstraction. Jackson Pollock would have loved the grand splash that appears everywhere on his later scrolls."[19] Because the exhibition included some paintings with Zen themes, such as Zen Master Feng-gan (J. Bukan) on a Tiger, a number of reviewers identified Tessai with this religious movement. George McCue

characterized Tessai as "one of the greatest modern Japanese painters . . . steeped in traditional painting styles and the paradoxical philosophy of Zen Buddhism."[20] This visual linkage of *nanga*'s aesthetic of amateurism and spontaneity with that of Zen is not surprising since Zen was then Japan's most familiar cultural export.

There may be some truth to the claim made in a 1965 monograph "that with the exception of the celebrated *ukiyo-e* artists, it is quite probable that there is no Japanese artist who is as well known and admired abroad as Tessai." But this did not necessarily lead American collectors or museums to want to acquire his paintings.[21] Tessai was so highly esteemed in Japan that perhaps Western collectors and curators were not shown his finest work, or perhaps it was too expensive in relation to that of other *nanga* artists.[22] Most of those paintings now in American collections, including twelve in the Museum of Fine Arts, Boston, were gifts from Sakamoto, but a few purchases were also made (fig. 2).

Despite the fact that few American collectors of Japanese art seem to have warmed to Tessai, the two highly publicized, traveling shows of his work undeniably helped to introduce *nanga* and, by linking it to modernist art, made it attractive to collectors. Both Kurt Gitter and John Powers came to *nanga* (and *zenga*) after having collected modern art.[23] Without these successful shows, moreover, it is unlikely that James Cahill would have launched a third, more scholarly venture into the realm of *nanga*, nor would Calvin French have followed two years later with the more narrowly focused *The Poet-Painters: Buson and His Followers* (1974).[24] While Cahill's *Scholar Painters of Japan* (1972) drew primarily from Japanese collections, by 1976 French was able to assemble a selection of sixty-five paintings borrowed for the most part from collections in the United States.

Like *nanga*, *zenga* took on a life of its own in the United States as part of a postwar trend with

roots in the early twentieth century, but its cultural impact and appeal to collectors were far broader. Although *zenga* had enjoyed only limited favor in Japan in the years before and immediately after the war, exhibitions of works belonging to two influential Japanese collectors—Idemitsu Sazō (1885–1981), an industrialist, and Hosokawa Moritatsu (1883–1970), a member of the hereditary aristocracy—helped to present Sengai and Hakuin abroad as important Japanese artists.[25] The discerning eye of these collectors was later validated when Sengai and Hakuin achieved worldwide acclaim following exhibitions throughout Europe.[26]

The first U.S. exhibition of Sengai's work, held in Oakland, California, in 1956 as part of a Japanese cultural fair, was modest, comprising only twenty-three paintings from Idemitsu's collection. The identities of the organizers are unknown, but the introductory words by Asahina Sogen, the abbot of Enkakuji, who had visited the United States in 1954, suggest that the show came about through the efforts of the American Zen community, which was well represented in the San Francisco area. Some students of Zen would have already been familiar with Sengai's work and may have been collecting it themselves, since by 1953 the Zen Institute in New York had a collection of Zen paintings.[27]

It was perhaps to support appreciation of Sengai's sketchy and often humorous paintings as Japanese fine art that the catalogue was prefaced by a characterization of the artist's work by Wada Sanzō (1883–1967), a Western-style painter, professor at Tokyo School of Fine Arts (Tōkyō Bijutsu Gakkō), and member of the Japan Art Academy (Nihon Geijutsuin). In his view, Sengai's "earliest brushstrokes seem at first reminiscent of the Chinese Southern School [*nanga*]," although in the end he was a "master of a brush all his own."[28] It is difficult to justify classifying Sengai as a *nanga* artist, but this effort to situate him—perhaps on

the basis of his artistic nonconformity—reveals the importance Wada attributed to identifying the monk-painter within a known Japanese school. It also suggests the degree to which *nanga* had become a catch-all for artists whose themes and styles defied easy definition within other schools.

There was little fanfare surrounding the Oakland show, since it was privately sponsored and did not travel, and little evidence of how the public responded to it. The situation was quite different when a larger exhibition of works by Hakuin and other Edo-period monk-painters toured Europe in 1959–60.[29] Kurt Brasch, a German collector residing in Japan and an early Hakuin enthusiast, organized it with his brother Heinz. Many of the paintings were from the Hosokawa collection. Yamashita Yūji, in a recent essay, has credited Kurt Brasch with coining the term "*zenga*," now widely used to classify the work of Edo-period Zen monk-painters and calligraphers.[30] The European genesis of this Japanese term is symptomatic of the global context in which taste for paintings by Sengai, Hakuin, and other Edo Zen monk-artists developed, and of the important role of the private collector within it.

Nanga was appreciated by American collectors before much was understood about its origins in China or its trajectory in Japan. Until 1972, when *Scholar Painters of Japan* appeared, most collectors depended on dealers for information about the artists and subjects of the work they saw.[31] Lacking linguistic training or knowledge of Chinese and Japanese art history, collectors recognized the idiom of *nanga* artists as a formal language not entirely devoid of content, but for most, that content as yet remained largely undecipherable. Zen art, however, had been reproduced and discussed since the 1920s in Western-language publications by D. T. Suzuki, Arthur Waley, Alan Watts, and others. Suzuki, following the Kyoto philosopher Nishida Kitarō, promoted the image of Zen as a direct, unmediated form of experience

that was uniquely Japanese. This nationalistic thread continued to run through Hisamatsu Shin'ichi's influential *Zen and the Fine Arts* (English translation, 1971), which presented Zen as the source of Japan's unique aesthetic sensibility.[32] Such writings were instrumental in creating an appreciative audience for the reception and interpretation of ink monochrome painting, the tea ceremony, garden design, and Noh theater within the context of Zen art.

Suzuki's role in making "Zen" and "Zen art" household words in the United States during the 1950s and 1960s cannot be overstated. He published prodigiously in English, taught for some years at Columbia University, and in 1957, when he contributed an article on Sengai and Zen art to the *Art News Annual*, he had just been the subject of articles in both *Vogue* and the *New Yorker*.[33] A magnetic public speaker, he attracted audiences of widely varying backgrounds. Between 1952 and 1955, he gave frequent lectures in New York that were attended by, among others, the composer and visual artist John Cage, the painter Ad Reinhardt, and the gallery owner Betty Parsons.[34] These were only a handful of the many American artists in the 1950s whose lives and art, accurately or not, were said to have been informed by Zen. This outspoken enthusiasm for Zen in turn led reviewers to liken the gestural spontaneity common to many members of the American avant-garde to the direct emotional experience of Zen. Action painting, performance art, compositions that combined word and image, or works that seemed to have "calligraphic" qualities were all invested with Zen meaning.[35] The Zen fad was not limited to the art world, of course, but spread to poetry, music, theater, film, and even psychology. For some, Zen offered an alternative spirituality; for others, an alternative to psychoanalysis. What most of its enthusiasts had in common was the disdain for convention conveyed in Jack Kerouac's

1957 and 1958 bestsellers *On the Road* and *Dharma Bums*.

The Zen boom of the 1950s and 1960s led many American collectors—it is difficult to know their identities or numbers—to acquire examples of the work of Hakuin, Sengai, and their followers. The range and quality of works available, as well as their still relatively modest cost, were no doubt factors in their appeal, but the spirit of the times also contributed to collectors' receptivity. Zen was in the air in 1963 when Sylvan Barnet and Bill Burto, collectors who would later focus on Buddhist art of earlier eras, bought from the New York dealer Mathias Komor *Chrysanthemums*, their sole painting by Sengai, as well as a painting by Tōrei Enji (1721–1792).[36] For John Powers, the former president of Prentice-Hall Publishing, collecting the work of Japanese and American artists whom he saw as unorthodox and individualistic represented an "ideological rebellion against corporate America and the conformist way of life [it] demanded."[37]

Even as American collectors were captivated by *zenga*, most Japanese scholars and collectors remained dubious of its artistic value. As Yamashita observed, the popular monthly *Nihon no bijutsu* (Arts of Japan) series, a useful barometer of trends in art historical studies within Japan, first devoted an issue to the subject in 1970, and even afterward few scholars were prepared to take the subject seriously.[38] This attitude may be attributed at least in part to a backlash against the American embrace of Zen and *zenga*. A noted Japanese art historian, participating in a 1972 "dialogue in art between Japan and the West," complained that Westerners flattered themselves into believing that they understand Zen, but "from our point of view, what they are talking about is certainly, in most cases, a *soi-disant* Zen, little resembling the teachings of orthodox Zen Buddhism."[39] Such claims overlooked the role that D. T. Suzuki and other Japanese

proselytizers had played in this phenomenon. They also failed to acknowledge that the Kokusai Bunka Shinkōkai and the Japan tourist bureau, as well as many business interests, promoted "Zen" as part of Japan's unique aesthetic heritage.[40]

Zen Painting and Calligraphy, shown in 1970 at the Museum of Fine Arts, Boston, was a blockbuster exhibition that, while capitalizing on the Zen mystique, heralded a new era of more historically grounded, balanced, and intellectually rigorous scholarship.[41] The works in this show were of an unprecedented range, artistic quality, and historical importance. Paintings by the twelfth- and thirteenth-century Chinese monk-painters Mu Qi, Liang Kai, and Yintuoluo, already familiar to enthusiasts of Zen art through reproductions, had never before been shown outside Japan. There were equally celebrated landscapes and figure paintings by fourteenth- and fifteenth-century Japanese artists including Mokuan Rei'an, Jōsetsu, Shūbun, and Sesshū Tōyō. This show also expanded the parameters of what was then understood to be Zen art by featuring the formal calligraphic writings of Chinese and Japanese monks as well as paintings and calligraphy by seventeenth- and eighteenth-century monks of the Huang-Po branch of Chan Buddhism, known in Japan as Ōbaku. Kurt Gitter, guided by scholar and fellow collector Stephen Addiss, was among those Americans who subsequently would turn their attention to the wide-ranging cultural manifestations of the last form of Buddhism introduced from China to Japan.[42]

It is not possible, in this short essay, to trace in full the progression in taste in *nanga* and *zenga* between 1956 and 1976, when *Zenga and Nanga: Paintings by Japanese Monks and Scholars*, the first catalogue of the Gitter collection, was published. Nor is it possible to claim that the exhibitions devoted to Tessai, Sengai, and Hakuin on which I have focused so closely had a direct impact on Dr. Gitter or other American collectors. Examining these early shows, however, does throw light on the political, social, and cultural circumstances that contributed to the warm reception given *nanga* and *zenga* in postwar America. The response to Tessai and Sengai also foreshadows the relatively limited appeal of *nanga* in comparison to *zenga*, even as it reveals the American impulse to see them as related forms of Japanese visual expression and to interpret them in the context of contemporary art. Recognition and appreciation of *nanga* and *zenga*, like that of *ukiyo-e* a century earlier, was helped by their assimilation into a rhetoric of modernity.

NOTES

1. Stephen Addiss, *Zenga and Nanga: Paintings by Japanese Monks and Scholars* (New Orleans: New Orleans Museum of Art, 1976). This show traveled to the Cincinnati Art Museum, Honolulu Academy of Arts, Fine Arts Gallery of San Diego, Portland Art Museum, and the University of Michigan Museum of Art between December 1977 and January 1979.

2. For works Addiss acquired, see listings for the Shōka collection in Calvin French, *The Poet-Painters: Buson and His Followers* (Ann Arbor: University of Michigan Art Museum, 1974), and Shimada Shūjirō, ed., *Zaigai hihō ōbei shūzō Nihon kaiga shūsei* (Treasures of Japanese art in Western collections) (Tokyo: Gakushū Kenkyūshu, 1969); for Brotherton, see Donald F. McCallum, "Edo Paintings from the Brotherton Collection at the Los Angeles County Museum of Art," *Oriental Art* (spring 1976): 97–99, and George Kuwayama, "Japanese Paintings from the Brotherton Collection," *Apollo* (February 1976): 140–43. For a list of the *nanga* paintings Avery Brundage bought from Harry Packard in the 1960s, see Yoko Woodson and Richard L. Mellott, *Exquisite Pursuits: Japanese Art in the Harry G. C. Packard Collection* (San Francisco: Asian Art Museum, 1994), 127. For paintings the Burkes acquired before 1976, see Miyeko Murase, *Japanese Art: Selections from the Mary and Jackson Burke Collection* (New York: The Metropolitan Museum of Art, 1975); for Peter Drucker's acquisitions, see John Rosenfield, *Song of the Brush: Japanese Paintings from the Sansō Collection* (Seattle: Seattle Art Museum, 1979); for John Powers, see John M. Rosenfield and Shimada Shūjirō, *Traditions of Japanese Art: Selections from the Kimiko and John Powers Collection* (Cambridge: Fogg Art Museum, Harvard University, 1970), and John M. Rosenfield and Fumiko E. Cranston, *Extraordinary Persons: Works by Eccentric, Non-Conformist Japanese Artists of the Early Modern Era (1580–1868) in the Collection of Kimiko and John Powers*, Naomi Noble Richard, ed. (Cambridge: Harvard Art Museums, 1999).

3. James Fenton, "The Exhibition Follies," *New York Review of Books* (December 21, 2000), 60.

4. See Yoshiaki Shimizu, "Japan in American Museums—But Which Japan," *The Art Bulletin* 83, no. 1 (March 2001): 123–34.

5. See *Art Treasures from Japan* (Los Angeles: Los Angeles County Museum of Art, 1965), cat. nos. 63–67. The exhibition, organized by the National Commission for Protection of Cultural Properties and the Los Angeles County Museum of Art, traveled to the Detroit Art Institute, the Philadelphia Museum of Art, and the Royal Ontario Museum, Toronto.

6. Ernest F. Fenollosa, *Epochs of Chinese and Japanese Art* (New York: Dover Publications, 1963), 1:165. I offer this as a possibility, but it is, of course, difficult to assess Fenollosa's impact at the time. James Cahill also recalled that Harold P. Stern, who was at the Freer Gallery in the 1950s, disliked *nanga* (personal correspondence, August 2001).

7. Information courtesy of Kate Mitchell, Smithsonian Institution Traveling Exhibition Service (SITES).

8. See Ellen P. Conant, Steven D. Owyoung, and J. Thomas Rimer, *Nihonga: Transcending the Past: Japanese-Style Painting, 1868–1968* (Saint Louis: Saint Louis Art Museum, 1995), 166–67.

9. Information courtesy Kate Mitchell, SITES.

10. The "typical" Japanese building installed in the garden of the Museum of Modern Art in New York in 1953 is a case in point. See Arthur Drexler, *The Architecture of Japan* (New York: Museum of Modern Art, 1966).

11. Conant et al., *Nihonga*, 325.

12. Bruno Taut, *Houses and People of Japan* (London: John Gifford, 1938), 268–69. This passage was quoted in the opening paragraphs of the English translation of a monograph by the leading Tessai scholar in Japan; see Odakane Tarō, *Tessai: Master of the Literati Style*, trans. and adapted by Money L. Hickman (Tokyo: Kōdansha, 1965), 11–12.

Bruno Taut, it should be noted, was instrumental in transforming Katsura Detached Palace into an icon of architectural modernity; see Isozaki Arata, *Katsura Villa: Space and Form* (New York: Rizzoli, 1987), 1–6.

13. *The Works of Tomioka Tessai* (Berkeley, Calif.: University Art Museum, 1968). Organized by the International Exhibitions Foundation, the show traveled from November 1968 through 1969.

14. Sakamoto Kōjō, "On Tessai," preface to *Tomioka Tessai, 1838–1924: A Loan Exhibition of Paintings from the Kiyoshi Kōjin Temple, Takarazuka, Japan* (New York: The Metropolitan Museum of Art, 1958), n.p. Originated by the Metropolitan Museum of Art, New York, and circulated by SITES, 1957–58.

15. Among these, one might include the Japanese-British exhibition held in London in 1910, the Harvard Centennial Exhibition, held in Boston in 1936, and, most spectacular of all, the exhibition of Japanese fine arts held in Berlin in 1939.

16. He gave this speech on April 2, 1957. See *Amerika junkaiten kiroku Tessai* (Tomioka Tessai: Commemorative picture album of Tessai's circulating exhibition in the USA) (Takarazuka, 1960).

17. The invitation is reproduced in *Amerika junkaiten kiroku Tessai*, between pages 20–21.

18. See *Time*, April 15, 1957, and *Apollo*, June 1957.

19. *San Francisco Chronicle*, April 27, 1958.

20. *Post Dispatch*, July 9, 1958 (clipping courtesy Saint Louis Art Museum). The invitation to the opening at the Museum of Fine Arts, Boston, which featured a flaming jewel painted in ink monochrome, also capitalized on this connection. See *Amerika junkaiten kiroku Tessai*, 13.

21. Odakane, *Tessai: Master of the Literati Style*, 51.

22. James Cahill suggested this explanation in personal correspondence, August 2001.

23. Gitter's first acquisitions were prints by Georges Roualt. John Powers's eye for both *nanga* and *zenga* also was guided by a visual grounding in modernism. He had amassed a large collection of works by American artists including de Kooning, Johns, Lichtenstein, Oldenberg, and Warhol.

24. James Cahill, *Scholar Painters of Japan: The Nanga School* (New York: The Asia Society, 1972); French, *The Poet-Painters*.

25. For accounts of their interest in these artists, see Idemitsu Sazō, "Sengai's Drawings and Myself," in D. T. Suzuki, *Sengai: The Zen Master* (Greenwich, Conn.: New York Graphic Society, 1972), xii–xiv, and *Hakuin, Hosokawa korekushon ni yoru* (Hakuin paintings from the Hosokawa collection) (Mishima: Sano Bijutsukan, 1977), 4–5.

26. For a list of Sengai exhibitions abroad, see Furuta Shōkin, *Sengai: Master Zen Painter*, trans. and adapted by Reiko Tsukimura (Tokyo, New York, and London: Kōdansha, 2000), 214–15.

27. Rick Fields, *How the Swans Came to the Lake: A Narrative History of Buddhism in America* (Boulder, Colo.: Shambala, 1981), 210.

28. Sengai, *India-Ink Drawings by the Famous Zen Priest, Sengai* (Oakland, Calif., privately published, 1956), 2.

29. For a review of this show written by Heinz Brasch, see "Zen Buddhist Paintings from the 17th to 19th Centuries," *Oriental Art* 6, no. 2 (summer 1960): 58–63.

30. Yamashita Yūji, "Reconsidering 'Zenga' in terms of America, in Terms of Japanese Art History," in *Zenga—The Return from America: Zenga from the Gitter-Yelen Collection* (Tokyo: Shoto Museum of Art, 2000), 22.

31. The relationship among collectors, scholars, and dealers, and the various roles they play in valorizing particular genres and artists, is an important issue that is too complex to address in this short essay.

32. Robert H. Sharf, "The Zen of Japanese Nationalism," in Donald S. Lopez, ed., *Curators of the Buddha: The Study of Buddhism under Colonialism* (Chicago: University of Chicago Press, 1995), esp. 121–31.

33. D. T. Suzuki, "Sengai and Zen Art," *Art News Annual* (winter 1957), pt. 2, 114–21.

34. Helen Westgeest, *Zen in the Fifties: Interaction in Art between East and West* (Zwolle, Netherlands: Waanders, 1966), 53–55.

35. See Bert Winther, "Japanese Thematics in Postwar American Art: From Soi-disant Zen to the Assertion of Asian-American Identity," in *Japanese Art after 1945: Scream against the Sky*, ed. Alexandra Monroe (New York: Harry Abrams, 1994), 55–67.

36. Sylvan Barnet and Bill Burto, personal communication, August 2001.

37. John Rosenfield, personal communication, August 2001.

38. Yamashita, *Zenga*, 24.

39. Cited in Winther, "Japanese Thematics in Postwar American Art," 55.

40. The Kokusai Bunka Shinkōkai, for instance, sponsored a Sengai exhibition that toured thirteen European cities between 1961 and 1964.

41. Jan Fontein and Money Hickman, *Zen Painting and Calligraphy* (Boston: Museum of Fine Arts, 1970).

42. See Stephen Addiss, *Ōbaku: Zen Painting and Calligraphy* (Lawrence: Helen Foresman Spencer Museum of Art, University of Kansas, 1978).

Stephen Addiss

Epilogue

Edo-period Painting and the Gitter-Yelen Collection

THE FIRST EXHIBITION OF THE GITTER COLLECTION, ENTITLED ZENGA AND NANGA: *Paintings by Japanese Monks and Scholars*, was held at the New Orleans Museum of Art in 1976. Although at the time Dr. Gitter owned works from other schools, his collection focused primarily upon the art of scholar-poets (*nanga*) and Zen masters (*zenga*), both outside the professional painting traditions of Japan. As Christine Guth notes in her essay (pp. 203–11), these areas had not been collected seriously by Americans before World War II but were coming into prominence. While exhibitions sent from Japan of the works of Tomioka Tessai and Sengai may have influenced some viewers, Dr. Gitter did not happen to see them, and these are not the artists he has collected most.

More important seems to have been the changing cultural atmosphere in America, particularly, in the field of painting, the rise of abstract expressionism. Both *zenga* and *nanga* feature individual expression more than technical skill, and the bold brushwork that characterizes *zenga* has affinities with the work of such artists as Franz Kline and Robert Motherwell.[1] Of course, a complex mix of people and influences shapes the world of collecting, including the participation of dealers, scholars, and museum curators. In this, as in many other cases, it seems to have been the dealers and collectors who led the way and the scholars and curators who followed. Discussions with Dr. Gitter and several other collectors of his generation suggest that the power and fascination of the works themselves were the strongest factors: shown Japanese paintings from a number of different schools, some Westerners responded most strongly to the works by monk-artists and poet-artists. In short, the new cultural, visual, and artistic climate helped set the stage, and collectors who did not feel bound by the tastes of the past led the way into these hitherto somewhat neglected fields.

During the past thirty-six years, however, the Gitter-Yelen collection has not only grown but also evolved to include significant works of art from many different schools of Japanese painting from the past four hundred years. In particular, the Edo period (1615–1868) nurtured a great number of high-quality artists who worked in a surprisingly broad range of styles and subjects, and the collection encompasses many of them. In recent years, works have been added from the Meiji (1868–1912), Taishō (1912–26), and early Shōwa (1926–89) eras that relate to earlier traditions while reacting to the art of the Western world which had become familiar in Japan. The focus of the collection, however, has remained the Edo period, when more different schools of painting came into prominence than had been seen before in Japan, or possibly in any other country up to that time.

It is always interesting to speculate which social conditions are most beneficial to artistic growth. Many scholars believe that creativity flourishes most strongly in times of social ferment, when values are being questioned and new energy is being released. One example might be the Momoyama period (1573–1615), when new forms and aspects of culture as well as government

Pl. 116. Yosa Buson. *Old Man with Attendant* (detail, cat. no. 22).

were being promoted by Oda Nobunaga, Toyo-tomi Hideyoshi, and Tokugawa Ieyasu, the three great warlords who reunited Japan after many decades of civil war.[2] The Momoyama was indeed an age of great creative change in the arts, with bold new initiatives in painting as well as in architecture, ceramics, textiles, and the tea ceremony. In contrast, during the succeeding Edo period, the strong and somewhat repressive Tokugawa government attempted to control many aspects of society while shutting Japan off from the outside world. Must this not have been a time of stagnation, rather than vitality, in the arts?

Not at all. Despite the efforts of the government to create a fixed and stable (if not static) society, the variety of schools of painting that flourished during the Edo period was completely unprecedented, and we are not amiss to ask why.

Among the number of reasons that can be offered are audience and patronage. In earlier Japan, as in many other cultures, the primary patrons of painting had been the church and the state, in this case the Buddhist establishment on one hand, and the court and the shogunate on the other.[3] Generally speaking, painting was an art for the elite, while commoners saw works of fine art mainly in temples or on the rare occasions when they were allowed to visit a palace, mansion, or castle.

During the Edo period, however, a number of different sponsors became patrons of painting. Some were continuations from the past, such as the Buddhist church for traditional religious paintings, the shogunate for professional paintings by government-supported artists of the Kanō school, and courtiers for works reminding them of past days of glory (such as paintings of scenes from the *Tale of Genji*) by traditional artists of the Tosa school. None of these schools, as it happens, is strongly represented in the Gitter-Yelen collection, which instead features works by newer schools of painting that blossomed, seemingly from infertile ground, during the Edo period.

Part of this apparent paradox can be explained by the difference between what a government orders and what actually happens. It is always dangerous to base history upon official pronouncements, since what people really do is so often different; the history of Prohibition in the United States is a clear case in point. In the case of the Tokugawa government, officials decided to divide society in Japan into four groups, following a neo-Confucian precedent. At the top were samurai, who during the era of peace were gradually transformed into bureaucrats. Next came farmers, since they produced the food that the country depended upon; government stipends paid to officials were based upon units of rice. Third were craftsmen and artisans, who were also considered helpful to society as makers and repairers of useful products; artists fell into this category. Lowest on the list were merchants, since they merely moved goods around rather than made them. This vertical division into four groups, however, never reflected reality in Japan, and as time went by, it came to be more and more a fantasy.

As so often happens, farmers were the least visible, least represented, and most easily taxed. They quickly sank to the bottom in terms of influence and status, although a few wealthy farmers in some of the more fertile areas of Japan became patrons of the arts. Artisans and artists basically maintained their position, although much of the painting during this period was done by members of other classes of society, ranging from merchants to samurai. The tradesmen themselves, in an increasingly mercantile economy, gradually gained great financial power in Japan, and despite a series of government restrictions, which even included what kind of clothing they could wear, they in many cases rose near the top of society. In the process, merchants developed their own artistic interests. As for the samurai, many did not adjust well to their new bureaucratic responsibilities, others found their fixed stipends of rice to be

inadequate, and only some were able to prosper as well as enjoy their prestigious social status.

As the Tokugawa government's vertical division of society increasingly failed to correspond to reality, many groups of people were not accounted for at all. Courtiers, for example, may have been considered enviable, but they were often close to impoverished; some noblemen came to deal with commoners by teaching them courtly accomplishments such as *waka* poetry. Monks and nuns were not part of the system, but they played a continuously important role in Japanese arts as well as in society as whole. As the Tokugawa government began to rely less on monastics and more on Confucian scholars regarding education and the arts, temple ateliers that had served as semiprofessional studios were closed. Instead, leading Zen masters now took up the brush to create the art called *zenga* (literally, "Zen painting"), which was primarily a form of Zen teaching rather than decoration for palaces and mansions. This was a switch in focus as well as in patronage; the art was now being created as a way of expressing Zen values to everyday people.

Another new segment of society consisted of Confucian scholars whom the government began to support as advisers and educators. At first concentrating upon assisting the Tokugawa shoguns and regional daimyo (feudal lords) to establish themselves in the new era, these scholars soon followed their earlier counterparts in China by becoming interested in the arts, especially poetry, calligraphy, and painting. Since Chinese-influenced education was becoming available to an increasing number of merchants, wealthy farmers, and artisans as well as samurai, the audience for *nanga* (literati) paintings ranged across the four "classes" ordained by the government.

As noted in my essay (pp. 27–47), Ike Taiga (1723–1776) and his followers were at the center of *nanga* as it became established as an important form of Japanese painting during the mid-to-later

eighteenth century. Although neither a Confucian scholar nor an outstanding poet himself, Taiga was a true master with the brush from his childhood; his bold imagination and remarkable range of subjects and styles made him the leader of a group of painter-calligraphers in Kyoto who transformed, rather than merely followed, Chinese traditions. Taiga's skills in depicting landscapes, plants, and figures are well documented by works in this exhibition (see cat. nos. 2–10). His pupils, including his talented poet-calligrapher-painter wife Gyokuran (1727/28–1784; see cat. no. 11), followed his lead, each adding a personal touch to his or her paintings, which often moved toward a world of fantasy that was less organically rooted than Taiga's vision.

By the end of the eighteenth century, however, *nanga* was changing direction. With the greater availability of Chinese literati paintings and styles to be studied, the freewheeling approach of Taiga was gradually abandoned in favor of a closer adherence to Chinese brushwork traditions. The audience for *nanga* was becoming more sophisticated and increasingly able to enjoy visual references to Chinese literati masters of the past. Turn-of-the-century artists such as Uragami Gyokudō (1745–1820; see cat. nos. 16, 17) and Okada Beisanjin (1744–1820; see cat. no. 18) maintained the individualistic character of their works while adhering more closely to Chinese conventions such as overlapping texture strokes to create architectonic form. During the era of Beisanjin's son, Okada Hankō (1782–1846; see cat. nos. 38, 39), however, a more conservative approach held sway over many *nanga* masters, particularly those who depended upon selling their works for a living.

In the meantime, a second stream of *nanga* painting had developed in the later eighteenth century led by the major *haikai* poet Yosa Buson (1716–1783), who is discussed in the essay by Patricia Fister (pp. 49–67). In contrast to Taiga, Buson was not a prodigy but gained his painting

skills gradually over his life, becoming a true master only in his later years, as is seen in the evocative brushwork of his *Spring Landscape* (cat. no. 21). His success as a poet brought new patrons not only to his works but to *nanga* more broadly, and his development of *haiga* (haiku painting) injected a native aesthetic into the literati tradition. His followers, several in the Lake Biwa region, continued his lead, but Buson's closest Kyoto pupil, Matsumura Goshun (1752–1811), took the rare step of switching styles and schools in mid-career, as is discussed later.

In general, two main trends can be distinguished in *nanga* during the nineteenth century, a period discussed in the essay by Patricia Graham (pp. 69–87). As both painters and patrons came to understand more about the literati tradition, many artists became more sinophilic in their approach to painting. As time went by, these increasingly professionalized painters tended to follow specific Chinese traditions, such as the minimalist compositions and dry, astringent brushwork of Ni Zan, or the wetter dot-method associated with Mi Fu. The conservative *nanga* theoretician-painter Nakabayashi Chikutō (1776–1853) went so far as to attempt to master every major tradition of Chinese literati brushwork, including, in his *Plum Blossom Studio* (cat. no. 36), the additive brushwork method of Huang Gongwang. Some artists became specialists in other subjects as well as landscapes, such as Chikutō's friend Yamamoto Baiitsu (1783–1856), who was extremely proficient in bird-and-flower painting, as can be seen in a scroll and a pair of screens in this exhibition (cat. nos. 40, 41).

Other *nanga* artists, however, especially the scholar-poets who painted as an avocation, continued to create works in very personal and sometimes eccentric manners. These include the scholar-artist Kameda Bōsai (1752–1826), whose depiction of a gourd (cat. no. 29) integrates calligraphy and painting in his own idiosyncratic fashion, as well as the Confucian teacher Murase

Pl. 118. Matsumura Goshun. *Night Vigil* (cat. no. 27).

Taiitsu (1803–1881), whose *Rakan* (cat. no. 47) well displays his relaxed and often whimsical style of brushwork. The difference in the two approaches to *nanga* was reflected in patronage, the professional and highly skillful works being enjoyed by the educated public and more personal works treasured most often by direct pupils and followers of the literatus.

Nanga was increasingly appreciated as the Edo period developed, but this did not hinder other schools of painting from finding receptive audiences. Rinpa, the decorative art discussed in the essay by Motoaki Kōno (pp. 139–63), appealed to well-to-do merchants in part because it was clearly expensive to produce, featuring works painted on costly silk using the highest-quality materials, including gold and silver. The boldness of Rinpa design, somewhat akin to *zenga* but done with consummate technical skill in bright colors, also attracted the attention of the wealthy. Many Rinpa paintings also proved engaging to merchants whose education allowed them to understand the references to early courtly literature such as the *Tale of Genji* or *Tales of Ise*. In contrast to the Chinese mode of *nanga*, Rinpa masters developed a more distinctly Japanese painting style that represented a revival of the elegant aesthetics of the Heian period (794–1185), the golden age of court culture. Now, however, it was merchants, supposedly the lowest class, who were enjoying what had been the prerogative of the Heian courtiers. In consequence, the delicacy of many Heian works was often replaced by larger-scale grandeur. It is significant that the Rinpa master Tawaraya Sōtatsu (d. c. 1643) had repaired an early Japanese handscroll (see Kōno essay, p. 140), for he led a revival of courtly aesthetics with such works as highly decorated handscrolls in gold and silver which his friend Hon'ami Kōetsu (1558–1637) inscribed with Heian-period poems. Rinpa was not one-sided, however; Sōtatsu also created evocative monochrome paintings with strong compositions

enlivened by subtle tones of ink (see cat. nos. 78, 79). These constituted a new and creative variation of the Zen-influenced ink-painting tradition and, as such, were clearly appealing to the taste of Dr. Gitter. Judging by the number of works in color still extant, however, Sōtatsu's sometimes nouveau-riche customers most often enjoyed the golden fans and lavish pairs of screens that he painted with powerful designs based upon courtly and classical themes.

Later Rinpa artists at first followed the lead of Sōtatsu, but especially after Sakai Hōitsu (1761–1828) moved to the new capital city of Edo, the style changed to one of more precise brushwork as artists continued to create their own variations of traditional Japanese subjects. Examples in the Gitter-Yelen collection, such as Hōitsu's *Triptych of Flowers and the Rising Sun* (cat. no. 91), affirm the high levels of talent exhibited by these later artists of the decorative painting tradition. The continued vitality of Rinpa is especially apparent in the work of one of its last masters, Kamisaka Sekka (1866–1942; see cat. nos. 97–100), who found new inspiration as well as new patronage when he created not only paintings but also woodblock books, lacquer, ceramics, and furniture with fresh approaches to age-old Rinpa designs.[4] The Gitter-Yelen collection was one of the first in America to focus attention upon this important twentieth-century artist; a large international exhibition of Sekka's work is now being planned that will be shown in both Japan and the United States.

Another group of artists who enjoyed the patronage of the merchant class in Edo-period Japan was the Maruyama-Shijō school. This name is actually a hybrid, referring to the work of Maruyama Ōkyo (1733–1795) and his followers as well as the Shijō (Fourth avenue) tradition of Matsumura Goshun, who as previously noted began his career as a pupil of Buson's but switched to the Ōkyo style mid-career. Most of the Goshun works in this exhibition show his indebtedness to

Buson in paintings that feature lively and expressive brushwork, but a later album of paintings and poems displays Goshun's softer Shijō style in which he utilized ink washes to create forms (see cat. no. 58). A few smaller schools[5] are also generally included in the Maruyama-Shijō tradition, which was primarily a naturalistic style of painting at first centered in Kyoto and Osaka and later becoming popular in Edo.

Maruyama-Shijō painting, as discussed by Jōhei Sasaki (pp. 89–101), is often appealing from the very first glance. The subject matter is meant to be readily enjoyed, comprising birds and animals, softly brushed landscapes of rural Japanese scenery, figures from everyday life (rather than exalted poets and sages), and beautiful women. This school, in fact, more consistently reflects everyday life in Japan than any other, although *ukiyo-e* certainly celebrates the entertainment aspects of its time. *Nanga*, in contrast, primarily invokes the idealized world of poetic responses to nature as developed in China. It may therefore seem surprising that Dr. Gitter came to *nanga* first and Maruyama-Shijō art more gradually, but sometimes the art that is easy to like can be passed by, at first, in favor of more complex visual values, and only later is it seen to be equally interesting. The subtleties of Maruyama-Shijō painting often come from the actual execution of the works: the soft washes in ink or light colors, the evocative use of empty space (so often a feature of Japanese painting), and the forms that are as often suggested as defined. This last feature is also a characteristic of haiku poetry, and in fact the *haiga* tradition passed from Buson through Goshun to Maruyama-Shijō artists rather than remaining within *nanga*. In most cases, Maruyama-Shijō paintings do not have poetic inscriptions, unlike *nanga*, but we can often imagine a haiku, or more generally the haiku spirit, inhabiting some of its less formal works.

Depending both on their mood and on their customers, Maruyama-Shijō artists had two major

styles. The first consisted of elaborately painted and highly colored works on silk, which must have been done for major clients. These are the works most often exhibited and reproduced in Japan, and they certainly show to the fullest the great skills of the artists. *Woman Washing Clothes in a Stream* (cat. no. 56), by Ōkyo's pupil Komai Genki (1747–1797), displays the exquisite brushwork and colors that the more formal works of this school often feature. Maruyama-Shijō painters also created a large number of more rapidly brushed works on paper, often in smaller formats, such as Ōkyo's delightful *Letter with Drawing of a Bull* (cat. no. 54), which served as a temporary substitute for a larger-scale commission not yet completed. Informal paintings in this style would have been available to less wealthy members of society, including the artisans who are sometimes charmingly depicted in them.

Everyday people, particularly in the city of Edo, had a school of painting and printmaking that catered to their own milieu and values: *ukiyo-e*, as discussed by John Carpenter (pp. 165–83). A Buddhist term, *ukiyo* (floating world) indicated the impermanence of life and implied that one should not cling to desires and passions. In the Edo period, the word retained the same basic meaning but its implication totally changed: since the pleasures of the world are fleeting, enjoy every minute while you can! Therefore, in *ukiyo-e* (pictures of the floating world), the temporal joys of the theater and the courtesan quarters were celebrated by townsmen as well as merchants. *Courtesan in Robes with Calligraphic Motifs* (cat. no. 105), by Takizawa Shigenobu (fl. c. 1716–36), shows how refined and elegant the world of courtesans could be. Admirers who could not afford paintings could buy woodblock prints of famous beauties or of actors starring in the Kabuki theater. Just as today, the world of entertainment was presented as a good deal more glamorous than it actually was, but this was a glamour encouraged not only by the courtesans and actors but equally by their avid public. As time went by, landscapes were added to the *ukiyo-e* subject matter, such as Utagawa Hiroshige's (1797–1858) *Suzumegaura in Kanazawa, Musashi Province* (pl. 119). These almost always depicted Japanese scenes that could be viewed by travelers on the major roads, and the spirit of enjoying one's temporal existence remained the same.

The audience for *zenga*, which is discussed by Masatomo Kawai (pp. 119–37), was quite different, comprising both monastics and laypeople who were followers of major teaching monks. The most important Zen master of the Edo period, Hakuin Ekaku (1685–1768), reached out to every segment of the population in his paintings and calligraphy as well as through writings and folk songs. In the process, he invented an entirely new artistic language for Zen. This now included flora and fauna of every kind, folk tales, popular deities such as gods of good luck, visual puns using figures made up of calligraphy, symbols of Zen values, and the more traditional images of Zen teachers and eccentrics. Hakuin's *Two Blind Men Crossing a Bridge* (cat. no. 118) was based upon an actual (and somewhat dangerous) bridge near his temple and combines Zen humor with the message that we must all cross through life to the other side, while his *Daruma* (pl. 120) exemplifies the remarkable power of his later brush-and-ink paintings. Although Hakuin gave his works away to the public rather than sold them, we can still speak of his audience, which included members from every level of society who might have an interest in Zen.

If these schools were not enough, there were others, including the Nagasaki school, which was based upon Chinese bird-and-flower paintings, and the Unkoku school that traced its ink-painting tradition back to Sesshū Tōyō (1420–1506). In addition, as discussed by James Ulak (pp. 103–17), a number of individualist artists in the Edo period added greatly to its variety and delight. Among these were Nagasawa Rosetsu (1754–1799), who

Pl. 119. Utagawa Hiroshige. *Suzumegaura in Kanazawa, Musashi Province* (cat. no. 115).

studied with Ōkyo but whose eccentric humor, seen in his *Tanka shō butsu* (cat. no. 72), distinguished him from his contemporaries. Another individualist was Soga Shōhaku (1730–1781), who claimed to descend from the Soga school of the fifteenth century but whose paintings (see cat. nos. 69, 70) show a lively and sometimes wild imagination that seems to deconstruct earlier traditions of brushwork and create a world all his own. The painter Itō Jakuchū (1716–1800) is even more difficult to classify, with influences upon his work ranging from colorful Chinese bird-and-flower paintings to free Zen brushwork in ink. Jakuchū's version of the Zen theme of Kanzan and Jittoku (cat. no. 65) demonstrates his powerful and often geometric compositional genius as well as his idiosyncratic use of ink.

Standing apart from the shelter of recognized painting schools, these individualist artists found a receptive audience in part because the second half of the eighteenth century was a time when individualism was highly appreciated. This is

manifest in the great popularity of the *Kinsei kijin den* (Biographies of modern eccentrics), a five-volume set of books issued in 1790, followed by five more volumes in 1798. Among the artists included were Ike Taiga and his wife, Gyokuran, so it is clear that unique personalities were not restricted to the artists now considered as "individualists." The Japanese taste for novelty in the eighteenth century was certainly allied to the fact that certain social classes had now achieved economic power, and they gravitated to newer forms of art that were less identified with previous taste-makers. Supporting painters who had no allegiance to the old power structure increased the new patrons' sense of participation in the fine arts and helped to more deeply authenticate their sense of cultural identity. In this way they were pivotal in endorsing, promoting, and maintaining a more varied group of artists, schools, and styles than ever before.

The more we learn about the various patronage groups in early modern Japan, the more we can

Pl. 120. Hakuin Ekaku. *Daruma* (cat. no. 120).

appreciate the social and historical background of the art. It is still, however, the individual painter starting with a single brushstroke who reaches out to us through his or her personal expression. Whether an individualist or member of a school, each painter using the flexible and responsive East Asian brush created a visualization of that which fascinates us in all human endeavors, the outer world seen through the interactions between personality, nature, and society. The variety of patronage was surely a factor in how Japanese art of different schools was produced and disseminated; without such audiences, most of the art would not have been created at all. Nevertheless, it is the one-on-one confrontation between each viewer and each work that matters most today, just as it did when the art was created.

As we have seen, art patronage in the Edo period was multifaceted and often did not correspond with the divisions of society ordained by the government. Nevertheless, the interest in painting penetrated deep into Japanese society during an age of peace and relative prosperity as artists of the many different schools found a responsive public for their work. As the Edo period reached its end, however, there was a gradual dissolution of clear lines between schools of painting, and styles began to merge as well as to evolve, as discussed by Paul Berry (pp. 185–201). The Maruyama-Shijō school, already a hybrid, began to add more features from *nanga* and occasionally Rinpa, and even artists of the government-sponsored Kanō school took on influences from other styles of painting, sometimes including the lowly but popular *ukiyo-e* school.

As Japan opened to the West, an interest in oil painting developed, and partly in consequence the traditional brush-painting schools of Japan tended to band together, ultimately becoming known as *nihonga* (Japanese painting) as opposed to *yōga* (Western painting). In recent years, the Gitter-Yelen collection has grown to include works by several important later Japanese artists.

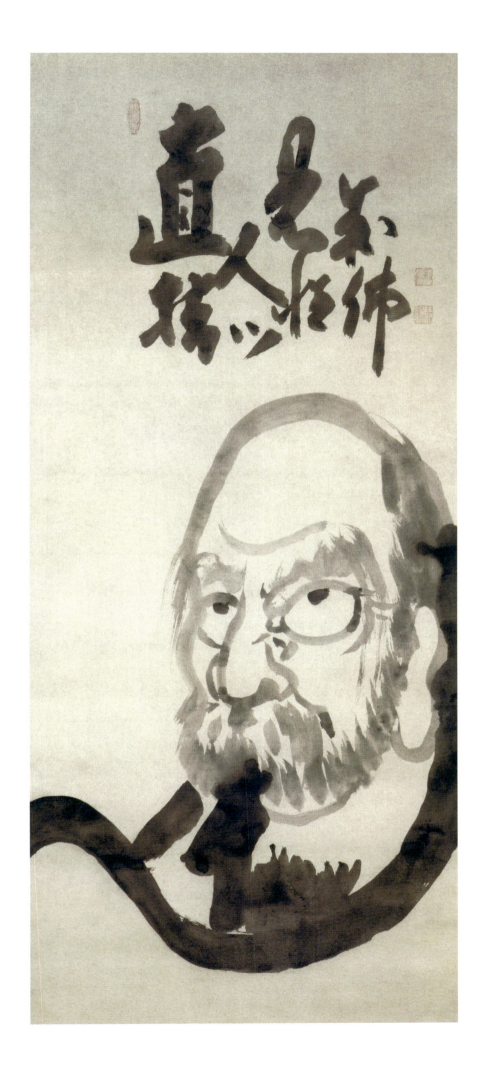

Some of these followed a traditional school quite closely, such as the *nanga* literatus Fukuda Kodōjin (1865–1944) or the previously mentioned Rinpa master Kamisaka Sekka (who did, however, first train with a Maruyama-Shijō artist). Others were more eclectic, striving to bring together some of the best features of different traditional schools and styles. Their audience, however, had changed from that of the Edo period and now consisted primarily of people from all classes who valued older traditions even as their society strove to modernize itself. This presented a challenge to artists, since twentieth-century Japanese painters shared with all their contemporaries the task of rejuvenating Japan while trying to preserve cultural values from the past.

This exhibition therefore not only presents the multifaceted artistic world of traditional Japan but also includes a number of works that show how Japanese painters responded to a new world of industrialization and internationalization. Viewing the scrolls by such artists as Kodōjin and Sekka makes it clear that age-old Japanese artistic values could still be creatively varied and freshly transformed by masters who had their roots in traditional schools. As had painters before them, they looked back to the past while adding their individual responses to the changing culture of Japan. In the process, they both reaffirmed and further developed the manifold artistic values that had been established in previous centuries. These values are exemplified by the great variety and high quality of paintings, primarily from the Edo period, in this exhibition of the Gitter-Yelen collection.

NOTES

1. For more discussion, see Stephen Addiss, "Robert Motherwell and Zen," in David Rosand, ed., *Robert Motherwell on Paper* (New York: Harry N. Abrams, 1997b), 59–81.

2. For example, there was a stress on grandeur and public magnificence in the Momoyama era, rather than the somewhat understated aesthetics influenced by Zen monks that had been influential previously.

3. Some scholars are now referring to patrons of the arts as consumers, but since the art remains and is not consumed, this word seems unrealistic.

4. See Audrey Yoshiko Seo, "Kamisaka Sekka, Master of Japanese Design," *Orientations* 24, no. 12 (December 1993): 38–44.

5. Such as the Kishi school founded by Kishi Ganku (1749–1838) and the Mori school of Mori Sosen (1747–1821). Both Ganku and Sosen trained in the Kanō school and then initiated their own more naturalistic styles with some influence from the Ōkyo tradition.

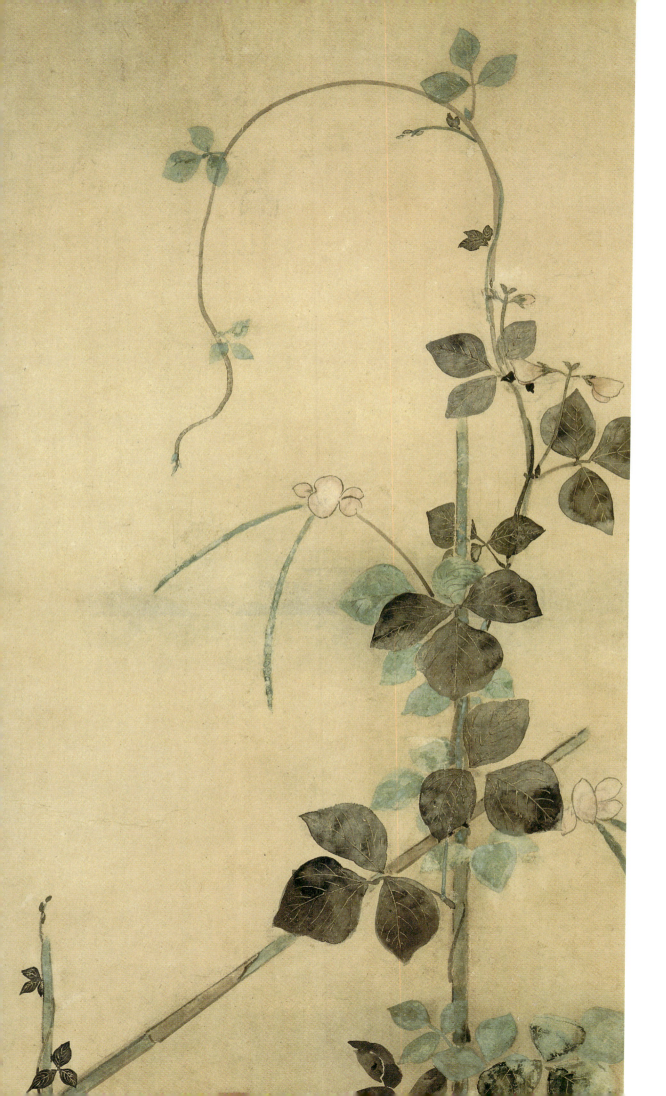

Catalogue
Works in the Exhibition

Lisa Rotondo-McCord

with genre painting
and *ukiyo-e* entries
by John T. Carpenter

Hasegawa School

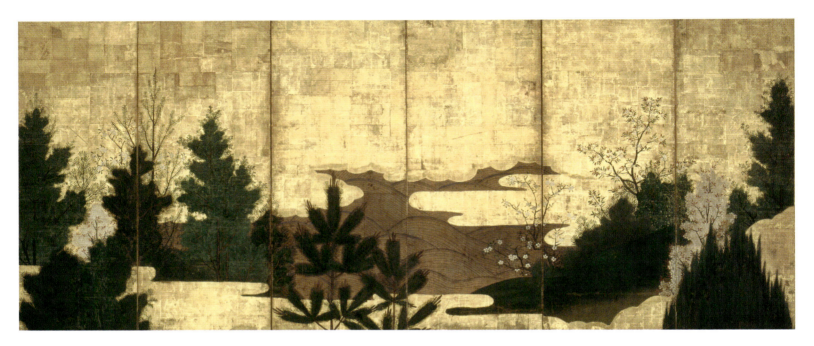

1. Unidentified artist

Pine Trees, Cherry Trees, and River, early 17th century
Six-panel folding screen: ink, color, and gold on paper,
150.1 × 329.4 cm

EVERGREENS AND BLOSSOMING cherry trees impart a sense of stillness and quietude to this screen. They are placed against a background of gold leaf, which reads as both mist and clouds. Bands of mist at the center of the screen part to reveal a lake, with black wave lines on dark brown indicating the water's movement. The wave patterns most likely were originally painted with silver on a light, possibly white, background; the silver oxidized long ago, and the background has discolored, creating a different effect for the contemporary viewer.

The artist who made this screen observed nature very closely. Different species of pine and cedar flank the water, and two distinct types of flowering cherry are within this surprisingly diverse wood. Using opaque pigments, the artist painted the trees almost as silhouettes whose different forms are not distinct at first glance. This style of painting as well as the subject are closely associated with the school founded by Hasegawa Tōhaku (1539–1610). This early seventeenth-century screen, originally one of a pair, reveals the synthesis of Chinese-inspired ink techniques with the colorful *yamato-e* style current at the earliest stages of the Edo period.

Nanga

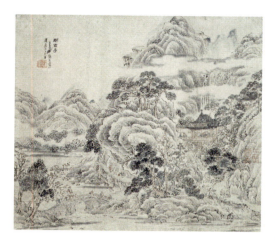

2. Ike Taiga, 1723–1776

Zuiweng Pavilion, c. 1757–60

Hanging scroll: ink and color on paper, 30.2 × 33.5 cm

Seals: Sangaku dōja; Tianli[1]

Inscription:

> *The Zuiweng Pavilion:*
> *Painted by Shao Zhen of the ancient state of Wu,*
> *for the venerable Master Haizhen.*

Literature: Sasaki 1998, pl. 9; Addiss et al. 1983, no. 36.; Yamanouchi 1981, no. 32 and frontispiece, no. 3; Sasaki 1979, fig. 48; Suzuki, ed. 1975, no. 28

PLATE 12

ONE OF THE MAJOR FIGURES in eighteenth-century *nanga*, Ike Taiga was a prodigious and precocious talent, with nearly two thousand works of painting and calligraphy associated with him.[2] An accomplished calligrapher as a child, Taiga began his career as a professional painter at age fourteen when he opened a fan shop in his native Kyoto to support himself and his widowed mother. With his great facility with the brush, Taiga also turned to painting, referring to a variety of sources for instruction and inspiration, including Chinese woodblock print manuals and Chinese and Japanese paintings.

The sources used by *nanga* artists are a subject of continuing interest and investigation. It is thus both rare and fortuitous to have Taiga's copy of a painting made c. 1667–68 by the mid-seventeenth-century artist Shao Zhenxian. The original, still extant, was part of an album, with ten leaves of painting and ten of calligraphy, by Shao and three contemporaries in the Suzhou area: Gao Jian, Niu Zhen, and Shi Han. This small painting served as the prototype for one of Taiga's most famous works, a large-scale rendition of the same theme in one half of a pair of screens (Tokyo National Museum). The small version likewise served as a model for a number of other copies.[3] Because the original Chinese version of this work still exists, it is possible to see both Taiga's faithfulness to and transformation of it. While adhering to the original composition and form types, Taiga employed his own more playful brush conventions, de-emphasizing the traditional brush vocabulary of the Chinese artist.

1. This seal is ostensibly a hand-painted copy of Shao's original seal. However, there appear to be differences between the seal on Taiga's painting and a photograph of it published in Sasaki 1979. The present seal covers an abraded patch, with remnants of the original seal beneath. See Addiss et al. 1983, no. 36.
2. For Taiga, see Takeuchi 1992.
3. Illustrated in Addiss et al. 1983, 118.

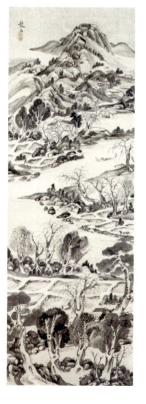

3. Ike Taiga, 1723–1776

Ink Landscape with Rice Fields

Hanging scroll: ink on paper, 131.2 × 43 cm

Signature: Mumei

Seals: Mumei; Taisei

Literature: Kurimoto 1960, no. 169

PLATES 13, 117

NANGA CAME TO ITS MATURE formulation under Taiga, who belongs to its second generation. Taiga synthesized the Chinese literati tradition with existing Japanese painting, using brush techniques associated with different schools and styles. Remarkably innovative and given to experimentation, he painted a broad range of subjects, from traditional landscapes and flowers to temple festivals and Zen-inspired themes.

Taiga's confident brushwork and sophisticated compositional structure are evident in this idealized landscape, indicating its production during the artist's mid to late thirties. The ink work, wherein each stroke articulates and animates the forms, is extremely lively. Taiga's dynamic brushwork is paired with a constantly shifting perspective, giving a sense of movement and animation to the landscape.

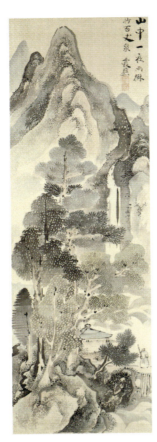

4. Ike Taiga, 1723–1776

Landscape
Hanging scroll: ink and color on silk, 106 × 34.5 cm
Signature: Kashō
Seals: Ike Mumei in
Inscription:

> *Half the mountains are covered with rain;*
> *At the tips of those trees, thousand-foot waterfalls.*
> —trans. Jonathan Chaves

Literature: Suzuki 1960, no. 631
PLATES 10, 14

TAIGA REFERENCES CHINESE painting and culture in many ways in his paintings. His literati-style landscapes, such as this work, have sources in woodblock printing manuals, authentic Chinese paintings, and his thorough knowledge of Chinese classics, philosophy, and the arts.

Here Taiga adopts and adapts the traditional idealized Chinese landscape to his own brush manner and accompanies the landscape with an excerpt from one of the great Tang poets, Wang Wei (415–443). Despite Taiga's status as a professional painter, he nonetheless possessed the talents of calligrapher, painter, and scholar associated with the Chinese literatus, and his paintings are manifestations of his learned and cultivated nature.

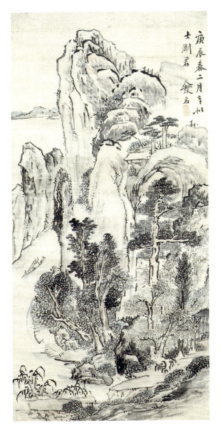

5. Ike Taiga, 1723–1776

Spring Landscape, 1760
Hanging scroll: ink and color on satin, 97 × 45 cm
Signature: Kōshin haru ni gatsu hōji shi gō kun Mumei
(Painted in the spring, the second month of 1760)
Seals: Mumei; Taisei; Gyokkō Kōanri
Literature: Zheng 1997, no. 346; Addiss 1976, no. 35; Suzuki 1960, no. 76.
PLATE 15

THE INNOVATIVE COMPOSITION and rich variety of brushwork in this scroll are elements that define much of Taiga's mature style. In the middle ground, he demonstrates his remarkable facility and versatility with the brush, delineating and differentiating the foliage with flat-sided strokes, short, slightly curved strokes of equal length, loops, and dots. Although rich in variety and coloration, the overall effect is one of clarity.

The highly structured composition of discrete landscape elements is unified by the tall trees that extend from the near shore to the looming mountains. Taiga's dotting and other brush motifs, dispersed throughout the painting, also serve to balance its composition and move the eye across its surface. Another unifying element is water: the waterfall that cascades from the mountain near the tallest pine descends to the stream at the lower edge of the painting and continues on, making a U-turn between the mountain forms. The boat floating on the upper reaches of this stream appears ready to slide off the picture plane.

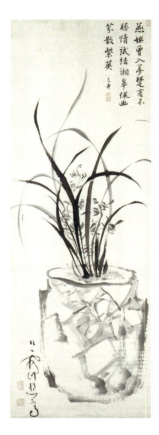

6. Ike Taiga, 1723–1776

Orchids in a Vase

Hanging scroll: ink on paper, 119 × 41.5 cm

Signature: Kyūka Sanshō sha

Seals: Kashō; Ike Mumei in

Inscription by Kan Tenju (1727–1795):

> The dancing goddess once came to him in a dream
> And the man from Chu was overcome with love.
> Try tying this waist ornament from the banks of the Xiang:
> Mysterious fragrance blooming in purple flowers.
> —trans. Jonathan Chaves

Literature: Addiss 1976, no. 36; Kurimoto 1960, no. 288

PLATE 20

A LUXURIANT STAND OF CHINESE orchids potted in a crackle-glazed vessel is the subject of this painting. The orchid, one of the so-called Four Gentlemen, a Chinese flower subject that also includes plum, bamboo, and chrysanthemum, carries connotations of purity, elegance, and refinement—the attributes of the erudite scholar. The Four Gentlemen theme was popular with Chinese literati painters, who employed the brush techniques and materials of their everyday calligraphy to create paintings of the theme.

For Taiga, a master calligrapher as well as a professional painter, the flora associated with the Four Gentlemen, in combination or isolation, provided an elegant showcase for his sure and confident brushwork. In this work, his handling of rich tonal variations in ink and undulating line, particularly for the orchid's foliage, imparts vitality and realism. The orchid clearly resonated as a theme among Taiga's artistic circle and patrons, given the large number of surviving large- and small-scale works of the subject.[1] Setting this work apart is the elegant Chinese-style poem written by Taiga's friend, the sinophile Kan Tenju. The crackle-glazed vessel holding the orchids further reinforces the continental associations. The vessel, most likely a Kangxi-era (1662–1722) monochrome with deliberate crackle, itself refers to Southern Song dynasty *guan* ware, a revered icon of Chinese ceramic history that was highly prized by and associated with scholars.

1. See, for example, Kurimoto 1960, pl. 52, and nos. 284–86, 308, 314–22.

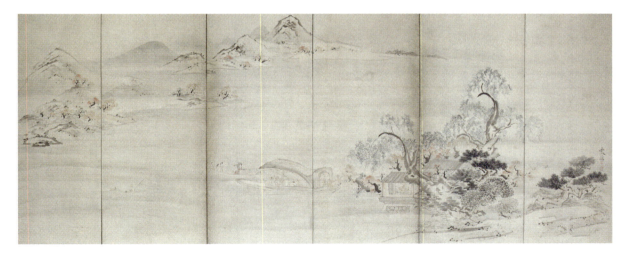

7. Ike Taiga, 1723–1776

Lake Landscape

Single six-panel folding screen: ink and color on paper, 143.7 × 353.4 cm

Signature: Kashō

Seals: Kashō; Zenshin Sōba Hōkyūkō

Literature: Addiss et al. 1983, no. 39

PLATE 23

SAILING UPON A LAKE, a gentleman in one boat is beguiled by a female entertainer in another. This scene, although without the traditional iconography, carries overtones of the classical Chinese Lute Song (Pipa Xing) theme, based on the Tang poet Bo Juyi's (772–846) poem about an official who hears the otherworldly voice of a courtesan famous in his youth.

Fragile and fine brushwork delineates the landscape elements and boaters. The near shore, populated by deciduous trees, firs, and two lakeside structures, exhibits Taiga's sure handling of the brush. Wet daubs of ink are combined with his familiar dotting techniques in the foliage, and the trunks of the willows are brushed with the same fluidity as seen in his *Orchids in a Vase* (cat. no. 6).

Despite the beauty of this work, the composition seems incomplete, an impression reinforced by the uneven dimensions of the first and sixth panels, which has caused speculation about the authenticity of the painting.[1] Recent examination reveals marks of *fusuma* handles on the fourth and fifth panels, indicating that the work originally was significantly larger and has been remounted to its present configuration.[2] If this theory is correct, the original composition would have comprised two stationary panels, on either side of a doorway, and two sliding panels. The left-most portion of the original would then be missing, a portion approximately the same size as the panels featuring the near shore.

1. Addiss et al. 1983, no. 39.
2. Tadashi Kobayashi, personal communication.

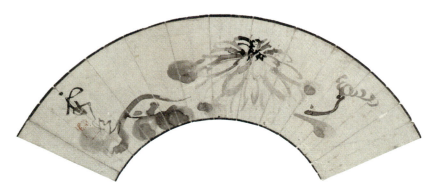

8. Ike Taiga, 1723–1776

Chrysanthemum

Fan: ink on mica paper, 11.5 × 42.2 cm

Signature: Kashō

Seal: Junsei

PLATE 21

DURING TAIGA'S LIFETIME, contemporary authors documented his early commercial activities, including the opening of a fan shop in Kyoto in 1737. Using compositions from the Chinese woodblock print manual *Hasshu gafu* (Ch. *Bazhong huapu*, Painting manual of eight styles), Taiga created fans for sale. While the *Hasshu gafu* was not solely devoted to literati Chinese painting styles, its contents may have sparked his interest in *nanga*, which at this time was not widely practiced in Kyoto.

This fan, however, comes from Taiga's mature period, long after he had absorbed and assimilated the material contained in style manuals. The chrysanthemum, another of the Four Gentlemen motifs and often associated with autumn, is created from fluid, controlled strokes of ink that vary in width and tonality. The abstracted composition, created quickly and surely, is more an exercise in calligraphic brushwork than descriptive reality.

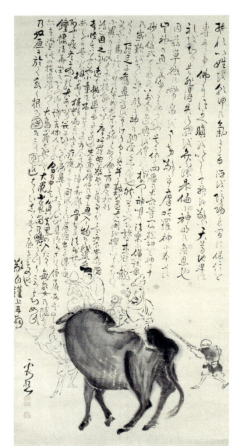

9. Ike Taiga, 1723–1776

Uzumasa Festival

Hanging scroll: ink on paper, 119.5 × 57.5 cm

Signature: Kashō

Seals: Kashō; Ike Mumei-in

Literature: Bowie 1975, no. 33

PLATE 2

TAIGA WAS A MAN OF MANY TALENTS and diverse interests. His knowledge of *nanga* may have been sparked by his association with Ōbaku Zen monks at Manpukuji, an important center of Chinese culture near Kyoto, where Taiga was taken as a young child to study calligraphy and demonstrate it for the Chinese émigré monks who lived there.[1] His pursuit of Zen forms of expression continued throughout his life, undoubtedly reinforced and furthered by his meeting in 1751 with Hakuin Ekaku (see cat. nos. 118–125).

In this highly individualistic work, Taiga combines a number of his artistic interests—the recording of an actual event, calligraphy, and quick,

descriptive brushwork. The event depicted is the Uzumasa Festival in Kyoto, wherein participants don masks and wooden helmets and are transported on bulls through the temple district. The main focus of the work is its long inscription; the bulls and festival performers are but a calligraphic extension. Taiga's fluid calligraphy is full of ligatures and abbreviations that make it difficult to decipher. It is clear, however, that the inscription lists the diseases, ailments, and ills from which adherents wished to be protected during the coming year.

1. See Takeuchi 1983, 143.

10. Ike Taiga, 1723–1776

Mibu Kyōgen

Hanging scroll: ink on paper, 115.7 × 22.6 cm

Seals: Kaika kiki fu sen ichi no; Gyokkō Kōanri

Inscription:

> *Where water does not gather,*
> *The moon does not dwell.*
> —trans. Stephen Addiss

PLATE 22

FOR THIS WORK, similar in conception to *Uzumasa Festival* (cat. no. 9), Taiga quickly brushed a particular event at a specific temple in his native Kyoto.

Every fourth month at the Mibu temple, a comedic form of Noh theater known as *kyōgen* was staged. In this depiction, the performers stand on a raised stage, beneath which audience members are visible. A pantomime is accompanied by music; some of the instruments, such as the *waniguchi* (gong) and the flute, are present in Taiga's painting. A woman in a darkly inked obi holds a lantern, and Taiga mentions the moon in his inscription, signs that the performances are held in the evening. The character for "moon," the second-last character of the first (rightmost) line of the inscription, is reminiscent of the form of the moon itself.

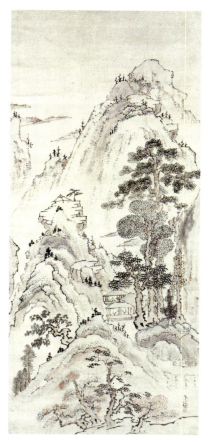

11. Ike Gyokuran, 1727/28–1784

Mountain Landscape

Hanging scroll: ink and color on paper, 127 × 55.5 cm

Signature: Gyokuran

Seals: Gyokuran; Shōfū

Literature: Addiss 1976, no. 38

PLATE 16

THE DAUGHTER AND GRANDDAUGHTER of independent women, both entrepreneurs and *waka* poets, Gyokuran was tutored in traditional Japanese poetry from childhood. She began the study of painting at the age of ten under the tutelage of one of the premier first-generation *nanga* artists, Yanagisawa Kien (1706–1758).[1] In her early twenties, Gyokuran married Ike Taiga (see cat. nos. 2–10), beginning an unconventional yet fruitful collaboration that flourished until Taiga's death.

Gyokuran schooled Taiga in poetry, and he exerted a strong influence on her painting. *Mountain Landscape*, although undated, is most likely a later work because in it Gyokuran is free from much of her husband's effect. While the triumvirate of a tall pine at the center, a mountain above, and foliage below is seen in Taiga's work, here the compartmentalized compositional elements enhance the overall decorative effect of the painting. The profusion of pink and blue dots, favorite motifs for Gyokuran, impart a liveliness and loveliness unique to this artist.

1. For Gyokuran, see Fister 1988, 74–75, 84–88.

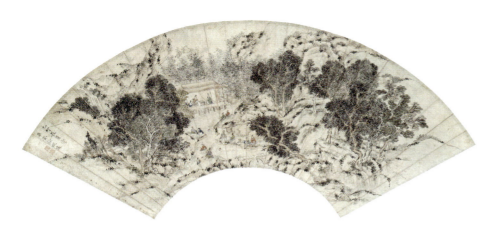

12. Aoki Shukuya, 1737?–1802

Lanting Pavilion, 1795

Fan: ink and color on mica paper, 17.8 × 52 cm

Signature: Kinoto-u chōka sha Heian Yo Shukuya
(Painted by Yo Shukuya of Heian [Kyoto] in the sixth
month of the year of the rabbit [1795])

Seal: Shukuya

Literature: Sasaki and Sasaki 1998, no. 170

PLATE 18

A JEWEL-LIKE DEPICTION, *Lanting Pavilion* amply demonstrates the strengths of one of Ike Taiga's most faithful students, Aoki Shukuya. Except for his relationship to Taiga, Shukuya's biography is relatively obscure. Born in Ise, he began his studies with Taiga while a young teenager. His closeness to his painting mentor is indicated by his contemporary appellation, Taiga the Second.

This work, dating to 1795, represents Shukuya's later style. Taiga had been dead almost twenty years, and while his influence may be seen in some elements, Shukuya's almost miniaturist attention to detail and balancing of color make this an extraordinary painting in its own right.

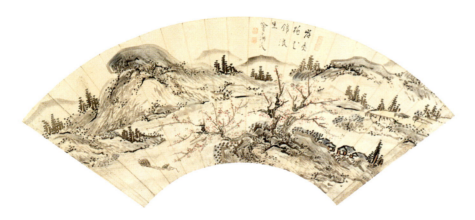

13. Satake Kaikai, 1738–1790

Peach Blossom Landscape

Fan: ink and color on paper, 17.3 × 49.7 cm

Signature: Kaikai shumin (Sake-loving Kaikai)

Seals: [illegible]; Sada; Kichi

Inscription:

> The banks are lined with flowering peach—
> embroidered ripples rise
> —trans. Jonathan Chaves

PLATE 17

LIGHT COLOR, SOFT INK washes, and gentle dotting impart a loveliness to this fan. With delicate but confident brushwork, fishermen on a stream between near and distant shores are depicted within a sure compositional structure. The foreground landmass is populated by solidly built habitations as well as flowering peach trees, whose petals have fallen into the water, creating a brocade effect.

Kaikai studied not only painting but also calligraphy and seal carving with Ike Taiga and was considered one of his primary pupils. A well-educated and talented painter and calligrapher, Kaikai aspired to live as a literatus. For reasons that remain unclear, he could not support himself and his mother on the income from his art and thus reverted to the trade of his ancestors, the making and selling of sake. Kaikai's self-deprecating humor is reflected in his signature, which reads "sake-loving Kaikai."

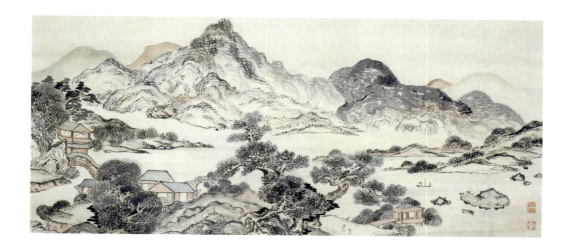

14. Ike Kanryō, 1753–1830

Landscape

Hanging scroll: ink and color on paper, 54.3 × 120.5 cm

Seals: Chōkei Kanryō; Heizei ippen no kokoro

PLATE 19

BORN TO THE ABBOT of Onkeiji on the Notō Peninsula, Ike Kanryō received his early education at religious establishments in Kyoto and Ise. While in Kyoto, he evidently began the study of painting with Ike Taiga and became one of his most devoted pupils. At Taiga's funeral, Kanryō, by then a monk, officiated. At this time, Kanryō adopted Taiga's surname, Ike, an indication of their close bond, and received from Gyokuran a gift of ten scrolls, an inkstone, and an ink stick. Kanryō returned to Notō, eventually assuming his familial position as abbot of Onkeiji.

Kanryō worked comfortably in Taiga's manner, and this landscape illustrates his mastery of the idiom. It is very rare to have such a large-scale work from Kanryō's brush, especially one with such delightful color. As might be expected, Kanryō devoted much of his life to his religious responsibilities, but as his *Heizei ippen no kokoro* seal, affixed at the lower right of this painting, explains, he "reserved a portion of his heart for art."

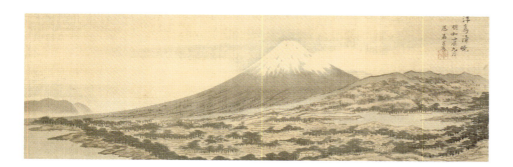

15. Niwa Kagen, 1742–1786

Mount Fuji, 1772

Hanging scroll: ink and light color on silk, 28.4 × 85.2 cm

Signature: Tō Kagen sha

Seal: Shōho

Inscription: *The floating island in pure dawn, painted in the ninth month, 1772*

NIWA KAGEN LIVED most of his life in Nagoya, relatively isolated from major centers of *nanga* painting. In his twenties he traveled to Kyoto and met Ike Taiga, who became a lifelong friend. After this trip, Kagen continued his studies of Japanese classical literature and began to sketch scenery. Typical of the literati of his time, Kagen was sensitive to outside influences, both Chinese and Western. Whether his experimentation with sketching from life was influenced by Taiga's "true views" or more direct Western influence through the port city of Nagasaki has yet to be determined.

Mount Fuji is a version of this artist's most famous and influential composition. Kagen painted several versions of Fuji combining a panoramic view of the famed peak and its surrounding landscape.[1] Despite Kagen's seeming isolation in Nagoya, his paintings of Mount Fuji were known and copied by later generations of *nanga* artists, including Nakabayashi Chikutō (see cat. no. 36) and Yamamoto Baiitsu (see cat. nos. 40, 41).

1. See Nagoya-shi Hakubutsukan 1981, pl. 17.

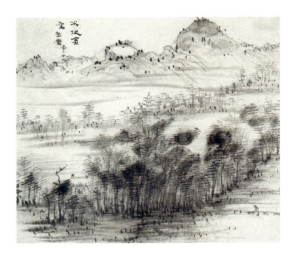

16. Uragami Gyokudō, 1745–1820

Colors Change from Red to Gold, 1814

Hanging scroll: ink on paper, 26.3 × 29.8 cm

Signature: Gyokudō toshi 70 nari (Painted at the age of seventy)

Seal: Kin i go ka (The *qin* is my home)

Inscription: *Colors change from red to gold (Kaifuku kinzei zu)*

Literature: Hillier 1987, no. 34; Tanaka 1979; Addiss 1977, pl. 145; Addiss 1976, no. 60

PLATE 24

GYOKUDŌ, NOW CONSIDERED one of the greatest practitioners of the *nanga* style, was known in his lifetime as a master of the *qin* (Chinese zither) and for his unconventional, somewhat eccentric personality.[1] Largely self-taught, he devoted himself to his music and art after the death in 1768 of the feudal lord he served. He developed a deeply personal, idiosyncratic style whose powerful brushwork and bold compositions resonate even today.

In this small work, painted just six years before his death, Gyokudō captured a moment of transition. In his inscription, he mentions fire (red) and gold, with fire referring to summer and gold to autumn. The lush leaves on the trees, brushed in Gyokudō's distinctive patterning of parallel brushstrokes, touch one another as the first autumnal winds blow through the swaying trees.

1. For Gyokudō, see Addiss 1987.

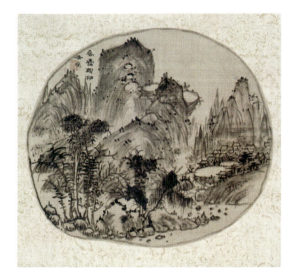

17. Uragami Gyokudō, 1745–1820

Spring Landscape

Hanging scroll: ink and light color on silk, 45 × 33.7 cm

Signature: Gyokudō

Seal: (impressed upside down) Suikyo

Literature: Addiss et al. 1983, no. 57; Tanaka 1980, no. 230; *Kobijutsu* 1971, no. 34

PLATE 25

THIS CIRCULAR PAINTING dates from Gyokudō's last, and greatest, decade. At that time he was living in Kyoto with his son, Shunkin, whose academic and literal translations of the Chinese literati style were in the mainstream of early nineteenth-century *nanga*. Gyokudō's idiosyncratic vision bristles with a seemingly disordered energy that belies the structural integrity and deliberate brushwork of his compositions.

Familiar elements of Gyokudō's mature style are present here. Relative proportions are absent in both the landscape and the figures, who are dwarfed by nature. Any recession in space implied by the careful S shape of the central mountain mass is contradicted by Gyokudō's round and ovoid plateaus, which punctuate the landscape and echo the shape of the painting. The entire composition may be seen as a play on the circle: in addition to forming the plateaus, circles are the primary element of the rocks at the near shore, and semicircles define the interior of the mountains at the center and left as well as the cluster of houses at the right. Gyokudō's mastery of ink and surface texture synthesizes seeming disproportion and improbable vistas. The nature enjoyed by the figures within, and the viewers without, is unique—far removed from reality and Chinese or Japanese precedent.

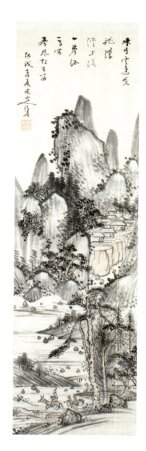

18. Okada Beisanjin, 1744–1820

Landscape, 1814

Hanging scroll: ink and color on paper, 97.3 × 27.8 cm

Signature: Ka-jutsu mōka (Poem and painting by Beisanjin, fourth month of the dog year of the [Bun]ka era [1814])

Seal: Den Koku no in

Inscription:

> Water falls beside the clouds;
> flowers fill the stream, and flow.
> A wanderer at sky's edge, with only his single lute:
> like the spring wind, he just comes and goes.
> —trans. Jonathan Chaves

PLATE 26

BEISANJIN USED HIS CAREER as a rice merchant in his native Osaka to finance his sinophilic interests. An active participant in the literati circles of his day, he associated with like-minded artists such as Uragami Gyokudō (see cat. nos. 16, 17) and Tanomura Chikuden (1777–1835) and with the Osaka patron Kimura Kenkadō. After retiring in 1809, Beisanjin devoted his remaining years to the study and practice of painting. Although evidently largely self-taught, Beisanjin accumulated wide-ranging knowledge of Chinese artists from the Song, Yuan, and Ming dynasties and was an avid bibliophile and collector of painting and calligraphy.

In *Landscape*, Beisanjin unites a calligraphic inscription with the subject of the painting. A traveler, with an attendant carrying his instrument, is on his way to or from a visit with a friend. Beisanjin's idealized landscape follows the Chinese precedents with which he was so familiar, but his bold composition and rather blunt brushwork make the painting thoroughly his own.

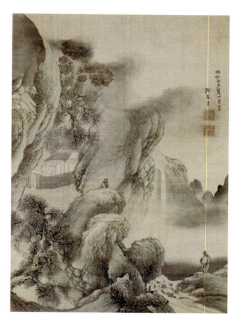

19. Yosa Buson, 1716–1783

Autumn Landscape, 1772

Hanging scroll: ink and light color on silk, 63.5 × 44.3 cm

Signature: Sha Shunsei

Seals: Sha Chōkō in; Shunsei

Inscription: *Painted in the fourth month, summer,* 1772

Literature: Sasaki, Ogata, and Okada 1998, no. 243; Cahill 1996, no. 3.22; Addiss et al. 1983, no. 44

PLATE 28

REGARDED AS THE TWO GREATEST *nanga* painters, Yosa Buson and Ike Taiga were the preeminent practitioners of this style in the eighteenth century. Absorbing and transforming the Chinese literati style, these men and their followers created a new and wholly Japanese art form.

Buson, second only to Matsuo Bashō as Japan's greatest haiku poet, came to painting relatively late in life, and it was not until the 1750s that he devoted more time to painting than poetry. Buson used a wide range of sources throughout his career —woodblock-print painting manuals, Chinese paintings of the Ming and Qing dynasties, Japanese paintings of diverse styles both antique and contemporary, and the work of fellow artists such as Sakaki Hyakusen (1698–1753).

This small landscape features a scholar-recluse leaning against a rock, welcoming or perhaps seeing off a visitor; his circular walled habitation is nestled in the mountain clearing behind him. The visitor, possibly a nun, stands on the other side of a rushing stream gazing upward at the man, who looks straight out at the viewer. Even though the figures are small, rendered with just a few brushstrokes and dwarfed by the looming landscape, Buson communicates their personalities and relationship through posture, attitude, and facial delineation. His use of ropy *cun*, or texture strokes, in the mountain forms gives a vitality and tension to the great vista of the landscape, which is furthered and balanced by the opposition of the enclosed mountain retreat. This contrast of openness and closure provides the compositional and psychological leitmotif for the painting and can be seen in other works by Buson from this period.[1]

1. See Cahill 1996, 159–60.

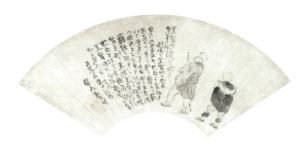

20. Yosa Buson, 1716–1783

Oku no hosomichi (Narrow Road to the Far North)

Fan: ink and light color on paper, 18.1 × 48.1 cm

Signature: Yahan ō Buson sha

Seals: Chōkō; Shunsei

> Mount Kurokami was visible through the mist in the distance.
> It was brilliantly white with snow in spite of its name, which
> means black hair.
> Rid of my hair,
> I came to Mount Kurokami
> On the day we put on
> Clean summer clothes.
> —Sora
>
> My companion's real name is Kawai Sogoro, Sora being his pen
> name. He used to live in my neighborhood and helped me in such
> chores as bringing water and firewood. He wants to enjoy the views
> of Matsushima and Kisagata with me, and also to share with me
> the hardships of the wandering journey. So he took to the road after
> taking the tonsure on the very morning of our departure, putting on
> the black robe of an itinerant priest, and even changing his name to
> Sogo, which means Religiously Enlightened. His poem, therefore,
> is not intended as a mere description of Mount Kurokami. The
> last two lines, in particular, impress us deeply, for they express
> his determination to persist in his purpose.[1]

Literature: Fister and Gitter 1985, no. 16

PLATE 29

BUSON'S POETIC GENIUS was not for Chinese verse but for the native Japanese poetry style, *haikai*. This fan painting illustrates an excerpt from the travel diary of the famed haiku poet Matsuo Bashō (1644–1694), *Oku no hosomichi* (Narrow road to the far north; 1694). The fan is in the form known as *haiga*, combining haiku with abbreviated and incisive painting. Buson's soft and fluid brushwork truly unifies the poetic inscription with the painting. The brushstrokes that define Bashō and his companion as they begin their long journey twist and turn just as the calligraphy in the inscription does. Buson produced a number of paintings based on this popular work of Bashō's during the period from 1777 to 1780.[2]

1. Yuasa 1966, 100–101.

2. At least five works by Buson share this subject, in fan, handscroll, and screen formats, in the Kyoto National Museum (Mason 1993, 296), the Itsuō Museum (Okada 1978, pl. 18), and the Burke collection (Fister and Gitter 1985, no. 17).

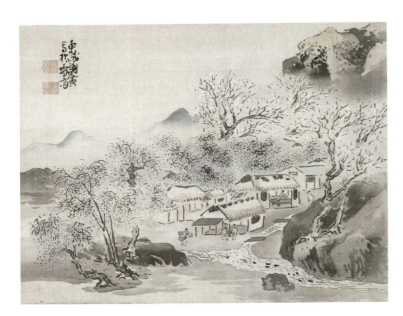

21. Yosa Buson, 1716–1783

Spring Landscape

Hanging scroll: ink and color on silk, 43.9 × 50.6 cm

Signature: Tōsei Sha-in sha Sessai ni oite (Painted by Buson at Snow Hall)

Seals: Sha Chōkō; Sha Shunsei

Literature: Sasaki, Ogata, and Okada 1998, no. 542

PLATE 30

THE FRESH, BEAUTIFUL COLOR present in this spring landscape is typical of Buson's works from his later years. Although color was not an integral part of the Chinese literati style, Buson employed it to great effect, amplifying the seasonal and atmospheric qualities of his paintings. Here Buson uses pink, white, greens, and blues to describe the idyllic scene of a rustic hamlet located at a fork in a stream. Villagers are seen in and around their homes, occupied with everyday tasks. On the slopes enclosing the structures are blossoming peach trees, whose fallen petals float in the running water.

After 1777 and until his death in 1783, Buson used the name Sha-in, the signature that appears on this painting. Works from the so-called Sha-in period exemplify Buson's fully developed personal style. The power of this master in his last period can be seen in the sure compositional structure and the relaxed, confident brushwork that defines landscape elements.

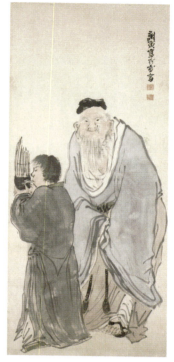

THIS PAIR OF FIGURE PAINTINGS dates from the last phase of Buson's life and bears a similar combination of seals and signatures as the previous entry. Buson's figural and landscape styles reached full maturity during his Sha-in period, culminating in a confident and free brush manner. Buson integrated elements of his *haiga* style with his mature landscape and formal figural styles, calling upon this rich repertoire to achieve his desired ends.

Although compositionally related, each of these monumental figures is isolated in the picture plane, and they do not interact. All knowledge of the men must be inferred from their attributes and Buson's portrayals. On the right, delineated in soft ink tones and light color, are a scholar and an attendant who blows into a *sheng*, a type of Chinese mouth organ known since antiquity. The venerable scholar, showing his age through his hunched posture and long scraggly beard, presents his thoughtful and honest face directly to the viewer. In contrast, on the left a darkly clad man, whose robes are more thickly and roughly outlined, is seen in profile. He stands tall, carrying a walking stick, from whence dangles a string of coins. His raised right index finger points upward, possibly toward himself. Although the identities of the men are not specified, their portrayals are clearly a study in opposing types. The simple, music-loving scholar, shod in sandals, faces the world forthrightly. His counterpart looks inward, concerned with money and himself.

22. Yosa Buson, 1716–1783

Man with Staff and *Old Man with Attendant*

Hanging scrolls: ink and light color on paper, 128.3 × 56 cm (each)

Signatures: (right) Sha-in Sessai ni oite sha su (Sha-in painted at Snow Hall); (left) Sha-in

Seals: (right) Sha Chōkō, Sha Shunsei; (left) Sha Chōkō in, Shunsei

Literature: Sasaki, Ogata, and Okada 1998, no. 559; Addiss et al. 1983, no. 45

PLATE 116

23. Matsumura Goshun, 1752–1811

Deer, 1777

Hanging scroll: ink and color on silk, 42.6 × 68.8 cm

Signature: Painted by Gekkei in the tenth month of 1777 at Hyakushōdō

Seals: Sonseki; Katen

Literature: Sasaki and Sasaki 1998, no. 56; Kobayashi and Sasaki 1993, fig. 61

PLATE 48

GOSHUN WAS A NATIVE OF KYOTO, and family tradition dictated his employment at the Gold Mint, where his father was a senior ranking official. But in the early 1770s, Goshun left his position to study the arts full-time. About this same time, he became a pupil of Yosa Buson, the preeminent haiku poet and literati painter of his day, by whom he was tutored in both haiku and painting. After the deaths of both his wife and father in 1781, a devastated Goshun moved from Kyoto to the town of Ikeda, where he devoted much of the next five years to the study of Chinese painting and the mastery of literati painting techniques. After Buson's death in 1784, Goshun returned to Kyoto, eventually associating himself with the studio of Maruyama Ōkyo. In 1793 Goshun established his own academy/atelier on Shijō avenue in Kyoto and quickly achieved success.

Deer is one of the earliest-known dated works by Goshun, painted when he was just twenty-five. Bearing the signature Gekkei, which he used during the early 1770s through 1781, the painting is in a style clearly derived from Buson, who painted a number of well-known renditions of single and paired deer. Painted six months before Goshun and his first wife married, this image of a contented pair of deer perhaps reflects the happiness the artist had found in his own life.

24. Matsumura Goshun, 1752–1811

One Hundred Old Men
Hanging scroll: ink and color on silk, 153 × 68.4 cm
Signature: Tama tama utsushi etari, hyaku rō zu wo Goshun
(By chance, Goshun copied a painting of One Hundred
Old Men)
Seal: Goshun
PLATE 115

THE THEME OF ONE HUNDRED OLD MEN was particularly popular among eighteenth-century *nanga* artists. Taiga, Buson, Goshun, and Ki Baitei are among those who rendered versions of this auspicious theme, which features large groups of men enjoying cultivated pursuits in their retirement.[1] Set outdoors amid rocks and pines, the men are situated in clusters around the seated god of longevity, Jurōjin. Replete with symbols of long life—rocks, pine, cranes, and deer—these works must have received wide patronage, given the number of extant versions. This painting most likely dates from Goshun's period of recuperation and work in Ikeda; it bears a seal reading "Goshun," the name he adopted after 1781 and by which he is best known.

Despite his claim in the inscription that he "by chance" copied a painting on the One Hundred Old Men theme, Goshun clearly drew heavily upon Buson's prototype. Copying, long a part of art education, provided students such as Goshun with the foundation upon which to formulate an individual style.

The box for this painting indicates that it was once in the collection of Maki Ryōkō (1777–1843), a late-Edo calligrapher and follower of Kameda Bōsai. Ryōkō received the painting in 1817 from a prominent doctor and associate of many literati in Kyoto, Koishi Genzui (1783–1894).

1. For the Buson version, see Addiss et al. 1983, no. 46; a similar subject by Ki Baitei is also in the Gitter-Yelen collection (see fig. 1 in Fister essay above).

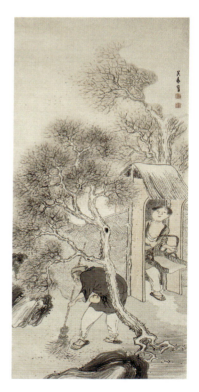

25. Matsumura Goshun, 1752–1811

Sweeping Autumn Leaves
Hanging scroll: ink and color on silk, 111.1 × 52 cm
Signature: Goshun sha
Seals: Goshun no in; Hakubō
Literature: Addiss et al. 1983, no. 75

THIS SCROLL DATES FROM Goshun's sojourn in Ikeda and was painted not long after he changed his name from Gekkei to Goshun. A wizened gardener uses a twig broom to sweep fallen leaves from the ground. An assistant carrying a handled wicker basket emerges from a gateway in the herringbone-patterned fence. The gusty wind of autumn is made manifest by the cloud formation, to which Goshun affixed his signature and seals, and by the bowed branches and fluttering leaves.

This work displays Goshun's facility with the Buson style; he borrowed not only the theme but

the composition and figural style as well. Numerous Buson works feature individuals engaged in various chores outside a walled retreat.[1] Likewise, semicircular enclosures are a constant feature of Buson's works. Goshun and, by extension, Buson focus on the individuals involved in the mundane upkeep of the retreat rather than on the lofty scholars who reside inside its walls.

1. See, for example, Museum Yamato Bunkakan 1983, nos. 30–31.

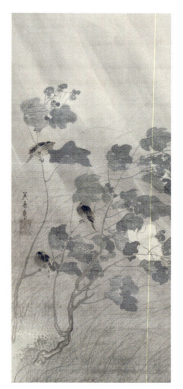

26. Matsumura Goshun, 1752–1811

Flowers and Birds in the Rain, c. 1783–85
Hanging scroll: ink and color on silk, 104 × 43.8 cm
Signature: Goshun sha
Seal: Sankadō Tosho in
PLATE 52

THE STRONG WIND AND RAIN of early autumn stream from the upper left of this painting, whipping against three blue birds perched on the stems of a hibiscus plant. Goshun isolated his subjects against an almost blank background, the groundline articulated by cursory grasses. The strong diagonal thrust of the rain, created by broad brushstrokes of ink, is counteracted by the graceful verticality of the hibiscus. The soft ink describing the light green leaves and fragile white flowers, one in full bloom, another still in bud, lightens the mood. Goshun's innovative treatment of this untraditional theme focuses the viewer's attention on the precariousness of life and beauty in the face of change.

Painted after Buson's death, this work bears his Sankadō Tosho in seal, which Goshun inherited and used on a limited basis. Dating to 1783–85, when Goshun was in his early thirties, the painting reflects both his mastery of the *nanga* style and his continuing search for new artistic avenues.

27. Matsumura Goshun, 1752–1811

Night Vigil, c. 1790
Hanging scroll: ink and color on paper, 122 × 28.5 cm
Signature: Gekkei
Seal: Goshun
Inscription: see below
Literature: Addiss 1976, no. 44
PLATE 118

GOSHUN STUDIED BOTH the *nanga* style and *haiga* under Buson. The loose brushwork and close connection between the calligraphy and painting in this work are features of Goshun's *haiga* paintings. The title *Night Vigil* refers to a character in the dramatic story *Heike Monogatari* (Tale of the Heike), which tells of the clashes between the Taira and Minamoto clans. The long calligraphic inscription, which appears below in italic type, transcribes a scene from this epic tale wherein Lord Jittei, a Taira courtier, returns to the capital after his clan's forcible removal by the Minamoto:

> *Now, thought Lord Jittei, only the Konoe-Kawara palace of his sister, the former empress, still stood as a reminder of the old capital he so fondly recalled. On arriving, he had his servant knock at the gate. From within, a woman's voice called out, "Who could that be, coming to a place where no one ever makes his way along the weed-choked path?"*
>
> *"Her majesty's brother, the general, has come from Fukuhara."*
>
> *"The front gate is locked, please enter by the small gate to the east," called the voice.*
>
> *Lord Jittei and his retainer did as they were bid. The empress dowager of late had whiled away her time reminiscing upon the past. But tonight she had had the lattice on the south side of her room drawn up and was playing her lute when Lord Jittei arrived. "Is it really you," she gasped, "or am I dreaming?"*

There was in the palace a lady-in-waiting called Matsuyoi, or Night Vigil. She had come to be called this after the empress dowager once asked which seemed more poignant, keeping futile vigil for a lover at night or parting from him at dawn. The woman had replied with this verse:

> *While keeping vigil*
> *The temple bell tolls the deepening night;*
> *To this, the cock's crow that signals parting*
> *Seems but a trifling thing.*

At daybreak Lord Jittei set out on his return to Fukuhara. He summoned one of his retinue, the archivist Fujiwara Tsunetada, and instructed him to return to the palace. "Matsuyoi seemed so sad to see us go. Go back and offer her some words of solace." Tsunetada hurried back and explained, "My lord commanded that I come back to offer a wish of farewell." Thereupon he composed this verse:

> *It is but a trifling thing, you said,*
> *The crow of the cock at dawn.*
> *Why then, this morning*
> *Should it make me feel so sad?*

Matsuyoi held back her tears and replied:

> *The tolling bells of deepening night*
> *May be painful to those who wait,*
> *But for me whom you have left forlorn*
> *The cock's crow is yet more sad.*

When Tsunetada returned to Lord Jittei with this, the general was quite touched. "That is why I sent you to her," he said. Thereafter, because of his poem, Tsunetada was known as the "Trifling-thing Archivist."[1]

1. Excerpt from a translation and summary by David Owens; previously published in Addiss 1976, no. 44.

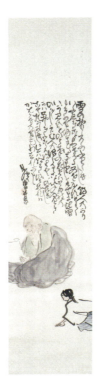

28. Matsumura Goshun, 1752–1811

Tsurezuregusa Haiga (Priest Kenkō Reading a Letter)
Hanging scroll: ink and color on paper, 115.9 × 28.3 cm
Signature: Gekkei sha narabi ni sho (Painting and calligraphy by Gekkei)
Seal: Goshun
Inscription:

> One morning, after a pleasant fall of snow, I sent a letter to someone with whom I had business, but failed to mention the snow. The reply was amusing: "Do you suppose that I shall take any notice of what someone says who is so perverse that he writes a letter without a word of inquiry about how I am enjoying the snow? I am most disappointed in you." Now that the author of that letter is dead, even so trivial an incident sticks in my mind.[1]

IN THIS PAINTING GOSHUN employs his informal *haiga* style to portray episode 31 of the *Tsurezuregusa* (Essays in idleness). This fourteenth-century work, authored by the Buddhist monk Kenkō (Yoshida no Kaneyoshi, 1283–1352), is a series of brief, linked observations and commentaries on the nature of life, beauty, and being. The text came to be considered a classic in the seventeenth

century and would have been familiar to all educated Japanese because it was used as a model in the teaching of Japanese prose style.

Goshun expertly combines his subject and mode of depiction. The abbreviated *haiga* brushwork that complements the text is an ideal choice for this excerpt, whose author believed that "leaving something incomplete makes it interesting."[2] Goshun chose a literal depiction of the scene. Enveloped in his robes, Kenkō sits on the floor reading the letter whose text is inscribed in the upper portion of the scroll. A servant, who perhaps had just delivered the gently chiding missive, awaits his next instruction. In the monk's huddled posture and facial expression, Goshun captures Kenkō's chagrin at his oversight in not mentioning the fresh snow to his correspondent.

1. Translated by Donald Keene, in Keene 1998, 31–32.
2. Ibid., xxiii.

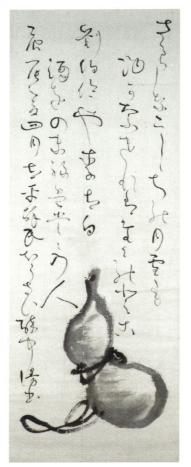

29. Kameda Bōsai, 1752–1826

Gourd, 1820
Hanging scroll: ink on paper, 129.5 × 47 cm
Signature: Kanoe-tatsu no natsu shigatsu Taihei Suimin (Painted in the fourth month [summer] of 1820 while inebriated, the peaceful drinker [Bōsai])
Inscription:

> Without sake, Sarashina with its moonlight, snow, and flowers
> Is just another place.
> Without sake to drink, Liu Ling and Li Bo were just ordinary men.
> —trans. Jonathan Chaves

Literature: Addiss 1984, no. 39; Addiss 1976, no. 50
PLATE 4

KAMEDA BŌSAI, a renowned Confucian scholar and calligrapher, was a true Edo-period literatus. The rigid social stratification promulgated by the Tokugawa shogunate technically prohibited Bōsai's education and subsequent career as a scholar, but his father, an Edo merchant, was able to send his talented son to a Confucian school normally reserved for the children of samurai. Bōsai excelled in his studies; he was a distinguished calligrapher by the age of twenty and opened his own private academy, teaching Confucianism, at twenty-two.

In 1790 the shogunate issued new regulations that allowed only one school of Confucianism to be taught. Bōsai, an ardent adherent of another tradition, was branded one of the "Five Heterodox Teachers," effectively ending his teaching career. Despite financial hardship, Bōsai continued to lead the life of a scholar, conducting research,

composing poetry, writing calligraphy, painting, and meeting with his wide circle of friends, including Tani Bunchō (see cat. nos. 31–33) and Sakai Hōitsu (see cat. nos. 90, 91).[1]

Here Bōsai depicts a double-gourd container for sake, his favorite beverage. In his inscription, which is as much the subject of the painting as the gourd, Bōsai comments on the inspirational qualities of rice wine. Without the intoxicating qualities of sake, Bōsai observes, the famed moon-viewing spot, Sarashina, becomes ordinary, and the famous Chinese drinkers Li Bo (a Tang dynasty poet) and Liu Ling (one of the Seven Sages of the Bamboo Grove) would not have achieved their fame. In his final years, Bōsai, famed for his Chinese calligraphy, sometimes wrote in Japanese kana script, as in this work.

1. For Bōsai, see Addiss 1984.

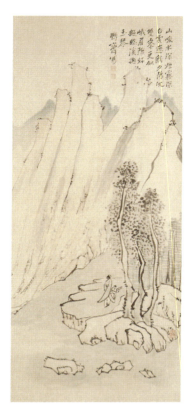

30. Kameda Bōsai, 1752–1826

Landscape with High Mountains
Hanging scroll: ink and light color on paper, 127.3 × 54.9 cm
Signature: Bōsai sha
Seals: Chōkō shi in; Bōsai kanjin; Shu in
Inscription:

> Mountains craggy, river sluggish,
> mist and fog lie thick;
> white clouds partially obscure
> the evening sun that sets.
> Now these twin peaks seem even more
> like dangerous Mount Emei:
> I too will take up facing the stream
> and play my jade lute.
> —trans. Jonathan Chaves

EVEN THOUGH HIS BRUSHWORK is economical and his range of motifs limited, Bōsai created complex and resonant images. In this painting he outlined the familiar forms of rocks, trees, and distant mountains in a controlled line. The artist used few interior texture strokes to define his forms, depending instead on compositional structure and his skillful, lightly colored washes to create a substantial and recognizable landscape.

A scholar walks, gazing upward at the towering peaks, accompanied by his attendant carrying a *qin*. The inscription speaks of Mount Emei, in Sichuan province, one of the four holy mountains in China. For Bōsai, Mount Emei was important not for its religious associations but as the birthplace of the great Song-dynasty literatus Su Shi (1036–1101). By recalling Su Shi, Bōsai invoked the entire literati tradition of China and the attendant interests of those who participate in its culture.

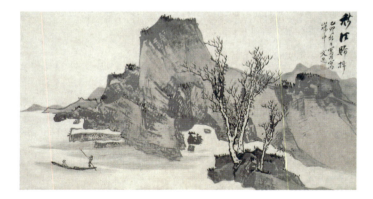

31. Tani Bunchō, 1763–1840

Returning Home on the Autumn River, 1795
Hanging scroll: ink on paper, 53.5 × 96 cm
Seals: Tani Bunchō; Bunchō Tani-shi
Inscription: *Returning home across the river in autumn; Painted at the Shazanrō studio in the autumn of 1795 by Bunchō.*
Literature: Addiss et al. 1983, no 52; Suzuki, ed. 1932, pl. 222

THE SON OF A POET and retainer to the Tayasu family, descendants of the eighth Tokugawa shogun, Tani Bunchō was born to status and privilege. In 1792 he began his association with Matsudaira Sadanobu (1758–1829), a member of the Tayasu family, who was serving as regent for the eleventh shogun. In his capacity as an official artist, Bunchō was charged with a number of important commissions, which gave him access to collections of Chinese and Japanese art and entrée with artists and patrons throughout Japan.

Bunchō began his study of painting at a young age in the Kanō style with Katō Bunrei (1706–1782) and Watanabe Gentai (1749–1822). In 1788 Bunchō left Edo for Nagasaki, intending to learn Western painting techniques. During his travels, he met the patron Kimura Kenkadō (1736–1802), who became a lifelong friend. Through Kenkadō, Bunchō met *nanga* artists in the Kansai area, including Uragami Gyokudō (see cat. nos. 16, 17) and Yamamoto Baiitsu (see cat. nos. 40, 41). Bunchō's artistic eclecticism led to a remarkable stylistic range that included Chinese, Japanese, and European traditions. Bunchō is best known, however, for his work in the *nanga* style and for his role in bringing the literati style to the capital from its traditional home in Kyoto and Osaka.

Returning Home on the Autumn River, an early work, displays Bunchō's knowledge of the *nanga* idiom and his serious study of Japanese and Chinese precedents. No one early painter or painting inspired this work, but Bunchō had clearly synthesized the efforts of Dong Qichang (1555–1636) and later Chinese artists in their treatment of form and space. The crystalline structure of the natural features and the ambiguities of size and spatial relationships recall conventions of sixteenth- and seventeenth-century Chinese landscape painting.

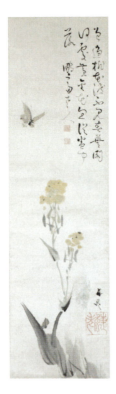

32. Tani Bunchō, 1763–1840
Kameda Bōsai, 1752–1826

Spring Flowers and Butterfly

Hanging scroll: ink and color on paper, 100.6 × 27 cm

Signatures: Bunchō; Bōsai rōjin

Seals: Shoso [Bunchō]; Chōkō shi in; Bōsai kenjin [Bōsai]

Inscription:

> Once I took the ferry to Peach Blossom Spring,
> Yet saw no sign of Spring Foliage Pavilion.
> Whence came these flowers of yellow gold?
> —Suddenly falling from the painted scroll!
> —trans. Jonathan Chaves

PLATE 34

THIS COLLABORATIVE WORK features yellow flowers and a butterfly painted by Bunchō and a poetic inscription by Kameda Bōsai (cat. nos. 29, 30, 92). In their own day, Bunchō and Bōsai were considered the best painters in Edo; it is remarkable to have a single work from both their hands.

The yellow flowers, a kind of rape blossom, are often combined with butterflies to symbolize the coming of spring in Japan. Bunchō's swiftly painted, loose strokes stand in sharp contrast to the deliberate manner of cat. no. 31. Bōsai's inscription refers to spring initially through the more commonly painted signal of the season, the peach blossom. The poem appears to describe Bunchō's creation of the flower itself. The close integration of subject and inscription on the scroll suggests that the artists produced this work when they were together, perhaps as a sort of performance piece for friends or patrons.

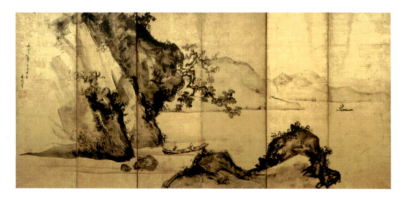

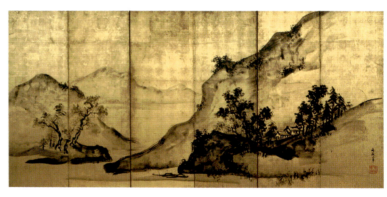

33. Tani Bunchō, 1763–1840

Landscape Screens, 1828

Pair of six-panel folding screens: ink on gold leaf, 174 × 352.2 cm (each)

Signature: (right) Bunchō hitsu; (left) Bunsei juichi nen kugatsu jūsan nichi. Bunchō histu (Painted by Bunchō on the thirteenth day of the ninth month of 1828)

Seal (on each): Gagakusai-in

Literature: Sasaki and Sasaki 1998, no. 58; Kobayashi and Sasaki 1993, vol. 19, nos. 38–39

PLATES 1, 42 a, b

DATING FROM BUNCHŌ'S mature period, this extraordinary pair of landscape screens displays his tremendous control of his medium and his mastery of the *nanga* style. The landscape itself comprises overlapping triangles of mountain formations in near, middle, and distant planes. Unlike his 1795 *Returning Home on the Autumn River* (cat. no. 31), Bunchō here presents a comprehensible, integrated sense of space, distance, and proportion. On the left screen, a ferryman poles his passenger through the waterway, moving toward a village nestled within the gentle sloping hills at the far right of the companion screen. Bunchō elicited a broad range of tones from a thick black ink, applied with a broad, flat *hake* brush in a technique reminiscent of the Rinpa *tarashikomi*, the ink wash pooling and puddling on the unabsorbent gold leaf. These accumulations of wash enliven the surface while balancing the structured elements of the composition.

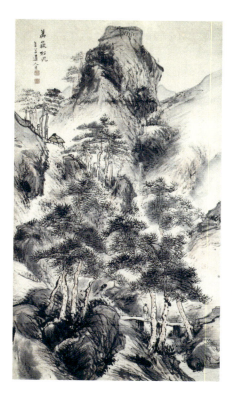

34. Yokoi Kinkoku, 1761–1832

Breeze through the Pines in the Myriad Peaks, c. 1806
Hanging scroll: ink and light color on paper,
169.6 × 94.2 cm
Signature: Kinkoku dōjin sha
Seals: Myōdō no in; Kinkoku; [illegible]
PLATE 31

ALTHOUGH NOT A DIRECT DISCIPLE of Yosa Buson, Kinkoku carried on elements of the Buson tradition into the early part of the nineteenth century. This monk-painter apparently came to both spiritual and artistic maturity after his life-altering pilgrimage to Mount Ōmine in the summer of 1804. The experience of climbing mountains as part of the practice of Shugendō radically informed his painting. Previously he had painted figures in both the *haiga* tradition of Buson and the Maruyama-Shijō tradition, but after his mountain treks, Kinkoku turned increasingly to landscape subjects, developing a painting style closely aligned to the *nanga* tradition of Buson and Goshun.

This scroll illustrates Kinkoku's intimate knowledge of nature and the beginnings of his mature landscape style. A solitary figure enjoys a moment's respite from the summer heat as he stands above the cooling rush of a mountain stream. Ropelike linear brushstrokes, derived largely from Buson and Goshun, define the central mountain peak and smaller rock formations nearer the viewer. The scene is tightly ordered and has a compositional unity typical of Kinkoku.

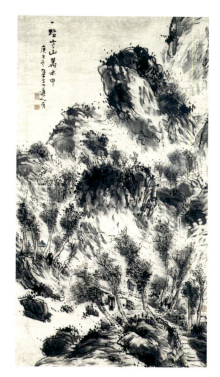

35. Yokoi Kinkoku, 1761–1832

Solitary Path through the Cold Mountains and Myriad Trees, 1810
Hanging scroll; ink and light color on paper,
159.4 × 83.7 cm
Signature: Kanoe uma fuyu Kinkoku dōjin sha (Painted by Kinkoku in the winter of the year of the horse [1810])
Seals: Kinkoku bokuchi (Ink-mad Kinkoku); Myōdō no in; Bokuchi shujin
PLATE 32

THIS LANDSCAPE, done in the winter of 1810, is a rare example of Kinkoku's large-scale work (as is cat. no. 34). The rough, active painting style associated with his later years is clearly evident here. The predominantly monochromatic ink landscape is accented with light pink washes in the tree trunks and some rock formations; two patches of blue highlight the upper garment of the traveler and the roof of a small hut across the rustic bridge.

The scene describes the coming of winter. The cold wind blowing through the trees is conveyed not only by leaves that flutter in profusion throughout the painting but also by the freely brushed mountain and tree forms. Kinkoku's sure, strong, and vibrant brushwork conveys a sense of the chill wind, but the scene itself is not forbidding. A path entering the landscape at the lower right invites the viewer's eye, and the man-made forms—the path, pavilion, and houses—are not dwarfed by nature but fit comfortably within its grandeur.

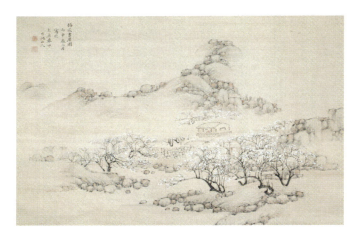

36. Nakabayashi Chikutō, 1776–1853

Plum Blossom Studio, 1836

Hanging scroll: ink and light color on paper, 50.5 × 75.5 cm

Signature: Chikutō Sanjin

Seals: Seishō no in; Chikutō Sanjin

Inscription: *The plum blossom studio, painted in spring, the second month of 1836, at Ohara hermitage.*

Literature: Addiss 1976, no. 66

PLATE 45

BORN IN NAGOYA, Nakabayashi Chikutō moved to Kyoto at the age of twenty-eight with his friend and fellow *nanga* painter, Yamamoto Baiitsu (see cat. nos. 40, 41). These young men soon became part of Rai San'yō's intellectual circle, an influential group of sinophiles. Unlike earlier generations of *nanga* painters, who were largely professionals, San'yō and his circle were scholar-amateurs in the tradition of their Chinese forebears. Chikutō and his peers advocated the systematization of brushwork and an accepted corpus of Japanese and Chinese models.

This spring landscape is a beautiful example of Chikutō's quiet painting style. The idealized landscape features a two-story structure, presumably a scholar's retreat, overlooking a scenic river whose banks are lined with flowering plum, a sign of the coming spring. Chikutō's effective composition gives a sense of cohesion and stability to the painting, which is further reinforced by the repetition of forms throughout the scene. The motif of small, squared-off rocks is a unifying element, as are the gentle curves seen in the arching trunks of the plum trees, which are echoed in the shapes of the distant mountains.

The painting is still stored in its original box, which bears an inscription by Ichida Banri (1842–1770), a student of Chikutō's. Banri's inscription, written just three months after the creation of the painting, records that Chikutō painted the work for the Sotomura family.

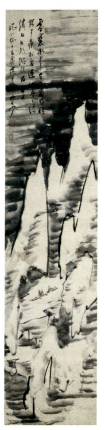

37. Hosokawa Rinkoku, 1779–1843

Sledding in the Icy Mountains

Hanging scroll: ink and light color on paper, 127.5 × 27.7 cm

Signature: Rinkoku Sanjin

Seals: Rinkoku koji; Uyu sensei; [illegible]

Inscription:

> *Moving through snow and ice without stopping*
> *I travel on journeys of several li faster than by boat.*
> *The serried mountains pile up like waves and billows to the top,*
> *Even on the banks of the nine-times winding stream, I am*
> *completely free.*

PLATE 41

THE MOST CELEBRATED SEAL CARVER of his day, Hosokawa Rinkoku was also an accomplished poet and *nanga*-style painter. Born on the island of Shikoku, he received a classical education and studied calligraphy, seal carving, painting, and poetry with local literati. As a young man he traveled to Nagasaki, at that time the only place in Japan where Chinese could legally reside, to learn more about Chinese culture. Rinkoku lived also for a time in Edo, where he was highly regarded as a seal carver and literatus. Using Edo as a base, he embarked on a series of journeys that fed both his soul and his art, making him a unique interpreter of the literati spirit in the first half of the nineteenth century.

This unusual painting of snow-covered peaks against a dark winter sky is a direct outcome of Rinkoku's travels, which are documented in an album of sketches from journeys taken between 1828 and 1838.[1] The album provides a visual record of these trips as well as the sources for many of Rinkoku's later paintings. In it is a small sketch of the artist being pushed on a sled along a mountain slope in northwestern Japan.[2] Rinkoku dramatized the scene in *Sledding in the Icy Mountains*, using broad, horizontal strokes of black ink to render sharply pointed mountain peaks against a dark sky. The same horizontal brush technique indicates the mist hanging over the peaks. The only patch of color is the artist himself, cloaked in a red garment, gliding down the steep, snow-covered slope.

1. Illustrated in *Kaikodo* 1997, no. 67.
2. See Addiss 1997, fig. 12.

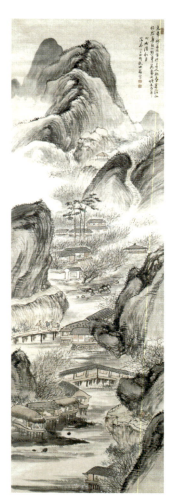

38. Okada Hankō, 1782–1846

Village among Plum Trees, 1838

Hanging scroll: ink and color on satin, 166.5 × 52 cm

Signature: Naniwa Jitekki Kanzan Gaishi Den Shuku sha

Seals: Hankō; Shuku in

Inscription:

> Wang Mian was unwilling to pass down his wonderful technique
> And so today there is no one who can paint the Immortal of Luofu
> Mountain
> But I have managed a few good brushstrokes
> And now three hundred years have been added to the plum
> blossom's life.
> —trans. Jonathan Chaves

Literature: Addiss 1976, no. 62

PLATE 44

OKADA HANKŌ, the son of Okada Beisanjin (see cat. no. 18), initially studied painting with his father. An extremely successful *nanga* painter during his lifetime, Hankō belonged to the literati circle surrounding Rai San'yō which included Nakabayashi Chikutō, Yamamoto Baiitsu, and Hine Taizan (see cat. nos. 36, 40, 41, 48), and he was a friend to numerous other literati, including Hosokawa Rinkoku (see cat. no. 37), whom he met in Osaka in 1835. Because looser regulations allowed more materials to be imported into Japan, this younger generation of *nanga* artists had much greater access to original Ming- and Qing-dynasty paintings, which they studied carefully and upon which they modeled their own works.

The inscription on this painting illuminates Hankō's spiritual source for it as well as his assess-ment of his role in the perpetuation of the literati style. Hankō's reference to Wang Mien (1287–1359), a Yuan-dynasty painter famed for his powerful depictions of plum blossoms, reflects his respect for and appreciation of earlier Chinese masters, not a literal model. The Chinese artist and technique most closely associated with Hankō is Mi Fu (1051–1107) and his horizontal dotting technique, which Hankō has adopted here for the rock formations. The landscape, carefully constructed of compartmentalized units that wind up toward distant mountains, displays the conservatism prevalent in the Kyoto-Osaka area during the first part of the nineteenth century.

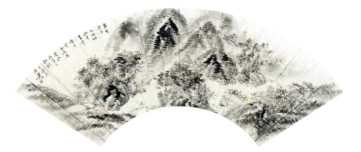

39. Okada Hankō, 1782–1846

Landscape, 1837–40

Fan: ink and light color on paper, 18.4 × 59.3 cm

Signature: Hankō

Seal: Den Shuku

Inscription:

> In those years, lit by fireflies and snow, how diligent I was!
> Now, looking back at those clouds in the blue, the past seems empty!
> I recently brushed this at Tsumino-e and captured its true
> appearance. Hankō.
> —trans. Jonathan Chaves

PLATE 27

OKADA HANKŌ WAS IN SERVICE to Lord Tōdō until 1832, when he resigned his position, moved to the banks of the Yodo River near Osaka, and actively pursued the life of a literatus. In 1837 a portion of Osaka, and possibly Hankō's home, burned during an insurrection against the govern-ment. At that time Hankō moved down the coast to Sumiyoshi, where he spent the remainder of his life and produced the majority of his works.

This small painting, according to the inscrip-tion, portrays Hankō's new home, but the artist's specificity is somewhat misleading. Although aspects of the landscape particular to the Tsumino-e district near Osaka might be present, the scene is typical of the idealized landscape of the literatus. The presence of two men—one on a bridge, the other in his home—illustrates the familiar theme of parting or greeting that permeates the literati tradition of both China and Japan.

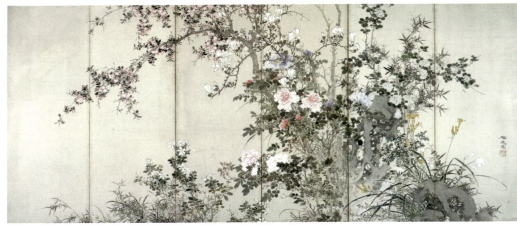

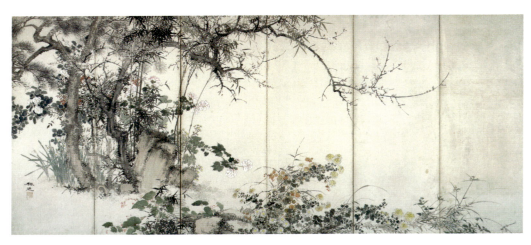

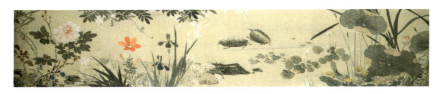

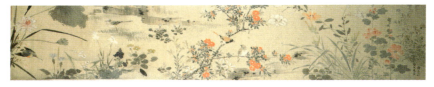

40. Yamamoto Baiitsu, 1783–1856

Flowers of the Four Seasons, c. 1830–40
Pair of six-panel folding screens: ink and color on paper,
167.2 × 372 cm (each)
Signature: Baiitsu
Seal: Baika Itsujin
Literature: Takeda et al. 1981; Osaka Bijutsu Club 1935,
no. 180
PLATE 40 a, b

LIKE MOST ARTISTS OF HIS ERA, Yamamoto
Baiitsu began his study of painting under the tute-
lage of a Kanō school artist, in his case, Yamamoto
Rantei (fl. mid-nineteenth century), in his home-
town of Nagoya. As a young man, Baiitsu met
Nakabayashi Chikutō (see cat. no. 36), also a na-
tive of Nagoya, and in 1802 the two left that city
to pursue their painting studies in Kyoto. Like
Chikutō, Baiitsu painted *nanga* landscapes, but
he became best known for his exquisite bird-and-
flower paintings, of which these screens are a
stunning example.[1]

Baiitsu focused only on the flowers and flower-
ing trees of the four seasons. The seasons are paired,
spring and summer on the right screen, autumn
and winter on the left. Baiitsu adopted a compo-
sitional structure that is anchored on each side by
concentrated groupings of flowers and rockery.
Bamboo, rendered in monochromatic ink, is a re-
curring motif in each section, the repeated brush
patterns providing continuity and accentuation.

Baiitsu reinforced the scholarly associations of
his subject by including pine, plum, and bamboo,
the Three Friends of Winter, at the far edge of the
left screen, and *taihu* rocks, so closely associated
with the literati, on the right. Despite the profu-
sion of flowers and trees, Baiitsu's mastery of subtle
color and composition allows an overall impression
of clarity and delicacy.

1. For Baiitsu, see Graham 1983.

41. Yamamoto Baiitsu, 1783–1856

Flowers and Birds by a Pond, 1853
Two sections mounted as single handscroll: ink and color
on silk, 31.4 × 159.3 cm and 31.4 × 159.3 cm
Signature: Mizunoto-ushi mōka Baiitsu sha (Painted by
Baiitsu in the fourth month [early summer, 1853])
Seals: Baika Itsujin; Baiitsu
PLATE 33

IN THIS LONG HANDSCROLL, Baiitsu presents a
tightly cropped view of the flora and fauna of a
pond in summer. Sequences of summer flowers,
pushed to the front of the picture plane, are pre-
sented in near isolation against a sketchily defined
shore. The flowers frame cells of space in which
the water life of the pond is depicted. In the first,
two turtles lazing in the water provide the focus;
in the second, a kingfisher about to pounce upon
a diving beetle captures the eye.

Clearly a close observer of nature, Baiitsu
employs an elegant *mokkutsu*, or "boneless," style

wherein he commands an extraordinary control
of wash to effect his forms with a minimum of
outlines. Originally one continuous work, this
handscroll has been remounted in two sections,
presumably because of damage. Although it is
impossible to determine how much of the original
has been lost, the arc of the lotus stem at the edge
of the first section can be followed across to the
upper edge of the second; it appears that the miss-
ing segment was not considerable.

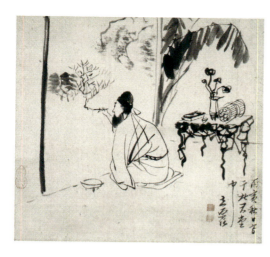

42. Tachihara Kyōsho, 1785–1840

Painting a Landscape, 1806

Hanging scroll: ink on paper, 29.5 × 31 cm

Signature: Tachihara Nin

Seals: Tachihara Nin in; Shi en; Shin itsu

Inscription: *Painted at the Shikundō in the autumn, 1806*

Literature: Addiss 1976, no. 53

PLATE 3

THE SON OF A CALLIGRAPHER and literatus, Tachihara Kyōsho grew up in a cultured environment and counted numerous *nanga* artists among his friends and colleagues. His father was Tachihara Suiken (1744–1833), whose friend Uragami Gyokudō (see cat. nos. 16, 17) visited the family with some frequency. Gyokudō taught Kyōsho to play the *qin* and provided early guidance in the art of painting. Kyōsho also studied with Tanke Gessen (1721–1809) and Tani Bunchō (see cat. nos. 31–33) and was close friends with Tsubaki Chinzan (see cat. nos. 44, 45) and Watanabe Kazan (1793–1841).

Kyōsho took an artist at work as his theme for this painting, made when he was only twenty-one. Surrounded by elements of literati life—a gnarled wooden table with ink stone, water dropper, vase, and roll of scrolls—the scholar-artist sits by his bowl of ink, engrossed in the creation of a monochromatic landscape. Artists conventionally painted on the flat surface of a floor or large table; here, however, the artist appears to be painting a *fusuma* panel already in position as a sliding door. Most likely a self-portrait, Kyōsho's painting gives the modern viewer an unusual glimpse into the practice of *nanga* painting of his period.

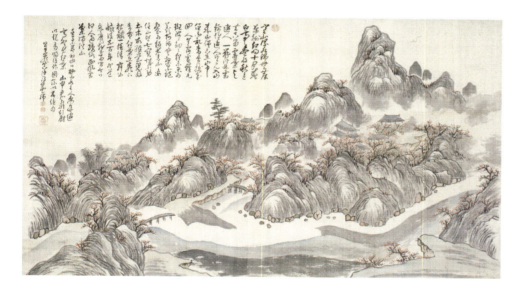

43. Yanagawa Seigan, 1759–1858

Mount Kōya in Autumn, 1852

Hanging scroll: ink and color on silk, 55.5 × 98.5 cm

Signature: Seigan Shin itsu Ryō Mōi

Seals: Itsu; Seigan; Ki-ki

PLATE 37

DURING HIS LIFETIME Yanagawa Seigan was best known as a traveler, scholar, and poet. His paintings are less familiar, and this landscape is an unusually good example of his work. Taking as his theme the landscape surrounding Mount Kōya, Seigan fashioned an expansive stylized view of this famous site south of Osaka. Drawing upon Chinese and Japanese literati precedents, Seigan organized the landscape in triangulated modules. Ropy texture strokes parallel the exterior forms of the mountains, their regularity imparting solidity and dimension.

Despite these repeated motifs, the overall effect is one of freshness, due in large part to the artist's beautiful use of color.

The Mount Kōya area is closely associated with the monk Kūkai (Kōbō Daishi, 774–835), who founded the monastery of Kongōbuji, home of the Shingon (True Word) sect. According to his inscription, Seigan and a group of friends traveled there on an excursion to view the maple leaves. Upon his return, Seigan commemorated the journey with this painting.

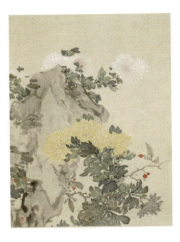 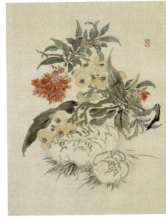

44. Tsubaki Chinzan, 1801–1854

Triptych of Flowers, 1847

Hanging scrolls: ink and color on silk, 37 × 26.5 cm (each)

Signature: Chin hitsu

Seals: (chrysanthemum) Chinzan; (medlar) Chinzan; (narcissus) Hitsu, Chinzan

Inscription: *Copied ten leaves of old paintings, late autumn 1847*

Literature: Addiss 1976, no. 54; *Kokka* 1949, no. 690

PLATE 43 a–c

TSUBAKI CHINZAN, a native of Edo, initially trained in the clan martial arts, serving as a spear bearer for the Tokugawa, but relinquished this career for one in painting, which had higher earning potential and for which he had demonstrated considerable talent. After initial study with Kaneko Kinryō (d. 1817) and Tani Bunchō (see

cat. nos. 31–33), Chinzan began his affiliation with Watanabe Kazan (1793–1841), eventually becoming his best student.

Kazan was a singular talent, espousing direct study from nature and the broadening of traditional literati subjects to include portraiture and scenes of daily life. While maintaining a close relationship with Kazan, Chinzan excelled in the more traditional realm of bird-and-flower painting, adopting a style almost completely based on the "boneless" method. Chinzan's manner is often described as being modeled after that of the Chinese artist Yun Shouping (1663–1690), and while a close visual affinity exists, it is not yet known if Chinzan ever saw any of the Chinese artist's work.

The paintings in this triptych, now mounted as hanging scrolls, were originally part of an album of ten leaves. Chinzan's refined style in both monochromatic ink and color is evident in them. The chrysanthemum scroll, which depicts one of the Four Gentlemen, is a graceful and decorative example of the artist's skill with light color. More brilliant tonalities are seen in the leaves depicting the lily, medlar, and pomegranate blossoms. This work exemplifies the artist's "boneless" method, wherein the flowers are formed solely of color, without the use of any outline. Chinzan's delicate monochrome ink painting is displayed in the narcissus painting, a graceful study in composition and line.

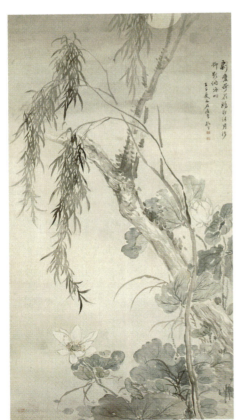

45. Tsubaki Chinzan, 1801–1854

Lotus Leaves and Willow Tree in Moonlight, 1852

Hanging scroll: ink and color on silk, 156.9 × 84 cm

Signature: Painted during the summer of 1852 when I was ill, Chinsei (Mizunoe-ne natsu go shitsu wo tsutomete utsusu Chin sei)

Seals: Hitsu-in; Chinzan; Chin-shi heki-in sanbō

Inscription:

> I'm ecstatic when lotus blossoms ornament the river. As the moon moves through the willow, casting shadows, I can enjoy the cool breeze of summer.
> —adapted from Harold P. Stern

Literature: Addiss et al. 1983, no. 53; Stern 1976, no. 74

PLATE 115

MADE ONLY TWO YEARS before Chinzan's death, this painting of lotus and willow in the moonlight is an elegant example of the artist's late work. A profusion of lotus blossoms, buds, and leaves is concentrated in the right corner of the composition. From among this grouping, a young willow shoots upward, creating a strong vertical line. Counterbalancing these elements is an older tree trunk, which transverses the painting surface.

Chinzan employed his "boneless" technique here, using cool colors and muted ink tones. The

willow is created solely of ink, appearing almost silhouetted against the light of the moon. The artist depicted the lotus in various stages of flower. A blossom in the lower portion of the painting has already begun to lose some of its petals; new buds, however, are visible within the leaves. Chinzan's use of this traditional concept linking beauty and perishability imparts poignancy and resonance to this evocative work.

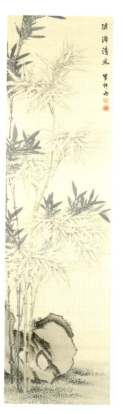
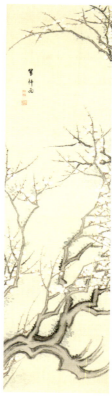

46. Takahashi Sōhei, 1802–1833

Bamboo and *Plum Blossoms*, 1830

Pair of hanging scrolls: ink and color on silk,
97 × 25.6 cm (each)

Signature: (on each) Sōhei U

Seals: (left) U in, Sōhei Kanmin; (right) Kosei, U in

Literature: Sasaki and Sasaki 1998, pl. 70; Kobayashi
and Sasaki 1993, figs. 36–37

PLATE 39 a, b

SŌHEI, A NATIVE OF BUNGO PROVINCE, became
a student of Tanomura Chikuden (1777–1835) at
age nineteen. Under Chikuden's guidance, Sōhei
studied Chinese and Japanese painting, and accom-
panied his teacher on his travels throughout Japan.
This pair of paintings, created when the artist was
twenty-nine years old, are relatively late examples,
given his early death.

The classic literati themes of bamboo and plum
blossoms are treated by Sōhei as both independent
and integrated subjects. The artist balanced the
elements of earth and sky, horizontal and vertical,
and positive and negative space in the two scrolls.
Bamboo features two types of bamboo, one bluish
green, the other white, growing from a ground
fashioned from dots of ink and color. Upon this

surface rests a monochrome ink *taihu* rock. In
Plum Blossoms, a cropped bough of a plum in bloom
is isolated against the silk, its branches entering
and exiting the picture plane at irregular intervals.
Sōhei's restrained and balanced application of
color creates an understated elegance.

Replete with literati associations, bamboo and
plum had long been popular painting themes in
China and Japan. With the rise of *nanga* painting in
the Edo period, these themes once again flourished.
For literati in China, the bamboo came to be closely
associated with the scholar—known for strength
and flexibility and esteemed for the ability to bend,
but not break, in adverse conditions. The plum,
the harbinger of spring, is closely associated with
scholarly integrity and purity. Bamboo and plum
are often combined with the pine to form the
Three Friends of Winter. In Sōhei's composition,
the bamboo is coupled with a *taihu* rock, a distinc-
tive, irregularly shaped and hole-filled rock native
to Lake Tai in China. Scholars in China collected
these rocks, placing large specimens in their gardens
and smaller ones upon their desks. Rocks, like pine,
are symbolic of longevity and fortitude.

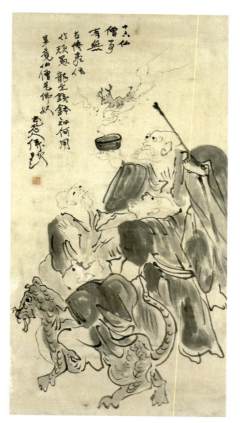

47. Murase Taiitsu, 1803–1881

Rakan

Hanging scroll: ink on paper, 115.3 × 60.3 cm

Signature: Taiitsu Rōjin narabi ni dai

Seals: Shirayuki; Taiitsu Rōjin san zetsu

Inscription:

> The sixteen Elders obstinately dispute the nature of "existence"
> and "non-existence" according to the ancient texts, yet they
> have no idea of the real use of the dragon-creating alms bowl.
> After all, these elders are slaves to the Buddhist law.
> —trans. John Stevens

TAIITSU WAS ONE of the most individualistic
of *nanga* artists. A student of the conservative
Rai San'yō, this scholar and teacher from Nagoya
lost his teaching position at the beginning of the
Meiji period when Western ideas predominated
in Japan's educational system. In the later part of
his life, Taiitsu supported himself as a private tutor
and with his painting and calligraphy. He was
something of a local eccentric, and his paintings
came to be appreciated only after his death.

As is typical for the artist, *Rakan* is in mono-
chrome ink. The theme is the sixteen *rakan*

(Ch. luohan, S. arhat), advanced disciples of the
Buddha. In the Mahayana tradition, these Buddhist
saints are commonly found in groupings of sixteen,
eighteen, or five hundred, although sixteen is seen
the most. According to Buddhist texts, *rakan* were
charged with protecting the Buddha's law from the
time of his death until the coming of the Buddha
of the Future and with blessing faithful donors
through their magical powers. While earlier de-
pictions of the *rakan* treat the iconography with
seriousness, this is a comic, irreverent presentation.

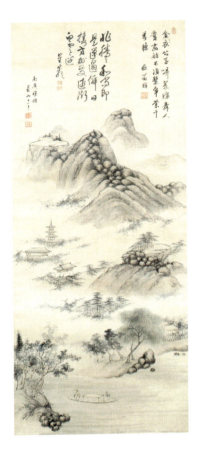

48. Hine Taizan, 1813–1869

Dawn Bell at Nanpin, before 1858

Hanging scroll: ink and color on satin, 125.1 × 50.6 cm

Signature: Nichi Taizan Nichi Shōnen

Seals: Nichi Shōnen in; Chōshoku

Inscription by Taizan:

> *Dawn Bell at Nanpin*

Inscription by Nukina Kaioku (1778–1863):

> *Young men in golden robes,*
> *Green threads are fastened around the dancers' waists.*
> *There is no need to tie up the painted boat*
> *Competing ribbons flutter in myriad rays of light.*

Inscription by Yanagawa Seigan (1759–1858):

> *The monk Hi Saisai is an immortal*
> *Who cares nothing for appearances,*
> *Daily with his laymen friends*
> *He wanders to the edge of the white clouds.*

Box lid inscription by Tomioka Tessai (1836–1924), dated 1916

Literature: Addiss et al. 1983, no. 63

PLATE 35

TAIZAN BELONGED TO THE SAME intellectual and artistic circle as Nakabayashi Chikutō (see cat. no. 36), Okada Hankō (see cat. nos. 38, 39), and Nukina Kaioku. These artists all participated in the generally conservative trend in *nanga* at the end of the Edo and beginning of the Meiji periods. A native of Hine, near Osaka, Taizan moved to Kyoto to study painting with Kaioku, although in later years Taizan claimed that he had been Kaioku's teacher, despite being thirty-five years his junior. The numerous tales among colleagues and friends of Taizan's boisterous, arrogant, and at times boorish behavior contrast sharply with the generally conservative nature of his paintings.

This carefully constructed painting, an early or middle work by the artist, is a variant on the literati theme Eight Views of Xiao and Xiang (Shōshō hakkei). The usual title for this scene is "Evening Bell at Nanpin," but Taizan altered the time of day in his inscription. He presents the landscape in an amalgam of motifs from earlier Chinese artists, including the tenth-century landscapist Juran, who typically painted circular rock formations along the spines of his mountain ranges, and the Ming artist Dai Jin (1388–1462). Taizan painted each of the landscape elements in isolation, obscuring their relationship through bands of mists.

The practice of fellow literati inscribing a painting was quite common during the Edo period. While neither of the poems inscribed here is directly related to the painting, each reflects the regard that Kaioku and Seigan, two of Kyoto's most esteemed literati, had for the maturing artist.

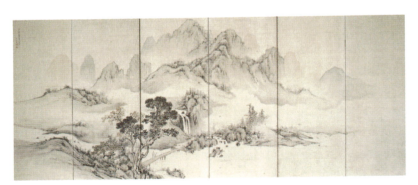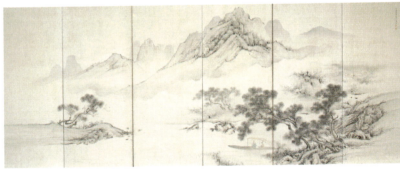

49. Nakabayashi Chikkei, 1816–1867

Summer and Autumn Landscapes, 1857

Pair of six-fold screens: ink and color on paper, 156.7 × 363.2 cm (each)

Signature: (on right screen) Chikkei gyō ga Higashiyama sōdō ni oite (Painted by Chikkei at the Higashiyama Grass Studio)

Seals: Seigyō no in; Azana Shōfu

Inscription (on left screen): *Painted in the summer of 1857 at the Higashiyama Grass Studio*

Literature: Addiss et al. 1983, no. 65; Addiss 1981, no. 30

PLATE 36 a, b

CHIKKEI, SON OF THE CONSERVATIVE master Nakabayashi Chikutō (see cat. no. 36), was schooled in the fundamentals of the *nanga* style by his father and his father's friend, Yamamoto Baiitsu (see cat. nos. 40, 41). While still working within the parameters of the conservative trends that permeated nineteenth-century Kyoto *nanga,* Chikkei came to employ a vigorous and romantic style quite different from that of his elders. Somewhat eccentric, he enjoyed receiving visitors while painting in the nude as well as walking through the town dressed as a medieval warrior or loudly playing the *shaku-hachi,* a woodwind instrument. He nonetheless made a living as a professional painter and achieved a measure of success during his lifetime.

Screens are relatively rare in Chikkei's oeuvre; these reveal the artist's lively brushwork, sensitive use of color, and sophisticated sense of composition. Chikkei's subject is the traditional literati theme of the scholar-gentleman isolated from the concerns of the everyday world, enjoying and communing with nature. In the left screen, a scholar carrying a staff gazes across a bridge to the lightly colored autumnal landscape before him. On the right, a scholar in a boat seeks respite from the summer heat. Chikkei's distinctive handling of the brush, using both dry and wet strokes, and his evocative and atmospheric sense of space display the mastery of this late-Edo *nanga* artist.

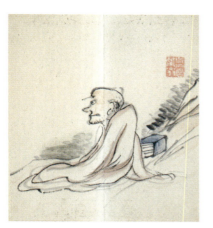

50. Fujimoto Tesseki, 1817–1863

Sixteen Rakan (Sixteen Arhats), 1861

Album of fourteen leaves: ink and color on paper,
20.4 × 18 cm (each leaf)

Signatures: (first leaf) *Fujimoto zu*; (last leaf) *Tesseki*

Seals: (leaves 1, 2, 7, 8, 10, 14) Tōmon Baisaiō; (leaves 3, 11,
13) Minamoto magane in; (leaves 4, 5, 6, 9, 12) Tesseki

Inscriptions: (first leaf) *The drifting cloud*; (last leaf) *Painted
in 1861*

PLATE 38

TESSEKI WAS BORN IN OKAYAMA prefecture but
moved to Kyoto about 1848 to further his study of
painting. Trained as both a warrior and a scholar,
Tesseki was a fierce loyalist, supporting the restora-
tion of the emperor and the abolition of the sho-
gunate. This position was common among many
literati in the mid-nineteenth century and perhaps
was most notably held by Rai San'yō and his circle.

Tesseki's support for the loyalist cause had tragic
consequences; he died as a result of injuries incurred
in a battle against Tokugawa forces in 1863.

Although known primarily as a landscapist,
in this small album Tesseki painted the *jūroku rakan*,
or sixteen arhats, the Buddhist worthies charged
with the protection of the Buddha's Law until the
coming of Miroku (S. Maitreya), the Buddha of
the Future. (See cat. no. 47 for another depiction.)

Seen either singly or in pairs, the *rakan* are
created of quick strokes of monochrome ink or
lightly colored wash, which Tesseki then overlaid
with thin strokes of black ink to outline and define
each figure. The abbreviated, loose brush style
creates an impression of immediacy and intimacy
most appropriate for a small album meant for a
single viewer.

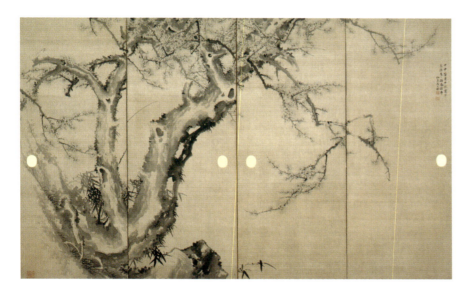

51. Taki Katei, 1830–1901

Plum Blossoms, 1884

Four-panel screen: ink on paper, 166 × 262 cm

Signature: Katei koji ken

Seals: Kokōkan sho ga; Azana shi choku go ran den;
Shinjō aruga gotoshi

Inscription: *Painted at the Sashunrō pavilion on the Ochanomizu
[Kanda River] in the middle of the fifth month, 1884 (Kinoe-saru
Ho-getsu Chu-kan cha-kei gai-jo sasshurō chū ni utsusu)*

EVENTUALLY TO BECOME one of the most popular
nanga artists of the Meiji period in Tokyo, Taki
Katei (born Tanaka Chōichi) received a typical
literati education, studying literature, calligraphy,
and poetry. The second son of a samurai, Katei
trained in Edo with a succession of painters until
his mid-teens, when he began working with Ōoka
Unpō (1764–1848), a literati artist from the Naga-
saki school. After briefly studying literati painting
in Nagasaki in his early twenties, Katei served the
shogunate in Edo, but he retired to northern Hon-
shu for ten years during the political upheavals
that preceded the Meiji Restoration. He received
a prize at the 1873 Vienna Exposition, one of many
accolades he accumulated. In 1893 Katei was made

an Imperial Household Artist, a prestigious honor
bestowed upon only a select group of artists.

In *Plum Blossoms*, the gnarled trunks of old
plum trees dominate the two left panels. Thinner
branches extend outward and reach down at sharp
angles. The plum trees are accompanied by bamboo
and a rock, forming a traditional literati grouping.
Isolated against the blank silk, the plum appears
to shimmer, as if captured in the moonlight. The
painting was originally mounted as *fusuma* (sliding
doors), but the handles have been removed, and it
was remounted as a screen. The original must have
been somewhat larger, as the thickness of the trunk
extending upward at the right dramatically de-
creases in the third panel.

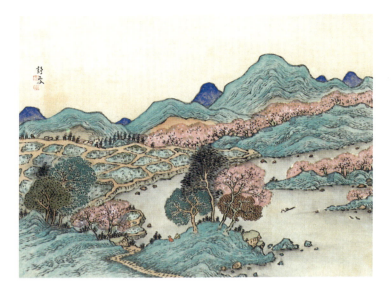

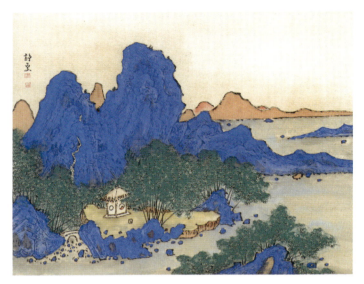

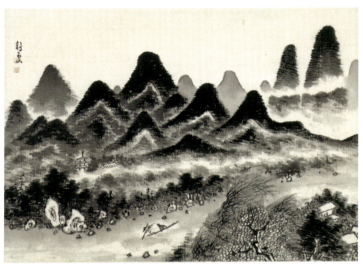

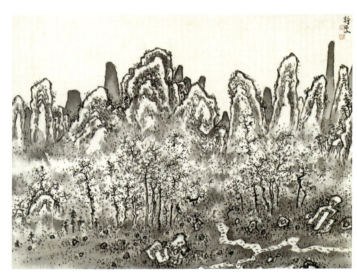

52. Fukuda Kodōjin, 1865–1944

White Cloud Album and *Album of Colored Clouds*

Albums, each of 12 leaves of painting and calligraphy: ink on silk, and ink and color on silk, 32 × 40.3 cm (each leaf)

Signature: Seisho

Seals: Sei; sho

UNLIKE MANY ARTISTS who came of age during the Meiji period (1868–1912), Kodōjin immersed himself in Chinese culture and the sino-Japanese scholarly ideal. He was an accomplished poet in both Chinese and Japanese verse styles and worked briefly as a poetry editor. A highly idealistic and strongly opinioned man, he rejected or at least distanced himself from the world in which he lived. From 1901 until his death in 1944, the artist resided in a small village near Kyoto, earning a meager living tutoring poetry students, including the Shijō master Takeuchi Seihō (see cat. no. 64).[1]

In this pair of albums, Kodōjin used both monochrome ink and brightly colored pigments to describe seasonal landscapes. The *White Cloud Album*, with its strong contrasts of black and white, dramatically recalls the long tradition of Asian monochrome ink painting as well as the importance of woodblock-print books in the transmission of the Chinese literati style to Japan. Stylistically, Kodōjin refers to past masters of Chinese painting such as the Song-dynasty Mi Fu (1051–1107), whose Mi dots became synonymous with the season of summer in the *nanga* tradition (see cat. no. 53, summer scroll).

The brightly colored leaves of the second album recall the blue-and-green style associated with Tang-dynasty landscape painting. Kodōjin's thick pigmentation, punctuated by wavering lines of ink, and densely organized compositions keep the eye on the surface of the paintings; spatial recession and illusionistic techniques were of little interest to this *nanga* master.

1. For Kodōjin, see Addiss and Chaves 2000.

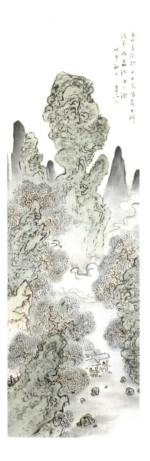
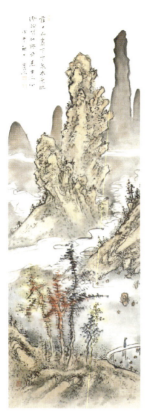
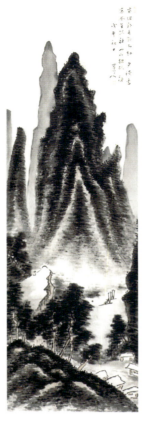
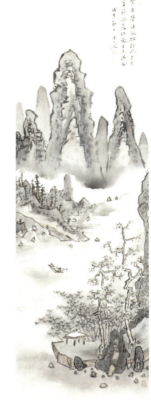

53. Fukuda Kodōjin, 1865–1944

Landscapes of the Four Seasons, 1918
Four hanging scrolls: ink and color on silk,
219 × 57.8 cm (each)
Signature: Kodōjin
Seals: (on each) Fukuda; Sei sho; Mu shin
Inscriptions:

Spring

> Rain clearing, spring trees green;
> sun rising, inspiring singing birds.
> I'll walk along the path south of the stream,
> to where the falls flow, plunging deep.

Summer

> The southern pond reflects my hanging fish-line;
> in northern pavilion at evening I read books.
> At Eastern Forest, I once joined the White Lotus;
> at Western Mountain, alone, rested in a hut.

Autumn

> Falling sun beneath hidden cliffs,
> cold stream where tree-leaves sink:
> crystalline, just like a mirror—
> gaze in and see the hearts of the ancients.

Winter

> I too will imitate the fisherman,
> At River Pan, in wind and moonlight.
> But I'll hide my tracks deep among the reeds
> so King Wen will never find me.
> —trans. Jonathan Chaves

PLATE 114

THE HIGHLY CHARGED IMAGES of this landscape quartet combine painting, poetry, and calligraphy in strong compositions with bold ink and color. The long familiar subject of a landscape with anglers or travelers, the poetic inscriptions accompanying each painting, and the style of the paintings themselves refer to past *nanga* masters such as Ike Taiga as well as Chinese antecedents.

Summer displays the common *nanga* convention of using Mi dots to describe the lush and misty landscape. In *Autumn*, Kodōjin manipulates the fourteenth-century Yuan master Ni Zan's famed tripartite compositional structure, using color to amplify the seasonal reference. The specific sources of Kodōjin's style have yet to be identified, but a fruitful avenue of investigation may be the artist's apparent reference to several mid- to late-seventeenth-century Chinese artists associated with the Anhui school, including Hongren (1610–1664) and Mei Qing (1623–1697).[1] Kodōjin's fingerlike distant peaks and triangulated forms,

seen here, recall Mount Huang, which is found in any number of Anhui school works.[2] Hongren and his contemporaries lived during the difficult and tumultuous transition between the native Ming and the Manchu Qing governments; they were among those who remained loyal to the Ming, and their idiosyncratic works reflect their alienation from the world.

This sense of disaffection in Kodōjin's work is reinforced by his poetry. Although many of his verses relay the conventional sentiments of a reclusive scholar, Kodōjin repeatedly insists on his "diligent solitude." In the poetic inscription for *Winter*, he names the Chinese recluse Tai Gong-wang, who served King Wen as a sage and adviser after being discovered living as a hermit fisherman. Kodōjin interjects his intention to avoid this distasteful fate by hiding more carefully.

In the poem inscribed on *Summer*, Kodōjin mentions the secret Buddhist White Lotus Society, with origins in the mid-fourteenth century.

Organizers of an anti-Mongol revolt during the Yuan, the White Lotus later fomented an uprising (1796–1804) that promised its impoverished supporters not only the end of personal deprivation but the restoration of the Ming.[3] While Kodōjin did not necessarily advocate revolution, his points of reference surely reflect his discomfort with the rapid changes and conflicts of his world and his longing for the surety of another time and place.

1. See Cahill 1981, figs. 5, 9.

2. Ibid.

3. See Naquin 1976.

Maruyama-Shijō School

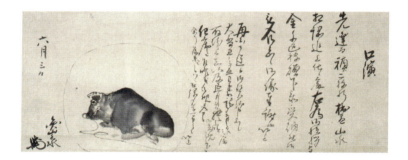

54. Maruyama Ōkyo, 1733–1795

Letter with Drawing of a Bull

Hanging scroll: ink on paper, 19 × 47.3 cm

Signature: Maruyama Shusui

Inscription:

> I recently sent you a pair of landscape fusuma, for which I have
> received payment of 1,000 hiki. Thank you. I had promised to
> create the design for a large sake cup for you, but have been very
> busy. Please allow me to send you this sketch of a bull. If it is not
> to your liking, I will create another.

Literature: Kyoto National Museum 1995, no. 81

PLATE 47

MARUYAMA ŌKYO HAD A PROFOUND impact on the history of Japanese painting. Drawing upon his familiarity with Western art, and sketching from life and anatomical studies, Ōkyo created a naturalistic style within the parameters of the Japanese idiom. His popularity during his lifetime was such that contemporary sources tell of carriages that lined the street in front of his shop, carrying patrons anxious to buy his works.

This brief letter, accompanied by a small drawing, is of a type found frequently in Ōkyo's work.[1] In this particular instance, Ōkyo thanks his patron for the payment he has received for a larger commission and sends him the preparatory sketch for the decoration of a lacquer sake cup.

1. See Kyoto National Museum 1995, nos. 81–86.

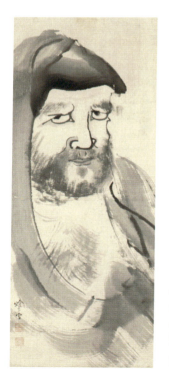

55. Maruyama Ōkyo, 1733–1795

Half-body Daruma

Hanging scroll: ink on paper, 72.7 × 29.1 cm

Signature: Tōka sha (Beneath the candlelight)

Seals: Ōkyo no in; Chūsen

PLATE 8

THIS UNUSUAL PAINTING of Daruma, the patriarch of Zen Buddhism, is singular in Ōkyo's oeuvre. Ōkyo seldom painted Zen subjects, though his thematic range was very broad. Seen in three-quarter view, Daruma wears an expanse of cloth that covers his head but leaves exposed his hairy chest. His characteristic bulging eyes appear to be deeply set, and Ōkyo has defined with almost portraitlike accuracy the large nose and bearded face of the Indian patriarch, who is painted solely in monochrome ink. Ōkyo defines the robe with just a few broad strokes of wet ink, carefully modulating the tonalities to create the darker area around Daruma's forehead. He deliberately employs the visual vocabulary of *zenga*, which was experiencing a resurgence at this time, either as an experiment or as an expansion of his already considerable repertoire.

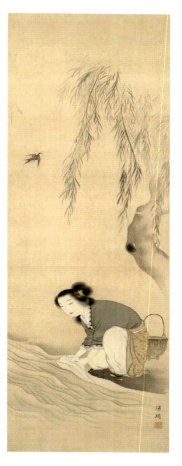

56. Komai Genki, 1747–1797
Woman Washing Clothes in a Stream
Hanging scroll: ink and color on silk, 102 × 36.9 cm
Signature: Genki
Seal: Genki
Literature: Addiss et al. 1983, no. 70; Tsuji 1980, pl. 53;
Huntsville Museum of Art 1977, no. 298
PLATE 49

THE ARTIST KOMAI KI, better known as Genki, was Maruyama Ōkyo's prize pupil. Later in his career, Genki collaborated with his teacher on a number of commissions and became the administrator for the school after Ōkyo's death in 1795. Genki, suffering from ill health, died only two years later, at age forty-nine.

Famed for his images of *bijinga*, or beautiful women, Genki here adapts the theme to reference a popularly illustrated Japanese tale, *Kume no sennin* (Kume the transcendent). The seventeenth- and eighteenth-century illustrations of this fable include a scene wherein an attractive woman washes clothes in a stream beneath an overhanging tree.[1] Genki overlaid this Japanese motif on his depiction of an elegantly attired woman in Chinese-style makeup and hairstyle at the riverbank, delicately

washing clothes. The fine detail in the elegant textile of her skirt and around the neck and sleeves of her garment indicate that this beauty is not the village washerwoman.

Much of the visual interest in this painting is created through Genki's use of contrasting painting techniques for its different elements. The willow is created from wash, the so-called "boneless" technique of ink wash with no hard-edged outline. The colorful sparrow, flying toward the cascading willow branches, however, is painted with great precision. Similarly, simple undulating lines serve to define the water of the stream, and an ink wash defines the shore, whereas the woman's outer skirt is finely detailed, as is the intricately woven basket beside her.

1. See Addiss et al. 1983, no. 70.

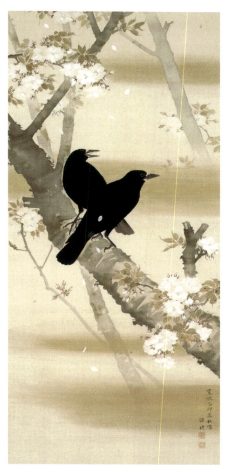

57. Komai Genki, 1747–1797
Crows and Cherry Blossoms, 1795
Hanging scroll: ink and color on silk, 125.1 × 57.1 cm
Signature: Genki no in
Seals: Genki no in; Shiun
Inscription: *Painted at the end of autumn*, 1795

ALTHOUGH BEST KNOWN today for his paintings of beautiful women, Genki also excelled in bird-and-flower subjects. In this work, painted only two years before his death, two crows perch on the trunk of a cherry tree. The trunk crosses the picture plane on a sharp diagonal, its branches extending both upward and down, the delicate cherry blossoms softening the sharp angles.

The focal point of the painting is a pair of crows, positioned so that their bodies appear to overlap, reinforcing and counteracting the

diagonal thrust of the branches. The uppermost bird is parallel to the tree trunk, its head turned over its shoulder. The second bird obscures the lower portion of its companion's body. Genki describes these birds with great detail and accuracy; his use of blue pigment within the black of the crows' feathers creates a remarkably realistic and decorative effect. Gold wash in parallel horizontal bands forms an ethereal backdrop for the tree and crows, isolating them and focusing the viewer's attention on their details.

58. Matsumura Goshun, 1752–1811

Haiga Album
Album of ten leaves: ink and color on paper,
30.4 × 20.4 cm (each leaf)
Signature: Gekkei
Seal: Goshun
Inscription, right:

> *Making footprints in the snow*
> *I head home*
> *"Forgetting the New Year" Party.*

Left:

> *Good fortune in the wind*
> *The woman with blackened teeth,*
> *Greeting the blossoming spring.*
> —adapted from David Lanoue, trans.

PLATE 51

MATSUMURA GOSHUN navigated the seemingly unbridgeable divide between the *nanga* (literati) painting advocated by his primary teacher Yosa Buson (1716–1784) and the more naturalistic and lyrical painting style promoted by Maruyama Ōkyo (1733–1795), the founder of the Maruyama school. After working with Ōkyo for several years, Goshun opened his own studio on Shijō avenue in Kyoto, working in a distinctive and luminous style of painting. Drawing upon his *nanga* expertise and Maruyama-school experiences, Goshun produced a new type of realism, which talented pupils and disciples continued into the nineteenth century.

This album, painted during Goshun's years in the Shijō avenue studio, is structured around the seasons of the year. Naturalistic vignettes are isolated against a blank background, highlighting the artist's quick and sure brushwork. These two leaves, the last in the album, depict both the end and beginning of the year. At the right, the close of the year is indicated by two snow-covered houses nestled between gently sloping hills. The companion leaf has the New Year's poem on the right with a bowing woman facing the blank page, as if greeting her unseen guests, who are ready to enter and celebrate the coming new year.

59. Yamaguchi Soken, 1759–1818

Kamo River Party
Hanging scroll: ink and color on silk, 50.1 × 71.6 cm
Signature: Soken
Seal: San-sai
Literature: Addiss et al. 1983, no. 72

PLATE 50

A STUDENT OF Maruyama Ōkyo's, Soken used one of his teacher's compositions as a starting point for this beautiful scroll. Soken's model was Ōkyo's long handscroll titled *Scenes of the Four Seasons* (Tokugawa Museum, Nagoya), which includes vignettes of the inhabitants of Kyoto enjoying the cooling summer breezes along the Kamo River. Several of Ōkyo's students as well as artists from other traditions copied this scroll, either in its entirety or in parts.

The Kamo River runs through the city of Kyoto, and numerous restaurants along the riverbank between the Sanjō and Shijō bridges set up outdoor dining areas. Customers such as the five couples seen here enjoyed food, entertainment, and the breeze off the water. Soken split the composition diagonally; in the lower right portion, men in various states of inebriation and undress enjoy the company of the beautifully attired geisha, whom they have hired for the evening. A specialist in *bijinga* (paintings of beautiful women), Soken portrayed the geisha as dignified and elegant women performing their jobs with equal measures of attention and detachment. Differentiated only by their detailed dress and posture, the women nonetheless project an aura of personal dignity, whereas the men, presumably of higher social rank, are seen as coarse and slovenly. In the upper portion, the Tadasu no Mori shrine can be seen in the distance. The purity associated with the shrine provides a sharp contrast to the more earthly delights seen on the other shore.

THREE CRANES, one on the left panel and two on the right, grace this striking screen. Isolated against a gold ground, the varied postures of the birds demonstrate Nangaku's facility with his subject: two are in profile—one pecking at the ground, the other fully upright—and the third is in three-quarter view, visible behind the standing bird on the right.

Created just one year after the death of his teacher Ōkyo, *Cranes* is a relatively early work by this artist who is best known for his paintings of *bijin* (beautiful women). Ōkyo painted numerous versions of cranes, and works of this subject are known by Ōkyo's teacher, Ishida Yūtei (1721–1786).[1] Like Ōkyo's, Nangaku's cranes are naturalistic and reflect careful observation, yet they are also stylized. Their placement against the beautiful gold ground is splendidly decorative, as is the careful patterning of dots along their legs and feet.

The cranes appear to be of a type known as *tanchō*, distinguished by their red crests, white plumage, and black cheeks, throats, and wing feathers. These beautiful birds are highly regarded in Asia and became a popular artistic motif in all media. According to legend, cranes were the vehicles for the Daoist immortals and lived for a thousand years; they were considered auspicious symbols, indicating the wish for a long life.

1. See Murase 2000, 276–77.

60. Watanabe Nangaku, 1763–1813

Cranes, 1796

Single two-panel folding screen: ink and color on gold leaf, 169 × 181 cm

Signature: Nangaku sha

Seal: Nangaku shi

Inscription: *Painted in spring, the third month of 1796*

PLATE 46

61. Shibata Zeshin, 1807–1891

Tea Screen with Two Fans

Two-panel folding screen with pasted fans: ink, color, and lacquer on paper, 21.3 × 56 cm (each fan)

Signature (on right): Zeshin

Seals: [2 illegible seals]

Inscription: *My painting teacher painted these, and I added red maple leaves Chikushin (Sensei Zeshin ō hitsu momiji soeru)*

PLATE 53 a, b

TWO FANS PAINTED by Shibata Zeshin in a distinctive lacquer technique, *urushi-e*, have been mounted on this small tea screen. On the right, a trailing vine with ocher *karasuri* gourds extends from the upper left across the fan. On the left, two double gourds and the netting used to carry them on autumnal leaf-viewing excursions form the subject of the painting. According to the inscription, Zeshin's pupil Shōji Chikushin (fl. first half of twentieth century) added the red maple leaves to this fan.

Chikushin also inscribed a label on the back of this screen in 1929, indicating that it was one of a pair. The other screen, whose whereabouts are unknown, also had two fans, one of a lotus root and an ant, the other of charcoal and a white rat.

Zeshin was one of the few Meiji-period artists known in the West during his lifetime. His lacquers were included in a succession of international expositions beginning with the one in Vienna in 1873. A versatile artist, Zeshin created lacquers, ceramics, woodblock prints, and paintings. The son of a shopkeeper and a former geisha in Edo, Zeshin studied as a young man with the lacquer artist Koma Kan'ya (1767–1835) and later with Suzuki Nanrei (1795–1844); in Kyoto he continued his studies with Okamoto Toyohiko (1773–1845), a prominent student of Matsumura Goshun's (see cat. nos. 23–28). During the early 1830s, Zeshin established a studio in Edo, where he worked for most of his life. In 1890 he was honored with the prestigious title of Imperial Household Artist, the only lacquerer to receive this designation.

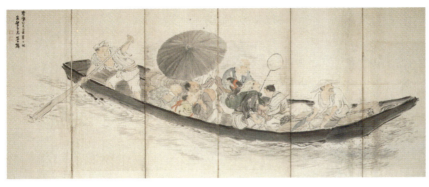

62. Shiokawa Bunrin, 1808–1877

Waiting for the Ferry Boat, 1865
Pair of six-panel folding screens: ink and color on paper,
155.6 × 364.6 cm (each)
Signatures: (right) Kachiku Rōjin Shio Bunrin hitsu (Painted
by Shio Bunrin); (left) Keiō kigen Kinoto-ushi Kajitsu saku
Sensei Tōsai Shio Bunrin (Painted in the summer of 1865 by
Sensei Tōsai, Shio Bunrin)
Seals: (right) Shio Bunrin in; Shio; (left) En Bunrin in; Shio
Literature: Addiss et al. 1983, no. 78
PLATES 54, 110 a, b

SHIOKAWA BUNRIN studied with Okamoto Toyo-hiko (1773–1845), a third-generation Maruyama-Shijō master who specialized in bird-and-flower subjects. While he is considered an artist in that tradition, Bunrin's knowledge of Japanese, Chinese, and even Western painting traditions made him a versatile artist of considerable range. Here he took the subject of waiting for a ferry, closely associated

with Hanabusa Itchō (see cat. no. 103), infused it with the *nanga* sensibility of Yosa Buson's figural style, and created a masterpiece; he painted it in his fifty-eighth year.

Festival participants, both the performers and those attending, are the subject of these screens. Rather than depicting the festival itself, Bunrin focuses on the ferry that takes people to and from the festivities. On the right (upper) screen are seven passengers waiting to board. Among them are two little boys dressed as entertainers, who enter the screen from the right. Closer to the water's edge, a fan seller rests upon a rock, his basket of wares by his feet.

The boat, its ferryman, and the passengers fill the left (lower) screen. Bunrin clearly delighted in his careful and anecdotal portrayals of men and women from all walks of life. A performer with a monkey perched on his back sits toward the front of the boat. A distinguished gentleman wearing a blue robe averts his gaze and contemplates the water. Toward the rear of the boat, a woman, shielded by her large umbrella from the summer sun and the view of others, sits isolated from the rest of the passengers.

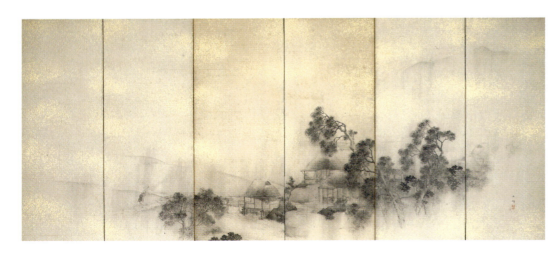

63. Hasegawa Gyokuhō, 1822–1879

Country Landscape in Summer Rain
Six-panel folding screen: ink and slight color on paper,
156.5 × 353.8 cm
Signature: Gyokuhō
Seals: Chō; Gyokuhō

A STUDENT OF Matsumura Keibun's (1799–1843), the younger brother of Matsumura Goshun, Hasegawa Gyokuhō is often considered one of the last true Shijō-school painters. In this atmospheric screen, Gyokuhō uses a gentle and controlled hand to describe a small wooded enclave with rustic houses. The soft brushwork and the scattered application of gold impart the feeling of a light summer rain falling upon this bucolic subject. The screen is most likely the right side of a pair; its companion would have been a similar scene, but with winter snow. The trees, with buildings nestled beneath them, curve and sway; feathery brushwork delineates the foliage. While Gyokuhō was not a major painter of the period, this fine work displays the vitality and continuity of the Shijō style well into the late nineteenth century.

64. Takeuchi Seihō, 1864–1942

White Heron on Willow and *Crows and Persimmon*, c. 1904
Pair of two-panel screens: ink and color on gold leaf,
165.7 × 177 cm (each)
Signature: (on each) Seihō
Seal: Seihō
PLATE 111 a, b

A STUDENT OF THE Maruyama-Shijō master Kōno Bairei (1844–1895), the prominent artist and art educator Takeuchi Seihō became the prime mover in the Kyoto *gadan*, or painting circles.[1] Teaching at both his private studio and newly established art schools such as the Kyoto Municipal School of Arts and Crafts (Kyōto Shiritsu Bijutsu Kōgei Gakkō) and the Kyoto Municipal Special School of Painting (Kyōto Shiritsu Kaiga Semmon Gakkō), Seihō profoundly influenced many of the leading painters of the succeeding generation in Japan as

well as artists outside the country, including the Gao brothers, founders of the Lingnan school of painting in Guangdong, China.

Seihō based his art on *shasei*, sketching from life, the foundation of the Maruyama-Shijō tradition and a reinvigorating force in *nihonga* (Japanese-style painting). He traveled in Europe for six months in 1900–1901 and subsequently incorporated elements of Western art and scenery into his art, though he never completely abandoned the Japanese tradition. In the early 1920s, he made two trips to China, and elements of Chinese scenery appear in his works. Late in life, Seihō devoted much time to haiku and counted among his instructors the literati painter Fukuda Kodōjin (cat. nos. 52, 53).

These masterful screens of a white heron atop an old tree and crows upon a rock pecking

at persimmons display Seihō's more traditional painting style. Similar in feel and formulation to the pair of screens titled *Desolation* in the National Museum of Modern Art in Kyoto,[2] these paintings depict isolated landscape and bird elements against an unarticulated background. In the Gitter-Yelen screens, Seihō elegantly opposed the vulgar black crows feeding on the land with the elegant, white, fish-eating heron perched on a tree branch ready to take flight. With economy of means, Seihō calls to mind the larger and more universal themes of reconciliation and the unification of opposing forces.

1. See Conant 1995, 104–5, 322–23.
2. Ibid., 160–61.

Eccentrics

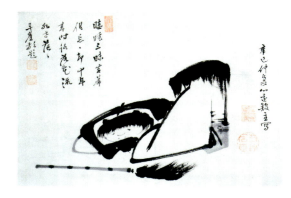

65. Itō Jakuchū, 1716–1800

Kanzan and Jittoku, 1761

Hanging scroll: ink on paper, 39.9 × 58.6 cm

Signature: Painted in the fifth month of 1761 by the master of Shin'enkan studio

Seals: Tō Jokin-in; Jakuchū koji

Inscription by Musen Jōzen (1693–1764):

> Drowsily dozing they enter samadhi
> Broom of twigs, entirely forgotten
> Forgotten is the journey of ten years leading here
> Flowers fall, waters flow, the world is vast and vague.
> —trans. Stephen D. Allee[1]

Literature: Kano, ed. 2000, no. 78; Kobayashi 1996, no. 22; Addiss et al. 1983, no. 68; Nihon Keizai Shimbunsha 1973, pl. 5; Kobayashi 1973, pl. 54; Kobayashi 1971, pl. 10; Awakawa 1970, no. 112

PLATE 56

THE LEGENDARY ECCENTRICS Kanzan and Jittoku were favorite subjects of Zen painters as well as of artists working outside the Zen tradition. A hermit-poet living in the Tiantai mountain region of Zhejiang province during the Tang dynasty, Kanzan (C. Hanshan, literally, "cold mountain") befriended Jittoku (C. Shide, literally, "foundling"),

a kitchen helper at the Guoqingsi. The unconventional friendship between the poet and the kitchen scullion signified the unworldliness and disregard for convention inherent in Zen.

Compressed within a triangular compositional construct are the two figures, one seated, the other recumbent, neither specifically identifiable. Jittoku's broom, lying parallel to the lower edge of the painting, defines the lower boundary of the composition. The face of the recumbent figure looks out at the viewer, in contrast to the seated figure, who turns his back to the outside world. The careful positioning of the two figures within the image, leaving room for the artist's signature at the right and the calligrapher's inscription at the upper left, indicates the collaborative nature of the painting. One of several works attesting the relationship between Itō Jakuchū and Musen Jōzen (Tangai), this painting appears to be the earliest documentation of their collaboration.

 1. Another translation of this inscription, by Michael Cunningham, may be found in Addiss et al. 1983, no. 68.

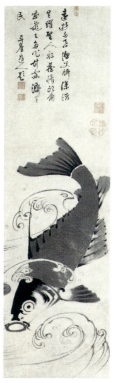

66. Itō Jakuchū, 1716–1800

Carp, 1760s

Hanging scroll: ink on paper, 99.5 × 28 cm

Signature on inscription: Tangai dōjin dai (Inscribed by Tangai)

Seals of Jakuchū: Tō Jokin-in; Jakuchū koji

Inscription by Musen Jōzen (1693–1764):

> Wandering far, he does not swallow the fisherman's bait.
> Plunging deep, why should he leap into the sage's boat?
> In hiding he grows horns, becomes a dragon, and departs,
> Sending down timely rain to succor man from drought.
> —trans. Stephen D. Allee

PLATE 57

THIS COLLABORATIVE WORK dates from approximately the same period as cat. no. 65. Jōzen's inscription, in the upper portion of the painting, serves as an explanatory text for the image. Any fish successfully navigating the treacherous Longmen Falls of the Yellow River would be

transformed into a dragon, a process described in the inscription.

This monochrome ink painting of a carp displays several painterly techniques and idiosyncrasies that recur throughout Jakuchū's career. The artist's distinctive handling of the smoky gray wash to create the carp's scale pattern was a technique he tried in the early 1760s and employed throughout his career.[1] Jakuchū exploited the particular properties of the paper upon which he painted, which allowed a subtle gray outline to form between areas of ink wash. The clawlike waves that frame the carp in the upper and lower regions and extend across the fish's body beneath the head are likewise typical of Jakuchū.

 1. For more on this technique, see Hickman and Sato 1989, cat. nos. 17, 20, and 42.

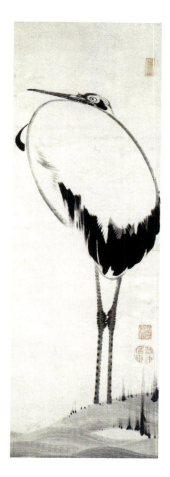

67. Itō Jakuchū, 1716–1800

Crane

Hanging scroll: ink on paper, 108.2 × 36 cm

Seals: Senga zeppitsu; Tō Jokin-in; Jakuchū koji

PLATE 58

A SOLITARY CRANE formed of a few monochrome ink brushstrokes stands upon a rounded hillock. Seen in profile, isolated against a blank background, the crane gazes to the left, completely still, with no indication of movement. A single sure brushstroke in gray ink describes the body of the bird, with darker ink tones used to define the tail feathers and details of the head and legs.

In both China and Japan the crane was popular as a painting subject and decorative motif. A venerated creature thought to live for a thousand years, the crane was considered a symbol of longevity and thus carried an auspicious connotation. Jakuchū painted numerous cranes throughout his career, both singly, as in this case, or as part of larger decorative programs.[1] This painting, done while Jakuchū was in his sixties, reveals his sure and confident hand.

1. See Hickman and Sato 1989, nos. 16, 17, and 21.

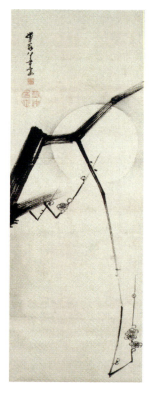

68. Itō Jakuchū, 1716–1800

Moon and Plum Blossom, 1800

Hanging scroll: ink on paper, 89.3 × 31.9 cm

Signature: Beito-ō 85 sai ga (Painted when eighty-five years old)

Seals: Tō Jokin-in; Jakuchū koji

Literature: Kano, ed. 2000, no. 101

PLATE 59

DATING FROM THE FINAL YEAR of the artist's life, this simple and abbreviated image features a blossoming plum silhouetted against the full moon. The dark, angular tree limb rises from no discernible trunk and is clearly more a compositional device than a simulation of reality. The sharp angularity of the leftmost bough is echoed in the two smaller branches that extend from its reaches. The strong composition is countered by delicate, even tentative brushstrokes, perhaps indicative of the artist's waning strength.

The flowering plum blooms in late January or early February, often coinciding with celebrations of the Asian lunar new year. Symbolizing both fortitude and rebirth, it was a favorite theme of Chinese and Japanese painters. The plum, a sign of the new year and a new season, is contrasted with the glowing full moon at the end of the day, an especially poignant choice for an artist at the end of his life.

In 1788, after devastating losses in the great fire of Kyoto, Jakuchū produced considerable numbers of quickly executed monochrome ink paintings to support himself and also to help finance his ambitious plan to create five hundred stone *rakan* sculptures for the Sekihōji, a project he began in 1776. Exchanging these paintings for a measure of rice equal to about four gallons, Jakuchū began calling himself Beito-ō, Four-Gallon Rice Man.

This pair of generalized landscape views originally were part of a larger set of images, perhaps a screen or pair of screens. The right scroll of the pair features a lone traveler who walks, staff in hand, toward a cluster of buildings nestled between a rock outcropping in the foreground and a mountain face in the background. This triangular formulation of rock, land, and vegetation extends from the upper right edge of the painting diagonally across to the bottom left; a cloudlike mass beyond indicates the far distance. Whether this ink play is meant to suggest distant mountains or clouds remains ambiguous.

Shōhaku's complementary composition for the left scroll concentrates the articulated forms in the upper portion of the painting, where a cluster of rooftops is situated among trees and mountains. The large rock face that extends from the middle ground to the near shore, its form defined solely by a brushstroke of grayish ink, creates spatial ambiguity and confusion. Triangular forms, perhaps indicating spits of land, are placed beneath this rootless cliff. In the middle ground, lightly inked landmasses are connected by a peaked bridge, traversed by a solitary figure. In each scroll a small skiff populates the waterway.

A singular talent, Shōhaku recalls here the long tradition of the Eight Views of Xiao and Xiang as well as numerous landscape themes and stylistic conventions in the monochrome painting tradition of both China and Japan. While evoking these compositional and stylistic precedents, he clearly subordinates particularized subject matter to the powerful brushwork and compositional idiosyncrasies of his personal artistic vision.

69. Soga Shōhaku, 1730–1781
Ink Landscapes
Pair of hanging scrolls: ink on paper, 106.5 × 48 cm (each)
Signature: (left) Shōhaku ga; (right) Soga Shōhaku ga
Seal: (on each) Jasokuken Shōhaku
PLATE 60 a, b

The marks for *hikite*, or handles, for interior sliding door panels (*fusuma*) are still visible on these screens, indicating their original configuration. The composition features two figures, each holding one end of a blank handscroll. The forbidding foreground, in which a spit of land rises to an abrupt and steeply curving end threatened by wildly splashing waves, is contrasted with the serenity and calm brushwork of the mountain waterfall that forms the background of the left panel. This contrasting aesthetic of rough action and serenity is echoed in the treatment of the two figures. The one at far right appears to be Shōki (C. Zhong Kui), the legendary Chinese demon queller of the Tang dynasty who dispelled the demons plaguing the emperor Ming-huang's dreams.

Although Chinese in origin, the figure of Shōki was quickly absorbed into the Japanese pantheon of lesser divinities. Images of this bulging-eyed demon queller had been the subject of Japanese paintings since at least the Kamakura period (1185–1333) and continued in popularity for both paintings and prints during the Edo period.[1] In addition to his distinctive eyes, Shōki is often portrayed with a flowing beard and long-tassled Chinese scholar's hat, wearing high boots and carrying a sword, though here neither boots nor sword are visible.[2] His upswept beard and hat, along with the rough and dynamic brushwork in his robe, appear in stark opposition to the quietude emanating from his seated companion, a figure that remains unidentified.

1. For an overview of images of Shōki in Japanese painting, see Matthew Welch, "Shōki the Demon Queller," in Addiss 1985, 81–89.
2. For images of Shōki by Shōhaku with all the traditional signifiers, see Tsuji, Hickman, and Kōno 1977, pl. 65, and Tsuji and Itō 1998, no. 59.

70. Soga Shōhaku, 1730–1781
Two Figures
Two-panel screen: ink on paper, 169.4 × 174 cm
Signature: Soga Shōhaku ō ga
Seals: Jasokuken Shōhaku; Shōhaku; Kishinsai
PLATE 61

71. Nagasawa Rosetsu, 1754–1799

Boy and Ox

Hanging scroll: ink and color on paper, 139.7 × 56 cm

Signature: Rosetsu sha

Seal: Inkyo fu

Literature: *Kokka* 560 (July 1937)

PLATE 62

UNDER THE RED SUN of early morning, a boy seated backward on a bull reaches up with a sickle toward a branch of flowering plum. The barely discernible pink wash used to color the background suffuses the entire image with the freshness and clarity of the morning light. The variation of brush techniques visible in this work—the wet washes that define the figure of the ox and tree trunk, the controlled stroke of the lead from the ox's mouth to the ground line, and the sure outline defining the young boy—displays Rosetsu's masterful control of ink.

Infused with resonance from its precedents in Chinese Song-dynasty painting and Zen Buddhism, the theme of the ox and young boy remained popular from its introduction to Japan in the thirteenth century through the Edo period. Rosetsu seemed particularly fond of the theme, painting a number of variations.[1] A lay follower of Zen, he frequently painted Zen subjects, either overtly, as in *Tanka shō butsu* (cat. no. 72), or more ambiguously, as in this work.

1. See, for example, Tsuji 2000, pl. 58, and Moes 1973, 133 (dated c. 1789–95).

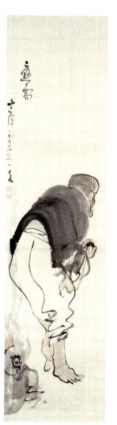

72. Nagasawa Rosetsu, 1754–1799

Tanka shō butsu, late 1780s

Hanging scroll: ink and light color on paper, 114.8 × 38.4 cm

Signature: Rosetsu sha-i

Seal: Nagasawa Gyo

Inscription: *By order of*

PLATE 63

THIS QUICKLY BRUSHED IMAGE of the Chan (J. Zen) master Tianran Chanshi (738–824; J. Tanka Zenshi) burning a wooden image of the Buddha to warm himself in the depths of winter displays both Rosetsu's humor and irreverence when dealing with traditional Zen subject matter.[1] His deft handling of ink is apparent in this work, particularly in the few lush brushstrokes of Tanka's upper garment. This work, perhaps done as a sort of performance piece,[2] is a more abbreviated treatment of the theme than that displayed on Rosetsu's six-panel screen dated to the late 1780s.[3] In it, a

fully recognizable statue of the Buddha is being burned in a small arrangement of sticks and tinder that serves to define, even in a limited way, the ground plane for the monk. Similarly, the form of the Zen master himself is more fully articulated with slower and more deliberate brushwork.

1. Excerpts from *The Record of the Transmission of the Lamp*, which recounts this tale, may be found in Fontein and Hickman 1970, 36–38.

2. See Kobayashi, above, pp. 15–25.

3. Tsuji 2000, pl. 36.

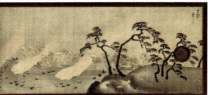

73. Nagasawa Rosetsu, 1754–1799

Cormorant Fishing

Pair of sliding panels: ink and color on silk,
23 × 51.7 cm (each)

Signature: Rosetsu

Seal: Myō myō

Literature: Addiss et al. 1983 , no. 71

PLATE 64

THESE SMALL SLIDING-DOOR PANELS probably formed part of a set of interchangeable panels, each with imagery appropriate to the season, for a set of covered shelves in an alcove. The doors depict a summer scene of fishermen using cormorants to catch *ayu*, a small Japanese river trout. The composition proceeds diagonally from the near shore on the right across both panels to a misty rendering of a distant shore and mountain range. A small fleet of boats crewed by nearly two dozen fishermen plies the waters. Traditionally undertaken on moonless nights, the activity is illuminated by baskets of fire that float upon the water and additionally serve to lure the *ayu* toward the

boats. The cormorants dive for the fish but are unable to swallow their catch because of the rope tethers about their necks. The fishermen retrieve the birds by means of the ropes and then make them disgorge the fish into baskets on the deck.

This subject was not a common one for Rosetsu,[1] but within it appear familiar elements of his style. He enjoyed the dramatic interplay of light and dark afforded by the depiction of fire, and the pine trees on both the near and distant shores are typical of his work.

1. See Colnaghi 1981, no. 46, for another version on silk.

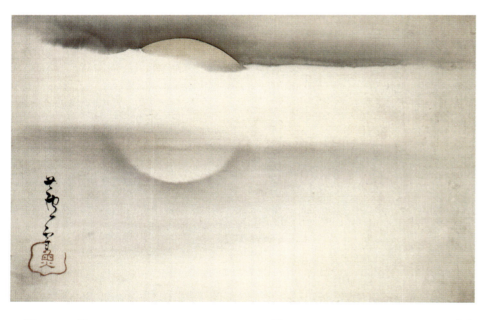

74. Nagasawa Rosetsu, 1754–1799

Moon

Hanging scroll: ink and gold on silk, 52 × 80.5 cm

Signature: Rosetsu

Seal: Gyo

PLATE 55

THIS IMPRESSIONISTIC RENDERING of a luminous moon partially obscured by mist is a singular image for Rosetsu. He had featured the moon in other paintings, but these included landscape contexts.[1] Here, a moment in time is caught as a moving band of mist partially obscures the shimmering full moon.

Moon in Four Seasons, a set of four paintings dating to 1794 by Rosetsu's teacher Maruyama Ōkyo, provides an interesting parallel to the present example.[2] Whether master inspired student, or former student the master, is unknown, but

given the late date of the Ōkyo works, they may be independent conceptions of the same theme. Ōkyo's paintings are long verticals, whereas Rosetsu's is horizontal. Ōkyo presented the moon in its differing seasonal aspects: the summer moon obscured by humid clouds, the full moon of autumn in a clear sky, the crescent moon of winter above snow, and the full moon in springtime, partially revealed amid floating cloud bands.

1. Cf. Moes 1973, no. 37, and Saint Louis Art Museum 1980, nos. 46 and 47.

2. *Kaikodo* 1994, pl. 61.

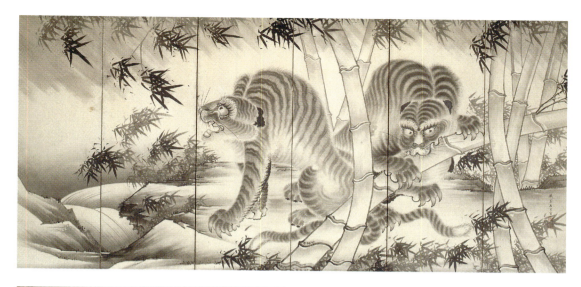

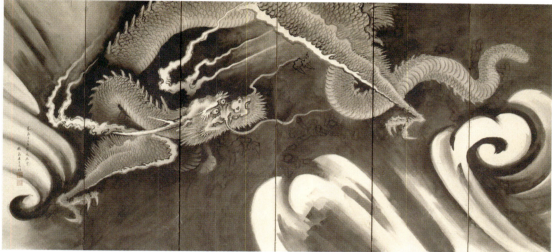

75. Chō'ō Buntoku, 19th century

Tiger and Dragon, 1849
Pair of six-panel folding screens: ink on paper,
161 × 334 cm (each)
Signature: (tiger) Chō'ō Kojisha; (dragon) Chō'ō Buntoku
Seals: Chō'ō Kojisha; [two illegible seals]
Inscription (on dragon): *Painted at the end of the fourth month
of Kaei 2* [1849] *(Kaei ni tsuchinoto-tori shuka raisha)*

DRAGONS AND TIGERS represent the contending forces of the universe in traditional Chinese geomancy. The dragon as the *yang* principle is paramount among aquatic creatures, while the *yin* tiger is lord over all the land animals. Both are beneficent figures that symbolize the harmonious function of the universe. Although tigers are indigenous to China, tigers and dragons are both creatures of the imagination in Japan, known only through paintings, prints, and other media.

The theme and compositional format of these screens, done by an otherwise unknown artist of the mid-nineteenth century, follows in the tradition established by the late-Muromachi painter Sesson Shūkei (c. 1504–1589). Sesson, in turn, drew upon a long tradition of dragon-and-tiger

painting, particularly the works of three artists: Mu Qi, the thirteenth-century Chinese Chan monk who created perhaps the most influential paintings of this type in Japan; the Southern Song painter Chen Rong (fl. 1235–44); and Kano Shō'ei (1519–1592), whose painting of a tiger in the Jukō-in subtemple at Daitokuji situates the distinctively curve-backed tiger in a bamboo grove.[1]

The dragon in this screen is a contorted beast who emerges from the depths of the ocean. The waves are outlined in black against the inky mist of moisture-laden clouds. The two stylized tigers sit among thick-trunked bamboo as rain and wind streams in from the upper left corner. While based in large part upon Muromachi and Edo models, this nineteenth-century rendition enlarges the

animal subjects so each creature occupies more pictorial space. The landscape setting for the tigers is more fully realized than in earlier versions. While the identity and training of this artist are still being investigated, it is clear that he was highly skilled in the art of *tarashikomi.* This technique is used extensively in the leaves of the bamboo in the tiger screen and throughout the misty sky in that of the dragon.[2]

1. For the Sesson screens, see Shimizu and Wheelwright 1976, no. 27.
2. For information on the dragon-and-tiger theme and its history in Japan, see Fontein and Hickman 1970, 28–32.

Rinpa School

76. Hon'ami Kōetsu, 1558–1637

Letter to Suga-oribe no kami
Hanging scroll; ink on paper, 17.2 × 39.1 cm
Inscription:

> *My messenger, Roku, will relay a message to you,*
> *given the urgent nature of the matter.*

PLATE 84

THE CREATION OF RINPA, a decorative style regarded as the purest expression of the Japanese aesthetic, has long been credited to Hon'ami Kōetsu and Tawaraya Sōtatsu (see cat. nos. 78, 79). Rinpa artists drew upon classical Japanese painting and literature from the Heian period (794–1185) for sources of inspiration, their most common themes being figural subjects from the Buddhist or Daoist tradition, classical Japanese poetry and literature, and designs of flowers and grasses.

Kōetsu was born to an illustrious family of sword polishers and appraisers, members of the upper echelon of *machishū*, or wealthy merchant class, of Kyoto. Cultivated, educated, and talented, Kōetsu became a celebrated calligrapher, ceramist, and designer of lacquerwares. A student of both Japanese- and Chinese-style calligraphy, he came to be considered one of the great calligraphers of his time. In this brief letter to a friend, the lord of Zeze castle, Suga-oribe no kami, Kōetsu's quick, sure brushstrokes showcase his direct and elegant hand.

77. Hon'ami Kōetsu, 1558–1637
Tawaraya Sōtatsu, act. c. 1600–1640

Waka Poem with Design of Shinobugusa Ferns
Section of handscroll, mounted as hanging scroll: ink, gold, and silver on paper, 33.2 × 41.7 cm
Inscription:

> *Autumn nights come early—*
> *already the ninth month has arrived!*
> *Without warning, I wake from my sleep.*
> —trans. David Lanoue

PLATE 83

ONE OF THE RICHEST artistic collaborations in Japanese art history was that of Kōetsu and Sōtatsu, who combined their talents during the Keichō era (1596–1615). Reviving the Heian tradition of calligraphy on decorated paper, Kōetsu brushed selections of classical poetry over delicate and evocative gold and silver designs created by Sōtatsu.

Kōetsu and Sōtatsu together produced a number of handscrolls, some with painted designs and others employing a woodblock-print technique. The chronology for these handscrolls has not yet been firmly established, although it has been suggested that the printed scrolls may have inspired the commissions for the painted examples.[1] The Gitter-Yelen fragment has a gold and silver printed fern pattern at the bottom of the scroll, with Kōetsu's carefully placed calligraphy of Emperor Kazan's poem from the *Shinkokinshū* playing off the design. The ferns have been printed so as to create a *tarashikomi* effect, an application of gold ink overlaying the silver. This technique involves the manipulation of a second application of ink or color to a previously painted area to create evocative contrasts, and it is thought to have originated with Sōtatsu. Another section of this handscroll is in the collection of the New Orleans Museum of Art.[2]

1. Fischer 2000, 75–77.
2. Ibid., 52.

78. Tawaraya Sōtatsu, act. c. 1600–1640
The Four Sleepers
Hanging scroll: ink on paper, 95.9 × 51.6 cm
Seal: Inen
Literature: Addiss et al. 1983, no. 10; Yamane, ed. 1977, vol. 1, pl. 63; Yamane 1962, 120
PLATE 81

LITTLE IS KNOWN OF SŌTATSU's life. Available evidence indicates that he was from the Tawaraya family of wealthy merchants and lived and worked in Kyoto from 1600 to about 1640. His patrons included that city's nobles and luminaries, including members of the imperial court. The first artist born to the merchant class to be given the honorific title *hokkyō*, Sōtatsu received it by about 1630.[1]

Sōtatsu was famed for his fan painting, but his works in monochrome ink were also highly regarded, although connoisseurship is difficult with so few secure attributions in this area. Like most of Sōtatsu's ink paintings, *The Four Sleepers* bears only the Inen seal, used by both the master and his followers. This work exemplifies the

Sōtatsu style. Perhaps by the master himself, it dates from approximately the mid to late seventeenth century. As was the case with Sōtatsu's fan paintings, this painting may originally have been part of a six-panel screen.

The Four Sleepers depicts the famed Zen quartet of Kanzan, Jittoku, the monk Bukan, and Bukan's pet tiger, united compositionally and thematically in peaceful slumber. Displaying the ultimate tranquillity of the enlightened mind, the theme is one of great antiquity, known in China as early as the Southern Song dynasty. The oldest and best-known Japanese rendition of it is a fourteenth-century work by the Zen monk Mokuan Reian, which is based on a Chinese prototype. It was not unusual, even in the early seventeenth century, for painters outside the Zen tradition to address this theme, which indicates the broader trend toward the secularization of Zen subject matter.

1. His successor, Kitagawa Sōsetsu, received the title *hokkyō* between 1639 and 1642; it is thus possible to infer that Sōtatsu was dead by this time.

79. Tawaraya Sōtatsu, act. c. 1600–1640
Duck Flying over Iris
Hanging scroll: ink on paper, 102.9 × 48.7 cm
Signature: Sōtatsu hokkyō
Seal: Taiseiken
Literature: Addiss et al. 1983, no. 9; Itabashi Art Museum 1982, no. 77; Yamane, ed. 1978, vol. 2, no. 133; Nihon Keizai Shinbun 1966
PLATE 82

LIKE THE PRECEDING WORK, *Duck Flying over Iris* belongs to the Sōtatsu monochrome ink-painting tradition. A duck, in mid flight, soars above two irises in full flower. As with most of Sōtatsu's ink paintings, this work is thought to have been remounted from its original screen format, likely comprising other views of ducks in flight.[1]

Despite the uncontested popularity of colorful, native decorative works, the large number of monochromes ascribed to Sōtatsu attests the parallel appeal of ink painting during the artist's lifetime. Members of the sophisticated tea culture in Kyoto preferred ink paintings for the tokonoma

of their tea rooms, and a number of Sōtatsu's friends and patrons came from within this community. These contacts undoubtedly also gave the artist access to Chinese and Japanese paintings in temple collections, which he studied with great result. Sōtatsu's developed use of *tarashikomi*, visible here on the body, wing, and tail feathers of the duck, and in the fur of the tiger in cat. no. 78, is an extrapolation of the Chinese master Mu Qi's "boneless" method of painting, i.e., without the use of outlines. This technique is seen in the works of almost all Rinpa practitioners.

1. See Yamane, ed. 1978, vol. 2, no. 134.

80. Kitagawa Sōsetsu, mid-17th–early 18th century

Autumn Flowers and Grasses
Single six-fold screen: ink, colors, and gold on paper,
61.1 × 201 cm
Seal: Inen
PLATE 86

A SPECIALIST IN FLOWERS and grasses, the artist known as Kitagawa Sōsetsu inherited the mantle of the Sōtatsu tradition in the mid-seventeenth century. Most of the extant works attributed to Sōsetsu are screens with separate compositions of individual flowers pasted onto each panel. Whereas his predecessor (also named Sōsetsu, but written with different characters) composed continuous compositions of plants and flowers across the panels of the folding screen, the later Sōsetsu preferred single images applied to each panel. The choice of a less expensive and more flexible format may have

been a reflection of the difficult economic conditions of his time.

Although this screen conforms in most ways to Sōsetsu's most common configuration of individual compositions placed upon each panel of a screen, the paintings appear to have been cut down from somewhat larger originals. The majority feature one flower or plant in isolation; the flowering grasses that extend across the second and third panels from the left appear to have once belonged to a single continuous composition.

81. Kitagawa Sōsetsu, mid-17th–early 18th century

Flowering Sweet Pea
Hanging scroll: ink and color on paper, 115 × 43.2 cm
Seals: Inen; Sōsetsu
Literature: Kobayashi 1990, no. 315
PLATE 85, PAGE 223

ISOLATED AGAINST THE PAPER background, a bamboo trellis of four stakes creates a gridwork across the lower third of the painting. On this framework, the vine of a sweet pea twists and turns, displaying delicate foliage in ink and mineral green, and lightly colored flowers, with long pods extending in pairs from the matured blooms. The painting, somewhat muted due to age, nonetheless retains

the subtle and quiet tonalities of the original. Sōsetsu's interest in naturalism as well as decorative composition is apparent in the deft treatment of the vine and the assured *tarashikomi* in the leaves. As with most works by this artist, this painting was probably one of six panels for a screen and not originally intended to stand alone.

82. Ogata Kenzan, 1663–1743
Square Ceramic Dish (detail)
Earthenware with underglaze iron oxide decoration
Signature: (on back) Kenzan sei (Produced by Kenzan)
Inscription:

> *The soundless fall of the evening rain*
> *erased by the splash of waves,*
> *I sat, unaware of the damp evening*
> *Until drops silently dripped their way*
> *through my boat's thatched roof.*

PLATE 87

UNLIKE MOST RINPA ARTISTS, Kenzan made his greatest impact with ceramics. He often worked with his elder brother Ogata Kōrin (1658–1716), who devised many innovative designs for these wares. Their collaboration was one of the most fruitful of the era and had an aesthetic impact that reverberates into the present day. Kenzan's first kiln opened in 1699 at Narutaki, in Kyoto. In 1712 he moved his production of ceramics to Nijō Chōjiyachō, in the center of Kyoto, and there attempted large-scale production of his wares. This square dish with its painted scene of a boat in gentle rain, accompanied by a *waka* poem in Kenzan-style calligraphy, most likely dates from this period. In 1731 Kenzan moved to Edo and spent most of the rest of his life there, producing ceramics and devoting more of his time to the art of painting.

83. Watanabe Shikō, 1683–1755
Flowers and Birds at the Shore
Eight-panel folding screen: ink and light color on paper, 60 × 330.2 cm
Signature: Watanabe Shikō
Seals: Shikō no in; Keiai
PLATE 88

A KYOTO NATIVE, Watanabe Shikō first studied Kanō-style painting and then turned to the style of Ogata Kōrin, though whether he was a direct pupil remains unclear. A versatile artist, Shikō painted not only in the Kanō and Rinpa styles for much of his career but also in the *yamato-e* style. He created works of great verisimilitude, such as his *True Depictions of Types of Birds* (Idemitsu collection), which was later copied by Maruyama Ōkyo (1733–1795).

This single screen shows a shoreline during winter. Flowers associated with the season—camellias, daffodils, spearflowers—can be seen on the embankment. Mandarin ducks, one in the water, the other captured mid-flight, are also

commonly associated with winter. Shikō's extraordinary aptitude at drawing from life is apparent in the flying duck, whose feather patterns are detailed with remarkable skill and accuracy. This unusual motif, seen in later works, began with Shikō. The ground line, which now appears to have been left in reserve, originally may have been white, indicating snow. The fragile surface likely was damaged, and then removed, though slight traces do remain.

This screen bears the signature of Shikō and also has his Keiai seal, which appears on his masterpiece, *Flowering Cherry Trees at Mount Yoshino*, the pair of six-fold screens in a private collection in Japan.

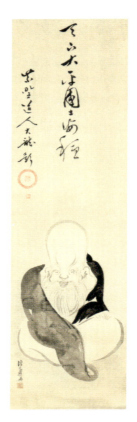

84. Watanabe Shikō, 1683–1755
Fukurokuju, before 1751
Hanging scroll: ink on silk, 97.1 × 28.5 cm
Signature: Watanabe Shikō
Seal: Shikō no in
Inscription by Dairyū Sōjō (1694–1751):
> *Peace in the universe, and stability in the nation.*
> *Written by Dairyū of the Daitokuji*
Literature: Murashige, ed. 1991, no. 169
PLATE 90

FUKUROKUJU, THE GOD of good fortune, isolated against a blank background, is shown seated cross-legged. The figure's overall shape, with elongated cranium and protruding knees, is that of the double gourd, an auspicious form with connotations of longevity. This gourd shape is echoed in the god's considerable ears. Shikō's indebtedness to Ogata Kōrin can be seen in the *tarashikomi* of Fukurokuju's upper garment, which trails upon the ground.

Shikō's painting of Fukurokuju exemplifies his Rinpa monochrome ink style. Shikō did many ink paintings in the Kanō tradition, and it is relatively unusual to see a work in this style. Especially significant in this painting is the inscription by Dairyū Sōjō, the 342nd abbot of Daikokuji in Kyoto. Given the prominence and position of the inscription in relation to the figure, it is likely that both painting and inscription were made contemporaneously and sometime before Dairyū's death in 1751. Dairyū also inscribed a pair of paintings by Shikō of the Zen patriarchs Hongren and Huineng, now in the Idemitsu Museum, Tokyo.

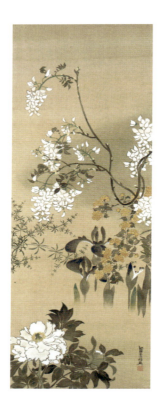

85. Watanabe Shikō, 1683–1755
Spring and Summer Flowers
Hanging scroll: ink and color on silk, 98.7 × 37.4 cm
Signature: Watanabe Shikō
Seal: Shikō no in
Literature: Kobayashi, ed. 1990, fig. 182; Yamane, ed. 1979, vol. 4, pl. 146; Tokyo National Museum 1972, pl. 192
PLATES 80, 89

THIS EVOCATIVE PAINTING of flowers of the spring and summer originally formed the right side of a pair of hanging scrolls illustrating the theme Flowers of the Four Seasons.[1]

A single large peony in full bloom occupies the lower left corner of the composition. Clustered to the right and above the peony, and arising as if from mist, are the upper portions of iris plants in various stages of bud and bloom. Yellow flowers from an unsupported and twisting vine of white wisteria cascade through the iris. The wisteria, whose white petals so carefully balance the color of the peony and iris buds, are seen in partial flower, with buds of shimmering gold.

1. See Kobayashi, ed. 1990, fig. 183. Its mate, featuring flowers of the autumn and winter, is currently in the Asian Art Museum of San Francisco.

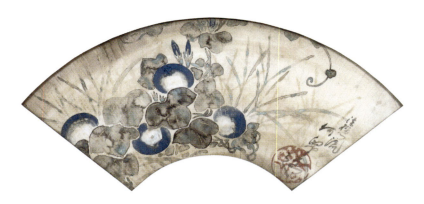

86. Tatebayashi Kagei, act. mid-18th century

Morning Glories and Grasses

Fan: ink and color on paper, 18 × 48 cm

Signature: Hokkyō monryū Kagei kore o egaku (Painted by Kagei, in the school of the *Hokkyō* painter [Kōrin])

Seal: [illegible]

PLATE 91

TATEBAYASHI KAGEI represents a crucial link between what has come to be called Kyoto Rinpa and Edo Rinpa, or the transmission of the Rinpa style from the city of its origins to the country's capital in the eighteenth century. Little is known of Kagei's life, though he has been identified as the doctor from Kaga province who moved to Edo and became a late pupil of Ogata Kenzan (see cat. no. 82), who had moved to the city in 1731. Indicative of Kagei's place as an heir to the Kōrin-Kenzan Rinpa tradition is his receipt from Kenzan, in 1738, of a Kōrin copy of a Sōtatsu fan.[1]

Kagei was known for his paintings of flowers, and this lovely painting of morning glories amid leaves and grasses displays his facility with Kenzan's painting style in his later years. The *tarashikomi* technique, evident in both the foliage and the flowers, provides depth and vitality to the painting. Kagei's paintings do not survive in great numbers, but each extant work tells us something of the style of Edo Rinpa in the years after Kōrin's death.

1. Yamane, Naitō, and Clarke 1998, 42.

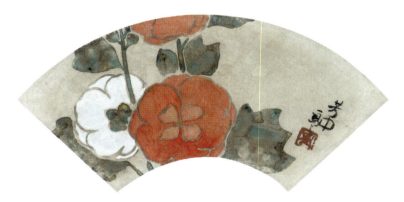

87. Nakamura Hōchū, d. 1819

Hollyhocks

Fan: ink and color on paper, 20.7 × 51.4 cm

Signature: Hōchū kore o utsusu (Painted by Hōchū)

Seal: Hōchū

Literature: Okudaira et al. 1993, no. 151; Kimura 1991, no. 5; Kobayashi 1990, no. 170; Fister and Gitter 1985, no. 9; Addiss et al. 1983, no. 12; Yamane, ed. 1979, vol. 4, no. 223

BORN IN KYOTO, Nakamura Hōchū lived for much of his life in Osaka. Active in the artistic circles of both cities, he associated with an eclectic group of artists such as Kimura Kenkadō (1736–1802), Totoki Baigai (1749–1804), Aoki Mokubei (1767–1833), and others. Hōchū lived in Edo in the early 1800s and during this time published the *Kōrin gafu* (Anthology of paintings by Kōrin), the result of years of personal research into the

art of Ogata Kōrin. His devotion to the works of this earlier Rinpa master endured, and in 1815 he published the *Kōrin hyaku-zu*, in which he copied one hundred works by Kōrin. It is not known whether Hōchū and Hōitsu knew each other, but it is noteworthy that Hōchū undertook his research of Kōrin and promoted his style before Hōitsu did.

A painter of landscapes and large-scale works of varying subjects, Hōchū is particularly noted for his distinctive fan paintings of flower subjects. *Hollyhocks* exemplifies his tendency to simplify forms and magnify the subject, using distinctive brush techniques and extensive *tarashikomi*. Hōchū employed a restricted palette to great effect: red for the surface of the hollyhocks' petals, white for their undersides, green in the vegetation. The addition

of water to the red and green broadens the color range, and slight touches of gold cause the surface of the ink and green leaves to shimmer. The curved fan format is particularly successful in this work, as it echoes the shape of the blooms and also frames and isolates the segment of the flower presented. Hollyhocks as a subject were not unique to Hōchū; they had been painted by Kōrin in works of large and small scale.[1] This painting originally belonged to a group of ten fans mounted on a two-panel screen.[2]

1. Most famously, Kōrin's hollyhocks appear on one half of a pair of screens now in the Hinohara collection, Tokyo.

2. Addiss et al. 1983, no. 12.

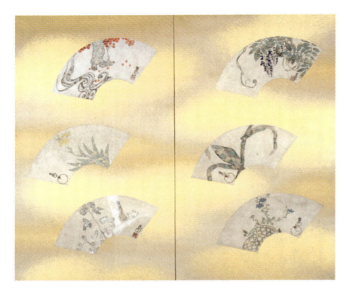
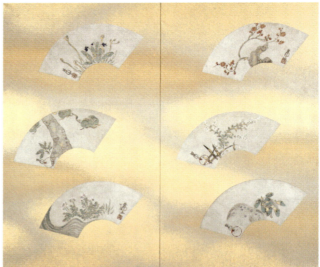

88. Nakamura Hōchū, d. 1819

Flowers of the Twelve Months
Twelve fans on a pair of two-fold screens: ink and color
on paper, 166.4 × 183.4 cm (each)
Signature: Hōchū kore o egaku
Seals: Hō; [illegible]
PLATES 5, 92 a, b

THE TRADITION OF PASTING thematic groups
of fans onto screens was strongly associated with
Tawaraya Sōtatsu. Although few such screens
survive today, they were a favored format through
the nineteenth century. In these screens, each of
the twelve fans features a flower associated with

a lunar month. The fans are not entirely in order,
having been mounted with a view toward aes-
thetic balance rather than strict adherence to
chronology.

The year begins with the first lunar month,
symbolized by the plum, at the upper right of the
right screen and ends with the twelfth month,
indicated by a black pine in snow, in the lower left
of the second screen. There are three fans for each
season. Spring, the first season of the year, is shown
by the plum, and two fans, one of violets and fern
and the other depicting primrose, are located at the
top and bottom of the left panel of the right screen.

Summer is indicated by wisteria and sweet corn,
the upper and middle fans on the right panel of the
left screen, and by daffodil, the middle fan on the
left panel of the same screen. Red maple leaves,
emblematic of autumn, are found on the fan
directly above the daffodil; a chrysanthemum fan
at the bottom corner of that same screen and the
middle fan, of white bush clover, on the first panel
of the right screen, complete that season. Winter
begins with the fan directly beneath the bush
clover, showing a rock and flower. The middle fan
on the adjacent panel shows a pine tree and bam-
boo, and the cycle ends with the pine and snow.

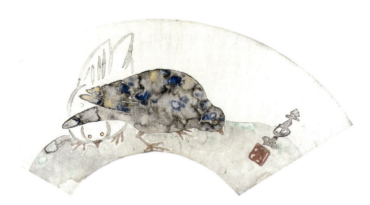

89. Nakamura Hōchū, d. 1819

Doves
Fan: ink and color on paper, 20 × 59.3 cm
Signature: Hōchū kore o egaku
Seal: Hōchū
Literature: Kimura 1991, no. 210; Kobayashi, ed. 1991,
no. 150

HŌCHŪ PORTRAYS TWO DOVES, one black, the
other white, pecking at the ground in this boldly
conceived and strikingly executed fan dating
from his mature period. The artist's distinctive
technique of outlining his forms in black ink is
clearly seen in the white dove. As is evident in
all the fans in the exhibition, Hōchū not only
outlined his forms in black but left those outlines
in reserve, filling in the spaces by manipulating
the pigments or ink up to the edges of the outline.

Hōchū had a masterful touch with *tarashikomi*,
and nowhere is that more evident than in the body
of the black dove. Unlike most Rinpa artists, who
used this technique in areas of secondary impor-
tance, like the trunks of trees or leaves, Hōchū
boldly employs *tarashikomi* in both the central dove
and the ground plane.

90. Sakai Hōitsu, 1761–1828

Mount Fuji and Cherry Blossoms
Pair of hanging scrolls: ink and light gold on silk,
86.6 × 26 cm (each)
Signature: (on each) Hōitsu hitsu (Painted by Hōitsu)
Seal: (on each) Ōson
Inscription by Hotta Masaatsu (1758–1832):

Spring

My heart is afloat
With the beauty of the cherry blossoms
On the hill path soon to be climbed,
The white clouds of the peaks

Summer

Drifting mists and clouds
Float across the heavens
Yet they never reach beyond
The lower slopes of lofty Mount Fuji

PLATES 94 a, b

Born in Edo to a high-ranking and cultivated family, Sakai Hōitsu had a privileged upbringing, during which he studied Noh, music, haiku, tea ceremony, calligraphy, and painting as well as the military arts. By all accounts a multitalented individual, Hōitsu devoted much of his life to the arts, even becoming a monk in 1797 to divest himself of some of his familial and societal obligations.

Like many Edo-period artists, Hōitsu first studied painting in the Kanō style, but his unending curiosity led him to study, either formally or on his own initiative, almost every major contemporary painting style before devoting his considerable skills to Rinpa. This pair of paintings of Mount Fuji and blossoming cherry trees represents Hōitsu's Kanō style; both the subject and the style were very appropriate to the samurai taste prevalent in the capital during the artist's lifetime. Each scroll bears an inscription by Hotta Masaatsu, a prominent politician from Sendai.

The paintings, two of what most likely was a set of four, take as their subject Japan's best-known and holiest sites. Mount Fuji, emblematic of the country itself, was revered not only as a sacred site but as a god. The cherry trees signify Yoshino, the site of a famed shrine, and certainly the favored place for viewing the flowering tree in springtime. The use of gold, while of course denoting luxury, can be seen here to signify the otherworldliness of these holy places.

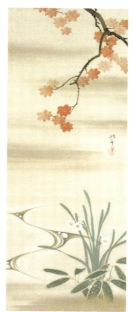
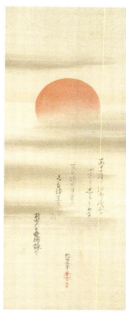
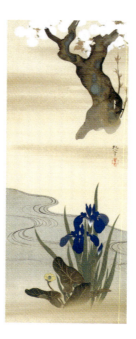

91. Sakai Hōitsu, 1761–1828

Triptych of Flowers and the Rising Sun, after 1824
Hanging scrolls: ink and color on silk, 104.4 × 40.9 cm (each)
Signatures: (right) Hōitsu hitsu (Painted by Hōitsu); (center) Kishin hitsu (Painted by Kishin); (left) Hōitsu hitsu (Painted by Hōitsu)
Seals: (right) Ōson; (center) Ōson, Bunsen; (left) Ōson
Inscription, on center painting, by Kazan'in Yoshinori (1754–1829):

Brightly shining
Is our emperor's reign
Throughout the world
Its radiant beams
Will never be overshadowed.

—trans. Patricia Fister

Literature: Tamamushi 1997, no. 90; Kano, Okudaira, Yasumura 1993, no. 27; Kobayashi, ed. 1991, no. 28; Yasushi and Kobayashi, eds. 1989, no. 81; Addiss et al. 1983, no. 14; Yamane, ed. 1979, vol. 5, nos. 90–92; Nihon Keizai Shinbunsha 1977, pl. 45; Kumita, Nakamura, and Shirasaki, eds. 1976, nos. 34, 35, 115; Shirahara and Tokuda, eds. 1975, vol. 3, no. 18

PLATES 6, 93 a–c

This triptych, comprising a pair of hanging scrolls depicting the four seasons and a central scroll of the rising sun, counts among Hōitsu's masterpieces. The central image is that of the red sun rising amid gold clouds. Symbolizing Japan's emperor, as explicated in the *waka* inscription by the calligrapher and official Yoshinori, the image

attests the loyalty felt toward the emperor even as the shogunate continued to rule in Edo. Yoshinori's career is well documented; he indicates his position as the former Minister of the Right in his signature. Having both received and resigned from this position in 1820, his signature alone points to the creation of the work during the period 1820–28. The style of Hōitsu's signature allows for further refinement of the date to the last four years of his life.

The two flanking scrolls show the four seasons of the year. The seasons progress in order, beginning with the scroll at the right. The blossoming cherry tree of early spring is in the upper portion of the composition, and the blooming iris and eastern water rail of summer are situated near a stream in the lower portion. Autumn is represented in the leftmost scroll by vibrant red maple leaves, and winter by the bamboo grass and narcissus growing beside the cracked ice of a frozen waterway. This combination of the seasons with the central image of the rising sun shows the year in its entirety and would have been a stunning image for the new year.

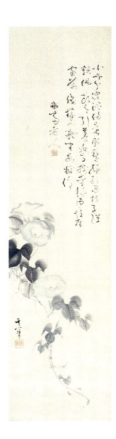

92. Suzuki Kiitsu, 1796–1858

Morning Glories, before 1826

Hanging scroll: ink and light color on paper, 100.4 × 26 cm

Signature: Kiitsu hitsu (Painted by Kiitsu)

Seal: Jō-un

Inscription by Kameda Bōsai (1752–1826):

> The small plant has a range of dark and light tones,
> Its flowers only open in the morning sun.
> Its form resembles tall grasses,
> And its color is blue like a Buddha's head.
> It entwines itself in the trunks of tall trees
> And extends over the edge of short trellises.
> When it blooms in front of the weaving girl's window,
> In admiration she stops her shuttle.
>
> —trans. Patricia Fister

Literature: Addiss et al. 1983, no. 15; Suntory Museum 1981, no. 38; Nakamura 1979, no. 79; Yamane, ed. 1979, vol. 5, no. 164

PLATE 96

THE PRINCIPAL PUPIL of Sakai Hōitsu, Suzuki Kiitsu began his study with the master at the age of eighteen. He later married into the family of Suzuki Reitan, another of Hōitsu's students and a retainer to the Sakai family. Kiitsu served as Hōitsu's assistant, studying painting, haiku, and tea ceremony until Hōitsu's death in 1828. Although he developed as an independent artist, Kiitsu remained in the employ of the Sakai family until his death in 1858.

Morning Glories is a rare early work by Kiitsu. Atypically for this artist, the painting has a muted tone that is created with ink and light blue wash. Some of the sections in *Morning Glories* are only in ink, others are only in blue, and then these two elements are melded in soft brushwork. The painting style is casual, the artist's touch light. The morning glories are described in a manner more compatible with the Shijō style than that of Rinpa.

Kameda Bōsai (see cat. nos. 29, 30), who brushed the inscription, was a good friend of both Hōitsu and Kiitsu and frequently inscribed their paintings. A noted literati poet and painter, Bōsai's inscription is remarkably descriptive of the subject matter and the manner in which the work was painted.

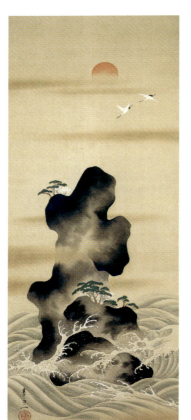

93. Suzuki Kiitsu, 1796–1858

Mount Hōrai

Hanging scroll: ink and color on silk, 109.9 × 44.9 cm

Signature: Seisei Kiitsu

Seal: Tei hakushi

Literature: Kobayashi, ed. 1991, no. 66; Kōno 1987

JEWEL-LIKE COLORS describe Kiitsu's Mount Hōrai, the imaginary paradise and home of the Daoist immortals in Chinese mythology. A favorite auspicious theme for Rinpa artists, the work is replete with symbols of longevity. The lapis-colored mountain, writhing and phallic, rises from a swirling sea, clawlike waves breaking over its shores. Small clusters of pine and blooming peach trees, both symbols of immortality and longevity, are situated upon the rock. Above the mountain and beneath the shimmering red sun, two cranes, the immortals' legendary vehicles, swoop down toward the mountaintop.

As Kōno Motoaki has shown, this painting is significant not only as evidence of Kiitsu's personal style but also for its similarities to one of a pair of scrolls bearing the signatures and seals of Hōitsu, in a private collection in Japan.[1] Tsuji Nobuo had suggested that the left painting of this Hōitsu pair, also featuring Mount Hōrai, might have been painted by Kiitsu. Given the similarities in composition and handling, the Mount Hōrai in the Gitter-Yelen collection gives support to this theory.

1. Kōno 1987, 30.

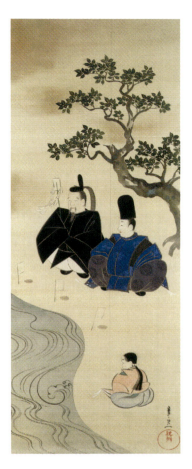

94. Suzuki Kiitsu, 1796–1858

Misogi Scene from the Tales of Ise
Hanging scroll: ink and color on silk, 111.4 × 42.2 cm
Signature: Suzuki Kiitsu
Seal: Shukurin
PLATE 97

THIS PAINTING'S SUBJECT is a scene from the tenth-century poetic narrative *Tales of Ise*, based on the poetry of Ariwara Narihira (c. 825–880). Episode 65 tells of Narihira's youthful love for a court lady. Recognizing that the relationship would jeopardize his career, Narihira underwent a Shinto ritual of purification (*misogi*), traditionally held at the water's edge, to rid himself of his inappropriate feelings. The white paper emblems of purification line the banks of the river, while Narihira, clad in brocade robes, sits beneath a curved tree trunk, the diviner accompanying him. The priestess, about to begin the ceremony, kneels at the water's edge. The ritual evidently failed to quench Narihira's desire, as he wrote in his poem:

> Although I have made offering asking the
> gods to rid me completely of this love,
> they have not granted such.

Although, or perhaps because, Rinpa was not a hereditary lineage, members of later generations expressed their connection to the tradition by copying and reworking the renowned compositions of their forebears. This is one such work. Rinpa artists beginning with Tawaraya Sōtatsu frequently depicted Misogi scenes, following this same basic compositional pattern. Kiitsu's composition is based on the well-known painting of the same theme by Ogata Kōrin. Now in the Hatakeyama Memorial Museum in Tokyo, Kōrin's painting obviously provided Kiitsu's prototype. The Kōrin work, in turn, was based on a Sōtatsu composition.

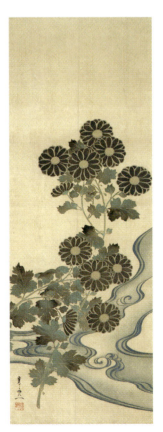

95. Suzuki Kiitsu, 1796–1858

Chrysanthemums and Flowing Stream
Hanging scroll: ink, color, gold, and silver on silk,
93.5 × 32.5 cm
Signature: Seisei Kiitsu
Seal: Shukurin
Literature: Kobayashi, ed. 1990, no. 298; Suntory Museum 1981, no. 40
FRONTISPIECE

THIS BOLDLY CONCEIVED painting juxtaposes stylized chrysanthemums in full flower against a flat and abstracted stream. Isolated on an otherwise blank background, the image could easily have served as a model for lacquerware or textile design. This flat, decorative style of painting is Kiitsu's own and far removed from that of his teacher, Sakai Hōitsu (see cat. nos. 90, 91).

As beautiful and striking as this painting is to the modern eye, its appearance was quite different at the time of its production. The dark, almost black petals of the chrysanthemum outlined in gold were originally silver, which has now discolored. Kiitsu's particular vision of flattened and abstracted forms and brilliant use of coloring attest his unique creative vision and talent.

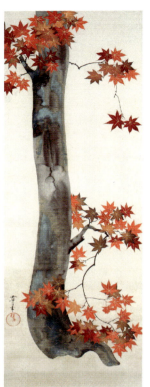

96. Sakai Ōho, 1808–1841

Autumn Maple
Hanging scroll: ink and color on silk, 115.6 × 41.4 cm
Signature: Ōho shashi (Painted by Ōho)
Seal: Bansei
Literature: Murashige 1992, vol. 5, fig. 349; Kobayashi, ed. 1990, vol. 2, no. 349; Addiss et al. 1983, no. 17
PLATE 95

SAKAI ŌHO WAS ANOTHER of Hōitsu's most talented pupils. Adopted by Hōitsu when he was ten years old, Ōho also was allowed to take one of Hōitsu's art names after his master's death and thus became known as Uke-an II.

As was often the case in Rinpa, the tradition was maintained through the practice of copying the compositions of one's predecessors. In *Autumn Maple*, Ōho reproduces a composition originated by Hon'ami Kōho (1601–1682), the grandson of Hon'ami Kōetsu (see cat. nos. 76, 77). The image of an isolated maple tree trunk, a long vertical with thin branches and bright red leaves, was developed by Kōho as the leftmost painting in a triptych.[1]

Hōitsu copied this triptych, inscribing it as following the style of the earlier master. In both the Kōho and Hōitsu versions, however, the tree trunk faces the opposite direction. Ōho is known to have painted a version of the triptych (now in the Yamatane Museum), but whether the Gitter-Yelen *Autumn Maple* was part of such a triptych is unknown. In addition to changing the orientation of the trunk, Ōho reduced the number of leaves, which serves to heighten the contrast between the velvety soft trunk and the sharply delineated red and orange leaves.

1. See Link 1980, 70.

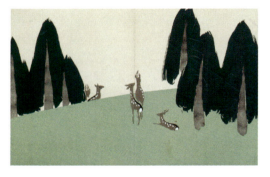

97. Kamisaka Sekka, 1866–1942

Momoyogusa (World of Things), 1910–11
Woodblock-print book, sixty illustrations in three volumes: ink and color on paper, 29.8 × 44 cm (each)
PLATES 7, 109

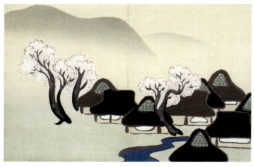

KAMISAKA SEKKA, one of the prime movers in the resurgence of Rinpa in the early part of the twentieth century, was a versatile and prolific artist. Not only a painter, he also created designs for lacquers, textiles, ceramics, furniture, and woodblock-print books.[1]

Having traveled to Europe in both 1888 and 1901, Sekka had firsthand knowledge of and appreciation for European design. In combination with his study of Japanese traditions, this experience informed his extraordinary and dynamic compositions. One of his greatest achievements is the *Momoyogusa* (World of things), a three-volume illustrated book originally published in

1909, which features sixty designs by the artist. In addition to landscapes and people at work, Sekka included modern interpretations of traditional Rinpa designs. In *Wave and Moon* (pl. 109), he closed in on the essence of this often-encountered theme: one cresting wave captured in mid-motion, with the full silver moon behind. The shapes are flattened and simplified, the palette reduced to a bare minimum, and yet the effect is striking and dramatic. Sekka's genius was in the selection and reduction of each theme to its barest essentials, and by doing so, he rejuvenated a traditional art form.

1. For Sekka, see Seo 1993, 38–44.

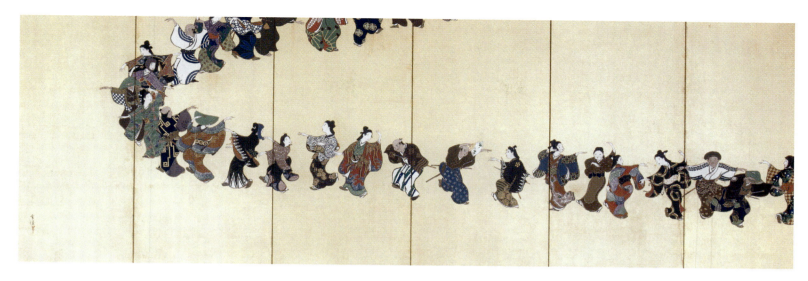

98. Kamisaka Sekka, 1866–1942

Dancing Figures

Single six-fold screen: ink and color on gold leaf, 76.9 × 230.2 cm

Signature: Sekka

Seal: Seisei

PLATE 98

SEKKA HAS COMBINED two of his areas of expertise in this work: kimono design and painting. This single screen, presumably the left side of a pair, features a line of spirited dancing figures. All are posed to display their patterned clothing to great effect. Most appear to be clad in garments appropriate to autumn, leading to the speculation that they could be participants in activities associated with the Obon Festival. The style and pattern of the garments do not appear to be contemporary to Sekka's time but are more in keeping with the Genroku period of the early eighteenth century. Sekka painted this composition more than once. A pair of screens in the Hosomi Museum features the same subject, but in a slightly different configuration, with the dancers extending in a long straight line.[1]

1. See Sakakibara 1981, no. 14.

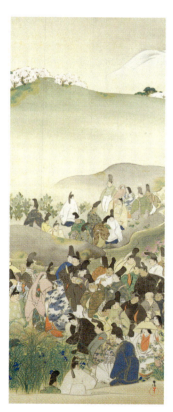

99. Kamisaka Sekka, 1866–1942

Gathering of Waka Poets

Hanging scroll: ink and color on paper, 129.2 × 50.7 cm

Signature: Sekka

Seal: Seisei

PLATE 99

SEKKA EVIDENTLY TURNED to the serious study of Rinpa after his first trip to Europe in 1888. Exactly how he undertook this study is not yet known, but his thorough grasp of its conventions allowed him to consciously manipulate and transform traditional themes, which in other hands may have appeared old-fashioned or trite.

In *Gathering of Waka Poets*, Sekka appears to have created a variant of the traditional poet portraits that has long been part of the Japanese painting tradition. During the Heian period, handscrolls featuring individual portraits of poets accompanied by selections of their verse became quite popular, a tradition that continued into succeeding eras. In addition to the single portraits, composite portraits in groupings of thirty-six, six, three, or two gained currency. In the Edo period, artists from various schools continued to portray the great poets and worthies of the past, often infusing their subjects with humor and whimsy. Ogata Kōrin, Sakai Hōitsu, and Suzuki Kiitsu all painted versions of the Thirty-six Poets (Sanjū-rokkasen) in both screen and scroll formats. Sekka's animated group of worthies, chatting and commiserating in their idealized landscape, brings this long-standing tradition into the twentieth century.

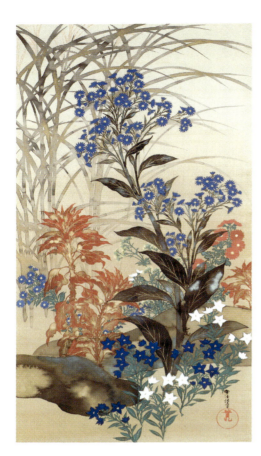

100. **Kamisaka Sekka**, 1866–1942

Autumn Flowers and Grasses
Hanging scroll: ink and color on silk, 129.5 × 70 cm
Signature: Sekka kinsha (Respectfully painted by Sekka)
Seal: Sō
PLATE 112

THIS SUPERB PAINTING of autumn grasses and flowers exemplifies Sekka's large-scale, formal style. The tall pampas grass (*susuki*) of autumn gracefully arcs across the painting, created from soft, controlled strokes of light ink wash with gold *tarashikomi*. The ground plane is defined by two rocks, around which grow blue and white Chinese bellflowers, red and gold cockscomb, and red and white chrysanthemums. The large blue dianthus that forms the central element of the work shows the contrast of the soft *tarashikomi* in the leaves and stems, and the opaque, flat colors Sekka favored for his blooms.

Genre Painting and Ukiyo-e

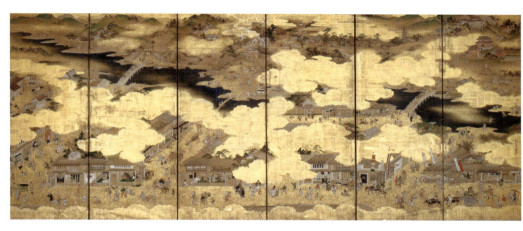

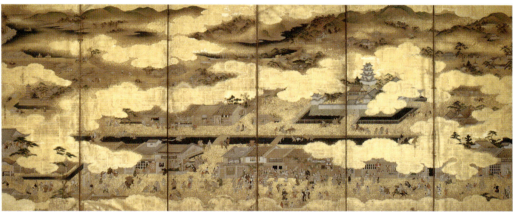

101. Attributed to **Tosa Daijō Genyō**, n.d.
Scenes in and around the Capital, c. 1700
Pair of six-panel screens: ink, colors, and gold on paper,
166.4 × 373.4 cm (each)
Signature: (on each) Tosa Daijō Genyō (Motoyasu)
Seals: Tosa; Fuji[wara] Genyō
PLATE 101 a, b

THIS PAIR OF SCREENS, with its panoramic views of Kyoto seen through billowing clouds of gold, belongs to the genre known as *Rakuchū rakugai zu* (Scenes in and around the capital). The first examples of this genre were commissioned by wealthy warlords of the early sixteenth century as artistic trophies celebrating their political and cultural domination of the capital. Others appear to have been commissioned by merchant guilds to commemorate the city's economic recovery after a long, bleak era of war and civil strife. The screens here, though based on compositional formulas established in the sixteenth and early seventeenth centuries, date to an era when more populist attitudes ruled the art market, and therefore the entire mood of the composition is more relaxed, capacious, and cheerful than that of its precursors.

Rakuchū rakugai zu depict not only famous buildings—temples and shrines, the imperial palace and aristocratic mansions, Nijō castle and elite samurai enclaves—but also the homes and shops of commoners. They present synchronic tableaux representing the four seasons in a continuous composition and comprise fascinating records of day-to-day activities and seasonal festivities. So densely packed with visual information, these scenes are unreadable from a distance and reveal their delights only when observed close up. In their sympathetic depiction of commonplace affairs, especially the activities of people enjoying themselves at festivals and street dances, lie the seeds of *ukiyo-e*.

The identity of Tosa Daijō Genyō remains a complete mystery. *Daijō* was an honorary title given to townspeople or artisans, usually puppet makers, puppeteers, or *jōruri* chanters, but not to painters. Though the painter styled himself a Tosa, this name of distinguished lineage was sometimes borrowed by *machi eshi* (town painters) to give added cachet to a work. —JTC

277

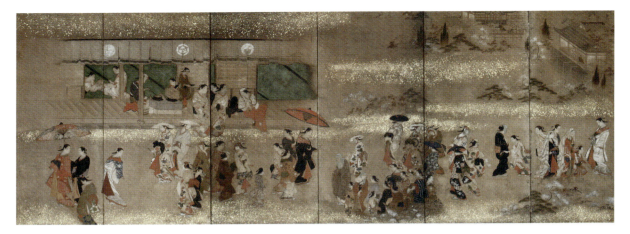

102. Unidentified artist

Women on a Flower-viewing Excursion, 1720s–1730s

Six-panel folding screen: ink, color, and gold leaf on paper, 97.2 × 261.2 cm

Literature: Christie's 1998a, no. 16; Kobayashi 1995, pl. 87; Azabu Museum of Arts and Crafts 1989, pl. 53; Azabu Museum of Art 1988, pl. 59

PLATE 102

THIS COLORFUL, GOLD-FLECKED screen captures a scene of groups of women—no men can be detected—on their way to or returning from viewing cherry blossoms in the Higashiyama (Eastern Hills) district of Kyoto (the same area shown in the two rightmost panels of the right screen of *Scenes in and around the Capital*). In the background of the three left panels, women stop along the way for refreshment at tea stalls, most likely the ones near Yasaka shrine. Some fifty women of all ages and walks of life are depicted on this screen, probably originally one of a pair. The two gorgeously costumed women promenading beneath parasols held by attendants are high-ranking courtesans, as is the woman at the screen's far right, who wears a robe with calligraphic motifs similar to that of the courtesan depicted by Takizawa Shigenobu (cat. no. 105). Most of the women with head-shades and flowery costumes with obi tied in front also appear to be young courtesans. Two women in blue cowls, one quite elderly and with a walking stick, are Buddhist nuns. Women with light-colored shawls (*kazuki* or *kinu-katsugi*) pulled up over their hair are ladies of high birth.

The hairstyles and textile patterns point to a date in the early eighteenth century for this work, though most likely slightly after the period of Kaigetsudō artists. The women's diminutive statures and soft, rounded features generally accord with the Kyoto style of feminine beauty consolidated by Nishikawa Sukenobu in the 1820s and 1830s (see cat. no. 106). —JTC

103. Hanabusa Itchō, 1652–1724

Mount Fuji from Sagami Province, 1710s–1724

Hanging scroll: ink and colors on silk, 31 × 49.6 cm

Signatures: Shihō [o] Sōshū Ba'nyū yori miru zu (Painting of Mount Fuji as seen from the Ba'nyū River in Sagami province); Hokusō-ō Itchō sho (Brushwork by the Old Man of the North Window)

Seal: Shuzai san'un senseki kan (Intending to dwell amid springs and rocks in cloud-capped mountains)

NOT AN EXAMPLE OF UKIYO-E, this painting of a river scene with Mount Fuji towering in the background is included here as a tribute to the artist Hanabusa Itchō, whose work was instrumental in bridging traditional Kanō landscape art and early genre painting. His careful brushwork, conservative vision, and serene tastefulness indicate academic training, while his choice of subjects, coloristic daring (as revealed in many of his genre-scene handscrolls), and cheerful tone align him with *ukiyo-e* artists. He received early training in the Kanō atelier under the powerful Yasunobu (1613–1685), who worked for both shogun and emperor but soon left; we can only speculate that perhaps he did not toe the artistic line. In 1698 Itchō was banished from Edo to Miyake Island (Miyakejima), either because he hosted parties at bordellos for close relatives of the mother of Shogun Tsunayoshi or (according to other sources) as punishment for creating a picture that was said to criticize the shogun's own sexual dalliances.

Itchō adopted the art name Old Man of the North Window, with which he signed this painting, while in exile when, it is said, he often gazed out his window to the north, toward Edo. Other sources say it was inspired by a line from the Chinese hermit-poet Tao Yuanming (365–427); it probably refers to both. After painting for nearly a decade under the moniker Islander Itchō, he was allowed in 1709 to return to Edo. There he painted for fifteen more years, taking the art name Itchō. Thus this painting can be dated to the final period of his career, perhaps to the last six or seven years of his life, when he seems to have reverted to a more subdued Kanō style. The inscription prefacing Itchō's signature suggests this image is based on a vista he actually saw along the Ba'nyū River in Sagami province (present-day Kanagawa prefecture).

Itchō founded the Hanabusa school of painting; both he and his students created numerous works of *ukiyo-e*. Woodblock-printed reproductions of Itchō's sketchbooks and drawing-instruction manuals (*gafu*), published late in the eighteenth century decades after his death, had a broad influence on artists of various schools. —JTC

104. Hanabusa Isshū, fl. early 18th century

Pleasure Quarters of the Various Provinces, early 18th century
Handscroll remounted as twelve hanging scrolls: ink and
color on paper, approx. 29 × 59 cm (each)
Signature: (on "Maruyama" scene) Hanabusa Isshū ga
Seal: Hanabusa [?]
Literature: Christie's 1998a, no. 35; Kobayashi 1995,
nos. 6–17

ONE OF THE CENTRAL SUBJECTS of *ukiyo-e* prints
was the officially licensed entertainment district of
Yoshiwara in Edo, yet artists often depicted scenes
of unlicensed areas as well. The artist Isshū, the
second son and a disciple of the bohemian artist
Hanabusa Itchō (see cat. no. 103), visually docu-
mented a representative selection of both official
and unofficial bordello districts throughout the
country. Each vignette is inscribed with a short
title giving the city and name of the entertainment
quarter. The scenes are listed in geographical
sequence, moving from Edo in the east, to the
Kansai region, and finally to Nagasaki in Kyushu,
the southernmost island of Japan.

Clockwise from top left, the screens are:
a, "Yoshiwara in Edo"; *c*, "Shinagawa"; *f*, "Shima-
bara in Kyoto"; and *l*, "Maruyama in Nagasaki."

a. "Yoshiwara in Edo." Edo's principal licensed
bordello district was first established in 1617
near Nihonbashi and, after the Great Fire of 1657,
moved to a more remote location north of Asakusa.
Also referred to as Shin Yoshiwara (New Yoshi-
wara), it was home to most of the famous courtesans
depicted in later Edo prints.

b. "Hachiman Shrine in Fukagawa." One of the
popular, unofficial bordello districts of Edo, its
prices were lower than Yoshiwara's. Hanbusa Itchō
and, we may assume, Isshū lived for many years
in Fukagawa.

c. "Shinagawa." Just south of Edo, Shinagawa was
the first station on the Tōkaidō Road and locale of
a pleasure quarter with restaurants and bordellos
overlooking Edo Bay.

d. "Myōjo in Ise." While on a visit to sacred shrines
of Ise, pilgrims would stop here for refreshments
and other diversions.

e. "Kitsuji in Nara." Nara is another area associated
with sacred sites. Tame deer, symbols of Nara, run
free among its temples and shrines.

f. "Shimabara in Kyoto." The major courtesan
quarter of the capital, Shimabara was established
in the western part of the Shimogyō district (south
of Sanjō) in 1640, when the licensed quarters for-
merly in Misujimachi in Rokujō were moved here.

g. "Ishigake in Kyoto." Ishigake-machi (or
Ishigaki-chō) was established in 1670 in Higashi-
yama on land reclaimed from the Kamo River. It
was noted for its concentration of houses of assigna-
tion catering to both homosexual and heterosexual
prostitution.

h. "Shumoku-machi in Fushimi." Located in the
southern section of Kyoto, the original name of
this pleasure quarter was Ebisu-machi. It acquired
its popular nickname because the T-shaped layout
was said to resemble a *shumoku*, a long-handled
wooden hammer used for striking a Buddhist
ritual bell.

i. "Bathhouse in Kyoto." Bathhouse women (*yuna*)
could be hired for a modest fee to help wash or
massage male customers; for additional fees they
could be hired as escorts.

j. "Kyūkenchō in Osaka." Kyūkenchō was a
section of the Shinmachi licensed quarters, which
was one of the largest and busiest in the country.

k. "Miyajima in Aki Province." Site of the famous
Itsukushima shrine in Hiroshima Bay, Miyajima
was one of the Three Scenic Places of Japan. As
in other sacred locales, there were facilities here
to cater to clientele with more worldly desires.

l. "Maruyama in Nagasaki." During the Toku-
gawa period, this was one of the most prosperous
licensed quarters, along with those in Edo, Kyoto,
and Osaka. The presence of men in Chinese attire
is a reminder that Nagasaki was the port of entry
for art and ideas from the continent; the wild boar,
which appears out of place in a bordello scene, is
a local specialty. This is the only signed section of
the set of twelve, indicating it was the final segment
of the original handscroll. —JTC

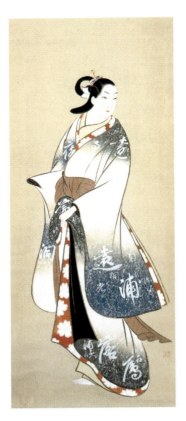

105. Takizawa Shigenobu, fl. c. 1716–36
Courtesan in Robes with Calligraphic Motifs, 1720s
Hanging scroll: ink and colors on paper, 103.5 × 43.0 cm
Seal: Shigenobu
PLATE 103

AN EXAGGERATEDLY TALL COURTESAN in long-sleeved robes glances back over her shoulder. The statuesque pose is clearly inspired by the conventions of Kaigetsudō painters, yet the prototype's robustness has given way here to a slightly more svelte form. Her hair, coiffed into a perfect circle, is held in place with a tortoiseshell pin and comb. The facial features are gentle and more cheerful than the attitudinizing poses of Kaigetsudō models: the face is rounded and has a long, prominent nose and parted, rosebud lips that almost break into a smile. Her robes have graduated areas of soft blue around the shoulders, lower sections of the sleeves, and hem of the lower skirt; an inner robe shows cherry blossoms on a brilliant red ground; and the ensemble is held in place with an understated persimmon-brown obi. In white pigment (representing white reserve of the paste-resist *hoguzome* method used to create the original kimono) are bold, cursively inscribed Chinese characters randomly disposed against a decorative background of scattered kana writing. The Chinese graphs refer to famous places associated with the Eight Views of Xiao and Xiang.

The figural style and decoration of the robes call to mind works by Baiyūken Katsunobu (fl. 1710s–20s), such as an example in the British Museum, London;[1] this painting probably dates to slightly later than that example. The close correspondence of styles suggests that Shigenobu may have been a pupil of Katsunobu or may have worked in the same circle. —JTC

1. See Clark 1992, no. 26.

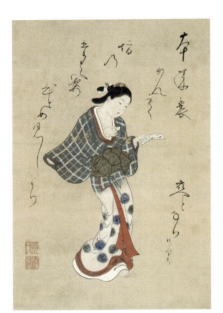

106. Nishikawa Sukenobu, 1671–1750
Courtesan Reading a Poem Card, 1730s–early 1740s
Hanging scroll: ink and color on paper, 40.5 × 26.4 cm
Seal: Nishikawa uji Sukenobu kore [o] zu [su] (This was painted by Sukenobu, of the Nishikawa family)
PLATE 104

A YOUNG COURTESAN SASHAYS to the right, her entire body a gentle swerve of movement. In one hand she holds a poem card; the other pokes out of the **V** of her robes, clutching a folded letter—from a patron, we may imagine. The upper part of her outer robe is a grayish blue shade with a white plaid pattern; its skirt is decorated with little bursts of blue and green pine-needle clusters on a white ground. The sensuousness of the garment's bright red lining is enhanced because we get only a glimpse of it. An olive-green obi tied in the front (the mark of a courtesan) is decorated with floral patterns and *manji* (reverse swastika), a symbol of long life. Her hair, elegantly coiffed in the style of the times and held in place with a white ribbon and a tortoiseshell comb, is characteristic of Sukenobu's ideal woman. The surrounding poem text playfully likens the courtesan to the Zen patriarch Bodhidharma.

A Kyoto artist, Sukenobu exerted a huge influence on popular artists of his day as well as the following generation in Edo through his widely circulated book illustrations depicting women in various poses and settings. His painting style became the archetype for an early Kyoto style of beauty, as seen to some extent in *Women on a Flower-viewing Excursion* (cat. no. 102) and in the works of the Kawamata lineage (see cat. nos. 107, 108). Suzuki Harunobu's print images of the 1760s, depicting similar diminutive young women with gentle, rounded faces, are stylistically indebted to the Sukenobu prototype. —JTC

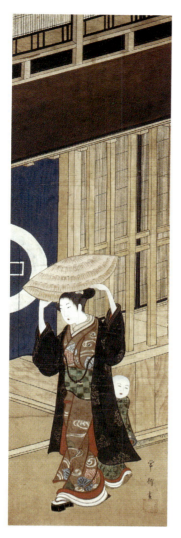

107. Kawamata Tsuneyuki, c. 1677 – c. 1744

Male Prostitute Leaving a Brothel, early to mid-1740s
Hanging scroll: ink and color on paper, 87.6 × 26.4 cm
Signature: Tsuneyuki ga
Seal: [illegible, probably Tsuneyuki]
Literature: Christie's 1998a, no. 40; Kobayashi 1995, pl. 31; Gluckman and Takeda 1992, 320, cat. no. 195; Azabu Museum of Arts and Crafts 1989, pl. 30; Azabu Museum of Art 1988, pl. 35; Narazaki 1982, vol. 3, 139, fig. 40; Asano Shūgō 1982, pl. 343; Kaneko 1977, no. 80

A YOUNG MAN STANDS in front of a two-story bordello with latticed windows and a blue door curtain; a little boy peeks from behind his robes. The young man's garb, hairstyle, and high-heeled geta reveal him to be a *kagema*, a male prostitute who dresses up in an ostentatious fashion more appropriate for a young woman, to titillate an older male clientele. Since many such youths danced on the Kabuki stage, they were also called *butaiko*, "dance-stage boys." His hair is tied into a topknot but his forelocks are still unshaven, indicating he is in his late teens. As he makes a graceful exit—we may assume after or on his way to a rendezvous—he prepares to don a bowl-shaped wicker hat. His stylish *haori* outer cloak, black with gold arabesque, has a stunning red lining to add a sensuous effect. The colorful robes beneath it are decorated with a motif of *kōhone* (a variety of water lily) amid waves, befitting the drifting nature of his profession. His green obi with its checked pattern is a style popularized by Edo Kabuki actor Sanogawa

Ichimatsu in the early 1740s. These fashion indicators and the painting style date the work, but its subject is also timely: with the relaxation of laws regulating prostitution in general, male bordellos had begun to flourish again in urban centers in the 1740s and 1750s, particularly in the Yoshichō district of Edo, where this painting might be set.

The faces of the figures as well as many of the ink lines in the architectural background have been significantly retouched. Although the original painting of the young man's face and robes is mostly intact, the cherubic face of the child attendant has been completely redone in a painting style neither of Tsuneyuki nor of the period. A painting by Ryū Juchō (act. 1760s) in the Freer Gallery of Art, Washington, D.C., has a remarkably similar composition.[1]

Little is known about Tsuneyuki's life, though he is recognized as the head of the Kawamata lineage or studio of artists who specialized in *ukiyo-e* paintings of *bijin* (beautiful women or men). The few surviving paintings by Kawamata artists other than Tsuneyuki and Tsunemasa (see cat. no. 108) make it hard to talk of a distinctive school or style. About twenty paintings by Tsuneyuki are known, likely from between the 1720s and 1740s; they sometimes include famous sites of Kyoto or Edo, suggesting that Tsuneyuki, like Tsunemasa, lived for a while in each city. —JTC

1. Cf. *Ukiyo-e shūka* 1981, 16:159, fig. 84.

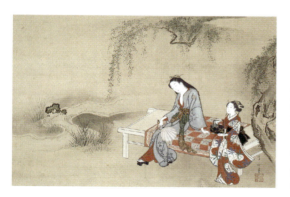

108. Kawamata Tsunemasa, fl. 1740s

Courtesan and Attendant Enjoying the Evening Cool, 1740s
Hanging scroll: ink, color, and gold on paper,
37.8 × 56.0 cm
Signature: Tsunemasa hitsu
Seal: Tsunemasa
Literature: Christie's 1998b, no. 216

ON A WARM SUMMER EVENING, a courtesan relaxes on a bench covered with a patterned cloth. Casually dressed in pale blue outer robes decorated with bush-clover motifs, she holds a round fan, an emblem of the season. Her young attendant, dressed in a cheerful red and white robe with green maple leaf motifs, arrives bearing a lacquer smoking kit. The scene's languid mood is set by the drooping branches of a willow and a stream gently swerving to the left–both common metaphors of floating-world art. A painting of a courtesan seated on a bench smoking a pipe by Edo artist Miyagawa Chōshun (1683–1753) in the Freer Gallery of Art, Washington, D.C., has a remarkably similar

composition, even to the detail of the stream (with a similarly shaped rock) under a willow, which may suggest that Tsunemasa had access to sketchbooks or actual works from Chōshun's studio.[1] Both Tsunemasa and Chōshun were known exclusively as painters; they never designed woodblocks. We lack detailed information on Tsunemasa's career, but various sources suggest that he was next in line after Tsuneyuki in the Kawamata lineage and that he probably lived in Kyoto and Edo at various phases of his life. —JTC

1. Cf. Stern 1973, no. 33, and Narazaki 1982, vol. 3, no. 6.

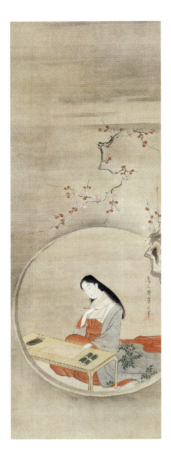

109. Chōbunsai Eishi, 1756–1829

Court Lady through a Round Window, late 1790s

Hanging scroll: ink and color on silk, 82.6 × 28.7 cm

Signature: Chōbunsai Eishi hitsu

Seal: Eishi

PLATE 105

THIS EVOCATIVE SCENE reveals the artist's skill in creating idealized portraits of women in calm, idyllic settings that create dreamy or poetic moods. His mastery of this elegant idiom has earned Eishi esteem as one of the aristocrats of late Edo *ukiyo-e* prints and paintings. Utamaro, to whom Eishi had at one stage turned as mentor, may have been praised as the greatest master of female portraiture, but a hyperrefinement in Eishi's work sets him apart. The son of a prominent samurai official, he had a more privileged upbringing than most *ukiyo-e* artists, who were usually of humble origin. His formal training in the Kanō academic style is not unusual among his contemporaries but he gained prominence by his appointment as official painter to the shogun. In a remarkable act of artistic rebellion, at age thirty he resigned his official post to devote himself exclusively to *ukiyo-e*.

Eishi and his pupils did a number of paintings using the device of viewing an elegantly attired woman though a round window framed by a bough of plum.[1] In 1796 Eishi created a design for the illustrated poetry anthology *Yomo no haru* (Spring in all directions), which shows a similar image, but with a high-ranking courtesan at a writing desk flanked by two attendants.[2] A magnificently detailed painting on a similar theme in the Tokyo National Museum by his pupil Eiri shows Eishi's influence.[3] Around the turn of the century, he seems to have gradually backed away from the print design at which he excelled to focus on handscroll paintings (including erotica) and hanging-scroll paintings intended, like this one, for display in a tokonoma. —JTC

1. Cf. Brandt 1977, 25.
2. Forrer 1982, 45, fig. 7.
3. Tokyo National Museum 1993, no. 64.

110. Gion Seitoku, 1781–c. 1829

Geisha Reading Poems, 1790s–1805

Hanging scroll: ink and color on silk, 113 × 41.4 cm

Signature: Heian Seitoku sha

Seals: Azana iwaku Hakuryū (Called by the art name Hakuryū); Seitoku

A GEISHA STANDS absorbed in reading a sheet of poems, probably from a male admirer, in a letter she has just unfolded. Her understated gray-blue outer robes (representing the graduated tones of the *akizome* dyeing technique) help tame the dazzling colors of the scarlet undergarments and the orange-red obi decorated with a gold peacock motif. An array of hairpins and tie-dyed cloth hair ribbon hold her elegant *Shimada-mage* coiffure in place. In contrast to the exaggeratedly tall, svelte ideal of feminine beauty epitomized by Edo artists such as Kiyonaga, Utamaro, and Eishi at the turn of the century, Seitoku captures more subdued Kyoto tastes in somewhat more realistic and less flattering portraits of women. They have shorter statures, rounder faces recalling a Sukenobu style, and often rather bulbous noses. Seitoku's realistic portrayal of figures and the use of shading on the robes were probably inspired by the Maruyama-Shijō style of portraiture.

Throughout his career as a specialist painter of female entertainers, Seitoku frequently prefaced his signature with place names specifically linking him to Kyoto: "Heian" (the ancient name of Kyoto), as on this painting, or "kōto" (imperial capital). Seitoku was especially famous for his portraits of geisha of the Gion district, and on other works his signatures specifically indicate that he was working on the east bank of the Kamo River, where Gion was located. Captivated by the elegant geisha culture "East of the River" (Kawahigashi), as Gion was also known, Seitoku seemed to have little or no interest in the Shimabara pleasure quarter, which by this time was a pale shadow of its heyday a century earlier. —JTC

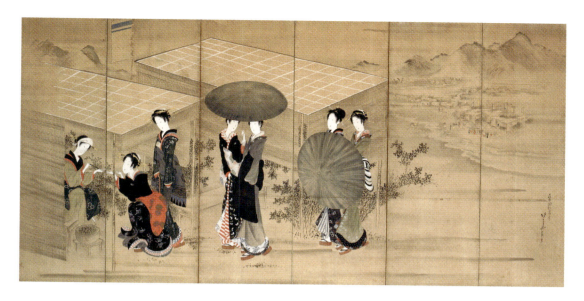

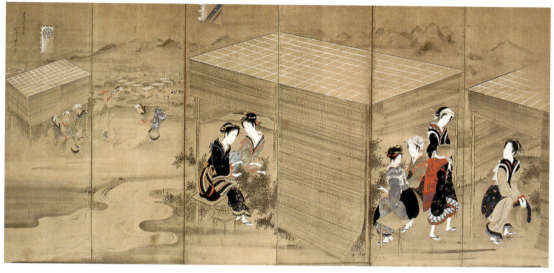

111. Hōtei Gosei, fl. 1804–44

Picking Tea, c. mid-1820s

Pair of six-panel folding screens: ink and color on paper, 167.4 × 335 cm (each)

Signature: (on each) Senshuken juō (Commissioned by Senshuken); Hōtei Gosei ga (Painted by Hōtei Gosei)

Seals: (on each) Hōtei; Sunayama Gosei

Literature: Christie's 1998a, no. 96; Kobayashi 1995, pls. 68, 69; Azabu Museum of Art 1988, pl. 88; Azabu Museum of Art 1986, no. 45; Tanaka 1986, "Hotei Gosei no kenkyū"; Kaneko 1977, no. 157

PLATE 106

GOSEI DISCARDED CONVENTIONAL turn-of-the-century *ukiyo-e* ideals of proportion and refinement for a rather idiosyncratic female beauty. He took the tall, lithe model of the 1790s and early 1800s, used by most *ukiyo-e* artists including his teacher, Hokusai, and exaggerated to an even greater degree its height and features. Faces become greatly elongated ovals; eyes formed by parallel lines are disposed at acute angles; noses stretch out long and straight; and V-shaped lips seem to express glee or animated conversation. The main figures in these screens, in particular, are engaged in ceaseless chatter.

The backgrounds of both screens show panoramas of tea-harvesting huts in what must be Uji, near Kyoto, and the Uji River meanders through the middle ground. In the right screen, two pairs of townswomen—probably geisha—in elegant dress and high geta and holding parasols approach a group of three women. One, in gorgeous black *kosode* robes, has stooped to chat and share a smoke with a well-dressed tea picker, whose hair is tied in a white kerchief. The scene continues in the left screen, where a group of six women converse as they pick tender leaves of high-quality *sencha* in the shelter of bamboo blinds (similar to the cultivation method used since the 1830s to raise fine *gyokuro* tea). As this work suggests, the cultivation and drinking of high-quality tea was and continues to be of great importance in Japan.

The poetry inscriptions and decorative motifs on the robes of several of the women indicate that this screen was commissioned by a patron with connections to poetry circles that engaged in the writing of *kyōka* (witty thirty-one-syllable verse). Gosei, a *kyōka* poet himself, had close connections at first with the Go-gawa (Group of Five) poetry club in Edo. As an artist he was best known for his *surimono* (privately commissioned woodblock prints) and illustrations for *kyōka* anthologies produced while he still lived in Edo (where, until around 1810, he used the art name Hokuga). He moved in 1819 to Matsumoto in Shinano (present-day Nagano prefecture), where he gained esteem for his paintings of beautiful women in elaborate scroll and screen formats. Clearly this large format and meticulous execution reflect the specific request of the patron, Senshuken, whose name appears next to the artist's signature. —JTC

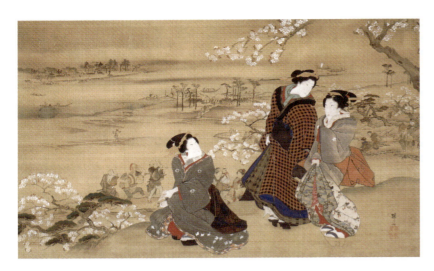

112. Teisai Hokuba, 1771–1844

Women Enjoying Cherry Blossoms, 1830s

Hanging scroll: ink and color on silk, 45.7 × 75 cm

Signature: Teisai

Seal: Hokuba ga in (Hokuba's painting seal)

PLATE 107

HOKUBA, LIKE GOSEI an early pupil of Hokusai, first acquired a name as a book illustrator and designer of *surimono* (privately commissioned prints). He is also known for paintings of groups of women that integrate courtesans or geisha rendered in a meticulous *ukiyo-e* mode, in atmospheric ink-wash landscape settings marked by Western-style spatial recession. In this finely painted work on silk, three women, probably geisha, clad in multiple layers of expensive robes, chat while enjoying the vista of blossoming cherry trees. In the background, softly rendered in ink and light color washes, we can just make out the torii of Mimeguri shrine at Mukōjima, on the far bank of the Sumida River. The women are probably atop Matsuchi Hill, in Asakusa, which commands panoramic river views. Just behind them, a group of revelers, indistinctly painted in light colors, is shown traipsing along what we may surmise is the Nihon Dike, the pathway leading to the Yoshiwara pleasure district. —JTC

113. Teisai Hokuba, 1771–1844

Boat Prostitute at Asazuma (Asazuma-bune), 1840

Hanging scroll: ink, color, and gold on silk, 35 × 54 cm

Signature: Shichijū ō Teisai hitsu (Painted by Teisai, old man of seventy)

Seal: Hokuba

PLATE 100

GORGEOUSLY ATTIRED in the costume of a *shirabyōshi* (a female dancer who wore male court costume), a woman in a small boat gazes at the pale reflection of the moon in the water, beneath dangling branches of willow. She is one of the boat prostitutes who plied the Asazuma inlet, along the eastern shore of Lake Biwa, near Osaka. With characteristic meticulousness, Hokuba uses rich, opaque pigments to render the woman's robes: the upper portions in black, decorated with gold arabesque, melt into a blue ground with waterwheel and wave motifs, above which stylized red and white plovers flutter. Her princess-style coiffure is crowned with silver plum-blossom spangles and a gold-colored *eboshi* (courtier's cap). She holds a gold-colored, half-splayed fan and keeps warm with a red wool blanket.

This painting theme was made popular by Hanabusa Itchō (see cat. no. 103), and a number of similar versions of this composition with slight variations were created by Hokuba toward the end of his career. For example, the version in the British Museum, London, shows the *shirabyōshi* gazing upward to look directly at the moon.

—JTC

1. Clark 1992, no. 119.

114. Utagawa Kunisada, 1786–1864

Women Representing the Four Social Classes, c. 1836–38
Pair of hanging scrolls: ink, color, and gold wash on silk, 124.8 × 54.1 cm (each)
Signature: (on each) Kōchōrō Kunisada ga
Seals: (on each) Hanabusa Ittai; Kunisada [no] in
Literature: Izzard 1993, no. 72; Kobayashi 1992, pl. 4
PLATES 9, 108 a, b

THE YOUNG WOMEN statically posed in this pair of paintings can seen as representatives of the four social classes as proposed by neo-Confucian scholars of early modern Japan: warriors, farmers, artisans, and merchants. In the right scroll, a woman of elite samurai status wearing flowery robes looks down on a peasant woman holding a basket. The companion scroll shows a fan maker looking up to the daughter of merchant family, who carries a wooden container. By the time this painting was created in the late 1830s, Kunisada had already achieved prominence as one of the most influential and prolific print designers of the late Edo period. His contemporaries Hokusai and Hiroshige were hailed for their landscape prints, but at the time Kunisada's portrayals of actors and beautiful women surpassed all others in popularity. During the mid-1830s, when famine and economic distress adversely affected the commercial print market, Kunisada clearly retained a loyal following for his prints and paintings of high quality, like this one. In places, the heavy mineral pigments used to render the robes and some of the bright white *gofun* (oyster shell pigment) of the faces have flaked off. —JTC

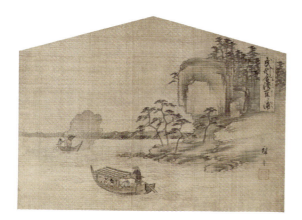

115. Utagawa Hiroshige, 1797–1858

Suzumegaura in Kanazawa, Musashi Province, late 1840s–early 1850s
Hanging scroll: ink and light colors on silk, 42 × 56 cm
Signature: Hiroshige
Seal: Ichiryūsai
Literature: Christie's 1998b, no. 275; Kobayashi 1995, fig. 49; Azabu Museum of Art 1986, pl. 21; *Kokka* 1910, 221, 225

PLATE 119

THIS SUBDUED INK LANDSCAPE has little to do with the traditional subjects or styles of *ukiyo-e*, but its artist is one of the most prominent designers of woodcut landscape prints, a genre that achieved immense popularity during the first half of the nineteenth century. Along with their celebration of scenic views of the Japanese countryside, artists such as Hokusai and Hiroshige added a sense of novelty and visual interest to their print designs by incorporating newly assimilated techniques of Western perspective, as seen in this painting.

Hiroshige achieved international fame for his various print series that captured scenes of stations along the Tōkaidō Road, of which Kanagawa was one. (In 1857 Hiroshige returned to this subject in *Buyō Kanazawa hasshō yakei* [Eight night views of Kanazawa in Musashi province], a magnificent panoramic print triptych.) This painting also invites comparison with a remarkably similar scene depicted in an album of seventy sketches, each bearing the seal of Hiroshige, preserved in the Freer Gallery of Art, Washington, D.C.[1]

In this scene of the bay of Suzumegaura (present-day Yokohama), the varying tones of ink, in traditional East Asian mode, give texture and depth to the foliage of the scraggly pines. In the foreground a man in a wicker hat poles a roofed passenger boat; slightly in the distance, fishermen cast a net from their small boat. The flat, faceted facade of the monumental cliff counterbalances the semitransparency of the fishing net. Landscape paintings such as this demonstrate that Hiroshige

was an artist well equipped to work in the idiom of other schools, whether *nanga* or Maruyama-Shijō styles.

When this painting was introduced in the journal *Kokka* in 1910, the editors speculated it had been designed to adorn an *andon* lantern because the thin pigments would have accommodated such a function. But this theory does not account for Hiroshige's production of a large number of similar hanging-scroll paintings in ink and light color washes. The unusual peaked shape of this work is no doubt the mounter's solution to hiding damage caused by its earlier mounting in a gabled frame of the variety used for votive shrine plaques. Other paintings on silk of a similar size and shape by Hiroshige and his pupils are found in the British Museum, London.[2] —JTC

1. Stern 1973, no. 116.
2. Clark 1992, nos. 140–42.

Zenga

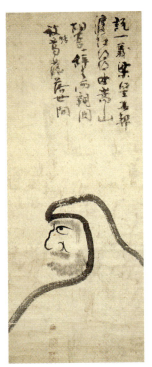

116. Konoe Nobutada, 1565–1614

Half-body Daruma

Hanging scroll: ink on paper, 106.2 × 41 cm

Seals: [three, illegible]

Inscription:

> He explained the First Principle, but the Emperor did not
> understand.
> He crossed over the Yellow River and sat in meditation on
> Mount Su.
> He abandoned the barbarian belief of his two mother countries.
> He lassoed vagrant thoughts and liberated himself from the world.
> —trans. John Stevens

KONOE NOBUTADA, a statesman and courtier, was classed as one of the three great calligraphers of the Kan'ei period (1624–44) along with Hon'ami Kōetsu (see cat. nos. 76, 77) and Shōkadō Shōjō (1584–1639). Although never a member of a Buddhist religious establishment, Nobutada studied Zen at Daitokuji during his service to the imperial court in Kyoto. In addition to his poems and calligraphy, he created numerous monochrome ink paintings, which are considered to be among the earliest *zenga* of the Edo period.

Nobutada displays his informal yet elegant calligraphic style in the upper portion of the painting. The inscription relates the story of the Zen patriarch Daruma—his journey from India to China and his years of meditation at the Shaolin temple before attaining enlightenment. The lower portion of the scroll contains Nobutada's portrait of Daruma, a profile view of the Indian monk meditating intensely while facing the cave wall beyond the picture plane. One even, controlled brushstroke defines the figure's body and head covering. His foreign facial features are defined by a few dark brush lines and applications of lighter wash for facial hair and eyebrows. Painted on a relatively coarse paper, this work exemplifies the economy of means employed by artists seeking to reveal the truth of Zen. Its surface has darkened and cracked, creating a patina of age that only adds to the power of the work.

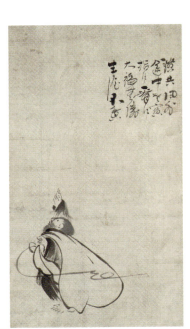

117. Fūgai Ekun, 1568–1654

Hotei Pointing at the Moon

Hanging scroll: ink on paper, 55.9 × 30.5 cm

Signature: Fūgai

Seal: Fūgai

Inscription:

> His life is not poor
> He has riches beyond measure
> Point to and gazing at the moon.
> This old guest follows the way of Zen.
> —trans. Stephen Addiss

Literature: Woodson 2001, no. 33; Yamashita 2000, no. 60; Stevens and Yelen 1990, no. 24; Addiss 1986, fig. 3

PLATE 74

FŪGAI EKUN WAS A PRIEST of the Sōtō sect, which, with Rinzai, is one of the most important Zen sects in Japan. Fūgai spent decades wandering, living in impoverished villages and residing in caves, thus giving rise to the appellation "Cave Fūgai." His meditative and eremitic lifestyle engendered both parallels to and empathy for Daruma and the other Zen worthies he painted. Fūgai's Zen works provide a bridge between earlier Zen traditions and Edo *zenga*. His adherence to traditional subject matter and gentle ink washes evokes earlier traditions, whereas his simply painted figures, presented against a blank ground, and his unfettered message established trends followed by later practitioners.

Fūgai often painted Hotei (C. Budai), a tenth-century Chinese monk famed for his untrammeled lifestyle. Hotei literally means "cloth bag," which, along with a staff and a fan, became one of his three standard attributes. After his death, Hotei came to be regarded as a patron saint of sorts for both merchants and children. Merchants identified with the wealth of treasures he carried in his bag, and children with his childlike demeanor and intense pleasure in their company, which he preferred to that of adults. Hotei later came to be considered an incarnation of Maitreya, the Buddha of the Future; he is second only to Daruma in frequency of appearance in Zen paintings.

Fūgai has placed Hotei toward the left side of the painting, his mannered and looping calligraphic inscription at the upper right balancing this configuration. Hotei gesticulates forcefully at the unseen moon, the string from his commodious sack flying behind his back in a long and elegant brush line.

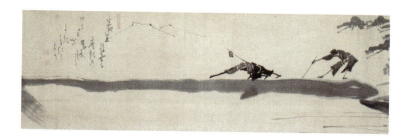

118. Hakuin Ekaku, 1685–1768

Two Blind Men Crossing a Bridge

Hanging scroll: ink on paper, 28 × 83.8 cm

Seals: Hakuin; Ekaku no in; Kokan-i

Inscription:

> Both inner life and the floating world outside us
> Are like the blind men's round log bridge—
> An enlightened mind is the best guide.
> —trans. Stephen Addiss

Literature: Woodson 2001, no. 19; Yamashita 2000, no. 15; Stevens and Yelen 1990, no. 46; Addiss et al. 1983, no. 20; Rosenfield and ten Grotenhuis 1979, no. 57

PLATE 68

Hakuin is one of the most extraordinary individuals in the history of Zen. A zealous reformer and prolific painter and calligrapher, he irrevocably changed the future of both Rinzai Zen and *zenga*. Spurred by the increased secularization of society and perceived corruption of Rinzai practices, Hakuin instituted dramatic reforms. These resulted in an overhaul of Zen monastic life and a reinstitution of rigorous meditative practices and asceticism still observed today.

Hakuin's paintings, created for pupils, disciples, and lay followers in need of encouragement, date primarily from the last three decades of his life. They have been divided into three phases—early, middle, and late—corresponding to his sixties, seventies, and eighties. This work, a relatively early painting, takes as its subject a rickety bridge that crossed a perilous chasm near the Shōinji, the small Rinzai temple where Hakuin served as abbot for most of his career.

Hakuin created the bridge from a single stroke of gray ink that extends across the width of the scroll. He then reversed direction, overlaying much of the original line with another application of ink. Two blind men grope their way across the precarious structure, one on his hands, the other using a walking stick for balance.[1] Gestural black ink strokes convey the men's tentative movement and the deliberation with which they undertake this hazardous journey. A sense of man's inconsequential place in the universe is imparted by the mountains, which loom in the background despite their scant definition by a few spidery lines. Hakuin's inscription combines with the painting to make this work a call to action for those who live an unconsidered life. In Hakuin's mind, moving through life with an unenlightened mind is as perilous an undertaking as the journey of the blind men on the bridge.

1. Other versions have different numbers of men; see, for example, Addiss 1989, pl. 55, and Yamanouchi 1978, no. 37.

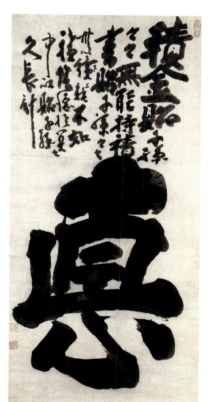

119. Hakuin Ekaku, 1685–1768

Virtue

Hanging scroll; ink on paper, 117.3 × 55.2 cm

Seals: Kokan-i; Hakuin; Ekaku

Inscription:

> Pile up money for your sons and grandsons—
> They won't be able to hold onto it.
> Pile up books for your sons and grandsons—
> They won't be able to read any of them.
> No, the best thing to do
> Is to pile up merit
> Quietly, in secret,
> And pass this method to your descendants:
> It will last a long, long time.
> —trans. Jonathan Chaves

Literature: Yamashita 2000, no. 22; Stevens and Yelen 1990, no. 61; Addiss et al. 1983, no. 24; Addiss 1976, no. 14

PLATE 66

This calligraphic masterpiece from Hakuin's last years demonstrates the power of his brush. The darkly inked character *toku* (virtue) dominates the lower portion of the scroll. Above it, Hakuin transcribed a passage from the Chinese historian and Confucian scholar Sima Guang (1018–1086) regarding the proper inheritance for one's offspring. As Hakuin broadened the subject matter for Zen painting, he likewise brought into the Zen tradition of calligraphy a far-ranging thematic vocabulary. This eleventh-century Confucian admonition was, in Hakuin's view, an eternal truth that transcended cultural and temporal boundaries.

Calligraphy from Hakuin's later years is notable for its tremendous force. Although Hakuin used a limited tonal range in this work, subtle variations in the ink suggest a sense of depth and animation. His use of a heavily sized and thus less absorbent paper caused the interesting puddling of ink seen in the character *toku*. Further visual interest is created by the varied size of the characters in the excerpt from Sima Guang and the slight slanting of the vertical lines of calligraphy, which prevents an overly frontal and staid presentation.

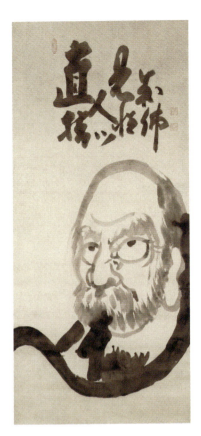

120. Hakuin Ekaku, 1685–1768

Daruma

Hanging scroll: ink on paper, 130.8 × 55.2 cm

Seals: Kokan-i; Hakuin; Ekaku

Inscription:

> *Pointing directly at the human heart,*
> *See one's own nature and become a Buddha.*
> —trans. Stephen Addiss

Literature: Woodson 2001, no. 5; Yamashita 2000, no. 1; Stevens and Yelen 1990, no. 2; Addiss 1976, no. 15

PLATE 120

HAKUIN PAINTED HUNDREDS of Daruma images, as was befitting of the Zen patriarch's role as the single most important signifier of meditation. With his widespread popularity, Hakuin was undoubtedly called upon to create numerous images for followers who benefited from this tangible reminder that only through the rigorous discipline of meditation could enlightenment be attained. This monumental work from the artist's later period is remarkable for its size, power, and efficacy; it numbers among the masterworks from his brush.

Hakuin's bold brushwork, both in the calligraphy and in the painting, conveys the force of his belief and the strength of his vision. He used one curved brushstroke to define the lower edge of Daruma's robe; three others mark the edges of the shoulder and neckline. These dark grays are balanced by similar tonalities in the inscription. Wet strokes of gray ink define the foreign facial features of Daruma, whose demeanor indicates his deep meditative state.

121. Hakuin Ekaku, 1685–1768

Mount Fuji and Eggplant

Hanging scroll: ink on paper, 54.4 × 156 cm

Seals: Kokan-i; Hakuin; Ekaku

Inscription: *What's this!*

Literature: Yamashita 2000, no. 20

PLATE 67

HAKUIN CREATED A DREAMLIKE, almost surreal scene in this extremely large painting. Mount Fuji, made of a single, even stroke, occupies almost one half of the scroll. Beside it, floating in undefined space, are three eggplants, two black and one white. Completing the composition are two simply defined hawk feathers. Conceived almost like a handscroll, this large painting takes as its theme auspicious signs for the New Year: Mount Fuji, eggplants, and the hawk. To have any of these signs appear in one's first dream of the year traditionally signified good fortune to come. Hakuin compounds the surreal nature of the image with his enigmatic inscription.

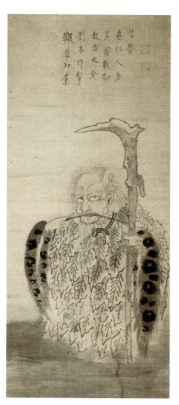

122. Hakuin Ekaku, 1685–1768

God of Medicine

Hanging scroll: ink and color on paper, 104.4 × 42.7 cm

Seals: Kokan-i; Hakuin; Ekaku

Inscription:

> He gathered grasses to learn about medicine.
> He cut a tree to make a plow.
> He taught us to cook with fire.
> He showed us how to utilize birds and beasts.
> His virtue and humanity were a boon to many—
> A true student of healing.
> —trans. John Stevens

Literature: Yamashita 2000, no. 14

PLATE 69

BY PAINTING SUBJECTS from Shinto, Confucianism, popular culture, and everyday life, Hakuin greatly broadened the range of Zen painting. In this work he depicts Shinnō, the Chinese god of agriculture and medicine. A rather daunting figure, Shinnō arises from a wash mist wearing a cloak of leaves. He chews on a plant stem to determine its medicinal properties, holding its end in his right hand. In his left hand he grasps a walking stick that curves above his head, dividing the composition neatly between the portrait of the god and the inscription above. Shinnō's upraised arms reveal the softly painted furlike trim on the sleeves of his cloak, a beautiful contrast to the linear articulation of the patterned coat of leaves.

Hakuin uses slight touches of color to augment his image. The leaves in the cloak are tinted a light green, and a slight touch of red adorns Shinnō's lips, drawing attention to his actions. The head of the figure is carefully and meticulously painted, with particular attention paid to his cranial protuberances and elaborate hairstyle. This work, a rare example of this subject by Hakuin, dates from his middle period.

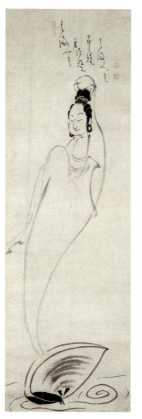

123. Hakuin Ekaku, 1685–1768

Kannon Emerging from a Clamshell

Hanging scroll: ink on paper, 87.5 × 26.8 cm

Seals: Kokan-i; Hakuin; Ekaku

Inscription:

> She takes the body of a clam, using its form to proclaim
> the Buddha Dharma.
> —trans. John Stevens

Literature: Yamashita 2000, no. 5

HAKUIN HERE DEPICTS the Hamaguri Kannon, the bodhisattva of compassion arising from a clamshell. Both in Buddhist scriptures and in art, Kannon (S. Avalokitesvara) appears in numerous manifestations, a consequence of the need to adopt manifold forms to alleviate the suffering of the world. This painting features the thin, light gray brushstrokes and spidery calligraphy typical of Hakuin's early style, when he was in his sixties. Pale strokes of gray ink define the elongated curving form of Kannon. Darker and finer brushwork describes the elaborate hairstyle of the figure; this darker tonality is echoed in the lower portion of the scroll by the bottom edge of the clamshell. Kannon's face, with its gently curved

and downcast eyes, hooked nose, and softly rounded cheeks, is often encountered in Hakuin's works and can be seen in the figure of Benzaiten in *Seven Gods of Good Fortune* (cat. no. 124).

Hakuin painted many versions of this bodhisattva, most famously as Byuku-e, or the Whiterobed Kannon, seated upon a rock. However, he displayed a predilection for the theme of the Hamaguri Kannon, painting other, often elaborate polychrome versions.[1] More commonly seen are paintings of this theme by Hakuin's students and followers Suiō Genrō and Tōrei Enji (see cat. nos. 127, 130).

1. Yamashita 2000, no. J11.

124. Hakuin Ekaku, 1685–1768

Seven Gods of Good Fortune (Shichifukujin)

Hanging scroll: ink and color on paper, 57.8 × 89.4 cm

Seals: Hakuin; Ekaku; Ryūtoku muge

Inscriptions:

> *One who is loyal to his lord and filial to his parents will receive*
> *my straw raincoat, hat, magic mallet, and bag.*

On Fukurokuju's book:

> *Under the eaves of the place [Shōki] conceals his sword, and*
> *stealthily guards the imperial household.*
> —trans. John Stevens

Literature: Woodson 2001, no. 42; Yamashita 2000, no. 6

PLATE 70

HAKUIN PAINTED the seven gods of good fortune a number of times, most often using ink and color, as in this work. Here the seven gods are arranged in a circular pattern, with Shōki, the legendary demon queller, the largest figure, occupying the center of the composition. Surrounding Shōki, from left to right, are Jurōjin, the god of longevity, with the elongated cranium; Hotei with his white bag; Ebisu, god of daily food; Benzaiten, the goddess of love and music, playing a flute; Fukurokuju, god of health, prosperity, and longevity; and Daitoku, god of wealth. Technically Shōki is not one of the seven gods, but Hakuin repeatedly replaced Bishamonten, one of the Four Guardian Kings, with Shōki when painting this theme.

In the inscription Hakuin admonishes viewers of this work to fulfill their duty to society and to family; those who do so successfully will be amply rewarded through the beneficence of Daitoku and Hotei. The mallet mentioned in the inscription is the traditional attribute of Daitoku, who strikes surfaces with this implement to create money.

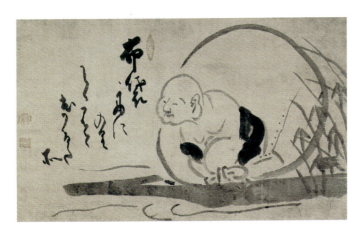

125. Hakuin Ekaku, 1685–1768

Hotei on a Boat

Hanging scroll: ink on paper, 33.5 × 52.2 cm

Seals: Ryūtoku muge; Hakuin; Hakuin

Inscription:

> *Hotei riding in a boat*
> *Goes out moon viewing*
> —trans. Audrey Seo

Literature: Yamashita 2000, no. 9

HOTEI WAS ONE of Hakuin's favorite painting subjects. Emblematic of happiness and innocence, Hotei is often seen as a jovial, well-fed fellow. This portrayal is more contemplative. Hotei sits in a small skiff emerging from a reedy marsh. His huge cloth bag, from which he derives his name, sits behind him, though surely a sack of that size would capsize such an insubstantial vessel.

Hakuin employs a number of idiosyncratic conventions in this very simply painted work. The outline of the skiff is created from the same type of horizontal stroke seen in *Two Blind Men Crossing a Bridge* (cat. no. 118). Similarly, the seams in Hotei's bag, with its inverted **Y** form paralleled by dotting, is seen in *Seven Gods of Good Fortune* (cat. no. 124) and in the works of Hakuin's followers. The soft grays of the bag, boat, and reeds are balanced by the darker tones seen in Hotei's upper garment and the calligraphic inscription.

The inscription immediately to the left of Hotei indicates that he is on a moon-viewing excursion. The moon itself does not appear either in the sky or as a reflection in the water. Hakuin placed the character for "moon" in the second line from the right in the inscription, directly at Hotei's eye level, so that in fact he is gazing at the moon. The circular outline of Hotei's treasure bag may also be read as a full moon, reinforcing the lunar reference.

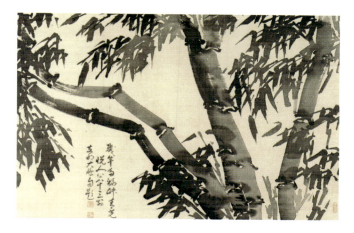

126. Ōbaku Taihō, 1691–1774

Bamboo, 1773

Hanging scroll: ink on silk, 51.5 × 77.5 cm

Signature: Hachijū-san ō Shina Taihō kudai (Inscribed by Taihō at age 83)

Seals: Kanchū higetsuchō; Taihō no in; Shakushi Shōgon

PLATE 11, PAGE 298

ŌBAKU TAIHŌ, a Chinese Buddhist priest who immigrated to Japan in 1722, became the sixteenth and eighteenth abbot of Manpukuji, the home temple of the Ōbaku order. Founded by émigré monks from Fujian fleeing the falling Ming dynasty, the order received special dispensation from the shogunate to establish its temple near Kyoto in the early part of the seventeenth century. In 1745 Taihō assumed the abbacy for the first time, but his tenure lasted only three years; he stepped aside during negotiations concerning native leadership of the temple. Taihō resumed leadership of the religious establishment in 1758, a position he held until 1765.

Highly regarded as a painter, poet, and calligrapher, Taihō was particularly noted for his paintings of bamboo. His bamboo greatly influenced his friend Ike Taiga, the *nanga* master. This work dates from the year before the artist's death. Its theme, Taihō's favored subject, is presented in a horizontal orientation rather than his usual vertical format. By both cropping and isolating his subject, Taihō created an image that focuses on the brushwork, not the subject. The gentle trajectory of the bamboo stalks and the subtle tonal variations in the overlapped bamboo leaves create an almost abstract pattern on the silk.

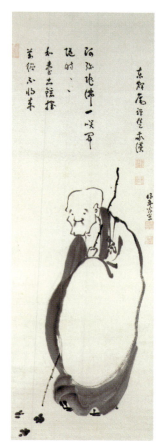

127. Suiō Genro, 1716–1789

Zen Monk Bukan

Hanging scroll: ink on paper, 129.3 × 41.9 cm

Inscription by Gessen Zenne (1701–1781):

> All of the virtue [of the Buddha] is not in the future. The old mirror and stable platform are shattered.
> [He replies]: "Whenever! Whenever! And makes Amida Buddha blossom all at once in this world."
> Respectfully inscribed by Zenne of Tōkian
> —trans. John Stevens

Box inscription by Awakawa Yasuichi (1902–1976):

> Ink painting of Bukan by the Zen priest Suiō, with an inscription by Gessen Zenne

PLATE 72

A RINZAI PRIEST, Suiō Genro is regarded as one of Hakuin's primary pupils. For more than two decades, Suiō had an unconventional master-student relationship with Hakuin. During his training, Suiō resided not at the Shōinji but a good distance away, returning to the temple only for special occasions or when summoned.[1] After Hakuin's death, Suiō assumed the abbacy of Shōinji but also continued Hakuin's practice of taking extended tours of the countryside to proselytize the populace.

Suiō's works are painterly and reserved, perhaps reflecting his association with Ike Taiga (see cat. nos. 2–10). Hakuin's early, quiet style can also be seen in the paintings of this follower, but the forceful directness of Hakuin's later works clearly did not resonate with Suiō's personality or painting style. In this scroll, Suiō depicts the monk Bukan, an associate of Kanzan and Jittoku at the Guoqingsi, who was best known for his companion, a tiger. Standing and holding his walking stick, Bukan gazes at the three paw prints that appear in the lower left corner of this painting, indicating the path his faithful companion has taken. For another depiction of this subject by Tawaraya Sōtatsu, see cat. no. 78.

1. See Seo 1997, 320–25.

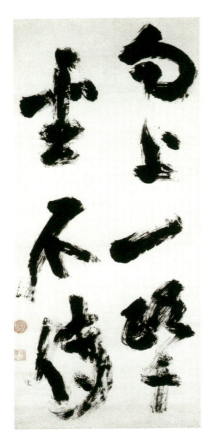

128. Jiun Sonja, 1718–1804

A Single Path

Hanging scroll: ink on paper, 117 × 52 cm

Seals: [illegible]; Jiun

Inscription:

> A single path upwards—
> The thousand sages do not assist me.
> —trans. Jonathan Chaves

Literature: Yamashita 2000, no. 64

PLATE 75

BORN OF THE SAMURAI CLASS, Jiun received a Confucian education befitting his social status. After the death of his father, he entered a Shingon temple, beginning a long and distinguished career as an abbot, scholar, and calligrapher. Pursuing eclectic interests, Jiun explored various sects of Buddhism as well as undertook the serious study of Confucianism, Shinto, and Sanskrit. He eventually published the 1,000-volume *Bongaku shinryō* (Examination and treatment of Sanskrit studies; 1759–72), the first systematic effort in Japan to explicate Sanskrit grammar and the history of its transmission through Buddhist texts from India to China and Japan. Jiun also founded Shōbōritsu (True Doctrine Discipline), a new syncretic Buddhist sect that fused aspects of Esoteric Shingon with practices of the Ritsu sect and other Zen meditative traditions.

The majority of Jiun's calligraphic work dates from his retirement years. His distinctive style of bold, heavily inked characters was created with a brush made of split bamboo. The resulting *hihaku*, or "flying white" technique, wherein gaps and spaces are left within a stroke, imparts an architectonic power to his characters. Jiun's balance of positive and negative space, movement and quietude, power and vulnerability, is unparalleled in Edo-period calligraphy.

129. Reigen Etō, 1721–1785

Hotei in a Boat

Hanging scroll: ink on paper, 40.1 × 53.6 cm

Seals: Kinkei Ichiryū Hakumai; Eshō; Reigen

Inscription: *Hotei in a boat*

Literature: Awakawa 1970, no. 97

PLATE 76

REIGEN ETŌ PLAYED a crucial role in the dissemination of Hakuin's new vision of Rinzai discipline and training. Born near Kyoto, Reigen received his early Buddhist training at Zenshōji in Tamba. He attempted to study with Hakuin during this period, leaving his home institution and traveling to Shōinji. The untimely death of his former teacher caused Reigen to return to Tamba, whereupon he embarked on a ten-year period of meditation. Following this eremitic decade, Reigen began his study with Hakuin and received an *inka* (certificate of enlightenment) from the master in about 1759. Shortly thereafter, Reigen assumed the abbacy of Zenshōji. In 1767 he became the supervisor of the monks' training hall at Tenryūji, a major temple in Kyoto, and assumed the abbacy there in 1769. Reigen thus became the first of Hakuin's followers to institute his major reforms and methodologies; from this point forward, Hakuin's methods began to dominate Rinzai practice.

Hotei in a Boat clearly derives from Hakuin's painting of the same subject (cat. no. 125). The differences between the two works are numerous and telling. Reigen employs the same simplified brush line common to most *zenga* practitioners, but he also imparts a sense of dimensionality to the boat uncommon in this tradition. His Hotei, hunched over, rests his elbows on the side of the boat as he searches for the moon's reflection. The carefully inked figure fits comfortably within the boat's confines, his sack appearing more like a tarpaulin-covered load than a magical bag filled with the stuff of good fortune.

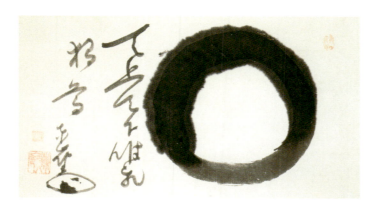

130. Tōrei Enji, 1720–1792

Ensō

Hanging scroll: ink on paper, 31.5 × 55.5 cm

Signature: Tōrei [and clam cipher]

Seals: Seizan bakugyaku; Enji; Tōrei

Inscription:

> *In heaven and on earth I alone am worthy of honor.*
>
> —trans. Jonathan Chaves

Literature: Woodson 2001, no. 46; Yamashita 2000, no. 32; Stevens and Yelen 1990, no. 44; Addiss 1976, no. 17

PLATE 71

THROUGH WRITINGS, teachings, and painting, Tōrei Enji perpetuated and furthered the beliefs and practices advocated by his primary teacher, Hakuin. Tōrei entered religious life at a young age, receiving instruction at a number of temples before traveling to Shōinji to study with Hakuin. Tōrei not only became Hakuin's disciple but was also entrusted by his teacher to lead several temples and lecture on his behalf. After Hakuin's death, Tōrei continued lecturing and writing, and he assumed the abbacy of a succession of temples, eventually retiring to a temple in his home village of Ōmi.[1] The author of numerous treatises on Zen, Tōrei became particularly known for his efforts to unite the teachings of Buddhism, Shinto, and Confucianism.

Tōrei, like Hakuin, used painting and calligraphy as a didactic tool. Although his works include a wide range of subjects, Tōrei identified most closely with *ensō*, Zen circles. Simultaneously straightforward and enigmatic, the *ensō* is the quintessential Zen subject. There are myriad interpretations for this shape, which represents everything and nothingness. Tōrei, considered the finest *ensō* painter in *zenga*, created numerous versions of this theme, each unique. Here his thick, heavily loaded brush created a dark, soft circle; the absorbent paper allowed the ink to bleed dramatically.

The inscription to the left of the circle transcribes the words attributed to the historical Buddha, Sakyamuni, upon his birth. While the phrase indicates the Buddha's knowledge of his own enlightenment, the statement also served as a common Zen koan.

1. See Addiss 1989, 131–38.

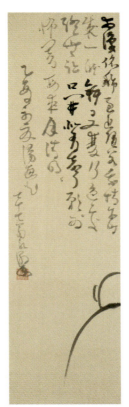

131. Gōchō Kaichō, 1749–1835

Shadow Daruma, 1825

Hanging scroll: ink on paper, 100 × 28.2 cm

Signature: Kinoto no tori, shoka manga dai 77 ō, Gōchō ga (Playfully brushed by the old man Gōchō at age seventy-seven, early summer 1825)

Seal: Gōchō no in

Inscription:

> *Shadow Daruma by Gōchō*
> *At first glimpse, he appears only dimly,*
> *But get closer and you will sense his presence.*
> *At high noon, you become one with him,*
> *But in the setting sun you seem to go separate ways.*
> *Proceed on until there is no more trace.*
> *When the mouth is opened there will be a voice.*
> *If you fear the dark and ask for help,*
> *He will make the moon illumine the night, pure and bright.*
>
> —trans. John Stevens

Literature: Bokubi 95, p. 42

A PRIEST OF THE TENDAI SECT, Gōchō Kaichō nonetheless was deeply knowledgeable about Zen and painted numerous works in the abbreviated *zenga* style. The son of a Buddhist priest, Gōchō began his religious training early and studied a broad range of Buddhist traditions. He became a highly esteemed cleric and was given the title *kankai daishi* by the imperial court.

In this work, Gōchō depicts Daruma, the Zen patriarch, seated in meditation. Daruma is seen from behind, with the blank paper functioning as the cave wall before which he meditated for many years.

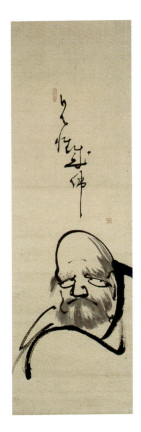

132. Kōgan Gengei, 1748–1821

Daruma

Hanging scroll: ink on paper, 97.4 × 28.7 cm

Seals: Totsu saisai; Kōgan

Inscription: *Kenshō jōbutsu (See one's own nature and become a Buddha)*

KŌGAN GENGEI BELONGS to the Hakuin lineage, although the difference in their ages meant he had only a tangential relationship with the master. Kōgan received his certificate of enlightenment from Sōkai, another of Hakuin's pupils, and eventually became the twenty-first abbot of Kōgenji in Tamba province in 1789.

Often grouped with Sengai's *zenga*, Kōgan's reveal a distinct, quiet intensity. He focused on traditional themes such as the Zen worthies Kanzan and Jittoku, the sixteen arhats, and Daruma. His characteristically spare use of ink is evident in this version of Daruma. The Zen patriarch occupies the lower portion of the scroll, with the thin, scratchy lines of inscription placed above.

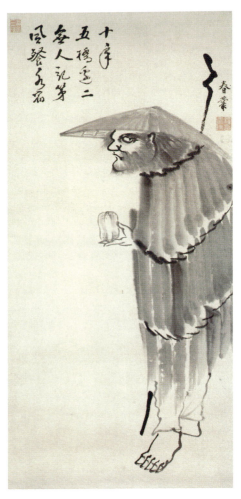

133. Shunsō Shōju, 1751–1839

Daitō Kokushi as a Begging Monk

Hanging scroll: ink on paper, 120 × 55 cm

Signature: Shunsō

Seal: Shaku genshu in

Inscription:

> Feeding on wind and sleeping on dew
> for twenty years,
> nobody knew his whereabouts
> around the Fifth street bridge.
> —trans. Yoko Woodson

Literature: Woodson 2001, no. 49; Yamashita 2000, no. 42; Addiss 1976, no. 24

PLATE 77

SHUNSŌ SHŌJU, a student of Suiō Genro, began his religious studies at age sixteen, eventually becoming a priest at the Jikōji in Awa province. In this, one of his finest paintings, Shunsō portrayed Daitō Kokushi, the distinguished founder of Daitokuji in Kyoto, one of the most influential figures in Zen history. Many tales surround his life. Shunsō chose to portray an episode when Daitō lived as a mendicant engaged in the ritual begging required of all monks as part of their discipline. According to the tale, Daitō left his temple for a considerable time, and the emperor, discovering that he might be out begging, sent aides to lure Daitō back into service by enticing him with melons, his favorite food.

Daitō is seen in profile, wearing his rain hat and cloak and holding a melon in his hand. Dark, even brushstrokes outline his distinctive facial features, and lush, broad strokes of varied tonalities of gray ink define his cloak. Shunsō's controlled use of wash in the cloak creates a glistening effect, as if the garment were soaked with rain. In this work, Shunsō follows the thematic model of Hakuin, who painted this subject several times.[1] Shunsō, however, transformed the earlier master's generalized view of Daitō into a specific and compelling portrait.

1. Addiss 1979, no. 12 and 78–79.

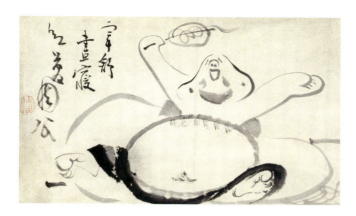

134. Sengai Gibon, 1750–1837

Hotei Yawning
Hanging scroll: ink on paper, 29.5 × 48.4 cm
Seal: Sengai
Inscription:

> *Zaishu takes a snooze*
> *And dreams of the duke of Zhou.*
> —trans. Melinda Takeuchi

Literature: Woodson 2001, no. 35; Yamashita 2000, no. 49; Stevens and Yelen 1990, no. 27; Addiss et al. 1983, no. 31
PLATE 65

SENGAI GIBON, the younger son of a farming family, was sent to a Zen monastery as a child, a common occurrence in traditional Japanese society, which practiced primogeniture. After his initial training, Sengai studied for ten years with Gessen Zenne (1701–1781) and from 1790 to 1811 served as abbot of the Shōfukuji in Hakata. He retired at a relatively young age and lived the remainder of his life as a layman in Hakata, where he brushed the majority of his paintings.

Sengai's paintings, characterized by humor and spontaneity, appear effortless in their execution. Despite their seeming artlessness, his compositions, subjects, and inscriptions betray both knowledge and sophistication. In this work, Sengai takes as his subject the beloved Hotei, seen as he awakens from a deep sleep. Sengai captured Hotei in mid-action, his legs splayed open and arms flung wide, stretching to revive his cramped muscles.

The rotundity of Hotei's stomach is echoed in his ample sack, which functions as a bolster behind him. In his inscription, Sengai alluded to traditional Confucian orthodoxy, referring to both Zaishu, a prominent follower of Confucius, and the duke of Zhou, a paragon of Confucian virtue. Sengai's imagery also recalls a story from Zhuangzi, the fourth-century B.C. Daoist philosopher, who upon awakening wondered if he had been dreaming that he was a butterfly, or if he were a butterfly dreaming that he was Zhuangzi. Zen adherents likewise recognized the fallibility of the human perception of truth and sought means to break out of the confines of rationality.

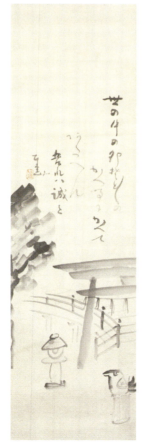

135. Sengai Gibon, 1750–1837

Dazaifu Shrine
Hanging scroll: ink on paper, 122.8 × 34.7 cm
Signature: Sengai
Seal: Sengai
Inscription: *Transforming lies into truths.*
PLATE 73

IN ADDITION TO his figural paintings, Sengai brushed numerous scenes of temples and shrines. The Dazaifu shrine and its annual festivities are the subject of this painting. The shrine is indicated by the large torii occupying the lower right half of the scroll. Beside it stands a stone lantern, and in front of the gate, a carved bird sits atop a column. This figure represents an *uso*, the small carved wooden bird made at this shrine. On January 7, visitors coming to the shrine may buy an *uso*, which reputedly has the power to transform one's lies into truth.

Information on the painting box reveals that this work once numbered among the more than one hundred paintings by Sengai in the collection of the *nihonga* artist Tomita Keisen, whose grandfather, Tomita Yoshihiko, had been a friend of Sengai's.

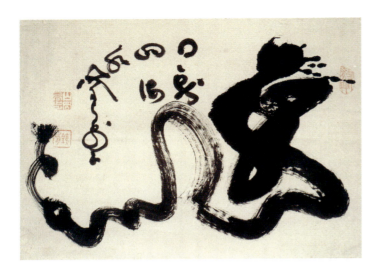

136. Yamaoka Tesshū, 1836–1888

Dragon

Hanging scroll: ink on paper, 44.5 × 60.3 cm

Seals: Fude ni shin ari; Yamaoka Koho; Tesshū

Inscription:

> *Dragon: It feasts on sunlight and the four seas!*
> —trans. John Stevens

Literature: Stevens and Yelen, 1990, no. 66

PLATE 78

A STATESMAN, swordsman, calligrapher, and avid Zen lay disciple, Yamaoka Tesshū was a great friend and supporter of Nakahara Nantenbō (see cat. nos. 137, 138). Tesshū devoted the latter half of his life to the study of Zen, and although he received his *inka* (certificate of enlightenment), he never entered monastic life.

Tesshū's calligraphic style relies on strength, abstraction, and speed. In this work, he created a literal pictograph from a single stroke of his brush.

Taking the character for "dragon," Tesshū manipulated its strokes and vertical orientation to create a painting of the beast itself. The dragon's head rears upward, marked by the splash marks left by the force with which Tesshū's brush hit the paper. The long, writhing body extends the full width of the scroll. The *hihaku*, or "flying white," at the center of the scroll expertly balances the dark ink of the dragon's beginning and the inscription placed above.

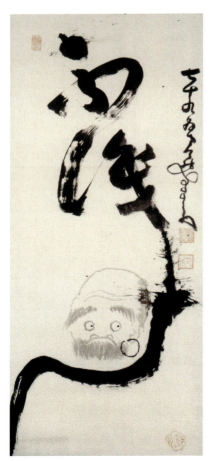

137. Nakahara Nantenbō, 1839–1925

Half-body Daruma, 1917

Hanging scroll: ink on paper, 92.2 × 40.6 cm

Signature: Nanajūkyū ō Nantenbō (Seventy-nine-year-old man Nantenbō) [with cipher seal]

Seals: Nantenbō; Hakugaikutsu; Tōjū; Tōjū

Inscription:

> *Don't know!*
> —trans. John Stevens

Literature: Yamashita 2000, no. 74; Stevens and Yelen 1990, no. 11

PLATE 113

THE ZEN MONK–ARTIST Tōjū Zenchū, better known as Nantenbō, produced more than 100,000 paintings and works of calligraphy during the last thirty years of his life. A zealous reformer of the Rinzai Zen sect, he was a tireless teacher known for his exacting standards and impatience with mediocrity. Nantenbō created a vibrant and explosive style in both painting and calligraphy that marks him as one of the geniuses of twentieth-century Zen painting.

Nantenbō's idiosyncratic style is clearly visible in this portrait of the grand patriarch of Zen, Daruma, one of his favorite painting subjects. Nantenbō began painting large-scale images of Daruma in his seventies. His characteristic brushwork, wherein he overloaded the brush with ink and applied it to the paper with such force that the ink splashed out from the point of impact, here creates and defines the body of Daruma. The inscription, occupying the upper half of the painting, reads, "Don't know!" This wild spontaneity is juxtaposed with the lightly and carefully inked face of Daruma, wide eyed and somewhat bewildered.

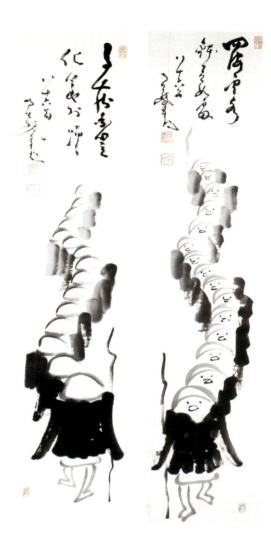

138. Nakahara Nantenbō, 1839–1925

Procession of Monks, 1924

Pair of hanging scrolls: ink on paper, 129.5 × 30 cm (each)

Signature: Hachijūroku ō Nantenbō (Eighty-six-year-old man Nantenbō) [with cipher seal]

Seals: (on each) Nantenbō; Hakugaikutsu; Tōjū; Shun getsu Kado (ni) Takashi

Inscription, right:

> Itinerant monks throughout the world,
> Their begging bowls resound like thunder;

Left:

> In straw coats and round hats,
> They return from the village.
> —trans. Matthew Welch

Literature: Woodson 2001, no. 68; Morse and Morse 1995, p. 58; Addiss 1989, p. 113; Yamashita 2000, no. 78; Addiss 1976, no. 29

PLATE 79 a, b

PAINTED THE YEAR BEFORE Nantenbō's death, this image of two long lines of monks, one setting out and the other returning home from their obligatory begging (*takuhatsu*), is one of the artist's most successful compositions. While Nantenbō was not the originator of the theme,[1] his treatment of the subject, with humor and immediacy, is masterful.

Nantenbō's monks enter and exit the viewer's space as a totality, the individual monks subsumed in the undulating lines. The freely brushed robes and abbreviated dots and lines of the faces create a sense of lightheartedness, which contrasts sharply with the somber demeanors of black-robed, chanting monks of the temples and shrines.

1. See, for example, Kōgan Gengei's (1748–1821) *Procession of Monks*, New Orleans Museum of Art, acc. no. 90.42. For a discussion of possible artistic precedents of this theme, see Welch 1995, 210–11.

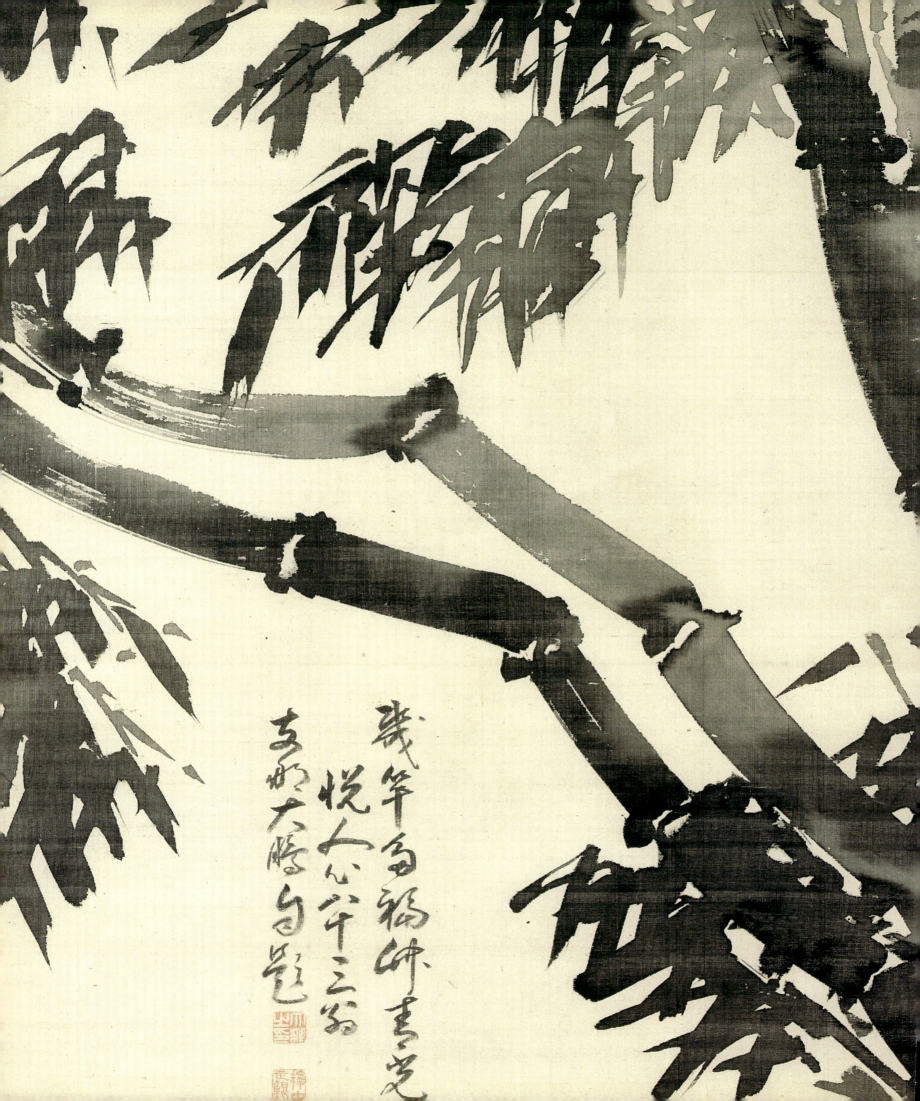

Seals

Seals are shown at actual size
unless otherwise noted.

* 50% of actual size

† 200% of actual size

NANGA

2 Ike Taiga
Zuiweng Pavilion

3 Ike Taiga
Ink Landscape with Rice Fields

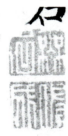

4 Ike Taiga
Landscape

5 Ike Taiga
Spring Landscape

6 Ike Taiga
Orchids in a Vase

7 Ike Taiga
Lake Landscape

8 Ike Taiga
Chrysanthemum

9 Ike Taiga
Uzumasa Festival

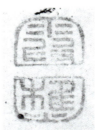

10 Ike Taiga
Mibu Kyōgen

11 Ike Gyokuran
Mountain Landscape

12 Aoki Shukuya
Lanting Pavilion

13 Satake Kaikai
Peach Blossom Landscape

14 Ike Kanryō
Landscape

15 Niwa Kagen
Mount Fuji

16 Uragami Gyokudō
Colors Change from Red to Gold

17 Uragami Gyokudō
Spring Landscape

18 Okada Beisanjin
Landscape

19 Yosa Buson
Autumn Landscape

20 Yosa Buson
Oku no hosomichi (Narrow Road to the Far North)

21 Yosa Buson
Spring Landscape

22 Yosa Buson
Man with a Staff and
Old Man with Attendant

23 Matsumura Goshun
Deer

24 Matsumura Goshun
One Hundred Old Men

25 Matsumura Goshun
Sweeping Autumn Leaves

26 Matsumura Goshun
Flowers and Birds in the Rain

27 Matsumura Goshun
Night Vigil

28 Matsumura Goshun
Tsurezuregusa Haiga

30 Kameda Bōsai
Landscape with High Mountain

31 Tani Bunchō
*Returning Home
on the Autumn River*

32 Tani Bunchō,
Kameda Bōsai
Spring Flowers and Butterfly

*

33 Tani Bunchō
Landscape Screens

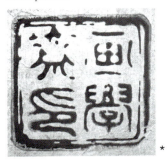

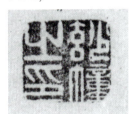

*

34 Yokoi Kinkoku
*Breeze through the Pines
in the Myriad Peaks*

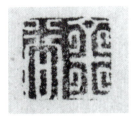

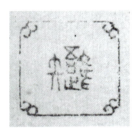

35 Yokoi Kinkoku
*Solitary Path through the Cold
Mountains and Myriad Trees*

36 Nakabayashi Chikutō
Plum Blossom Studio

37 Hosokawa Rinkoku
Sledding in the Icy Mountains

38 Okada Hankō
Village among Plum Trees

39 Okada Hankō
Landscape

40 Yamamoto Baiitsu
Flowers of the Four Seasons

*

41 Yamamoto Baiitsu
Flowers and Birds by a Pond

42 Tachihara Kyōsho
Painting a Landscape

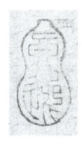

43 Yanagawa Seigan
Mount Kōya in Autumn

44 Tsubaki Chinzan
Triptych of Flowers

45 Tsubaki Chinzan
Lotus Leaves and Willow Tree in Moonlight

46 Takahashi Sōhei
Bamboo and Plum Blossoms

47 Murase Taiitsu
Rakan

48 Hine Taizan
Dawn Bell at Nanpin

49 Nakabayashi Chikkei
Summer and Autumn Landscapes

50 Fujimoto Tesseki
Sixteen Rakan

51 Taki Katei
Plum Blossoms

*

52 Fukuda Kodōjin
White Cloud Album and
Album of Colored Clouds

†

53 Fukuda Kodōjin
Landscapes of the Four Seasons

MARUYAMA-SHIJŌ SCHOOL

55 Maruyama Ōkyo
Half-body Daruma

56 Komai Genki
Woman Washing Clothes in a Stream

57 Komai Genki
Crows and Cherry Blossoms

†

58 Matsumura Goshun
Haiga Album

59 Yamaguchi Soken
Kamo River Party

60 Watanabe Nangaku
Cranes

61 Shibata Zeshin
Tea Screen with Two Fans

62 Shiokawa Bunrin
Waiting for the Ferry Boat

*

*

63 Hasegawa Gyokuhō
Country Landscape in Summer Rain

64 Takeuchi Seihō
White Heron on Willow
and *Crows and Persimmon*

*

ECCENTRICS

65 Itō Jakuchū
Kanzan and Jittoku

*

*

66 Itō Jakuchū
Carp

*

67 Itō Jakuchū
Crane

*

*

68 Itō Jakuchū
Moon and Plum Blossom

*

69 Soga Shōhaku
Ink Landscapes

*

70 Soga Shōhaku
Two Figures

*

*

*

71 Nagasawa Rosetsu
Boy and Ox

*

72 Nagasawa Rosetsu
Tanka shō butsu

73 Nagasawa Rosetsu
Cormorant Fishing

†

74 Nagasawa Rosetsu
Moon

*

75 Chō'ō Buntoku
Tiger and Dragon

*

*

RINPA SCHOOL

78 Tawaraya Sōtatsu
The Four Sleepers

*

79 Tawaraya Sōtatsu
Duck Flying over Iris

*

80 Kitagawa Sōsetsu
Autumn Flowers and Grasses

81 Kitagawa Sōsetsu
Flowering Sweet Pea

*

83 Watanabe Shikō
Flowers and Birds at the Shore

84 Watanabe Shikō
Fukurokuju

85 Watanabe Shikō
Spring and Summer Flowers

86 Tatebayashi Kagei
Morning Glories and Grasses

87 Nakamura Hōchū
Hollyhocks

88 Nakamura Hōchū
Flowers of the Twelve Months

*

89 Nakamura Hōchū
Doves

90 Sakai Hōitsu
Mount Fuji and Cherry Blossoms

91 Sakai Hōitsu
Triptych of Flowers and the Rising Sun

92 Suzuki Kiitsu
Morning Glories

93 Suzuki Kiitsu
Mount Hōrai

94 Suzuki Kiitsu
Misogi Scene from the Tale of Ise

*

95 Suzuki Kiitsu
Chrysanthemums and Flowing Stream

96 Sakai Ōho
Autumn Maple

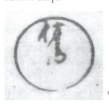

*

98 Kamisaka Sekka
Dancing Figures

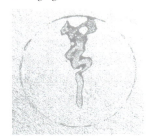

99 Kamisaka Sekka
Gathering of Waka Poets

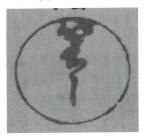

100 Kamisaka Sekka
Autumn Flowers and Grasses

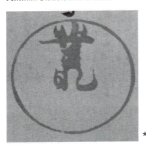

*

Genre Painting and
Ukiyo-e

101 Attr. Tosa Daijō Genyō
Scenes in and around the Capital

103 Hanabusa Itchō
Mount Fuji from Sagami Province

104 Hanabusa Isshū
Pleasure Quarters of the Various Provinces

105 Takizawa Shigenobu
Courtesan in Robes with Calligraphic Motifs

106 Nishikawa Sukenobu
Courtesan Reading a Poem Card

107 Kawamata Tsuneyuki
Male Prostitute Leaving a Brothel

108 Kawamata Tsunemasa
*Courtesan and Attendant Enjoying
the Evening Cool*

109 Chōbunsai Eishi
Court Lady through a Round Window

110 Gion Seitoku
Geisha Reading Poems

111 Hōtei Gosei
Picking Tea

112 Teisai Hokuba
Women Enjoying Cherry Blossoms

113 Teisai Hokuba
Boat Prostitute at Asazuma (Asazuma-bune)

114 Utagawa Kunisada
Women Representing the Four Social Classes

115 Utagawa Hiroshige
Suzumegaura in Kanazawa,
Musashi Province

ZENGA

116 Konoe Nobutada
Half-body Daruma

117 Fūgai Ekun
Hotei Pointing at the Moon

118 Hakuin Ekaku
Two Blind Men Crossing a Bridge

119 Hakuin Ekaku
Virtue

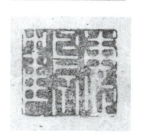

120 Hakuin Ekaku
Daruma

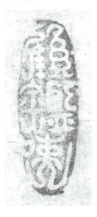

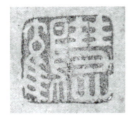

121 Hakuin Ekaku
Mount Fuji and Eggplant

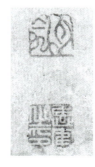

122 Hakuin Ekaku
God of Medicine

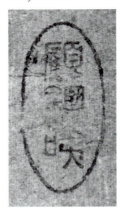

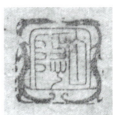

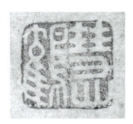

123 Hakuin Ekaku
Kannon Emerging from a Clamshell

124 Hakuin Ekaku
Seven Gods of Good Fortune
(Shichifukujin)

125 Hakuin Ekaku
Hotei on a Boat

126 Ōbaku Taihō
Bamboo

127 Suiō Genrō
Zen Monk Bukan

128 Jiun Sonja
A Single Path

*

129 Reigen Etō
Hotei in a Boat

130 Tōrei Enji
Ensō

*

131 Gōchō Kaichō
Shadow Daruma

132 Kōgan Gengei
Daruma

133 Shunsō Shōju
Daitō Kokushi as a Begging Monk

134 Sengai Gibon
Hotei Yawning

135 Sengai Gibon
Dazaifu Shrine

136 Yamaoka Tesshū
Dragon

137 Nakahara Nantenbō
Half-body Daruma

138 Nakahara Nantenbō
Procession of Monks

Bibliography

Addiss, Stephen. 1976. *Zenga and Nanga: Paintings by Japanese Monks and Scholars.* New Orleans: New Orleans Museum of Art.

———. 1977. *Uragami Gyokudō: The Complete Literati Artist.* Ann Arbor, Mich.: University Microfilms.

———. 1978. *Ōbaku: Zen Painting and Calligraphy.* Lawrence: Spencer Museum of Art, University of Kansas.

———. 1984. *The World of Kameda Bōsai: The Calligraphy, Poetry, Painting, and Artistic Circle of a Japanese Literatus.* New Orleans: New Orleans Museum of Art.

———. 1986. "The Life and Art of Fūgai Ekun (1568– 1654)." *The Eastern Buddhist,* n.s. 19, no. 1 (spring): 59–75.

———. 1987. *Tall Mountains and Flowing Waters: The Arts of Uragami Gyokudō.* Honolulu: University of Hawaii Press.

———. 1989. *The Art of Zen: Paintings and Calligraphy by Japanese Monks, 1600–1925.* New York: Harry N. Abrams.

———. 1996. "Nanga, Edo Period, Third, Fourth, and Fifth Generations." *Dictionary of Art Online.* New York: Grove Press.

———. 1997. "Hosokawa Rinkoku: Seal-carver, Poet, and Literati Painter." *Kaikodo Journal* (spring): 196–212.

———. 1997b. "Robert Motherwell and Zen." In *Robert Motherwell on Paper,* David Rosand, ed. New York: Harry N. Abrams.

———, ed. 1985. *Japanese Ghosts and Demons: Art of the Supernatural.* New York: George Braziller Publisher.

Addiss, Stephen, and Jonathan Chaves. 2000. *Old Taoist: The Life, Art, and Poetry of Kodōjin.* New York: Columbia University Press.

Addiss, Stephen, Michael R. Cunningham, Patricia Fister, William Jay Rathbun, and Melinda Takeuchi. 1983. *Myriad of Autumn Leaves: Japanese Art from the Kurt and Millie Gitter Collection.* New Orleans: New Orleans Museum of Art.

Aimi Shigekazu. 1915. "Higashiyama no shogakkai" (The Higashiyama exhibitions of calligraphy and painting). *Shoga kotto zasshi* 88.

Amagasaki Sōgō Bunka Sentaa, ed. 1981. *Itō Jakuchū ten* (Exhibition of Itō Jakuchū). Amagasaki: Amagasaki Sōgō Bunka Sentaa.

Aoki Shigeru, ed. 1991. *Meiji nihonga shiryō* (Sources of Meiji nihonga). Tokyo: Chūō Kōron Bijutsu Shuppan.

Asana Shūgō, ed. 1982. *Genshoku ukiyo-e dai hyakka jiten* (Encyclopedia of ukiyo-e in full color), vol. 4. Tokyo: Taishūkan.

Awakawa Yasuichi. 1970. *Zen Painting.* Trans. by John Bester. Tokyo: Kōdansha.

Azabu Museum of Art. 1986. *Azabu Bijutsukan: Shūzōhin zuroku* (Azabu Museum of Art: Catalogue of the collection). Tokyo: Azabu Museum of Art.

Azabu Museum of Art and Osaka Municipal Museum of Art. 1988. *Nikuhitsu ukiyo-e meihin ten: Azabu Bijutsukan shōzō* (Ukiyo-e painting masterpieces in the collection of the Azabu Museum of Art). Tokyo: Azabu Museum of Art; Osaka: Osaka Municipal Museum of Art.

Azabu Museum of Arts and Crafts and Japan Institute of Arts and Crafts. 1989. *Edo no fashon, kaikan kinen ten, I: Nikuhitsu ukiyo-e ni miru onnatachi no yosooi* (Fashion of Edo: Women's dress in ukiyo-e paintings). Tokyo: Azabu Museum of Arts and Crafts.

Barrett, William, ed. 1956. *Zen Buddhism: Selected Writings of D. T. Suzuki.* New York: Doubleday.

Berry, Elizabeth. 1994. *The Culture of Civil War in Kyoto.* Berkeley: University of California Press.

Berry, Paul. 1999. "The Relation of Japanese Painting to Nihonga," in Michiyo Morioka and Paul Berry, *Modern Masters of Kyoto: The Transformation of Japanese Painting Traditions.* Seattle: Seattle Art Museum, 32–39.

Berry, Paul, and Yokyō Ken'ichirō. 2001. *Unexplored Avenues of Japanese Painting: The Hakutakuan Collection.* Seattle: University of Washington Press.

Bowie, Theodore. 1975. *Japanese Drawings.* Bloomington: Indiana University Art Museum.

Brandt, Klaus J. 1977. *Hosoda Eishi, 1756–1829: Der Japanische Maler und Holzschnittmeister und Seine Schüler* (Hosoda Eishi, 1756–1829: The Japanese artist and woodcut master and his followers). Stuttgart, Germany: Eike Moog.

Brasch, Heinz. 1960. "Zen Buddhist Paintings from the Seventeenth to Nineteenth Centuries." *Oriental Art* 6, no. 2 (summer): 58–63.

Brasch, Kurt. 1957. *Hakuin to Zenga* (Hakuin and Zen painting). Tokyo: Japanisch-deutsche Gesellschaft.

———. 1962. *Zenga.* Tokyo: Nigensha.

Cahill, James. 1972. *Scholar Painters of Japan: The Nanga School.* New York: The Asia Society.

———, ed. 1981. *Shadows of Mt. Huang: Chinese Painting and Printing of the Anhui School.* Berkeley, Calif.: University Art Museum.

———. 1982. "Yosa Buson and Chinese Painting." In *Proceedings of the Fifth International Symposium on the Conservation and Restoration of Cultural Property.* Tokyo: National Research Institute of Cultural Properties.

———. 1996. *The Lyric Journey: Poetic Painting in China and Japan.* Cambridge: Harvard University Press.

Carpenter, John T. 1998. "The Human Figure in the Playground of Edo Artistic Imagination." In *Edo: Art in Japan 1615–1868*, Robert T. Singer, ed. Washington, D.C.: National Gallery of Art; New Haven, Conn.: Yale University Press.

Christie's. 1998a. *An Important Collection of Japanese Ukiyo-e Paintings.* New York: Christie's, October 27.

Christie's. 1998b. *Japanese Screens, Paintings, and Prints.* New York: Christie's, October 27.

Clark, Timothy. 1992. *Ukiyo-e Paintings in the British Museum.* Washington, D.C.: Smithsonian Institution Press.

———. 1997. "Utamaro's Portraiture." *Proceedings of the Japan Society*, no. 130 (winter).

Clark, Timothy, Anne Nishimura Morse, Louise E. Virgin, and Allen Hockley. 2001. *The Dawn of the Floating World, 1650–1765: Early Ukiyo-e Treasures from the Museum of Fine Arts, Boston.* London: Royal Academy of Arts.

Cleary, Thomas, and J. C. Cleary, trans. 1992. *The Blue Cliff Record.* Boston: Shambala.

Colnaghi Oriental. 1981. *One Thousand Years of Art in Japan.* London: Colnaghi Oriental.

Conant, Ellen, Steven D. Owyoung, and J. Thomas Rimer. 1995. *Nihonga, Transcending the Past: Japanese-Style Painting, 1868–1968.* Saint Louis: Saint Louis Art Museum.

Drexler, Arthur. 1966. *The Architecture of Japan.* New York: Museum of Modern Art.

Ekai. 1957. "The Gateless Gate." In *Zen Flesh, Zen Bones: A Collection of Zen and Pre-Zen Writings*, Paul Reps, ed. and comp. Rutland, Vt., and Tokyo: Charles E. Tuttle.

Fenollosa, Ernest F. 1963. *Epochs of Chinese and Japanese Art.* New York: Dover Publications.

Fenton, James. 2000. "The Exhibition Follies." *New York Review of Books* (December 21): 60.

Fields, Rick. 1981. *How the Swans Came to the Lake: A Narrative History of Buddhism in America.* Boulder, Colo.: Shambala.

Fister, Patricia. 1983. *Yokoi Kinkoku: The Life and Painting of a Mountain Ascetic.* Ann Arbor, Mich.: University Microfilms.

———. 1985/86. "Kinkoku and the Nagoya Haiku World." *Oriental Art* 31, no. 4: 392–407.

———. 1988. *Japanese Women Artists, 1600–1900.* Lawrence: Spencer Museum of Art, University of Kansas.

———. 1990. "The Impact of Shugendō on the Painting of Yokoi Kinkoku." *Ars Orientalis* 18: 163–95.

Fister, Patricia, and Dr. Kurt A. Gitter. 1985. *Japanese Fan Paintings from Western Collections.* New Orleans: New Orleans Museum of Art.

Fontein, Jan, and Money Hickman. 1970. *Zen Painting and Calligraphy.* Boston: Museum of Fine Arts.

Forrer, Matthi, ed. 1982. *Essays on Japanese Art Presented to Jack Hillier.* London: Robert G. Sawers.

French, Calvin. 1969. *Zaigai hihō: Ōbei shūzō Nihon kaiga shūsei* (Treasures of Japanese art in Western collections), Shimada Shūjirō, ed. Tokyo: Gakushū Kenkyūshu.

———. 1974. *The Poet-Painters: Buson and His Followers.* Ann Arbor. University of Michigan Art Museum.

Fujimori Seikichi. 1965. *Kinkoku shōnin gyōjō ki* (Record of the eminent monk Kinkoku's activities). Tōyō Bunko series, no. 37. Tokyo: Heibonsha.

Furuta Shōkin. 2000. *Sengai: Master Zen Painter.* Translated and adapted by Reiko Tsukimura. Tokyo, New York, and London: Kōdansha.

Gerstle, C. Andrew, ed. 1989. *Eighteenth Century Japan: Culture and Society.* Sydney: Allen and Unwin.

Gluckman, Dale Carolyn, and Sharon Sadako Takeda. 1992. *When Art Became Fashion: Kosode in Edo-period Japan.* New York and Tokyo: Weatherhill; Los Angeles: Los Angeles County Museum of Art.

Graham, Patricia. 1998. *Tea of the Sages: The Art of Sencha.* Honolulu: University of Hawaii Press.

Guth, Christine. 1996. *Art of Edo Japan: The Artist and the City, 1615–1868.* New York: Harry N. Abrams.

Haga Kōshiro. 1980. "Zen geijutsu to ha nani ka" (What is Zen art?). Special edition, *Taoiyō.* Tokyo: Heibonsha.

Haga Toru and Hayakawa Monta. 1994. *Buson.* Vol. 12, *Suibokuga no kyoshō* (Great masters of ink painting). Tokyo: Kōdansha.

Hatanaka Jōen. 1951. "Rakuyō garanki no sho hanpon to sono keito" (The lineage of printed versions of *The Record of Monasteries of Luoyang*). *Ōtani gakuhō* 30, no. 4: 39–55.

Hayakawa Monta. 1994. *Yosa Buson hitsu "Yashoku rōdai zu"* ("Night Snow over the City" by Yosa Buson). E wa kataru (Cultural memory in art), no. 12. Tokyo: Heibonsha.

———. n.d. "Eighteenth-century Kyoto and Yosa Buson." Unpublished manuscript.

Herf, Jeffrey. 1984. *Reactionary Modernism: Technology, Culture, and Politics in Weimar and the Third Reich.* Cambridge: Cambridge University Press.

Hickman, Money. 1976. *The Paintings of Soga Shōhaku (1730–1781).* Ann Arbor, Mich.: University Microfilms.

Hickman, Money L., and Yashuhiro Satō. 1989. *The Paintings of Jakuchū.* New York: The Asia Society Galleries.

Hillier, Jack. 1987. *The Art of the Japanese Book.* 2 vols. London: Philip Wilson Publishers.

Hisamatsu Shin'ichi. 1970. *Hisamatsu chosokushū* (Collected writings of Hisamatsu). Tokyo: Risōsha.

———. 1971. *Zen and the Fine Arts.* Tokyo: Kōdansha International.

Hughes, E. R. 1960. *Two Chinese Poets: Vignettes of Han Life and Thought.* Princeton, N.J.: Princeton University Press.

Huntsville Museum of Art. 1975. *Art of China and Japan.* Huntsville, Ala.: Huntsville Museum of Art.

Hyōgo Kenritsu Kindai Bijutsukan. 1992. *Morita Shiryū to "Bokubi"* (Morita Shiryū and "Bokubi"). Kobe: Hyōgo Kenritsu Kindai Bijutsukan.

Hyōgo Prefectural Museum. 1994. *Maruyama Ōkyo kinen tenrankai.* (Anniversary exhibition of works by Maruyama Ōkyo). Kyoto: Hyōgo Prefectural Museum.

Inui Norio. 1997. *Kindai no haiga to haiku* (Haiga and haiku of the modern era). Kyoto: Kyōto Shoin.

Iriya Yoshitaka, et al., eds. 1992. *Hekiganroku.* Tokyo: Iwanami Shoten.

Ishikawa Jun, Iriya Yoshitaka, Nakata Yujiro, and Kohara Hironobu. 1974–79. *Bunjinga suihen* (The essence of literati painting). 20 vols. Tokyo: Chūō Kōronsha.

Ishimaru Shōun. 1994. "Ōmi ni okeru Buson-ha no keifu" (The Buson lineage in Ōmi). In *Ōmi no bijutsu to minzoku,* Uno Shigeki, ed. Kyoto: Shibunkaku.

Isozaki Arata. 1987. *Katsura Villa: Space and Form.* New York: Rizzoli.

Itabashi Art Museum. 1982. *Karasumaru Mitsuhiro to Tawaraya Sōtatsu* (Karasumaru Mitsuhiro and Tawaraya Sōtatsu). Tokyo: Itabashi Art Museum.

Iwanami Shoten. 1999. *Suzuki Daisetsu zenshū* (Collected writings of Suzuki Daisetsu). 40 vols. Tokyo: Iwanami Shoten.

Iwasaki Haruko. 1984. *The World of Gesaku: Playful Writers of Late Eighteenth-century Japan.* Ann Arbor, Mich.: University Microfilms.

Izzard, Sebastian. 1993. *Kunisada's World.* New York: Japan Society.

Jenner, W. J. F. 1981. *Memories of Loyang: Yang Hsüan-chih and the Lost Capital,* 493–534. Oxford: Clarendon Press.

Kamisaka Sekka. 1919. "Shumi no kakumeika toshite no Kōrin" (Kōrin as the revolutionary of taste). *Geien* 2, no. 2 (February).

Kano Hiroyuki, ed. 2000. *Jakuchū!* Kyoto: Kyoto National Museum.

Kano Hiroyuki, Okudaira Shunroku, and Yasumura Toshinobu. 1993. *Hōitsu to Edo Rinpa* (Hōitsu and Edo Rinpa). Tokyo: Shūeisha.

Keene, Donald. 1976. *World within Walls: Japanese Literature of the Pre-Modern Era, 1600–1867.* Tokyo: Tuttle.

———, trans. 1998. *Essays in Idleness: The Tzurezuregusa of Kenkō.* New York: Columbia University Press.

Kimura Shigekazu. 1991. *Nakamura Hōchū gashū* (The paintings of Nakamura Hōchū). Kyoto: Fuji Art Publishing.

Kitazawa Noriaki. 1991. "'Nihonga' gainen no keisei ni kansuru shiron" (A personal view of the formulation of the concept of "nihonga"). In *Meiji nihonga shiryō* (Sources of Meiji nihonga), Aoki Shigeru, ed. Tokyo: Chūō Kōron Bijutsu Shuppan.

Kobayashi Tadashi. 1971. *Jakuchū tokubetsu tenkan zuroku* (Catalogue of the special exhibition of Jakuchū's paintings). Tokyo: Tokyo National Museum.

———. 1973. *Jakuchū, Shōhaku, Rosetsu.* Tokyo: Kōdansha.

———. 1992. "Utagawa Kunisada hitsu onna mitate shi-nō-kōshō" (Women representing the four social classes, by Utagawa Kunisada). *Kokka,* no. 1165.

———. 1996. *Itō Jakuchū.* Shincho Nihon Bijutsu (Shincho Japanese Art), no. 12. Tokyo: Shincho Bijutsu Bunko.

———. 1999. "Amerikan korekuta: Nihon bijutsu akogareta hitobito" (American collectors: People beguiled by Japanese art). *Asahi Graph* 4050 (October).

———, ed. 1990. *Fūgetsū chōjū* (Landscapes, birds, and animals). Vol. 3, *Rinpa* (Rinpa painting). Kyoto: Shikōsha.

———, ed. 1991. *Kachō* (Seasonal flowering plants and birds). Vol. 2, *Rinpa* (Rinpa painting). Kyoto: Shikōsha.

———, ed. 1995. *Nikuhitsu ukiyo-e taikan* (Compendium of ukiyo-e paintings). Vol. 6, *Azabu Bijutsu Kogeikan* (Azabu Museum of Arts and Crafts). Tokyo: Kōdansha.

Kobayashi Tadashi, and Kōno Motoaki, eds. 1998. *Nihon kaigaron taisei* (Compendium of Japanese painting). Tokyo: Perikansha.

———. 2001. *Kohitsu tekagami to gajō no meihin: Kinsei Nihon no aato arubamu* (Masterpiece albums of calligraphic exemplars and paintings: Art albums of Edo-period Japan). Tokyo: Suntory Museum of Art.

Kobayashi Tadashi, and Sasaki Jōhei. 1993. *Taiga to Ōkyo* (Taiga and Ōkyo). Nihon no bijutsu zenshū (Japanese art series), vol. 19. Tokyo: Kōdansha International.

Kobayashi Tadashi, Tsuji Nobuo, and Yamakawa Takeshi. 1977. *Jakuchū, Shōhaku, Rosetsu.* Suiboku bijutsu taikei (A survey of the art of ink painting), no. 14. Tokyo: Kōdansha.

Kokka 1910. "Andō Hiroshige hitsu Bushū Suzumegaura zu" (A painting of Suzumegaura in Musashi province by Andō Hiroshige). 237: 221, 225.

Kokufu Shutoku. 1928. *Kodōjin shushi* (A viewpoint of Kodōjin). Privately published.

Komatsu Kazuhiko. 2002. *Kyōto makai annai* (Guide to the world of spirits in Kyoto). Tokyo: Kobunsha.

Kōno Motoaki. 1981. "Kyōto gadan to Edo gadan—Kansei kara Bakumatsu-e" (The painting worlds of Kyoto and Edo—from the Kansei era to the close of the Edo period) and "Ōkyo to Goshun" (Ōkyo and Goshun). In *Ueda Akinari,* Matsuda Osamu, Kōno Motoaki, and Shinzaburo Oishi, eds. Vol. 17, *Nihon no koten* (Classical literature of Japan). Tokyo: Shueisha.

———. 1987. "Ten Rinpa Paintings: Recent Discoveries, no. 10." *Nihon keizai shinbun* (February 3): 30.

———. 1997. "Itō Jakuchū hitsu tsuru zu sofuku" (A pair of crane paintings by Itō Jakuchū). *Kokka* 1225 (November): 23–25.

Kumita Shōhei, Nakamura Tanio, and Shirasaki Hideo, eds. 1976. *Sakai Hōitsu gashū* (Collection of paintings by Sakai Hōitsu). Tokyo: Kokusho Kankōkai.

Kurashiki Shiritsu Bijutsukan, ed. 1990. *Yokoi Kinkoku to Kurashiki* (Yokoi Kinkoku and Kurashiki). Kurashiki: Kurashiki Shiritsu Bijutsukan.

Kurimoto Kazuo, ed. 1960. *Ike Taiga sakuhinshū* (Collected works of Ike Taiga). Tokyo: Chūō Kōron Bijutsu Shuppan.

Kurokawa, Mamichi, ed. 1914–15. *Nihon fūzoku zue* (Japanese social customs in illustrated books), vol. 1. Tokyo: Nihon Fūzoku Zue Kankōkai.

Kuwayama, George. 1976. "Japanese Paintings from the Brotherton Collection." *Apollo* (February): 140–43.

Kyōto Hakubutsukan, ed. 1934. *Ōmi Buson Kyūrō tenkan mokuroku* (Catalogue of an exhibition of Ōmi Buson Kyūrō). Kyoto: Kyōto Hakubutsukan.

Kyoto National Museum. 1995. *Ōkyo: Poetic Sentiment and Reformation*. Kyoto: Kyōto Shimbun.

Kyōto Shinbunsha. 1997. *Kindai nihonga no kakushin to sōzō—Kokuga Sōsaku Kyōkai no gakatachi ten* (Innovation and creation in modern nihonga—Exhibition of artists of the Association for the Creation of National Painting). Kyoto: Kyōto Shinbunsha.

Lawton, Thomas, and Thomas W. Lentz. 1998. *Beyond the Legacy: Acquisitions for the Freer Gallery of Art and the Arthur M. Sackler Gallery*. Washington, D.C.: Freer Gallery of Art and Arthur M. Sackler Gallery.

Link, Howard. 1990. *Exquisite Visions: Rimpa Paintings from Japan*. Honolulu: Honolulu Academy of Arts.

Los Angeles County Museum of Art. 1965. *Art Treasures from Japan*. Los Angeles, Calif.: Los Angeles County Museum of Art.

Makoto, Aida. 1999. *Aida Makoto sakuhinshū* (Collected works of Aida Makoto) Tokyo: Mizuma Art Gallery.

Markus, Andrew. 1993. "Shogakai: Celebrity Banquets of the Late Edo Period." *Harvard Journal of Asiatic Studies* 53, no. 1: 135–67.

Maruyama Kazuhiko. 1975. "Buson to Gyōdai to no kōshō" (The relationship of Buson and Gyōdai). In *Buson/Issa*. Tokyo: Yūseidō.

Mason, Penelope E. 1977. *Japanese Literati Painters: The Third Generation*. New York: The Brooklyn Museum.

———. 1993. *History of Japanese Art*. New York: Abrams.

McCallum, Donald F. 1976. "Edo Paintings from the Brotherton Collection at the Los Angeles County Museum of Art." *Oriental Art* (spring): 97–99.

McKelway, Matthew P. 1997. "The Partisan View: Rakuchū Rakugai Screens in the Mary and Jackson Burke Collection." *Orientations* 28, no. 2 (February): 48–57.

Mitchell, Charles. 1972. *Biobibliography of Nanga, Maruyama and Shijō Illustrated Books*. Los Angeles: Dawson's Bookshop.

Miyake Hitoshi. 1973. "Monzeki no mineiri ni mirareru kyōdan soshiki" (The organization of the religious fraternity seen in the mountain pilgrimages of imperial abbots). *Shinto shūkyō* 69, no. 19.

Moes, Robert. 1973. *Rosetsu*. Denver, Colo.: Denver Museum of Art.

Morioka, Michiyo, and Paul Berry. 1999. *Modern Masters of Kyoto: The Transformation of Japanese Painting Traditions*. Seattle: Seattle Art Museum.

Morris, Mark. 1989. "Group Portrait with Artist: Yosa Buson and His Patrons." In *Eighteenth Century Japan: Culture and Society*, C. Andrew Gerstle, ed. Sydney: Allen and Unwin.

Morse, Anne Nishimura, and Samuel Crowell Morse. 1995. *Object as Insight: Japanese Buddhist Art and Ritual*. Kathona, New York: Katonan Museum of Art.

Murase, Miyeko. 1975. *Japanese Art: Selections from the Mary and Jackson Burke Collection*. New York: The Metropolitan Museum of Art.

———. 2000. *Bridge of Dreams: The Mary Griggs Burke Collection of Japanese Art*. New York: The Metropolitan Museum of Art.

Murashige Yasushi and Kobayashi Tadashi, eds. 1989. *Kachō* (Flowering plants and birds of the four seasons). Vol. 1, *Rinpa* (Rinpa painting). Kyoto: Shikōsha.

———. 1991. *Jinbutsu* (Scenes from literature, people). Vol. 4, *Rinpa* (Rinpa painting). Kyoto: Shikōsha.

———. 1992. *Sōgō* (Assorted themes). Vol. 5, *Rinpa* (Rinpa painting). Kyoto: Shikōsha.

Nagoya-shi Hakubutsukan, ed. 1981. *Owari no kaigashi, nanga* (A history of painting in Owari: Nanga). Nagoya: Nagoya-shi Hakubutsukan.

———. 1990. *Owari no bunjinga* (Bunjinga in Owari). Nagoya: Nagoya-shi Hakubutsukan.

Nakamura Shin'ichirō. 2000. *Kimura Kenkadō no saron* (Kimura Kenkadō's salon). Tokyo: Shinchōsha.

Nakamura Tanio. 1979. *Hōitsu-ha kachō gafu* (Edo Rinpa and the artists surrounding Sakai Hōitsu), vol. 4. Kyoto: Shikōsha.

Nakao Chōken. 1998. "Kinsei itsujin gashi" (Painting history of the early modern eccentrics). In *Nihon kaigaron taisei* (Compendium of Japanese painting), vol. 10. Kobayashi Tadashi and Kōno Motoaki, eds. Tokyo: Perikansha.

Naquin, Susan. 1976. *Millenarian Rebellion in China: The Eight Trigrams Uprising of 1813*. New Haven, Conn.: Yale University Press.

Narazaki Muneshige. 1982. *Chōshun. Nikuhitsu ukiyo-e meihin* (Famous examples of ukiyo-e painting), vol. 3. Tokyo: Shueisha.

Nihon Keizai Shinbun. 1966. *Sōtatsu ten: Kinsei nihonbi no sui* (Sōtatsu exhibition: The essence of the early modern aesthetic). Osaka: Nihon Keizai Shinbunsha.

———. 1973. *Kinsei itan no geijutsuten*. Osaka: Nihon Keizai Shinbunsha.

———. 1977. *Sakai Hōitsu ten* (Exhibition of Sakai Hōitsu). Tokyo: Nihon Keizai Shinbunsha.

Nishimura Tajirō. 1932. "Yokoi Kinkoku to Ki Baitei" (Yokoi Kinkoku and Ki Baitei). *Shoga kottō zasshi* 286: 10.

Odakane Tarō. 1965. *Tessai: Master of the Literati Style*. Translated and adapted by Money L. Hickman. Tokyo: Kōdansha.

Ogata Tsutomu, Sasaki Jōhei, and Okada Akiko, eds. 1998. *Buson zenshū* (Complete works of Buson). 8 vols. Tokyo: Kōdansha.

Okada Rihei. 1973. *Oku no hosomichi emaki* (The *Oku no hosomichi* illustrated handscrolls). Tokyo: Tōyō Shobō.

———. 1979. *Buson*. Vol. 5, *Haijin no shoga bijutsu* (Calligraphy and painting of the haikai poets). Tokyo: Shūeisha.

Okudaira Shunroku, Katagiri Yayoi, Kano Hiroyuki, and Kimura Shigekazu. 1993. *Kōrin to Kamigata Rinpa* (Kōrin and Kamigata Rinpa). Vol. 2, *Rinpa Bijutsukan* (Rinpa Museum). Tokyo: Shūeisha.

Osaka Bijutsu Club. 1935. *Sannōsō zōhin tenkan zuroku* (Exhibition catalogue from the Sannōsō collection). Osaka: Osaka Bijutsu Club.

Ōtani Tokuzō, ed. 1972. *Buson shū* (Collected works of Buson). Vol. 12, *Koten haibungaku taikei* (Collection of classical haikai). Tokyo: Shūeisha.

———. 1981. "Tegami ni miru Buson: Gyōdai e no kizukai" (Buson seen through letters: His concern toward Gyōdai). *Biburiya*, no. 76 (April).

Ōtsu City Museum of History. 2001. *Avenues of Japanese Painting: The Hakutakuan Collection*. Seattle: University of Washington Press.

Ōtsu-shi Rekishi Hakubutsukan, ed. 1810. *Baitei hokku shū* (Collection of Baitei's hokku). Privately published.

———. 1994. *Bashō to Ōmi no monjintachi* (Bashō and his pupils in Ōmi). Ōtsu: Ōtsu-shi Rekishi Hakubutsukan.

Ōtsu-shi Yakusho. 1980. *Konan no haidan* (The haikai world of Konan). *Shinshū Ōtsu-shi shi*, vol. 3. Ōtsu: Ōtsu-shi Yakusho.

Parker, Joseph. 1999. *Zen Buddhist Landscape Arts of Early Muromachi Japan (1336–1573)*. Albany: State University of New York Press.

Poster, Amy, Richard M. Barnhart, Christine Guth, and John Bigelow Taylor. 1999. *Crosscurrents: Masterpieces of East Asian Art from New York Private Collections*. New York: Japan Society.

Rittō Rekishi Minzoku Hakubutsukan, ed. 1991. *Oka Ritsuzan to Yokoi Kinkoku: Kurita no bunjin gaka* (Oka Ritsuzan and Yokoi Kinkoku: Bunjin painters of Kurita). Rittō: Rittō Rekishi Minzoku Hakubutsukan.

———. 1999. *Ōmi Kotō/Kōnan no gajin tachi* (Painters of the Kōtō and Kōnan areas of Ōmi). Rittō: Rittō Rekishi Minzoku Hakubutsukan.

Rosenfield, John. 1979. *Song of the Brush: Japanese Paintings from the Sansō Collection*. Seattle: Seattle Art Museum.

Rosenfield, John M., and Fumiko E. Cranston. 1999. *Extraordinary Persons: Works by Eccentric, Non-Conformist Japanese Artists of the Early Modern Era (1580–1868) in the Collection of Kimiko and John Powers*, Naomi Noble Richard, ed. 3 vols. Cambridge: Harvard University Art Museums.

Rosenfield, John M., and Shimada Shūjirō. 1970. *Traditions of Japanese Art: Selections from the Kimiko and John Powers Collection*. Cambridge: Fogg Art Museum, Harvard University.

Rosenfield, John M., and Elizabeth ten Grotenhjuis. 1979. *Journey of the Three Jewels: Japanese Buddhist Paintings from Western Collections*. New York: The Asia Society.

Rubinger, Richard. 1982. *Private Academies of Tokugawa Japan*. Princeton, N.J.: Princeton University Press.

Sakakibara Yoshirō. 1981. *Kindai no Rinpa Kamisaka Sekka* (Modern Rinpa Kamisaka Sekka). Kyoto: Kyōto Shoin.

Sakamoto Kōjō. 1958. "On Tessai." In *Tomioka Tessai, 1838–1924: A Loan Exhibition of Paintings from the Kiyoshi Kōjin Temple, Takarazuka, Japan*. New York: The Metropolitan Museum of Art.

———. 1960. "Amerika junkaiten kiroku Tessai" (Tomioka Tessai: Commemorative picture album of Tessai's circulating exhibition). Takarazuka, Japan.

Sasaki Jōhei. 1975. *Yosa Buson*. Nihon no bijutsu (Arts of Japan), no. 109. Tokyo: Shibundō.

———. 1979. "Ike Taiga: Sono seisaku katei ni kansuru ikkōsatsu" (Ike Taiga: A consideration of his production process). *Yamato bunka* (October).

———. 1998. *Bunjinga no kanshō kiso chishiki* (Appreciation and basic knowledge of literati painting). Tokyo: Shibundō.

Sasaki Jōhei and Sasaki Masako. 1998. *Bunjinga no kanshō kisho chishiki* (Foundation for the appreciation of nanga). Tokyo: Shibundō.

———. 2001a. "Tokushū Yosa Buson: Edo jidai runesansu saidai no maruchi aatisuto" (Yosa Buson: Versatile artist of the Edo renaissance). *Geijutsu shinchō* (February). Special issue.

———. 2001b. *Koga sōran: Maruyama Shijō ha* (Survey of old paintings: Maruyama-Shijō school). Tokyo: Kokusho Kankōkai.

———, eds. 2001. "Buson: Sono naiteki sekai no tabi" (Buson's inner journey). In *Buson: Sono futatsu no tabi* (Buson: His two journeys). Tokyo: Asahi Shinbunsha.

Sasaki Jōhei, Ogata Tsutomu, and Okada Akiko. 1998. *Buson zenshū* (Complete works of Buson). Tokyo: Kōdansha.

Satō Dōshin. 1996. "*Nihon bijutsu*" tanjō: Kindai Nihon no "kotoba" to senryaku (The birth of "Japanese art": Strategies of "terminology" in modern Japan). Tokyo: Kōdansha.

Sato Yasuhiro. 1989. *The Paintings of Jakuchū*. New York: The Asia Society Galleries.

Screech, Timon. 1993. "The Strangest Place in Edo: The Temple of the Five Hundred Arhats." *Monumenta Nipponica* 48, no. 4 (winter): 407–28.

———. 1999. *Sex and the Floating World: Erotic Images in Japan, 1700–1820*. London: Reaktion Books.

———. 2000. *The Shogun's Painted Culture: Fear and Creativity in the Japanese States, 1760–1829*. London: Reaktion Books.

Seigle, Cecilia Segawa. 1993. *Yoshiwara: The Glittering World of the Japanese Courtesan*. Honolulu: University of Hawaii Press.

Sengai. 1956. *India-Ink Drawings by the Famous Zen Priest, Sengai*. Oakland, Calif.: Privately published.

Seo, Audrey Yoshiko. 1993. "Kamisaka Sekka: Master of Japanese Design." *Orientations* 24, no. 12 (December): 38–44.

———. 1997. *Painting-Calligraphy Interactions in the Zen Art of Hakuin Ekaku (1685–1768)*. Ann Arbor, Mich.: University Microfilms.

Seo, Audrey, and Stephen Addiss. 2000. *The Art of Twentieth-Century Zen*. Boston: Shambala.

Seto-shi Shi Hensan Iinkai. n.d. *Tōji shi hen* (Section on history of ceramics). Vol. 3, *Seto-shi shi* (History of Seto). Tokyo: Daiichi Hōki Shuppan.

Sharf, Robert H. 1995. "The Zen of Japanese Nationalism." In *Curators of the Buddha: The Study of Buddhism under Colonialism*, Donald S. Lopez, ed. Chicago: University of Chicago Press.

Shiga Kenritsu Biwako Bunkakan. 1964. *Kyūrō* (Old man [Baitei]). Ōtsu: Shiga Kenritsu Biwako Bunkakan.

Shiga-ken Kurita-gun Yakusho, ed. 1926. *Ōmi Kurita-gun shi* (A history of Kurita county, Ōmi). Gifu: Shiga-ken Kurita-gun Yakusho.

Shiga-ken Kyōiku Iinkai, ed. [1917] 1986. *Ōmi jinbutsu shi* (Record of Ōmi notables). Tokyo: Rinsen Shoten.

Shimada Shūjirō, ed. 1969. *Zaigai hihō ōbei shūzō Nihon kaiga shūsei* (Treasures of Japanese art in Western collections). Tokyo: Gakushū Kenkyūshu.

Shimizu, Yoshiaki. 2001. "Japan in American Museums—But Which Japan?" *The Art Bulletin* 83, no. 1 (March): 123–34.

Shimizu, Yoshiaki, and Carolyn Wheelwright. 1976. *Japanese Ink Paintings from American Collections: The Muromachi Period. An Exhibition in Honor of Shūjiro Shimada*. Princeton, N.J.: Princeton University Press.

Shinshū Nagoya-shi Shi Henshū Iinkai, ed. 1999. *Kinsei zenki ni okeru Owari no haikai* (Haikai in Owari in the early Edo period). Vol. 3, *Nagoya-shi shi* (History of Nagoya city). Nagoya: Shinshū Nagoya-shi Shi Henshū Iinkai.

Singer, Robert T. 1998. "Old Worlds, New Visions: Religion and Art in Edo Japan." In *Edo: Art in Japan, 1615–1868*, Robert T. Singer, ed. Washington, D.C.: National Gallery of Art, 203–24.

Singleton, John, ed. 1993. *Competition and Collaboration: Hereditary Schools in Japanese Culture*. Boston: Isabella Stewart Gardner Museum.

———. 1999. *Learning in Likely Places: Varieties of Apprenticeship in Japan*. Cambridge: Cambridge University Press.

Stern, Harold P. 1973. *Ukiyo-e Painting. Freer Gallery of Art: Fifteenth Anniversary Exhibition—I*. Washington, D.C.: Smithsonian Institution.

———. 1976. *Birds, Beasts, Blossoms, and Bugs: The Nature of Japan*. New York: Harry N. Abrams.

Stevens, John, and Alice Rae Yelen. 1990. *Zenga: Brushstrokes of Enlightenment*. New Orleans: New Orleans Museum of Art.

Suntory Museum of Art. 1981. *Sakai Hōitsu to Edo Rimpa* (Sakai Hōitsu and Edo Rimpa). Toyko: Suntory Museum of Art.

———. 2001. *Kohitsu tekagami to gajō no meihin* (Masterpiece albums of calligraphic exemplars and paintings). Kinsei Nihon no aato arubamu (Art albums of Edo-period Japan), no. 69. Tokyo: Suntory Museum of Art.

Suzuki, D. T. 1957. "Sengai and Zen Art." *Art News Annual* (winter), pt. 2: 114–21.

———. 1959. *Zen and Japanese Culture*. New York: Pantheon Books.

———. 1972. *Sengai: The Zen Master*. Greenwich, Conn.: New York Graphic Society.

———. 1977. *Hakuin, Hosokawa korekuson ni yoru* (Hakuin paintings from the Hosokawa collection). Mishima: Sano Bijutsukan.

Suzuki Einosuke, ed. 1932. *Kenhi kinen Bunchō iboku tenrankai zuroku* (Memorial exhibition catalogue of Bunchō's paintings and calligraphy). Tokyo.

Suzuki Susumu. 1960. *Ike Taiga no sakuhinshū* (The collected works of Ike Taiga). Tokyo: Chūō Kōron Bijutsu Shuppan.

———, ed. 1975. *Ike Taiga*. Nihon no bijutsu (Arts of Japan), no. 114. Tokyo: Shibundō.

Tabei Ryūtarō. 1911. *Chūkyō gadan* (Discussions of Nagoya painting). Tokyo: Tōyō Insatsu Kabushiki Kaisha.

Tajima Shiichi, ed. 1909–10. *Nanga jū taika shū* (A collection of the ten great literati painters). 2 vols. Tokyo: Shinbi Shoin.

Takahashi Shōji. 2000. *Buson denki kōsetsu* (A consideration of Buson's biography). Tokyo: Shunshūsha.

Takamura Kōtarō. 1910. "Ryokushoku no taiyō" (A green sun). *Subaru* (April). Reissued in *A Brief History of My Imbecility*. Honolulu: University of Hawaii Press, 2001: 180–86.

Takeda Kōichi, ed. 1997. *Yoriai shogajō: Bunjin shoka* (Assembled albums of calligraphy and painting: Bunjin and other artists). *Edo meisaku gajō zenshū*, vol. 10. Tokyo: Shinshindō.

Takeda, Sharon Sadako. 1992. "Clothed in Words: Calligraphic Design on Kosode." In Dale Carolyn Gluckman and Sharon Sadako Takeda, *When Art Became Fashion: Kosode in Edo-period Japan*. New York: Weatherhill; Los Angeles: Los Angeles County Museum of Art.

Takeda Tsuneo, ed. 1981. *Byōbu-e taikan: Nihon byōbu-e shūsei, bekkan* (Survey of screens: Collected Japanese screen paintings, appendix). Tokyo: Kōdansha.

Takeuchi, Melinda. 1983. "Ike Taiga: A Biographical Study." *Harvard Journal of Asiatic Studies* 43, no. 1 (June): 141–86.

———. 1992. *Taiga's True Views: The Language of Landscape Painting in Eighteenth-century Japan.* Stanford, Calif.: Stanford University Press.

Tamamura Takeiji. 1955. *Gozan bungaku* (Gozan literature). Tokyo: Shubundo.

Tamamushi Satoko. 1997. *Sakai Hōitsu.* Tokyo: Shinchōsha.

Tanaka Ichimatsu, ed. 1979. *Uragami Gyokudō gafu* (Paintings of Uragami Gyokudō). Tokyo: Chūō Kōronsha.

Tanaka Tatsuya. 1986. "Hōtei Gosei no kenkyū" (Research on Hōtei Gosei). *Azabu Bijutsukan kenkyū Kiyō* (Bulletin of the Azabu Museum of Art), no. 1 (spring): 38–39.

Taut, Bruno. 1938. *Houses and People of Japan.* London: John Gifford.

Toda, Kenji. 1931. *Descriptive Catalogue of Japanese and Chinese Illustrated Books in the Ryerson Library of the Art Institute of Chicago.* Chicago: Art Institute of Chicago.

Tōkyō Kokuritsu Kindai Bijutsukan. 1999. *Yokoyama Misao ten* (Exhibition of Yokoyama Misao). Tokyo: Tōkyō Kokuritsu Kindai Bijutsukan.

Tokyo National Museum. 1972. *Rinpa.* Tokyo: Tokyo National Museum.

———. 1993. *Nikuhitsu ukiyo-e* (Ukiyo-e painting). Tokyo: Tokyo National Museum.

Tōkyūsha. 1942. *Daitōa sensōga* (Greater East Asia war painting). Tokyo: Fuzanbō.

Tsuji Nobuo. 1974. *Jakuchū.* Tokyo: Bijutsu Shuppansha.

———. 2000a. *Nagasawa Rosetsu: Botsugo 200 kinen* (Nagasawa Rosetsu 200th anniversary exhibition). Tokyo: Nihon Keizai Shinbunsha.

———. 2000b. *Bosuton Bijutsukan nikuhitsu ukiyo-e* (Ukiyo-e paintings in the Museum of Fine Arts, Boston). Tokyo: Kōdansha; Boston: Museum of Fine Arts.

Tsuji Nobuo and Itō Shiori, eds. 1998. *Edo no kisai: Soga Shōhaku* (Edo genius: Soga Shōhaku). Tokyo: Asahi Shimbun.

Tsuji Nobuo, Money Hickman, and Kōno Motoaki. 1977. *Jakuchū/Shōhaku.* Nihon bijutsu kaiga zenshū (Complete collection of Japanese painting), no. 23. Tokyo: Shūeisha.

University Art Museum. 1968. *The Works of Tomioka Tessai.* Berkeley, Calif.: University Art Museum.

Uno Shigeki, ed. 1994. *Ōmi no bijutsu to minzoku: "Ōmi ni okeru Buson-ha no keifu."* (The Buson lineage in Ōmi). Kyoto: Shibunkaku.

Wattles, Miriam. 2001. "Ukiyo-e's Debt to the Hanabusa Gafu." *Ukiyo-e Society Bulletin* (spring): 1–5.

Welch, Matthew. 1985. "Shōki the Demon Queller." In *Japanese Ghosts and Demons: Art of the Supernatural,* Stephen Addiss, ed. New York: George Braziller.

———. 1995. *The Painting and Calligraphy of the Japanese Zen Priest Tōjū Zenchū, alias Nantenbō.* Ann Arbor, Mich.: University Microfilms.

Westgeest, Helen. 1966. *Zen in the Fifties: Interaction in Art between East and West.* Zwolle, Netherlands: Waanders.

Winther, Bert. 1994. "Japanese Thematics in Postwar American Art: From Soi-disant Zen to the Assertion of Asian-American Identity." In *Japanese Art after 1945: Scream against the Sky,* Alexandra Monroe, ed. New York: Harry Abrams.

Woodson, Yoko. 2001. *Zen: Painting and Calligraphy.* San Francisco: Asian Art Museum of San Francisco.

Woodson, Yoko, and Richard L. Mellott. 1994. *Exquisite Pursuits: Japanese Art in the Harry G. C. Packard Collection.* San Francisco: Asian Art Museum.

Wu Hung. 1995. *Monumentality in Early Chinese Art and Architecture.* Stanford, Calif.: Stanford University Press.

Yamane Yūzō, ed. 1962. *Sōtatsu.* Tokyo: Nihon Keizai Shinbunsha.

———. 1977–80. *Rinpa kaiga zenshū* (Rinpa Paintings). 5 vols. Tokyo: Nihon Keizai Shinbunsha.

Yamane Yūzō, Masato Naitō, and Timothy Clark. 1998. *Rimpa Art from the Idemitsu Collection, Tokyo.* London: British Museum Press.

Yamanouchi Chōzō. 1981. *Nihon nanga shi* (History of nanga in Japan). Tokyo: Ruri Shobō.

Yamashita Yūji. 2000. *Zenga—The Return from America: Zenga from the Gitter-Yelen Collection.* Tokyo: Shōtō Museum of Art.

———, ed. 2000. *Zenga—Kaettekita zenga* (Zenga—The return of zenga). Tokyo: Asano Kenkyūjo.

Yonezawa Yoshiho and Chu Yoshizawa. 1974. *Japanese Painting in the Literati Style.* New York: Weatherhill; Tokyo: Heibonsha.

Yuasa, Nobuyuki, trans. 1966. *Bashō: The Narrow Road to the Deep North and Other Travel Sketches.* Harmondsworth, England: Penguin Classics.

Zheng Liyun. 1997. *Bunjin Ike no Taiga kenkyū: Chūgoku bunjin shishoga "sanzetsu" no Nihon-teki juyō* (Literatus Ike no Taiga research: Japanese reception of Chinese literati paintings of the "Three Perfections"). Tokyo: Hakuteisha.

Zolbrod, Leon. 1988. "The Busy Year: Buson's Life and Work, 1777." *Transactions of the Asiatic Society of Japan,* 4th series.